MW00558757

For information address Disney Editions, 77 West 66th Street, New York, New York 10023.

Editorial Director: Wendy Lefkon
Senior Editors: Jennifer Eastwood and Jim Fanning
Design: Scott Piehl and Lindsay Broderick
Managing Editor: Monica Vasquez
Production: Jerry Gonzalez and Marybeth Tregarthen

ISBN: 978-1-368-04936-8
FAC-067395-23039
Printed in the United States of America
First Hardcover Edition, November 2022
10 9 8 7 6 5 4 3 2 1
Visit www.disneybooks.com

Certified Sourcing

www.forests.org
SFI-01681

Logo Applies to Text Stock Only

THE IMAGINEERING STORY

THE OFFICIAL BIOGRAPHY OF
WALT DISNEY IMAGINEERING

For Marty Sklar, whose vision and love for Walt Disney Imagineering inspired the documentary series and book.

To Bob Weis, whose continued dedication and passion made this possible.

To the thousands of Imagineers past and present who have created the impossible.

And to all the fans whose love for Disney parks make them the happiest places on Earth.

THE IMAGINEERING STORY

THE OFFICIAL BIOGRAPHY OF WALT DISNEY IMAGINEERING

Leslie Iwerks

with Bruce C. Steele and special contributions
by Mark Catalena

EDITIONS

LOS ANGELES • NEW YORK

CONTENTS

THE IMAGINEERING STORY

THE OFFICIAL BIOGRAPHY OF
WALT DISNEY IMAGINEERING

Inside Walt Disney Imagineering, Leslie Iwerks lines up a shot to capture the Disney creative process for her Disney+ docuseries, *The Imagineering Story* (2019), which served as the inspiration for this book.

PROLOGUE

I N 2008, I was invited to screen my recently completed feature documentary *The Pixar Story* at Walt Disney Imagineering. It had been a long time since I had visited the unassuming campus in Glendale, California, and I was thrilled to step back into this illusive place that had long been shrouded in secrecy.

After the screening and Q&A were over, I remember Marty Sklar, then the Global Imagineering Ambassador, and a protégé of Walt Disney himself, walked up to me and asked very directly, "So, Leslie, when are you going to make the Imagineering story?" And without hesitation I responded, "Well, Marty, you tell me!" And that was the beginning of one of the happiest periods of my career to date, to tell the then sixty-plus-year history of Walt Disney Imagineering since its formation by Walt Disney in 1952. The result would be a six-part documentary series for Disney+ along with this official biography for Disney Publishing, both called *The Imagineering Story* in honor of Marty's initial question.

The film was originally commissioned by WDI as a feature documentary to be completed within a year or so; however, it wasn't long before Marty and the leadership felt I should travel to all the parks over the span

of five years—which ultimately became seven—to capture a new golden age of Imagineering during one of the company's greatest periods of growth. At this time, the Imagineers were just breaking ground on a new Disney resort in Shanghai, overhauling Disney California Adventure in Anaheim, revamping Walt Disney World's New Fantasyland in Orlando, mapping out a whole new *Star Wars*: Galaxy's Edge in Disneyland and Walt Disney World, and about to launch two new state-of-the-art Disney Cruise Line ships, the *Disney Dream* and the *Disney Fantasy*, out to sea. At the time, I had no idea all this and more was currently in the works, but was soon given unprecedented access to document virtually every secret work-in-progress attraction around the world.

Back during the construction of EPCOT in the early '80s, my dad, Don, oversaw the Studio Machine Shop where hundreds of state-of-the-art projectors and camera systems were being designed and built for the many unique attractions in the park. He would take me with him on weekends and let me loose while he worked extra hours to meet the grueling deadlines. These were the wondrous days of the Studio Machine Shop and backlot, and it became my own haven to roam around. I remember seeing one of my favorite film stars—Herbie the Love Bug—parked on the side of the backlot street, right in front of the *Shaggy D.A.* set. Then walking through the old Western saloons to find no interiors, but just plywood infrastructure holding up the exterior facades. So much of this behind-the-scenes magic was imprinted in my mind because of the sixteen-millimeter Disney movies my dad brought home to project for my sister and me and the neighborhood kids, and then to see the real locations backstage was awe-inspiring. I remember him driving us through the back gates of EPCOT, where large animatronic dinosaurs and other hydraulic creatures were being built and tested. Being a fly on the wall to all this activity growing up was the spark that fueled my lifelong interest in telling stories about creators, artists, visionaries, and innovators.

Cut to nearly four decades later, and I am walking backstage at every Disney park around the world and Walt Disney Imagineering, meeting and interviewing over two-hundred Imagineers, so many of the brightest minds the film and themed entertainment industries have ever seen. From

dirt to opening day, I made numerous trips to Shanghai Disney Resort to document the journey, but what was captured through my lens was just a fraction of the enormity and scale of the Imagineers' monumental endeavors. It became clear that Walt Disney created "The Happiest Place on Earth," but creating happiness is hard work. I was guided through history by Imagineers of each generation. Bob Gurr walked me inside the echoey chambers of the Matterhorn, where we took a narrow elevator up and shot hoops on the basketball court where mountain climbers of decades past took their breaks. Kim Irvine and I strolled down Main Street, U.S.A., discussing John Hench's original color schemes, then down into the Haunted Mansion dining room to film dancing ghosts. Marty Sklar toured me through Pirates of the Caribbean (at four a.m.!) and, standing amidst pirates, he illustrated the genius of Imagineering storytelling under one roof, from X Atencio's songs, to Marc Davis' character designs, Alice Davis' costumes, to the state of the art Audio-Animatronics technology developed by a cadre of geniuses. And how could one not mention being one of the first people to launch out of a vehicle at 60mph with Scot Drake, the creative lead on TRON Lightcycle Power Run as he proudly showed off the fastest Disney roller coaster yet in Shanghai Disneyland. Imagineers have one of the best jobs in the world, and nothing was more clear than when Scott Trowbridge toured me through the *Star Wars*: Galaxy's Edge prior to one of the most historic opening day's in Disney theme park history. His enthusiasm to show off every bit of handcrafted detail, not only overt but hidden, all in service to the new Batuu story, was truly inspiring. It was especially touching when Kevin Rafferty and Charita Carter toured me through Mickey & Minnie's Runaway Railway in Disney's Hollywood Studios, only to reveal their own "hidden Mickey" homage to my grandfather, Ub, with a sign above the culvert that reads IWERKS AND UWERKS WATER WORKS, seen just before the railway car is swept into the city by a digital rush of water. The passion for all things past inspires the present at Imagineering.

From blue sky ideation, to pencil on paper, to digital models, to plaster and paint, Imagineers build dreams. They *never* say "never," and the sky is *not* the limit. No idea is a bad idea (at first, anyway!) and they

inherently have it in their veins to say "Yes, *if*," instead of "No, because," to any creative idea. Imagineering is a mindset. It is teamwork. It is passion. It is egoless. It is about creating the most exciting, immersive, and unexplored experiences yet. This goes across every facet—be it a ride, an attraction, an Audio-Animatronics figure, a show, a restaurant, a hotel, a meal, a parade, a costume, or just a simple story pulling you through a queue. The goal of every Imagineer, just like Walt Disney himself, is to reassure you—to make you smile, to make you laugh, and to make you wonder, *how did they do that?*

For every person documented in this biography, there are thousands more who have contributed greatly behind the scenes. This is just a marker in time as the next generation of Imagineers rise up and stand on the shoulders of those who've come before, and build on the great legacy of Walt Disney and his original Imagineers.

Leslie Iwerks
June 2022
Santa Monica, California

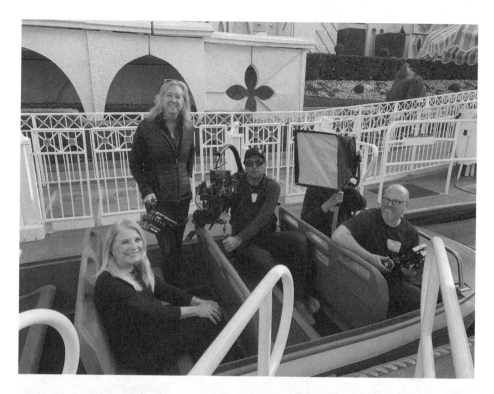

TOP: Embarking on The Happiest Cruise that Ever Sailed, Leslie and her crew prepare to film Imagineer Kim Irvine on the "it's a small world" attraction at Disneyland. BOTTOM: While filming for *The Imagineering Story* at Disneyland, Marty Sklar—Disney Legend and former vice chairman, Walt Disney Imagineering—swaps tall tales about the buccaneers of the quintessential Disney theme park attraction, Pirates of the Caribbean.

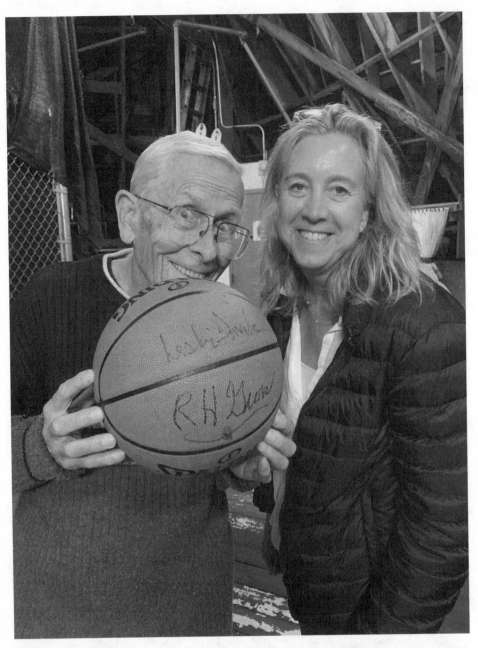

Leslie has a ball with Disney Legend Bob Gurr, one of the original Imagineers, inside the "secret" basketball court inside Matterhorn Mountain at Disneyland, and they signed the basketball for posterity.

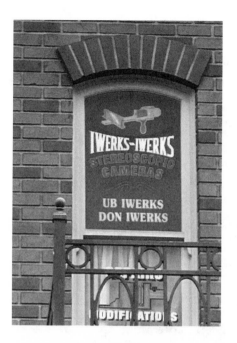

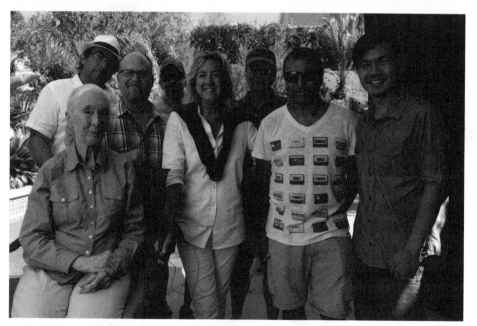

TOP LEFT: In filming *The Imagineering Story*, Leslie filmed at each of the Disney theme parks around the globe, including Magic Kingdom at Walt Disney World, where her legendary father and grandfather are honored with a Main Street, U.S.A. window. TOP RIGHT: Joe Rhode—former portfolio creative executive, Walt Disney Imagineering—shares secrets behind the creation of Disney's Animal Kingdom Theme Park with Leslie. BOTTOM: Hundreds of interviews formed the through line of *The Imagineering Story*, both the documentary series and this book, as with Dr. Jane Goodall for her contributions to Disney's Animal Kingdom Theme Park.

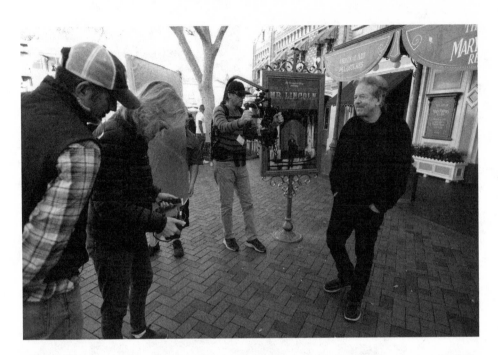

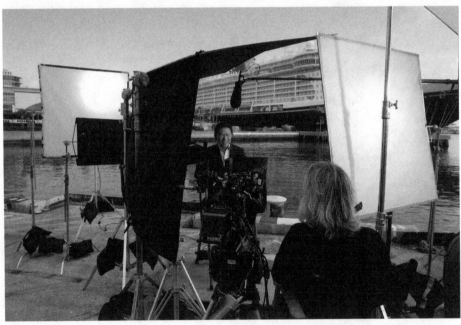

TOP: Imagineer and Disney Legend Tony Baxter is interviewed by Leslie and her crew outside The Disneyland Story presenting Great Moments with Mr. Lincoln attraction in Main Street Opera House at Disneyland. BOTTOM: While filming for *The Imagineering Story* in Orlando, Wing T. Chao—Disney Legend and former executive vice president, Walt Disney Imagineering—shares their "high seas" design and engineering principles for the Disney Cruise Line ships.

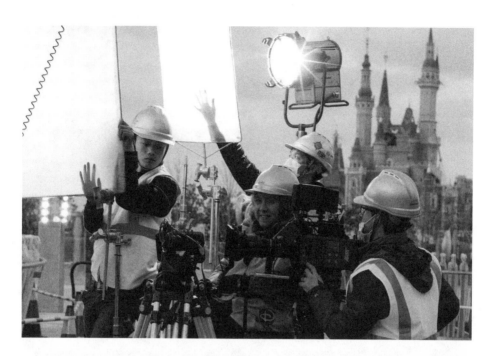

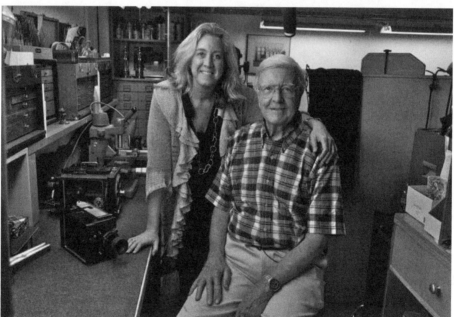

TOP: Leslie and her crew filmed at Shanghai Disneyland Resort over a period of six years—from dirt to opening day—as the spectacular and spectacularly unique Disney theme park was still under construction. BOTTOM: Leslie with her dad, Disney Legend Don Iwerks (and son of Disney Legend Ub Iwerks, who with Walt Disney co-created the characters Mickey and Minnie Mouse, among others), in his home workshop. Both Ub and Don made many technological Imagineering contributions throughout their Disney careers, and as Leslie explains, "Being a fly on the wall to all this activity growing up was the spark that fueled my lifelong interest in telling stories about creators, artists, visionaries, and innovators."

CHAPTER 1:
AN IMPOSSIBLE IDEA

"When I see things I don't like, I start thinking,
'Why do they have to be like this and how can
I improve them?'" —Walt Disney

I. WALT DISNEY CALLING

HERBERT RYMAN could not say no to Walt Disney—even though he didn't work for the man. Ryman *had* worked for Walt, for eight years. From 1938 until 1946 he'd been an artist and art director for *Dumbo* and *Fantasia* and other early classics. But on this Saturday morning in 1953, he was at his home in Van Nuys, California, north of Los Angeles, working on one of his circus paintings. He had begun his series of oils while traveling for two summers with the Ringling Brothers and Barnum & Bailey Circus; he was the only artist the circus had ever hosted for such an extended time. Ryman was a respected painter—his circus art had been the subject of two New York exhibitions. He had an impressive Hollywood résumé—not just his work at Disney but also at the MGM Studios in the early 1930s, creating scenic designs and prop art for classic films such as *Mutiny on the Bounty* and *The Good Earth.* After MGM and Disney, Ryman had worked at 20th Century Fox on films including *Anna and the King of Siam*, a 1946 release that fed his passion for Asian culture, acquired on a two-year trip around the world he had taken after leaving Disney. He had lived in Siam and France and England

and spent one winter in Peking and the Gobi Desert, just "for my own self-edification," as he put it.

He had worked hard, traveled hard, and had earned some quiet time at home, just painting. Then the phone rang.

It was Walt. Could Herb come down to the Disney studio? Ryman's former boss made it sound urgent—no time to shave and shower, just get to Burbank immediately. When he got there, Ryman learned that the crisis was related to Walt's amusement park project, which he called "Disneyland." As Ryman told the story, Walt said, "Well, Herbie, my brother Roy has got to go to New York on Monday." Roy O. Disney, the brother with the financial smarts, would be trying to raise millions from investors, Walt said, who "don't understand anything except money. And we've got to show them what we're going to do." A crucial selling point would be a grandly scaled drawing depicting an aerial view of the proposed park. Ryman's interest was piqued. "Well, gee," he said, "I'd like to see it, too." To which Walt quickly responded, "You're going to do it."

Ryman said no—or tried to. Creating such a persuasive illustration from scratch in less than forty-eight hours, he said, was "an utter impossibility." But Walt did not back down. "He paced all around the room, and he was thinking, and he went over and stood in the corner, facing the corner. And he kind of turned around and looked at me and he said, 'Well,' he said, 'Well, you'd do it if I stay here with you?' And then I thought, 'Well, if he wants to sit up all night Saturday night and all day Sunday and all night Sunday night—if he wants to stay here with me, I'll give it a try.'" And that was that. Ryman had one demand: "a big chocolate malted milkshake." He got it.

"Walt, as you know, was a very persuasive person. He could make anyone do anything," remembered Ryman, one of the original and most celebrated of the Imagineers who worked to bring Disneyland to life. "When he had this idea, and whoever he called in, it was instantaneous. You were supposed to be instantly useful and instantly productive and a kind of instant genius, if that's possible."

That Saturday morning, Walt showed Ryman preliminary sketches of proposed sections of the Disneyland park, created by Disney artists,

and a "Proposed Diagrammatic Layout," created by Walt's friend Marvin Davis just a couple of weeks earlier. (Davis was an in-demand Hollywood art director, having worked on that year's musical hit *Gentlemen Prefer Blondes*.) From those fragments, Ryman went to work, with Walt at his side, hunched over a drawing table in the studio, around the clock, to produce the first complete depiction of what would become Disneyland. The drawing had a castle, a Fantasy Land, a World of Tomorrow, and, of course, a Main Street leading to the central hub. It had a train and a riverboat, docked at Frontier Country. And it had dozens of teeny-tiny patrons, wandering through the park's streets and pathways or stopping to watch the carousel. By Monday morning, this penciled masterpiece, measuring forty-three by seventy inches, was ready for Roy Disney to roll up and take to New York.

Marty Sklar, who worked at Disneyland on Opening Day and later became president, vice chairman and principal creative executive of Walt Disney Imagineering, recalled Ryman referring to his weekend's achievement as "the drawing that Roy Disney used to raise the $17 million from the bankers"—a not entirely accurate account—but Sklar saw more than that in Ryman's work. He saw the future. "If you look at the original drawing," he said, "there's so much in it because it was all in Walt's head. Things that were not done in Disneyland for five or six years later." It was as if Ryman had reached into Walt's brain to pull out all those images he had bouncing around, then neatly organized them into a rendering so that less imaginative minds would be able to grasp them.

In the early days, this was the magic of Imagineering—work that went on in a company called WED Enterprises, initially intertwined with the Disney studio and taking its name from Walter Elias Disney. Walt later called Imagineering "the blending of creative imagination with technical know-how," which was true, but it was more intangible and more instinctive than that. From the start, Imagineers were people in touch with Walt's psyche, and Walt was in touch with their abilities—sometimes talents they didn't even know they had. Unbeknownst to them at the time, an animator would become the sculptor who created characters that would live on for generations. A background artist would become

a master at ride layouts. A man known for his ability to draw would write lyrics that park visitors would be humming their whole lives. A woman who painted props and sets would help build castles and create lifelike singing birds from piles of feathers. Imagineering grew beyond the confines of Walt's mind, but it has never stopped coaxing out hidden talents from artists, craftspeople, scientists, and technicians who were, like Walt, unfettered dreamers.

In that sense, the secret of Imagineering's initial success was "Walt knowing his staff," Sklar said. "I always thought that Walt Disney was the greatest casting director I'd ever worked with, because he could put together people that you would never expect to work together very well and something magic would come out of it. He understood what he could get out of almost every one of the people that he had here at Imagineering in those early days. Many of them he'd worked with for twenty or thirty years already before working on Disneyland."

Certainly the seeds of Imagineering were sown in the movie studio Walt created, where fairy tales and dreams were molded and shaped into stories that audiences would revisit again and again. In fact, though, just a few of the top artists from Disney's early animated classics made the leap to WED Enterprises. So how did Walt know exactly who would be perfectly suited to turn his Disneyland dreams into reality? How did he know that of all the artists in Hollywood, Herbie Ryman was the one to coax to the studio to put pencil to paper that September Saturday?

The origin of Imagineering reaches back well before that 1953 weekend, since Walt had recruited proto-Imagineers Richard "Dick" Irvine, Marvin Davis, and a few others to start work on Disneyland before Ryman got roped in. The Imagineering story is inevitably woven into the history of Disneyland itself—a history that poses its own challenges of origin. Was the theme park's birth as simple as the story Walt himself liked to tell about an epiphany at a carousel? Perhaps it had its roots a century earlier, when a young military officer and magazine publisher convinced the king of Denmark to let him build a fanciful park called Tivoli in Copenhagen to amuse the monarch's subjects—a park from which Walt would later borrow many ideas. Closer to home, the DNA of Disneyland

was determined in part by Walt's love of railroads—an obsession that led him to build a scale railway around his own residence that amused his guests until it went literally off the rails.

Knowing the importance of an authoritative origin story, Walt pegged the source of his conception of the modern theme park to a particular place and time. "It came about when my daughters were very young," he would explain, suggesting a summer day in the late 1930s. "Saturday was always daddy's day with the two daughters. So we start out and try to go someplace—you know, different things—and I'd take them to the merry-go-round and I took them different places. As I'd sit there—while they rode the merry-go-round, did all these things—I'd sit on a bench eating peanuts." Walt felt left out, disconnected from the girls' enjoyment of the carousel, and he had a vision of something better. "I felt there should be something built, some kind of amusement enterprise built where the parents and the children could have fun together."

For proof of this account, visitors to the original Disneyland could point to what is reportedly the exact bench where Walt's idea took hold. Inside the Main Street Opera House, behind a rope barrier that confirmed its historic stature, sat a forest-green seat of wooden slats that bore a plaque declaring it to be "The actual park bench from the Griffith Park Merry-Go-Round in Los Angeles where Walt Disney first dreamed of Disneyland."

As with any fairy tale, the history that went into the formation of Walt's epiphany narrative was more complex than the surface story. By his own account, Walt's buoyant dream remained amorphous—"some kind of amusement enterprise"—until it was shared and given form and substance not just by Walt's imagination but also by the artists in his employ. If Walt wanted a riverboat, his studio's craftsmen could interpret his vision in design sketches and construction drawings and wood and paint and smokestacks. That seemed easy enough. But if Walt wanted to re-create a fully functional city street from his childhood or an adventure into a hazardous jungle—and to make those experiences endure for generations—to whom could he turn? Movie sets were fragile and temporary, while architects were practical and averse to whimsy. The creation

of a new kind of amusement park would require the invention of a new kind of artist, and it was Walt's special talent to uncover the oddball geniuses who could give the spark of life to his yearnings. The Imagineers would celebrate not one moment of birth, but many.

II. FAIRS, PARKS, AND DECAY

In 1951, Walt Disney and his friend Art Linkletter, the popular TV personality, visited Tivoli Gardens, the enduring amusement park in Copenhagen. It had opened in 1843 on fifteen acres that Denmark's king had leased to its founder, a former army officer named Georg Carstensen. One of the world's earliest and best-known amusement parks, Tivoli from the beginning featured a carousel, a small railway, and a lake, which reflected fireworks on special occasions. It was also a true park, with flower-filled ornamental gardens, lawns, and paths. Its amusements included a theater, concerts, and restaurants. Tivoli's famous wooden roller coaster from 1914—so old that it had no name other than the Danish word for "roller coaster"—was still operating when Walt visited with Linkletter. (The coaster's mountain theming would later be echoed in the Matterhorn Bobsleds in Disneyland.) Walt wandered around Tivoli, soaking up the atmosphere and making notes about everything: the amusements, the food, the furniture, the re-created pirate ship docked in a lake. Tivoli was spacious, clean, family-friendly, and beautifully landscaped. Indeed, it was everything that American amusement parks of the time were not.

Just as small American towns were home to minor league baseball teams, for fans who couldn't get to the big cities, American amusement parks were miniature imitations of the grand and infrequent World's Fairs—and, to a lesser extent, annual state fairs. World's Fairs, temporary and urban, combined exhibitions with rides, entertainment, and restaurants. The first in the United States was the Centennial International Exhibition of 1876 in Philadelphia, followed by the nation's most celebrated fair, the World's Columbian Exposition of 1893 in Chicago—where Walt Disney's father, Elias, had worked as a contractor. The fairs created a vast, meticulously planned, safe, and well-scrubbed

world closed off from the surrounding city's hubbub. They inspired awe, offered glimpses of foreign cultures, teased the future, and introduced visceral amusements, such as the original Ferris wheel at the Chicago exposition. But they were short-lived and out of reach for most Americans, either economically, geographically, or both.

State fairs, which began as annual events in the mid-1800s, were more affordable and more modest, chiefly concerned with showcasing agricultural accomplishments through stock animal competitions and exhibitions of farm products. The early state fairs were more akin to farmer conventions than amusement parks, but simple carnival rides and midways and musical performances were gradually added to entertain the attending families. By the end of the nineteenth century, most states had extensive permanent fairgrounds—a few buildings and arenas meant to house exhibits, contests, and shows—that hosted well-attended annual fairs, some lasting a week or longer.

By the beginning of the twentieth century, as state fairs grew more elaborate and World's Fairs earned international acclaim, many cities and towns had seen the establishment of more accessible local amusement parks, borrowing aspects from both state fairs (intimacy and affordability, minus the agriculture) and World's Fairs (amusements and relaxed settings, minus the exhibitions). These local parks, with their merry-go-rounds and funhouses, were often situated at the ends of mass transit lines—whether on Coney Island at the Brooklyn Rapid Transit terminus or on the edge of some New England or Midwestern hamlet, where the trolley line ended, often in a park or alongside a body of water. Coney Island's Sea Lion Park, which opened in 1895 (and was replaced by Luna Park in 1903), is thought to have been the nation's first permanent amusement park with a single entry point and admission fee. Imitators in the hundreds followed, across the country, as entrepreneurs erected a few food stands and a midway, strung up the latest electric lights, and offered occasional live entertainment and simple rides as the seasons permitted. The operators gave their parks names that would promise excitement: Electric Park, Luna Park (borrowed from Coney Island), and White City (the nickname of the Chicago World's Fair) were among the most popular.

Walt would have been familiar with all these variations—starting with stories from his father about building the White City. By 1911, when the Disney family moved from Marceline, Missouri, to Kansas City, Missouri, the Missouri State Fair in Sedalia, one hundred miles to the east, was ten years old, and there were at least two Electric Parks not far away from the Disneys' home. Walt's daughter Diane recalled that her father used to sneak into Fairmount Park as a boy. Fairmount, opened in the mid-1890s, was a true park of fifty acres situated on a lake in the eastern part of the city. It offered outdoor recreation as well as entertainment, roller coasters and other rides, a miniature train, a zoo, horse shows, and a racetrack—much to amuse a growing boy.

But the so-called trolley parks' glory days of the 1910s and '20s ended with the Great Depression and World War II. Fairmount Park in Kansas City closed in the 1930s, the victim of fires and reduced revenue. At amusement parks that stayed open, thin attendance led to neglect, and their reputations suffered as much as or more than their appearance. The games of chance along their midways were notoriously rigged against those wagering to win prizes, and lax maintenance meant the lure of a serene escape had been tarnished by an atmosphere of decay. The return of soldiers after the war and the subsequent economic boom worked against many smaller amusement parks, as families moved out of the cities served by trolleys and bought automobiles of their own, expanding their amusement options via the burgeoning interstate freeway system.

One of the reigning kings of the amusement industry, Luna Park on Coney Island, had burned in August 1944 and never recovered, closing permanently two years later. By the time Walt Disney visited Coney Island in the early 1950s, its surviving amusement destination, Steeplechase Park, was on its last legs, demolishing attractions rather than building new ones. Walt judged it ugly and off-putting, its employees unpleasant. (It closed in 1964.) Coney Island's impressive 150-foot Wonder Wheel, built in 1920, was still operating, but it was a standalone attraction, its owner unable to control the dilapidation at its base. Walt wanted nothing to do with Coney Island, and no typical roller coaster-type rides appeared in his initial plans for Disneyland.

Walt also visited countless other amusement parks across the country, talking to their owners and operators, hearing their stories of what rides people liked, how they handled staffing, and which ventures were the most and least profitable. He was friends with some of the park operators, including Beverly Park owner David Bradley, whose wife, Bernice, had once worked in the story department at Walt Disney Productions. But the typical amusement park's disjointed collection of attractions, unremarkable food, and disinterested workers was a far cry from the cohesive and welcoming place he envisioned.

More to his liking was Greenfield Village, a "living history" park that opened in 1929 outside of Detroit, Michigan, as part of the Henry Ford Museum. It consisted of some one hundred historical buildings, bought by Ford from locations around the country and moved to the Village site, where they were arranged to re-create the sense of a late-eighteenth-century American town. Greenfield Village was staffed not with barkers but with trained interpreters, who explained how early Americans lived and worked, and performed craft demonstrations.

Walt had visited Greenfield Village before—he took his daughter Diane there in 1943—but he went again in August 1948 with Disney animator Ward Kimball, as a side excursion on their visit to the Chicago Railroad Fair. The two men even posed, dressed as old-time railroad engineers, in the village's tintype studio. Greenfield was laid out on a grid of mostly straight streets, and one block lined with vintage shops resembled what Walt recalled of the Main Street in his boyhood hometown. It also had a small church, not unlike the chapel depicted just off Main Street in Ryman's pencil drawing of Disneyland. More than specific design ideas, however, what stayed with Walt from his Greenfield Village visits was its warm sense of nostalgia, of separation from the present day. That was something he'd want to accomplish in his park.

Nostalgia was also a theme at Knott's Berry Farm in Orange County, south of Los Angeles. As its name suggested, the park began as a farm, in 1921. It started serving Cordelia Knott's chicken dinners in 1934, in the small berry shop and tearoom she and her husband Walter had opened. Over the years, the dining room grew to seat 350, but the wait

time extended to three hours on some nights. In an effort to amuse the waiting crowds, Walter started building scenes around the property—a rock garden, a waterfall, a twelve-foot volcano that emitted steam. In 1940, he added what he called Ghost Town, a Western village consisting of wooden buildings constructed from actual abandoned wrecks he had relocated or bought for scrap. By 1947, when the Knotts gave their business its current name (replacing "Knott's Berry Place"), the lively Ghost Town—with a Pan for Gold spot and staff members portraying Western characters—was attracting more people than the restaurant. While businesses founded as amusement parks were foundering, Knott's Berry Farm, which sought to amuse its restaurant patrons but not to fleece them, was expanding. Ghost Town strove to be, first and foremost, a coherent and welcoming place. Rides would come later.

Walt Disney and his wife, Lillian, were friends with the Knotts and had enjoyed Cordelia's famous fried chicken on many occasions. They had watched the Knotts' park grow and attended the opening of the Berry Farm's narrow-gauge Calico Railroad ride in 1952. By then, the park also featured a carousel and a stagecoach ride—elements that would find their way into Walt's plans for Disneyland. One aspect of Knott's Berry Farm was not part of Disney's planning: the park did not charge for admission until 1968.

The Knotts had a head start on Walt, but his notion of opening a Disney-themed park predated the expansion of the Berry Farm into amusements. Walt's epiphany at the Griffith Park carousel—or maybe at Beverly Park—likely took place no later than about 1946 or 1947, when his two girls were still young. It was about that time that Walt started in earnest to plan the kind of park he envisioned.

III. DISNEYLANDIA

On August 31, 1948—soon after his return from Greenfield Village—Walt Disney's office issued a memo to Disney studio artists describing a proposed park (he would refer to it as "Mickey Mouse Park" in a letter to a fellow train enthusiast later that year) in some detail. It would

have a Main Village, Indian Village, Western Village, carriage and stage-coach rides, and a railroad that circled the property, mostly along the perimeter. The proposed site was an eight-acre plot in Burbank, across Riverside Drive from the Walt Disney Studios. Future Imagineer John Hench, who lived on Riverside Drive, remembered seeing Walt in that "weed-filled lot—standing, visualizing, all by himself." Hench thought Walt was measuring distances in strides, referring to a paper he was holding that might have been a layout or other early plans.

By the early 1950s, Walt had a good idea of what he wanted to build, but he needed to present his proposal to the Burbank City Council to get its approval—he needed concept art. That meant he needed an artist to execute his vision, just as Herb Ryman would do two years later. After a lifeless attempt by an architectural firm, the man Walt selected to sketch out his Burbank park was, like Ryman, a Hollywood designer and illustrator. His name was Harper Goff, and Walt had not met him in Los Angeles through their mutual movie connections. In one of those fateful coincidences that reverberated through the decades, the two men had met while shopping in London.

Goff was an accomplished artist who had painted illustrations for magazines in New York before moving back to Southern California, where he'd spent his late teens. He was soon employed assisting in set design for many Warner Bros. films—*Captain Blood, The Life of Emile Zola,* and *Sergeant York* among them—from the 1930s through the 1940s. In 1951, having left Warner Bros., he was on vacation in London and stopped in at a retail location for Basset-Lowke, the highly respected British manufacturer of model trains. A longtime railroad enthusiast, Goff was looking for unusual miniature locomotives to add to his collection. He found one he wanted, but the shopkeeper told him it was on hold for another buyer until that afternoon. If the original buyer changed his mind, Goff could have it. He decided to drop by again before closing time, just in case. As Goff told the story, "We came back that afternoon and we saw this fellow in the store, and he had purchased the locomotive. He turned to me and said, 'I'm Walt Disney. Are you the man that wanted to buy this engine?' Well, I almost fell over. He asked me what I

do for a living, and I told him that I was an artist. He said, 'When you get back to America, come and talk to me.'"

Goff did just that, curious to see what an animation studio might want with a live-action set designer. Walt explained that Disney's partially live-action *So Dear to My Heart* (1949) and its adventure hit *Treasure Island* (1950) were just the first two of a planned full slate of non-animated movies. Goff took the job and would become best known as the artist who created the designs that convinced Walt to turn Jules Verne's novel *20,000 Leagues Under the Sea* into a movie. But first there was the matter of Walt's proposed Burbank park: could Goff create a lively aerial view? He could, and he produced several variations, showing the park's train, puffing steam; its Mark Twain–era paddle wheeler on a loop of artificial river; its stagecoach, pulled by galloping horses; its carousel and child-friendly carnival; its Old Town Western village; and other features, most of them described in Walt's 1948 memo.

The name of the project was now Disneyland, as described in some detail in a March 1952 article in a Burbank newspaper. The name was a variation on a different Walt idea, which he had called Disneylandia—not a theme park, but a traveling exhibit.

The Disneylandia concept had emerged from another of Walt's fascinations: miniatures. He had begun collecting and making miniature rooms and buildings after visiting the Golden Gate International Exhibition in San Francisco in 1939. A display there called the Thorne Room Miniatures showed thirty-two intricately furnished chambers from different historic periods, each one hand-crafted at two feet tall by three feet wide, and eighteen inches deep. Back at the studio, Walt asked Ken Anderson, veteran art director and a future Imagineer, to sketch out scenes from the Old West to turn into mini dioramas.

Walt told Anderson, "I'm tired of having everybody else around here do the drawing and the painting. I'm going to do something creative myself. I'm going to put you on my personal payroll, and I want you to draw twenty-four scenes of life in an old Western town. Then I'll carve the figures and make the scenes in miniature." Some furnishings Walt would construct, some he acquired through ads in newspapers and hobby

magazines. "When we get enough of [the miniature scenes] made," he continued, "we'll send them out as a traveling exhibit." The name of the proposed collection and tour was Disneylandia. The first scene that was completed was a scale model, not even a foot tall, of the set for Granny Kincaid's cabin, seen in *So Dear to My Heart*, with a tiny spinning wheel, rocking chair, and shelves filled with teeny jugs and other crockery. It was exhibited in late 1952 at the Festival of California Living at the Pan Pacific Auditorium in Los Angeles, intended to promote the upcoming Disneylandia tour.

Walt's traveling show plan had been inspired by a national charity tour of silent film star Colleen Moore's Fairy Castle, a doll-house-like collection of miniature rooms that had mesmerized visitors across the country in 1935. It had taken one hundred people and $500,000 to build the Fairy Castle, and Walt himself had donated to Moore two tiny portraits of Mickey and Minnie Mouse that hung over a fireplace. The castle had been displayed in a series of toy stores, but Walt thought he could install his Western town miniatures in railway cars and take them from town to town, charging visitors to see the scenes.

Walt then decided to up the ante in his exhibition, adding movement to some of the miniature tableaux. On a visit to New Orleans, he had bought a mechanical bird that moved its wings and sang, powered by a wind-up clockwork mechanism. Walt's idea was to re-create and advance that technology for what came to be known as Project Little Man—a mechanical puppet on the stage of his miniature Western opera house, as depicted in one of Anderson's paintings from 1949. The Little Man would have a cane and straw hat, and his routine would be based on a reference film Walt had commissioned of actor Buddy Ebsen doing a little soft shoe. Once Project Little Man was in the works, Walt expanded his idea to encompass another of Anderson's scenes. Inside the old-fashioned barber shop, the barber, his seated customer, and two friends would become a mechanical barbershop quartet, moving in time to a recording of "Down by the Old Mill Stream."

Future Imagineer Roger Broggie, the head of the studio's Machine Shop, and his team got the Little Man to work, although the machinery—hidden

beneath the scene—was cumbersome and high-maintenance, which would have made a traveling display a touchy prospect. Broggie got as far as creating half the barbershop quartet when the Disneylandia project was called off. Among other impediments, estimated revenue wouldn't have covered the costs, and grimy railroad yards, where the traveling boxcars would have been parked, were considerably less family-friendly than toy stores. But Disneylandia's development work had been another significant step toward the creation of Imagineering. Future Imagineer Marc Davis, who had joined the studio in 1935 during the production of *Snow White and the Seven Dwarfs*, remembered both Anderson and Goff working on the plans and sketches for Walt's miniatures—each unaware of the other's involvement—with contributions from future Imagineer Wathel Rogers, who made models as a hobby. The line between work on Disneylandia and the proposed park was blurred, since the park's Old Town would feature some of the same Western scenes Anderson had been drawing for years. Walt's love of miniatures and mechanical people would guide aspects of Disneyland for decades, and model-making would become a cornerstone of the Imagineers' work.

Little by little, Walt was seeing what his artists were capable of, directing their talents away from their original assignments—whether animation, background painting, filmmaking machinery, or set design—and toward his own visions of a buildable fantasy realm that would transport people out of the present day. Instead of creating models that people could view but not enter, Walt set his sights on something grander. "We're going to do this thing for real!" he told Broggie. Disneylandia would be supplanted by Disneyland.

But it would not be in Burbank. Despite Goff's engaging drawings and layouts, and Walt's best effort to make the park sound clean and educational, the presentation to the city council was a bust, the members voting against the project for fear of noise, accidents, and an undesirable "carny atmosphere." Walt was miffed, but the rejection was a blessing in disguise. It was spring 1952, and it was becoming clear that Walt's dream of Disneyland could not be shoehorned into a cigar-shaped plot of land along the decidedly un-scenic (and usually dry) Los Angeles River. (The

site is even less scenic today, as the Ventura Freeway was built alongside the riverbed, on the edge of the property. The Disney Company found other uses for the land, building a new Animation Building there in 1995, with a giant Sorcerer's Hat from *Fantasia* over the entrance. The West Coast headquarters for the ABC television network was built there in 1999.)

Walt was undaunted by Burbank's rejection and continued to work on planning a park. He had gained an important deputy in Richard Irvine, whom everyone called Dick. Irvine had been an art director at 20th Century Fox when he agreed to leave the studio to work on Disneyland— Walt's first full-time artist dedicated to creating his park. Irvine's first assignment was to serve as liaison with the architectural firm Walt had contracted to create preliminary plans. The first was headed by Charles Luckman, an architect, and William Pereira, an art director at Paramount Studios. Despite guidance from Walt and Irvine, the firm's work was unimaginative and dull, lacking whimsy and charm. It wasn't what Walt had in mind. He next went to his friend and neighbor architect Welton Becket to ask for help. Becket listened, then gave Walt some of the best advice he would ever get: Disneyland, he said, was such a particular project, so entwined with Walt's own imagination, it needed to be designed by the artists at the Disney studio, by set designers and others who understood how Walt thought. Architects could be consulted as needed to turn the artists' ideas into buildable blueprints, but not to do the original designs. Walt took his friend's advice. Irvine would help him put together the team he needed from within his own studio, adding other motion picture artists as fate dictated (as it had in the case of Harper Goff).

"Because Dick had worked with movie set designs, creating structures and settings, he understood our needs more than standard architects," observed John Hench, who would soon be one of the artists tapped for Disneyland. The people Walt needed to realize his vision were Hollywood storytellers, whether animators, art directors, or technicians—people who knew how to engage an audience and what it took to transport them to a new realm for a few hours. "Very few architects have any experience

with theater at all," Hench added, "and the kind of architecture we use is closer to the theater."

On December 16, 1952, Walt solidified his dream team by founding a new company, separate from the studio and wholly owned by Walt and dedicated to the Disneyland project. Originally called Walt Disney, Inc.—a name confusingly similar to Walt Disney Productions—it was renamed WED Enterprises the next year, a name derived from Walt's initials. While the studio had gone public in 1940, and was therefore answerable to the shareholders, WED Enterprises was a private company where Walt could do as he pleased. His instincts for who would fit in at WED were sharp, recalled Marty Sklar. "He put people here in the beginning that he wanted here. He picked people out of the studio—John Hench, and Claude Coats. Claude was a background artist in animation, and turned out he was the best layout artist we ever had here at Imagineering."

Walt needed artists with more than pencil skills, as he had understood when he called Herb Ryman in September 1953. He needed partners, co-conspirators, people who would listen and also talk back, who would do his bidding but with an additional layer of vision and creativity. That described Hench and Coats and certainly Ryman, who finished his drawing of Disneyland just in time that September. A few days after he'd gone home from his marathon drawing session and caught up on his sleep, he got another phone call. "Walt was ecstatic," Ryman recalled. "And he said, 'Herbie,' he said, 'we've got the money. We've got the money. . . . Now we can start.' And he said, 'Could you help us?'"

Once again, Ryman could not say no. "Walt had unassailable confidence in his convictions. He believed in this thing. And when he looked at you, you gotta believe it, too," he said. He would have to give up all that free time he had been using to work on his portraits and circus paintings, "but I thought, 'Well, this is just as interesting as anything else I'm doing. And if Walt thinks that I could be useful, I will be.' And I told Walt, 'I'll work on this thing as long as it's interesting and exciting. When it ceases to be interesting, I'll go back to my work.' And Walt

said—and I remember very well—he said, 'Well, Herbie, I'll try to make it interesting.' And of course he did."

IV. ALL ABOARD

In a sense, Walt Disney's dry run for Disneyland was built at his home in Holmby Hills, a hilly neighborhood of spacious lots west of Beverly Hills that was bisected by Sunset Boulevard. Walt bought a five-acre plot there in 1949, planning not just a new home for Lillian and their two daughters but also his own scaled-down railway, circling the property. The address was 355 Carolwood Drive, just north of Sunset, and the train line would be known as the Carolwood Pacific.

It was the year after Walt's visit to the Chicago Railroad Fair with animator and fellow train enthusiast Ward Kimball. Kimball not only collected model trains; he owned a full-size locomotive. Walt wasn't planning to go that far, but the plans for his new home included the track for a small-scale, 7¼-inch-gauge train, just big enough for adult passengers to ride atop the cars like Gulliver in Lilliput. The layout was roughly oval, with an additional figure eight behind the house and a tunnel beneath Lillian Disney's flower garden in the front of the property. The ninety-foot tunnel was designed with an S-curve, so the exit was not visible from the entrance, creating a few moments of thrilling darkness for passengers. Traversing the uneven terrain and crossing over itself, the layout included three bridges, a forty-six-foot trestle, and eleven switches.

The one-eighth-scale steam engine for this railroad was built in the Disney Studios Machine Shop under the supervision of Roger Broggie, based on plans acquired from the Southern Pacific Railroad; Walt dubbed the locomotive the *Lilly Belle*, after his wife. Walt himself built its whistle, flag stands, and handrails. Within the studio's Machine Shop, "Walt had his own bench and tools, and he'd come down and work at night," Broggie recalled. "He was a perfectionist." The engine had a functioning steam boiler fired by coal chopped to a diminutive size to match the

scale of the burn box. The Machine Shop and Prop Shop joined forces to create the rest of the train: a flatcar, two boxcars, two cattle cars, six open-top gondolas, and a caboose. The Carolwood Pacific had its inaugural run in May 1950.

The project taught Disney a lot—not just about railroads, but about the skills of his machine shop and props department, and about designing landscaping to produce a desired effect. Building the Carolwood Pacific was as much about shaping the surroundings to match the ride as it was about laying the track to match the terrain. Trees and shrubs were relocated or brought in to block sightlines and muffle the train sounds on adjoining properties. The tunnel through the front yard preserved the atmosphere of a completely separate domain—the serenity of Lillian's flower garden, visible from the house. Guests enjoying either experience might not even be aware of the other—just as guests on Main Street, U.S.A. in Disneyland would never know there was an exotic Jungle Cruise right behind City Hall.

The Carolwood Pacific also imparted a lesson in working with outside contractors. "I was out there helping him lay the track when they were building it," recalled Harper Goff. "There were all kinds of problems, and the contractor thought he'd be helpful and, you know, score a few points with Walt. So he said to him, 'Mr. Disney, this is turning out to be very expensive. I'll tell you how you can simplify it and save money: make the tunnel straight or with a mild curve.' Walt looked at him long and hard and raised one eyebrow the way he always did. 'Do you think,' he finally said, 'that if I wanted to save money, I'd be engaged in building this complicated railroad around my house?' The contractor was taken aback, of course—and the tunnel was built just the way Disney wanted it." Builders were grounded in numbers and schedules and could not be expected to share or even understand the storytelling their work was designed to accomplish. They needed to be closely supervised, lest their helpful suggestions destroy part of the guest experience.

The railroad also wound up imparting an unpleasant lesson in rider safety. Walt loved to serve as the engineer himself, seated on the coal car attached to the engine and lifting the roof of the cab to reach the controls

inside. But so many people clamored for rides that he often had to depu-
tize others to drive the train. A famous photo of surrealist artist Salvador
Dalí seated on a gondola in a dapper suit, holding his signature walking
stick between his knees, for example, depicts an unidentified young man
in a railroading outfit in Walt's place behind the engine. In the spring
of 1953, one of these substitute engineers was driving the *Lilly Belle* when
it took a curve at too high a speed and derailed. Walt closed down the
railway for good. It was a mishap that would not be repeated at his park,
where the railroad would be operated by trained engineers—safely and
precisely.

The people who worked with Walt on the Carolwood Pacific were
some of the original Imagineers, Broggie and Goff among them. Broggie
also represented the porous divide between WED Enterprises and the
Disney Studios, since the Machine Shop headed by Broggie was part
of the studio, but it serviced many of the mechanical needs of WED
projects. WED, meanwhile, worked exclusively on the proposed park,
even before funding was secured. Under the leadership of Walt and Dick
Irvine, WED had a growing staff, some coming from outside the Disney
studio. "Dick [Irvine] was from 20th Century Fox, an art director, and
had worked on many pictures there," Marty Sklar recalled. "Dick knew
all the art directors and would bring them in for different projects. Some
of them stayed."

But many of the early leaders at WED Enterprises were artists Walt
knew well, and he simply plucked them from their jobs at the Disney
studio—sometimes abruptly. "There's some wonderful stories about
that," Sklar said. "I remember John Hench told me that Walt came into
his office [at the studio] one day and looked over his shoulder at what
he was doing and then started to walk out and said, 'By the way, John,
you're going to work on Disneyland.' And he turned and said, 'And
you're gonna like it.'"

Hench was the quintessential Imagineer, often referred to as
"Disney's Renaissance artist" for his voracious appetite for knowledge
of all things and for the ease with which he adapted his artistic talents to
all the different forms needed to create a theme park. He read fifty-two

magazines a month and was a natural storyteller, never hesitating to share his experience, whether as a hands-on teacher or more generally as a philosopher despite being somewhat shy. More intently than anyone, perhaps including Walt himself, Hench sought the meaning behind what the Imagineers were creating—the goals and guiding principles—so that wisdom could be verbalized and passed on. He was particularly fascinated by and adept with color theory, and generations of Imagineers would hold their breath as Hench reviewed their choices of hues for everything from castle turrets to cobblestones. His expertise was largely self-taught, learned through years of experience in different aspects of animated film production. For *Fantasia*, *Dumbo*, *Peter Pan*, and other Disney classics, Hench had worked on effects animation, contributed to story and layout, and painted backgrounds. He spent three years in the Camera and Special Effects Department. He collaborated with Salvador Dalí on the animated short *Destino*, begun in 1945, shelved in 1946, and finished in 2003, when Hench was ninety-four.

So when architect Welton Becket advised Walt to look to his own artists to build a team to create Disneyland, Hench was among the recruits, although not until 1954, more than a year after the founding of WED Enterprises. The team who had worked on the designs and fabrication for Disneylandia—Harper Goff and Ken Anderson among them—were the most natural first picks. Dick Irvine helped Walt select others, including his former Fox associate Marvin Davis, an art director whose work on movie sets demonstrated "how to create architectural form that had a message for people," as Herb Ryman observed.

Ryman joined the team permanently not long after Walt had brought him in to sketch that aerial view of Disneyland. In the months that followed Roy's fateful 1953 New York trip, Ryman said, "We'd attack each problem as it came, knowing really full well that eventually there would be scores and hundreds of people involved in this thing to bring it to its necessary completion. But we did have the privilege of being in on the birth of the baby. And it was quite a baby."

Ryman recalled that he and other early Imagineers "have talked many times about, what was it that brought these particular people together,

these special original people? And of course it was coincidence, it was accident, and it was naturally a fortuitous thing." That Saturday morning in 1953, he speculated, "Dick Irvine, my friend, and Marvin Davis were already there in the parent company, WED Enterprises. And so naturally when Walt was casting around for somebody to do this job that was needed for Roy to go and get the money, very likely Bill Cottrell and Dick Irvine and Marvin Davis said, 'Why don't you give Herbie a call? It's Saturday and he's probably at home and maybe he could come over.' So that was the way it worked."

But despite Ryman's modesty, it wasn't quite that simple. Walt had an instinct for which of his studio artists, present and past, would best contribute to Disneyland. "He was a very intuitive guy," Hench said. "He got his knowledge dropped in his lap from somewhere and he didn't even know where it came from. It's hard to beat intuition." Disneyland, Hench believed, could not have been built "except by people that had had some motion picture experience, because we relied so much on all the techniques—introducing an idea and following through a theme or an idea or a story very much as you do in motion pictures."

This narrative approach to an amusement park came to define Imagineering, long before the word *Imagineer* came to define the artists at WED Enterprises. Disneyland would be a place that shared some characteristics with both the thrills of Steeplechase Park and the historic wistfulness of Greenfield Village. It would echo the elegance and rich history of Tivoli, offer some of the aspirational and educational characteristics of World's Fairs, and enlarge the homey fun of Walt's Carolwood Pacific to the scale of nearly full-size steam engines. What it would not be was vulgar and grimy—the chief concern of Lillian Disney in another oft-told anecdote about Walt. "When he told his wife that he was going to build what became Disneyland," Sklar recounted, "she said, 'Why would you want to do that? Those places are so dirty, people who work there are so unfriendly.' Walt looked at her and he said, 'My park's not going to be like that.'"

CHAPTER 2:
THE HAPPIEST PLACE ON EARTH

"When we opened Disneyland, a lot of people got the impression that it was a get-rich-quick thing, but they didn't realize that behind Disneyland was this great organization that I built here at the studio, and they all got into it and we were doing it because we loved to do it." —Walt Disney

I. SELLING DISNEYLAND

WALT DISNEY wasn't going to make the same mistake twice. He had taken his plans for a nine-acre Disneyland park to a meeting of the Burbank City Council believing his presentation would win the votes he needed to press ahead. He had been mistaken, turned away like an itinerant carny. This time around, he would bring the council members to The Walt Disney Studios for a presentation on his own turf, out of public view, and he would make sure he had their support before taking the issue to a formal meeting. The city was no longer Burbank, and the park was no longer nine acres for his ideas had evolved and multiplied. A 160-acre site in Orange County, southeast of Los Angeles, was his new target, in a sleepy town called Anaheim that had far more orange trees than people. Once again, some council members had been grumbling that the park would bring an unwanted carnival atmosphere to their peaceful village. Walt would nip that in the bud.

Thus it was that in 1952, a contingent of local politicians from Orange County found themselves being given the royal treatment at The Walt Disney Studios in Burbank. The Herb Ryman drawing didn't yet exist, but other sketches did, and Walt had honed his presentation. As Marty Sklar recounted the story, "That sold the idea to the city fathers in Anaheim. And they were able to do some things like closing a city street that enabled Walt to pick that site."

The Anaheim location had been carefully selected by Harrison Price, an economist working for the Stanford Research Institute, an organization recommended to Walt Disney by one of the architects who had briefly worked on Disneyland. SRI was hired within months of the Burbank council disaster and went right to work to find a new location for the park. Price, known to everyone as "Buzz" and then in his early 30s, set about studying population shifts and planned freeway routes. He drove around Los Angeles and four adjacent counties looking for a flat, largely unpopulated plot of land situated somewhere with favorable weather patterns. He settled on Anaheim, where the Santa Ana Freeway would soon provide easy access from Los Angeles, 25 miles to the north. Walt already had the city manager and chamber of commerce on his side and sworn to secrecy. He then hired two local real estate agents to buy up the necessary land from its several owners. Without disclosing for whom they were actually working—if people knew Disney was the buyer, prices would have skyrocketed—the agents acquired the land at prices within Disney's budget. The city government pitched in by closing a pesky street in the middle of the plot and arranging to annex into Anaheim's city limits some parts of the property that were in unincorporated Orange County (where taxes were higher).

Most people in Los Angeles at that time gave barely a thought to Orange County. Much less had they heard of Anaheim. But "Walt was ahead of everybody else," recalled Don Iwerks, who joined Walt Disney Productions as a camera technician in 1953. "I mean, he'd take the gamble, because he was a believer that it was going to work, despite people who were naysayers. It was just orange groves, lemon groves, citrus and so forth down there. No freeway. Most people thought he was crazy to

build some kind of a big park like that way down there where nobody could get to it." But build it he would.

Price and his colleagues at SRI had a second contract with Walt Disney, one that was more in line with the research facility's roots in business economics: a feasibility study. The problem was, there were no comparable businesses to what Walt had in mind. Price dutifully surveyed existing amusement parks for data about pricing, attendance, location, attractions (how long does a ride last?), and so on, but he quickly learned they had a different relationship with their customers than the one Disney wanted to develop. To Walt, visitors would become the "guests" in his fanciful realm. To most amusement park operators, they were "marks," to be shaken down for as much money as could be squeezed out of them in a few hours. No one expected people to stay at a park all day, as Walt had in mind for Disneyland.

In November 1952, Price, Dick Irvine, and other Disney representatives attended the amusement industry's national convention in Chicago, giving a detailed presentation to a group of top park operators. Their feedback was immediate and uniformly negative: Disneyland was a ridiculous idea. It was full of wasteful expenditures like buildings that didn't generate revenue (that castle!) and extensive landscaping (no one cares!). It needed more rides (where's the roller coaster? the Ferris wheel?) and more entrances and less of a focus on cleanliness (not practical!). Price returned to California to report back to Walt. The guys in Chicago, he said, "don't get it."

(Walt once credited Price with coining the term "Imagineer"—a combination of the words "imagination" and "engineer." Price later said he did not recall inventing the term, although he didn't argue the point with Walt. Where Walt picked it up is lost to history—as it was apparently lost even to Walt—but the word had existed since at least 1942 in advertisements for the Alcoa, the Aluminum Company of America, where Walt or Price may have seen it. It was in common usage at WED Enterprises by the late 1950s and was trademarked by The Walt Disney Company in the 1980s.)

Despite Price's report from Chicago, Walt was undaunted by his

nominal competition's vitriol. He had a plan, Disneyland had a home, and the soon-to-be Imagineers at WED Enterprises had a blank slate on which to render his dreams. In years to come, they would learn that 240 acres wasn't nearly enough to contain the ever-growing park, but that problem would come only with a success of which no one was yet certain.

The unconvinced included Walt's brother, Roy Disney. He had been Walt's partner from the beginning—after all, the company had been founded as the Disney Brothers Cartoon Studio in 1923. (It became the Walt Disney Studio in 1926, then Walt Disney Productions in 1929.) Walt was the ideas guy; Roy was the numbers guy. They were, as Sklar phrased it, "the business side and the creative side working together." In 1952, when Walt got serious about his amusement park plan, Roy called it "another one of Walt's screwy ideas." The brothers butted heads about the project on and off, but Walt persisted. Roy eventually budgeted $10,000 of the studio's funds for the park and figured not much would come of it. When funds ran out, though, Walt borrowed money on his own, and soon after the Burbank City Council debacle, Roy gave in, supporting the idea of a bigger park. The train had left the station and could not be stopped, so Roy got onboard. Better to stand with the engineer and try to stoke some fiscal discipline than to let it run away without him.

When the time came to find backers to put up the millions still needed, it was Roy who headed to New York. But Herb Ryman's account of his sleepless weekend in 1953 got one detail wrong, perhaps because Walt Disney himself misspoke: Roy Disney was not flying east to meet with bankers, who were too conservative to risk money on Walt's pipe dream. Roy was going to try to convince a television network to finance Disneyland in exchange for an exclusive weekly Disney television series. It was a brash move at the time, since other Hollywood studios considered TV to be the enemy and flatly refused to provide the medium with content of any kind. But Walt and Roy knew that the networks were keen to land a Disney series, in part because the industry's attention had been riveted by two one-off Christmas Day specials in 1950 and 1951. The two shows, called "One Hour in Wonderland" (to promote the *Alice* movie)

and "The Walt Disney Christmas Show," were the company's first forays into television and both had been huge ratings successes.

Roy first hit a brick wall, as both NBC and CBS, which had aired the holiday shows, declined to finance the highly speculative Disneyland project as part of the deal for a series. That left the struggling third-place network, ABC, which was hungry for a hit. The network eventually signed on to a complicated deal that gave it a weekly TV show, a roughly 35 percent stake in Disneyland (equal to the Disney company's), and all the park's food concession profits for ten years. Disney's longtime publishing partner, Western Printing and Lithography, put up $1 million for a stake of about 14 percent. Walt's personal stake was just over 16 percent—with the crucial proviso that he could buy out all the other investors after two years.

The ABC deal, netting Disney a half-million in cash, $4.5 million in loan guarantees, and the assurance of steady income from the television series, took Roy and Walt months to negotiate. It was announced in April 1954, by which time the artists at WED Enterprises had been at work for nearly 16 months. Their mission was "a simple one," according to a prospectus for the park issued by Disney. "Disneyland . . . will be a place for people to find happiness and knowledge. It will be a place for parents and children to share pleasant times in one another's company; a place for teachers and pupils to discover greater ways of understanding and education. Here the older generation can recapture the nostalgia of days gone by, and the younger generation can savor the challenge of the future." On second thought, maybe it wasn't so simple. In either case, Walt Disney himself would have an hour every Wednesday night for about five months to explain his park to his prospective guests. (The show did not move to its well-remembered Sunday evening time slot until 1960, after four seasons on Wednesdays and two on Fridays, always at seven p.m.)

The television series, called simply *Disneyland*, debuted October 27, 1954, with an episode called "The Disneyland Story," in which the families of America got their initial peek at what would become the world's first theme park. Utilizing the song "When You Wish Upon a Star"

from Disney's animated *Pinocchio* (1940) and Tinker Bell from *Peter Pan*, released the year before, the show immediately introduced the park's four "worlds": Frontierland, Tomorrowland, Adventureland, and Fantasyland, "the happiest kingdom of them all." Walt Disney himself hosted the show, sharing "our latest and greatest dream" through a large aerial painting of Disneyland, considerably revised from Ryman's drawing of a year earlier. The park, he said, would be "unlike anything else on this Earth: a fair, amusement park, an exhibition, a city from the Arabian Nights, a metropolis from the future—in fact, a place of hopes and dreams, facts and fancy, all in one." Walt even showed off a ¼-inch-to-the-foot scale model of Main Street, U.S.A. The rest of the episode previewed not so much the park's attractions as the ABC show's upcoming content such as the studio's True-Life Adventures documentaries (dating back to 1948), the space-travel-focused speculative tales of the future, and the cartoons that would represent Fantasyland. The credits mentioned both John Hench ("Effects") and Walt Disney's longtime friend and creative associate Ub Iwerks ("Special Processes"). Iwerks, the co-creator of Mickey Mouse twenty-six years earlier, would be a vital contributor to WED Enterprises.

Right from the start, the series was required viewing for millions of families across the United States. Walt "became like your favorite uncle, coming in your home every Sunday night and talking about animals and talking about fantasy," recalled Marty Sklar, who would later write the script for one of Walt's most memorable screen appearances. "He just became so relaxed about it." Most people already knew who Walt Disney was, certainly, but the show made him a cultural icon of a prominence and affection unmatched by any behind-the-scenes Hollywood figure. When "Uncle Walt" invited America to come play at Disneyland, who could resist?

II. A WILD RIDE

Despite its official separation in ownership and financing from Walt Disney Productions, WED Enterprises began its life on the studio lot in Burbank. The initially tiny team was housed in a makeshift structure

called the Zorro Building, named for the vigilante hero Walt thought he might turn into a movie. (He eventually developed the property as a television series, launched in 1957.) But not much Zorro work was ongoing in the Zorro Building, so named in part to disguise its inhabitants' real mission, the top-secret Disneyland project. Marvin Davis recalled Zorro as frigid in the winter and miserably hot in the summer, with a central workspace that once housed the entire WED staff. Davis had four drafting tables, and sketches of scenes from the proposed rides hung as storyboards on the walls. Walt was a frequent visitor, Davis recalled. "The back of my neck was red many times from him looking over my shoulder."

Walt and Dick Irvine had recruited Davis as well as another 20th Century Fox art director, Bill Martin, because they needed to complement their visual artists with people who knew a bit more about how to build things. Since Disney had yet to shoot a full live-action film in the United States when WED was founded—*Treasure Island* was made in England—the studio had no in-house set designers. Just as Davis had laid out the entire park, in several iterations, Martin became adept at creating the layouts of what would become the "dark rides"—the retelling of Disney animated film stories through a series of scenes that guests would travel past in small vehicles moving on tracks. These would be the main attractions for Fantasyland, a realm dedicated to the studio's animated features. It was Martin who came up with the crucial idea for Peter Pan's Flight, conceiving of flying ships suspended from an overhead rail. He then sketched out a diagram of the vehicles' winding path through a rectangular building divided into different scenes—as he would for all the dark rides. Ken Anderson, the artist who had worked on the Disneylandia miniature designs, did the storyboards for the Peter Pan tableaux as well as for the Snow White attraction, with its more traditional earth-bound track. Neither attraction included depictions of its title character, since the concept for both was that the guest was experiencing the story from the perspective of the protagonist.

The same was true for Mr. Toad's Wild Ride, the third dark ride that would open with the park. "The quickly passing scenes illustrated, not

the plot of the film," recounted an article in *The "E" Ticket* magazine, "but Toad's 'motor mania' as he (and Cyril) might have experienced it from behind the wheel of their runaway motorcar." The Toad ride had been conceived at one point as a roller coaster, with obstacles that would clear the track just as the train approached, but that idea was set aside.

Martin again did the layout. "As Ken Anderson and Claude Coats started designing sets and interiors, I made modifications to work with their ideas," he recalled. The team came up with a "train coming at you" gag, accomplished with little more than a bright light and a sound effect in the darkness of "R.R. Tunnel No. 13"—after which Mr. Toad (and the park guests riding in his place) landed in Hell. "That idea of going through the Devil's mouth, through the Jaws of Hell, was okay with Walt at the time, too," Martin said.

Coats had worked on the animated film that inspired the attraction, an anthology titled *The Adventures of Ichabod and Mr. Toad*. He had been with Disney since 1935, just a year after earning a degree in architecture and fine arts from the University of Southern California. His passion was watercolor, and he continued to exhibit his paintings for years after starting at the animation studio as a background apprentice, working with Anderson and the other artists who defined the Disney studio style, with its bright colors and intricate details. He became an expert in color styling and worked on every major animated film into the 1950s. His first task for WED was working on the model for Mr. Toad's Wild Ride, and he quickly became the go-to person for solving spatial problems in attraction design.

After layout and storyboarding, model building was the next step for the attractions—necessary to make sure what had been drawn in two dimensions could be successfully rendered in three. As WED gradually staffed up its Model Shop, one of its first artisans was Fred Joerger, an Illinois native who had moved to Los Angeles and joined the art department at Warner Bros., where he built models of movie sets. That's where Walt found him, and he came to Disney to work on Project Little Man and barbershop quartet projects for Disneylandia. With no established model shop in which to work, Joerger found space in a railroad boxcar

(actually a long and narrow purpose-built building) in one of the studio parking lots, used as a workroom for the nearby Machine Shop. At one end were machinists' drills and lathes; at the other, Joerger's workbench.

"Fred could build anything," Imagineer Rolly Crump recalled. "He was probably one of the most versatile guys who worked at WED. He had huge hands and gigantic thumbs and could push clay very quickly over foundations. The sad thing is that about 90 percent of the models that we built at WED were thrown away. They would say, 'Well, we just don't have any place to keep this stuff.'"

Joerger was soon joined at his end of the train car by a young woman named Harriet Burns who was working on sets and props for the *Mickey Mouse Club*. They didn't know it when they met, but they would soon be best friends and the core of WED Enterprises' legendary Model Shop.

Burns was the first woman on the WED team, joining the crew when the Disneyland project was running at full tilt. A native of San Antonio, Texas, she had studied art at Southern Methodist University in Dallas and moved to Los Angeles in 1953 with her husband and daughter. She found work fabricating props and sets for television and hotels. She didn't arrive at Disney until 1955, where she reported for work every day in a coordinated blouse and skirt, or a dress, with high heels on her feet. She never wore slacks—unless she had to climb something that day, in which case she'd quietly disappear to change into the pants she kept in her carryall.

When the demands on Burns and Joerger grew to an impossible level, Walt added to the team Wathel Rogers, who had joined the Disney animation department in 1939. He'd been an in-betweener and an assistant animator, but he'd caught Walt's attention for the toys and miniatures he built on his own time. When Walt brought to the studio the mechanical bird he'd bought in New Orleans, it was Rogers to whom he gave it, with instructions to figure out how it worked. Rogers had worked on the Project Little Man, and for Disneyland he constructed models that included the mock-up of Main Street, U.S.A., seen on the first episode of *Disneyland* on ABC. "We had a unique situation, being just three of us in this shop," Burns said. "Fred was a union model maker, and Wathel

was very talented in both mechanical and electrical. And then, I had this artistic display background. I had worked with all the power tools, and fiberglass was very new. The combination [of talents] was good for all of us. We helped each other. We did everything from the design in 3D, in a model, to the final production."

Like many early Imagineers, Rogers straddled the divide between the studio and WED Enterprises, continuing to work on film projects once the crush of Disneyland work eased. Indeed, it was impossible to draw a definitive line between WED and Walt Disney Productions during the creation of Disneyland. With no space to call their own, save for the dilapidated Zorro building, Imagineers did their work wherever they happened to be. They were scattered everywhere—but Walt knew where to find each of them and checked in regularly. He especially loved visiting the model makers in their makeshift workshop, a habit he retained later when WED had its own home and the Model Shop no longer shared a boxcar with the Machine Shop.

Wherever they were, the WED artists worked long hours and often six- or seven-day weeks with no overtime pay. With just a year to design, build, and install everything that would become Disneyland, they were just doing what they needed to do to get things done. But they were also setting in motion a creative process that would be followed for decades to come. Much of it was adapted from filmmaking practices—narrative development, design sketches, storyboards, models—but modifications and digressions came naturally. No one making a movie needed to figure out how many vehicles could fit into a dark ride at one time, for instance. Martin recalled that the Mr. Toad team eventually settled on a total ride time of 98 seconds—not including loading—and that information, along with the speed of the cars and the length of the track, made it possible to calculate the number of vehicles running at any given moment. There would be nine cars on the track, three held in reserve, for a top capacity of 700 riders an hour. Speed also determined the spacing of certain gags: if a hinged wall was to swing open suddenly upon the approach of a Toad car, it needed time to let the vehicle pass through and to close again

before it came within view of the next car. The mathematics of theme park attractions would only get more complicated as the decades passed.

The practical effects were worked out by Robert A. Mattey Jr., known as Bob, who had been frequenting film sets since the silent days, when his father worked on movies such as *The King of Kings* as a costume jeweler. The younger Mattey became known for his mastery of mechanical effects, assisting the special effects teams on *King Kong* (1933) and other films. Harper Goff recruited Mattey to Disney to work on *20,000 Leagues Under the Sea* after seeing a mechanically animated octopus Mattey had created for a John Wayne sea adventure film called *Wake of the Red Witch* (1948). Mattey's contract work on the famous giant squid in *20,000 Leagues* earned him a full-time job as head of Disney's Mechanical Effects Department—just in time to assist the WED team with Disneyland. For Mr. Toad, he devised teetering wooden crates that appeared ready to fall onto the riders, among other effects.

According to Martin, much of the final rigging was worked out only after construction and installation had begun. Since Disneyland itself was still just beginning to emerge from the former orange groves when the WED team was ready to start building the attractions, the sets for Peter Pan and Mr. Toad were assembled on a studio soundstage. With no time or money to train assistant painters, Anderson and Coats did much of the black-light painting of the plywood flats themselves.

The vehicles for most of the attractions were fabricated by an amusement park ride company called Arrow Development, based in Mountain View, California, just south of San Francisco. Disney could not have built Disneyland—and certainly not in a one-year time frame—without its partnership with Arrow. The company had been founded after World War II by four friends who had worked together at an ironworks foundry. They had built many carousels for smaller amusement parks and traveling carnivals, as well as miniature trains and boats fashioned from sheet metal. They heard about Disneyland early on—before its Anaheim location had even been settled—and contacted Disney. Impressed with the work Arrow described, Walt and Dick Irvine visited the company

along with Francis X. Bruce Bushman. The son of silent film star Francis X. Bushman, Bruce Bushman was a layout artist and art director on Disney's animated shorts and features, starting in the early 1940s, and had worked with Goff on *20,000 Leagues*. Then Walt recruited him for WED Enterprises, deciding he would oversee Fantasyland. With Arrow's experience on carnival rides, the Disney team decided to give the company a shot at the land's animation-inspired rides, starting with the Mr. Toad cars, a Ford Model T–like vehicle that Bushman had sketched out.

Disney was happy with the company's work, and Arrow wound up fabricating most of the attraction mechanisms and vehicles for Fantasyland's original attractions: Snow White; the Casey Jr. Circus Train; the Mad Hatter's Tea Party (soon dubbed the "tea cup" ride); and the many-armed, rotating Dumbo the Flying Elephant, again based on a Bushman sketch. The company also worked on the King Arthur Carrousel, a renovation job on an existing merry-go-round relocated from a Toronto amusement park, with Disney artists modifying additional vintage horses to make sure every mount was a galloping steed, as Walt insisted. Arrow fashioned the Peter Pan's Flight galleons while a different company, one that made customized overhead tracks for factory floors, made the machinery. The twelve Mr. Toad vehicles were first, though, made out of 200 pounds of sheet metal and fiberglass—then a relatively new material for vehicle bodies.

The Arrow relationship established another of WED Enterprises' standard practices: close partnerships with experienced ride manufacturers to produce the mechanisms and vehicles needed for attractions. The soon-to-be Imagineers would provide designs and experiential goals— could the riders make the Dumbo elephants go up and down?—and the vendors would do their best to turn those fancies into fabrications. There was always a back-and-forth. For example, the Toad cars' minimum turning radius, as set by Arrow, determined the sharpness of the turns possible along the track—and there were many. The position of the billowing sail on the Peter Pan vehicles, designed as miniature galleons, was determined in part to hide the riders' view of the ship's connection to the overhead track. The art of storytelling within the parameters of

practical considerations would be a hallmark of WED Enterprises for years to come—as well as a motivation for innovations that regularly expanded the definition of what was practical.

III. BUILDING A DREAM

As busy as the WED Enterprises team had been in late 1953 and early 1954, the job of clearing all those orange and walnut trees from Disney's 160 acres in Anaheim did not begin until July 21, 1954, a little less than a year before the park was to open. Surprisingly, there was no ceremonial groundbreaking for the press. A public event was planned for August 25, but it didn't happen, perhaps because there was simply too much to do to stop and smile for the cameras.

The speed was largely a financial decision. The park could not generate revenue until it was open, and both Walt and the Disney company were struggling just to fund the construction. The ABC deal had earned the project a $4.5 million line of credit, but that didn't go far for a park that would end up costing $17 million—triple the original budget. The other partners provided some additional funds, and Walt kicked in everything he could: he sold his Palm Springs vacation home and took out the maximum allowable loan against his life insurance policy. But costs kept rising. "Much to the chagrin of Roy, who had to balance the books all the time," recalled Don Iwerks, who worked in the studio camera department, "Walt would say, 'Well, we're gonna do it anyway.' 'Well, it's gonna run over.' 'Well, we're gonna do it. We don't want to do a job that isn't first class.' You know, that permeated the whole company."

Disney's massive investment was chided by some as "Walt's folly" in the press, since few people other than Walt and the Imagineers really understood how different Disneyland would be from the grubby collections of rides and rip-offs that Americans were familiar with. "Amusement parks were dying in this country," Marty Sklar noted, "and Disney was a very small company in those days. And taking that on, if it hadn't worked, it probably would have been the end of the Disney empire."

Among those struggling to convince people that Disneyland would

be a brand-new experience was the marketing team, aggressively recruiting sponsors. "Nat Winecoff [WED's VP and general manager] and Dick Irvine were taking these [Main Street, U.S.A.] drawings in a portfolio all around the United States to try to sell square footage," Herb Ryman related. "And believe it or not, it wasn't too easy to sell people on the success of Disneyland because there were a lot of doubting Thomases. And finally the ball began to roll and it began to get bigger and bigger and bigger."

In time, some prominent companies signed on. Among the best-known to Americans in the 1950s were the Atchison, Topeka & Santa Fe Railway, which underwrote what became the Santa Fe & Disneyland Railroad; Carnation, which leased space and paid to build a café on Main Street, U.S.A.; and Chicken of the Sea, which would serve tuna dishes from WED's land-locked recreation of the Captain Hook's pirate ship from Peter Pan. There would even be an Intimate Apparel Shop, sponsored by the Hollywood-Maxwell Brassiere Company and featuring a mechanical figure with a turban and bushy white beard called the Wizard of Bras. (The Wizard could wave a "magic wand" and speak a few repeated lines about fashion "then and now" via a tape recording, but he was more window display than robot.) Main Street's "Upjohn Pharmacy" would sell nothing, instead simply displaying vintage pharmaceutical equipment and promoting the company's products. The drug manufacturer estimated its name would be seen by six million people a year for the cost of a one-page ad in *Life* magazine. (It remained open until 1970.)

All these revenue streams were just drops in a very leaky budget, though. The only lasting fix for the money drain would be paying customers, so the park had to open on time. To make sure that would happen, Walt hired retired Rear Admiral Joseph W. Fowler, who had supervised all the Navy's West Coast shipyards during World War II, to be in charge of the construction. A man who had built aircraft carriers with wartime hustle should be able to get Disneyland built in about a year. Having started work in April 1954, while the Anaheim location was still blanketed by orange groves and dotted with private homes—the

last family didn't move out until a month after construction began—one of Fowler's first tasks was to build Walt's long envisioned riverboat, to be called the *Mark Twain*. Like the railroad, it would be built at approximately 5/8 scale, measuring 105 feet long, but otherwise it would resemble a paddle wheeler from the mid-19th century, when its namesake author was a steamboat pilot on the Mississippi. Fowler hired a shipyard in San Pedro to build the keel, while Disney set builders constructed the decks at the studio. Some details would later be fabricated at the machine shop Fowler set up in Frontierland, where the vessel would be assembled.

The *Mark Twain* would then need a river to navigate—something Fowler had less experience in building. Several waterways in Disneyland were dug out early in the construction period, and the dirt was used to build the berm around the park, as well as an undeveloped mound next to Fantasyland known as Holiday Hill. What became the Rivers of America and the Jungle Cruise would be connected via an underground channel, so their waters could be managed jointly. A first attempt to irrigate a section of this giant ditch was a resounding failure. The river segment filled up, as planned, but the water quickly soaked into the soil. After rejecting the idea of artificial liners, such as a layer of plastic, Fowler hit paydirt—more precisely, pay-clay. A layer of common, impervious clay held the water in place in a test section of river and was extended to both waterways.

The Jungle Cruise, in various incarnations, had been part of Walt's vision for Disneyland from early on. It was included on Marvin Davis's mid-1953 overall site plan, labeled "True Life Adventure," after the animal-focused Disney documentary series. "It was going to be all the tropical rivers of the world," Herb Ryman recalled, "which is a marvelous idea. And then we were talking about live animals and put an elephant in here and we put a chimpanzee in here, and there'll be a giraffe here. In other words, it was a kind of a zoo that you'd ride through. And it wasn't until long after that that we were told by authorities that you couldn't do that. They said, you'll go through and the animals will be hiding. They'll be asleep, because they don't like human beings." Animal care experts explained that not only were creatures unpredictable, they would be

expensive and complicated to feed and house. Except for guest appearances, live animals at a Disney park would have to wait several decades.

The answer was to take the Project Little Man technology into a new realm—and to new depths—fabricating a herd of artificial animals suitable to the ride environment. As Harper Goff recalled, he and Walt "had both seen *The African Queen*"—the 1951 Oscar-winner with Humphrey Bogart and Katharine Hepburn navigating the Ulonga River—"and we began to think of hippos and other animals which could be operated without wires and still have animated elements." The attraction became the centerpiece for Adventureland, inspired by the True-Life Adventure films but no longer explicitly tied to them.

While the True-Life documentaries were entertaining, they were also explicitly educational. The attraction inspired by them was less so. "One of [Walt's] theories, which has been repeated many, many times," Ryman recounted, was, "I would rather entertain people and hope that they will learn than to teach them and hope that they will be entertained." Ryman continued, "We call him a showman, the world's greatest showman, which there's no doubt of. . . . But he was a great teacher."

Initially burdened with the name The Tropical Rivers of the World, the soon-to-be-beloved Jungle Cruise became Goff's responsibility. He went to work on a rough layout of the attraction and made sketches of the boats he envisioned, inspired in part by the Bogart film.

And that's how Goff found himself one day in 1954 driving around a sandy trench in a station wagon. "We finished laying out the Jungle Cruise river with all its twists and turns and made a mock-up of the cruise boat and mounted it on a Jeep so that we could fit [it] around the course of the river and under the waterfall," he recalled. The test was needed to lock down the timing, exact distances, and radius of the turns for his proposed river course—information the engineering team needed to start work. "I was anxious about it and looked forward to making the first run with 'no one looking' in case there were problems. But before I could start, Walt came roaring up. He had heard I was going to make a test run and wanted to come along. Luckily it went very well."

Mechanical master Bob Mattey was again called upon to create artificial animals that would move and menace the ride boats. "The first ones that we tried were alligators and hippos, which worked on simple animation—no kicking or swimming," Goff said. It was the first extensive assignment for the lifelike robots that came to be called Audio-Animatronics—and a future maintenance challenge, since many of the creatures would be moving back and forth through water day after day. (When Mattey was done with the Jungle Cruise, he went on to add realistic bears, deer, and elk along the shores of the Rivers of America, and to animate the figure of Timothy Mouse at the pinnacle of the Dumbo the Flying Elephant attraction, among other contributions to the park. Mattey remained with the studio for years, working on both the flying Model T car in *The Absent-Minded Professor* as well as the Volkswagen cars in the Herbie movies.)

The final engineering of the Jungle Cruise menagerie and the other moving figures also owed a lot to Machine Shop head Roger Broggie, noted Don Iwerks. Mattey was great at time-limited movie effects, which didn't need to last, while Broggie could create mechanisms "that would last much longer and with little maintenance," Iwerks said.

The next challenge for the tropical river ride was to turn the former orange grove into a thick, convincing jungle. It was a job Goff undertook with landscaper Morgan "Bill" Evans—the humble man who dressed all of Disneyland in living plants, setting the standard for every theme park to come. The artists at WED could draw pretty trees and shrubs and flowers in their every sketch, but it fell to Evans to find the 800-plus species of plants needed to turn those doodles into reality.

Evans was a third-generation horticulturist who co-owned, with his father and brother, a nursery in Santa Monica. The Evans men were known for their creative introduction to Southern California of non-native plants from all over the world. Their inventory of rare and exotic plants had earned them an impressive list of Hollywood clients including Greta Garbo, Clark Gable, and Elizabeth Taylor—as well as Walt. Bill Evans had worked with Walt on the grounds of the Disneys' Holmby

Hills home—including the plantings around the tracks of the Carolwood Pacific.

For Disneyland, Walt hired Bill and his brother, Jack, in 1954, giving them just about a year to transform the former orange groves into a neatly manicured and abundantly green park. But the assignment was much more complex than the Holmby Hills job. As the artists at WED had envisioned, each of the four lands—plus Main Street, U.S.A., and the hub—needed to be landscaped in a way that supported its individual story and differentiated it from the park's other realms. Though he hadn't worked on movies, as most WED artists had, Evans understood the narrative character of Disneyland and considered his plants to be actors in the park's stories. His plants were like his children, and he knew the history of every tree he planted—whether grown from a seed or transplanted from somewhere else.

Evans didn't have time to wait for trees to grow up from seedlings—and he didn't have the budget to buy all the full-grown trees he needed from pricey nursery suppliers. So he turned to the builders of the Santa Ana and other freeways under construction at the same time as Disneyland, striking a deal to buy and relocate trees from the highways' paths that otherwise would have been destroyed. For $25 each, Evans' team was allowed to rescue and relocate the adult trees. He also ran ads in Orange County newspapers in search of anyone with a big tree they wanted to get rid of. When people contacted Evans, his team would visit the residence, carefully dig up the tree, preserving as much of its roots as possible, refill the hole in the ground, sometimes with the addition of a young tree, and carry the adult tree off to Disneyland.

Goff encouraged Evans to knock on doors in search of cheap trees. "We would call cities to see if they were tearing out trees for improvements and go and buy them," Goff recalled. "We got many that way. We drove all around in places like Pasadena, seeing great, big, nice trees. We'd go up to people and ask them, 'Any chance that you're tired of that tree? We'll give you $200 and carry it away.' Most of these people looked at us like it was some kind of joke."

One particular banyan tree shading a front yard in Beverly Hills,

along the route from the Evans' nursery down to Anaheim, became an obsession for Goff. It was, he said, "a wonderful tree. Each time we passed it, we talked about getting it, and it became kind of a joke. Finally, I thought, 'What have we got to lose?', and had Jack Evans stop while I went in to ask the people if they could consider selling it. I told the owner we would replace it with a flower bed or anything they wanted and surprisingly enough the owner told me yes—it was blocking the sunlight and view coming through his front windows and we could just come and take it away." The homeowner didn't even want any money, just a smaller replacement tree. Once Goff convinced the Evans brothers that the owner was serious, they went and carefully dug up the tree and carted it to the park. It wound up in the Jungle Cruise next to a re-creation of a Burmese temple.

Goff even thought up a way to use some of the unwanted walnut trees along the boat channel by planting them upside down, so their gnarled roots would look like exotic plants. Some of the orphaned orange trees, right side up, were used as filler farther back from the water—although in future years, the landscaping team tasked with maintaining the ride had to go in and pluck the blossoms and any errant fruit, since orange trees didn't belong in a jungle.

"As for wildlife," Goff recalled, "Walt had asked me to line up a source of wild birds—crown herons, waterfowl. But when we filled the river with water, all kinds of wild birds found it by themselves. We canceled all our orders for the exotic ones."

Many books have been filled with tales like these—the missteps and innovative solutions that marked the construction of Disneyland—and all need not be recounted here. Expectations rose and fell as disasters were averted or plans fell apart. Record rainfall flooded some areas, delaying the build, and labor disputes threatened to halt work altogether. Flooded or dry, the construction zone, for much of that year, looked like a disaster zone. "Everything wasn't sweetness and light and beautiful during the construction," Harper Goff recounted. "Walt always came down on Sunday morning. And he looked all around all over everything, took a couple of big sighs and he said, 'We've spent a little over half the money

we have on this park. There isn't one thing that any human being would spend fifteen cents to come and see. And he said, 'I'm scared.' And he was. This is what worry is."

Despite their worries, neither Walt nor the WED artists ever gave up or took their foot off the gas. That included the young soon-to-be-Imagineer in charge of Tomorrowland's gas-powered Autopia. Robert Henry "Bob" Gurr was just 21 years old when WED Enterprises was founded, and he'd already crossed one career path off his list. He had been obsessed with airplanes and automobiles since he was a toddler in Southern California, and he had studied industrial design at the Art College Center of Design in Pasadena on a scholarship from General Motors. He worked briefly in Detroit but didn't like the city or the menial tasks he was given, so he gave up on the auto industry.

When Gurr moved back to Los Angeles in late 1953, having decided to start his own design firm, he caught up with his friend Dave Iwerks, with whom he had attended North Hollywood High School. He would sometimes visit the home of Dave's father, Ub Iwerks, particularly when Ub was remodeling classic cars. Through Ub Iwerks, Gurr learned some of what was going on at the Disney Studio, and Ub was impressed enough with Gurr to recommend him for a job. "Shortly after that," Gurr recalled, "I got a call from Art Center College and they said, 'Bob, go out to the Disney Studio. Somebody's going to meet you.'"

Waiting for Gurr just inside the studio gate was WED's Dick Irvine, who took him to see a miniature car chassis without a body. "They wanted somebody to design a body for that little car. So my knowledge of cars and my interest in cars eventually paid off," Gurr said. "By golly, I'm over at the studio, and we're going to design cars for Disneyland."

Autopia was to be a miniature version of the freeways that were then taking over Southern California, with scaled-down, two-person vehicles that older children could drive. "Walt had in his mind he wasn't going to buy a standard car for his park," Gurr said. "He wanted to have his own car, his own design, and that's where I came in." He'd been hired as a contractor, but he was soon a full-time WED employee, creating a fleet of forty cars, the design of which he based on Ferrari sports cars. Gurr

didn't know much about the mechanical side of car design—but he soon learned what he needed to know to get the job done, supported by Roger Broggie and the team at the studio Machine Shop and anyone else who might have skills to offer.

No one in the world had ever had a comparable experience to the design and construction of Disneyland, but at age 23, Gurr was particularly amazed at how much got done. "I just thought it was an absolute marvel of super organization without being organized," he recalled. "We were able to move so fast. We built it before the Xerox machine got invented. There was an orange grove full of bulldozers and a lot of dust and concrete trucks, everybody running around in circles. I thought, 'Well, I've never worked in a movie studio before, I guess this is the way it is'—not knowing that this was one of the fastest design projects in the history of America. It seemed totally normal to me at the time."

It would seem less normal on opening day.

IV. BLACK SUNDAY

There was no adjusting the grand opening: ABC Television would be broadcasting the most complex live television show ever conceived from Disneyland on Sunday, July 17, 1955. The network had cobbled together a record-setting fleet of bulky television cameras—at least two dozen, some shipped all the way across the country—along with all the necessary sound systems, camera operators, segment directors, and other personnel and equipment needed to carry off a ninety-minute special that would originate from locations throughout the park. The ABC team needed nearly three weeks to set up and rehearse this unprecedented undertaking, so dozens of broadcast workers mingled with the hundreds of construction workers—and a good number of WED employees—rushing around to get the park finished in those final days. Perhaps the only calm found in the week before the opening was aboard the *Mark Twain*, where Walt and Lillian Disney celebrated their thirtieth wedding anniversary with about three hundred guests. The party began with dinner at the Golden Horseshoe in Frontierland, followed by a cruise around the Rivers of America.

It was the first full circle on the underwater track of the *Mark Twain*, and Admiral Joe Fowler joined Lillian on board beforehand to sweep the construction dust off the decks.

Marty Sklar recalled the nonstop leadup to the opening simply as "chaos." It consisted, he said, of "running as fast as you can and getting as many people to do as many things as you can." One frantic meeting was between a director for the ABC show and WED's art director for Tomorrowland, Gabriel Scognamillo—another of the Hollywood art directors recruited by WED Enterprises. Tomorrowland "was a mess," Sklar said, "and so the director of the TV show said, 'What am I going to have to shoot on Sunday?' and the art director said, 'You'll have plenty to shoot. We're going to be pouring cement.'"

Tomorrowland was the last of the four themed realms to come together, and many of its planned attractions would not be ready on July 17. Its "wienie," a 76-foot-tall model of a rocket ship called the TWA Moonliner, was in place, but the attraction to which it welcomed guests, Rocket to the Moon, missed opening with the park by several days. The not-quite-finished state of Tomorrowland in July 1955 was in some ways symbolic of the decades to come. The land would always be a work in progress for the artists at WED—and, later, at Walt Disney Imagineering—as the future became the present and then slipped into the past. Wherever there was a Tomorrowland, in some sense, the Imagineers would always be pouring cement.

The land's exhibits and shows were not always successful at predicting the future lives of its visitors, but several did provide glimpses of Imagineering's own future. Rocket to the Moon, for example, established the soon-to-be-standard Imagineering practice of creating duplicate auditoriums to present the same experience, increasing the number of guests who could experience the attraction in a day, a stat referred to as ride capacity. In this case, two circular theaters with three tiered rows of seats each were dressed out to represent a capsule soaring into space. Each had two flat, circular screens standing in for windows: one in the ceiling showing where the rocket was heading and another in the center of the floor showing what was dropping away behind it.

Neither the auditorium nor the seats moved, but the attraction nevertheless established the template for the motion simulator rides to come, with its combination of projected media, sound and lighting effects, and an auditorium designed to give guests the impression of being inside a moving vehicle.

Also ready to go—and media-centric—was the Circarama theater, a round movie auditorium that used eleven 16mm projectors and eleven curved screens to present in 360 degrees a travelogue film called *A Tour of the West*. Walt had envisioned a circular movie presentation some years earlier, an idea he shared with Ub Iwerks after viewing CinemaScope dailies together in one of the studio's projection rooms.

As Iwerks's son Don Iwerks recalled, "Walt says to my dad, 'Hey, Ub. Can we do a 360-degree continuous movie? You know, if we could, we could probably get a sponsor for it and it could be an attraction down at the park.' And my dad says, 'Yeah, I think we could do that.' So within a few days, my dad had figured out how he would go about doing that and went to Walt and said, 'Yeah, we can do it, and here's how we do it,' and Walt says, 'Let's do it.'" To shoot the film, Ub Iwerks devised a circular rig with eleven 16-mm cameras mounted to a round metallic plate, facing out, like spokes on a wheel. A chain drive below the rig locked the cameras in sync. Once the mechanism was built, Don Iwerks was part of the crew that went on the road with director Peter Ellenshaw to film *A Tour of the West*. It was a delicate system, he recalled. "If you had a film jam on a camera, you didn't lose just the one, you lost all eleven of them, because you couldn't use [that footage]. So we were always concerned about making sure we were all threaded up just right." One crowd-pleasing shot put viewers aboard a fire truck rushing through the streets of Beverly Hills. Walt was impressed enough to order a second, more-elaborate film, called *America the Beautiful*, which debuted a few years later, and Imagineering and the Iwerks father-son duo continued to update the 360-degree technology for decades to come.

With opening day approaching and not enough attractions in Tomorrowland, Walt decided to fill one exhibition hall with props and sets from Disney's big summer release, *20,000 Leagues Under the Sea*. The

movie had opened in New York City at Christmas time, but its big roll-out in theaters across the nation was the same month as the opening of Disneyland. Ken Anderson served as art director for the exhibition, which included the mechanical giant squid that does battle with Captain Nemo—a creature Walt had once imagined as part of the boat ride that became the Jungle Cruise—as well as Nemo's pipe organ and other distinctive remnants from the Oscar-winning production design. (The exhibit remained open until 1966, and the organ's base and keyboard found a new home in the Haunted Mansion in Disneyland in 1969.) Another walk-through was the Monsanto Hall of Chemistry, an informational display relating the history of its subject. That left Autopia as Tomorrowland's only really kinetic attraction for opening day.

Despite the mad rush to the finish, Walt wanted to share Disneyland with everyone at the studio, whether they had worked on the park or not, and he invited them to come down to Anaheim for a preview. Ruthie Thompson, who had joined the Ink & Paint Department while the studio was still working on *Snow White and the Seven Dwarfs*, recalled that afternoon vividly: "The whole studio went the day before the opening." It was stifling hot, she remembered, but there was a grand luncheon served to the invited guests under a tent. "We rode on the rides, we had tickets and we had—well, we had everything." The park was an overwhelming experience: "My eyes were popping out of my face, hanging on my cheeks," she recalled.

Thompson, like many studio staffers, had been on some of the rides before, when they had been set up in mock-up form inside buildings or in outdoor spaces at the Burbank studio. "I'd seen everything on the lot except the cars [of Autopia]." On a Saturday afternoon when the studio craftsmen had just finished the 5/8-scale stagecoach, Walt made an event out of it. "He hitched up six ponies to the stagecoach, and he was just driving it around the lot. We were working overtime on something, and he rode by us [on our lunch break] and he says, 'Hey, girls. Wanna go for a ride?' So, of course, we left our lunch to the ants and we ran off and got on the coach and he took us around the lot a couple times. I

got on twice—the first time I got on, I sat beside him on the driver's seat and everybody got all loaded [inside]. And he says, 'Ruthie could drive these down at the park.' And I said, 'Oh, I don't think so.' He didn't say anything after that. He didn't like to have somebody disagree with him." She got a second ride anyway, but inside the coach, and her opinion of Walt was unaltered. "He was true blue," she said. "I admired him until the end."

"Opening Day" was something of a misnomer for July 17. It was the day Disneyland was revealed to the public, certainly, but the guests were limited to press and invitees, with regular ticket buyers welcomed for the first time on July 18. At least, that's how it was supposed to be. Between six thousand and ten thousand invitations went out to studio staff, construction team members, reporters, and sponsors and their families—each admitting the invitee "and party" at a set admission time—but someone made counterfeits of the paper passes. More than 28,000 people showed up—about twice the number Disney had planned for—and even people with legitimate invitations ignored the assigned entry times.

It wasn't just some of the attractions that remained unfinished. A plumbers' strike had made it impossible to finish both the drinking fountains and the restrooms in time for the opening—Walt had to choose one or the other and wisely enough elected to have working toilets. "He was accused later of forcing people to buy Coca-Cola because there were no drinking fountains," Sklar related. It was a crucial omission—with a heat wave having hit Orange County that weekend, temperatures soared to over 100 degrees Fahrenheit and softened the newly laid pavement on Main Street, U.S.A. "There were stories later about women's high heels—in those days, they actually wore high heels even to amusement parks—being caught in the asphalt," Sklar continued. "There were things like that all over the park."

The huge crowd meant that lines were long—especially outside those restrooms—and the restaurants and vending machines ran out of food. Fuses blew out on Mr. Toad's Wild Ride, leaving guests briefly in the dark. "I was located as an assistant supervisor in Fantasyland, and we

were unloading Dumbo with stepladders," recalled Dick Nunis, who would go on to become the park's director of Operations. "Opening day at Disneyland was really tough. We had gas leaks. The *Mark Twain* was overloaded and was [on the verge of] sinking. I could go on and on telling you disaster stories." It was no wonder that Disney staffers came to call the press preview day "Black Sunday."

At Autopia, the cars kept breaking down. "There were, I think, sixty cars originally, and not one of them was running at the end of the first day," Sklar recalled. Part of the problem was the drivers: unlike later incarnations of the attraction, the Autopia of 1955 had two lanes and no center guide rail, and drivers took that as license to attempt to race one another. Crashes were frequent—including Sammy Davis Jr. thumping Frank Sinatra's car from behind for the TV cameras. There were less congenial confrontations in the boarding area, as guests ignored the queue and stormed the miniature freeway.

"They all had the attitude that they were gonna ride those cars no matter what," Gurr recounted. "And instead of waiting in line like they should, they were jumping over the fence running up the track and commandeering cars coming back into the load area and pulling people out of the cars and taking over the cars themselves. Nobody had anticipated this, and it was a complete mad house." The problems elsewhere were more critical, he added. "The teacup ride was mechanically falling apart. The welders were told, 'Well, the first thing you do is go over and weld the teacup cracks and then go off and fix everything else.'"

ABC did its job well, though, and despite a few glitches, the live *Dateline Disneyland* special made the park look appealing and full of guests (especially children) enjoying themselves. Hosts Art Linkletter, Bob Cummings, and Ronald Reagan appeared at sites all over the park, extolling the virtues of the rides and of the park's sponsors. Walt himself appeared frequently, including for his recitation of the text on the dedication plaque in Disneyland: TO ALL WHO COME TO THIS HAPPY PLACE: WELCOME. DISNEYLAND IS YOUR LAND. HERE AGE RELIVES FOND MEMORIES OF THE PAST—AND HERE YOUTH MAY SAVOR THE CHALLENGE AND PROMISE OF THE FUTURE. DISNEYLAND IS DEDICATED TO THE IDEALS, THE

DREAMS, AND THE HARD FACTS THAT HAVE CREATED AMERICA—WITH THE HOPE THAT IT WILL BE A SOURCE OF JOY AND INSPIRATION TO ALL THE WORLD. The TV show was a ratings juggernaut, attracting an estimated 90 million viewers in the United States at a time when the total population was just 165.9 million. The numbers guaranteed that Disneyland would instantly be a top tourist draw, and that Disney's television presence would only grow in the years to come. (Disney's *Mickey Mouse Club* was already set to premiere on ABC in October.)

It can only be imagined what each WED Enterprises artist felt on July 17 and July 18, 1955, but one hopes they had some recognition of what they had created. Perhaps some of them felt like ABC co-host Cummings, who summed up his own emotions for one of those twenty-some TV cameras on *Dateline Disneyland*: "Standing here has been one of the most exciting moments in my life. I think, ladies and gentlemen, that anyone who has been here today will say, as the people did many years ago when they were at the opening of the Eiffel Tower, 'I was there!' I am proud to say I was at the opening of Disneyland. It's a fabulous thing to happen."

The print press coverage of the opening was less ecstatic. Reporters recounted various unpleasant experiences and sights with sometimes venomous language. One newspaper branded the park "Walt's nightmare," and many journalists predicted Disneyland would soon fail. They were, of course, quite wrong, failing to account for the speed with which Disney could deal with the park's shortcomings—and with soothing the press. Among the reporters, "everybody was mad," said Sklar, then part of the marketing team. "For the next few weeks during the summer, the public relations department invited all the news media separately—the *Los Angeles Times* and the Associated Press, etc., etc.—to come and see the park the way we wanted them to see it, to repair all those damages of the so-called Black Sunday."

Whether it was the PR push, the connection people felt through Walt's ABC show, or old-fashioned word of mouth, guests quickly understood that Disneyland offered an experience far removed from anything they'd known before. Sklar heard it from the guests themselves. He had an office

in the building identified as the Police Station but which actually housed the park's tour guides. "I realized that if I left my door open, I could find out what people didn't understand about the parks," he recalled. Every now and then, someone would come in looking for directions and saying something like, "I want to go on the Jungle Cruise and I want to go on the *Mark Twain* riverboat and I want to go on the Flight to the Moon. But I don't want to go on any of the rides."

"We realized that in those days, rides were from the real amusement parks—the shoot-the-chutes and the whips and all those kinds of things," Sklar noted. "So we invented a new language—'attractions' and 'adventures' and 'stories'—and that became so important. In fact, I had responsibility for a lot of the written material for many years and I would not let anybody use the word 'rides,' because people related that to something that was dying at that time."

Disneyland was just being born, and people flocked to see it. The proof was in the day after Black Sunday, when the paying public was first admitted, and people started lining up at two a.m. An estimated 6,000 were in line by dawn, for a ten a.m. opening. The freeways were almost as jammed as they had been the day before, and the parking lot filled up again. So it continued throughout the summer. It took just two months to reach the one millionth visitor. The return of school that fall slowed the pace a bit, but an estimated 3.5 million visitors came in the first year. The park would be fine, and the money crunch soon eased off, with revenues enough to devote funds to expansion plans. New attractions continued to open throughout the rest of 1955—Dumbo, for instance, closed for modifications after the opening and didn't fly again until August—and more were planned for the years ahead. When reporters continued to complain about the number of attractions not yet open, Walt responded, "Disneyland will never be completed. It will continue to grow as long as there is imagination left in the world." This oft-quoted line became a mantra for Disney's Imagineers, applied not only to their first theme park, but to every park—indeed, every attraction—that was yet to come.

CHAPTER 3:

INNOVATE AND RENOVATE

"[Walt Disney] was never interested in what you did yesterday. He was only interested in what you were going to do today and tomorrow, because he was moving on, he was doing new things, he was challenging us constantly. That was exciting. . . . Imagine that you have no idea whether you can perform, whether you can live up to that, but he had faith in you, so you did it." —Marty Sklar

I. MOVIE METHODS

DISNEYLAND WASN'T JUST A PARK. It was an interactive movie rendered in three dimensions. The artists at WED Enterprises, taking their lead from Walt Disney, had approached its design not as a series of unrelated amusements but as one ongoing experience. It was a film turned into a place, the order of the narrative selected in part by the guests but the character of the storytelling built into the park itself. The idea was to integrate every element into a seamless experience, a completely immersive world, from the color of the castle to the color of the cobblestones, from the plantings to the graphics. It was, like a movie, art directed and edited, leaving nothing within the frame to chance. The "sets" were designed by film artists but taken two steps further: they were fully realized on all approachable sides, and they would be built to last, rather than to be torn down when the show wrapped.

The park surrounded visitors with an all-encompassing dream

reality—or rather, a series of dreams, represented by the four lands, by Main Street, U.S.A., and by the all-important hub. Going from one land to the next, or from the hub into any of the five realms, was like a motion picture dissolve, as the design elements of where you had been gradually blended into those of where you were going. By the end of their Disneyland day, guests had had an extraordinary experience all their own, registered as much with their emotions as with their intellect, just as a good movie would provide. Ideally, guests would be transformed by the experience—and moved to want to return.

"It's an experience you get through time," John Hench explained. "And of course it's a much, much heightened thing [compared with a film], since it's an experience. You're not watching somebody walk down Main Street; you're doing it yourself." Meaning, he continued, is conveyed not just visually but by what guests touch and feel as they proceed through the story. "It's the same kind of unfolding that goes on in a [motion] picture or a book, for that matter. And the transitions from one place to another have been carefully thought through." He compared the passage from one land to another to "a segue in a piece of music, and it happens so easily that people don't really realize what's happening."

The experience even began with a kind of opening credits—the giant floral portrait of Mickey Mouse just inside the entrance, beneath a depot sign reading DISNEYLAND in the train station above, serving as a title card. The entry plaza was followed by a dissolve to the first scene: the gradual reveal of Main Street, U.S.A., as guests passed beneath the train tracks and walked up the slight slope into the Town Square. To ensure that every "viewer" shared at least the first reel of their individual movie, Disneyland had only one entrance and exit—a break with the then-dominant practice at most larger U.S. amusement parks of having multiple points of entry, with parking adjacent to each.

"The visitor or the guest is going to enter and then he's going to find himself in another world," Walt told Herb Ryman. "You're going to forget the world outside and you're going to be in a very nostalgic Americana period of the turn of the century."

Main Street, U.S.A., was this living movie's first act, the scene that

set the tone for the stories to come. It was an abrupt separation from the real world and induction into a place of nostalgia and fantasy where there were no stoplights or traffic jams, everyone was treated the same as everyone else, and nothing could go wrong. One of Walt's well-known inspirations for Main Street, U.S.A., was his hometown of Marceline, Missouri, and the street reflected the Victorian sensibility that remained dominant when Walt was growing up in Marceline from 1906 to 1911, from age four to nine. But the street's execution by the WED team again drew on movie magic.

"Of course, we tried to select typical examples of [Victorian] architecture," Ryman recalled, "but we reduced the scale because the miniaturization of these buildings lends another dimension to fantasy. And so there's nothing on the second floors of the buildings because they're too small." From the perspective of the guests, the second floor did not appear immediately out of proportion with the normal-sized street level, but the scale of the Main Street buildings shrank above the ground floor, an artistic technique called forced perspective, common on movie sets. The upper floor appeared normal because the brain interpreted the reduced scale not as shrinkage but as increased distance. The effect added to the dreamlike atmosphere, the impression of a street both familiar and fantastical.

As the set designers–turned–Imagineers were working out the dimensions for the Main Street buildings—actually, of course, just a few buildings on either side of the street, with a series of connected store-front facades that made them appear to be separate businesses—Walt had been working out the dimensions for the sidewalks and the street itself. As Ryman recalled, "I'd seen him when we were there at the studio—he'd be pacing off distances between curbings at the studio. And he'd do this for weeks at a time. And I said, 'What are you doing?' He said, 'I'm trying to work out the relationship of the curbing to the sidewalk to the width of the street.' You'd think it was very easy to arrive at, but this was one of the toughest things that Walt did for Main Street. The theory was, . . . on a day when there's nobody in the park, if you've got a wide street, people come in and they think, 'Oh, nobody's here.

Nobody likes this place. It's not a success.' On the other hand, if the street is too narrow and the place becomes popular and people love it and they're milling around elbow to elbow and shoulder to shoulder, they're going to feel very unhappy with these squeezed-in curbings. So what was arrived at, I think, was a pretty ideal dimension, considering the height of the buildings."

The final street was about thirty feet wide, with the sidewalks on each side about fifteen feet wide, the curbs providing the pleasing proportions of 1:2:1 as they directed guests' eyes to the castle in the distance. Ryman judged the widths to be just right. "I've been down there on very crowded days and I don't hear anybody complaining about the tiny little narrow Main Street," he said. "And I don't hear anybody say, 'Well, that's not the way my hometown looks, those little tiny windows.'" One explanation for guests' ready acceptance of the reduced size of the Main Street buildings lay in a trick of memory: an adult who revisited a street they had not seen since childhood tended to find it smaller than they remembered, since the observer had grown in the meantime.

Inside the shops, Walt envisioned additional cinematic dissolves. As Ryman related, Walt had "this percolating idea of going inside and following through the shops and stores"—walking from one to the next by passing through where walls would have been in an actual downtown. "This was not the concept in the beginning," Ryman said, "but it soon developed that Walt insisted that there be entrances that you'd percolate through all these shops. And, of course, in the beginning I thought, 'Well, that isn't the way a little town in the Middle West is done. I never walked into a hardware store and then found [an entryway to] a shoe store next door. You'd have to go outside and back in again.'" But in a film made about that hamlet, the story could do exactly that—dissolve from one location to the next without traveling along the street between them.

As Walt described it to Ryman, the park's Main Street would begin with a Town Square, "but at the end of Main Street, you're going to see this beautiful castle. And that's going to be where eventually you wish to go." It needed to be, Ryman recalled, "a very, very conspicuous castle." Walt told him that it needed to be "high, tall, and beautiful, because

the castle is going to be the symbol of this whole place. . . . It's going to represent the land of your dreams. . . . I want this castle to be seen from miles around, so that when people drive near it, they'll say, 'Oh, there it is!' It's the equivalent of one of the great cathedrals in Europe in a little village. It towers above everything else."

Walt had a term for the impressive structures that both denoted a location and drew visitors forward. He called them "wienies"—perhaps named after the chilled frankfurters he used to grab from the refrigerator to lure his poodle, Duchess, from room to room when he got home at night. A wienie was both a visual magnet and a point of orientation that helped people navigate. It rewarded their wanderings with a big reveal around certain corners and lured them to move into a new area. The castle was the dominant wienie in Disneyland, but individual lands would have their own visual draws: the Moonliner rocket ship in Tomorrowland, the *Mark Twain* Riverboat in Frontierland, the enticing entrance to the Jungle Cruise in Adventureland. Wienies kept people moving and kept them oriented, and at the same time served as the focus of the land in which they sat. Even the train station at the entrance to the park could be considered a wienie, since it invited people inside at the beginning of their day and showed them the way to go home when they decided to leave.

The castle was dubbed Sleeping Beauty Castle, promoting Disney's upcoming animated feature, then in production. (It was released in January 1959.) According to Ryman, by the time he joined WED Enterprises, "Marvin Davis and Dick Irvine had already had a conception of [the castle,] borrowing the architectural features of the Mad King Ludwig's castle at Neuschwanstein" in the mountains of southern Germany—a late-nineteenth-century palace imagined in part by a stage designer.

A model of the castle was created by WED model builder Fred Joerger, and Walt was scheduled to come approve it one Saturday. "Dick and Marvin were sitting there and Walt was on his way down," Ryman recalled. Joerger had left the front section of the castle loose, presumably so it could be picked up to expose the courtyard beyond. "I went to the castle

and touched it and I said, 'Well, you've done the same thing. This is Neuschwanstein. Everybody knows it's Neuschwanstein.' And I saw that it was loose. I picked it up and turned it around so that [the facade] faces the courtyard and so the dormer faces Main Street. And Dick said, 'Now, Herbie, quit playing with that. Put it back, put it back. Walt's going to be here any minute and Walt won't like it. Turn it around, put it back.' And now Walt is standing in the doorway, and Walt said, 'Oh, I like that a lot better.' So then Marvin and Dick began to like it a lot better. And today [the intended facade] is facing inside, because Walt liked it a lot better."

The tallest turret of the castle was seventy-seven feet tall, but the structure was little more than an ornamental gateway to Fantasyland. It had a vacant second floor that was not accessible to guests—an arrangement Walt was unhappy with. (At Walt's insistence, two years after the park opened, the Imagineers added to the second floor a series of walk-through dioramas telling the story of Sleeping Beauty.) It was far smaller than the castle that would be seen in the *Sleeping Beauty* film, but its soaring blue-roofed turrets and stone walls did echo the movie's fortress. To make the castle seem taller than it actually was, the designers again utilized forced perspective—the higher the turret, the smaller its scale, providing an impression of increased height. Thus the castle served its purpose as a wienie, drawing visitors down Main Street, U.S.A., and beckoning to those outside the park with a hint of the wonders within.

Visibility in the opposite direction—from inside the park to the world outside—was strictly limited. As Walt's industry rivals had noted, his creation set itself apart from the amusement parks of the day, with their many entrances, their openness to their surroundings, their flat expanses of space broken up only by rides and concessions and ticket booths, without a tree to be found. Disneyland had a berm up to twenty feet tall circling the entire park, with a dual function. It blocked views of the outside world from inside, and it served as the path for the five-eighths-scale steam train that would travel all the way around Disneyland.

Perhaps the place most emblematic of Walt's determination to separate the park from the outside world was the hub. The calm, elegantly landscaped, attraction-free center was an idea Walt had from the very

beginning, and he described it to Ryman while they were crafting that original drawing of the park. "When I was in Europe, when I was studying this thing," Walt said, in Ryman's account, "one of the great problems about amusement parks, any kind of a park, is that people get exhausted walking. Now . . . I want to have these radiating spokes from the hub so that people that are tired or sick or old, . . . they can say, 'Well, you kids run on ahead. We'll meet you here in forty-five minutes.'" If Disneyland was experienced as a movie, the hub allowed viewers to hit pause. "And there again was the secret of Walt's amazing concept of entertainment," Ryman said. "He knew that people had to be comfortable, and he knew that they had to feel at ease."

Borrowed in part from the radial boulevards that led like spokes to landmark structures in central Paris (the Arc de Triomphe) and Washington, D.C. (the United States Capitol), "the hub system probably is one of the salient characteristics of Disneyland that makes it work," Ryman said. The plan effectively eliminated a common problem at amusement parks Walt had visited: those arranged around a main drag saw traffic significantly reduced to any location reached by way of a side street, since guests tended to congregate on the principal thoroughfare. Main Street, U.S.A., lived up to its name, but it ended at the central hub, which offered four destinations at roughly equal distance. "So you go over here to Tomorrowland," Ryman said. "You can go over here to Adventureland, you can . . . infiltrate and pass through all of these lands, which was a little bit of an additional idea."

The schematic layout Ryman had worked from in September 1953 had been created by Marvin Davis after what he later claimed was 129 iterations. Even that late 1953 snapshot was soon cast aside, as the land called True-Life Adventure shifted from one side of the park to the other, a proposed Lilliputian Land was merged with Fantasy Land, and Holiday Land shrank from a full land to a lightly landscaped mountain called Holiday Hill, created from dirt excavated from the man-made rivers in Disneyland. The final plan called for the hub to open up to just the four lands introduced in the *Disneyland* TV show—with their compound names, so familiar to generations of fans.

The details evolved, but Walt never wavered in his overall vision. "Walt was very hypnotic, and he could convince you that this was going to be the greatest thing that ever happened," Ryman said. "And then afterwards, the hypnotic spell would wear off and you'd think, 'Well now, what if this fails? What if the people don't like it? What if it's too far away? What if they can't afford it? What if they go once and never come back? But anyway, that's Walt's problem, because it's called Disneyland. It's not called Herbieland or Rymanland or anything like that. So if he fails then it's his failure.' But it didn't fail, as everyone knows."

II. PLUSSING THE PARK, PART I

James Ingebretsen had just graduated from high school in Northern California when he visited Disneyland one Memorial Day weekend in its early years. He was there with friends from St. Elizabeth High School in Oakland, and while they expected encounters with Disney characters, there was one sighting they hadn't planned on. "As we were waiting for the *Mark Twain* to dock," he remembered more than forty years later, "I looked up at the bow, and there stood Walt Disney himself, looking over his kingdom. Nobody else had caught sight of him yet, so it was a peaceful moment for him, but it was one of my most exciting moments. What a sight! I can still picture it very clearly in my mind."

Walt Disney loved to wander around Disneyland, enjoying both solitary surveillance and interactions with the guests. Tourists might be standing in front of the Mickey Mouse Club Theater in Fantasyland, for example, and suddenly they'd hear a familiar voice behind them. They'd turn around, and there would be Walt himself, perhaps accompanied by Mickey Mouse. As the children gravitated to the costumed character, the adults could spend time with Walt, shaking hands, chatting casually. "He didn't seem to be in a hurry," one dad remembered. "People didn't crowd around him."

Did a family need a hand filming their vacation? No problem. "As I was riding the merry-go-round, my mother called to me to pass my movie camera to her," a guest named Charles Warren Wickman said,

recalling when he was twelve years old. "A man standing just inside the fence said he would pass the camera to my mother. Instead of passing it to my mother, he began to film me, then swung around and filmed my mother watching me." It was only later, after the man had handed the eight-millimeter camera to a cast member and disappeared, that mother and son realized the kind stranger had been Walt Disney. "Mr. Disney spends hours a day here helping people have fun," the cast member told the family.

Walt insisted that his Imagineers do the same. "Walt expected us to go down there," John Hench recounted. "We would spend—I think it was—at least twice a month." The visiting Imagineers would mingle with the crowds, checking out guest reactions to the attractions they'd worked on—no cutting in front allowed. "He didn't want us to go in the back way. He said that we should walk in, stand in line at the front, if there was one, and have the same experience as our guests." Their assignment was to watch and listen and learn. This was the point of everything they did, after all—to bring happiness to the guests. There was no way to judge their success from Burbank, much less from the skewed lens of press reports. Furthermore, everything in Disneyland was subject to revision, and the park itself was still growing. Imagineers could incorporate their observations into plans for additions and changes. And if something was just a little bit off, it could be quietly corrected. "I don't know any other design firm that has ever had this privilege," Hench said.

With the park open and a phenomenal success, the staff of WED Enterprises had a new challenge: there were so many guests—including repeat customers—that the visitors needed more to do. The park, to use Walt's phrase, needed "plussing."

In a 1956 interview with journalist Pete Martin, Walt spelled it out: "The park means a lot to me in that it's something that will never be finished—something that I can keep developing, keep plussing and adding to. It's alive. It will be a live, breathing thing that will need changes." This was, he said, in contrast to the movies he made. "A picture is a thing that once you wrap it up and turn it over to Technicolor, you're through. *Snow White* is a dead issue with me." His goal with Disneyland, he

continued, was to create "something I could keep plussing with ideas. . . . Not only can I add things, but even the trees will keep growing; the thing will get more beautiful every year."

So Walt's unheralded visits to Disneyland in the early days were as much to imagine its future as to assess its present. Walt, Marty Sklar recalled, "was never interested in what you did yesterday. He was only interested in what you were going to do today and tomorrow, because he was moving on, he was doing new things, he was challenging us constantly. That was exciting, you know, because somebody tells you that what you did yesterday is never going to be good enough again. Imagine that—you have no idea whether you can perform, whether you can live up to that, but he had faith in you, so you did it."

The park began changing within days of its opening. Two delayed attractions in Tomorrowland debuted before the end of July: Rocket to the Moon and the Tomorrowland Boats, an Autopia-like attraction on a none-too-scenic lagoon. The water ride was not a success. Renamed the Phantom Boats, which sounded more fun, it closed after just a year, in part because guests proved such poor drivers that each of the fourteen little four-person fiberglass vessels had to be assigned a cast member pilot. The reduced guest capacity and increased staff costs could not be sustained.

More enduring were the Astro Jets, a made-to-order ride manufactured by an outside vendor that opened in March 1956. Similar to Dumbo, its rocket-like vehicles were on spokes, "flew" in a circle, and could be moved up and down by the riders. (Like Rocket to the Moon, which was updated and renamed in 1967 and 1975, Astro Jets would be "plussed" at least twice in the decades to come.) Tomorrowland was also a haven for sponsor-related exhibits. In the first few years of Disneyland operations, such drop-in areas were hosted by Monsanto, Kaiser Aluminum, and Dutch Boy Paint. L. M. Cox Manufacturing, a hobby company, supervised a circular outdoor space dubbed the Flight Circle, which featured cast members building and testing model airplanes. Though now little remembered, it lasted until 1965.

The sponsored exhibits were free, but all the more engaging

attractions—what some would have termed "rides"—required separately purchased tickets. In October 1955, the marketing team streamlined this potentially confusing assortment of fees by offering Value Books that included general admission and coupons that could be used on the attractions, which were categorized as A (the Carrousel, Main Street vehicles), B (Mad Tea Party, Dumbo, Phantom Boats), or the coveted C tickets (Jungle Cruise, Fantasyland dark rides). Even the 20,000 Leagues exhibit required an A ticket.

But Walt had another idea for a value-added attraction: a circus. For the park's first holiday season, guests could get the full circus experience— trapeze, acrobats, clowns, animal acts—for an additional 50 cents, or a full dollar for premium reserved seats. In an attempt to lock the show into the Disney brand, it was dubbed the Mickey Mouse Club Circus, and some of the child stars from the ABC TV show appeared with the circus professionals. Located in "the world's largest striped circus tent" in a flat area near Holiday Hill, adjacent to Fantasyland, the circus lasted from late November 1955 until early January. Bruce Bushman was credited as the circus art director, but otherwise WED artists had little involvement. While guests may have enjoyed the Thanksgiving Day circus parade along Main Street, U.S.A., a circus was not what most were looking for from Disney. Attendance in the 2,500-capacity tent was short of expectations, and the show lost money. It was not repeated.

The empty plot next to Fantasyland was soon filled with other attractions, all of them since lost to subsequent expansions and additions, including a self-driving Motor Boat Cruise to replace the Phantom Boats (with a guiding track, this time). A second land-based self-driving attraction opened in July 1956, called Junior Autopia and designed for smaller drivers. The original attraction's capacity was regularly reduced in the early days because the cars broke down constantly and "we had no maintenance facilities," Bob Gurr recalled. Soon after the park's opening, "I came down here in my old yellow Cadillac, with my trunk open and my own tools and for about a week, repairing the Autopia cars." When Walt came by and saw the few working vehicles and the long line of guests, he said simply, "Well, Bobby, do you need some help?" Soon the

attraction had its own maintenance shed and two dedicated mechanics. It was another lesson learned in not just park design, but park operations.

One iconic feature of Disneyland—one featured even on Herb Ryman's 1953 drawing, though it had not then been named—was also ready in the summer of 1956. Tom Sawyer Island, accessible only via guided rafts across the Rivers of America, had trails and caves and a fort and tree house for children to explore. It was the play area Walt wished he'd had growing up. "I put in all the things I wanted to do as a kid—and couldn't," Walt told Marvin Davis, after Walt had completely revamped Davis's own design for the island. The Rivers of America also soon gained a guest-powered canoe ride and two thirty-eight-foot Mike Fink Keel Boats.

But the most elaborate new water ride was in Fantasyland: the Storybook Land Canal Boats. The attraction had actually opened with the park under the name Canal Boats of the World, but at that time the journey had passed by nothing more exciting than banks of weeds to which the Imagineers had added placards identifying them by their Latin names, to make them appear intentional. (Another Walt idea.) It soon closed down for a full renovation, reopening in June 1956 as a ride through the newly installed Storybook Land. The landscape was populated by one-twelfth-scale miniature buildings and props that would create a Lilliputian realm of scenes from Disney shorts such as *The Three Little Pigs* and *The Old Mill*, as well as many of the studios' animated features.

The attraction—which could be viewed from either the kid-sized Casey Jr. Circus Train or the Canal Boats—put the focus on the creations of WED's talented Model Shop, previously visible only within WED Enterprises. "Harriet Burns, along with Fred Joerger, built every single building out there," recalled Kim Irvine, the daughter of Dick Irvine and a future Imagineer, "putting in little stained glass windows and little wrought-iron knockers on the doors. The details on those buildings are outstanding."

The Storybook Land Canal Boats were judged exciting enough to be given one of the first D ticket designations (35 cents), along with the rafts

to Tom Sawyer Island and reclassified former C-ticket choices including Rocket to the Moon, the *Mark Twain*, and the Disneyland Railroad.

The most visible new attraction in June 1956 was the Skyway—an aerial cable car ride between stations in Tomorrowland and Fantasyland. The round gondolas seated two passengers and were open to the elements. These "buckets," as they were often called, traveled along overhead cables between three T-shaped metallic towers that rose as high as sixty feet over the park, the tallest sitting atop Holiday Hill. The view was dramatic, and the ride was so popular that the initial round-trip option was soon eliminated, making every ride a one-way journey, for one D ticket. Like the Astro Jets, this was an "off-the-shelf" ride, its mechanism and vehicles made by a sky-ride vendor in Switzerland. But it was the first installation of this particular gondola system in the United States, and one of the first in the world, so it would be new to Disneyland guests.

The railway options in Disneyland also increased in the summer of 1956 with the opening of the Rainbow Caverns Mine Train, a narrow-gauge locomotive ride through a desert landscape in Frontierland. The trip was most memorable for its Imagineer-created cavern with a waterfall in which adjacent cascades of water were dyed in the six primary colors. The effect was conceived and supervised in part by Yale Gracey, an art director and layout artist who had joined Disney in 1939. Gracey was known as a master tinkerer and was recruited by Walt to help with visual effects in the park. Gracey and Claude Coats together figured out a complicated mechanical system to keep the waterfall colors from mixing. "That was a good example of what Walt meant by Imagineering," Coats said, explaining that "imagination all by itself doesn't get anywhere, and engineering all by itself isn't very entertaining."

Coats also art directed the creation of a 300-foot-wide mural and three-dimensional diorama depicting the Grand Canyon, which was housed in a building that served as a tunnel for the Disneyland Railroad just before it arrived at the Main Street station. It opened in March 1958 and still exists today. More short-lived was another train ride, called the Viewliner. The small-gauge railroad had a locomotive of sleek modern

design that pulled passenger cars in a loop around Tomorrowland. It opened in June 1957 and closed after less than fifteen months.

But the Viewliner—like the circus and the Phantom Boats—should be viewed less as a failure than as a stopgap: Walt and the Imagineers knew they'd be adding major new attractions to Disneyland, but it would take time to get them designed, built, tested, and opened, and simpler offerings would need to keep guests occupied in the meantime. The first new attraction that had WED's signature fusion of animation art and narrative was a dark ride in Fantasyland based on Disney's 1951 animated feature *Alice in Wonderland*, begun in late 1957 and opened to the public June 14, 1958. (It shared its name with the film.) This was also a Coats project, and the Imagineer designed everything about it, from the ride layout, sets, and backgrounds to the two-bench, three-wheel vehicles, decorated to resemble the movie's Caterpillar. Limited time and budget had forced the Imagineers to dress the exteriors of the three original dark rides with simple painted flats resembling tents at a medieval jousting tournament, rather than the fully realized Bavarian village originally imagined, but Alice had an elaborate facade with giant, colored artificial leaves and real landscaping. (Since it was around the corner from Mr. Toad and behind Peter Pan's Flight, the contrast in design was not glaring.) It was also the first multi-level dark ride, enticing riders with a winding, diagonal ramp on which the caterpillars traveled back down to the loading area.

Debuting the same day as Alice in Wonderland was the Sailing Ship *Columbia*. Even with the keel boats running, Walt had wanted to further increase guest capacity on the Rivers of America and had asked Admiral Joe Fowler to suggest a historic ship to re-create. Fowler picked the first American vessel known to have circumnavigated the globe. Once again, the admiral supervised construction at the same San Pedro, California, shipyard that had built the keel for the *Mark Twain*. On busy days, both the *Columbia* and the *Mark Twain* could operate, using the same underwater track and sharing a boarding area.

Yet all of these additions in the first three years Disneyland was open were mere prelude. The target date for a massive unveiling was exactly

one year after the debut of Alice and the *Columbia*: June 14, 1959. Before then, WED would have a lot of work to do—not the least of which was convincing Walt that a roller coaster could be a good thing.

III. UPHILL, UNDERWATER, OVERHEAD

A founding member of the Disneyland Operations team, Dick Nunis had trained many of the park's Opening Day workers, even before Walt had renamed them "cast members." Now he tried to school Walt Disney. At a meeting after the park had opened, which Nunis attended with his boss, Admiral Joe Fowler, Walt asked him what he thought the park was lacking. Nunis replied, as politely as possible, "Well, sir, we really need a thrill show attraction." Everyone knew what he meant: a roller coaster. As Nunis told it, Walt's reaction was swift and unequivocal: "'Damn you, Nunis. This isn't an amusement park.' And I said, 'I know, sir, but surely our creative people can come up with a concept and create a thrill show attraction.'" Some time later, at the Operations team's regular Monday lunch—the day the park was closed—Nunis took his usual seat at the far end of the table, as a junior member of the squad. To his surprise, Fowler indicated that he should sit near the head of the table, next to him. After he sat down, Walt himself addressed him: "You're gonna get your thrill show attraction. We're gonna build a scale model of the Matterhorn and put a bobsled in it." Nunis was in shock: "I had no idea what he was talking about."

Several factors had worked to change Walt's mind about a roller coaster. One was his visit to the set of a live-action adventure film Disney was making titled *Third Man on the Mountain*, which was filming in Switzerland in 1958. Based on a novel about a young climber attempting to summit a peak called the Citadel, the story was inspired by the real mountaineer who was the first to climb the Matterhorn in 1865—and the real mountain had been cast in Disney's movie as the fictional Citadel. While there, an oft-told story goes, Walt was so impressed by the peak that he bought a postcard of it and mailed it back to WED Enterprises with the simple message, "Build this." Harriet Burns remembered there

being several such postcards, at least one of which went to Imagineer Vic Greene, who became the attraction's art director.

Walt wanted the mountain more than he wanted the roller coaster that would go inside it. Holiday Hill—the pile of dirt between Tomorrowland and Fantasyland—was a particular fixation. At one point, Walt imagined the mound transformed into a year-round sledding destination, utilizing manufactured snow. (Drainage issues prevented exploring that idea.) Bill Evans and his landscaping team had made Holiday Hill into an inviting park by planting shrubs and small trees and creating paths leading to the top. The hill had been helpful in the installation of the Skyway, since its twenty-foot height raised one of the cable-car towers to a dramatic altitude and improved riders' view. But after seeing the Matterhorn, Walt wanted a real mountain—or rather, an artful facsimile of a real mountain. So Burns and Fred Joerger got to work building a model of the Swiss peak. The goal for the final attraction was a 1:100-scale re-creation of the Matterhorn, rising 147 feet rather than the 14,692 feet of the original. It would be the highest structure in Orange County.

Seeing bobsleds zipping down the slopes in Switzerland seemed to flip a switch in Walt's mind. He might not want a roller coaster in his park, but he did like the idea of a bobsled run. (He may also have been reflecting on his visit to Tivoli, where the roller coaster had a Matterhorn-like theme.) With Vic Greene busy working on the mountain's design, Walt cornered Bob Gurr—whom he evidently considered a mechanical maestro for his work on Autopia—gave him a bunch of photos of Swiss bobsleds, and said, "Now all you've got to do is put that [bobsled] track inside that mountain. And, oh, by the way—do two tracks to intermingle and fit inside." Walt had envisioned little wheels on the bottom of his bobsleds, but the Imagineers—working again with Arrow Development—came up with a different solution, which involved completely rethinking the engineering of a roller coaster. "You've got to remember, at that time, roller coasters were always wooden structures, out in the open. You could see everything," Gurr said. "The track was usually metal plates facing the

wood." But this attraction was set to open in June 1959, less than a year in the future, which wasn't enough time to design and manufacture a traditional coaster. "Karl Bacon and Ed Morgan [of Arrow Development] came up with the idea to use black iron pipe, because pipe is cheap and we can bend it and it will go faster than trying to build another type of structure." That settled it: the Matterhorn bobsleds would run on steel tubes. As Gurr noted, "Walt accidentally invented the first pipe roller coaster in the world, while not trying to invent anything."

Arrow would do the manufacturing, but Gurr would design the track—*tracks*, actually, since Walt wanted two spiraling paths intertwined within the mountain, to maximize capacity. Before he got started, Gurr did a little research—as little as possible. "My little boy and I went to a roller coaster, rode it once, and I came back and said, 'Walt, I know everything about them now.' Because I don't like roller coasters and here I am designing this roller coaster." He set to work on a big drawing board, using just a compass and a pencil. One piece of paper was for the track layout, another for keeping track of the slopes' angles and heights, "because you can go down, but you can't come back higher each time. To do all the dimensions, I had to learn trigonometry, which I never got in high school." The calculations were enormously complicated, Gurr explained, encompassing the exact effect of gravity and friction in reducing the sleds' speed going upslope and around curves, and the precise acceleration going downslope—all to make sure a fully loaded vehicle would make it through the complete journey without stopping. "If I am designing an Autopia car, I am designing machinery. But in the Matterhorn, I am designing physics."

Gurr also had to figure out how to weave the bobsled paths around the steel girders holding up the mountain. "We are inside a steel-and-stucco mountain," he said. "The drawings of that track had to be perfect to begin with. Because you can't back up." The schedule also left no room for error. As Gurr recalled, he calculated where the superstructure would connect with the foundation one night and gave the plans to the construction crew the next morning. The following day, the construction

supervisor told him simply, "'Bob, don't change the columns again. The mixed concrete trucks are on their way.' That is how fast we would do stuff."

There was one further complication. The Matterhorn was replacing Holiday Hill, so it would be directly in the path of the Skyway. Walt's solution was to ask the Imagineers to design a tunnel through the top of the mountain for the buckets to pass through. The Matterhorn would replace the existing cable-car tower. "So in my design of the track layout, I had a space that I couldn't use," Gurr said. "I had to go over the top of the Skyway, make a quick turn, and go under the path of the buckets. This was a very complex thing to do, because the mountain is tapering. Luckily, I could see in 3D—I could visualize spatial relationships. I didn't have any trouble looking at a flat drawing here and a flat drawing here, and in my head, I could see where everything was going. So a sky ride going right through was just another piece of designer accoutrements."

Using an innovative signaling system, Gurr and his engineering partners also figured out how to run multiple cars on the same track at the same time with no danger of collision—another step forward in capacity. To further increase safety, Arrow developed an electronic braking system, which replaced the previous standard in roller coasters at the time, namely "a man with a big long lever, pulling on it to stop the car," as Gurr phrased it. "We had the pinch-brake system—brakes that would come up underneath the bottom of the car. If your car came up to a portion [of the track] where a brake station is, the brake would raise up and the car would skid to a halt on top of it, and then the brake would drop down and the car would be released to continue on. That's pretty much standard technology today, but that was a first."

Since Dick Nunis had been the coaster's most vocal advocate, he was one of the test riders on the Matterhorn. "I always wanted to be the first one on it," he said, "after the sandbags." (Engineers loaded sandbags onto empty bobsleds for weight during initial runs, just to make sure everything was working safely.) His reaction to that first ride was twofold: "Scared me to death." And: "It was fun!"

Over the decades, the Matterhorn became a legend among theme park aficionados. It was, after all, the first of many mountains that the Imagineers would build and scale in the years ahead: Space Mountain, Big Thunder Mountain, Splash Mountain, and so on into the future. (They would also soon work on resorts perched on actual mountains.) Theme park guests were drawn to the mountain, as were some actual mountain climbers, permitted to scale the peak for press events. And what could serve as a more effective "wienie" than a towering peak glimpsed from a distance? Especially one with fast-moving vehicles threading its peaks and crags. "I think any amusement park has to have a lot of kinetics," Gurr observed, "attractions where, yes, you would ride it, but if you weren't riding it, you would see it moving." While a castle spoke of fantasy and magic, a mountain promised adventure and thrills.

At the foot of the Matterhorn, the Imagineers were at work on another major attraction for the park's 1959 expansion. At the same time Disney took guests to their highest point yet, it would also take them below the surface. The submarine attraction—which would occupy the reconfigured lagoon where the Phantom Boats briefly reigned—had a "be careful what you wish for" origin story, according to Gurr. "We had the little Viewliner train, a little track going around the Phantom Lagoon. Roger Broggie, my boss, and Truman Woodworth, manager of the park, were just walking along [the Viewliner track] in late 1957. And [Broggie] says, 'You know, Walt's got everything in this park except a submarine.' About a week later, Roger Broggie comes [to me] and says, 'Walt wants you to get started on designing a submarine ride.' You've got to watch out what you say here, with a suggestive idea. It was simple as that. We had a lagoon that was pretty but the boat that was in it wasn't very good. So I thought, 'Oh, what the heck? We can make a bigger submarine out of them and they'll make a bigger lagoon.' And, of course, they made it into a big underwater dark ride show."

The not-so-secret secret of the Submarine Voyage, of course, was that it wasn't a submarine at all. It was "just an electric boat moving in the water with a guide track," as Gurr phrased it. The vehicles were

designed and painted gray to resemble the nuclear-powered U.S. subs after which they were individually named. They carried up to thirty-eight passengers, with a porthole for each that floated just below the surface of the water, providing a view of the dioramas the Imagineers had designed on the "ocean" floor. Curtains of released bubbles simulated the "dive," and the submarines passed into a dark building where additional scenes were set up. In the dark, the water's surface, just inches above each porthole, was nearly invisible, and the strategically lit props depicted deepwater scenery, including a sea serpent and the ruins of the lost continent of Atlantis.

Despite its novelty, the Submarine Voyage was a simple ride system, Gurr said. "Actually, we didn't have to invent." The vehicles had wheels on the bottom for guidance along the track, but the subs were actually afloat and moved "up and down, just a little bit, as the people get in and out of it." The underwater guide truck below the passenger cabin floated up and down independently. "All the ride operator has to do is give it throttle and it goes forward. Pull back and it will stop. It's a conventional drive propeller in the back, operated by a little diesel engine and an electric motor. Very basic." Simple or not, the sub design was rigorously tested, with a full-scale mock-up at the studio. "We wanted to make absolutely sure, because you know, once you start [constructing] steel hulls, there was nothing to change later. We even put it next to a test tank, so that we could test all of the effects to see how it would look in the water, looking out of the porthole. Nothing was left to chance."

Once built and placed on their track in the lagoon, the submarines were likely to stay there. "The boat is extremely heavy because it has to displace a lot of water. Every cubic foot of water is fifty-three pounds. You've got to build sixty-three pounds of iron boat [per cubic foot] to get it to go down far enough. We started with a floor [made from a] three-inch-thick steel plate. One-inch walls of steel on the outside of the boat. Extremely heavy, but once it's in the water, it has no resistance to move." If the propulsion system went out, a man with a rope could tow the vehicle along its track, Gurr said.

In the early days of the Submarine Voyage, not all of the ocean inhabitants stayed underwater. On most days, the rocks of the lagoon would be populated by mermaids. As Peggie Fariss recalled, "young women would be carried to the submarine lagoon in their fish fins and then they'd swim around and sit on the rocks, flap their fins around and comb their long blonde hair. I thought they must have the worst tans, too, because they were exposed from the waist up—except for some clamshells, well positioned—then their legs were always encased in those scales."

And where do you find a mermaid? You place a help wanted ad, of course. That's how an Orange County high school senior and synchronized swimmer named Susan Hoose wound up at a tryout, wearing her gym clothes among a hundred other young women in bikinis and swimsuits, lined up in four rows alongside the pool at the Disneyland Hotel. "A man and a woman walked up and down the aisles and looked us over. If they tapped you on the shoulder, you were told to go and sit by the side of the pool." One requirement was long hair, so the inspectors tugged at the women's locks, dislodging a few hairpieces. "So, of course, they were immediately eliminated." With lifeguards at the ready, the finalists had their knees and feet tied loosely together, then dove into the deep end to swim, "porpoise style," to the shallow end. That was it. She left her name and number and went back to high school. A week later she got the news: she was among the eight mermaids hired for the summer. It was her first job.

When practices began, Hoose learned she was the youngest of the group, the only one rushing to rehearsals after her high school classes let out. She even had rehearsal on her graduation day, rushing back to the school with a damp ponytail to join her classmates for the ceremony.

Not long before the attraction opened, the mermaids were issued their fins: thirty-pound costumes with a zipper from the knees to the waist in back that they needed assistance to get in and out of. The lagoon water was clean, circulated through the biggest swimming pool filtration system in Orange County, but it was frigid, around fifty-five degrees Fahrenheit. "The water was so cold, they would have us swim for an hour

and then be out for like a half hour and then come back in," Hoose said. "It was painful. You had to force a smile, because we were really cold." Besides sunning themselves on the rocks, the mermaids performed synchronized swimming to music that was audible both underwater and above the surface. When they were in the water, the mermaids could be seen from the portholes of the submarines that were outside the dark section of the attraction. In between the choreographed routines, "we'd smile and twist and [do] anything that we thought might be entertaining." With the cold and the heavy fins and the swimming, "it was physically very taxing. But at seventeen, you think that you can conquer the world."

The mermaids did not endure much past that first summer, but they were a first step in Imagineering's recurring efforts to integrate live performers with mechanical attractions. Future projects such as The Great Movie Ride and Muppet*Vision 3D would also require human actors, more integrated to the narrative than were the mermaids. The finned ladies had brief revivals in the summers of 1965–67 (when Fariss saw them) before disappearing for good. Hoose learned later that the man she would eventually marry had seen her as a Submarine Voyage mermaid while he was on leave from the military.

Those waiting in the queue for the Submarine Voyage would also have a view of the third major addition for the summer of 1959: the Disneyland Monorail System. One version of the Monorail origin story—shared years later by Bob Gurr and Roger Broggie—is set, once again, in Europe in 1958, where Walt was visiting the set of *Third Man on the Mountain*. Walt was driving through Germany with his wife, Lillian. Suddenly, on a concrete beam suspended above the ground, a sleek new monorail appeared, and Walt was smitten. In his rental car, he chased the train and found its source: the offices of a company called ALWEG, an acronym for the name of its Swedish founder, Axel L. Wenner-Gren. It's a good story, but in fact the ALWEG test track ran nowhere near any major roadway, and Walt already knew about the technology, because he had wanted a monorail for his park before Disneyland even opened. Admiral Joe Fowler discouraged Walt from attempting to build it in the first

wave, but Fowler then heard about ALWEG's test model and traveled to Germany in 1957 to meet with the company. As Fowler told Walt biographer Bob Thomas, he gathered pictures and other info and brought it back to Dick Irvine at WED Enterprises, saying, "Dick, if we show these to Walt, we're sunk. He's going to build it, I'm sure." And that's exactly what happened.

"I think what frustrated Walt the most, he always wanted to get things done sooner," Nunis observed. "And I think he was never really satisfied, because he kept reaching for that intangible quality called perfection. And how do you know when you reach it? So, you keep reaching." The Monorail was a dream Walt had been chasing for years, and now it seemed possible, even with less than a year to go until the scheduled reveal of the park's expansion.

Once again Walt turned to his presumed mechanical boy genius, Bob Gurr. "Walt handed me that job in October of 1958 and said, 'Well, we are going to open the following June, Bobby, so get started.' That's the way that Walt did. He wouldn't order people to do something. He would say, 'Well, this is what we are going to do, and I want you to get started on this.' I had never seen a monorail in my life, other than the hanging type. So Walt showed me pictures of a beamway and a train on it, which is the German saddlebag [design], because it straddles the beamway. Within two weeks, I had come up with just enough of the design of the vehicle, based upon the little Viewliner train, which we had done two years before. I literally made one external drawing. We showed it to Walt, and he said, 'Can you build that?' and I said, 'Yes,' and then the meeting was over. Just as simple as that."

This was no semi-submerged iron boat dressed up as a dark ride. This was, as Gurr put it, "a big, risky new attraction that was going to be way up in the air, on a very complicated beamway system. Vehicles are going to go like forty miles per hour." To get it right, they needed help from ALWEG, so Gurr headed to Cologne, Germany, with his boss and the Monorail's co-designer, Roger Broggie, to negotiate. The Disney duo convinced them to share their engineering with a promise that the

attraction would bear ALWEG's name. As Gurr recounted the story, he and Broggie started work on the project around Thanksgiving 1958, built the train at the Disney Machine Shop early the next year, and delivered it to the park two weeks before opening day.

The Monorail moved along its beamway using quiet electric motors that drove rubber wheels along the beam—meaning it made little noise to bother the passengers or to distract guests in the park below. The original track was just eight-tenths of a mile, looping along the border of Tomorrowland, then turning into a second, tighter loop that twisted across the Submarine Voyage and both Autopias before returning to the fringe and coming into the single station for boarding and unloading. The first iteration—of many to come, over the decades—featured two trains, Monorail Red and Monorail Blue, with three cabins each, the first distinguished by its bubble top above the driver's position. Electric engines in the first and third car kept it moving, while the rubber tires beneath the center car rolled along without direct power.

Officially dubbed the Disneyland-ALWEG Monorail System when it opened, the attraction was nicknamed "the highway in the sky" and promoted as the urban mass transit of the future. It was the first daily operating monorail system in the Western Hemisphere, but despite Imagineering's best efforts—including a feasibility study for the city of Los Angeles—it was not an idea that caught on in the automobile-obsessed United States. Outside of airports and tourist attractions, the only metropolitan monorails in the United States in 2021 were in Seattle, Washington; Tampa, Florida; and Las Vegas, Nevada, ranging from one to four miles long. But for that moment in 1959—for Gurr, at least—the Monorail represented a triumph over the car manufacturers that Gurr had found so stifling a few years earlier. "It looked like Buck Rogers, super streamlined, very dramatic," he said. "I think that the automotive industry kind of looked [at it] with jealousy—'How does Walt get away with designing transportation that is so advanced? And he's not even in that business!' That has to do with the heart of inspiration to do something. Even just the visuals of it excites somebody else to say, 'Oh, wow. They did it. We could do that, too.'"

IV. A NEW PEAK

From the moment it opened, Disneyland had attracted celebrities, dignitaries, and royalty. In the wake of the Rat Pack members who attended opening day in 1955, along with Debbie Reynolds, Jerry Lewis, and Danny Thomas, came Hollywood royalty from Groucho Marx to Shirley Temple. Elizabeth Taylor and husband Eddie Fisher brought their two sons in the late 1950s, and the early 1960s would see visits from current and former heads of state, including the king and queen of Nepal, the prime minister of India, and President Dwight D. Eisenhower, who visited with his grandchildren not long after leaving the White House in 1961.

It would be Ike's vice president, though, who got star billing, along with Walt, at the Sunday, June 14, 1959, debut of the park's dramatic new attractions. Another TV special was planned on ABC, and Southern California native son Richard M. Nixon would bring his family for the occasion. But there was a problem with the Monorail. "The first test train moved about an eighth of an inch, stopped with an electrical fault," Gurr said of the initial trial, just two weeks before opening. "Every day, the train went a little further. Every day, our testing and adjusting [went on]. It wasn't until the night before, when there was going to be [the taping of] a ninety-minute television broadcast, did the train actually go around by itself without breaking down. So I parked it on the platform [near the Tomorrowland station], knowing that we would cut a ribbon in the afternoon. The train could drive out of the scene and the TV people would have their scene." And it would be "all about Walt's new Monorail train."

The back-to-back ceremonies to dedicate the Submarine Voyage and the Monorail would be in midafternoon, after a grand parade viewed by Nixon, a clutch of naval officers, Hollywood celebrities, and other guests seated on temporary bleachers dubbed the "reviewing stand." Art Linkletter was back as host, and Walt was ubiquitous, as always. The advantage this time was that although the show was taped in a series of live, largely unedited segments, it would be spliced together with pretaped

sequences into a broadcast called *Kodak Presents Disneyland '59* for airing the next evening, June 15. Naturally the mermaids had ample screen time, in footage shot on June 14 as well as in pretaped clips shot with special underwater cameras. "How about that submarine ride? I tell you," Linkletter said, "there'll be lots of youngsters whose dreams come true on that one."

Much of the show focused on Tomorrowland—with the introduction of the subs and the Monorail. Viewers would also see the soaring peak of the Matterhorn, which members of the Sierra Club were climbing, with all their gear in use, as if it were the real thing. The climbers raised the Swiss and U.S. flags at the summit, yodeled a bit, then rappelled back down to the ground. (The climbing stunt would be repeated now and again over the years.) For guests at the park, Disney underscored this trifecta of exciting new attractions by introducing a new ticket tier: the E ticket. The new, 50-cent level included not only the three big new rides but also the Disneyland Railroad, Rocket to the Moon, the two large Rivers of America ships, the Jungle Cruise, and a few other attractions. The term "E ticket" soon grew well beyond the park, to be used by Americans to express the ultimate in thrills even long after the ticket itself passed into history. Perhaps most famously, NASA astronaut Sally Ride, after returning from her first space flight in 1983, exclaimed to reporters, "Ever been to Disneyland? That was definitely an E ticket!"

One opening day event not broadcast on the ABC special was the vice president's rendezvous with the Submarine Voyage mermaids. "I have memories of sitting on the dock with Richard Nixon," said Susan Hoose. "He knelt down in between myself and another mermaid and we had our picture taken. And Art Linkletter [was there as well]. Then Pat and Richard Nixon were on the submarine and they christened it with a bottle of champagne. We were in the water below the submarine." Four of the eight mermaids had been assigned to swim in the lagoon that day, while the other four appeared in the parade, tossing beads from a float dominated by a statue of King Neptune.

V. PLUSSING THE PARK, PART II

In 1960, Marc Davis hit an unexpected low point in his career as a Disney animator. He had been with the company since *Snow White and the Seven Dwarfs*, when he had been an assistant animator, and he had spent three years on story for *Bambi*, work that earned him a promotion to full animator. He had soon become the go-to artist for expressive, usually female characters, creating Cinderella, Tinker Bell, Maleficent, and others. He worked on everything from Goofy shorts to the classic features to the studio's World War II propaganda film, *Victory Through Air Power*. After Disney's remarkable postwar run of animated classics, from *Cinderella* through the not-yet-released *One Hundred and One Dalmatians* (he developed and animated Cruella De Vil), Davis found himself in a rare spell without immediate deadlines. So he spent his time working with Ken Anderson and some others from the Animation Department on a long-cherished project: a pitch for a Disney feature based on Edmond Rostand's allegorical play *Chantecler*, about "a vain rooster who believes that crowing makes the sun rise," as Davis summarized it.

Davis and Anderson put together a full-scale pitch, with dozens of lively drawings to illustrate their earnest enactment of the story, a social satire set in a barnyard but full of the men's signature humor and colorful characters. But the presentation, in front of a roomful of Disney executives in suits, landed with a thud. Davis summarized their dismissive reaction as, "You can't make a pleasant character out of a chicken." He continued, "They walked out on us, without really giving it much more thought than that." Walt, too, walked out without saying a word. There would be no *Chantecler*. The experience was disheartening, to say the least, and it compounded Davis's concern that Walt was about to disband the Animation Department, after *Sleeping Beauty*'s failure to recoup its costs, leaving Davis and so many other artists without a home. But Walt relented on dissolving his animation team—*Dalmatians* would be a huge hit the next year—and he was far from done with Davis.

The animator had done a number of smaller projects for Disneyland

through the years, including designing the backdrop of the Golden Horseshoe and the Tinker Bell–like figurehead on the Chicken of the Sea pirate ship. Now Walt wanted him at WED Enterprises full-time. As Marty Sklar recounted the story, "Marc said, 'Well, what you want me to do, Walt?' and Walt said, 'Well, go down to Disneyland, give me your take on it.'" And so Davis drove to Anaheim, visited the attractions, looked around the park, and returned to Walt with a concise report: "There's not enough humor."

The Jungle Cruise, for example, remained a straight-faced excursion through the tropics, with matter-of-fact narration describing the real-life rivers that inspired the flora and fauna for each segment of the trip. There was nothing wrong with the attraction as Harper Goff had designed it, but the park's popularity had raised the bar for what constituted a success. With repeat business suddenly not just an aspiration but a reality, and a business imperative, guests needed not just to enjoy a ride the first time—they had to be sufficiently engaged to want to go on it again. Davis thought the Jungle Cruise should be more fun, with more to see, and Walt gave him the go-ahead to soup it up. Soon the elephants in the bathing pool were squirting their trunks at the guests, and the animated figures of a safari party were climbing up a tree trunk while their lowest member risked impalement by an angry rhino—while gorillas ransacked their camp nearby.

"When I started working down there, there was nothing that was funny in any of the attractions that I can recollect," Davis recalled. "This was the thing all the way through that I have tried to do, was to bring in humor. I think the trapped safari was probably the first laugh that Disneyland had in an attraction."

There were other Audio-Animatronics additions to the Jungle Cruise already in the works, including some new animals—all featured in a May 28, 1961, episode of the *Disneyland* television show. It was a scaled-down version of the 1959 program, minus Art Linkletter and the vice president, and it promoted an array of upgrades, as well as recent and new attractions. There was even a catchy jingle:

"Where the future meets the past, and it's all for fun,
You will really have a ball at the happiest kingdom of them all.
Always building something new, new sights to see, new things to do,
At Disneyland, '61!"

"Since Disneyland opened in 1955, each year has seen many changes," Walt told his viewers, "and 1961 is no exception." The show introduced viewers to the new Nature's Wonderland in Frontierland; the enhanced Jungle Cruise in Adventureland; topiaries and Snow White's Wishing Well in Fantasyland; and the expansion of the Monorail system in Tomorrowland, which now reached the Disneyland Hotel. Rolling the Matterhorn and Submarine Voyage into the mix, the show even featured live mermaids, despite their absence from the park for nearly two years.

After his work on the Jungle Cruise, Davis had suggested scenarios to add to the Submarine Voyage, as well (not in time for Walt's *Disneyland '61* show, however). These recommendations were not humor so much as clarified narrative moments, such as a giant squid battling a killer whale, a lobster that had a fish's tail snagged in the tip of its claw, and mermaid figures sorting through the treasures of Atlantis. Also in Davis's sights was the newly reopened Mine Train Through Nature's Wonderland. The Rainbow Caverns ride had been upgraded with the addition of dozens of mechanical creatures, but many of the entertaining animal scenarios Davis suggested were delayed by more than a decade, in part because the attraction had just undergone a major renovation.

Davis's suggestions for adding humor and narrative clarity to Disneyland had one common thread: most of the scenarios involved some form of Audio-Animatronics—the term that Walt had begun to use for WED's robotic humans and creatures (and which the Disney Company would trademark in 1964). Some form of mechanical movement had been part of Disneyland from the first—in the dark rides, along the Rivers of America, within the Jungle Cruise, and so on. But by the early 1960s, it was clear that these mechanized beings had the potential to be much more than set decoration. With the sensibilities and talents of so

many of the Imagineers wrapped up in feature animation, they began to see Audio-Animatronics as just another form of animation and story-telling through the illusion of life. As Walt put it, "our whole forty-some odd years here have been in the world of making things move, inanimate things move. It's a new door, it's a new toy for us. And we're having a lotta fun. It's just another dimension in the animation that we've been doing all our life." So it was inevitable that the next stage of Audio-Animatronics would be a fully realized performance.

The actual stage for this performance started off in 1961 as a restau-rant, which Stouffer's, then one of the most popular eatery chains in the United States, was to sponsor. It was dubbed the "Bird Café" and "Tiki Gardens," to be located just inside the entrance to Adventureland. "Walt always wanted a tea room, but instead we were going to do a little restaurant," Imagineer Rolly Crump recalled. "John Hench was asked to do a rendering. And in there, he had birds in cages. And Walt took one look at it and said, 'John, you can't have birds in cages.' John says, 'Why not?' And Walt said, 'Because they'll poop in the food.' That's exactly what he said. We all cracked up. John says, 'No, no, no. Maybe they're little mechanical birds?' And Walt said, 'Oh, little mechanical birds.' And that's how it all got started."

Crump had joined WED Enterprises in 1959 after working for seven years as an in-betweener and assistant animator on features including *Lady and the Tramp* and *Sleeping Beauty*. But it wasn't his animation work that attracted Walt's attention; it was his collection of handmade propellers. The miniature kinetic sculptures—inspired by just a single sample he'd acquired from Wathel Rogers—seemed to fill his office in the Animation Building, spinning gently in the breeze from the air-conditioning. "I'm amazed that I got anything done in animation at that time because I was so busy building propellers," Crump recalled. His sculptures intrigued Walt. Someone with a knack for kinetic, three-dimensional whimsy ought to be working on Disneyland, he thought. So Crump became a WED artist, working at first with Claude Coats on an attraction based on L. Frank Baum's Oz books. (Walt owned the rights to all the books in the series save for the first one, *The Wizard of Oz.*) "The first project I had

was to design this field of flowers that were all propellers," he recalled. The Oz attraction never came together, but it demonstrated Crump's talents as a designer and landed him responsibility for the renovation and expansion of the bazaar in Adventureland—an appropriate warm-up for the "Bird Café" project.

Walt's fascination with mechanical people and creatures had come full circle—from the little mechanical bird he had bought in an antique store in New Orleans to a roomful of Audio-Animatronics birds. For the first year or so of development, the attraction was conceived as dinner theater, with a full show for each seating in the Stouffer's restaurant. But as the ideas for the feathered revue grew, the restaurant was eventually moved out of the building—Stouffer's would shift to the Tahitian Terrace next door—while Hench's design for the space was adapted to become a theater in the round, with guests on four sides facing in and the entertainers overhead, in the walls, and all around. "That whole room comes to life," as Davis observed. This would be Walt Disney's Enchanted Tiki Room, a breakthrough moment for Imagineering.

"All of this—the birds and the flowers and all that—it was actually the first time that everything came together with Audio-Animatronics figures to create a whole show," Marty Sklar noted. It was an all-hands-on-deck project for WED Enterprises. The art directors included Hench and Bill Martin, while Davis was in charge of designing many of the key bird and flower characters, as well as the singing statues of Polynesian gods and the drummers on shelves overhead. Crump created the statues in the outdoor waiting area and the Busby Berkeley–style mobile of female show birds that drops from the ceiling, using ideas from a Davis sketch. (Walt had wanted a hundred, but there was room for only about thirty.) Blaine Gibson sculpted a body for the birds, and Wathel Rogers was in charge of working out the Audio-Animatronics that needed to fit inside their slim bodies. Harriet Burns handcrafted many of the final bird figures, along the way developing very particular—and teachable—rules about how to select and place the feathers.

The Audio-Animatronics work gradually created a group of specialists in the Machine Shop, according to Don Iwerks, who worked with

shop head Roger Broggie at the time. For simpler mechanical figures, like the original Jungle Cruise animals, designers could draw up detailed sketches and send them to the machinists, who would simply build what was depicted. The more complicated figures within the Enchanted Tiki Room, though, required "a group of machinists who were very clever, inventive-type guys, who could machine their own parts," Iwerks said. Looking over their shoulder would be Walt or Davis, who "would come around and look at what was being done and talk to the machinists and [say,] 'I want that tail to move a little different, or that head to tilt a little bit more,' or something, and leave it up to the machinist to just alter it. So they'd modify it, call them, and they'd come back and look until they got an approval on it. Then, once we had a prototype and it was working, then it went up to engineering and they made the drawings so that you could make a production version of it."

Wally Boag, the comic star of Frontierland's Golden Horseshoe Revue, was brought on board to help develop the story, characters, and dialogue—all with a good dose of humor. George Bruns worked on the music, a collection of classical and semiserious selections including "Let's All Sing Like the Birdies Sing." The show elements were tested in a mock-up on a soundstage at the studio, but as he watched it come together, Walt still wasn't satisfied. And his test audiences weren't sure what to make of the show.

As songwriter Richard Sherman recalled a test run, "We were all sitting around there and Wathel Rogers was sitting behind a screen with a whole bunch of gadgets like the Wizard of Oz. He was pulling levers and pressing dials and he said, 'Okay. Try and start it up.' And all of a sudden down from the sky came this bevy of birds singing 'Let's All Sing Like the Birdies Sing.' And then this whole show went on. It was Walt's toy. He used to bring VIPs and friends down to the room [where the mock-up was set up] and they would say to him, universally after it was over, 'It's really wonderful, Walt. What is it?' And so when [my brother] Bob and I and the other fellas were sitting there after it was over, we said, 'It's wonderful, Walt. What is it?' And he said, 'That's what you guys are

going to write a song about. You're going to explain what this thing is all about.' So that was the birth of the very first Audio-Animatronics song."

In short order, Richard M. Sherman and Robert B. Sherman, the sibling songwriting team who were then working on tunes for the upcoming film version of *Mary Poppins*, penned "The Tiki Tiki Tiki Room" theme song. It was their first theme park original but far from their last. The song needed someone to sing it, which led to the invention of the attraction's four international macaw hosts, José, Michael, Pierre, and Fritz. The song and the colorful narrators gave the show a cohesiveness and an attitude of playfulness that seemed to justify everything that came after. That was enough for Walt. With the theme song and the host birds added, the show was ready to be broken down and shipped to Disneyland for installation in Hench's building.

The June 19, 1963, press preview was widely covered in the media nationwide, the journalists having been blown away by the new "space-age" technology that made the show possible. It was the first time the term "Audio-Animatronics" was heavily promoted by the Disney company and repeated by many reporters. Disney also touted the attraction's "ten years in research and development" and its $1 million cost. It was money well spent. Hollywood gossip columnist Louella O. Parsons dubbed the Enchanted Tiki Room "sheer magic," and the *Los Angeles Times* called it "revolutionary." When it opened to the public officially on June 23, 1963, the Enchanted Tiki Room was an attraction so unique that it was outside the A-through-E ticket system. Not included in the coupon booklets, it required a separate 75-cent adult admission purchase within the park (the equivalent of about $6.50 in 2022). Guests were not discouraged, and crowds clogged the passageway from Main Street, U.S.A., into Adventureland. (Within a few years, the Enchanted Tiki Room became an E-ticket attraction, referring to the top tier of the Disneyland ticket books that granted individual attraction admission.)

Audiences were not just enthusiastic; they bought into the illusion. "When people first saw it, they used to have debates," Richard Sherman recounted. "I remember standing outside listening and they would say,

'They're real, you know. Those are real birds.' And they would say, 'No, they're not real birds.' 'But how do they get them to sing?' 'I don't know.' It was fun to listen to that. People loved it."

"It's been around for so long and yet it still communicates to people," Sklar said. "I mean after fifty years this show still has a packed audience every afternoon, and that's a tribute, I think, to the artists." The Enchanted Tiki Room, he continued, "just feels like a very relaxed place to come and it's easy for little kids to relate to. I think this is one of the great family experiences in Disneyland. To me that's part of the magic of Disneyland—how many things in your life today still exist and work like they did fifty, sixty years ago? And yet you come into Disneyland and you feel at home."

It was a stellar example of Walt having recruited the ideal collection of artists for WED Enterprises and created an atmosphere in which they could collaborate while still exercising their individual talents to the fullest. "Just about everybody in the organization could focus on this one idea," Sklar noted, and its success was "because of that dynamic of having all that talent working together. The talent complemented one another, and [wound up] creating something that had never been done before."

"I always felt that one of the greatest things that Walt ever did was to put all of us together and keep us from killing one another," Davis said. "Because this is literally the reality of putting this many creative people together. And we got along pretty darn well because we didn't dare not to, in a sense."

The full show at the Enchanted Tiki Room—the Audio-Animatronics, yes, but also the clever script, engaging songs, and richly creative set design—"introduced a whole new possibility in entertainment," Sklar said. "You could almost trace all the major attractions that were done for many years back to this one place where so much of the early Audio-Animatronics was developed. So much was traced back to this show as an experiment, in many ways, of [creating] something that could be repeated over and over and over again, and that became the foundation in many respects for what happened afterwards—" 'it's a small world,' "

Pirates of the Caribbean, Haunted Mansion. And a lot of it can be traced right back to this room."

He continued, "I think the most challenging aspect of our business really is that Walt didn't want to repeat himself, and he set that pattern. I think the challenge has always been to top yourself the next time and, you know, not necessarily to make the next thrill ride but to create a new story and bring in some new technology that enables you to do something that you couldn't do the last time you did it—something brand-new, something that no one else is doing, something that has the Disney magic in it that people don't expect."

Guests certainly could not have expected the show that wound up entertaining diners in the Tahitian Terrace, once the restaurant was uncoupled from the birds attraction. Opening in Adventureland a year earlier than the Enchanted Tiki Room—and without the sponsorship of Stouffer's—the Tahitian Terrace had a thirty-five-foot artificial tree at its center, a waterfall, and Polynesian-themed live entertainment. As the restaurant menu described it, guests would see "sarong-clad natives appear to perform the swaying rhythms and amazing rituals of the islands," including a barefoot firewalk, a flaming knife dance, and a hula, with women dancing in grass skirts. It was a different kind of "plussing" the park.

VI. A NEW HOME

Having more than proved themselves with the initial success of Disneyland and the "plussing" of subsequent years, the artists of WED Enterprises had earned themselves a home of their own. For more than eight years, the ever-growing staff had been scattered through the offices, workshops, and other facilities of the Disney Studios lot in Burbank. Many of those who had begun at the company working on animated features still had offices in the Animation Building, including Marc Davis, Ken Anderson, Claude Coats, and Rolly Crump. Dick Irvine also had an office in the Animation Building, not far from Herb Ryman. The

studio's Model Shop housed Harriet Burns, Fred Joerger, and Wathel Rogers, while Roger Broggie and Bob Gurr spent most of their time in the studio's nearby Machine Shop. When it came time to create full-scale mock-ups to test attractions like the Enchanted Tiki Room, the WED staffers would have to procure any unused space available, sometimes sharing soundstages with crews for live-action films. Some fabrication of attractions was also done backstage at Disneyland.

The WED diaspora became more and more difficult to manage within the studio as its staff grew, and by 1961, the team needed a playing field of their own, as well as room to expand. The relocation would also solve the problem of so many WED workers using space and resources on the Burbank lot when they were not studio employees. At that point, WED Enterprises remained a private, separate company owned by Walt, while Walt Disney Productions was owned by its stockholders.

About the time that WED was looking for a new home, Glendale, the California city east of the famous Griffith Park and a short drive southeast of Burbank, was repurposing its former Grand Central Airport as the Grand Central Business Park. The airport—a former haunt of Amelia Earhart and Howard Hughes—had closed in 1959; its runway eventually became Glendale's Grand Central Avenue. Unlike the Disney Studios, the business park had plenty of space for growth, and WED Enterprises moved there in August 1961.

Not that the company started off with a sprawling campus. "WED in the early days was in one little building over here, and everybody parked in the back," Marty Sklar remembered. "You would walk in through the Model Shop and you could see everything that was going on. And so everybody knew everything about what was happening and the status of the project and all of that, and so you really felt like you were part of the whole team whether you were working on that project or not." The new WED headquarters—with its cast-concrete brick wall out front and dramatic V-shaped canopy over the entrance—reminded some of its staffers of a 1950s coffee shop, and it was soon nicknamed the Pancake House.

The Model Shop—originally housed in an annex to the headquarters, with a corrugated roof—took on a central social and creative role

at WED. Its collegial, sometimes party-like atmosphere underscored the unpredicted benefits of throwing together so many artists talented in so many different media and from so many diverse backgrounds, all crammed together at adjacent worktables. The shop quickly became a favorite haunt for Walt Disney. "The Model Shop here was the center of all the action," Sklar recalled. "Here was Harriet Burns, this wonderful Texas lady, who came to work every day beautifully dressed. She could do all those things that the men were doing, whether that was using a power saw or getting up on a ladder and repairing something. I tell you, when she was with the boys, she was one of the boys."

Kim Irvine, Dick Irvine's daughter-in-law, spent a lot of time in the Model Shop in the 1960s, visiting her mother, Leota Toombs, who worked there. Young Kim would come by when school was out and soak in the creative atmosphere, on her way to a future career in Imagineering herself. "There were only a few women in the model shop," Kim Irvine recalled, "but everybody worked together in one big room, and they were one big family. I mean it was such a happy place to work. The custodian would come around and sing songs to everybody." The artists all worked on big tables, crowded with tools and materials as well as the models they were building. "Everybody in the Model Shop would wear many hats. You could sculpt one day, you could paint the next day, and then you would go down [to Disneyland] and do figure finishing the next day. So they really worked together—a lot of collaboration and a very tight-knit family."

The advent of dedicated space meant much larger projects could also take shape. "The second [generation of] Monorail trains were actually built here right on this campus," Sklar said, "so it was kind of soup to nuts, if you will. Everything was here and it was no problem at all to go see what was happening on your project or other projects. So everybody was kind of up to date. And there were a lot of pranks and a lot of humor and just fun." These were not whoopee-cushion level gags, but elaborate, labor-intensive jokes, such as repainting someone's office a color that the occupant was known to despise. "Rolly Crump and I did that a couple of times," Sklar said. There were handstand contests in the Model Shop,

and Frisbee games outside. Break time might bring a magic demonstration by Crump or a yo-yo competition.

It was a playground for the Imagineers in every sense. The goofing around underlined the camaraderie that created a tight-knit team at the top of their game. Walt loved everything about this new concentration of WED talent: the unbridled creativity, the relaxed atmosphere, the openness about what everyone was working on—particularly in the Model Shop. It was, Kim Irvine said, "the heartbeat of WED. Walt would come in often. He loved to come over there [from the studio] and visit with all of them and find out what they were doing."

Whatever was going on in the rest of the studio to annoy him, Walt found an escape at WED Enterprises. "His moods depended upon where he just came from," Crump recalled. "So when he'd come over to WED to meet with us, he might be in a different mood each time he came, but on the whole it was a good mood. I said to him one time—I grabbed him by the arm. 'Walt,' I said, 'you know, you should get an office over here.' And he says, 'No, Rolly. I don't work over here. I come to play.' I think he kind of looked at WED as his sandbox. You know, he could come over, play around [with] all his ideas."

As Walt himself put it, WED was "my backyard laboratory—you know, my workshop away from work. Some of the things I was planning—like Disneyland, for example, was pretty hard for the banking mind to go with it. I had to go ahead on my own. It's pretty hard to sell people on what you have in your mind, so you have to go ahead and develop it. And that's what I've been doing with WED. I can do things at WED without asking anybody, even my wife."

CHAPTER 4:

A FAIR DEAL

"We developed so many talents as we went along that I lay awake nights figuring out how to use them. That's how we became so diversified. It was a natural branching out." —Walt Disney

I. MEANWHILE, FAR FROM DISNEYLAND

THE GLORY DAYS of New York's Flushing Meadows Corona Park—built in the 1930s on the city's former ash dump—have passed. The 140-foot-tall Unisphere globe still stands nobly at its center, its familiar hollow mesh displaying stainless steel continents and satellite rings. The squat, rectangular Queens Museum faces the sphere from the west, while a series of shallow pools stretch out from the globe's east side, essentially bisecting the 897-acre park, their blue bottoms fading beneath water typically peppered with leaves from the park's many trees—or, in the winter, dry and cracked in the cold air. Another curious construction stands just south of the Unisphere: a looming ellipsis of sixteen 100-foot-tall concrete pillars. Next to it are three abandoned observation towers of different heights, also concrete, looking like the neglected little sisters to the Seattle Space Needle, their bases marred with graffiti. Surrounding these architectural relics are the usual dusty ballfields, expanses of lawns, and cement sidewalks of any city park.

This backwater of curious constructions was once the most talked-about destination on the planet: 1964–1965 New York World's Fair.

The pillars of that giant ellipsis, then the New York State pavilion, were topped with flags then, its colorful arena—dubbed the Tent of Tomorrow—covered by the largest cable suspension roof in the world. Visitors waited in line to sip at the blocky concrete drinking fountains that still dot the park, and they snapped photos of the gleaming new Unisphere. Indeed, more than fifty million people visited during the fair's two April-to-October seasons, paying $2 or $2.50 to visit its 140 pavilions, of which New York's is the only one still standing.

Four of those now-lost pavilions housed attractions handcrafted and designed nearly three thousand miles away, at WED Enterprises. This was the Disney Imagineers' most dramatic performance so far on the world stage, a kind of audition for whether they would be able to enrapture audiences outside the safe confines of Disneyland. It challenged them in ways they could not have anticipated, and it inspired technological leaps forward that would determine the course of Imagineering for decades to come.

It was not Disney's first exercise in applying the company's unmatched skill for entertaining diverse crowds outside of Disneyland. A kind of trial run for the fair had taken place four years earlier, at the eighth Winter Olympic Games, known as "Squaw Valley 1960" for the event's Northern California location, a spot just across the border from Lake Tahoe, Nevada. The Winter Games would be the first Olympics hosted in the United States since 1932, and the first ever promoted as a major television event on a single network, with more than fifteen hours of events to be broadcast on CBS. Wanting to make an indelible impression on this potentially huge audience, the Olympic Organizing Committee appointed Walt Disney to chair its Pageantry Committee.

As decor director, John Hench led a crew of Imagineers in turning the built-to-order resort—created out of almost nothing in the four years leading up to the event—into a memorable setting. The Imagineers decorated the world's first Olympic Village to house and amuse the athletes and created thirty 16-foot-tall statues representing athletes from the various winter sports, scattered throughout the valley. Two more statues, 24 feet tall, stood at either end of a semicircular concrete wall that served

as the backdrop for a huge metal sculpture designed by Hench. Topped by the multicolored, interlocking Olympic rings, the impressive structure was dubbed the Tower of Nations, and it loomed over an equally impressive Olympic cauldron that burned throughout the eleven days of the competition. The medal ceremonies, previously held at different locations for different events, all took place at the foot of Hench's tower.

The Disney team was also in charge of the opening and closing ceremonies—a distinction that looked dubious when opening day, February 18, began with a blizzard harsh enough to delay the arrival of Vice President Richard M. Nixon. But as the athletes assembled in the blowing snow for the Parade of Nations around midday, the skies cleared, and Nixon arrived just in time to declare the Olympics open. The cauldron was lit by an Olympic torch redesigned by Hench, and CBS viewers saw the most impressive opening Olympic ceremonies to date, including a cast of five thousand performers, the release of two thousand homing pigeons, and a fireworks extravaganza. (The snow started falling again soon after the ceremonies ended.) All-star entertainment continued nightly throughout the Olympics, as Disney brought in some of the biggest names of the day to perform for the athletes: Bing Crosby, Roy Rogers, Marlene Dietrich, Red Skelton, Jack Benny, Danny Kaye, and others. Disney even found a spot for the cast members from the Golden Horseshoe in Disneyland, led by Wally Boag.

The Olympics went off without a hitch, under mostly sunny skies, despite geopolitical disputes that kept China and North Korea from competing. The Soviet Union dominated the medals count, but the United States won the gold in ice hockey, defeating both the U.S.S.R. and Canada. The closing ceremonies, also under Disney's supervision, were less spectacular than the opening, ending with the release of balloons rather than pigeons or fireworks. The *Los Angeles Times* declared that year's Olympics "near perfect," and the Disney-led pageantry set the standard for all Olympics to come, winter and summer.

More important to Walt and the Imagineers, their Olympics laurels boded well for their next can-you-top-this project—the four Disneyfied pavilions at the 1964–1965 New York World's Fair. Walt had big

ideas for WED's East Coast debut and had no doubt their work would stand out even surrounded by pavilions created by some of the best event and exhibition designers in the world, representing eighty nations and twenty-four U.S. states, as well as top global corporations. As WED began to focus on fair attractions, the Enchanted Tiki Room was getting ready to open, and Walt tasked the Imagineers with taking their proprietary Audio-Animatronics technology to new heights—increasing both the realism and the sheer size.

The New York World's Fair had caught Walt's attention even before the Squaw Valley Olympics. A bold front-page headline in the *New York Times* in August 1959 had announced a "$500-Million Fair Planned to Mark the 300th Anniversary of New York." The theme, in the midst of the Cold War, would be "Peace Through Understanding," promoting "friendship, humanity, and hope." As many as seventy-one million visitors were expected, and American corporations, national and regional governments, and other institutions were soon clamoring to participate. The tradition of World's Fairs in the past century had established the dominance of sponsored exhibition pavilions, each design approved by the organizers to create a uniformity of theme and appearance—a philosophy that earned Chicago's World's Columbian Exhibition the nickname "the White City" in 1993. In New York, for the first time, fair organizers planned to charge rent to the pavilion sponsors—on top of the cost of building and maintaining the structures—so the bar for participation would be high.

Walt knew immediately that the well-off American sponsors of pavilions, those huge corporations, would want their offerings to stand out among the 140 choices, and the cachet of a Disney-created attraction might be just the thing to accomplish that. In early 1960, Walt charged his Imagineers with developing ideas for such crowd-pleasing exhibitions— without knowing who might sponsor them. They would focus on creating jaw-dropping Audio-Animatronics displays as well as creative means of moving the fairgoers through the shows. If Walt could attract sponsors to pay for the construction of a few dramatic pavilions, he could also retain the rights to the contents and turn them into Disneyland attractions

when the fair ended. Thus WED Enterprises could build on its accomplishments of 1959 and Disneyland '62 while someone else footed much of the bill. Largely unspoken was another motive: Walt was considering an East Coast location for a second theme-park complex, and the New York World's Fair would test the appeal of the Imagineers' work for Easterners.

The fair was to take place in the same location as the 1939–1940 World's Fair, atop that former garbage heap that master builder Robert Moses had transformed into Flushing Meadows Park. Moses had wielded great power over public works in New York for decades, and in 1960 he added World's Fair president to his many other titles, which at that time included commissioner of the city's parks department, chairman of the city's planning commission, and chairman of the Triborough Bridge and Tunnel Authority, to name a few. Moses and Walt became acquainted, and the builder would even serve as matchmaker between Disney and one of its four pavilion sponsors. The others Walt secured on his own, winning corporate sponsors for the World's Fair with the same charm and enthusiasm he'd been using for years to lure sponsors into Disneyland. "Companies started coming to Walt when they realized that what he had done at Disneyland was so popular with the public, and here they were going to do major pavilions about their company," Marty Sklar recalled. "And they were not equipped to do it themselves." Still busy with "plussing" Disneyland in the early 1960s—in addition to the Enchanted Tiki Room, a pirate attraction and a haunted house were in the works—the Imagineers would be tested as they had never been before, by both the scale and ambition of the projects and by the unyielding timetable.

II. THE ILLUSION OF LIFE

Soon after Disneyland opened, the Imagineers had sketched out an extension of Main Street, U.S.A., that would have been called Thomas A. Edison Square—a Victorian cul-de-sac that would have extended from Central Plaza, tucked in behind the Red Wagon Inn (now the Plaza Inn) and extending a short distance alongside the back of Tomorrowland. The

drawings were done as part of a prospective partnership with General Electric—founded by Edison and once known as Edison General Electric. In an early example of the blend of education and entertainment that would characterize many WED creations in the decades to come, the square highlighted the history and innovations of the nation's oldest manufacturer of electrical lights, appliances, and other gadgets. The attraction within the square was called Harnessing the Light, an animated history of sixty years of electrical advancements in American homes, starting at around the turn of the century (the era of the exterior of the square) and jumping to the 1920s and then to the present day (1958). Audio-Animatronics technology was still in development at the time, but the Imagineers planned to have an animated figure host the show as if he were the owner of the evolving household. Guests would have exited the attraction through an exhibition hall featuring the latest GE products.

Edison Square never came to be, in part because it would have cost more than GE was willing to spend at the time. But when General Electric decided to invest in an exhibition at the World's Fair, the company came back to Disney. Within a pavilion called General Electric Progressland, the Imagineers devised the Carousel of Progress, an Audio-Animatronics show that vastly improved on the ideas for Harnessing the Light. Borrowing a conceit from Thornton Wilder's 1938 play *Our Town*, in which a narrator related decades of domestic drama directly to the audience, designer John Hench envisioned a series of living room scenes narrated by a father figure, with a grandfather, wife, and children engaged in different pastimes appropriate to the four time periods depicted. To demonstrate the dramatic strides forward in domestic life attributable to electrical service and appliances, scenes were set in 1890 (just before electricity reached most private homes), the 1920s (when radio was new), the postwar 1940s (just as television debuted), and the present day (the 1960s). Marc Davis designed the figures and directed the show along with Hench and Herb Ryman.

Rather than having the audience move from room to room, as had been the plan for Edison Square, the Imagineers created a rotating auditorium with stationary stages at the center and six slices of the outer ring

holding 250 theater seats each. The seating sections formed a six-part circle that rotated, rolling on steel train rails beneath the donut-shaped auditorium, stopping for about four minutes at each of the four Audio-Animatronics scenes—with the final two stops, without performance stages, used for unloading and reloading. The vital lesson about ride capacity in Disneyland was by then ingrained at Imagineering, and the Carousel of Progress could accommodate 3,600 guests an hour.

Each transition from one stage to the next was accompanied by the singing of the attraction's theme song, which would once again be composed by Walt Disney's Enchanted Tiki Room songwriters Richard and Robert Sherman. Walt previewed the attraction for the brothers and asked them to get right to work on a song, saying, "I need it yesterday." "I remember walking out of that meeting, walking out of Walt's office," Richard Sherman recalled. "And I remember Bob and I were talking. We said, 'Well, Walt has a dream and that's the start.' And we looked at each other and said, 'That sounds like a title—Walt has a dream. No—man has a dream and that's the start.' So we started in the middle of the song." The tune containing that line became "There's a Great Big Beautiful Tomorrow," which Sherman said was "really an anthem to Walt Disney, 'cause it's all about his belief in tomorrow."

Their second experience composing an attraction theme song also gave the Shermans insight on how Walt interacted with the WED artists. "I don't believe Walt ever felt he was working," Richard Sherman said. "He was having a good time at his hobby. And we were like part of a big party. It was not like a job. The Imagineers had formed this special group of geniuses, really. And if he'd come up with some abstract idea, these guys could figure out a way to make it happen."

The Carousel show ended with a depiction of the mid-1960s and "its leisurely push-button living." At least, that was how Walt Disney phrased it in a May 1964 episode of *Walt Disney's Wonderful World of Color* that promoted the Disney attractions at the fair. The former *Disneyland* television show had gotten a new name and a new home (NBC) in the fall of 1961, after the Disney Company bought out ABC's ownership stake in its theme park for $7.5 million—fifteen times the network's initial

investment. (Disney had not been happy with the 1959 cancellation of *Mickey Mouse Club*—especially when ABC exercised its contractual right to prevent the show airing on a different network. The afternoon children's show existed only in syndication until 1977.) The World's Fair episode gave viewers a glimpse of how far along the Imagineers had come in making Audio-Animatronics technology more lifelike. One scene, shot on a soundstage where the first scene of the Carousel Theater had been built, depicted Imagineer Wathel Rogers seated in a chair and with a metallic exoskeleton attached to his head, shoulders, and arms. This, Walt explained, was "a control harness for programming the gestures of our Audio-Animatronics figures." As Rogers moved, so moved the father figure on the stage. Through the wired harness, "all of the operator's actors are recorded on tape," Walt explained. The system used different sound frequencies, one assigned to each gesture, which could be recorded as the movements were captured through the harness, then played back to trigger the tiny motors that reproduced that gesture in the mechanical figure. The mouth movements would be programmed separately, to match a prerecorded vocal track. Walt even showed off the huge reels of magnetic tape, in a floor-to-ceiling console, that controlled each performance and gesture, "from the lifting of an eyebrow to a smile, and the dialogue."

Rogers, who had made mechanical toys out of scraps as a teenager, had been the studio's lead innovator on Audio-Animatronics technology since Walt's earlier discovery of that mechanical bird. Most recently, he and his team had worked out how to synchronize a soundtrack of music and dialogue to mouth movements in order to create the hyper-chatty occupants of the Enchanted Tiki Room. The programming harness was the breakthrough necessary to shift from the four-position joystick that controlled the Enchanted Tiki Room birds to a system that could realistically reproduce the familiar gestures of a human subject. It was the world's first motion-capture technology, long before computers were sophisticated enough to map out gestural nuances within three-dimensional space.

For now, it was sufficient to use sound frequencies to represent the speed and angle of movement of a predetermined set of variables—a neck that could turn, an elbow that could bend, fingers that could grasp.

To bring to life the couple of dozen Audio-Animatronics humans depicted in the four scenes of the Carousel of Progress, Rogers spent day after day in the programming harness, often with Marc Davis holding cue cards in front of him to direct his performance. "It became very, very trying at times to do this," he recalled. "I would strap into [the harness] in the morning and spend four hours in it, and then they would let me go for lunch and then I would come back and spend four hours. Towards the end of [working on] the World's Fair, we were working eleven hours a day or more. It was kind of like flying an airplane or driving or something. You became used to the mechanism."

Rogers mastered the overacting necessary to produce a readably expressive performance in the mechanical figures, and the concentration necessary to perform in real time. Each character's movements for each four-minute sequence needed to be recorded from beginning to end, without interruption. At that time, the tapes that controlled the movements could not be edited, which meant any mistake required starting over again from the beginning. Rogers also needed to return at the end of his performance to the precise position in which he had begun, or there would be an unnatural jerk as the character started up again.

The Carousel of Progress family weren't the only humans Rogers had been trying to develop as Audio-Animatronics figures. Even while the Enchanted Tiki Room was still in development, Rogers had been tinkering with the mechanics necessary to create a fully credible human figure. He had started with a talking head based on the philosopher Confucius, which Walt imagined using in a show at a Chinese restaurant in Disneyland. Some of the Enchanted Tiki Room technology came from early breakthroughs with Confucius. But Walt wanted more than a chatty head and singing birds. He wanted a fully convincing human—and he insisted that it should be Abraham Lincoln.

For years, Walt had been developing an attraction that would include

what he called a "hall of presidents," in which all the chief executives would appear as partially animated figures and a lifelike Lincoln would be the star. It was to be the main attraction in a proposed Disneyland expansion area called Liberty Square, which would have been situated behind the eastern side of Main Street, U.S.A. Herb Ryman had done a sketch of the area in the late 1950s, but it never got much further. Still, "the Mr. Lincoln thing was something that stuck in Walt's mind," Davis said. "Walt was a great admirer of Abraham Lincoln. I remember him saying that even as a youngster, he had portrayed Abraham Lincoln at school on Lincoln's birthday. So this was something he wanted to do."

Mr. Lincoln, as all the Imagineers referred to him, started as a head created by WED Enterprises' star sculptor, Blaine Gibson. Gibson had joined Disney's animation team in 1939 and had worked his way up from in-betweener to effects animator to character animator. But his skills went beyond drawing. As a boy, growing up in Colorado, he won a contest for soap carvings of animals, and as an adult, he took evening classes in sculpting as a way of honing his skills at depicting distinct characters. Disney artists occasionally displayed their outside artwork in modest shows within the studio library, and so Gibson brought in some of his sculptures to share. As Marty Sklar related, "Walt saw some of Blaine's sculptures and put it in the back of his mind, and when [work on] Disneyland started, he said, 'Blaine, you're going to be my sculptor.' And Blaine said, 'I'm not a sculptor. I'm an animator.' Walt said, 'No, no, no. I need you to do this.'" And that was that.

Gibson started off working part-time on WED projects while keeping his day job as an animator on *Lady and the Tramp*. For *Sleeping Beauty*, he crafted reference sculptures of the three fairy characters so the other animators could see them in three dimensions. But after *One Hundred and One Dalmatians* wrapped, Walt asked Gibson to move to WED Enterprises full-time. He became the company's director of sculpture, with a staff of two: him and another sculptor and model builder named Jack Ferges. Together they worked on sculpting the additions to the Jungle Cruise from drawings by Davis. It was an artistic partnership that would last for years.

Naturally, then, the sculpting of Mr. Lincoln's head became Gibson's responsibility. He worked from a copy of a life mask made of the soon-to-be president in 1860—borrowed from the Smithsonian—but precise duplication was not his top priority. "When we do a figure, we're thinking of a character," he said of his Audio-Animatronics assignments. "A living, breathing character. The things that Walt asked us to do, we wouldn't have thought we could do if he hadn't just insisted on it. Walt once remarked, 'It's kinda fun to do the impossible.'"

The impossible was what Rogers's team was busy trying to accomplish. They had made their own pliable mask from Gibson's sculpture that was then fitted onto a head filled with the electromagnetic coils, hinges, and motors that would make Mr. Lincoln into an Audio-Animatronics figure. By early 1962, Rogers had a full-bodied Mr. Lincoln prototype, seated in a chair, able to stand up but not yet fully animated. That was about as far as they'd gotten when Robert Moses came to California for a visit in April 1962. Proud of his Imagineers' work so far, Walt showed off Mr. Lincoln to the World's Fair president, along with a model of his proposed hall of presidents. Moses was so impressed that he insisted that the full-body Lincoln should appear at his fair. He promised to find Disney a sponsor to fund it. It took him a year, but he came through.

Moses knew that the state of Illinois wanted to participate in the fair, and in early 1963, the state legislature established a World's Fair commission and settled on the theme "Land of Lincoln." Moses urged the commission's acting chair, Fairfax Cone, to visit WED Enterprises—which he did that April, taking his wife along. The Cones were duly impressed with the Imagineers' demonstration—as were, in quick succession, both Lincoln scholar Ralph Newman, who was the fair commission's newly appointed permanent chair, and Otto Kerner, the governor of Illinois. As Imagineer Neil Gallagher later recalled, "I was running the figure manually, so I made Lincoln stand up and make a few gestures. We had a speech on tape at the time, and Walt played [Kerner] the speech. After the speech, Walt told him all about the project. Well, by the time Walt was through talking, *I* was ready to put money into this thing." In fact, when the budget appropriated by the Illinois legislature came up short

of what was needed to finance the Lincoln show, Moses *did* invest. The fair committee put up $250,000 toward the project, its only recorded support for an individual exhibitor.

"All of a sudden, great pressure was put on us to [get Lincoln done in time]," Davis said. "Knowing that I was an animator, but also that I knew a lot about anatomy, Walt came to me and asked me to give it some thought." Davis looked up everything he could find about prosthetic limbs, but his main role was to challenge Rogers's engineers and Broggie's fabricators to create realistic body movements, guided by Davis's drawings. "I just had to go to the machinists and say, 'Hey, can you do this? Can you do that?' They were quite cooperative."

The goal, Davis knew, was "not to create a mechanical man, but to create an illusion—because these things were on the stage, and they were illusions of things that had happened. So Mr. Lincoln would be seated and Mr. Lincoln would have to get up. Mr. Lincoln would have to move one leg forward and stand and give his speech." This figure would not be like the robots seen in the popular science-fiction films of the day—it didn't need to walk or shoot a gun or laugh or pilot a spaceship. It just needed to do what the Imagineers needed it to do, then sit back down and be ready to do it all over again. Davis sketched out the script in detail for the machinists. For the set designers, he included suggestions for lighting to focus attention on the face, which Davis felt was more convincing than the limb movements.

Davis wasn't the only one looking over the shoulder of those in the Machine Shop. "Walt used to come into our shop and look at and watch what we were doing, and what we were making, offer suggestions," recalled Don Iwerks. "And it was all developmental at the time, because none of that had been done before or was in existence."

Broggie's team's initial iteration of Lincoln's body was heavy, its movements stiff as a result. To help Broggie help Abe lose weight and limber up, Walt once again called on the young man he thought of as his resident mechanical wizard, Bob Gurr, who had already been working on the Carousel of Progress figures. "The Abraham Lincoln animated figure was very radical, one-of-a-kind," Gurr said. "Now, remember, I'm

a car guy. Lincoln has no wheels. We had to figure out how to make an animated human and design all the mechanical parts with all the motion and everything. We'd take those details to the studio. The studio would make the parts. No time to explain how it's going to work, how it's going to go together. They just build it on faith, and see if we can make it run."

The overhaul, Gurr recalled, took him about ninety days, sped along in part by everything Gurr had already learned by working on the General Electric figures. One breakthrough had been the use of hydraulic cylinders mounted to ball joints, which had increased the fluidity of motion in the limbs. The completed Mr. Lincoln, Gurr wrote in his memoir, had "13 main structural units, all moving in dozens of directions. This would require a rat's nest of linkages, bearings, bell cranks and a ton of monkey-motion doo-dads to provide articulated motions. These motions would be powered mostly by large pneumatic servo cylinders." All that hardware was needed to take Mr. Lincoln a step further than the GE family—literally. While all the Carousel of Progress people stayed seated or standing in each scene, Mr. Lincoln would stand up from his chair before speaking, shifting one foot as if stepping forward. It was something that no one had ever seen a life-size mechanical figure do before.

Rogers, meanwhile, was working on the complex electronic miniaturizations necessary to create the illusion of life. To make the lip sync credible, for example, tiny actuators were created and installed all around the lips. Lincoln's brain consisted of electromagnetic coils, called solenoids, that were triggered by the sound cues on those magnetic tapes; the coils then triggered the actuators, which moved the body parts.

Early tests had sometimes resulted in dramatic failures that might have been funny if they hadn't been so disastrous. "They were going crazy," recalled Alice Davis, Marc Davis's wife, "because it took them about three months to make just one, but when he would have a glitch or something would go wrong, he would sit down on the floor and he'd go right through the oak chair"—breaking it into pieces.

After Gurr slimmed him down, the sixteenth president gradually learned his routine without wrecking the set—although he still had

occasional relapses. "The problem was, a tape is moving through a machine and it has to move at a precise speed," Gurr said. "If you don't have that speed the same, the frequencies will shift slightly. It's sort of like the needle jumping the groove. The result was that Lincoln would go into a complete spastic fit!"

The state of Illinois had signed on to the Lincoln project less than a year before the World's Fair was set to open, so there was no cushion of time to work out the kinks before taking Mr. Lincoln to New York. Ready or not, the final tweaks would have to be done on-site. "One night there was a big thunderstorm, a week before the figure had to go to New York and they were still trying to program it," Sklar said. "A big thunderstorm, and nothing would work. And I remember Marc saying, 'You know, I think God doesn't want Walt to do this.'"

"To make a long story really short," Marc Davis recounted, "we had great technical difficulties in getting the character to move properly in New York." The audiotapes necessary to run the show would be edited and re-edited at a recording studio in Manhattan by Disney sound engineers every night from seven in the evening until seven in the morning. (Editing the tapes was a breakthrough that came after the Carousel of Progress programming.) The editors, Davis continued, "would bring back their work and we would run it through Mr. Lincoln, and, God, it would be going great. And then all of a sudden he would do a great jerk or decide to sit down." The problems persisted and caused the team to work many late hours as the fair's opening date approached.

Finally, Moses—who had personally arranged for this attraction to happen, after all—could wait no longer. "One day Mr. Moses came to the park and said, 'I want to see Mr. Lincoln,'" Davis said. Moses was accompanied to the Illinois pavilion by an entourage of World's Fair VIPs and their wives for this command performance. "They all sat down, and Walt was there, next to him, Mr. Moses. I was sitting there next to Dick Irvine, and we watched. And by golly, Mr. Lincoln went all the way through and there was great applause by everybody there. I don't think Walt applauded, but he was relieved as we were."

III. THE BIGGEST AND THE SMALLEST

The Imagineers thought they could create a bright, sunny version of one of their signature "dark rides" for Ford Motor Company's World's Fair pavilion. Tentatively titled "Symphony of America," the show would take visitors in Ford vehicles past WED-constructed versions of famous U.S. sights such as the Grand Canyon, the Everglades, a redwood forest, and a Louisiana bayou. But the Imagineers hadn't taken into account the then-ubiquitous jingle of Ford's chief rival, General Motors: "See the U.S.A. in your Chevrolet." So, no, that wouldn't work. Besides, Ford wanted something to knock the socks off its pavilion visitors—something that General Motors couldn't match even with the $55 million GM planned to spend on its own pavilion. That was why Ford was talking with Disney in the first place: they wanted drama and surprise, a huge scale, and a word-of-mouth home run—all at a cost about half of GM's budget.

The Imagineers countered with a guaranteed crowd magnet: living dinosaurs. More accurately, life-size Audio-Animatronics dinosaurs that would look as alive as WED ingenuity could make them. The attraction became Ford's Magic Skyway—so named because the guest vehicle track began on a level above the ground and took a long curved ramp through a glass tunnel high on the outside of what Ford called the Wonder Rotunda, giving riders a spectacular view of the fairgrounds. (The rotunda was designed by Walt's friend, the architect Welton Becket, out of sixty-four pylons, each a hundred feet tall.) The vehicles—160 Ford motorcars, nearly bumper to bumper—turned from the top of the ramp to head inside the pavilion to visit a prehistoric world occupied by giant brontosaurs, chewing on a primordial salad; flying pterodactyls; a triceratops family watching infants break out of their eggs; and a looming battle between a tyrannosaurus and a stegosaurus, among other scenarios. The journey continued past an equally detailed—and warmly comedic—diorama of a tribe of early humans on a woolly mammoth hunt and enjoying a warm fire while also inventing the wheel, then concluded with passage through a model of a city of the near future, with soaring

highways in the air and rockets setting off for space journeys. But it was the dinosaurs everyone would remember.

The attraction was designed by Marc Davis (whose influence was clear in the comic cavemen) and Claude Coats, with support from sculptor Blaine Gibson (those cavemen, again) and a host of other artists. Just the crews necessary to construct the giant dinosaurs were extensive. Each beast was fabricated, covered in skin, and tested in the California studios—where the work was filmed for the World's Fair episode of *Walt Disney's Wonderful World of Color*—then broken down, shipped to New York, and put together all over again. Walt knew the appeal the dinosaurs would have for audiences—hence the prominent and extended airtime the creatures got on the NBC show—but he was likely more interested in the mechanism that would move the Ford cars along the Skyway. As coverage of the Monorail had made clear, Walt was intrigued by possible solutions to modern transportation congestion, and the Skyway was a sort of subversive experiment in mass transit. While Ford saw the attraction as a way to highlight its new Mustang and popular Thunderbird, Falcon, and other current-model cars (all of them convertibles, of course), Walt saw it as a way to continue to hone a people-moving system that might one day replace the automobile.

The ride system moved the vehicles along two separate tracks at a steady rate of speed not by motorizing the vehicles but by motorizing the tracks. It was another Bob Gurr–led project, an evolution of the speed-control system at the top of the peaks of the Matterhorn. On the coaster, Arrow Development had installed horizontal motorized wheels that would come into contact with the underside of each vehicle and could speed up or slow down the car as needed. Gurr adapted that idea for the Skyway, placing motors that powered propulsion wheels every few feet along the tracks beneath the cars, pushing the vehicles along at a set speed. It was a system that would later be adapted for a Tomorrowland attraction, and one that Walt imagined could be put to use in cities of the future to take residents safely where they needed to go without cars.

For this initial instance, however, the dual-track system had another purpose: keep the people flowing through the Magic Skyway at a steady

rate. Ford wanted as many people as possible to ride in its cars and to be awed by the WED-created dioramas, and WED's motorized track could carry four thousand guests an hour through the twelve-minute attraction, at up to six per automobile, depending on the model. Along the way, the car radios were used to deliver a narration recorded by Walt himself. Once the Imagineers worked out the vehicle-spacing issue—early on, the cars had a tendency to bump into one another along tight curves—the system worked almost perfectly. But the Imagineers also made sure there was a team of car body repairmen on hand to fix crushed bumpers, broken taillights, and scraped paint, just in case.

A fourth attraction had been under discussion between Walt and Coca-Cola in 1962. With work on the Enchanted Tiki Room under way at WED Enterprises, Walt hoped to rope in the cola company to pay for its completion so it could be featured at the Coke pavilion at the fair—then Disney could ship it back to Disneyland, ready for installation. The price for the World's Fair show, which would have been much larger than the attraction later opened in the theme park, turned out to be too high for Coca-Cola, and Walt was unable to find another sponsor, electing instead to complete the smaller theme-park attraction with Disney's own money and get it opened before the fair.

But Walt wasn't done with cola companies. In early 1963, he jumped at the chance to work with Pepsi-Cola. The drink company was sponsoring a pavilion that would benefit UNICEF, the United Nations International Children's Education Fund, and asked Disney to design the show—or so Walt thought. When he sent Joe Fowler to New York to finalize the details with Pepsi's board of directors, a couple of the older members expressed reservations about working with the creator of "an automated mouse," Fowler recalled. That didn't sit well with the board's most prominent member, actress Joan Crawford, widow of the company's former president. "She gave those two boys a beautiful dressing down," Fowler said. Crawford apologized to Fowler, "and in ten minutes we finalized what we were going to do."

The next step was to break the news to the Imagineers. As Rolly Crump recounted, "One day we were called in to have a meeting and

Walt came in and said, 'You know, there's one more piece of real estate left at the World's Fair, and I'd like to get that piece of real estate. I have an idea for a little boat ride about children around the world.'" Walt asked Marc Davis to start sketching the doll-like children Walt imagined. Davis's drawings brought to Walt's mind one particular Disney studio artist who had contributed to the art direction for animated features from *Dumbo* through *Peter Pan*. She had left a decade earlier to work as a freelance artist in New York, creating everything from Nabisco ad graphics to children's book illustrations to Radio City Music Hall set designs. "What's Mary Blair doing?" Walt asked his Imagineers.

Blair was convinced to join the project by June—working at first by mail and telephone. "It wasn't because [Walt] didn't like what Marc did," Crump said. "He just realized when he looked at Marc's drawings the best person would be Mary Blair, because he was the best casting director that was ever put on this planet. He knew exactly who to put on what." Blair—whom Davis characterized as "the most amazing colorist of all time"—eventually spent a total of two months in California finalizing the designs.

Crump, then in his early thirties, was over the moon that Blair would be coming back to California to work on the show. "She was a legend," he said. "Everyone talked about Mary Blair, and the animator I worked for had worked on a lot of her films that she had done the backgrounds on. So she came out, and I remember I happened to be in the Model Shop the day that she came in. Of course, Mary had a flair the way she dressed. She had on a big cape that was mustard-colored, a black turtleneck sweater, dark black tights, and some black boots—and with her blond hair, I thought, 'Wow. She's really something else.' I was sitting on a big stepladder when she came in, and she walked by and looked up at me and smiled, and I looked down and smiled. She told me later that when she first looked at me and smiled, she said [to herself], 'Yeah, I want to work with that kid.'"

Originally referred to as "Children of the World," the attraction got its final name from Walt by way of the Sherman brothers, who were once again called upon to come up with a memorable song in short order.

Walt's original idea was to have the Audio-Animatronics children singing the anthems of different countries as the boats moved among the different national displays, but the result was a disagreeable cacophony. To fix the problem, he brought in Robert and Richard Sherman, telling them, "You guys again are going to write me something that will explain all this," as Richard Sherman recalled. Walt continued, "I want something simple that can be translated into different countries, into different languages, slightly different arrangements for the different countries. A simple song like a folk song." Walt suggested a round that looped endlessly throughout the 10-to-12-minute journey, but the Shermans thought that could get monotonous and suggested "two little melodies that could fit together—so you could hear one and then the other," Richard recounted. "So we wrote this little roundelay."

For the lyrics, the Shermans borrowed from Walt's own words. "Walt was saying, 'Let's talk about the children of the world—the small kids of the world.' Small. World. So we said, 'It's a small world, after all,' and that's how we got the title." It became, he said, the song that "everybody around the world knows and they either want to kiss us or kill us for having written." The initial run-through for Walt was at a slow pace, "like a prayer for peace and understanding," but Walt asked for a brighter tempo. It was that version the brothers performed later that day for the Imagineers, who pronounced the tune "just perfect." The UNICEF attraction became "it's a small world," and the song was translated into more than a dozen languages and played throughout the ride, each language blending into the next as the boats moved through scenes from different cultures.

With less than a year between Walt's agreement with Pepsi-Cola and the opening of the fair, "it's a small world" was another full-team project. Blair was the art director, with Davis supervising the animation of the children. Crump designed the toys and worked with Blair on many of the sets. The ride layout, weaving through a series of rooms themed to different parts of the world—Scandinavia, Continental Europe, Africa, South America, and so on toward a grand finale of all nations—was handled by Claude Coats.

The Imagineers again consulted with Arrow Development on the ride vehicles, settling on flat-bottomed boats that were propelled not by individual engines, but by a series of water jets embedded in the walls of their artificial canal. It would be another triumph of capacity. "No attraction in the amusement industry had ever carried more than about 1,500 or 1,600 people [an hour]," Marty Sklar noted. "So, all of a sudden the water ride became capable of carrying over three thousand people an hour." (The capacity was reduced in spring and fall, when New Yorkers' heavy coats meant that only two guests would fit on the boat benches intended to hold three at a time.)

Blair suggested Marc Davis's wife, Alice Davis, to design the costumes. Alice had first met Marc at the Chouinard Art Institute (the precursor to CalArts) when she was a student and he was an instructor. She had aspired to become an animator, but at that time the women in Disney's animation division were permitted to work only in the Ink and Paint Department, so the school insisted that she study costume design. She graduated and got a job designing brassieres, girdles, and lingerie. "It was good education," she recalled, "because I learned about all kinds of materials and elastics." Her reluctantly acquired expertise also gave her former instructor an excuse to call her while he was working as an animator on *Sleeping Beauty*. Marc wanted Alice to sew a real-life version of Aurora's skirt from his drawings, so he could study how it moved, to inform his animation. That request turned into a regular freelance gig, making reference garments for Disney animators, and also became a budding romance. The couple married in 1956, but it was another seven years before Alice joined WED Enterprises full-time. The day after Blair told her she should be working on the costumes for "it's a small world," Alice got a call from the studio offering her the job. She was to start the next morning at nine a.m. She arrived at eight a.m. and remained an Imagineer for the next twenty-five years.

Among Alice Davis's first questions when she met Walt Disney was what her budget was for the hundreds of costumes that needed to be designed and sewn. "He looked at me and said, 'No, Alice, that isn't it.' I want you to design a costume for each one of these dolls that every

woman would love to have from the age of one to one hundred.' And he said, 'I have a building over there filled with people that find out where to get the money.' So that was it. I never had a budget." Davis started drawing right away, she recalled, at the same time immersing herself in books and magazines to research a world's worth of national garments. Particularly influential was an old copy of *National Geographic* that depicted the traditional holiday costumes for countries from around the world. Time was too short to make colored sketches, so Davis worked with Blair on black-and-white drawings to which they would staple swatches of fabric. The costume fabricators worked from that.

Blair "set up the whole color scheme," Davis said. "I would tell her what colors the costumes should be with the country, and she would take the colors and design what colors she wanted them to be. She was an absolute genius. Fantastic with color." Blair ignored the "color wheel" theories of the day, which dictated what hues should be paired as complementary. She would combine colors according to her own unique sense of design—the brighter the better—putting pink and orange together, say, or turquoise and olive green. It was a bold approach that would soon become popular in design realms far from Disneyland, including in clothing and interior design, but Blair rarely got the credit. "She had this sense of color that was absolutely marvelous," Davis said. "Nobody really appreciated her as much as they should have. People would say, 'Oh, she just puts the color down.' I'd say, 'Listen, can you put color down like that?' None of them could."

The Model Shop also played a vital role under Blair's supervision. "Mary sat down with all the gals in the Model Shop, and they took her artwork [and turned it into models], because Mary couldn't do anything three-dimensional," Crump said. "Everything she did was totally flat, and that's the way it was. So that's when all of a sudden '[it's a] small world' started really falling into place." Blair became especially close with Harriet Burns, the lead modeler on the project. While Blair was in California, Burns would pick her up every morning at her motel in Toluca Lake to take her to WED in Glendale, about eight miles to the east.

By that time, Burns was the acknowledged soul of the Model Shop.

As Sklar recalled, "Harriet had the main seat in the Model Shop and would do all kinds of delicate work on different models. But when Walt came here for any meeting, the first thing he did was always stop—it didn't matter whether it's five minutes or ten minutes—he'd stop and talk to Harriet. She was his favorite." She also made sure to prove she could do anything the men in the shop could do, Sklar said, "whether it was using a power tool or getting up on a ladder doing a repair on something. She was really one of the boys. That's the way I would put it."

The models became full-size sets, and the entire "it's a small world" attraction was constructed—minus the boat canal—within one of the Disney studio soundstages. It was a complete mock-up, with Audio-Animatronics figures—built in the Machine Shop—sets, lighting, and sound. A "boat" on wheels followed the track where the canal would go. To get Walt's approval, the Imagineers simply pushed him along at the speed they estimated the boats would go. Walt gave it the thumbs up, and the whole thing was broken down into parts, shipped off to New York, and reconstructed there. It was, Crump said, "an incredible time frame. We actually broke the world's record. We designed and built " 'it's a small world' " in nine months. We were just—*boom!* Straight ahead."

IV. HOMECOMING

By the spring of 1964, much of WED had relocated to New York City, doing final fabrication, installation, and testing for each of Disney's four attractions. There were hiccups—under New York union rules, for example, Alice Davis couldn't touch the costumes she had designed, forced instead to explain every alteration verbally to sometimes less-than-enthusiastic local union costumers. But it all got done.

On the fair's rainy opening day, April 22, 1964, Walt Disney gave a short welcome speech at the entrance to the Pepsi-Cola pavilion, accompanied by Mickey Mouse and other costumed Disney characters from *Snow White, Alice in Wonderland*, and *Three Little Pigs*. Most of the key Imagineers were there—exhausted by the previous weeks of long days (and nights) finishing the exhibits but also exhilarated to welcome guests inside for

the first time. About "it's a small world," Mary Blair called it "the most interesting job I've ever done," crediting the contributions of 1,500 workers on that one attraction alone. "The audience moves, the performers move, and everyone—especially the children—seem to have a grand time."

Rolly Crump had more to be proud of than just his design of about 200 toys and animals within "it's a small world." Outside the Pepsi-Cola pavilion stood a momentous kinetic sculpture Crump had designed called the Tower of the Four Winds—so named because of its dozens of elements that would move in the breeze. It had been his first assignment for the fair, and he had worked with Blair on the bright and varied color design. "Walt wanted me to do a tower of propellers as a marquee for 'it's a small world,'" Crump recalled. "I built a working model of the Tower of the Four Winds with all the propellers spinning." Walt approved the design in miniature, and WED contracted with a Southern California engineering design firm to get it built. The company altered Crump's specifications, much to his disappointment. "I had to take Walt down to take a look at it," the designer recalled of their first trip to see the finished tower. "I was really upset with it because the engineers had gotten a hold of it and—because the wind loads in New York are terrible—they fattened everything that I designed. Everything that was six inches in diameter became sixteen inches. Everything that was maybe a foot became two feet. It lost the delicacy that we had in the model, and I was furious about it, but there was nothing I could do."

When Walt asked what he thought of the final tower, Crump was frank: "It's a piece of crap." Walt calmly responded, "No, Rolly, it can't be a piece of crap. It cost me $200,000." Walt, Crump said, "totally understood why I was upset, because he had seen the delicacy of the model. And he says, 'Even so, Rolly, it may be a bit cumbersome, but I love it.' And after a while, I got to love it myself." The final tower was certainly impressive: 110 feet tall, plus a 10-foot pedestal, and 46 feet wide at the bottom, weighing more than one hundred tons. It had three main support columns, several curved buttresses, and many additional connections and extensions holding more than one hundred moving

parts—among them a carousel of animals from different parts of the world and elements shaped like birds, flying fish, and butterflies.

But the stats didn't really capture Crump's creative combination of childlike playfulness, monumental proportions, delightful details, and kinetic energy. By opening day, Crump could look with satisfaction at the crowds of people in raincoats who gathered at the base of the tower—on its circular platform about ten feet above the ground—to look out over the fairgrounds and the opening of "it's a small world." Disney marketing promoted the phrase "Meet me at the Tower of the Four Winds" to great success, as the sculpture became a favorite rendezvous point for fairgoers. (Ironically, the Pepsi tower's closest competitor at the fair was the Coca-Cola tower, a three-sided 120-foot spire enclosing a 610-bell carillon, said to be the world's largest.)

During the fair's two-year run, "it's a small world" would sell some ten million tickets—95 cents for adults, 60 cents for children—raising millions of dollars for UNICEF. Disney's other attractions were also critical and popular successes. Ford's dinosaurs indeed outdrew the more baldly self-promotional General Motors pavilion, as the Magic Skyway became the fair's fourth most-visited attraction. Within GE's Progressland, people sometimes waited as long as an hour to see the popular Carousel of Progress, despite its high ride capacity. GE later reported 15.7 million people saw the show.

The most dramatic audience reaction in the fair's early days, though, belonged to Disney's fourth show, Great Moments with Mr. Lincoln in the State of Illinois pavilion. Audiences had never seen a mechanical figure so lifelike, and some were convinced it was actually an actor pretending to be a robot. "They'd throw coins at it to see if that real person would jump or would try to bat the coins away," Marty Sklar recalled. Even worse were the ball bearings. SKF Industries, which manufactured ball bearings for machinery, had a pavilion not far from Illinois's and handed out free samples of its product—which some guests then lobbed at the Audio-Animatronics Mr. Lincoln. The bearings became a hazard for guests, requiring their regular removal from the floor, and for Mr. Lincoln, occasionally requiring surgery to repair a broken glass eyeball.

The press was also wowed. Marc Davis was especially pleased that one observer reported that Mr. Lincoln took a step forward before delivering his speech, proving that the illusion created by the sliding foot and strategic lighting had been successful.

Great Moments with Mr. Lincoln was also the first of the fair attractions to debut back at Disneyland. The fair was seasonal, running from April 22 through October 18 in 1964 and again from April 21 to October 17 in 1965. At the end of the first season, the Imagineers liberated Mr. Lincoln and took him back to California, where he was updated with some refined technology and installed in the Opera House on Town Square in Disneyland. He also got new hands: believing the original hands were too large for the figure, Don Iwerks's hands were cast in plaster and used to create Lincoln's. They turned out to be just right. As Iwerks put it, "My hands have been on Lincoln for a long time."

With Mr. Lincoln Mark I moved to Disneyland, a second Mr. Lincoln, Mark II, was fabricated and installed at the fair for the 1965 season. The Disneyland attraction opened July 18, 1965, and just as in New York, "crowds . . . were blown away by a gesturing, talking Abe-like robot," according to the *Los Angeles Times*.

Having been a longtime dream of Walt's, Mr. Lincoln would likely have made an appearance at Disneyland without the fair, but it would have taken much longer to happen. The fast-tracking of the Audio-Animatronics technology was thanks to the state of Illinois and fair president Robert Moses. Two additional attractions—"it's a small world" and the Carousel of Progress—would follow Mr. Lincoln's path west, along with part of the Magic Skyway. "That showed you how smart Walt was," Bob Gurr noted. "We would use somebody else's money to develop this technology and develop this show that we would run for two years in New York. We had a nice, brand-new attraction that we could put in Disneyland and we didn't have to pay for it."

The relocation and reconfiguration of the three remaining World's Fair attractions led to a surge of work for the studio machinists who specialized in Audio-Animatronics technology. But as studio staffers, the machinists did not report to WED and had to return to their Walt

Disney Productions responsibilities when each WED job was completed. This complication was eliminated in 1965 by the addition of a second building at WED's Glendale facility, housing a dedicated Machine Shop. Funded with the profits from the 1964 feature film *Mary Poppins*, it was named accordingly: MAPO. "They did everything from building Audio-Animatronics figures to Monorail trains," Sklar said. "It was soup to nuts, if you will."

The fact that MAPO was a non-union shop—since it was not part of the studio, it was not covered by Hollywood's union contracts—was also a factor in its formation, said Roger Broggie, who moved to MAPO from the studio along with the artisans he supervised. Union jurisdiction on WED projects underway at the studio could be a nightmare. One example: "For the Audio-Animatronics figures, we used spaghetti wire for the fingers," Broggie said. "The electric union figured this was their jurisdiction. But the figures also had some pneumatic installations, and the plumbers said that this was their department." Meanwhile, Broggie continued, the machinist who was trying to get his work done just "had to stand back and watch them argue." After enough such delays, Broggie went to Walt Disney. "I asked, 'Could I move out of the studio and set up shop?' That's how MAPO was formed." More than a machine shop, MAPO manufactured "all the items we can't buy," Broggie said.

That included most of the parts that went into Audio-Animatronics figures—and many new ones were needed to get the World's Fair attractions settled in Disneyland. No figures were added to the Carousel of Progress, but those that existed were updated and their costumes remade and, in some cases, revised. The "present day" scene was also rethought, since the show would debut on July 2, 1967, more than three years after its New York premiere. (The snowy winter scene outside the windows in the "present day" scene, for example, was replaced with a strategically lit skyline of what the Imagineers had dubbed Progress City.) The show was again sponsored by General Electric, as part of a more general updating of Tomorrowland.

Ford, on the other hand, ended its sponsorship with the close of the

fair. The automobile company kept just one WED-created element from their pavilion before it was demolished: an Audio-Animatronics band called the Auto Parts Harmonic Orchestra, designed by Rolly Crump, which had greeted visitors as they joined a Magic Skyway queue that sometimes stretched to three hours. That left Disney to decide what to do with the rest of the attraction. Rather than attempting to transport and reproduce the full show at Disneyland—which in any case would have needed a new ride system to replace the Ford convertibles, which were on their way to a resale lot—the Imagineers opted to preserve the dinosaur scenes and build them a new home along the Disneyland Railroad. "The Primeval World," as the diorama came to be known, was installed adjacent to the Grand Canyon scene, in an expansion of the tunnel-like building just before the trains reached the Main Street, U.S.A., station. Needing less updating than the Carousel of Progress, the Primeval World debuted along the railroad on July 1, 1966, a year and a day before the GE attraction opened in Disneyland. The Magic Skyway's ride system would also soon be regenerated at the park, albeit in a completely different form.

The most prominent renovations were made on "it's a small world," which became an even longer experience, stretching from twelve minutes to nearly fifteen. A room representing Oceania—Australia and the islands of the South Pacific—was added, along with a polar scene and separate chambers to welcome and bid farewell to visitors. But the Tower of the Four Winds did not make the trip to Disneyland. The cost to break it down, ship it west, and reconstruct it would have been prohibitive, and at the end of the fair it was taken down, cut up, and discarded. But Crump would get a consolation assignment: design the facade for the new building that would house "it's a small world." Working from ideas by Mary Blair, Crump created a quilt of layered geometric shapes and simplified representations of architectural icons from around the world, some identifiable, like the Eiffel Tower and Leaning Tower of Pisa, and some more generalized forms evoking bell towers, minarets, windows, and stairways. "I loved Mary's style so much that I knew how to trace her

work and make it three-dimensional," Crump noted. "We would talk about different shapes and stuff."

Walt liked Crump's design but wanted something more. "He said, 'Why don't you put a clock up there?'" Crump recalled. "His little ideas dropped into your lap just at the right place." The thirty-foot-tall square clock tower with its oscillating happy face became something of an attraction in itself. On every quarter hour, doors within its walls would open up to reveal a display of the exact time and to release a brief parade of dolls out of the structure before welcoming them back in.

Once again, the work on "it's a small world" was completed in record time, with less than seven months between the closing of the fair and the opening of the reconstructed and expanded attraction at Disneyland on May 28, 1966. Disney turned the debut of its latest E-ticket attraction into a grand media event, with children dressed in traditional garb representing a long lineup of different countries (although most of the children were actually from Southern California). A reported fifty representatives from foreign consulates attended, and some of the children poured vials of water from each of the world's oceans into the attraction's canal, dubbed the "Seven Seaways." (A similar water ceremony would become something of an Imagineering tradition years later.)

It wasn't the first party Disneyland had hosted since the opening of the 1964–1965 New York World's Fair. Throughout 1965, including during the fair's second summer, the Anaheim park marked its tenth anniversary with its own grand celebration—and, of course, a special episode of Disney's weekly television show. By the time the theme park turned ten, Disneyland was a cultural phenomenon, having hosted some fifty million visitors and inspired a host of imitators. The first Six Flags amusement park opened near Dallas in 1961. Universal opened its Studios Tour (then chiefly a tram ride) in Southern California in 1964, the same year SeaWorld opened near San Diego. While lists of popular tourist destinations were still dominated by world-class cities (New York, London, Venice), history-rich locales (Rome, Egypt, Greece), and awesome natural landscapes (mountains, beaches, forests), Disneyland was the lone wholly engineered attraction that remained consistently near

the top. The only similar destination, created specifically to lure visitors, was Las Vegas, Nevada—which would learn its own lessons from the Imagineers in the decades to come.

WED Enterprises had spent the late 1950s leveraging the success of Disneyland to continue to expand and improve what the park offered. The early 1960s had seen WED's artists reach outside of Southern California to apply their skills at the Winter Olympics and the New York World's Fair, while keeping one eye on the park that made it all possible. Once the fair was up and running, though, the Imagineers didn't stop to take a breath, since there were still major attractions at Disneyland in the works that had been delayed by the long, hard work to make a splash on the world stage. The dreams Walt and his Imagineers had for their Anaheim home base were encouraged by their success at the fair and powered by some of the new technology developed along the way. When it was time to celebrate the birthday of Disneyland on NBC, then, Walt did not start with the parade, the dancing birthday candles, or the unmemorable theme song ("Ten years of fantasy, ten years of fun. Ten years of growing, and you've only just begun!"). He began with what was coming next—attractions with pirates and ghosts.

What he didn't talk about, though, was another secret project he had in the works, one that would revolutionize the nascent theme park industry by tapping into the talents and imaginations of both the current Imagineers and future generations and guide them into a hazy but hopeful future.

CHAPTER 5:
A VISION FOR THE FUTURE

"I can never stand still. I must explore and experiment. I am never satisfied with my work. I resent the limitations of my own imagination." —Walt Disney

I. THE PSEUDONYM REAL ESTATE DEVELOPMENT COMPANY

IN THE FALL OF 1963, Walt Disney; his daughter Sharon and her husband, Bob Brown; and a handful of company executives embarked on a secret tour of sites in the eastern United States. A private Gulfstream I jet took them from Burbank, California, to St. Louis, Missouri, and Niagara Falls, New York—but these stops were just feints to confuse any Disney-watchers tracking their progress. The real destination was the final one: Central Florida, just south of Orlando—a modest city with a municipal airport so small that most commercial jets had to land at a nearby Air Force base.

"We flew all the way down the coast of Florida and across the Everglades," recalled Card Walker, then vice president of marketing and a board member at Walt Disney Productions—and one of the few who knew about what had been dubbed "Project X." To disguise the final destination, the Gulfstream landed in Tampa and the Disney group then took cars into the center of the state, stopping to pace around various parcels in Osceola and Orange counties—land that was then just flat expanses of scrub forest, swamps, grazing lands, orange groves, and a few scattered homes.

The day turned out to be memorable for another, much darker reason. After the site exploration in Central Florida, the Gulfstream took off again from Tampa and crossed the Gulf of Mexico, landing in New Orleans for refueling. It was too late to continue the journey that day, and the passengers disembarked to head to a hotel for the night.

"We were riding in our cars. I was in one car; Walt was in the car behind us," Walker recounted. "And we saw people in their cars being disturbed and their radios going and we couldn't figure out what the hell it was. We finally turned on our radio and we pieced together that Kennedy had been shot in Dallas."

It was Friday, November 22, 1963, and President John F. Kennedy had been struck by an assassin's bullets at 12:30 p.m. Central Time. He was declared dead thirty minutes later—news the airborne Disney team had not heard.

Walker continued, "When we got to the hotel in New Orleans, Walt came in behind and I walked over and told him, 'We just heard, Walt, that the president has been shot.' He was shocked." The news made for a nearly silent flight back to the Burbank airport that Saturday. Finally, though, Walt spoke up. "That's the place," he said, confirming that their Project X site search was over. "Well," he continued, "how do we get that real estate together? How do we get ahold of it?" (Walt made no public statement about Kennedy's death, but he did order the first-ever unscheduled closure of Disneyland, on November 23—which was a statement in itself.)

For years, Walt Disney had been quietly determined to build a second theme park in the eastern United States, tapping into the vast market of Disney fans for whom a trip to Anaheim was too far or too expensive. Florida soon became the focus of the search for a home for Project X, because of its year-round climate, established identity as a tourism hub, and its relatively inexpensive, undeveloped land.

But putting together the vast spread Disney wanted took nearly two years. And the planning went on without the knowledge of most of the Imagineers, who were busy working on the attractions for the 1964–1965

New York World's Fair and, later, new E-ticket attractions for Disneyland, as well as a complete revamp of Tomorrowland.

"The reason Walt did four shows at the New York World's Fair," Dick Nunis said, "is he wanted to challenge his Imagineers to see if they could really compete with the world's designers. That really gave Walt a lot of confidence to go forward with Project X."

"Walt was always looking for the next thing," said Marty Sklar. "We didn't always know what those things were." While most of WED was busy with the World's Fair attractions, "Walt had a whole different group of people looking for property in Florida. And we didn't know any of that was going on."

"If any of us leaked what Project X was, we would be fired by Walt personally," said Carl Bongirno, the treasurer of WED, one of the few people there who was brought onto the clandestine team.

The effort to acquire the land involved absolute secrecy, fake names, indirect airplane flights, and tracking down landowners all over the country—Sklar recalled, to give the Imagineers the freedom to accomplish what Walt had in mind.

The team of California and Florida lawyers and real estate agents working to acquire thousands of acres was led by Robert "Bob" Price Foster, a young lawyer who had been serving part-time as the Disneyland assistant secretary and counsel. Asked by Walt to work on Project X in August 1963, he sold his private practice and prepared to work full-time on the secret endeavor. Foster and Walt had considered and discarded several sites—one in the Baltimore–Washington, D.C., corridor—before that November trip to Orlando. Foster then spent months researching the area and learning who owned the land Disney wanted.

The initial suggested size of the acquisition, he later recalled, was five thousand to ten thousand acres, and he started work in California, through public records. When he headed to Florida in the spring of 1964, "Bob took an assumed name," Walker said, recalling the nom de guerre as Al Davis from Kansas City. (Walker may have been thinking of another Disney executive's alias: Roy O. Disney during this period

checked into the Dupont Plaza Hotel in Miami as Roy Davis, picking a name that would match the initials on his luggage.) Five dummy corporations were set up through the state of Delaware to handle the purchases without apparent connections to Disney.

"That was all pretty hush-hush, because we realized that if anybody knew that it was Disney, the price of real estate would go like this," Walker said, describing a rapid rise with one hand.

At one point, in a May 1964 meeting with Walt, Foster even pitched a completely different site, between Deland and Daytona Beach in northern Florida. Walt's reaction was simple but definitive: an arched eyebrow and the comment, "Bob, what the hell are you doing way up there?" The Daytona plot would be too cold in the winter, the Disney team had concluded, and Walt didn't want his development to be too close to the beach, for fear tourists would spend their afternoons tanning and swimming rather than spending money at his park. Foster accepted the challenge to focus on the Orlando site, eventually negotiating with at least sixty-five separate landowners.

"We kept all of the maps of the acreage that we wanted to buy in Florida in the president's conference room [at the studio], which he [Card Walker] had a key to, I had a key to, and Walt had a key to," Bongirno says. "Nobody else was familiar with that conference room. As the attorneys purchased property, I color-coded it as to what we owned, what was under contract, and what we were still trying to negotiate. Walt would come up at least once a week to review that map and ask how the process was going."

Gradually, news outlets in Central Florida figured out that some undisclosed company with deep pockets was buying up a lot of land. The names Rockefeller and Boeing and Howard Hughes were bandied about, but Disney's veil of secrecy held until October 1965. That's when an ill-advised lunch between Walt Disney and an *Orlando Sentinel* reporter, Emily Bavar, turned into front-page news.

Bavar suspected Disney was behind the land purchases and flew to Burbank, ostensibly to attend an event for the "Tencennial," as the park's tenth anniversary celebration was being called. Her real purpose, though,

was to confirm her suspicion that Disney was behind the Central Florida land acquisitions. Over lunch, she asked Walt directly about the deals, and while he did not confirm, his weak denials and equivocations—along with his remarkable knowledge of rural Florida weather and tourism statistics—convinced the reporter she was right. "In talking to Disney, it became immediately apparent he had watched the eastern United States with interest and speculation," she wrote as part of her front-page story on October 24, under the headline "We Say: 'Mystery' Industry is Disney."

"It hit the papers the next day and the property we were buying for $300 an acre went to $100,000 an acre in one day," Bongirno says. "We didn't get some of the property that we had wanted to." Even after the revelation, Foster continued to travel the country, negotiating with own-ers of the bits and pieces needed to fill in the "outages" in the huge tract.

By the end, the clandestine operation (and a few later deals) had yielded quite a new playground for the Imagineers to work their magic: 27,440 acres of largely untouched land in Central Florida, equal to the size of San Francisco. Disney had paid about $5.5 million, or an average of $180 an acre. To memorialize the successful completion of his mis-sion, Foster was later honored by the Imagineers with a window on Main Street, U.S.A., in the Magic Kingdom, trumpeting the Pseudonym Real Estate Development Company and its owners, Roy Davis and Bob Price.

Dick Nunis, by then the director of Operations for Disneyland, recalled his reaction on learning about the land WED would be expected to transform: "Do you know why Walt loved this piece of property? Two swamps, Bonnet Creek and Reedy Creek. He said, 'Just think, Dick, nobody will be able to build on that.' And that's when I thought . . . 'We're in trouble.'"

II. A NEW CONCEPT

As it turned out, the story broke just three weeks before Disney had planned to announce it anyway. With Disney's blessing, the governor of Florida, Haydon Burns, confirmed the facts the next day. A full press

conference—including Burns, Walt Disney, and Roy Disney—was held in Orlando November 15, beneath a neatly hand-lettered placard reading, "Florida Welcomes Walt Disney." There Disney boasted that the Florida project was "the biggest thing we've ever tackled" and estimated an initial investment of well over $100 million, including both Disney's as-yet-undisclosed attractions as well as hotels and other ancillary developments. He said he had no worries about getting it done.

"I have a wonderful staff now that have had ten years' experience of designing, planning, and operating," he told the gathered press, alluding to WED Enterprises and the Disneyland Operations team. "In fact," he added, "we did the four shows at the World's Fair, and it was a new departure for us." Disney declined to provide any details about what the company was planning to build but said the new project would not be a carbon copy of the first park. "There will never be another Disneyland, Governor," he said. "You hate to repeat yourself. I don't like to make sequels to my pictures. I like to take a new thing and develop something, a new concept."

The journalists came with either good sources, good guesses, or both. One asked pointedly, "Have you entertained the idea of calling the Florida attraction Disney World?" (Walt didn't answer directly but noted that the phrase "Disney World" was already in use in other contexts within the company.) Another asked about constructing a "city of tomorrow." "I would like to be a part of building a model community," Walt responded vaguely, suggesting he might build two communities, one called Yesterday and the other Tomorrow—echoing a balance between nostalgia and futurism long familiar to Disney Imagineers.

According to master site planner Marvin Davis, "another theme park was secondary to Walt. He wanted to solve the urban problem." Davis recalled, "We were sitting at a table playing with names. Walt said, 'Why don't I call it what it is: Experimental Prototype Community of Tomorrow.' He spelled out the letters: E-P-C-O-T. 'That's what it's going to be.'"

Walt Disney introduced his plan for an Experimental Prototype Community of Tomorrow in a twenty-five-minute film made in the fall

of 1966, with a script by Marty Sklar. It was actually the third script Sklar wrote as part of the selling of Project X to its future neighbors in the Sunshine State. The first was about the economic impact of Disneyland on Orange County, California—a preview of what Florida could expect—and the second was about the impact of Walt's entertainment ventures, titled "The Disney Image." This second presentation was not cleared by Walt before being shown to two hundred people at the studio, and its glorified depiction embarrassed its subject. "Walt came up to me afterwards and said, 'I didn't realize anyone was writing my obituary,'" Sklar said. "And I felt like about this small." (Walt later clarified that he liked the presentation—it had just surprised him.)

Crafting the script for the EPCOT film "was one of the great experiences that I had at Disney," Sklar said, "because I spent two or three meetings in Walt's office—just me and him." It was easy to write, he said, "because he just laid it out exactly." As Sklar recalled, Walt had been visiting the research labs of the great companies of the day as part of his planning for EPCOT, including DuPont, IBM, and RCA's David Sarnoff Laboratories in Princeton, New Jersey, which worked on the development of color television, transistors, integrated circuits, lasers, computers, and other consumer-targeted technology. His interest in such labs presaged Imagineering's own creation of a dedicated research and development division, still decades in the future.

"Whenever Walt Disney came to those places, they would trot out the newest thing they were working on and show it to him, and he would say, 'When can I buy something with that technology?' and they'd say, 'Well, I don't know if the public's interested in that,'" Sklar recounted. Disney knew better, having just seen the public's eager interactions with the Ford and GE exhibits at the World's Fair. According to Sklar, Disney thought, "'Why can't I be the middleman between these companies with new things that are coming along and shaping the future?' And that was really the genesis, I think, of the whole idea for EPCOT."

The EPCOT film, intended for *Walt Disney's Wonderful World of Color* on NBC but never broadcast, began with more than ten minutes of introduction by an unseen narrator and by Walt himself, standing at the foot

of a huge map showing the planned development on the Florida property. Yes, there would be a Disneyland-like theme park, he explained, as well as a thousand-acre industrial park. "But the most exciting, by far the most important part of our Florida project—in fact, the heart of everything we'll be doing in Walt Disney World," he said, "will be our Experimental Prototype Community of Tomorrow. We call it EPCOT." Conceived and built from scratch to solve the problems of urban living, EPCOT—like Disneyland—"will always be in a state of becoming," Walt said. "It will never cease to be a living blueprint of the future."

The film-within-a-film scripted by Sklar then began, combining design plans and concept drawings with animation imagining the city's neighborhoods, transportation systems, greenways, and so on. It described what in many ways was the ultimate challenge to Imagineering: blending Disney's own utopian imagination with his optimistic estimations of the powers of technology and industry. He and WED Enterprises had created a small island of cleanliness, courtesy, and cooperation in Disneyland—why couldn't they also reconceive urban living, stripped of dirt, danger, and discord? EPCOT would enlarge the Imagineering mission—to create happiness—from one site in Southern California to cities that could spring up around the world.

The city, designed on a hub-and-spokes plan not unlike Disneyland, would have an urban core, including a luxurious thirty-plus-story hotel, shops, and theaters, as well as offices to "suit the . . . needs of major corporations." The hub was surrounded by a ring of apartment housing; then came an outer green belt filled with recreational facilities and single-family homes. In EPCOT's industrial complex, "Disney staff will work with individual companies to create a showcase of industry at work," the narrator said.

The work of WED's Imagineers was integral to the EPCOT plan. Transportation would be provided by an elevated, high-speed Monorail, for travel to and from the city, and by the connecting "silent, all-electric" WEDway PeopleMover for residents and visitors moving within EPCOT. (The film at this point featured film clips of the Monorail and People-Mover in Disneyland.) Except for some streets in the greenbelts, autos

would be restricted to subterranean roads and parking decks, with a separate and lower system of truck routes. Pedestrians would rule the ground level, which would be dominated by "foot paths reserved for pedestrians, electric carts, and bicycles."

EPCOT would house twenty thousand people, each of whom "will have a responsibility to help keep this community an exciting, living blueprint of the future." The promotional film-within-the-film ended and Walt returned to close out the presentation, asserting that the city would "influence the future of city living for generations to come. It's an exciting challenge."

But it was a challenge that would never be met.

III. A REAL SHOCKER

The suddenness of the death of Walt Disney reverberated through the halls of WED Enterprises and the Burbank studio, across the nation, and around the world. Few knew how sick he had become, and how quickly he had deteriorated. On November 2, 1966, just days after filming his segments for the EPCOT short, Walt was admitted to the hospital. Publicly, the studio said he was receiving treatment for an old neck injury from playing polo, but in fact he was weak and in respiratory distress and was diagnosed with lung cancer. Surgery a little over two weeks later removed the tumor and much of his left lung, but his malady was officially reported as "an abscess."

The Imagineers were kept in the dark with everyone else. "We didn't know," Rolly Crump recalled, recounting the polo injury cover story. If Walt knew he was facing a terminal illness, "he never talked about it." After the surgery, Walt did not get better and returned to St. Joseph Hospital in Burbank on his sixty-fifth birthday, December 5.

Again, the studio soft-pedaled the news, calling it a routine postoperative checkup. He died ten days later, at 9:35 a.m. December 15. "The death of Walt Disney is a loss to all the people of the world," Roy Disney said in a statement issued by the studio later that day. "There is no way to replace Walt Disney. He was an extraordinary man. Perhaps there will

never be another like him." But, Roy promised, "we will continue to operate Walt's company in the way that he had established and guided it. All of the plans for the future that Walt begun will continue to move ahead."

That Thursday morning, Don Iwerks was at WED Enterprises having his hands casted to serve as part of an upgrade for the Audio-Animatronics figure of Abe in Great Moments with Mr. Lincoln in Disneyland. "We were right in the middle of it when word came that Walt had passed away," he said. Although the Imagineers had known Walt was ill, his death "was a real shocker for us," Iwerks said.

When the casting was finished, Iwerks went back to the studio lot, where his father, Ub Iwerks, told him the news had been announced over the PA system. The studio was closed, and "the whole company was dismissed." Still in shock, Don and Ub did not leave immediately. "We talked for a while about Walt," Don recalls. "And my dad's comment was 'the end of an era.'" No one at the studio or WED had been with Walt longer than Ub Iwerks. Born the same year, Ub met Walt at a commercial art studio in Kansas City, Missouri, when both men were about eighteen years old. They spent the next forty-six years as friends, colleagues, and collaborators, including on the creation of Mickey Mouse. Ub had struck out on his own for a decade but had returned in 1940, reporting directly to Walt as the go-to person for solving all technological challenges, a job that had him working often with Imagineers. Now that long, productive, and open-ended partnership with Walt had been in an instant transformed to something "all in the past."

"Oh, God, it was devastating," Crump said. "It was John Hench who told me. It was early in the morning. We were out in the Model Shop, and John had said Walt had passed. It devastated everybody. The whole group of us—Marc [Davis] and myself and Claude [Coats] and some of the other architects—we all went down to a restaurant and celebrated his life and had a few drinks. It was just terrible. I almost cried the whole night."

"We were all in tears. All in tears," Alice Davis recalled. "Couldn't

believe it. Everybody went to the front office and we were all standing there crying."

Dick Nunis was driving to work at Disneyland when he heard the news on the radio early that Thursday morning. His grief and shock were great, but he also had a job to do. "So the first thing [when] I got into the office, I called Card Walker and [asked] my big number one question, 'Card, shall we open [the park]?'" Walker said he'd call Nunis back with a decision, apparently speaking to Walt's widow, Lillian, in the interim. Walker called Nunis back and told him to open Disneyland, adding, "'And put the flag at half-mast.' And I said, 'Yes, sir. Are you sure?' Card Walker said, 'Dick, Lilly made that decision. She said Walt would say, "The show goes on."' And I got a tear in my eye." Some cast members were disappointed in the decision, at least until they learned that Lillian had made the call. If the world wanted to grieve the loss of Walt Disney among other people who loved him and the stories he shared, where better than Disneyland?

Future Imagineer Tony Baxter, then a teenager, was one of those who went to the park to grieve. "When I got into the parking lot, I looked at Main Street and saw the flag going down in Town Square," he recalled. "I never had that experience for anyone else in my life—like your whole vitality and everything was drained out. I walked into the park. The music was 'It Came Upon a Midnight Clear.' And the tour guides were in tears. I can remember it like it was yesterday. It was so eerily sad."

Work at WED stopped that day, but everyone came back on Friday, shell-shocked but needing to get back to work, and to be with the other people who understood how they were feeling. Intruders into their grieving were not welcomed. "The next day the press came in and asked all kinds of asinine questions about Walt," Alice Davis said. "Was it true that he did this and that. I said, 'Well I'm not the one to ask. I don't know,' and just let them go off on their own way. But it was very hard to take. It was hard to concentrate."

Walt's absence was nearly as deeply felt as his presence had been. "I think we all kind of liked the idea that Walt was walking around," Bob

Gurr said, "because he'd come in the building and he had a little ciga-
rette cough, and about ten feet before he comes in and opens your door
he gives that little cough, like the early warning that 'Walt's coming down
the hall, so straighten up real quick. He'll just pop in.' We didn't have
that little cough coming down the hall anymore. I think everybody said
they missed that."

The Imagineers were busy with so many ventures that inertia would
carry them forward for months, if not years. And Walt left imaginative
leaders behind. "The great thing about Walt, he was always dreaming past
his lifetime," Nunis said. "But he also knew that it would take people
to carry on the great dream. And I think people like John Hench, who
was still there when Walt died, and, frankly, [Ub] Iwerks—those types of
people carried on the great traditions and philosophies."

CHAPTER 6:
WHAT WOULD WALT DO?

*"All of our hearts collectively sank. That's when it dawned on us that we were out of the energy that Walt left us with, and somebody is going to have to figure out what the direction is." —*Bob Gurr

I. EXIT WALT DISNEY

IN 1964, well before he took ill, Walt Disney previewed an attraction that had been in the works for years. He was joined on the Disney Studio's Stage I by a camera crew and by a young woman in a spotless, neatly pressed equestrian uniform, complete with red vest, plaid skirt, black domed cap, and riding crop.

The woman was twenty-year-old Julie Reihm. She'd spent two years as a Disneyland tour guide and had recently been named "Miss Disneyland Tencennial," in honor of the park's upcoming tenth anniversary. The camera crew was filming the episode of *Walt Disney's Wonderful World of Color* that would kick off the next year's Disneyland birthday celebration. With cameras rolling, Walt showed Julie WED's meticulous tabletop models for the upcoming New Orleans Square and an attraction he called the Blue Bayou—a ride that would eventually be renamed Pirates of the Caribbean.

Those who tuned in to NBC on Sunday, January 3, 1965, were treated to a rare glimpse inside WED's workshops—however recreated and cleaned up for the cameras—as well as inside the process by which

Imagineers turn barely formed ideas into all-encompassing guest experiences. There on a bulletin board were Marc Davis's original pirate drawings. One table was littered with the small maquettes that were the first three-dimensional iterations of Davis's vision, some of them painted in full color. Walt introduced Julie to sculptor Blaine Gibson—neatly dressed in a blue dress shirt and thin black tie—who was transforming one of Davis's sketches into a full-size clay bust ("Quite an angry-looking fellow," Julie commented).

The broadcast was also a showcase for the little-seen creations of WED's unparalleled Model Shop. Walt pointed out a model of "the town that the pirates are sacking," where Claude Coats was placing skiffs in the painted lagoon surrounding an anchored pirate ship. Walt introduces Coats as "the Imagineer in charge of the entire project," and as the camera zooms in on the model, Coats describes a "walking the plank" tableau (which wouldn't make it into the final attraction). The models for the lagoon, the fort, and the town all sat about four feet off the ground, with a walkway in place of the canal where the guests' boats would eventually travel, so the Imagineers could walk through the model and see it from the guests' perspective.

"Walt wanted to see everything dimensionally," Marty Sklar later recalled. "He didn't want [the guests] to be coming around the corner in a ride and see a blank wall. So everything was created with the dynamic of trying to see something as the guest would see it in the park."

That Pirates mock-up was one of the first things Carl Bongirno saw when he came to work at WED in 1965, the year after the *Wonderful World* filming. "The thing that impressed me most was, the models . . . were elevated and you could walk through the model and actually see it as people would see it in the boat ride. And I thought, 'Wow, the attention to detail.'" Walt, Bongirno said, "would walk through [and] he would change certain things and move certain things, and I thought . . . 'I'm really with a fabulous company.'"

Bongirno had arrived as head of finance just as WED Enterprises finally became an official part of Walt Disney Productions. Walt sold his interest in WED and turned over formal control to the public corporation

in February 1965—a move motivated by the enormous financial commitment necessary to undertake Project X, Bongirno said. It came with a new WED president, Mel Melton, who had previously been an assistant treasurer at the studio. Melton would take care of administration and the financial overview, Bongirno would manage finances day to day, and Dick Irvine remained in charge of the division's creative side.

When Walt Disney died in December 1966, Bongirno had been with the company for just over a year. It was his unpleasant task to share the news with WED staffers. "I talked with just [about] every creative person," he recalls, including walking through the bustling Model Shop, where work soon came to a halt. "Jaws would drop and tears would come to their eyes." It was "a very, very difficult day," Bongirno says. "I drove home myself and cried all the way. I think most people did. It was quite a loss, and everybody felt it very deeply."

No one knew for sure what the impact on WED would be, in part because of Walt's informal relationship with the enterprise. "He never held a position. He didn't sign any papers," Bongirno said. "But you knew who ran the company and who was instrumental in making this company what it was."

A few days after Walt's death, Roy Disney asked the top administrative people in finance to meet at the studio first thing in the morning. "There were about fifteen of us," Bongirno recalled. "And Roy was late, which was very unusual for Roy." The meeting was called for 8 or 8:15 a.m., and Roy didn't arrive until 9. "He finally comes in, very slowly, obviously very sad. He stands in front of this group and doesn't say anything for a while. He just looks around and as I can recall, he said, 'Gentlemen . . . you know the world has lost a fabulous individual, a great leader.' He said, 'I've lost a brother. . . . The creative people in this company have lost their leader. So I want to impress on you, when you leave this room, be very easy on these people until they find their leaders, until they can fill the voids that Walt is going to leave.'"

"When Walt passed away at the end of 1966, it was like a terrible shock to all the people who used his enthusiasm to fire them up," songwriter Richard Sherman recalled. "We had to fire ourselves up. It was a whole different thing. We had a board of directors that was not quite sure where

they were going. They were always trying to say, 'What would Walt do? What would Walt do?'—instead of, 'What will we do?' And it was kind of a frustrating time for the creative people because many times great ideas and projects were killed, because they weren't quite sure which direction to go."

As 1967 unfolded, work continued on attractions that had been far along under Walt's supervision, as well as a major update of Tomorrowland, everyone working diligently but with the knowledge that the Imagineering ship had lost its anchor. As the months passed, Dick Irvine's leadership on the creative side was made official, as he was appointed vice chairman of the board and executive vice president and chief operations officer of WED Enterprises. Once the shock of Walt's loss wore off, everyone at WED took on a small portion of Walt's role as creative sounding board, providing "the kind of oversight that Walt would give them when he'd come around and point out things that he liked and things he didn't like," Bongirno said. "They were doing that with each other now more than they did before."

That was a fine system with veteran staffers, but Irvine worried that newer employees—especially those working on the Florida park—would need more guidance. After hearing Irvine's concerns, Sklar had a suggestion: "Why don't we put together a booklet of things people said about Disneyland and also Walt's philosophy about Disneyland?" Irvine agreed, and Sklar had soon compiled a spiral-bound booklet, dated September 21, 1967, and titled simply "Walt Disney World Background and Philosophy." It soon became known as the "Blue Book" because of its robin's egg–colored cover. The booklet included everything from Bill Walsh's description of how Disneyland was originally imagined, and a lengthy transcript of Walt Disney's 1965 Florida press conference, to relevant news clippings and science-fiction author Ray Bradbury's story of riding Peter Pan's Flight with Oscar-winning actor Charles Laughton—as well as pages and pages of quotes from Walt himself.

Sklar intended the book to impress upon readers "the ethic that Walt brought to doing these parks, and his attitude about the public," Sklar

said. That included never putting people down and the overarching goal of "bringing happiness, bringing magic, bringing new things, bringing fun—you can't forget fun—to people."

II. ENTER THE PIRATES

Many of the "new things" that remained on track at WED after Walt Disney's death were those in which he had had extensive developmental input. "I think everyone wanted to finish what Walt had asked us to do," Alice Davis said of that uncertain time. "And I think we did a good job of finishing up what we were doing when Walt was ill."

Among those ongoing projects was Pirates of the Caribbean, an attraction that was cinematic in scope and peopled with the most elaborate and extensive cast of Audio-Animatronics figures ever assembled, both human and animal. Before the World's Fair, the attraction had been conceived as a walk-through, but "with the success of moving so many people through 'it's a small world,'" Marty Sklar recalled, "Walt said, 'We can't just do a walk-through. We can handle three thousand people an hour now.'" So Pirates, like "it's a small world," became a boat ride, which "changed the dynamics of the whole attraction."

The Pirates story began with the designs of Claude Coats, the six-foot, six-inch Imagineer briefly seen in that *Wonderful World of Color* episode in his buttoned-up yellow polo shirt. The watercolorist and former background artist for classic Disney animation "was the best layout artist we ever had here at Imagineering," Sklar noted.

The layout was epic, and the ride building simply would not fit within the confines of Adventureland—a problem that arose while Walt was still around to provide a solution. "I'd gotten information from MAPO about what the boats would do, and what curves and radiuses it would take," Coats recalled, but the available plot assigned to the attraction was "very small and very tight. We had a model going on it and Walt came around and looked at it one day, and then finally said, 'We're just going to go under the railroad track and to a big building outside the

berm. There are too many ideas happening that are too confined in this small space.'" WED's facilities architect, Bill Martin, worked out the new spatial arrangements, and Coats revised the design.

Coats "laid out the whole pirate attraction," Sklar recalled, "and then he brought Marc Davis over, and Marc brought humor to the attraction."

Coats designed all the attractions' settings, rendering them in colorful, beautifully illustrated paintings, while Davis sketched out all the memorable pirate characters, animals included. Both men were focused on the story. Just as in the classic Disney films they had once worked on, "the animation is the thing that really tells the story," Coats said, going on to summarize some foundational principles of all Imagineering projects. "The background has to support all of that [story]. It has to add mood to it and give the character the proper space to work in and the proper light to work in. The background can't be overdone; you can't make something super-important that is distracting. It is a matter of balance."

Davis's partnership with Coats was something of an odd-couple pairing, since Coats was quiet and introspective and Davis was outgoing and assertive, but it generated a dynamic blend of immersive, detailed sets with a lively, expressive cast of Audio-Animatronics actors. Also crucial were sculptor Blaine Gibson, who gave Davis's drawings dimension, and Alice Davis, who designed the many costumes.

Together, these artists—and many others, including the Machine Shop and the Model Shop—created a narrative attraction of unprecedented complexity. It was filmmaking made compact and all-encompassing, with sets and actors and scenes, sound and music and special effects. Its tale progressed through plot, character, emotion, humor, and even suspense. Utilizing the lessons from the World's Fair—the high-capacity boats, the sophisticated Audio-Animatronics figures, the conjuring of convincing historical scenarios—guests would be immersed in an experience so rich in detail and incidents that they would be both thoroughly entertained and moved to return again and again.

The storytelling extended to the smallest details in Pirates of the Caribbean, such as the many lanterns throughout. "Walt wanted a

simulated flame . . . and asked Ub [Iwerks] if he could come up with a way to do it," Don Iwerks wrote in his 2019 book about his father's work, *Walt Disney's Ultimate Inventor: The Genius of Ub Iwerks*. "Ub often delved into electronics, and he decided that there was a way to build a circuit of solid-state components that could produce a constantly varying electric current to illuminate a bulb. The result was a very believable light effect that replicated the random flicker of a candle flame."

Also contributing flames was Yale Gracey, WED's resident special effects artist. To make it appear the village was on fire, Gracey positioned in the windows pieces of red, yellow, and orange film, blown by unseen fans from below so they would lick and billow like flames. "I tried everything," Gracey recalled. "I tried silk and I tried projected stuff, and then, I finally came up with the Mylar, which works pretty good if it's put in there properly. In fact, the Anaheim Fire Department had a fit when they first saw it, and they made us put switches on the sprinkler system. So if they had a real fire, [the switch] would cut off my effects so they could find [the actual flames]."

"Walt wanted realism," Sklar said. That included Gibson's mission to make Davis's cartoon-inflected character designs somewhat grittier in his three-dimensional sculpts. "I asked [Blaine] about how he decided what these characters should be—taking Marc's drawings and then turning them into real people. And Blaine said, 'Well, I used to study people all the time at different places.'" Gibson's wife used to kick him under the table at restaurants for staring at interesting-looking people seated nearby, and he'd even find himself studying faces during Sunday morning worship. "You mean some of these characters might have features that are based on people you went to church with?" Sklar asked. "He finally admitted to me that that was true."

Living up to the name Audio-Animatronics figures, many of the pirates and townspeople also spoke, and a narration—recorded by the deep-voiced Thurl Ravenscroft—guided guests into the experience. The dialogue and narration for Pirates was written by Imagineer Xavier "X" Atencio, another recruit from the Animation Department. Atencio had worked for Disney since 1938, when he was eighteen, beginning as an

in-betweener on *Pinocchio*. He rose to assistant animator before a break to serve in World War II. He returned to work on shorts and features, storyboarding, and stop-motion animation (such as the nursery scene in *Mary Poppins*) before Walt recruited him to work on the dinosaurs for Ford's Magic Skyway. The Pirates script was his first major assignment at WED—as well as his first script.

Atencio immersed himself in pirate movies, such as Disney's *Treasure Island*, to work out the jargon. He nervously presented his first scene idea to Walt—to his relief, Walt's reaction was, "Yeah, that's great. Fine. Just keep going"—so then he started at the beginning of the attraction and wrote his way to the end, taking the completed script back to Walt.

"He thought he'd written too much narration," Sklar noted. "And Walt said, 'No. Think of it this way: it's like a big cocktail party, and at a cocktail party you hear bits of dialogue here, bits of stories over there. And this is even better, because people can come back and go through it again and they'll see something new and they'll hear something new.'"

Atencio even wrote the attraction's well-known theme song, "Yo Ho, Yo Ho, a Pirate's Life for Me." He later recalled, "When we finished the script, I came up with a lyric. There's no concentration on how I'm going to do this, it just happens. Knowing the Disney philosophy, it just becomes second nature to you."

Built adjacent to Frontierland on the banks of the Rivers of America, New Orleans Square opened July 24, 1966—the last park dedication ceremony to include Walt himself. But the square's centerpiece, Pirates of the Caribbean, didn't debut until the following March 18. Its original name, the Blue Bayou, was given to the full-service restaurant situated within the ride, across the water from the boarding area, bathed in perpetual twilight.

Pirates of the Caribbean was a major milestone for the Imagineers. As Sklar put it, the attraction "changed the whole dynamic of what Disney did, and it became what everybody else tried to achieve." The collaboration of some many WED artists at the top of their game set a new standard for narrative attractions at Disneyland and future parks

that would endure for half a century. It engaged guests to a degree not previously achieved, as their imaginations would instantly conjure the backstories necessary to explain the mayor being dunked in the well, the drunken pirate cavorting with pigs, and the trio of prisoners trying to lure a dog with a key ring in its mouth—not to mention all the skeletal pirates in the cavern sequence.

"It's a thorough way that you tell a story that has to involve all that storytelling with perfect characterizations and a setting that is so intriguing," Imagineer Bob Gurr observed. Pirates of the Caribbean was, he continued, "the high point of how you design and operate an attraction," a pinnacle of character design, costuming, mechanics, effects, music, and more. It demonstrated "the way to tell stories in the most thorough manner."

On one occasion soon after the attraction opened, the storytelling got a little too real, fire illusionist Gracey recalled. "They did have a fire in there once. One of the drunk pirates hanging on to the lamppost, hydraulic fluid got down onto the light inside the [drunk pirate's] torch. So, the whole thing was blazing and somebody [told] the front office and said, 'Hey, there's a fire down there,' and they said, 'Well, where is it?' 'It's in the fire section.' 'Oh sure, we know about those fires.' And finally, the thing was a big melted mess on the floor. I did turn on the sprinklers and shut off the [flame] effects. A lot of people were riding it and thought, 'Gee, that's a keen effect.' They didn't notice the rain coming down."

III. TOMORROWLAND ON THE MOVE

As Walt Disney had shepherded Pirates of the Caribbean nearly to completion before his death, he also spearheaded a complete revamping of Tomorrowland that was underway when he died. As Don Iwerks recalled, "By 1966, Walt said, 'You know, it's not Tomorrowland anymore. We've got to do an upgrade.'" Despite the 1959 expansion, which added the Submarine Voyage and the Monorail, Tomorrowland had not aged

well. Since Disneyland had opened in 1955, the Space Race between the United States and the U.S.S.R. had heated up, producing countless man-made satellites, human spaceflight, and the promise of an eminent moon landing. The Federal Aid Highway Act of 1956 had generated much of its promised forty-one thousand miles of the Interstate Highway System. The invention of integrated circuits had begun to revolutionize and shrink computers, and network television had evolved from nearly all black and white to nearly all color.

Some of the technology within Tomorrowland had also become outdated, including the projection system used in the Circarama 360-degree film attraction. The off-the-shelf Kodak film projectors the park was using didn't hold up to the grueling schedule of six or seven 18-hour days every week. The loops of film needed to be replaced regularly, and the system had to be monitored by a projectionist at all times. In early 1966, Walt Disney asked Ub Iwerks, the inventor of Circarama, to set up a meeting to discuss how to reduce the rate of breakdowns in the projection system. Don Iwerks, who had been a camera technician on the Disney film *20,000 Leagues Under the Sea* and often applied his skills at WED Enterprises, was one of the leads on the improvement project.

"We soon found . . . the film going through a commercial kind of projector had to go through sound heads, so the film was making many tight little bends and loops," Don Iwerks says. "I said, 'Why don't we take the sound off the film and get rid of all these little loops?' . . . So we wound up building a very simple projector . . . [that] just had very general curves." The sound track was shifted to a separate machine synced to the projectors. Ub Iwerks and his team also replaced the film platters—on which the giant loops of film wound perpetually from outside to inside, before being pulled out at the central spool to run through the projector and then return to the rim of the platter—with cabinets, where the film wove through gentle curves among many rollers. That allowed the loops of film to make their circuit to and from the projectors without the friction generated by layers of film rubbing together as they rotated tightly through a platter.

With those innovations, "the film went from maybe one thousand

runs [before wearing out] . . . up to ten thousand or fifteen thousand," Iwerks says. The savings in film costs were significant. The new system was also automated, so it no longer needed a projectionist to babysit every showing.

The revised circular film attraction, featuring a new thirty-five-millimeter version of *America the Beautiful* shot with nine cameras and screened with nine modified projectors, was dubbed Circle-Vision 360, and it debuted in 1967 in a larger auditorium that replaced Circarama.

Also new to the refreshed land was a science-based dark ride called Adventure Thru Inner Space, sponsored by Monsanto and replacing its Hall of Chemistry; a revamped Rocket to the Moon, now called Flight to the Moon; and the PeopleMover, a continuously moving transport system inspired by the Ford pavilion at the World's Fair and presented at Disneyland by Goodyear.

The refurbished land took on the theme "World on the Move." The overhaul cost $22 million, or $5 million more than the whole park did in 1955. That summer, Bob Gurr said, "it *was* a world on the move, and there were PeopleMovers and rocket jets and submarines and all those kinetics."

The ride-through attraction Adventure Thru Inner Space had been in the works for at least two years before its August 1967 debut in Tomorrowland, including input from Walt Disney. The concept was to take guests into a subatomic world, starting with a special effect using sound, light, and scale change meant to produce the sensation of being miniaturized. The Sherman brothers composed a song—"Miracles from Molecules"—and Paul Frees performed the narration.

"People still talk to me about it," said Peggie Fariss, who worked at the Inner Space attraction in the late 1960s before beginning her career at Imagineering. "[They say,] 'Remember when you could see those people being shrunk . . . through the little microscope, and then you went through the atom?'" At the time, she adds, the experience "worked beautifully."

Both the PeopleMover and the Inner Space attraction utilized a new ride system that was christened the Omnimover. Based on the technology

that moved the Ford cars along the Magic Skyway, the Omnimover vehicles moved continuously at a set rate of speed, and they were loaded while moving alongside a conveyor belt–like walkway that moved at the same rate as the vehicles. The cars in Adventure Thru Inner Space also swiveled on a central pivot, allowing the Imagineers to send guests' attention in multiple directions. Inner Space was the first new-generation dark ride to use the Omnimover system, which would be a crucial addition to the Imagineers' next major attraction.

IV. WALL-TO-WALL COBWEBS

After the revamp of Tomorrowland, WED artists' next major reveal would be back in New Orleans Square. There a creepy Southern antebellum-Victorian hybrid mansion had been built in 1963 and had sat empty while WED Enterprises focused first on the World's Fair, then on all the other Disneyland projects left unfinished at Walt Disney's death.

It was that New Orleans Square attraction that had Imagineer Yale Gracey sitting at his desk one day, thinking about a disembodied head. It was a mysterious woman, and she was talking. As Imagineer-to-be Kim Irvine recounted the story years later, Gracey could "see it in his mind's eye" but was trying to figure out how to turn the woman he envisioned into a convincing effect for the long-planned haunted house in Disneyland. So he went to Blaine Gibson to ask for help. If Gibson could sculpt the head, the projection wizards in the Machine Shop could figure out how to make it appear she was speaking—in real time, and in three dimensions.

And that's how Irvine's mother, WED Model Shop artist Leota Toombs, found herself sitting in a chair with a plaster-like goo dripping down her face and onto her chest. "They wanted someone that had a very kind of exotic face—high cheekbones and dark hair—and so Yale just came over to Mom in the Model Shop." He pitched her his concept and asked her to sit for the casting. She responded simply, "Oh, it sounds fun!" The fun turned into many days of not-entirely-pleasant work. "I was about fifteen or something," Irvine continued, "and every day she

would come home and tell us what she had done that day in the creation of Madame Leota."

Madame Leota would not have happened—at least, not in the way she did—without *Pinocchio*. Kim Irvine's dad, Harvey Toombs, had started with the studio as an animator in 1939, in time to work on Disney's second animated feature, which premiered in February of the next year. At the studio, Harvey met Leota, who was an in-betweener in the Animation Department. Harvey and Leota, known to her friends as Lee, married in 1947. "My mother was an artist from the very beginning," Irvine recalled. Even though she left the studio for a while after her marriage, to raise her daughters, Kimberly and Launie, "she always stayed an artist. She was always doing crafts and art projects."

By the time Leota had rejoined Disney in 1962, working in WED's Model Shop, Harvey Toombs had left Disney to animate for other L.A.-based production companies—so their daughters were thrilled that at least one of their parents was back at Disney. "Whenever we had a day off from school," Irvine recalled, "I would go to work with her. WED was very small then, and they allowed the kids to come in, especially in the Model Shop, and work with their parents." On her visits, Irvine met soon-to-be Imagineering legends such as Harriet Burns, Joyce Carlson, and Malcolm Cobb—"a lot of really fun people. And I would go in and just sit at a table with them . . . and they'd teach me how to make things. Glendra Von Kessel would teach me how to make little model pieces and I'd help her to paint them. We got to be good friends. It was really neat to be able to be a Disney brat in those days."

It wasn't just the visiting children: everyone in the Model Shop helped out everyone else, whatever the project. "They had kind of open tables," Irvine said. "You were separated a little bit by some small pony walls, but it was really very open, so everyone could talk to one another across the room, or see what people were doing. They had a camaraderie that was just incredible. I always hoped that I was going to be a part of it as well." (She got her wish with an entry-level Imagineering job in 1970.)

Gibson's work area was on one side of the Model Shop, Irvine recalled. "I loved going back into Blaine's sculpture studio, because he was such a

gentle, kind man, and he would always be sculpting these amazing figures with so much expression on their faces." The exception to that would be the life mask of Lee Toombs that Gibson and Gracey were making for their Haunted Mansion soothsayer. To ensure the projection effect they were planning would work effectively, they needed essentially a blank slate, an unmoving and stoic face onto which they would literally project movement and emotions. Gibson's work would start with the raw cast of Lee's features, made from a thick white goop that would completely cover her face. Her hair was tied back tightly behind her head and she had straws in her nostrils to allow her to breathe through the mask.

"She had quite a time doing that," Irvine said. "Blaine took her back into the sculpture shop and they set her up in a chair. She had to hold very, very still and lean back and they were going to create a life mask." Gibson mixed up some alginate—a quick-drying compound still used today by Hollywood effects teams to create actors' life masks—and began applying it to Lee's face. "It was this very gooey, almost like wet bubble gum material," Irvine said. "And she was in an upright position . . . and it all dripped down her chest and into her bra. And Blaine said, 'I don't think I better take a sculpt of that. Harvey won't like that very much.' So he mixed it a little bit heavier and put it on her face, and he finally got it to stay."

The drippy genesis of Madame Leota is but one tale behind the richly layered Haunted Mansion at Disneyland. The concept of a ghost-centered attraction dated back to the earliest concept drawings for Disneyland, for which Harper Goff sketched a dilapidated manor house that might have been located off a "dead-end" spur from Main Street, U.S.A. Rolly Crump recalled working on the project even before WED Enterprises got its own home in Glendale—the first WED project he was invited to join. "Walt always wanted to do a haunted mansion," Crump said. "So he thought it would be a good idea to put Yale Gracey and me together. So Yale and I spent a whole year doing nothing but reading ghost books and going to the movies wherever there was a ghost film. Walt let us do whatever we wanted. We were like a couple of kids in a playpen."

Gracey had founded what was dubbed the "illusioneering" team when

he started working with WED in the late 1950s, after twenty years as a layout artist in the studio's Animation Department. An amateur magician, Gracey mixed popular mechanics with a mastery of special effects. "If you didn't work for me," Walt told him, "you would be doing the same thing that you are doing here, but in your garage." Before devoting themselves full-time to the Haunted Mansion, Gracey and Crump also worked on upgrading the fading painted characters and undependable mechanical effects in Fantasyland's dark rides. Gracey created new illusions, as well, such as the tea that seems to pour endlessly in the tea party scene in Alice in Wonderland. For the most part, though, Gracey was assigned simply to brainstorm and tinker, and to be available to help other Imagineers with illusions they could envision but not construct. "He just sort of screwed around with stuff," Crump said.

Gracey's and Crump's work on the Haunted Mansion was interrupted for a couple of years by the World's Fair projects, after which they returned to their ghosts. Along the way, the exterior of the mansion had become elegant and spooky but not dilapidated, since Walt Disney didn't want an ugly ruin in his park. For inside the attraction, Crump developed a series of scenes and prop sketches for what he called the Museum of the Weird—which he previewed in person in the same January 1965 *Wonderful World of Color* episode that included Pirates. "I had never liked what was being done on the Haunted Mansion," Crump said of his macabre creations, "because it seemed like a ghost house. It didn't have any magic in it or any charms or anything different." Some of his ideas, like images of a candle man with his fingers on fire and chandeliers made from human parts, didn't make it into the final attraction, while others, such as a séance room and ghosts dancing in a ballroom, became cornerstones of the final experience.

Fellow Imagineer Jack Fergis assisted in making models out of Crump's sketches, and his often-disturbing drawings and models were pitched to Walt in a meeting that also featured drawings by Marc Davis and Claude Coats. In the three-hour meeting that followed, Walt barely looked at Crump's work, which was sequestered on "a little table" off to the side, Crump recalled. Towards the end of the meeting, Walt asked,

"Well, what did Rolly do?" and the Imagineer got his chance to pitch an attraction with "a lot of imagination," akin to movies by Fellini and other groundbreaking artists of the time.

After a few minutes, Disney got up and left, and Crump thought his pitch had failed. But when Crump got to his office at 7:30 the next morning, Disney was already there, sitting in Crump's chair, wearing the same clothes he'd had on the day before. "You son of a bitch," he said. "I couldn't sleep last night . . . [from] all that weird stuff you showed me yesterday." Disney told Crump he wanted to create "a museum of the weird in the Haunted Mansion that when you leave . . . you go through," and he told Crump, "you can design all the weird shit that you want to put in there, and we'll say that this is stuff that we've collected all over the world."

At one point, Crump says, "I put my hand on his arm and said, 'Did I go too far?' He says, 'No.' He says, 'You go as far as you want. . . . I'm the one to bring you back if it's necessary.'" After brainstorming over the museum idea for forty-five minutes with Crump and Dick Irvine, who had joined the discussion, Disney announced, "Now I'm gonna go home and go to bed." But Crump's museum never happened. "When Walt passed, Dick [Irvine] didn't know what to do with me, so he made me supervising art director of Disneyland and sent me to Disneyland." Crump wasn't involved in attraction design again until Project X got underway a couple of years later.

The focus of the attraction became the combination of Audio-Animatronics figures, in Davis's semiserious style, with Coats's more eerie scenarios and a series of then-stunning three-dimensional illusions created by Gracey. In fact, the entire mansion was something of an illusion, since the ride-through portion of the attraction was housed not in the haunted house but in a building on the far side of the Disneyland Railroad tracks. To get people to the boarding area outside the original park boundaries, they would need to be moved through a tunnel beneath the berm. Thus was born what Davis termed "our elongating, stretching room," with four expanding portraits designed by Davis to slowly reveal their dark narratives. The chambers—there were two—were

actually disguised elevators, but they also served as a prime example of the growing mandate for Imagineers to add theming to the queues, blurring the line between what's waiting area and what's part of the show. The portraits were dark but funny, while the disembodied narration struck a scarier tone, still with a hint of a smirk. That duality was in part a reflection of the dynamic between Imagineers Davis and Coats. Davis's drawings leaned toward the amusing, while Coats's creations were more intensely scary. From the start, this combination set the tone for the rest of the attraction—creepiness with wit, spookiness with a wink.

What guests would be most awestruck by were Gracey's illusions. After riders boarded the Omnimover ride coaches, dubbed "Doom Buggies," they were greeted by visual effects that combined new innovations with technology more than a century old. One such effect produced transparent apparitions by using the mirror properties of an angled layer of clear glass, a nineteenth-century trick known as "Pepper's Ghost" that had been popular with some vaudeville acts. The mirror illusion's grand showpiece was the ballroom scene, viewed from above by guests through a thirty-foot-high pane of glass. As they glided along what was essentially the room's mezzanine, they peered into the room below, populated with dozens of ghosts that appeared and disappeared in variations on the Pepper's Ghost trick. The actual moving figures were above and below the ballroom scenery in separate, darkened chambers, so that their translucent reflections appeared on the glass. But their dimensionality and perfect placement gave the effect a certain realism. It didn't feel fake.

The other illusionist contributing to the Haunted Mansion was Ub Iwerks, a master of projection technology. The original attraction had some forty-four projectors, including those that gave life to Madame Leota in her crystal ball and a quintet of singing stone busts in the final graveyard scene. Don Iwerks worked on those illusions. "We photographed actors with kind of white paint on their face so that they looked like a white statue," he recalled of the cemetery busts. "And they're all singing. It was projected onto tombstones shaped like their faces." One of the voices belonged to Pirates narrator Thurl Ravenscroft, while Paul Frees provided the voice of the Ghost Host, the narrator heard throughout

the attraction. As in Pirates, a recurring theme song—"Grim Grinning Ghosts"—had lyrics by X Atencio (set to music by Buddy Baker).

The projection effect was more complicated in the séance room, where the disembodied fortune-teller spoke from inside a crystal ball. Her voice belonged to Eleanor Audley—best known as the voice of Maleficent in Disney's original *Sleeping Beauty*—but her face was Leota Toombs's. Don Iwerks filmed Toombs reciting the Madame's lines during one lunch hour in Gracey's office, where Gracey had set up a black backdrop. Sitting in a chair, Toombs had to hold her head absolutely still, Iwerks recalled—only her mouth and eyes moved. In the final effect, the film was projected onto the sculpt of her face, "and that just comes alive," he said. "It looks like she's just sitting there, talking."

The Madame Leota illusion is considered by many attraction designers as the first known public display of projection mapping technology—that is, the projection of moving images onto an object with a distinct shape, rather than onto a flat screen.

It's likely that Iwerks and Gracey themselves were among the many Imagineers who worked to set up the mechanics within the Haunted Mansion before it opened. They dreamed it up, sketched the designs, supervised the fabrication, and then picked up hammers and screw guns to get everything installed just the way they wanted it. The Haunted Mansion would be "plussed" over the years—its illusion technology updated, Madame Leota's head set to floating around the séance room, a holiday overlay introduced. But the core character of the attraction was always preserved. It remained a living tribute—perhaps a "living dead" tribute—to the many original Imagineers who created it.

CHAPTER 7:

BRAVE NEW WORLD

"The whole thing here is the organization. Whatever we accomplish belongs to our entire group, a tribute to our combined effort. . . . [What we have done] was possible only because we already had the staff that had worked together for years, blending creative ideas with technical know-how." —Walt Disney

I. WALT'S DREAMS MADE REAL

IN THE MIDDLE of sunny Florida lies a ten-acre city that never sees the sun. Its colorfully dressed residents bustle through long, wide corridors with artificial lighting and concrete walls painted purple and red and blue. They walk or ride on electric carts, subject to traffic rules, including red stop signs where passageways intersect. This invisible village has a hair salon and a cafeteria, restrooms and break rooms and control rooms. More than a dozen stairways lead to the world overhead.

The occasional appearance of Mickey Mouse or Queen Elsa—along with stairwell signs such as TO FRONTIERLAND / ADVENTURELAND—make it clear these are the utility corridors, known since their creation as the utilidors, that form the basement of the Magic Kingdom. Fifteen feet overhead and affixed to many of those brightly painted walls—color-coded to indicate what land lies above—are the miles of pipes and cables and ducts needed to run the park's electrical, HVAC, and plumbing

systems, along with encouraging signs: HERE WALK THE GREATEST CAST MEMBERS IN THE WORLD and SAFE-D BEGINS WITH ME.

This is not the Experimental Prototype Community of Tomorrow Walt once envisioned, but the system does borrow that plan's concept of an underground network of service tunnels that keep deliveries and infrastructure elements out of view. It also eliminated two of Walt's irritations from a decade of operating Disneyland: cast members costumed for one land would no longer be seen outside their assigned realms, and the park's hundreds of trash cans could be emptied invisibly, without garbage collectors mingling with the guests. Still in operation, the AVAC—for Automated Vacuum-Assisted Collection—uses air pressure to force the garbage, which drops from the park's many trash receptacles, through twenty-inch tubes at speeds of up to sixty miles an hour to a central collection facility.

Trash was no small thing to Walt Disney. Harper Goff remembered him admonishing every cast member, including top executives, to pick up any litter they saw in Disneyland. "Walt said, 'You are the hosts when you clean up the street. You're making this look nice. You go around and you don't just leave something there. You pick it up, because for that instant after you pick it up, it's clean, and the people remember that,'" Goff related.

As much as anything in Walt Disney World, the AVAC and the utilidors represented the vision of Walt Disney made real by the people he left behind. As seen in his EPCOT film, a second iteration of the Disneyland theme park had always been a part of Walt's plans for Florida—the Magic Kingdom having taken its name from a longtime nickname for Disneyland. But Walt wanted enhancements: wider sidewalks, a larger castle, a new land honoring American history—as well as that underground network of tunnels. This was just a partial wish list for a project that—along with the Disneyland improvements already underway—would keep WED Enterprises working at full tilt for the nearly five years between Walt's death and the opening of the Magic Kingdom.

Taking the reins was Walt's brother, Roy O. Disney, the company's chairman of the board. As recounted by Dick Nunis, head of operations for Disneyland, soon after Walt's death, "Roy called me to his office and asked me the question, 'Dick, what do you think we do without Walt?'"

He was asking whether the company should proceed with the Florida project, likely a question he had put to other leaders in both park operations and Imagineering. Nunis answered firmly, "I think that we ought to try. And I think that we have the talents in the organization to do it."

It was a sentiment many at Disney shared, and Roy wasted no time in confirming that Project X was full speed ahead. According to an account from Imagineer Marvin Davis on the Disney Family Museum website, Roy gathered the staff in a studio projection room just a week after Walt died. "We're going to finish this park and we're going to do it just the way Walt wanted it," he said. "Don't you ever forget."

Six weeks after Walt's ashes were laid to rest at the Forest Lawn Memorial Park in Glendale, California, Roy was in Florida, touring the Disney property with retired Army Major General William E. "Joe" Potter and others. On February 3, 1967, the day after Walt's EPCOT film was shown to Florida legislators, Roy and Potter took a boat around the muddy Bay Lake in Orange County. Project X was now front-page news: the *Orlando Sentinel* (then called the *Sentinel Star*) that day published a special full-color "Disney World Souvenir Edition," and Roy hosted a press conference, making it clear that in Walt's absence, he would be the face of Disney for this project.

It was not what Roy had planned for himself. "Roy was in transition to retirement when Walt passed away," recalled Carl Bongirno. "He was only coming in one or two days a week, turning things over to the rest of us—administration and finance. When Walt passed away, he made a decision that he was going to stay on and try to fulfill Walt's dream of getting Walt Disney World open in Phase I. And that's what he did."

Phase I would not include Walt's elaborate blueprint for EPCOT, which was put on hold, but would focus instead on the Magic Kingdom theme park, two hotels, two golf courses, a man-made lagoon, a campground, and all the necessary infrastructure and utilities nonexistent in this essentially barren land. Indeed, when Imagineer Bill Martin first visited the 27,000-plus acres that was to be transformed into Disney's vacation destination in 1966, the man who designed the original Fantasyland (and would soon lead the utilidors design team, among

other duties) saw little to inspire him. "It was foggy and cold and very swampy," he recalled. "We'd get in these Land Rovers and drive through the bush. Bay Lake at that time looked like tea: it was all brown until we drained it. There were a lot of snakes and a lot of wildlife. We saw deer and a lot of these beautiful herons. Lots of turkey vultures." In addition to the cattle that had yet to be relocated, Martin said, "Armadillos were just all over the place. Just all over. You couldn't drive down any road without armadillos running around in front of you."

Imagineer Frank Stanek's impression on his own 1966 visit was no more impressive. The land was, he said, "nothing but swamp." Stanek, who had graduated from a teenage job selling food at Disneyland to working on business planning for WED projects, had flown into Orlando to check out the site. "It was literally palmetto in the dry spots and cypress trees in the wet spots and pine trees in a little drier spot."

It was on this soggy, porous ground that Roy O. Disney would make his stand to bring into reality the dreams of his brother Walt, backed by an army of Imagineers—an army that would need a lot of new recruits.

Roy's February 1967 Florida visit was about much more than publicity. The first order of business before construction could begin was to win the right from the Florida legislature to develop the property without getting mired in local government bureaucracy. That involved passing a law to create what came to be called the Reedy Creek Improvement District, which allowed Disney to take on the building of all the infrastructure that would normally be supervised by local government. The creation of Reedy Creek was tasked to Potter, the retired U.S. Army major general, but the idea went back to Walt Disney, according to Dick Nunis. "We would have never been [in Florida] if we had had to depend on local residents to pay for the financing of Walt Disney World" through their taxes, he said. "And Walt didn't want to do that. He wanted to show how through free enterprise you could take virgin land and develop it properly without government subsidy. So that was the Reedy Creek Improvement District."

Signed into law in May 1967, a trio of statutes created the improvement district as well as the municipalities of Bay Lake and Reedy Creek (soon renamed Lake Buena Vista) and allowed Disney "to establish our

own building department, develop our own building code, establish our own zoning, and do all of those things that are normally done by a county," Potter later recalled. That freedom was integral to the Imagineers' work. "You must realize that at the time, Orange County did not have the facilities to examine plans for, let's say, a castle. No complicated buildings had been built in Orange County, so the county, of course, was not staffed to examine plans and conduct the inspections requiring all buildings to meet the safety and welfare specifications of those buildings."

Without government assistance or supervision, Disney and its contractors would construct a power plant and electrical grid, string telephone lines, create a freshwater system, and install many miles of drainage pipes and canals to prevent flooding even from most hurricanes. They would dredge lakes, create a lagoon, and build dikes and levees. They would lay down roads and put up traffic lights. Once their little city was up and running, Disney would provide waste management, road maintenance, fire protection, and emergency medical services. (The company was still obligated to pay Orange County property taxes and continues to do so to this day.) It was a rapid self-education in municipal and land management—lessons the company would come back to in the future when facing similar challenges across the globe.

With the new law in place, the official groundbreaking for Walt Disney World began without much fanfare on May 30.

When construction began, it quickly became clear that Walt's vision for the utilidors would mean raising the Magic Kingdom well above ground level. In early plans, "we expected that the Magic Kingdom would be on the original plain surface of the ground," recalled Joe Fowler, the retired admiral who had supervised much of the building of Disneyland and led the construction team for the Florida Project. "But we found out from the water table and from our excavation of the lagoon and the problem of sinkholes and the deep layer of mud that goes down twenty feet sometimes that we had to modify it. We took the excavation [dirt] from the [Seven Seas] Lagoon and built up the surface of the park sixteen feet. That way, we could put the underground in."

To this day, the utilidors beneath the Magic Kingdom in Walt Disney

World remain the most extensive underground service system in any Disney theme park, according to Phil Holmes, vice president of Magic Kingdom Park from 2001 to 2015. Holmes had a special connection to the utilidors, since his first Disney job took him there during construction. One day, during a torrential downpour, young Holmes was sent to the half-built Magic Kingdom to deliver updated blueprints to the on-site crew. "A couple of the construction guys grabbed me and said, 'Hey, come on in. We need to make sure the pumps are going in the tunnel.'" Holmes had never set foot in the tunnels and immediately found the unfinished, dimly lit corridors "this magical place." Many months later, after the park's opening, Phil had been reassigned and found himself in the utilidors once again. "So I'm in my Haunted Mansion costume, trying to find my way," he recalled. The many signs and wall colors that now help cast members navigate had not yet been devised, so he had to ask for directions to find the little offshoot hallway that led to Liberty Square and the Haunted Mansion. "Certainly after your first day, you found a way to do it," he said. But that first time, "I felt like I should leave some breadcrumbs so I can find my way back and forth."

Mel Melton was fairly new as president of WED when the Florida Project launched. As Stanek remembered, the initial budget for the Florida Project was $500 million—or about four or five times the entire Disney company's annual revenues at that time. Melton, in charge of budgets and administration, brought in Stanek early on to instill financial controls. Stanek formed a trio of WED supervisors that consisted of himself along with Dick Irvine, who led the design effort, and Roger Broggie, who dealt with manufacturing of all the necessary equipment and materials. Melton soon asked Stanek to oversee construction scheduling as well, and Stanek began to calculate an opening date for the park. His estimate would be based in part on several days he arranged to spend in New York City with the crew then building the twin towers of the World Trade Center, soaking up everything he could about construction scheduling for a massive multiyear project. "I made a recommendation as to when we should open," Stanek recalled, "and with just a slight modification, that was accepted. So we decided October 1, 1971, was gonna

be the opening date. That became the schedule, and we worked to that."

What this half-billion-dollar development would be called also needed to be decided. Bongirno recalled well the moment that name was settled. It was late at night in one of the makeshift offices at the Florida Project, and Roy O. Disney was meeting with Bongirno and Card Walker, who was vice president of marketing for Walt Disney Productions from 1965 to 1967 before becoming executive vice president of operations, then, in 1968, executive vice president and chief operating officer. As Bongirno related, Walker "wanted to call it Disney World. And Roy kept saying, 'No, it's Walt Disney World. My brother's name is going to be attached to this project.' He was adamant about it."

"I thought that it should have been [called simply] Disney World," Walker said later. "The point I made [to Roy] was, no matter what we call it, the people are going to call it Disney World. They're not going to call it Walt Disney World." But Roy, "rightfully so, I guess, made that decision and felt that considering everything he should make it clear it is Walt Disney World. We said, 'Fine.'"

Walker's prediction that general usage would drop the "Walt" was soon borne out: "When the highway people made their signs," he noted, "they just put up DISNEY WORLD signs on the highway, not WALT DISNEY WORLD, because you just don't say 'Walt Disney World,'" Walker said. Nevertheless, Bongirno countered, "Roy was right. It's Walt Disney World. So his brother's full name is associated with that project."

II. THE NEXT GENERATION

The Magic Kingdom could not have been constructed, certainly not on deadline, without the institutional knowledge held within the minds and hands of the first generation of Imagineers. The paper record documenting the creation of Disneyland attractions—many of which would be re-created or reimagined in Florida—was spotty at best. Except for the attractions that were being built for Disneyland during the construction of Walt Disney World, or those recently relocated from the World's Fair, it was often like starting from scratch. Attractions that had

opened at Disneyland in 1955, and had been little changed since, needed to be reconceived and rebuilt and ready for opening day in the Magic Kingdom in 1971. These included Dumbo the Flying Elephant, Jungle Cruise, Mad Tea Party, Peter Pan's Flight, and Snow White's Adventures. These would be joined on opening day by new versions of the recent Disneyland additions Walt Disney's Enchanted Tiki Room, the Haunted Mansion, and "it's a small world"—plus three entirely new extravaganzas featuring Audio-Animatronics figures.

"Disneyland was designed and built in just a few years," Frank Stanek recalled. "Most of the knowledge of that was not recorded." The main resource for re-creating attractions in Walt Disney World would be the skills and memories of the people who had worked on the originals at Disneyland—a situation that didn't bother the leadership at WED enough to change how things were done for the Magic Kingdom. "Walt Disney World followed pretty much a similar thing," Stanek says. "We designed Walt Disney World; we built things. Audio-Animatronics figures at the time were essentially custom made. It's like building a one-time Formula One race car. The art director would spec out—'Okay, we need this pirate figure to do this'—and somebody at MAPO would take that information and go into the parts bin and start putting parts together." Much of it, he adds, was trial and error, "and that was the way it worked. There was no real documentation of a lot of this effort."

WED treated its artists, in short, like artists, and artists didn't do paperwork. For an artist trying to make a living, working at WED was "like getting set free," in the words of Bill Martin, who credited both Walt Disney and Dick Irvine with giving WED's artists the freedom to create.

It was a freedom Kim Irvine already knew from her childhood days hanging out with her mother, Leota Toombs, and Toombs's colleagues in the WED model shop. Now it was her turn to get to work. "Mom came home one day [in 1970] and said, 'They're looking for kids to be trained in the Model Shop, and I would really love for you to come work there when you graduate this summer,'" Irvine recalled. So she reluctantly gave up the summer freedom she'd been looking forward to and returned to the Model Shop, this time as an employee.

"Several other people started with me that were other people's children, which was kind of neat." It was, she continued, "kind of like in the old days when a carpenter trains their child to be a carpenter, or a seamstress trains their child to be a seamstress. We felt that we were trained to be a Disney artist and work at Imagineering. And so Maggie Elliot was there, Maggie Irvine at that time [Dick Irvine's daughter and Kim's future sister-in-law], and [Norman] 'Stormy' Palmer's daughter Lindsey worked with us for a long time." (Stormy was a film editor at the studio who had worked on *Pinocchio* and *Fantasia* and other features as well as on Disney television productions.)

Maggie and Kim were first assigned to assist in re-creating "it's a small world" for Walt Disney World, under the supervision of Joyce Carlson, who had worked on the attraction for both the New York World's Fair and its transfer to Disneyland. Directing the project were the attraction's original visionaries, Marc Davis and Mary Blair. "That was wonderful to get a chance to work with them," Kim Irvine said. "I learned from Joyce color mixing and the consistency of paint and painting on different substrates and just all kinds of things in the first year. It was amazing to me." At the end of the summer, Kim had the opportunity to attend art school but elected to stay in the Model Shop instead. "I thought, 'Where could I have better art instructors than at WED? Where could you possibly learn more than I'm learning right here with these people?'"

The learning curve was steep. "There was such a bustle of activity," Kim Irvine said. "Everybody really bounced around a lot. You weren't just assigned to a project and stuck to it. They'd say, you know, 'We need some help over here on feathering [an Audio-Animatronics figure of] a bird. We want you to learn how to do that.' So I'd sit down with Harriet [Burns] and she would show us for days—that's a very complicated process. And so we'd work on those for a while and then [Rolly] Crump would say, 'Oh, we've just finished sculpting one of the birds' perches and we need it painted,' so we'd go over and work on that for a couple days." It was, she recalled, simply "wonderful."

Burns was especially fun, Irvine said. "She had the best sense of humor and it was this funny dichotomy between [her sense of humor

and her] looking very sophisticated, like Betty Crocker, with her perfect hair and makeup—and she always had a scarf tied around her neck and [was] just impeccably dressed every day."

Burns's desk was near Fred Joerger's, "together up by the sink in the front of the Model Shop, where you had to rinse your paint water and wash your brushes pretty regularly during the day. And when I first started there, they had a mynah bird." The bird's name was Joker, and he had been acquired as a model for the Enchanted Tiki Room, then stuck around WED as the Model Shop mascot. "He sat in a big cage right on Harriet's desk," Kim recalled. "So when you went up to the sink, you got to talk with Joker for a while and then joke around with Harriet and Fred, who were fast friends and had a lot of fun together. Every day you would hear from that corner hysterical laughing from the two of them constantly all day long as they joked around. It wasn't like they were goofing off," she added. "They just had fun while they were working."

While the mood at WED remained high, Roy Disney carried the weight of knowing what could happen to the Disney company if Walt Disney World didn't open on time. "There are a lot of people who won't take the worry of running a place," he said at the time. "There is a lot of worry. You don't work forty hours a week. You work forty and worry forty. And it goes on that way." After an angry confrontation with the construction contractor, whose executives flatly stated that the park would not be ready by October 1971, Roy terminated the contract. Disney would build the park on its own and on time. Roy spent the last four months of construction working out of a small office next to Carl Bongirno, who had also relocated to Florida for the duration. It would not be the last time that Disney elected to take a contract back into the company when a vendor failed to live up to its high expectations.

The construction of Walt Disney World involved much more than building the Magic Kingdom theme park—more even than building a city's worth of utilities and transportation infrastructure atop a patch of muddy ground. It was to be Disney's first foray into creating signature resort hotels—with theming akin to a Disneyland attraction—an effort to keep guests on Disney property throughout their vacations. (The

Disneyland Hotel in Anaheim was originally owned and operated not by Disney but by Wrather-Alvarez Hotels, which repeatedly declined to sell the property to the Disney company. It wasn't until the widow of Wrather's founder died, in 1988, that Disney finally acquired the hotel, by purchasing the entire Wrather Corporation.)

Elaborately themed high-end hotels were an untested concept but one that would become a cornerstone of Imagineering's future efforts around the world. Yet the first two such resorts on Disney property, set to open in October 1971, were not designed by WED. Instead, Walt Disney's old friend and onetime neighbor, Los Angeles architect Welton Becket, had designed both: the Contemporary, with its striking A-frame shape and internal Monorail station, and the Polynesian, with a South Seas islands theme and village-like layout. The hotels were adjacent to the 172-acre Seven Seas Lagoon, built by Disney to connect to the natural Bay Lake, which was drained, cleaned, and refilled during construction. While the hotels were not the creations of Imagineers, WED artists did have limited input, most visibly in Mary Blair's colorful four-story mosaic inside the Contemporary. Both hotels were being constructed in an innovative manner, with much of the construction done off-site in modular units that were then fit together; both were due to start checking in guests on the day the Magic Kingdom opened. (The 750-acre Fort Wilderness campground opened a few weeks later.)

To provide all the trees, bushes, and other plants necessary for the sprawling property, landscaper Bill Evans—who had supervised landscaping in Disneyland—planted a tree farm on the property years before opening day. Carl Bongirno recalled, "As they completed lands and areas at Walt Disney World, those trees and shrubs were all there at the tree farm, ready to go."

III. DOES THAT COMPUTE?

Not all the attractions set to open with the Magic Kingdom were copies from Disneyland and the World's Fair. Three new shows would again advance WED's application of Audio-Animatronics technology. One

would be Walt's long-envisioned attraction The Hall of Presidents, while the other two would be chiefly musical: the Mickey Mouse Revue and Country Bear Jamboree. But the technological leap forward for these and all the other Audio-Animatronics figures in the new park would be behind the scenes, as WED prepared to scrap the mechanical systems previously used to run the animated figures. In the Magic Kingdom, Audio-Animatronics figures would be programmed and driven by computers.

The man in charge of making this happen was David Snyder, hired from the aerospace industry, where his job had been to program computers to run missile systems. Now he was in charge of programming computers to run singing bears and talking U.S. presidents. "The goal was to have all the shows being run on digital computers," said Snyder, who joined Disney in 1968, working for both the studio and WED. It would be a complete break with the systems used to control the Audio-Animatronics figures at Disneyland. Snyder said that when he first toured the theme park and looked at how the animated figures were programmed, "almost each show was run with different apparatus. There was all kinds of cool gadgetry, but it certainly was not anything in the digital world."

Some used paper or magnetic tape to trigger the regularly repeated movements, while "another show might've been done with a plastic drum with pieces of tape pasted on it with lights shining through it," Snyder recalled. The most often used system was the cam machine, a device with a series of slowly rotating aluminum disks with curved notches carved into the edges and holes punched through the surface. Each cam machine could have up to twenty rotating disks stacked vertically, with light beams shining through them. When light passed through a notch or a hole, it generated voltage that would trigger movement for one particular body part or would switch on an accompanying audio track. The system was a kind of steampunk jukebox, using rotating platters and flashes of light to create repeating patterns of both movement and sound. To complicate matters further, the animation control devices required a lot of maintenance and were typically repaired by the WED staffers who invented

them, who would simply fabricate new parts when needed. That wasn't going to be possible at Walt Disney World.

The cams were proprietary—the devices had been developed and built by Disney innovators, chiefly Wathel Rogers, in the Machine Shop, and Ub Iwerks—but they were not plausible drivers for a stageful of singing bear musicians or nodding presidents. Each disk was painstakingly carved and punched by hand through trial and error, and programming just one figure in a show could take weeks. Like the Carousel of Progress on steroids, the new shows had dozens of figures performing for as long as several minutes without repetition. "The challenge became, how do we accomplish making all the shows at Walt Disney World run on a digital system of some sort [in time] for opening day?" Snyder said.

It had to be a real-time system, the computer programs triggering sound and movement instantly, with none of the processing delays common to computers at that time. With his aerospace background, Snyder knew where he'd find that digital expertise: defense contractors. "When a gunner aimed the gun and pulled the trigger, he didn't want to wait until Friday afternoon until the bullet came out. It had to happen now. IBM wasn't making real-time process-control computers. RCA certainly wasn't."

Under Snyder's supervision, WED wrote specifications for what would become its Digital Animation Control System—still called DACS today—and requested proposals from seven or eight companies. They settled on a small military contractor in Orange County, California, using then state-of-the-art Honeywell computers. But when the outside company went bankrupt just two years before opening day, Disney once again brought the contract in-house. Snyder quickly began hiring staff, starting with a mathematician and programmer named Luis Compare. "I brought him over and said, 'Well, here's what we have to do.' And he said, 'Oh, you're kidding.'" Snyder's crew soon grew to a dozen or more.

The next people Snyder needed to bring on board were the WED animators, who would need to learn to use the control panel Snyder's team developed. The console looked not unlike a supersized version of the 1960s board game Operation, with a crude bipedal figure outlined

on the left side of the light-orange panel, with knobs and switches placed at each point where the corresponding Audio-Animatronics figure might need to move. The right side of the box had arrays of control buttons and pads. "No more pencil and paper," Snyder told the Imagineers. "No more cam machines. Learn how to use this animator's box, turn the knobs, push the buttons, turn the lights, and you will program a show."

He recalled that at first, "the animators weren't exactly thrilled." They did not initially see the box as a tool that required an artist's brain to function, and they worried, "'The computer is going to take our jobs.' It took a little hand-holding and going out to lunch . . . to convince key animators." Among the first to be trained and to get comfortable with the new system were Imagineers Bill Justice and Wathel Rogers, who had both worked on Great Moments with Mr. Lincoln, as well as Marc Davis and Ken O'Brien, skilled 2D animators who had long since transferred their skills to Imagineering. "They caught on pretty fast," Snyder said. "They were less quick to get used to the reality of computer crashes that could wipe out a whole morning's work in an instant." The words exchanged when that happened, Snyder said, "I can't repeat."

Of course, the computer controllers were just one aspect of the new Audio-Animatronics attractions. Someone still needed to carve the faces of the thirty-six presidents, build and dress the furry bodies of a couple dozen singing bears, and turn Mickey Mouse and his pals into three-dimensional figures who could star in a concert of Disney animation's greatest hits.

Someone also needed to create the first half of the show at The Hall of Presidents, the centerpiece of the only completely new land in the Magic Kingdom, Liberty Square. (The park would not have a New Orleans Square; when Pirates of the Caribbean opened in Florida in December 1973, it was in Adventureland.) The Hall of Presidents revealed a stage peopled by thirty-six Audio-Animatronics figures, each chief executives, as the show's finale. As in Great Moments, Don Iwerks said, "Lincoln would still be the centerpiece, would stand up and deliver a speech, but [Walt had] wanted to have all the presidents onstage. One of the big problems that arose is they wanted to do a preshow in the same theater. It

was a story told about the high points in the history of the United States, and it had to be done on the screen that was about thirty feet high and two hundred feet long. I said, 'How in the world are you gonna tell a story on that?'"

Don's father, Ub Iwerks, came up with a solution, using five projectors and commissioning giant paintings to serve as historic tableaux, many done by English portrait painters. To keep the oil paintings from being static images, Ub created a camera system to shoot the vignettes that allowed for dollying in, pulling back, and panning—techniques that were then revolutionary but would become computerized and commonplace decades later. Ub Iwerks's system used "a special thirty-five millimeter camera that would pull a real long strip of thirty-five millimeter film— big enough to shoot the entire painting," Don Iwerks said. The camera captured one long frame. Then the painting could be shifted, left or right, closer or farther away. Then another frame would be captured, and so on. "Then they had to extract five sections off of that [negative] and print it onto separate pieces of film so that it could be projected onto the screen" by five projectors in a nearly seamless effect. Unfortunately, Ub Iwerks didn't live to see the show finished. "They were in the midst of shooting it when he passed away," Don Iwerks recalled. "But everyone who was working on it knew what they had to do to get it done, and it was finished and it was a huge success."

For the dramatic Audio-Animatronics finale, WED again assigned Imagineer Blaine Gibson to sculpt each chief executive's head. He later said, "The most difficult presidential head I ever did was Nixon. There has to be a bond, an attachment, to what I'm doing, and that's emotional." Gibson may not have found a bond with the then sitting president, but his goal didn't waver. "What you have to shoot for, but may not always get, is the feeling that the sculpture could speak or be alive. We tried to do the same thing in animation, and I think most of the good animators didn't stop animating until they felt that their creations were alive."

Considerably less serious was Country Bear Jamboree, an attraction that had been conceived for a Disney-themed ski resort in the Mineral King Valley, adjacent to Sequoia National Park. That plan was abandoned

while the Magic Kingdom was being built. Like The Hall of Presidents, Country Bear Jamboree had been an original idea hatched by Walt Disney. As later related by Wathel Rogers, Walt envisioned "a bear band" that would "perform two or three programs of entertainment. We'll say that the bears had come out of the sequoias and we trained them to be entertainers." The final attraction, designed chiefly by Marc Davis and fellow Imagineer Al Bertino, became a tongue-in-cheek tribute to country music, with classic tunes and some humorous new ditties by George Bruns, who served as musical director, and X Atencio. The sixteen-minute show proved so popular that it was installed in Disneyland in March 1972 with two duplicate auditoriums to double the capacity.

As opening day for the Magic Kingdom approached, Synder related, a DACS control room was built in the utilidor space, and "the animators were able to work on their consoles out in the show areas." While final construction and decoration of the park was going on around them, "we had plenty of time to work out the bugs—which were plenty," Snyder said. "We would have one animator working on the jungle ride with a console sitting in a jungle boat, we would have another animator in the Mickey Mouse theater and another one in the bear band theater—all running off the computers in Fantasyland basement. Everything worked like a charm. The shows went together without a hitch."

IV. "WHERE ARE ALL THE PEOPLE?"

Opening day of the Magic Kingdom arrived as scheduled years earlier: Friday, October 1, 1971. It was a photo finish: "We opened at nine o'clock with helicopters flying over Fantasyland, drying the concrete so that the guests wouldn't get stuck," Carl Bongirno recalled. "That's how close it was to opening." There was no formal dedication that day, just a morning welcoming ceremony. Having learned from the many frustrations of opening day at Disneyland sixteen years earlier, the events team had set the official celebration for the debut of Walt Disney World more than three weeks later. Early weeks were dubbed a "preview," leaving time to work out any unexpected kinks and to finish design details that hadn't

quite made the deadline. And kinks there were: trams that, when fully loaded, didn't have enough power to get up the hill from the parking lot to the Magic Kingdom ticket booths, which were at a slightly higher elevation; wiring still visible in a few places; walls unfinished—but nothing like the problems that had plagued the opening day of Disneyland.

Cast members who were there on opening day recalled a joyful day and happy guests. Kevin Myers, later the vice president of resort operations, was assigned to the Adventureland Veranda restaurant that day. He was able to watch the opening "rope drop" and saw "thousands of people stream into the various lands of the park and occupy this place for the very first time ever. You could imagine the fulfillment of Walt's dream that he never got to see come to fruition," he said forty years later, in one of several accounts posted on the Chip & Company website. Roy Disney was there, too, spotted by Darlene Kennedy from her workstation serving guests at the Tomorrowland Terrace. "We could see all the balloons going up and could hear some of the opening ceremony," recalled Kennedy, who eventually become manager of creative costuming for the entire resort.

Roy "looked very good that day," Bongirno recalled. "On opening he was really up." The same could not be said for Bongirno and the other Disney executives who were headquartered in the freshly opened Polynesian Hotel. "We were watching guests drive in, and several of us went out to the gate," he recalled. What they saw was worrisome: "They just weren't coming in. I mean, it was just a trickle of cars. And we thought, 'Oh my gosh,' you know? 'Where are all the people?' We thought it was going to be mobbed."

Opening day, recalled Dick Nunis, "was kind of tough. They were projecting we'd have five hundred thousand people." Nunis had arrived some months earlier to join in overseeing the final construction efforts and the training of the new cast members necessary to get the park open on time. "We picked October because we projected it to be our slowest month, picked Friday because it was going to be our slowest day, because we didn't want to live through [another] Disneyland opening, which was in July." Of course, he added, "you're never ready for an opening," and

the Disney team certainly wasn't ready for a head count of just ten thousand guests—"and that's counting all the comps, and all the bands coming in the back gate," Nunis said. "And Wall Street said, 'Well, they've done it. Disney's failed.' Our stock went down nine points."

Roy Disney, Nunis said, "was really nervous about it." A meeting was convened, and Jack Lindquist, vice president of marketing, told those present that the make-or-break day wouldn't come until November 26. As Nunis recalled, Lindquist said, "Roy, look, we really had projected that the day after Thanksgiving, we will have to close [the gate, having reached full capacity], and if that doesn't happen, then we have to start worrying. But if it does happen, then we better start building, sir."

As it turned out, Disney executives weren't the only ones who remembered the overcrowding on opening day of Disneyland. Tourists had stayed away for fear of getting mired in a similar throng. "Many days later, when people realized there weren't the crowds going in, they all started coming in and we started hitting those thirty-five thousand, fifty thousand days," Bongirno said.

The increasing numbers eased concerns somewhat by Monday, October 25, the day selected for the dedication ceremony. For one of the only times in his long career, Roy Disney took center stage, reading the text of the plaque unveiled in Town Square at the base of Main Street, U.S.A.: "Walt Disney World," he told the crowds and the TV crews, "is a tribute to the philosophy and the life of Walter Elias Disney and to the talents, the dedication, and the loyalty of the entire Disney organization that made Walt Disney's dream come true. May Walt Disney World bring joy and inspiration and new knowledge to all who come to this happy place—a Magic Kingdom where the young at heart of all ages can laugh and play and learn together."

After his short speech, Roy gamely posed for photos and video crews on a bench along Main Street, U.S.A., seated next to Mickey Mouse, as Goofy and Pluto stood behind and to the side. In his few candid remarks after the formal ceremony, Roy kept the attention focused on Walt. Asked by reporters why a man of his age had taken on the leadership of such a formidable project, Roy responded simply, "I didn't want to have to

explain to Walt when I saw him again why the dream didn't come true." Later that day, Roy retreated to a boat on the Seven Seas Lagoon. Asked why he wasn't basking in all the media attention, he answered, "Today is my brother's day. I want them to remember my brother today."

Exactly one month later, on November 25, the Disney team had its long-awaited confirmation that Walt Disney World would be a success. As predicted and hoped, the Magic Kingdom reached capacity and stopped admitting additional guests at ten a.m. Traffic on the freeways coming from the north was slowed by the heavy traffic as far away as Atlanta. "Then Roy Disney knew that he had a winner," Nunis said.

Less than a month later, on December 20, 1971, Roy O. Disney died of an intracranial hemorrhage at age seventy-eight—exactly five years and five days after his brother's death. Whether his death was related to his unrelenting work schedule in the previous years can never be known, but as Bongirno observed, the Herculean task "really took a toll on Roy over the years."

He never got to enjoy the retirement he had been planning five years earlier, but without his efforts, Walt Disney World might never have existed. It certainly would not have happened in the time frame and on the colossal scale on which Roy insisted. After Walt's death, "Roy commanded everyone to turn their total energies in one direction, and that was to get Walt Disney World open," Nunis said. "Nothing else mattered. And I think that energy that he gave—to go for the direction of getting his brother's dream open—that was the power base that made it happen, and Roy deserves a lot of credit for that."

Nunis said, "I think Roy was ecstatic over the fact that we opened the project, and I think that he was very proud of his organization and very proud of the people that got it opened. But as Walt would say, and Roy followed suit in saying many times, we are just getting started."

CHAPTER 8:

SIGN OF THE TIMES

"Growing up in the seventies, it was kind of uncool to like Disney. . . . [What does an] entertainment company that produces animated films and does a great entertainment park—what do we have to do with the future in influencing the world?" —Tony Baxter

I. LIGHTING UP THE NIGHT

PARADES AT DISNEYLAND dated back to the park's opening day, July 17, 1955, when a cavalcade of Disney characters, Autopia cars, marching bands, and others led guests up Main Street, U.S.A., toward Sleeping Beauty Castle. Bands and Disney characters often marched up the street in the early years, with more elaborate celebrations on special days, such as Easter Sunday. The parades were the most visible expression of a core philosophy Walt Disney had always held for his park: it was not just a collection of attractions but a living place, where guests could have encounters with characters from stories and from America's past and future. (Cast members in astronaut suits sometimes wandered Tomorrowland.) The storytelling that was the foundation of Imagineering also needed to take to the streets and waterways.

Like Main Street itself, the early parades evoked small-town life, seeming almost homespun. Much of the park's other live entertainment was even more intimate and nostalgic, expanding on the stories

the Imagineers had carefully woven into each land: Golden Horseshoe Revue in Frontierland; the Dapper Dans barbershop quartet on Main Street, U.S.A. (starting in 1959); and the spontaneous Disney character appearances, particularly in Fantasyland.

It was a one-time-only holiday parade in 1957, called Christmas in Many Lands Parade, that launched the gradual evolution of the more elaborate, repeated parades for which the park would soon be known. Christmas parades became regular occurrences in 1958, and a non-holiday parade called Mickey at the Movies ran from spring into fall starting in 1960. The Tencennial Parade ran daily through much of 1965.

Non-holiday parades were not planned for the Magic Kingdom when Walt Disney World opened in October 1971. But there was one parade outside the park. The Electrical Water Pageant had been hastily assembled to entertain guests at the new hotels along the Seven Seas Lagoon and Bay Lake. Overseen by Bob Jani, then director of entertainment, the floating parade debuted October 24, 1971, the evening before Dedication Day, as part of ceremonies celebrating the opening of the Polynesian Resort. The pageant consisted of fourteen floats carrying twenty-five-foot-high screens displaying a series of images created with colored lights. The characters had a sea life theme—a serpent, a whale, dolphins, Neptune, and so on—and many were animated by changing patterns of the hundreds of bulbs, all accompanied by electronic music. The hotel guests loved it, and visitors not staying on Disney property sought out vantage points along the water to watch the show before leaving for the night.

It was exactly that kind of guest magnet Disney president Card Walker was looking for to convince Disneyland guests to stick around after dark. "We had no nighttime business [at Disneyland] at that point in time," Jani said in a 1987 interview. "And also we had an enormous morale problem. The employees at Disneyland just felt like they were working for a second cousin after Walt Disney World opened. . . . It needed something new." In a meeting with Walker, Ronald Miziker, then the director of entertainment and show development, brought up the successful Electrical Water Pageant and asked Walker, "Why can't we make Main Street our stage?"

Miziker's and Jani's initial intent was to reproduce the Electrical Water Pageant's effects on land with flat panels of animated multicolor lights. But Disneyland seemed to call for something more in keeping with its immersive setting, so Jani was inspired to ask his designer to make most of the floats three-dimensional, in some cases by wrapping existing vehicles in strings and webs of bulbs. Others were built from scratch by Disney mechanics in tents set up backstage at Disneyland after an outside contractor fell hopelessly behind schedule. The final lineup required a half million Italian-made miniature white lights, most of them hand-tinted to create the desired color effects, all powered by rechargeable nickel-cadmium batteries. The parade was controlled by a computer console that triggered pretaped audio piped through separate amplifier and speaker systems placed along the route in twenty zones, one after the other. The music was a looped version of the peppy electronic "Baroque Hoedown," recorded in 1967 on early Moog synthesizers by Gershon Kingsley and Jean-Jacques Perrey—the same music that had been used for the Electrical Water Pageant.

The Main Street Electrical Parade, as it came to be called, debuted in Disneyland, as scheduled, on Saturday, June 17, 1972, led by a super-sized Blue Fairy (from *Pinocchio*)—waving at the crowd from atop a conical skirt on wheels, about twelve feet tall and draped with strings of lights. Its two nightly performances—down Main Street, U.S.A., for a show soon after sunset, a two-hour break to recharge the batteries, then back up the street not long before closing time—energized visitors. Guests lined up along the curbs enthusiastically for each procession. And while they were waiting for this cool new show, they stayed in the park and patronized its shops and restaurants.

The parade had a temporary hiatus in 1975-76, replaced by an American Bicentennial event called America on Parade. This period was used to upgrade the effects and build new floats. But the parade returned in 1977 with what the Disneyland *Vacationland* magazine promised was "140 bigger-than-life units in three-dimensional configurations that will serve to give guests on either side of the street a more realistic view of each unit as it passes by." The revised cavalcade ran at Disneyland for the

next nineteen years (save for 1984, when a Fantasyland-themed parade supplanted it), and it returned periodically thereafter. One Disneyland estimate was that more than seventy-five million people had seen the Main Street Electrical Parade by 1996.

The parade did not, however, make Disneyland cool among teenagers and young adults. Nor did the musical acts booked by the entertainment division. Swing bands played the park often in its early years, including stars such as Count Basie and Duke Ellington, appearing in the Plaza Gardens dance pavilion (originally called Carnation Plaza Gardens), which was nestled between the castle and Frontierland. Pop concerts were added in the 1960s, with cover bands appearing on weekends at the Plaza Gardens or at the Space Bar in Tomorrowland. In the early 1970s, the larger Tomorrowland Stage sometimes hosted pop stars such as the Osmonds and the Carpenters. The land-themed musical offerings also expanded as jazz combos let loose in New Orleans Square and a recurring hoedown was introduced in Bear Country—an area beyond Frontierland themed to house the Country Bear Jamboree, which opened in 1972.

But youths did not gravitate to theme parks to hear Benny Goodman or "(They Long to Be) Close to You." Kids wanted to rock and roll in the kinetic sense: they wanted thrill rides, and Disneyland had just one, the Matterhorn Bobsleds. This shortcoming became a particular handicap in May 1971, when the Magic Mountain amusement park opened just north of Los Angeles. It had a steel roller coaster and a flume ride from day one and added a second steel coaster in 1973. Even Orange County neighbor Knott's Berry Farm had joined the thrill ride race, opening the world's first coaster with two inversions, appropriately named the Corkscrew, in 1975.

"When I was growing up as a teenager [in the 1970s,] the only thing at Disneyland for a teenage mentality was the Matterhorn," recalled Tom Morris, a Southern California native who would become an Imagineer in 1980. "But Knott's Berry Farm had three or four thrill attractions. And then Magic Mountain opened and it had many." That's where his junior high and high school friends wanted to go. Not Disneyland. The

continuing drain of teenagers and young adults was not going to be solved by a peppy parade or nostalgic and soft-rock musical acts. This was a job for the Imagineers, and they already had something in mind—drawn on the back of an envelope.

II. THE FINAL FRONTIER

The 1959 success of the Matterhorn Bobsleds convinced Walt Disney that even a roller coaster could tell a story and create the sense of visiting a fantastic place. Dick Nunis, head of operations for the park, was in favor of building a second high-capacity thrill ride and didn't hesitate to say so in the early 1960s. At one meeting with Walt and other executives, he recalled, when the Matterhorn was mentioned, the consensus was, "Why don't we do a 'Space Mountain' in Tomorrowland with the same type of concept?" Walt greenlit the project, which at one time was part of a larger "Space Port" complex conceived (but not built) as part of the renovation of Tomorrowland that debuted in 1967.

The lead designer on the attraction would be John Hench, who had already doodled his ideas for the fully enclosed coaster. "I think the original sketch was on an envelope, really," he said, "but it was drawn many times. I had an idea of a type of architecture which was kind of cartilaginous at the time, as [if] made out of lots of vertical parts that fit in certain ways." Hench's "cartilaginous" details eventually evolved into diagonal spines on a giant white conical peak studded with spires.

After Walt Disney died, Hench was considered one of the creative leaders at WED Enterprises. "I don't look on myself as any replacement for Walt," he said not long after Walt's death, "but I do think that the thing that has held us together is a kind of momentum. We are more separated, of course, than we were with him, but still we were taking instinctively the same directions."

As he visited the Imagineers' workstations, Hench was hard to miss, recalled Kevin Rafferty, who joined WED in the late 1970s. "John Hench had kind of an aura about himself, with his ascot and his sweaters and

his look and his demeanor. He was really cool. He was like Walt Disney himself, you know. He had the little moustache and everybody respected him because he kind of had a legitimate [artistic] background."

Hench also had a sense of fun, recalled Imagineer Peggie Fariss. Soon after she started at WED Enterprises in 1976, she said, "I remember being in a meeting with Marty [Sklar] and John Hench on Halloween when the graphic design department marched into the conference room playing kazoos and wearing corsets and tutus—and it was hysterical. And I think that really signaled to me that this is a place that is full of fun, full of imagination, and full of the unexpected."

Hench's philosophical approach to theme park design reflected Walt's own. "John was pretty amazing in the way that he accepted change," recalled Imagineer Kim Irvine, for whom Hench was a mentor. "He didn't mind if a shop [at Disneyland] turned into something else or an attraction turned into something else. He thought that was good. And of course, Walt always impressed upon his original Imagineers that the park was alive and could always be evolving and changing."

Space Mountain was certainly another step forward: a roller coaster experienced in near total darkness. It was to be a thrill ride, certainly, but Hench saw it as creating the same "feeling of reassurance" as any other attraction in the parks. Its narrative began with the space-themed interior queue and continued in the boarding area (complete with departure announcements), building anticipation and—as the riders ascended the initial slope through a kind of launch tube—trepidation. Then the rocket vehicles were "hurled into the dark void of deep space," as Disney publicity put it, "weathering a blazing meteor shower . . . at infinite speed." The actual maximum speed was twenty-eight miles per hour, but it felt faster in the dark. From the designers' point of view, Hench said, the idea was to confront the guest with a "simulated threat, but controlled in such a way that he feels like he's been through an experience all right, and he's licked it." When guests got to the end, he continued, "they feel much more alive. They have a lot more adrenaline in their blood when they started and they feel exhilarated because they've met something that seemed to be a challenge and they won."

The first Space Mountain would open not at Disneyland, as originally planned, but in the Magic Kingdom, and more than ten years after it was conceived. It had been delayed not just because there had been a decade of focus on the World's Fair and Walt Disney World but also because its technological demands seemed insurmountable in the mid 1960s. "Computer technology wasn't sophisticated enough to keep the cars separated inside the mountain," Marty Sklar said. "Eventually, the technology caught up with the idea." The United States space program also caught up as the Apollo moon landing in 1969 fueled a popular fascination with space travel, especially among young people, that would benefit Space Mountain. President Nixon announced the Space Shuttle program in 1972, and suddenly space adventures that had seemed a distant dream a decade earlier were felt to be within reach.

Imagineer Bill Watkins had designed the track of the Space Mountain coaster for Disneyland, but George McGinnis was assigned to adapt it for Florida. "My concept turned the track around to get the up ramp sloping to the back, which in doing so created the Strobe Tunnel," McGinnis said. His original layout for the two tracks—dubbed Alpha and Omega—included sections that extended outside the mountain, covered to maintain the ride's darkness conceit. It was an idea Hench especially liked, dubbing the exterior curves "satelloids." "We eventually put a three-hundred-foot diameter cone over the mountain, enclosing all the track. So the satelloids went away, much to John Hench's disappointment."

Construction began in December 1971, just two months after the Magic Kingdom opened. The mountain was to sit on the far side of the Walt Disney World Railroad tracks, with a tunnel, dubbed the Star Corridor, connecting it to Tomorrowland. Each "rocket" would seat six guests in two connected cars holding three people each. To maximize capacity, the coaster utilized a computerized control system—the first such system on any roller coaster.

"The goal for the rides was two thousand people an hour, and you didn't do that by pushing one train at a time. So we had computers doing ride control," said David Snyder, the computer programmer who had

also helmed the creation of the Audio-Animatronics console. More important, he added, "the computer systems were used there to make sure the spacing of the vehicles was such that guests would be safe. Prior to that the only way to safely run a roller coaster was send one train down with people, wait till it got to the top of the next [rise] before you send the other one down."

The ride opened January 15, 1975, an event that included an appearance by U.S. astronauts Scott Carpenter, Gordon Cooper, and Jim Irwin. It was sponsored by RCA, which had put up half the estimated $20 million budget. Space Mountain immediately became one of the most popular attractions in the Magic Kingdom, and it opened at Disneyland on May 27, 1977. It replaced Tomorrowland Stage in Disneyland and was accompanied by a 650-seat restaurant, a thousand-seat amphitheater, and the Starcade, featuring electronic games. Preopening publicity had promised that the 117-foot-tall Space Mountain would be "the most incredible attraction in 22 years," and young people seemed to agree. For teenagers, the coaster was a lure Knott's Berry Farm and Magic Mountain did not have.

The music now integral to the Space Mountain experience at Disneyland was not added until 1996, by which time the ride vehicles were replaced; the new rockets had stereo speakers adjacent to every headrest. The central narrative of the attraction never changed, however, and ride designer Hench remained proud of the experience he had created. It wasn't just that guests loved it: Space Mountain was his own favorite ride at Disneyland, Kim Irvine related. As Walt Disney had done before him, Hench advised his fellow Imagineers to visit the parks as often as they could, and he took his own advice.

"When John would come down here for his visits, we would always come to Carnation Café for our lunchtime," Irvine said. "We just loved to sit at one of the front tables and talk and watch the people. He loved to watch people enjoying Disneyland. Oftentimes in the middle of our walks, he would stop and just watch a family or watch a child on the carousel or watch a gentleman put his hand over his heart when we would lower the flag. And those things just really moved him and sometimes

he would say, 'This magic really works. It really does work, doesn't it? People really do love it. It happened just the way that we were hoping it would.'"

The next stop, Irvine continued, was Hench's roller coaster in the dark. "We'd always take one ride on Space Mountain, because that was his favorite ride. Even up until the time that he was in his late seventies, he'd still ride. And we would get off with shaky knees and sometimes he would go, 'Let's do it once more.'"

CHAPTER 9:
A HIGHER PURPOSE

"If the Magic Kingdom is fantasy made real, EPCOT is reality made fantastic. These stories that we were telling about real stuff, about science and the future, and about culture could be as compelling as fantasy stories." —Tony Baxter

I. NEW RECRUITS

JUST DAYS AFTER the opening of Disneyland in 1955, it had its own newspaper. Issue number one of *The Disneyland News* carried the banner headline 50,000 ATTEND GALA PARK OPENING and other related stories, such as CONGRESS INFORMED ABOUT MAGIC KINGDOM. Sold by newsboys on Main Street, U.S.A., and in Frontierland, the tabloid-size paper cost a dime. For fifty cents at the Main Street Print Shop, guests could get a customized headline, such as ELIZABETH EULER VISITS DISNEYLAND, inked onto a souvenir copy (although the stories beneath the banner remained the same). Fans could also pay for an annual subscription—just $1.20 for twelve monthly issues.

The editor in chief of this new journalistic enterprise—"hot off the presses!" one blurb trumpeted—was a twenty-one-year-old college student named Marty Sklar. At that point, he had just finished his junior year at the University of California Los Angeles. "Walt wanted to put out a tabloid newspaper on Main Street and they hired me to do it, even though I was still in school," Sklar recalled. He had gotten the job after an unexpected telephone call from Card Walker, then a marketing

executive at the Disney studio. Sklar was editor of UCLA's *Daily Bruin*—just the guy Walt Disney needed.

Excited to be part of this new thing called Disneyland, he took the summer job just a month before the park was to open. Two weeks later, he was called in for a meeting with the man himself. "I had to present this idea to Walt Disney, and believe me I was scared as hell. . . . I couldn't figure out how he had time for this little project I was doing when there's chaos all around, because Disneyland was going to open two weeks later."

The meeting went well, and Walt wanted to know every little thing about the first issue of *The Disneyland News*. "There were about six people in the room, and he took the time to look at the layout I had done and the kind of stories that were going to be in the newspaper." The paper was a success and continued publication into the school year—but without Sklar, who returned to UCLA to finish his degree. The newly minted graduate was back at Disney the next year, however, joining Walker's marketing department.

Sklar's marketing job kept him in close contact with the Imagineers, and in 1961, he joined WED Enterprises full-time. His experience working with corporate sponsors for the Disney attractions at the 1964–1965 New York World's Fair, and his close collaboration with Walt Disney on Walt's film presentation about EPCOT, had given him crucial experience he would need when he was appointed WED's vice president for concepts and planning in 1974.

But his summer job at Disneyland taught Sklar a valuable lesson. Walt Disney, he learned, thought of Main Street, U.S.A., as "a real town, and he wanted a newspaper that reflected that [in] 1890, 1900 every little town had its own newspaper." Sklar's job wasn't just to write bubbly news stories but to help give Main Street, U.S.A., a depth of character beyond its forced-perspective facades. And it was Sklar's indoctrination in the basic credo of Imagineering: "It was all about story," he said. "Everything that went into Disneyland was about story."

That philosophical cornerstone was much on Sklar's mind when he was assigned to lead WED Enterprises' next nearly impossible project,

one with a budget about ten billion times the cost of an issue of *The Disneyland News:* EPCOT Center, Disney's third theme park and the first one not based on the Disneyland model. Sklar's creative partner would be John Hench, then senior vice president at WED. They were charged with their monumental task by Walker, who had become Disney's president and stepped—philosophically, at least—into the shoes of Roy O. Disney. "Card wanted to do EPCOT because that was Walt's dream," said Frank Stanek, who also worked on the project. "He wanted to carry that through and make it happen." Walker had other concerns in the mid- to late 1970s as well. The energy crisis that began with the October 1973 OPEC oil embargo had lasting repercussions, including crushing levels of inflation and a two-year recession. The Disney company's film business remained stagnant, its biggest hits middling fare such as *Herbie Rides Again* and *The Apple Dumpling Gang*, while annual attendance to Disneyland seemed stuck in place. (Space Mountain's arrival boosted that a bit.) The company stock price in the late 1970s hovered around a third of its peak value in early 1973, before the energy crisis hit.

For Walt Disney Productions, prospects for growth were centered in Florida. But Walt Disney World would not be a thriving, multiday tourist destination without a second park—a "second gate," in amusement industry lingo. "Everyone accused Walt of being an idiot when he built Disney World," Walker told *Forbes* magazine in 1981. "I know pumping $800 million into EPCOT is a big gamble with the current fuel crisis and poor economy, but we believe it's going to pay off really big."

Part of that investment would augment WED Enterprises with its next generation of Imagineers—the people who would serve as the hardworking backbone supporting the increasingly complicated organism WED was becoming. The era when most Imagineers had known Walt was coming to an end, and the vast expansion of the technology needed to run a modern theme park meant that the new recruits would include people from more and more diverse backgrounds. Even an aspiring Roman Catholic priest turned dishwasher could find a home.

Kevin Rafferty had left his clerical studies after five years, enrolling as an art student at Cal State Fullerton and working a summer job as a

dishwasher at the Plaza Inn in Disneyland. He studied animation but had decided he really wanted to be an Imagineer. A promotion to assistant manager at the private Club 33 in Disneyland got him no closer to his dream job—until he saw an internal Disney posting for design work on a project called EPCOT.

He interviewed at WED, hoping for any kind of artistic position. "They said, 'No, you can start entry-level,'" Rafferty recalled. "'You can set up conference rooms for meetings. You can dust models. You can empty trash cans. You can basically support the real artists and designers who are working on the EPCOT project, cutting their mats and getting them pencils and things like that.' So I was like a nobody back in the day." But he was a nobody with access to all the somebodies, "all of the people who invented the industry, [who were] still here at that time," he said. "I was kind of mentored by them indirectly." Rafferty said that as he rubbed shoulders on garbage duty, "I was paying attention to them and learning the fundamental design principles from the masters who created Disneyland. And what an amazing time it was to be here."

Joining Kevin soon would be Tom Morris, whose father had worked on the Pirates of the Caribbean attraction not long after it opened. Growing up in West Covina, a half hour east of Los Angeles, Tom had been visiting Disneyland with his family every Fourth of July since he was small enough to be terrified by Snow White's Adventures and awed by meeting Captain Hook. His favorite part of the park was Tom Sawyer Island: "It seemed like it was real," he said, recalling the smell of the trees and the freedom to climb and wander a land so different from his suburban neighborhood. *The Wonderful World of Color* was a Sunday-night staple, and Tom was especially fascinated by the behind-the-scenes episodes about Disneyland attractions, like the Enchanted Tiki Room.

Then his dad, a high school teacher, got that summer job as a ride operator on the opening crew for Pirates of the Caribbean. It was 1967, and riding Pirates with his father, Tom recalled, "was life changing." His father provided his son a running commentary during the ride: "When we went down the second waterfall, he said, 'We are right under where we started, at the loading area.' And I'm like, 'That's impossible, you're

wrong.' And he was right, of course." The spatial manipulation intrigued Tom, and the atmosphere—"so convincing and romantic"—moved him. "It seemed like you've gone so far away, and it's all just on this one tiny little acre at Disneyland."

Tom got his own job at Disneyland in high school and made friends with Imagineer Tony Baxter, who gave the seventeen-year-old a couple of tours of WED Enterprises—and that was it: working at WED, he decided, "seemed just so interesting and a different job every day." He took drafting classes in high school, designing imaginary structures, and started college at Cal State Fullerton. It was his teenage portfolio of fantasy cottages and futuristic buildings, he said, that got him a job offer as an apprentice draftsperson at WED, "because they needed really good craftspeople for EPCOT." He put his education plans on hold and by 1980 was an Imagineer.

New Yorker Tom Fitzgerald was fresh from Northwestern University when he showed up at WED Enterprises, hoping for a job. He had been obsessed with Disney attractions from the time he'd seen Great Moments with Mr. Lincoln at the New York World's Fair—not to mention being glued to NBC-TV once a week as a boy, hoping Disneyland would be featured on *Walt Disney's Wonderful World of Color*. On the wall of his bedroom hung his precious Disneyland map, a gift brought back from one of his parents' business trips to California, "and I studied and studied [it]." Unlike other kids, young Tom didn't want to visit Disneyland to flit from ride to ride as much as to absorb the artistry of its very existence. When the family finally flew west for a Christmas vacation at the park, it was "one of the happiest days of my life." As soon as they went through the turnstiles, the twelve-year-old ran off to get in line at the newly opened Haunted Mansion. "It was a dreamworld," he said, and he recalled immediately understanding the depth of the design work involved. "Everything was integrated seamlessly into this immersive world where the landscape and the color of the graphics and the color of the ground—everything was art directed, so really it was stepping into a dream."

Tom vowed that day he would work for Disney and got a series of summer jobs at the newly opened Walt Disney World while still in college. He

worked his way up from the Tomorrowland Skyway to Peter Pan's Flight and finally, after college graduation, the Haunted Mansion, his favorite attraction of all time. He also started dropping ideas into the suggestion box in the employee cafeteria—so many and so creative that "I finally got called to the head of Walt Disney World." The boss told him some of his ideas had been sent to WED—and promised him an interview with Marty Sklar if he went to California at the end of the summer.

To impress Sklar, Tom designed his own Winnie the Pooh ride and built a model of it, which he took with him on the long drive to Los Angeles. His timing was good: "That fall," Tom said, "they announced EPCOT." His storytelling skills were even better. Sklar interviewed him, along with Randy Bright, and offered him a job as a writer, impressed with the script and story progression in his Pooh ride. But the job, he remembered ruefully, came "with one condition from Marty Sklar: that I'd never build another model in my career, because the model was really hideous." Nevertheless, he had made it: "I was lucky enough to be in that EPCOT generation, hired to bring EPCOT to life."

II. A VISION REENVISIONED

The exact shape of the EPCOT that Sklar, Hench, and the other Imagineers would create was still undecided in the two years after Walt Disney World opened. But the WED team had no other big projects in the works and so had time for what Frank Stanek termed "concept work." That included reconceiving EPCOT and selling the idea to the corporate sponsors who would help pay for it. That was in addition to finishing aspects of the Magic Kingdom that had lagged past opening day—more food facilities, for example—and attending to the long-neglected Disneyland. "So finally we were caught up in 1974, I would say," Sklar recalled. "And that's when Card Walker came to me and said, 'What are we going to do about EPCOT?'"

In July 1975, Disney officially revealed that it would build what came to be called EPCOT Center—although the announcement was short on details, since plans were far from final. What had been determined,

however, was that what Walt imagined was not feasible. "Walt's original vision, unfortunately, couldn't be accomplished because of the 'one person, one vote' concept," said Carl Bongirno, who became vice president of finance and treasurer of Walt Disney World in 1972. The Disney company might have been able to marginalize local government in the creation of Walt Disney World, but no legislative blanket could suppress the rights of individuals to shape their own lives and living spaces. "As soon as you build it, you lose control of it," Bongirno said. "You couldn't get the right to dictate to people living in their own homes." Disney's legal team had begun its research into how to bend Florida laws to permit EPCOT's regimentation under Walt Disney's direct supervision, and after he died, they "did everything they thought was possible to overcome [legal obstacles] and there's just no way," Bongirno said. The decision had less to do with the capabilities of the Imagineers and more to do with the liabilities of the Disney company. Walt Disney's EPCOT was not a project that Disney post-Walt was willing to risk.

In their months of brainstorming, the Imagineers sought to retain EPCOT's underlying principles—innovation, futurism, harmony, ecology—and use them to build a new kind of theme park. "It became my assignment to try to figure out how we took Walt's idea for a community and turned it into a park," Sklar said. His goal was "to underpin the park with what Walt was trying to achieve in communicating an optimistic vision about the future."

Walt's vision for EPCOT was "kind of the perfect Utopia where humans could live and work and play together," Rafferty observed. The EPCOT that WED Enterprises would create in its place would instead be a kind of "permanent World's Fair." In that spirit, two ideas for EPCOT eventually coalesced: a park that showcased nations from around the world and their cultures, and a future-focused park where the attractions would feature technological innovations in different fields, such as health, transportation, and energy. It was the classic Disney dichotomy, the simultaneous impulses to romanticize history and lore and to digest the past, improve the present, and launch bravely into the future.

To design the pavilions in the two parks, Sklar reached out to some

WED legends who had left the company—such as Harper Goff and Rolly Crump—as well as the veterans who remained. "What was amazing is a lot of the folks that Walt Disney himself handpicked to come over and reinterpret their skills as filmmakers and art directors and animators and such were here on campus working on EPCOT," Kevin Rafferty recalled, "people like Claude Coats and Herbie Ryman and Marc Davis and X Atencio and Rolly Crump and Harriet Burns. They were all here and they were at the top of their game."

"I don't think that EPCOT could've been done without the talent that had been trained through Disneyland and the World's Fair by that time, and this in many ways was the swan song for a lot of this great talent," Sklar said.

But it was clear to all who was in charge: "John Hench and Marty Sklar were kind of joined at the hip during the EPCOT development days," said Kevin Rafferty. The duo were yin and yang on the project— "Marty as a writer with his background and working with corporate alliances and trying to get industries interested in EPCOT, and John with his filmmaking experience and his color sense and everything else, and [together] putting together this massive, epic project." For a youthful artist like Rafferty, "to watch those two work together and interact together and check and balance each other when it came to decision-making—it was pretty marvelous to see."

"We originally started out to try to do two separate parks: one about countries around the world and the other about future ideas," Sklar explained. "And we couldn't get enough sponsorship to make that happen." One day in 1976, Sklar and Hench were scheduled to meet with Card Walker and Donn Tatum, who had become Disney's chairman and CEO after Roy O. Disney's death. The Imagineers had models of the two parks but were in a quandary about presenting them, fearful both ideas would be summarily scrapped. "We said [to each other], 'Unless we do something radical, we're not going to get this approved,'" Sklar recalled. The solution proved to be both radical and simple: "Hench and I pushed the two models together and it became one." They rushed to the Model Shop, which in just a couple of hours "did a wonderful job of being able

to make these things match. And it worked. It's what is there today." The combination of the two parks, Sklar said, "enabled EPCOT to happen. It gave us enough dynamic with different kinds of entertainment and enough sponsorship so that we could make the project viable."

Sponsorship was crucial, because the project would be enormously expensive. Carl Bongirno took over the responsibility for budgeting the park, which Walker had determined should cost no more than $800 million. Bongirno's first calculations of the cost of WED's plans came in at about $2 billion. Months of meetings to whittle the project down followed, with input from WED's creative team, consulting engineers, administrators, and others. "So that was a difficult process," Bongirno said, "but I think the guys did a heck of a job in bringing it in at the amount and on time, which was really important." He noted that, as had been the case with the Magic Kingdom, "If we hadn't opened the project on time, it would have actually bankrupted the company."

A good portion of that budget needed to come from the corporations that would sponsor individual attractions, and Sklar spent months and months on the road, selling EPCOT to America's industrial leaders. With the United States economy limping along, "The biggest challenge in creating EPCOT was getting the big sponsors involved," Sklar said. "Almost every one of them required the CEO of the company to bless the project."

Some of Sklar's industry contacts came from events WED organized called EPCOT Future Technology Conferences, covering topics such as food, transportation, and health. "We found people who were doing really advanced things around the world, and they really helped us to create the pavilions that were in EPCOT initially," Sklar explained. One of those experts was a scientist from General Motors, who helped arrange a meeting for Sklar with Roger Smith, then GM's chief financial officer. "We took every model we had, every piece of art we had, and we took it over to the GM Design Center in Warren, Michigan," Sklar related. The presentation, in January 1978, was art directed by three-time Oscar winner John DeCuir (*Cleopatra*), and it filled the GM center's showroom floor. It had required two trucks just to get the materials

to Michigan from WED Enterprises in California. "Card Walker had brought everybody who was going to be involved in a key position at EPCOT: operators, the Disney Channel—at the time just beginning—the parks' [leadership], and of course the design group."

Smith loved it and got GM's president, Pete Estes, on board as well. "General Motors became the first sponsor. That was a real watershed for the project," Sklar said. GM would support what became the World of Motion pavilion, a whimsical ride through the history of human transportation, designed in part by Ward Kimball. Following GM's lead within the month was Exxon, for the Universe of Energy.

By the time Walker made public Disney's actual plans for EPCOT Center—on October 2, 1978, at the Contemporary Resort, almost exactly four years in advance of opening day—sponsors also included AT&T and Kraft. It still wasn't Walt's EPCOT, but it shared a devotion to human advancement. "I don't think it lost that dream of people coming together in the sense of community and experiencing wonderful things and little peeks into the future," Rafferty said. Given the impediments to the planned community Walt had envisioned, Rafferty added, "I think if Walt had lived through the EPCOT project, it may very well have evolved into what it became."

III. THE EPCOT GENERATION

A crucial supporting player in the development of the intellectual foundation for EPCOT was Peggie Fariss, who had begun working at Disneyland in 1965 as a hostess on the Storybook Land boat ride. For the Disneyland opening of Great Moments with Mr. Lincoln, Fariss became one of eight "Abe's Babes": "We had these adorable T-shirts for the canoe team that we wore," she recalled. In the spring of 1969, Fariss was one of ten Disneyland hostesses invited to participate in the three-day Orlando press event promoting plans for Walt Disney World. She was awed by the presentations and went back to Disneyland to tell her boss, "I really want to be part of this [Florida] project."

With the help of her superiors at Disneyland, Fariss landed a job with

Disney partner US Steel, which was building two modular hotels at Walt Disney World; she was charged with supervising guest activities once the properties opened in 1971. In early 1972, she became a cast member again when Disney bought out US Steel's interests in the hotels. "I spent the next five and a half years planning meetings and traveling around the country to introduce the idea of Walt Disney World as a destination for conventions and incentive travel," she said. It was that experience working with businesses that got the attention of Marty Sklar. Fariss joined his team in 1976, working from the WED offices to set up the Orlando conferences and managing the resulting advisory boards, panels of experts who met with the creative teams at WED every six months or so during EPCOT's development. When the conferences ended and hands-on design for EPCOT attractions began, she stayed on as part of the creative team. "And that," Fariss said, "was how I traveled from being an Abe's Babe to Imagineering."

Fariss, who started on the EPCOT creative team as a researcher, joined the other fresh faces of Imagineering's second generation, a class in which women were considerably better represented than among the veterans. "There were some wonderful women" among the more experienced Imagineers, Fariss noted, mentioning Harriet Burns in particular as "one of a kind." "But I think this second generation came in with women as well as men." That, she added, "might have been new for people, but I found people to be very accepting of having women in the room." Every now and again, she recalled, "Someone would say, you know, 'We'd all like coffee here.' Not everyone, but I heard it a time or two. We were at such a transitional period in time, and over time I found that people respected one another for the talent and the energy and the enthusiasm that they brought to their work."

Among the new generation of Imagineers with Fariss were Kim Irvine (née Thomas), Maggie Elliott (née Irvine, daughter of Dick Irvine), Lindsey Palmer (daughter of Disney studios film editor Norman "Stormy" Palmer), Eli Erlandson ("a wonderful architect"), Tori McCullough (an interior designer and the daughter of X Atencio), and Lynne Rhodes (née Macer, a producer with the research and planning

group). Many of the young women arrived with impressive credentials. "Lynne had a master's in public administration," Fariss said. "People came to Imagineering from a broad variety of disciplines and then sort of adapted those skills to the work they found."

Elliott said there were so many young women whose fathers had worked at Disney that Herb Ryman sometimes referred to the Model Shop as "Daughterland." One of those daughters was Katie Olson, née Polk, who was just nineteen when she joined Imagineering, between school years at Cal State Northridge. Her father was head of security at the studio, and she had won one of the Disney scholarships available to the children of cast members. "I started here in 1975 as summer help in the Model Shop, painting anything that they asked me to paint," she recalled. She got her degree in art and returned as a permanent employee in 1979, working on the color boards for EPCOT's World Showcase.

Compared with the Walt Disney Imagineering of the twenty-first century, "It was a completely different dynamic back then," she said. "It was a much smaller company." Since Hench and Sklar were the creative leads, "we called it the John and Marty Show." Olson, who would eventually become Imagineering's principal color designer, worked closely with Hench, a master of color design, for many years. He and the other Disneyland veterans "were all our mentors," she said. She had been hearing stories about the legendary artists of WED Enterprises from her father since she was a girl; now she was working with them. "We were very lucky—we were taught by the masters."

That didn't make it easy. "John was very intimidating," Olson said of Hench. "He was a very elegant man, always beautifully dressed," but he was also "very, very tough. I remember one time I walked into his office and I was showing him a color board—our basic document for color. They are architecture illustrations, basically, but we actually hand mixed every color." Hench looked at Olson's boards and pointed at one section, asking, "What's this line here? Why did you color change here? Why did you do that?" Shell-shocked, Olson looked at him and said, "I don't know what that line is." His response was quick: "If you don't know, then get out of my office. Because you are wasting my time." Olson learned

quickly that Hench "believed in excellence, and he had a vision for what our parks needed to look like that he imparted to all of us that worked for him."

Thinking of color from the perspective of its impact on guests was a "tough challenge," she said. "You can't just go, 'Oh I think that would look pretty in pink' and 'I think that would look pretty in green.' You have to think, 'What do I want the guest to focus on?'"

Not all the young women's mentors were men. Maggie Elliott fondly recalled working with Glendra Von Kessel, "the most amazing woman. Glendra was a baroness. She married Baron Von Kessel." The baroness had fled Germany with her two sons after the Nazis took power; her husband remained behind and was killed. Von Kessel eventually made it to California and became one of Disney's ink and paint artists before moving to the WED model shop. "She was a character and a half," Elliott said. "She had this long, bleached blond hair and inch, inch-and-a-half nails that she filed to a point. She had her husband's signet ring that she always wore. It was way too big, so she kept her pinky finger and her ring finger together to hold the ring on." Von Kessel was known for her delicate miniatures, like the tiny chandeliers for a model of the Haunted Mansion. One day, Elliott asked her, "'How can you even hold that bead with those fingernails?' She told me she had an allergy to paper, so she used her fingernails as tweezers so that it wasn't touching the pads of her fingers. Whether that was a true story, I don't know. But I believed her. I asked her one time, 'Glendra, how old are you?' She said, 'Darling, I'm three years older than God.' She was just a character and a half." Some of Von Kessel's work could be seen in the park, such as the reverse painting she did on mirrors in the New Orleans Square perfume shop. "If you know anything about painting and try to paint in reverse before the glass is mirrored on the back—I mean, just amazing work," Elliott said.

The young women in the Model Shop jumped from project to project, sometimes hour by hour. Kim Irvine recalled working on the dolls for "it's a small world": "We glued jewels on whatever had to be glued. We were kind of an all-purpose service center to the company." The designers, who had offices in another part of the building, would often drop

by. "These were famous art directors—Claude Coats, Herbert Ryman. They'd walk into your area, sit down, and go, 'Do you have a piece of illustration board and an X-Acto knife? I want to try something.' And they'd sit at your desk and start cutting and gluing together . . . just exploring ideas. So we were very lucky back then, because it wasn't so specialized. We were very much jack-of-all-trades."

For EPCOT, Irvine said, every attraction was created first as a scale model in the Model Shop, it got approved by Hench and Sklar, and "it would get drawn [as architectural plans] and immediately go into production in two, three weeks." For her first assignment as a lead, she recalled, "I was put in charge of the colors for the United Kingdom pavilion in EPCOT and I was working for a color-blind architect. Now that was a challenge."

Olson, Fariss, and the other younger Imagineers—"I'll call us the EPCOT generation," Fariss said, "because we're the people who came to Imagineering specifically to work on EPCOT"—arrived already indoctrinated in Disney culture. They had grown up as fans, enjoying the studio's movies and TV shows and seeing Walt himself on television every Sunday, and most had first experienced Disneyland as children. "I think our sense was Walt Disney was always encouraging his teams to go farther than they had ever gone—to try things that they hadn't tried before," Fariss said. "And to me that was the spirit that pervaded the whole EPCOT effort."

She continued: "One of the things Imagineering always prides itself on is we're not doing sequels. We're doing things that have never been done before. And I think certainly with EPCOT we had a palette for just *doing*. And we called people from all over the world. And I think the opportunity for young talent to work with leaders in the industry was also a really wonderful experience"—for veterans and new recruits alike. "My impression was the old guard was really welcoming and happy to nurture that young talent," she said. "The mantra was 'We're going to do this and nobody's done it before."

Unlike in the Magic Kingdom, the majority of which comprised reproductions of attractions created for Disneyland and the World's Fair,

everything in EPCOT would be fresh, created from scratch. It was a rare carte blanche for the creative minds of Imagineers of all ages, and its parameters were a major shift from the fairy tales and nostalgic lore that informed the existing parks. "We were really having to use the technology to tell an entirely different kind of story," Fariss said. "This would be a place where people would be exposed to new ideas." The project required WED's artists to learn an encyclopedia's worth of new information, but "I think the feeling was 'Let's start with what we know. Let's start with storytelling, which is our foundation.'"

Fariss had seen Walt in person exactly once, at a luncheon for Disneyland Ambassador finalists (she made the final five but wasn't selected), so she didn't approach the challenge of EPCOT from the perspective of "What would Walt do?" Her generation of Imagineers, she said, turned that question into a statement: "Walt would want us to do the best we can. So let's just go do it." It was a philosophy supported by Sklar, as WED's creative leader. "Marty was never saying, 'Well, that's not what Walt would have done.' He gave us free rein to develop the ideas as best we could."

IV. THE SPACESHIP

Author Ray Bradbury was one of Walt Disney's biggest fans. In one of several articles he penned about Walt and the Imagineers, he called Walt "the greatest shaker, mover, and changer of the 20th century." He had been enamored of the Imagineers' kinetic storytelling since his first trip to Disneyland. He had been so moved by the experience of Peter Pan's Flight that he'd written a thank-you note to Walt himself: "I will be eternally grateful. Today I flew out of a child's bedroom window in a pirate galleon on my way to the stars." Bradbury met Walt in person while Christmas shopping in Beverly Hills in 1963, and they agreed to have lunch the very next day in Walt's office. Walt treated him to sandwiches, then to a two-hour tour of Imagineering works in progress: a new Jungle Cruise hippo, the Pirates of the Caribbean model, plans for an urban transportation system Walt called the PeopleMover. Over the years,

Bradbury would return again and again to the halls of Imagineering, dubbing it a "ghost manufactory" and a "madhouse of costumes and ambulatory self-wrapped gifts." In 1976, he spoke to the gathered staffs of WED Enterprises and MAPO, declaring, "What you are is Renaissance people." The artists and explorers of Renaissance Italy and Victorian England, he said, had "changed the world forever, [and] you are doing the same thing here." The EPCOT project, he hoped, would "set an example for the world."

By the time of that speech, Bradbury was one of the most acclaimed science fiction and fantasy writers in history. He even had a crater on the moon named after him. But when he turned in the narration he'd agreed to write for the Spaceship Earth attraction in EPCOT, a young Imagineer was assigned to rewrite the master's words. "To be asked to rewrite Ray Bradbury was a terrifying thing," remembered Tom Fitzgerald, then a WED writer hoping to graduate someday to designer. "The problem was the script was so beautiful . . . but people were on a ride; they couldn't decode poetry." Like the Carousel of Progress, Spaceship Earth was both Audio-Animatronics entertainment and a journey through time—in this case, 40,000 years of human language, writing, and related innovations. The Spaceship Earth attraction recounted communications history through a series of Audio-Animatronics tableaux viewed from Omnimover vehicles. As Fitzgerald sat down with Bradbury's draft, he told himself, "We can never get this to be as beautiful as Ray Bradbury, but let's see if we can simplify the script." To find just the right tone, Fitzgerald wanted to hear what it would sound like from the seventies' best known and most trusted voice. "So we got Walter Cronkite to come and read the script."

This would be the park's signature creation: 165 feet in diameter, it was the world's first geodesic sphere. Hench personally led the design team. The name, Spaceship Earth, was a phrase popularized by R. Buckminster Fuller, the inventor of the geodesic dome and one of EPCOT's consultants. Visible from miles away, the massive ball would be an appropriate symbol for the largest construction project in the company's history at that time. At 260 acres, EPCOT was twice the size of the Magic

Kingdom, and it needed an architectural icon at least as imposing and as recognizable as the 189-foot-tall Cinderella Castle, which sat just over three miles to the northwest.

On the day of the official groundbreaking for EPCOT Center—October 1, 1979—Spaceship Earth made a cameo in the form of a full-scale stand-in, meant to feature prominently in photos and other press coverage. Suspended from two construction cranes was a flat, circular matrix of golden triangles, 178 feet high—just two feet short of the full height of Spaceship Earth once it was installed on a pedestal Hench devised to lift the structure just a bit higher off the ground. Once finished, after twenty-six months of construction, Spaceship Earth would be "the premier attraction for Future World—for EPCOT, really," said Peggie Fariss, who worked on researching the attraction's compressed but authoritative history. "It's the first thing people see. Architecturally, it makes such a statement."

That idea was, in part, *Here is a theme park without a castle. Come here to glimpse the future.* "All of Future World was really intended to take us into a world where we were addressing not only what the future might hold but how did we get there," Fariss said. "And each of the pavilions in EPCOT had a slightly different tone. So when Ward Kimball was working on World of Motion, the transportation pavilion, he brought his very wacky sense of humor to what the history of transportation would be. And it was just adorable."

Bradbury's input into Spaceship Earth was just one of countless stories of the world's most creative minds offering insights during the park's creation. "Every pavilion we developed at EPCOT, we had an advisory board of academics and industry people," said Barry Braverman, a former schoolteacher who joined WED Enterprises in 1977 and worked on integrating education and entertainment in the Future World pavilions. "We were privileged to get these peeks into the laboratories and thought centers of this country and the world, and be able to see things that were just truly amazing that the public didn't know about. It was really a very inspiring time."

"To me, EPCOT was epic," Kevin Rafferty said. "It was a symbol of

optimism, of good things to come. . . . Here was something bold and exciting and huge and brand-new and not a castle park, but something entirely different." It might not have been the Experimental Prototype Community of Tomorrow that Walt Disney envisioned, "but it was an experimental prototype of the future of the projects that Imagineering would embark on. It was kind of proof that we could do big things. We could do marvelous things."

V. THE FUTURE HAS ARRIVED

The marvelous things Disney had planned for Walt Disney World extended beyond the confines of EPCOT but were still in line with the park's focus on technology and ecology. The Disney utility company was headquartered in a solar-heated and air-cooled office building, and by 1978, the solar panels on the building's roof alone were able to heat the interior throughout the winter. The on-property power plant utilized both solar power and natural gas. Excess heat was captured to chill water for air-conditioning.

Within EPCOT, the roof of the Universe of Energy pavilion held 80,000 photovoltaic solar cells that generated electricity used by the attraction inside. "The building itself makes a big statement about solar power," Peggie Fariss said. "And then you enter what appears to be a theater, and then the theater seats you're sitting in break off into [six] sections and you travel through an attraction. And we'd never done that before." The Universe of Energy show combined live-action films, 2D animation, and Audio-Animatronics dinosaurs—some repurposed from the Ford pavilion at the World's Fair—that detailed both the past and possible future of humans' harnessing of various sources of energy.

"When I got involved in EPCOT, there was a sense of idealism and possibility there that was really unprecedented," Barry Braverman said. "This was a park that was about something. It was about the future, it was about energy and how we can live on this planet in a sustainable way." Braverman recalled fellow Imagineer Tony Baxter's summation of the

park's philosophy: "If the Magic Kingdom is fantasy made real, EPCOT is reality made fantastic."

The park demonstrated, Braverman said, that "these stories that we were telling about real stuff—about science and the future and about culture—could be as compelling as fantasy stories." And much about EPCOT *was* real. The Land pavilion, sponsored by Kraft Foods, included not just a revolving restaurant and a child-friendly Audio-Animatronics show about nutrition but also a twenty-minute boat ride that familiarized passengers with the history and future of farming innovations. The final section of Listen to the Land toured a series of working greenhouses focused on hydroponics, or raising crops with nutrient-rich water and no soil. The displays were based in part on the work of consultant Carl Hodges, "an agricultural guru of the time," recalled Steve Kirk, then a young Imagineer who worked on the pavilion.

Of course, The Land also featured the Kitchen Kabaret, the cartoonish Audio-Animatronics show Kirk worked on under the leadership of Rolly Crump. "We had a great time with Kitchen Kabaret," Kirk said. "I'm not sure how much nutritional information actually got across, but it was just wonderful. I mean, singing fruits and vegetables—how can you go wrong, right?"

Throughout Future World, Disney struck a balance between entertainment and information, drawing a sharp contrast with the Magic Kingdom by having no attractions that included existing Disney characters. In the park's Future World front half, the stars were the various cutting-edge technological advances that were both displayed and utilized. Communicore, two semicircular buildings at the center of Future World, was to include rotating displays of the latest inventions, and it was here many guests would get their first view of a fax machine, laser discs, and a video telephone; a robot that employed early voice synthesis and voice-recognition programs; and touch screen–controlled computers.

It was more than just entertainment: EPCOT Center was intended to surround guests with the big ideas bubbling around the world, to inspire their own imaginations and empower them to think of the future

as an untapped wealth of possibilities. Guests would come to EPCOT, discover the innovations coming their way, and return to communities all over the world hopeful and more willing to embrace both new technologies and cultures different from their own.

Film projection technology had made leaps forward since WED's inception. In planning EPCOT, Don Iwerks recalled, sixteen-millimeter film would be abandoned. The mandate was "wherever we use sixteen, we're going to use thirty-five. Wherever we use thirty-five, we're going to use seventy." Some of the films would advance the 360-degree technology Walt Disney and Ub Iwerks had created for the Circle-Vision 360 movie *America the Beautiful*, which had debuted at Disneyland in 1967.

The film wish list for EPCOT was ambitious. In addition to incidental clips that would augment many exhibits, film would be the center of attention in the Universe of Energy (along with those dinosaurs) and at three World Showcase pavilions: France, Canada, and China. All the World Showcase movies were to be original Circle-Vision productions, with a five-screen semicircular auditorium for *Impressions de France* and full 360-degree cinemas for *Wonders of China* and *O Canada!* The 3D film *Magic Journeys* would be the first show open in the Imagination pavilion (while the other Journey Into Imagination attractions were finished), and The Land would have its own 2D feature, about human interaction with the land, called *Symbiosis*.

It was a tall order, especially the Circle-Vision features, which had to be shot and exhibited with custom-made equipment. "We had to build special cameras, all kinds of special projectors," Don Iwerks recalled. "It was a monumental effort on the part of our studio Machine Shop." The shop was charged with creating made-to-order projection systems as complicated as Swiss watches that would also need to run like clockwork, hour after hour, day after day, without breaking down—handling the looped films as gently as possible, to make each print last as long as possible.

The EPCOT project was the "highlight of my career," Iwerks said, as his department added personnel—going from thirty or forty to "a couple hundred, working three shifts in two locations, to just get all that work

done." Over a period of two years before EPCOT opened, the Machine Shop crew churned out fine-tuned equipment as if they were the General Motors of projection systems, with a success rate Iwerks estimated at "99.9 percent perfect" and morale soaring. "It was just so much fun to work there," Iwerks said. "It seemed like every night you're going home and you're thinking about what you're going to do the next morning and you almost can't wait to get back."

Early on, Iwerks brought together the cast members who'd been managing and maintaining the projectors at Disneyland, the Magic Kingdom, and the Disney studio for a four-day meeting with the Machine Shop personnel. "Rather than build the same thing over again," he recalled, they asked the projector servicemen what the day-to-day problems were. "And so we were able to make a number of changes that helped them—which reduced maintenance, which reduced cost." They built new film cabinets to house the looped prints—requiring over one thousand sprockets, also built in the Machine Shop—and at least 125 specialized motion picture projectors. The systems would also take advantage of the digital revolution, as Iwerks convinced Disney to invest in control systems run by computers.

Digitization extended to sound as well as projection control. "Everything for EPCOT was new," said Glenn Barker, who joined WED in 1975 to work on audio and video production. Up until that point, sound in Disney park attractions was recorded on thirty-five-millimeter film and played back on one-inch thirty-two-track magnetic tape on reel-to-reel machines. In the early 1960s, attractions used what was termed a "shuttle system" that included a pair of tape players. When the audio tape on one unit ran out, a mechanical trigger would start a second playback unit; the tape on the first machine would then rewind to get set to take over again when the second reel-to-reel reached its end. The installation of "it's a small world" at Disneyland saw the advent of the "bin loop," in which the looped audio tape was pulled out of the center of a reel, ran through the player, then wound back onto the outside of the reel. The bin loop audio players could be synchronized with inaudible tones called "sync pulses" superimposed on the recording every sixtieth of a second—with

the unfortunate potential for machines to be locked into incorrect syn-chronization if a pulse or two was missed. This was a particular hazard within "it's a small world," where the many versions of the theme song needed to blend together, and a failure of synchronization would create a harsh dissonance.

That's why Barker and the other Imagineers charged with rigging the audio for EPCOT were ecstatic to learn of a computerized system with a nearly foolproof potential for synchronization. "We had just heard about this new thing coming out called digital audio," Barker recalled. "We bought four thirty-two-track digital tape machines and overnight became the largest digital facility in the whole world." Instead of audio tones, the new system used what was called an SMPTE time code—named after the Society of Motion Picture and Television Engineers. "They invented this actual recording of a clock, broken down into frames so that you could have exact identification of every single frame in there. And using that, you could synchronize multiple machines [so that if] they were all told, go to one hour, ten seconds, they would all go there and then lock and then play together."

Some of the Audio-Animatronics figures also took a leap forward—almost literally—with the depiction of a Founding Father previously unseen at any Disney park. "We were looking for, how do we push that Audio-Animatronics technology even further so it feels like these figures have come to life," Peggie Fariss said. "And what would be more lifelike than to have one of them walk up the stairs?" That's what Ben Frank-lin would do at the American Adventure pavilion, which also featured Audio-Animatronics figures of Mark Twain and Will Rogers, among others, all of them on platforms that could appear and disappear from the stage—an innovation over the static stage at The Hall of Presidents. "By having so many moveable show elements, it really brought the story to life," Fariss said.

The writer and producer on the American Adventure was Randy Bright, an Imagineer with one of WED's most colorful Disney resumes. He had begun his career during a summer break from college in 1959 when, he liked to say, "I had enlisted in the navy—the Disneyland Navy."

His first job, on the Sailing Ship *Columbia*, led to several summers of working on nearly every attraction at the park. For a time, he had even roamed Tomorrowland as the costumed spaceman. "John Glenn had just gone into orbit," he recalled. "And each guest that came by [would] say, Colonel Glenn, I presume, and I would have to laugh and pretend that I'd never heard that before. And I heard it at least seven hundred times a day."

He earned a degree in political science from Cal State Fullerton but in 1965 began working full-time at Disneyland, creating publications and audio-visual presentations for Disney University, the park's training program for new cast members. In 1968, he joined WED at the urging of Marty Sklar as a staff writer working on attractions for both Disneyland and the Magic Kingdom. He left briefly for a three-year stint as manager of employee communications at the Florida branch of Disney University, but by the late 1970s, Bright was head of WED's communication team—and also using his experience in attractions to head up the design team for the American Adventure pavilion for EPCOT. As producer and director, he wrote the original script, conceived the show, and supervised the creation of the accompanying film and Audio-Animatronics figures.

Among his many talents, Bright was a writer, but he was adamant that words were among the least important tools Imagineering had. He had two design commandments, the first being "think visually—even if you were a writer." He continued, "If you are dealing with verbal communication, you better do it in a very sparse way, because these guests are not coming here to read signs and to read books and to be talked to." Most of the information visitors were taking in would be visual—which led to Bright's second commandment: "Keep your audience in line." In other words, Imagineers needed to put themselves in the shoes of their guests at every moment, anticipating their reactions whether they were in the middle of an intense attraction or standing in the calm of the Disneyland hub, surrounded by flowers. They may take photos of the blossoms or they may seem to ignore them, Bright argued, but every visual input "begins to chalk up bits of information on their own computer memory bank in the back of their minds. So the sum total

of a hundred thousand visual stimuli like that at the end of the day [is that] Disneyland is fantastic." Wherever they may be in a Disney park, guests "are being entertained through snapshots and beautiful scenes in their own mind. Only these scenes are living." In his assessment even the other guests—strangers taking photos, say—were part of that complete experience Imagineers needed to consider.

Bright encouraged what he termed "radical thinking." Conventional thinking, he said, led only to a predictability that in turn led to bored guests. Imagineers needed "the freedom to really think from a blank piece of paper . . . without any preconceived set of tools or notions or ideas in that earliest concept stage." Feasibility, budgets, and schedules came later, but the creative idea came first. "You've got to let that thing hatch by itself and get out of the embryonic stage to begin with."

"Randy was like, anything goes," Kevin Rafferty recalled. "He was just so optimistic, and he always had fun, you know? You can't create fun unless you have fun. And he always had ideas. I think one of the blessings and the curse combined of being an Imagineer is it never turns off. You're always thinking. You're always doing." Bright commuted to WED in Glendale every day from Orange County, "and on that long drive home, he would come up with fifty new ideas. And the next morning he would call me into his office and say, 'You know, I was thinking about this idea for a show that maybe Mickey Mouse is fighting the forces of evil and Maleficent comes up in the moat in front of Sleeping Beauty Castle.' And so we'd start talking about it, and that was kind of the beginnings of Fantasmic!" Another time, thinking about how to theme an additional water park at Walt Disney World, he told Rafferty, "'I was thinking of an idea where maybe this freak storm comes in—maybe a typhoon,' and he called me in to help him think about what that [would be like,] and that became Typhoon Lagoon."

As EPCOT came together, all of WED was bustling with new ideas, and the fragments of what would become more than a dozen different attractions blended together in a bountiful banquet of creativity. During that time, Rafferty said, he loved to visit the area dubbed Pelican Alley in the MAPO Building, where "they had artisans and technicians putting

together all of the Audio-Animatronics figures for EPCOT—you know, the family that rode in the station wagon at World of Motion and Mark Twain for the American Adventure," he recounted. "What an amazing time! I mean, people were running into each other. It was just crazy."

It was also collaborative and fruitful, Orlando Ferrante recalled. "Everybody knew they could help each other. No one said 'That's not your job, man' or 'That's not my job, man.' We didn't allow that type of attitude. If someone was having trouble, they didn't hesitate to ask for help. When we were doing installations, I used to set up a bar in the hotel room or in the apartment, wherever it was. We would all meet after-wards, and we would go over the day. Primarily, it would be, who needs help, where do you need it, what type do you need—and we'd arrange to have it."

VI. BRINGING THE WORLD TO EPCOT

The American Adventure had at one time been designated the entrance to EPCOT's circle of international exhibitions, rather than the apex, directly across the lagoon from the bridge to Future World. It was one of many changes that the World Showcase went through on the way to its final form. The chief visionary on that half of the park was Harper Goff, back among the Imagineers for the first time since his work on Disneyland.

Before Goff took over design for the World Showcase, that half of the park was conceived as two semicircular buildings—similar to what became Communicore—"with maybe just a courtyard in the center," Goff recalled. The pavilions were pie-slice wedges, one country not that dif-ferent from another. It would be, Goff thought, an unappealing setup, so he created concept paintings of a more elaborate configuration: an arc of themed pavilions with architecture inspired by each nation's familiar sites. He hung one of his most enticing versions strategically over his desk, where visitors to his office—such as Card Walker—couldn't miss it. "I finally sold [the idea of] building it outdoors and not putting it inside, not by arguing. I just made a lot of big illustrations of the way I

envisioned it, and people gradually accepted that it was the way to go"—
and that Goff would be the project director.

Goff brought to the project the concept of pavilions that reproduced
the architecture and landmarks of each county, with separate plazas onto
which individual shops and restaurants would open. "I like the idea of
walking out of one part of the world and walking across a narrow no-
man's-land and hearing different kinds of music and smelling different
kinds of incense and different kinds of food cooking, and then sud-
denly saying, 'This must be this country.' And then losing yourself in that
country until you almost forget where you are. Then you come out and
right next door is something else." His mission, Goff said, was "to bring
what I had brought to the films that I had done, which was satisfying the
desire of people to travel that probably never would get to go [abroad]."
He sketched out some national pavilions, such as Sweden and Australia,
that were omitted from the final lineup, as well as the countries now
familiar to EPCOT visitors. (Only Morocco and Norway were added to
World Showcase after opening, in 1984 and 1988, respectively.)

By opening day in 1982, EPCOT Center was about $400 million
dollars over its original $800 million budget, even though some major
attractions—including The Living Seas and Wonders of Life pavilions—
were still years away from opening. But the park welcomed its first guests
with an elaborate (if brief) celebration at nine a.m. October 1—exactly
three years, almost to the minute, since the groundbreaking. In his
remarks at the opening, Card Walker, CEO and chairman of Walt Disney
Productions, called it "by far the most exciting day in my whole career
with this wonderful company." Honoring the Imagineers and their col-
laborators, he added that the park "represents the culmination of more
than 25 million hours of effort by talented artists, designers, engineers,
and technicians, with hundreds of advisors and thousands of construc-
tion workers, all propelled by the power and force of an idea—of one
wonderful man, Walt Disney." The mention of Walt was the first line in
his speech to rouse the crowd to spontaneous applause.

A reported twenty thousand people visited that first day, and Walker
expected the first year's attendance would exceed the company's projection

of eight million. Inevitably, not everything ran perfectly. According to Imagineer Orlando Ferrante, there wasn't enough time to fine-tune some of the brand-new ride systems in the park. "We were literally doing a lot of the adjusting on these rides way after we opened," he said. One of the most problematic attractions was the Universe of Energy, with its six large mobile platforms of theater seats. For the first six months, the ride system broke down repeatedly, requiring guests to walk through the stalled attraction to exit.

As with the Magic Kingdom, a more formal dedication ceremony took place some weeks after the opening, on Sunday, October 24. There were ten thousand invited guests, including Walt Disney's widow, Lillian; a giant marching band; and representatives from some two dozen nations, including all those with pavilions in the World Showcase. Walker spoke again, quoting from the dedication plaque that included an excerpt from his remarks weeks earlier. It paraphrased the Magic Kingdom plaque and concluded, MAY EPCOT CENTER ENTERTAIN, INFORM, AND INSPIRE, AND ABOVE ALL MAY IT INSTILL A NEW SENSE OF BELIEF AND PRIDE IN MAN'S ABILITY TO SHAPE A WORLD THAT OFFERS HOPE TO PEOPLE EVERYWHERE IN THE WORLD.

Not everyone was immediately impressed, perhaps because EPCOT was so vastly different from the Magic Kingdom that it was difficult to fulfill some guests' expectations. One eleven-year-old who had been hearing about the park for years arrived with great enthusiasm soon after the opening for a three-day stay with his parents. "Unfortunately," he reported, "you only needed half a day to ride the rides and another two and a half to shop for French knickknacks."

But even if EPCOT Center did not follow Walt's blueprint for an Experimental Prototype Community of Tomorrow, it was still true to his wider vision of the world. Future senior vice president of operations at Walt Disney World Jim MacPhee—who was in the EPCOT parking lot as the first car drove in on opening day—noted that Walt Disney had wanted EPCOT "to be a place where people from around the world came to have fun and to play and to learn and to interact."

"Walt was always interested in education too," Barry Braverman said.

"This is kind of a part of his legacy that doesn't often get talked about. He was fascinated with everything. He didn't draw a line between education and entertainment. He just wanted people engaged in what was going on. So, those of us that came from the education side, we were really on a mission to prove that we could do this."

Braverman, the former elementary school teacher, found personal satisfaction in what EPCOT Center had accomplished. "I remember one time I was walking around World Showcase during the early days of EPCOT and there was the [America Gardens Theatre] on the far side of the lagoon, and there was this dance troupe or a musical troupe from Africa performing, and I remember looking across that over at Spaceship Earth and thinking, 'Wow, this place . . . there's never been anything like this. The art, the culture, the science, you know, brought up to a level of public communication that was really unprecedented. So I think it really was important."

EPCOT certainly offered a unique blend of experiences to its guests—and soon after opening, it also provided a kind of mascot for the Imagineers: Figment, the purple dragon who starred in the Journey Into Imagination attraction, which opened in Future World on March 5, 1983. The character actually predated EPCOT, Steve Kirk recalled, having emerged from an unbuilt land called Discovery Bay, conceived for Disneyland on the north end of the Rivers of America. Tony Baxter was the Imagineer leading the development of the area, which he conceived of as a Jules Verne–style land in which the *Nautilus* submarine from *20,000 Leagues Under the Sea* would be right at home. One show would be a kind of circus of steampunk-inspired mythological creatures, presided over by a character Baxter had dubbed Professor Marvel. Kirk made a sculpture of the professor, but when the project went nowhere, Marvel was shelved—relegated to a high shelf in Kirk's office while the Imagineers were busy ramping up for EPCOT.

Much later, Kirk continued, "Tony came into my office and said, 'Where's that little figure you did of Professor Marvel?'" Kirk pointed to a cabinet, where the Captain Marvel sculpture sat in his top hat, holding a little dragon. Baxter took it to a meeting with representatives from

Kodak, who were considering sponsorship of the Imagination pavilion. "The Kodak people said, 'This is fabulous! This is wonderful! Do we get the dragon, too?' And Tony said, 'Oh yeah! You have the dragon, too. He goes along with the little guy there with the top hat.'"

That was the unlikely origin of the Dreamfinder, a character Baxter invented to "run around the universe collecting imaginative ideas," Kirk said. "So Professor Marvel was reincarnated as Dreamfinder and the dragon—Tony came up with the idea of calling him Figment. And they were the stars of the Imagination pavilion for Kodak." With Mickey Mouse and friends banned from EPCOT Center in the early years, Dreamfinder—with a Figment puppet on his left hand—became one of the few characters to wander the park's walkways, posing for photos with the guests. "It just proves," Kirk concluded, "don't ever throw an idea away."

CHAPTER 10:
ZEN AND THE ART OF THEME PARK EXPANSION

"The emotional appeal that we had was basic to begin with—
things that adults could enjoy without feeling embarrassed . . .
which has given us our international appeal. We've had a
tremendous international audience ever since we started.
I've been conscious of that." —Walt Disney

I. JAPAN CALLING

ESMOND CARDON WALKER, known throughout his life as "Card," was eight years old in 1924 when his family moved from his birthplace in Rexburg, Idaho, to Southern California. In Los Angeles, he had a paper route in his teens, which led to his fateful first encounter with a neighbor named Walt Disney. The meeting would change his life.

After graduating from the University of California, Los Angeles, in 1938, Walker knew just where he wanted to go. He headed to Walt Disney Productions for his first job out of college, taking an entry-level position in the mailroom as a "traffic boy," spending most of his time transporting drawings between departments. That led to a job in the camera department, then as a unit manager on short subjects.

Soon after the 1941 attack on Pearl Harbor by the Japanese, Walker went to Walt Disney and told him he was enlisting in the navy. Walt was

both sorry to see him go and envious: after trying to talk the young man out of it—perhaps just testing his resolve—he told him he wished he could do the same.

Walker served for the duration of the United States' involvement in World War II, becoming a flight deck officer aboard the USS *Bunker Hill*. The aircraft carrier saw heavy action in the Pacific from 1943 to 1945, including being hit by two kamikaze planes within thirty seconds on May 11, 1945, during the Battle of Okinawa. At least 372 sailors died in the attack.

After the war, Walker returned to Walt Disney Productions, where he rose to head of the marketing division on his way to being named president in 1971. It was then he encountered the Japanese again, across a negotiating table. An ambitious group of Japanese investors wanted to build a Disneyland near Tokyo.

"Card had a really tough time dealing with the Japanese," Marty Sklar said some years after Walker died in 2005. "The hardest part for him was coming to grips with the loss of so many of the people he served with on the carrier. Many of them were his friends."

Walker's counterpart in the negotiations, Masatomo Takahashi, had also fought during the war, on the side of the Japanese. By the time he and Walker started talking, Takahashi's organization—called the Oriental Land Company—had been trying to convince Disney to build a park on its land for more than a decade. Oriental Land Company was founded in 1960 to reclaim and develop land off the coast of Urayasu, a town on Tokyo Bay in the Chiba Prefecture, about ten kilometers east of central Tokyo. The reclamation work began in September 1964—by which time the telephone calls to the Disney offices in Burbank had already started. Part of Oriental Land Company's mission from its founding had been to build a "recreational facility" on the reclaimed land by the bay, and a Disney park—though a long shot—was considered the ideal development.

Nothing happened until after the opening of Walt Disney World, when Disney was pondering what should be the next big project for its Imagineering team. EPCOT might have been the top option, but it wasn't the only idea on the list. "Phone calls were coming into the

studio to build parks everywhere in the world," recalled Frank Stanek, then WED Enterprises' vice president of research and planning. Stanek led a study of the options around the globe, concluding that the top two options were Europe and Japan, the latter offering "the highest potential for success, even though it may be more difficult."

Whether due to his war service, concern about overreaching, or other reservations, Card Walker did not want to deal with the Japanese. But Oriental Land Company wouldn't go away. By 1973, company representatives were calling Walker's office every week. Still, Carl Bongirno remembered, "Card did not want to do any other projects other than EPCOT Center. Every so often he'd say, 'Oh, the Japanese are calling me. They want us to do a project.' And one day, Dick Nunis and I were in his office and his secretary comes in and says, 'Card, the Japanese are on the phone.' And he turned to Dick and I and said, 'What do I do with the Japanese?'" The three men brainstormed and decided to tell the Japanese that Oriental Land Company would have to pay all costs on the project—design, construction, everything—and Disney would retain control of operating the park. And succeed or fail, Disney would get paid its percentage from the first dollar earned. They expected such conditions would be too onerous for the Japanese to accept. Instead, when Walker got Takahashi on the phone, Bongirno said, "He gave him all these ridiculous demands and they said, 'Okay, let's go.' And Card's jaw dropped and he said, 'We've got a project.' And so we did it."

The company did not jump in without due diligence. Disney executives and Imagineers, including WED vice president Orlando Ferrante, went to Japan in December 1974 to see the Oriental Land Company site in person, and Stanek began an intensive six-month study of everything involved—the physical location, the viability of the company, the local market for a theme park, and so on. "We'll get to understand what their thinking is and how they are to work with," Stanek told Ferrante. "Disney didn't work with partners a lot, other than certain sponsors," so this project would be groundbreaking in more ways than one.

It would not be the first theme park in Japan. Among the many amusement centers dotting the country, the best known was Nara Dreamland,

which opened in 1961 in Nara, Japan, about 275 miles southwest of Tokyo. It was a blatant knockoff of Disneyland, complete with a train depot at the entrance, a Matterhorn-inspired roller coaster called the Bobsleigh, a monorail, and a pink turreted castle at its center. Dreamland had been built on the cheap by businessman Kunizo Matsuo after he had tried and failed to reach a licensing agreement with Walt Disney. Being the closest thing to Disneyland in Japan, Dreamland did a brisk business for many years, and a second Dreamland opened in 1964 in Yokohama, just 25 miles south of central Tokyo.

But Dreamland and its lesser competitors were not Disneyland, and in the years after World War II, the Japanese had developed a particular affinity for Disney. The United States had occupied Japan for a while after the surrender, with strict controls on the media. The censorship meant that some of the earliest films that were allowed to be shown in Japanese theaters were Disney films—*Snow White and the Seven Dwarfs*, *Cinderella*, and *Bambi* among them, and none of them previously released in the country. When it reached Japanese theaters in 1950, *Snow White* was quickly embraced by both audiences and Japanese filmmakers. Many animation scholars trace the origins of the distinctly Japanese animation genre known as anime to artists' attempts to imitate Disney design and techniques on much more restrictive budgets. Now the children who grew up after World War II on an abundance of Disney stories had children of their own, and Oriental Land Company would capitalize on their lifelong fandom. Tokyo Disneyland would be an authentic western theme park that would give guests an all-encompassing experience closer to California than Tokyo. There would be American food and English-language signs. There would not be vending machines or mats spread on the ground. Tokyo Disneyland would be an island of Americana dropped in the suburbs of Tokyo. That, Takahashi believed, would be the magnet needed to draw millions of his countrymen to the park.

The conclusions of Stanek's viability study surprised him. At a time when annual attendance at Disneyland was approaching 10 million, "we came up with a potential of 17 million visitors [a year that] could visit this park." The number was so high Stanek asked for the estimates to

be recalculated. "We tested it and tested it, and we still came up with 17 million."

Creating a brand-new park with that capacity in a reasonable time frame, Stanek concluded, was not possible, so he recommended using the Magic Kingdom as the model for the Tokyo site: attendance in Florida was just over ten million a year. With the assistance of Marty Sklar, Claude Coats, John Hench, and others, Stanek's team created a plan, with a park and hotels, for the Urayasu site. Finally, in September 1975, a Disney executive team went to Japan: Stanek, Dick Nunis, Donn Tatum, and others. The Oriental Land Company was a joint venture of two older companies, Mitsui Real Estate and Keisei Electric Railway, so the Disney group headed to the Mitsui Real Estate headquarters in Tokyo. Stanek took the stage for a presentation in the middle of a ring of seats holding about a hundred Japanese—an experience he later compared to a hospital operating room, "where instead of an operating table in the middle, it was Frank Stanek." Presenting his group's findings took three hours, in part because every word had to be translated by an interpreter. "I'll tell you, I was a wreck when I finished that," he said with a laugh. But it was worth it, as the report was well-received.

That was a Monday. On Tuesday, Nunis handed the Japanese a two-page "memorandum of understanding," saying, "We'd like to have this signed by the time we leave at noon on Friday." Oriental Land Company signed, and the real work began, with Stanek as project manager. He would be "coordinating everything," he said, "plus working with the engineers, the designers, setting criteria, doing studies, communicating, organizing"—as well as serving as go-between for Walker and Oriental Land Company. A full plan for design and construction was finally ready by April 1979, some five years after that first phone call Walker made to relate Disney's terms. There was one significant difference between Walker's 1973 demands and the final, 1979 agreement: Oriental Land Company would operate the park itself, but with close supervision by Disney.

Once the construction plans were approved by the Chiba Prefecture, the groundbreaking and an international press conference were

held December 3, 1980. The groundbreaking included a solemn Shinto purification ceremony—called Kiri-Nusa-San-Mai—on the 114-acre Tokyo Disneyland site.

Disney would have its first international theme park. It would be paid for, owned by, and operated by Oriental Land Company, which would pay Disney for its designs, its intellectual property, and its expertise. For the first time, Disney would teach an outside entity how to run and maintain a theme park to Disney's high standards. The venture might be financially risk-free for the company, but it would put Disney's reputation on the line, testing whether the Disneyland concept could work outside the United States. It was a big gamble with both the company's image and the Imagineers' history of success. And the WED Enterprises team would have to design and build all the attractions for Tokyo Disneyland at the same time it was creating EPCOT Center. The hiring frenzy continued, and a good number of the young Imagineers would be headed to Japan.

II. THE TOKYO GENERATION

When Craig Russell was ready to graduate from college with a mechanical engineering degree, his plan was just to stay in school to get a master's and a PhD. Then he saw a posting that Disney would be on campus, interviewing for engineers to work on a Disneyland in Tokyo. A Southern California native for whom everything Disney was a lifelong passion, "I decided to interview just for the heck of it." After all, he thought, the park would be done in three years and he could then go back to school having had this great Disney experience. He got the offer, took the job, "and probably about six months in, I just decided that I found what I loved to do and I never looked back."

When Russell started at WED Enterprises in 1980, "very few people worked on Tokyo," he recalled. "Almost all the company was working on EPCOT and was absorbed by EPCOT at the time. And a very small group of us got to work on the first international park." Since the design of Tokyo Disneyland would be based on the Magic Kingdom in Florida, veteran Imagineers who had worked on the original Disneyland,

including Marc Davis and Claude Coats, were the creative leads. "It was the perfect blend of both the first opportunity to go overseas and teach," Russell said, and "the amazing good fortune to work with so many people who worked very closely with Walt."

He would also be working closely with a lot of other Imagineers just starting out, such as Bob Weis. Weis had grown up in Southern California going to Disneyland with his family every year on his birthday. Calling himself "as close to a Disney kid as possible," Weis recalled fondly his first job with the company—selling popcorn and ice cream at age nineteen, watching as Space Mountain was constructed, little by little. Only later did he understand that this part-time gig was his first lesson in Imagineering, teaching him "what it's like to serve that many people and keep them all happy in a day." He studied theater and architecture at California Polytechnic University in Pomona and was on the verge of graduating in 1980 when he learned Disney was recruiting on campus. He got an interview and then a job offer and started work at WED Enterprises two weeks after graduation. "They offered me, at the time, two different opportunities," he recalled. "One was on EPCOT and one was on Tokyo. EPCOT was the big project, the big thing that everybody was focused on, and there was kind of a tiny little team across the street working on Tokyo." Weis weighed his options and quickly favored the chance "to pick up and move to Japan and work on this very challenging project with a small group of people. I just fell in love with that idea. So I immediately took the Tokyo project."

Early on, Weis understood that the company had undertaken much larger financial and creative risks with EPCOT, and that team had priority within WED. "It was really kind of a totally separate unit to do Tokyo," he said. "And it was very hard if you called somebody on EPCOT because you needed help. They would say, 'That person is too busy with EPCOT. You're going to have to find another way to do it.'" The upside was that "it made the Tokyo team very resourceful, because we had to figure out how to get things done . . . even when the majority of the resources were really devoted to EPCOT." The downside was that "it was tough to be the scrappy second project."

EPCOT had its roots in the vision of Walt Disney, while a Disneyland in Japan was a proposal Walt had simply ignored or brushed off. In one view, the Tokyo park was Oriental Land Company's mission, which WED Enterprises had been hired to accomplish. "EPCOT, to many people, was the realization of the dream that Walt could not realize himself," Russell said. "And Tokyo, by comparison, was a bit of an afterthought." As a result, he said, "we had a very small number of people who were assigned to build a very large park. It was supposed to be easy, because it was supposed to be this replication of what we had already done in Florida—and to some degree in Anaheim. But I think the company, going in, didn't really have a very clear view of just how big a job it would be. Which made it very exciting for those of us who got to do it."

That excitement was amplified by the fact that anyone working on Tokyo who was based in Glendale—as Weis was to start—was subject to winding up in Japan. "On the Tokyo team," Weis said, "we had a joke about business trips that two weeks would get you three weeks, and three weeks would get you relocated. Because once you got over there, that little small team in Tokyo would say, 'Wow, we really need this person. Can you just stay?'" Weis was relocated to Japan within eight months of starting his job—the first time he'd ever been out of the United States. Except for occasional visits, he didn't come back for two years. Vacations were often spent going east rather than west: "Everybody got to travel up and down Japan or to Korea or across Asia." Weis eventually got to travel even through mainland China, visiting Beijing, Shanghai, and other cities—an experience he would draw on decades later.

Because the team in Tokyo was so small, Weis said, "you got a lot of responsibility very quickly." As an architectural graduate, his first assignment was as a coordinator on interiors and architectural graphics and orientation. The bulk of the design work had been done before he joined up, so his chief concern was making sure the Disney and Oriental Land Company teams were on the same page, "and trying to get the construction done properly under the direction of these very senior mentors." The size of the WED group meant "everybody kind of knew each other. We all rode buses across Tokyo to come to work in the morning." It was,

he said, "a family," and as within a family, "the older Imagineers invited the younger ones over for dinner and took us around and introduced the company to us—helped us figure out how to do things. And we brought, of course, new tools to innovating the process."

"It was kind of a new generation of creative and technical talent coming into this company," Barry Braverman said of WED's explosive growth during the EPCOT and Tokyo projects. The two teams didn't cross-pollinate much, with their attention focused in opposite directions—and not just geographically. The EPCOT people believed they were plotting the course to the future, while the Tokyo team was reproducing the past. Nevertheless, Braverman said, "Everybody was very young and there was so much to do that the opportunities were abundant. I mean literally you could just start working on something and if you were doing a good job people just let you keep doing it. Whatever you had the imagination and energy to get involved in, they didn't stop you until you really got off track. It was a good time."

There was some advantage to their limited experience. Not having worked on the Magic Kingdom or any previous WED project, the young Imagineers had no baseline against which to judge their Tokyo experience, no habits or expectations they needed to adjust. Working with the Japanese wasn't unusual—it was just the way things were. Still, building trust with Oriental Land Company and local contractors took time and patience. At first, Russell said, "I encountered not a lack of trust, but a little bit of stiffness between [these] two big companies. . . . [They] just sort of had to figure out how to dance with each other."

As the face of the Disney company in Tokyo, Frank Stanek found his own job required more than just good business sense. "We had to learn to deal with a partner that was not proficient in our language, so that created a whole bunch of other issues," he said. "We were in a foreign country and had to learn about cultures and business operations and so forth. I was not so much a business executive; I had become a diplomat."

In Glendale, the Imagineers had strategized about how to build trust, but once they got to Japan, strategy gave way to the interpersonal dynamics. Trust was built less from company to company than from person

to person. Eventually, Russell said, "there were lots of wonderful get-togethers and parties that were outside the office. And people got to know each other really well and really got to be very clearly aligned with what we were doing."

Masatomo Takahashi, the president of Oriental Land Company, demanded there be no compromise on quality, despite costs that rose above initial estimates. It was his company's goal to set a new gold standard for the service industry in Japan. Takahashi, Dick Nunis said, "was the Walt Disney of Tokyo Disneyland. First of all, I think he saw through entertainment you could have a better understanding among people. And boy was he right. Takahashi-san was really a dreamer, and he allowed us to bring nine of his top executives to Disneyland for one year to train. And we had the buddy system, where we'd put one of our top operating people with [each of] them, and they would live it"—the Japanese executives shadowing the Disneyland operational team day by day and minute by minute.

Those first nine were just the start. More than a hundred Oriental Land Company employees followed, spending a year with their Disneyland counterparts at the parks in Anaheim and in Florida and at WED in Glendale for hands-on learning—not just the management routine and nuts and bolts, but the quality standards, courtesy, and efficiency. These one-hundred-plus would return to Japan to train the thousands of cast members who would be hired to work in the park. To aid that effort, they would have meticulous manuals covering every aspect of the park, written by Imagineers and translated into Japanese.

Familiarizing the Japanese with the parks sometimes involved putting on rubber pants in the wee hours of the morning—an experience just as instructive for the young Imagineers as for the foreign guests. "One of the ways I actually learned a lot about really what goes on at our parks was that I was charged with strapping on hip waders and walking through Pirates and [it's a] small world,'" Craig Russell recalled. He and his Japanese pupils toured closed attractions "all night long during the third shift for days and weeks and months, because it was the way that

we could actually learn what these attractions were." It was an experience that "just let it settle on everybody what the magnitude of this was."

III. MEET THE WORLD

Even though the Tokyo park adapted much of the Magic Kingdom—reproducing most of its opening day attractions as well additions such as Space Mountain—it was not a carbon copy. For one thing, any attraction with narration needed to be translated—a process more complicated than it sounds. Imagineer X Atencio, who had written the original Pirates narration and theme song, recalled "the challenge of working with the Japanese on translating our scripts into Japanese." Atencio went to Japan to supervise the new recordings for Pirates of the Caribbean and found some of the translations problematic. "For instance, we sent a script over there and they recorded a voice—[but then] you found out the ghost, instead of saying, 'Dead men tell no tales,' he says, 'There is no mouth on a dead person.' That doesn't make sense. That isn't what we're trying to do. Well, there's no Japanese equivalent of 'Dead men tell no tales.' They had to come up with something else." Atencio suggested "If you're not careful, you will not pass this way again," which was more easily translated. "But we had to keep massaging the script until we got something that we said, 'Well, the Japanese will understand this.'"

Another translation problem arose in the Country Bears show. "There was a scene about hibernating, and they said, 'We can't use that,'" Atencio remembered. "And I said, 'Well, why not? Don't the Japanese understand "hibernate"?' They said, 'Yeah, they understand that bears go to sleep in the wintertime.' I said, 'Well, what's wrong?' 'This might be the summertime, and you can't say it in the summertime.' This was a general thing about bears hibernating. I don't know. They just would not buy it. We had to delete it from the script completely." And so it went, line by line, show by show.

Some attractions needed a three-dimensional translation, starting with Main Street, U.S.A. The grand promenade leading to the park's

central hub and Cinderella Castle became the World Bazaar. "Originally it was going to be a much bigger international market," Stanek said, "but we reduced it back to more of the traditional Main Street. Then we put a roof over it." The angled glass ceiling meant that the wide street needed no curbs or gutters, and it was an acknowledgement of Japan's less tourist-friendly weather: sixty inches of rain a year—15 percent more than Orlando and more than four times the average in Anaheim. Another change: Center Street, the cross street in the bazaar, unlike the cul-de-sacs on Main Street, U.S.A., extended beyond the bazaar in both directions, taking guests along paths to Adventureland on the left and Tomorrowland on the right.

Frontierland was renamed "Westernland," since the Japanese word for "frontier" did not carry the same sense of pioneers and gunfighters, but its features were much the same as in the Magic Kingdom, including a shooting gallery, the Diamond Horseshoe Revue, and the watercraft. The railroad route was also altered: rather than circumnavigating the entire park, the Western River Railroad encompassed just Adventure-land and Westernland. It had only one station, on a second floor above the boarding area for the Jungle Cruise. This avoided the attraction's regulation under the Japanese government's transportation authority: a railroad with just one stop was not considered a railroad, while a second station would have required meeting government regulations.

The biggest changes were to Tomorrowland, where the Monorail was missing and two new attractions—The Eternal Sea and Meet the World—were situated along with Space Mountain, StarJets (a version of the Disneyland Astro-Jets that had also opened in the Magic Kingdom in 1974), and a Circlevision theater. The two new attractions were the only shows in the park to have a distinctly Japanese point of view. *The Eternal Sea* was a 200-degree film attraction, akin to the *Impressions de France* movie for EPCOT, telling the story of humans' relationship to the oceans from a Japanese perspective. Meet the World was the more elabo-rate of the two, a nineteen-minute Audio-Animatronics show hosted by a talking crane—a bird revered by the Japanese. Aided by film clips and more than thirty animated figures representing historical figures,

the crane recounted the story of Japan. The emphasis was on trade and diplomacy with other countries, particularly the opening up during the Meiji period, from 1868 to 1912. The attraction was an inversion of the Carousel of Progress, as a pie-wedge block of theater seats in the center gradually rotated to face four different sections of a surrounding circular stage. (Meet the World was also planned to appear in the Japan pavilion of EPCOT Center's World Showcase but was canceled after construction had begun.)

The Sherman brothers were commissioned to write the show's theme song, and veteran Imagineer Claude Coats was the lead designer, with Blaine Gibson sculpting the heads for most of the Audio-Animatronics figures. Recounting Japan's history was fairly straightforward, Coats recalled at the time, until the Second World War approached. "We want to tell the Meiji period, which we do on the carousel, moving for forty-five seconds. But that ends in a period just before what we want to represent the war. Yet we don't want to get into the war as a bad-news thing. So we're doing that just with a few quick [flashes] of lightning and red and angry black clouds—and I think it'll be absorbed by our Japanese audience as something that had to be there, but not overemphasizing it at all." The narration referred obliquely to "dark days" that were now passed, and then moved on quickly to the present.

The park opened on schedule on Friday, April 15, 1983, just six months after EPCOT Center, and Disney chairman of the board Card Walker was on hand to cut a red, white, and blue ribbon, standing on a small platform at the entrance to the World Bazaar, accompanied by Masatomo Takahashi as well as Mickey Mouse and Minnie Mouse and Donald Duck. The bazaar's glass roof was a blessing, since the day was rainy, but still there were marching bands (in rain slickers), dancing Disney characters, and thousands of balloons released into the air. As with EPCOT, Walker was charged with reading the inscription on the dedication plaque, which wished the park to remain "an eternal source of joy, laughter, inspiration, and imagination to the peoples of the world" and "an enduring symbol of the spirit of cooperation and friendship between the great nations of Japan and the United States of America."

The English-language plaque was installed to the left of an identically sized plaque in Japanese. Since English is read from left to right and Japanese from right to left, each plaque appeared to have the primary position to readers of that language.

Oriental Land Company had spent the year before the opening frantically hiring and training three thousand part-time workers as cast members, hindered by the poor public transportation options to the site. A train station within walking distance of the park's entrance would not open for more than five years, so Tokyo Disneyland guests and workers alike depended on bus service from a train station twenty minutes away. A sixty-one-acre parking lot was available, but many Japanese did not own automobiles—particularly Tokyo residents—or simply preferred mass transit. Nevertheless, Tokyo Disneyland was an immediate sensation, selling nearly three million tickets before it opened. Park capacity was 55,000 a day, and Sundays in May were sold out by mid-April. Attendance would reach ten million guests on April 2, 1984, less than a year after the opening. Oriental Land Company reported a profit, including recovering the entire $650 million start-up cost, within four years. Disney's revenues began immediately, including 10 percent of admissions, 5 percent from sales of merchandise and food, and a portion of the profits generated from Oriental Land Company hotels.

Dick Nunis judged that the completed Tokyo Disneyland lived up to Disney's traditions and quality standards. "Walt would say, 'A good song is good in any language in the world.' I think he'd be very proud of Japan. Walt's probably up there in heaven saying, 'What took you so long?' That was Walt."

The park quickly became among the most visited sites in the country and by far the most popular theme park. It became the site of countless school excursions and Tokyo's number one date destination. In one poll, a majority of Japanese women named the park the single most pleasurable experience of their lives. "When Tokyo Disneyland opened, it was so far beyond any other amusement park of its time in Japan that in fact, many of them closed because they realized there is no way they can ever compete," Bob Weis said. Yokohama Dreamland stuck it out until

2002 and Nara Dreamland until 2006, "but some of the secondary ones just closed [soon after Disneyland opened] because, you know, Tokyo so dominated the landscape."

The success of Tokyo Disneyland was interwoven with the recent history of Japan, noted Israeli sociologist Aviad E. Raz in *Riding the Black Ship*, his book about the remarkable integration of a Disney theme park into Japanese culture. With foreign travel difficult or impossible for many families, OTC had wanted its "Japanese visitors to feel that they were taking a foreign vacation" by coming to Tokyo Disneyland. The "authenticity" travelers seek in exotic destinations, Raz wrote, was replaced by theming, the historical supplanted by the adorable. Largely as a result of America's seven-year occupation of Japan after World War II, he noted, American culture was "the spiritual foundation for Japanese society after the war," and OTC judged that "Disneyland represents the best America has to offer." In particular, the escapism of Disney stories appealed to a traumatized nation. Tokyo Disneyland quickly developed a devoted following, with returning customers representing an estimated 85 percent of visitors.

Three decades and many expansions later, that loyalty remains. "There is a reverence for Tokyo Disneyland in the team, in the people of Japan, the audience, the people who work there that is really different than anywhere else," Weis said. "There is this positive reverence, and the people who get to work on Tokyo projects at Imagineering love it because of that desire to be such a fantastic cultural icon. It's so important to the people." Weis was also quick to credit Oriental Land Company, which "has always wanted to do the right thing, and the best thing"—regardless of cost.

"In Tokyo we've made a cultural landmark," he said. "It's not a business. It's a symbol of Japan. . . . That's what we create. These moments that people take their kids, take their grandchildren, keep going generation after generation. So that deeper meaning of what it means to us then gets conveyed on to the audience. And that's why people do this work."

THE SURVIVAL OF WED

"We were under a lot of stress. . . . New work wasn't coming in. I think there was a sense that this place might be closed down." —Carl Bongirno

I. NEW DIMENSIONS

IN THE EARLY 1960S, guests at Disneyland could walk the plank of Captain Hook's Pirate Ship—to get to the Chicken of the Sea quick-service restaurant inside. It served all things tuna, including a tunaburger, for which the "secret recipe" was shared on placemats. (Hint: Think mayonnaise and chopped celery.) Guests could eat their burgers, tuna salad (served in a mini pirate ship), and hot tuna pie on little round tables in view of the adjacent Skull Rock Cove. There, a skull made of rock—or, at least, of Imagineers' rock equivalent—loomed over a wall of stone, water spilling from its mouth. The skull's eyes were dark during the day but lit up with an eerie green at night.

After gobbling down their meals, kids could play on the deck of the pirate ship, perhaps reenacting scenes from Disney's 1953 animated feature, *Peter Pan*, perhaps with one of the film's characters—a pirate, the evil captain, or Peter himself—on hand. When parents caught up, they might have the children pose at the ship's steering wheel, with a blue Chicken of the Sea logo behind them. Overhead, the Jolly Roger flag of skull and crossbones was always flying.

Chicken of the Sea's Pirate Ship Restaurant had opened soon after

Disneyland debuted, on August 29, 1955. Skull Rock Cove followed in 1960. But in late 1982, both went "into storage," to cite the *Disney News* euphemism for permanent removal. Fantasyland was getting a major face-lift, set to open in 1983—the sixtieth anniversary of the founding of the Disney company, and not long after the opening of Tokyo Disneyland.

Somehow amid the frenetic rush to open two new theme parks within six months, WED Enterprises had also found the resources necessary to redesign the heart of Walt Disney's original park. With opening day attractions inspired by the stories of *Sleeping Beauty*, *Peter Pan*, *Snow White*, *Dumbo*, *The Adventures of Ichabod and Mr. Toad*, and *Alice in Wonderland* (the Mad Tea Party), Fantasyland had always had the closest ties to the animated features that were Disney's signature achievements. "You always think of the heart of Disneyland being Fantasyland," Imagineer Tony Baxter said in recounting the restoration some years later. "It's where all of Walt's classic stories existed." But its flat facades, intended to evoke the tournament camp at a Renaissance Faire, had not been what was originally envisioned.

Fantasyland designer Herb Ryman and animation artist/architect Ken Anderson had envisioned a fully realized Bavarian town around the back of the castle, but time and budget constraints had reduced the attraction exteriors to colorful flats. They were intended to be temporary. Now it was more than twenty-five years later, during which time Jungle Cruise had been expanded and Tomorrowland completely revamped, while the thin Arthurian story line that defined Fantasyland had received only a new paint job. The land still fell short of the fully immersive experience the Imagineers had since achieved in attractions including Pirates of the Caribbean and the Haunted Mansion. Similarly, Captain Hook's Pirate Ship had been eclipsed by the 1958 debut of the Sailing Ship *Columbia*, a fully functional vessel with billowing sails that took guests around the Rivers of America. In any event, Captain Hook's landlocked boat fell apart during the Fantasyland renovation.

The "New Fantasyland" project of 1982–83 was inspired by Ryman's original designs and by Anderson's miniature architecture of the fairy-tale

buildings in Storybook Land. It would consist of a detailed and dimensional English village on the Peter Pan and Mr. Toad side and an equally warm and expressive German town on the Snow White side. The Imagineers began by "taking each of the pieces of architecture and giving it an emotional twinge," Baxter said.

The new buildings were designed by Ken Anderson, a trained architect who had been an art director on *Snow White and the Seven Dwarfs*—for which he had built a scale model of the dwarfs' cottage to guide the other animators. Anderson's involvement was particularly appropriate because the major new attraction to be added to Fantasyland was Pinocchio's Daring Journey, a dark ride akin to Mr. Toad. Anderson had been the art director for the *Pinocchio* feature and would now have the opportunity to re-create his designs in three dimensions, down to the detailed chimneys and brickwork.

Kim Irvine worked on the color schemes for the new building with John Hench, she recalled, including "all the little patterns, the little hand-painted things that are on the walls and such." The color schemes were meant to evoke guests' feelings about each movie, so Peter Pan's new facade was in greens and blues, Pinocchio's in yellows and in reds that matched the feather in his cap. "We also landscaped in all those colors and worked very closely with Julia Fisher, our landscape architect, and the horticulture group to make sure that the fronts of the buildings are always planted with types of flowers that would be in those regions, [and blooming in] color schemes that go with those movies." For instance, she continued, for the newly renamed Snow White's Scary Adventures, "we put the red roses climbing up the walls and different images that came from the film itself."

The totality of the overhaul spoke to the Imagineering principle that all design should enhance the storytelling. "That was something that John [Hench] used to impress upon us also," Irvine said. As guests walk from one land into another, Hench would say, "I want people to just feel that they're going into a different story—from what they see landscaping-wise and even what they feel under their feet." Coming from Adventureland into Fantasyland, for instance, guests would go from sensing the

hard-packed mud below their shoes to little European cobblestones. It was the Imagineers' signature evocation of a movie effect—the cross dissolve—that guests might not notice consciously but still altered their overall experience.

The indoor attractions were also rebuilt, with many of the original buildings razed and new ones constructed; the rides themselves were reconceived and reconstructed from scratch. Each followed a similar story line, but with more detailed sets, three-dimensional characters in place of the painted flats, higher-tech special effects, and some new Audio-Animatronics figures. Previously, the queues had all been outside the buildings; now the front loops of the waiting areas were inside themed spaces. Not much from the original attractions was preserved, although Dave Smith, who had founded The Walt Disney Archives in 1970, did a walk-through before each demolition and pointed to the things he wanted to preserve, such as a BEWARE THE WICKED WITCH sign from Snow White's Adventures and a twelve-inch Tinker Bell from Peter Pan's Flight.

Outside, the land's crowded layout was revised and opened up. The King Arthur Carrousel was shifted twenty feet farther from the castle— the better to appreciate the merry-go-round framed in the back doorway of Sleeping Beauty Castle as guests entered Fantasyland. The Mad Tea Party attraction moved around the corner to the plaza in front of the Alice in Wonderland attraction. To free up space for an outdoor seating area for the new Pinocchio-themed Village Inn restaurant, the Dumbo attraction—also redesigned, with a Victorian flair—moved to the former location of the pirate ship restaurant.

The cost of the Fantasyland overhaul was estimated at $36 million, or more than double the initial cost of Disneyland. It began with closings in early 1982 and would not be finished until the Alice in Wonderland attraction reopened in 1984. The rededication ceremony did not wait that long, however. Once both sides of Fantasyland adjacent to the carousel were ready to reopen in early 1983, plans were made for the requisite pageantry of a Disney unveiling. On May 25, the drawbridge to Sleeping Beauty Castle was lowered for only the second time in its history, after having been closed for more than a year. As guests were admitted to the

revamped area for the first time, they were led by some of the children who had first crossed the same bridge in 1955—now parents accompanying their own children.

II. TROUBLE AT THE TOP

The Fantasyland grand reopening was just weeks after the debut of Tokyo Disneyland, and the crew of Imagineers who had worked in Japan for two years or more were still making their way back to Glendale—and an uncertain future. "I had been away from the home office for a couple of years," recalled Bob Weis, who was just coming up on three years with WED Enterprises. "I didn't really have much experience in Glendale. And we all came back, and the EPCOT team had come back. Everyone was kind of resettling after this enormous amount of work. And it became clear that there was no plan for what was going to happen next."

A number of ideas were on the table: an expansion of EPCOT; a European park; an expansion in Tokyo. But none of these projects was ready to launch, much less grand enough to employ the entire EPCOT and Tokyo teams. Worse, they weren't even funded for early development. "The head of the company was so focused on getting EPCOT Center done that we couldn't get decisions on starting anything else," said Carl Bongirno. To have something in place to keep WED Enterprises steaming along, preliminary design would have had to start at least a year before EPCOT opened. That hadn't happened.

"You could tell that there was going to be a period of readjustment," Weis said. "So it became very quiet. It became very austere. People thought there were going to be big layoffs and prepared themselves for that. So it's interesting that you go through this incredibly high, tremendous success celebration of the opening of Tokyo, the opening of EPCOT—everybody talks about what we achieved together—and then the black cloud comes down. And it was a very difficult time."

The underutilization of WED Enterprises, in Bongirno's view, was tied to a leadership change at the top of Walt Disney Productions. Card Walker had been chief executive officer—and, beginning in 1980,

chairman of the board—throughout the EPCOT and Tokyo projects. But just after EPCOT's opening, Walker announced he was stepping down as CEO. He also relinquished the chairman title to another board member, Raymond Watson, but remained on the board. Walker was replaced as chief executive by Ron W. Miller, a former Los Angeles Rams football player who had married Walt Disney's daughter Diane in 1954—a time when the young athlete had had no intention of working in show business. According to Miller, Walt saw him knocked unconscious in a Rams game and asked him to join Walt Disney Productions to get him out of harm's way. He worked briefly as a director for Disney television programs before shifting into film production. After a series of coproducer credits, he graduated to sole producer with *Never a Dull Moment*, a Dick Van Dyke heist comedy from 1968. After producing a series of successful movies in the 1970s—including *Freaky Friday*, *The Rescuers*, and *Pete's Dragon*— he became president of the studio in 1980, under Walker's leadership as CEO. Miller's ascent to CEO in February 1983 had been marked at the Tokyo Disneyland opening, where Walker cut the ribbon but Miller also delivered brief remarks.

Walker felt Miller, with his background in film production, knew how to churn out hit movies, and he wanted the company to make "feature films that were somewhat more daring and provocative than the company's traditional films to attract the movie-going teen-age audience," according to a *New York Times* story. Miller had never worked closely with the parks division and had no firsthand experience collaborating with Imagineers. But he did see the bills WED Enterprises had racked up—the cost of opening EPCOT Center, in particular, since it was funded chiefly by the studio. Those numbers, Bongirno said, led Miller to buy into some bad advice from new board chair Watson about what Imagineering really ought to cost. Watson had an architectural background and didn't understand why Imagineering's costs ran to about 15 percent of total project costs. Architectural firms were expected to make do with fees equal to about 3 percent of total construction costs. So, Bongirno said, "he kept pressuring Ron to cut us back, cut us back, and that we

could do everything by outsourcing. Take the twenty top people and have them outsource everything."

Bongirno fought back. "I argued, 'That can't be done. You can't maintain this—you can't do the projects this organization does with twenty people. You need the story concept people. You have to do pre-liminary design. You do model work. You do Audio-Animatronics. All these are specialties that we have people knowledgeable in how to do that that you can't go on the outside and buy." In short, he concluded, "It never would have worked." As the inevitable layoffs began at WED, Bongirno dug in for a long fight, not knowing whether anyone would come to the Imagineers' rescue.

Impressed with the work Frank Stanek had done in Tokyo, Miller promoted him out of Imagineering, making him vice president for corporate planning. It would be his job to diversify the company and increase growth. "In 1983," Stanek related, "eighty percent of the company's revenues were coming from the theme parks and only twenty percent from all the other businesses." Because theme park attendance isn't consistent—a point made by the significant dips during the 1973–1974 oil embargo and the 1979–1980 energy crisis—"we needed to spread out and grow the company and expand it."

Stanek immediately put a European theme park on the studio's agenda, but it wasn't the highest priority. The company launched the cable Disney Channel in April 1983, then turned its attention to its live-action film division. "We had the whole issue of being known as a G-rated filmmaker," Stanek said, "which was great, because [parents] could send any of their children to the movie and not be worried about what they would be seeing." But it also meant no adult-targeted movies could be released under the Disney name. Despite pushback from some Disney Productions old-timers, Miller established Touchstone Films as a new film division in February 1984 and weeks later released the PG-rated adult romantic comedy *Splash*. Adored by critics, it also became one of the ten top-grossing movies of the year and catapulted stars Tom Hanks and Daryl Hannah and director Ron Howard onto Hollywood's A-list.

The success was among Miller's last, however. By the time Touch-stone got its second release—a rural drama called *Country*, with Jessica Lange and Sam Shepard—into theaters, Miller had been forced out.

The source of Miller's troubles was Disney's sweet and steady cash flow, which corporate raiders could smell all the way from New York City. With the completion of EPCOT Center and Tokyo Disneyland, revenue at the company quickly outpaced expenses. Even the success of *Splash* played a role. In short, Bongirno said, "the company was just accumulating a lot of cash"—and it didn't have any major projects, such as a fourth theme park, to soak up the green.

Disney's nemesis was Saul P. Steinberg, a forty-four-year-old New York financier. In early 1984, Steinberg started accumulating Disney stock, which he believed to be greatly undervalued at about $47 a share. By the end of March, his Reliance Financial Services Corporation owned more than 6 percent of Disney's outstanding shares. Within a month, Steinberg's company announced it would seek to acquire 25 percent of the company—a far larger stake than the 4 percent owned by Shamrock Holdings Inc., the company controlled by Roy E. Disney, Roy O. Disney's son. (Roy E. Disney had recently quit the Disney board out of frustration with Miller's leadership.) Steinberg's plan was assumed to be simple: acquire control of Disney, break it up into its component parts, and resell the pieces for a considerable profit. The parks might have survived as a unit, owned by some other company, but the plan would have been the end of Walt Disney's company—and, in all likelihood, of the already hobbled WED Enterprises.

Disney's board developed a plan to stop Steinberg, with the help of four brothers in Texas. The Bass brothers—Sid, Edward, Robert, and Lee, ages twenty-four to forty-two—had built a financial empire from their shared inheritance from their great-uncle, an oil and ranching magnate. Along with their investment guru, Richard Rainwater, the Basses saw potential for long-term profit where Steinberg saw just a quick payout. A takeover battle ensued, with Disney management spending hundreds of millions and issuing new stock to purchase smaller companies, including a huge real estate company owned by the Bass brothers. The deal gave

the Basses a big stake in Disney and also diluted Steinberg's holdings, complicating his plan to gain control. Eventually, Steinberg agreed to a deal. For his 4.2 million shares, Disney would pay him $77.50 a share—well over the market price—and the company would reimburse him an additional $28 million for his expenses. In return, Steinberg agreed not to purchase any Disney shares for ten years. The total payout was $325 million, or $60 million more than Steinberg's shares were worth on the open market. He didn't succeed in the takeover, but he did walk away with a substantial profit, dubbed "greenmail" (rather than "blackmail") by the financial press. Disney, on the other hand, paid dearly, at least in the short term. Its stock fell 25 percent and its debt load soared to $866 million, or about three-quarters of the value of the company.

Roy E. Disney, who still controlled a considerable bloc of stock despite having left the board, was unhappy with the greenmail payout and threatened legal action. Instead of getting into a fight, the board invited him to return as a member—which he did, also becoming the company's first vice chairman and the director of animation. The fight wasn't over, though: another corporate raider, Irwin Jacobs of Minneapolis, soon appeared and started buying Disney stock. He even offered the Bass brothers a premium for their Disney holdings, but they turned him down, and his takeover plans fizzled. (Sometime later, the Bass brothers bought Jacobs's shares, giving them ownership of 24.8 percent of Disney stock. By 1986, the stock had risen to nearly $130 a share, and the Bass brothers had a paper profit of about $850 million.)

On September 8, 1984, Miller resigned, reportedly under pressure from the company's directors, including Roy E. Disney. The takeover battles "tarred Disney's management with an image of weakness," the *New York Times* reported that day, "and some Wall Street analysts complained that the company's credibility had been seriously damaged." Miller was forced out, according to the *Times*, because board members "gradually came to believe that Mr. Miller . . . did not have the management breadth to run what is now a large company, with 29,000 employees and sales last year of $1.3 billion."

Roy E. Disney had his own view of the management change. "If you

look at the financial data from those years, the company was on a pretty heavy downhill slope," he said later. "There really was no creativity within the company at all. There were people thinking, 'Let's pick it up, buy it, and sell it for the parts,' which is pretty ugly stuff. It got me in a tough place. We just said, 'You know what, we've gotta create chaos around here.' Long story short, we managed to change the management."

In light of the greenmail deal, which had been concocted more by the board than by the CEO, the *New York Times* brought up the possibility of "scapegoatism" in Miller's ouster. Miller himself reportedly called the ouster a "betrayal." "I've given my life to this company," he told the board, according to journalist John Taylor, who published a book about the greenmail saga. "I've made progress with this company. I think I've taken great strides in leading it as far as it has come." But the man who launched Disney Channel and Touchstone Pictures was out of his depth when it came to corporate machinations. As Imagineering veteran William "Sully" Sullivan put it, "Ron was a good guy, but miscast in the executive role. He was a great big jock."

The whole affair could have been avoided, Bongirno believed, if planning for WED Enterprises had not stalled. "That [takeover attempt] wouldn't have happened if we had had a master plan and work going on toward that master plan from the very beginning," he said. In other words, the failure to have another big project for WED Enterprises, which would have invested the company's ample revenues in expansion, was a major factor in the battle for corporate control. By starving the Imagineers, Miller had set the stage for his own exit.

III. THINGS BREAK APART

What the long-term impact of Ron Miller's departure would be on Imagineering was anybody's guess, and it neither lifted the dark cloud nor brought back laid-off colleagues. What was missing in the years after EPCOT and Tokyo, Weis said, was "a sense of a vision." The company's failure to select and greenlight another park had left WED Enterprises with hundreds of staffers and not much for them to do. "It was like, we

did these great projects but we don't really know what we're going to do next," Weis said.

"After EPCOT opened, it was a really difficult time," Peggie Fariss recalled. "First of all, you make such fast friends when you're working on projects that have incredible deadlines and you're pulling out all the stops and you're helping each other—and then the project opens and you've succeeded. And you know, there's just that elation of, 'We did it.' But now we know that we don't have enough work to sustain the workforce."

Fariss had heard tales of a "Black Friday" after the opening of Walt Disney World, when a massive number of Imagineers had been laid off in one day. The bleeding after EPCOT and Tokyo was more gradual. There was a period of time, she said, "when people would be called into a meeting with HR and then they would be gone. But it was so slow and it was so painful . . . I think it just felt like a big black cloud was hanging over everybody and no one knew, you know, Am I here next week or not? It was really difficult to see good friends leave and to know that people who had done amazing work were not going to be at Imagineering."

Craig Russell saw his newly embraced career slipping away. "It was a very interesting thing as a young professional to look at this and be thinking, 'Wow, I found my life's calling'"—then to be given nothing to tap that enthusiasm. "I thought, 'There's gotta be a plan. I simply must not be able to see the plan.' In fact, in hindsight, there wasn't a plan."

"Here's the problem," Frank Stanek said. After Tokyo opened, "we've got two thousand people sitting here at WED with no projects. So there was a whole series of layoffs. You have to get down to the core company, which at the time we always thought was around four hundred to five hundred people, a core group of people to maintain what we wanted to do as concept work." Without big projects in the works, he added, "you can't afford the overhead. It's an expensive place to run." The situation brought up existential questions, Stanek said, such as, what is WED's real role in the company? How much do you cut back? "But bottom line," he concluded, "it was a lot of angst going on."

Carl Bongirno, the president of WED Enterprises, called this period

"survival mode." During the EPCOT and Tokyo projects, WED had ballooned from about two hundred employees to three thousand. Once the parks were opened, the layoffs commenced. "We got down to about five hundred people, and the studio kept asking us to cut some more, cut some more," Bongirno said. Another two hundred headed out the door.

"It was kind of a dark time," Kevin Rafferty recalled. "The Disney Board of Directors, and one person in particular"—likely meaning Ray Watson—"took a look at WED Enterprises at the time and said, 'You know what? This company doesn't make any money. They just spend money. We have to get rid of them. You know, it would be a good business decision to do.'"

Some Imagineers created their own lifelines. Bob Gurr had left WED Enterprises in 1981—after nearly twenty-seven years—to start his own company, Gurr Design. Around the same time, one of WED's Audio-Animatronics experts, Dave Schweninger, also left WED, after twenty-one years, to join AES, a California company that was developing a chain of pizza restaurants called Captain Andy's River Towne, which had an animatronic band. In 1984, Gurr and Schweninger teamed up with an architect, Thomas J. Reidenbach, to form Sequoia Creative, which worked on the animated King Kong and Conan's serpent and other projects for Universal Studios Hollywood. For a time, Craig Russell also left WED to team up with Gurr, serving as a project manager on non-Disney attractions in California and Asia, as well as the 1984 Summer Olympic Games in Los Angeles.

Disney's board had kept Walt Disney Productions together at great cost. But WED Enterprises was now breaking up bit by bit. Bongirno did his best to hold things together, believing that the Imagineers were grossly undervalued by the company. "The employees are the most important asset that a company has," he said, and it was unacceptable to him to lose the Imagineers' talents and collective experience, "this knowledge that we all had." The cuts were brutal, eventually trimming WED Enterprises down to 230 employees, "and if we had lost any more, we could have lost something that would have possibly prevented the company from ever doing the things that they're doing today."

In the meantime, Bongirno did his best to help those who were laid off—and to keep the door open for their eventual return. "I spent a million dollars on outplacing all of the employees that we let go after EPCOT Center—with no approval. I just called the Employee Relations guy and I said, 'This is what I want to do. I want to provide secretarial help. I want companies brought in. I want to provide all the services we can provide to all the people that are transitioning out of Imagineering. I want them to come back when they're needed.'"

But Bongirno's most important action during Miller's tenure and immediately after was his inaction: he refused to implement the order to reduce the staff to twenty key people and move them to the studio. "I just dragged my feet," he said, "and asked the [WED] vice presidents to drag their feet on any more cuts." They would tread water, hoping for a lifesaver.

CHAPTER 12:
NOTHING BUT BLUE SKIES

"You couldn't walk through the theme parks and not know the potential. Everybody before I got there was saying, 'What would Walt do? What would Walt think?' His picture was like pinned to the wall everywhere. He can't be replaced. So I'm just going to have to do what my instincts tell me to do." —Michael Eisner

I. THE LIFESAVER

MICHAEL EISNER AND FRANK WELLS—the new leaders of Walt Disney Productions—were going to be late to their meeting with the Imagineers. Their driver, Disney board member Ray Watson, was lost. It had been so long since Watson had been to WED Enterprises in Glendale—if, in fact, he'd ever been there—that he couldn't remember the way. It was just another indication of how isolated WED had become from the rest of the company. It was the fall of 1984, and this was the day the Imagineers would find out whether they'd be pushed further away or out the door altogether. Or maybe, just maybe, they'd be brought back inside.

Such were the thoughts of the WED artists as they milled around the patio at the Flower Street complex on this breezy, cloudy Monday, awaiting two all-powerful strangers. The WED team had not immediately exhaled with the arrival of Eisner more than a week earlier, on September 22. The company's new chairman and CEO was a film

production executive—as Ron Miller had been—and some feared he'd be laser-focused on live-action movies. Eisner readily admitted that his most recent experience with the company's theme parks had been waiting in line for Space Mountain. His partner at the top of the company was another film exec, Frank Wells, now Disney's president and chief operating officer. For his part, Wells preferred actual mountains to the roller coaster variety: he was coming off a one-year break he'd spent scaling the highest peaks on each of six continents. (A storm on Mount Everest prevented him from reaching the pinnacle of all seven.)

The summer's corporate brinkmanship had compounded the worries of the few hundred Imagineers who remained. "We thought any day the hammer was going to drop on Disney and Imagineering specifically, because of the economic environment," recalled Tom LaDuke, who had joined WED Enterprises during the EPCOT and Tokyo hiring boom. "One day, we were all summoned out to the patio here at 1401 [Flower Street,] and we thought, 'Okay, this is it.' And we waited and we waited and we waited. Well, it was Michael Eisner and Frank Wells and an entourage coming over from the studio [in Burbank] to tell us about how they were going to run the Walt Disney Company."

The navigation snafu just increased the Imagineers' anxiety level as they paced on the patio, muttering about their uncertainty, expecting the worst. Then Eisner and Wells walked in and—metaphorically, at least—the clouds lifted. "It was very casual," LaDuke said. "There was no audio system. They just walked out on the patio and introduced themselves to everybody with their big booming voices." Then came the news everyone had been waiting for, hoping for. Eisner and Wells, LaDuke recalled, said "they had spent the previous week learning the company inside and out and looking at all the assets and looking at where the value was and felt that Imagineering was really the crown jewel." Some of the Imagineers wondered if they'd heard that right. "We were like, 'You're talking about us?' You know, we thought we were about to get the axe."

"When I arrived, Disney was under siege," Eisner said later. "What

happens when you are under siege is you shrink down. So the Imagineers were shrunk down." That was about to change.

The WED event was only one of many stops on the Eisner/Wells "getting to know you" tour. They had also flown to Florida to visit Walt Disney World, standing onstage in front of Cinderella Castle, addressing the hundreds of cast members who had come out to see what these new guys were all about. As he went from site to site within Disney, Eisner knew it was his job to calm a lot of jangled nerves after months of uncertainty. It was a "tremendous pleasure to be here," Eisner told the crowd in the Magic Kingdom. As the father of three boys in Southern California, he said, he had visited Disneyland "about three thousand times." He had grown up on Walt Disney entertainment, adding that he had "wanted to be involved with the Disney organization for all my life."

A passing reference to Cinderella Castle as "Magic Castle" suggested he still had a lot to learn about the theme parks, even if he had been on Pirates of the Caribbean "about 5,200 times." His purpose, though, was not to prove his Disney literacy but to reassure both the thousands of cast members in front of him and the Imagineers back in California that "this company will be led from a creative point of view." He directly addressed the summer's corporate power struggle, saying, "I did not come to this organization to watch it be dismantled. I came here to try and continue what Walt Disney and his associates set in motion fifty years ago. And that is very simply this: it is essential to maintain the old, to respect the old, to replenish the old . . . and to make sure that we move forward. At the same time, it's essential to do what Walt Disney himself would have done, which is experiment with every kind of new and innovative kind of entertainment possible." He closed with a quote from writer Maxwell Anderson that he linked to Walt Disney but could just as easily have been applied to the team at WED Enterprises: "There is nothing more important in our society than the artists."

Wells's remarks were briefer and less personal, but he hit the same keynote: "If there's anything that Michael and I stand for, it is to keep this company the way Walt Disney laid it down decades ago. We pledge

that to you. We are thrilled to be here and to welcome ourselves with you as part of the Disney family."

Looking back, Eisner said a lot of his and Wells's initial presentations were putting on a good front. "Frank and I had no idea what we were doing," Eisner said later. "I knew I had a creative bent because of what I'd done. We knew Frank had a legal and business affairs bent. We brought in a financial person to help us add two and two together, and then we were off running. And I kind of took responsibility for the creative direction of the company."

"They didn't know the first thing about Imagineering," Marty Sklar said—but they knew what they didn't know. Eisner had come to Disney directly from having been chairman of Paramount Pictures, while Frank Wells had been president and co-CEO of Warner Bros. before his one-year break. "They didn't know any of us [Imagineers] at all. We weren't movie people working on films. We were park people, if you will. And they had no experience with the parks."

Still, Eisner's and Wells's introductory tour was like a healing balm on the Imagineers' wounded souls. Eisner's public message was no different from what he had said to the cast members. He told the *New York Times* that "significant" resources would be devoted to the parks: "You generally don't fix something that's not broke." The job of Dick Nunis, president of the Walt Disney Outdoor Recreation Division (formed in 1980 to manage parks and resorts), was safe.

Eisner and Wells would need Nunis, in part because they had a lot to learn. Paramount and Warner Bros. had been the industry's two most successful film companies in the previous couple of years—accounting together for six of the ten top-grossing movies in 1983, a year when Disney's most successful film was a rerelease of *Snow White*—but neither studio had a theme park. According to Carl Bongirno, Eisner and Wells reached out to WED Enterprises' leadership soon after they arrived. "In a few meetings, they realized the importance of Imagineering," he said. "And we never had the pressure any longer to cut back. . . . I just gave a sigh of relief. I called the [WED] vice presidents together and I said,

'We're alive. They're not going to close us down.'" The lifesaver had arrived.

II. "WE CALL IT IMAGINEERING"

Roy E. Disney, Walt's nephew and Disney's recently appointed vice chair-man, was the recruiter who had brought Eisner to the company, and it had been a rapid process. "I was at a summer camp with my children and I got a call from Roy Disney," Eisner said. Roy knew Paramount Pictures, where Eisner had run the film studio for eight years, was in turmoil after the death of the chairman of its parent company, Gulf + Western, and he urged Eisner to make no firm decisions about his future until they could talk. When the two men met, Eisner recalled, Roy told him Disney was "really looking for somebody that's as crazy as Walt. That was their opening statement: 'We're looking for somebody who is not afraid to take risks.'"

Eisner was intrigued and quickly came to believe "I was what they were looking for." At the same time, Gulf + Western indicated Eisner was not in line for the CEO position at Paramount. As he told the *New York Times*, "I aggressively wanted this [Disney] job, as did Mr. Wells," and Eisner went on to describe Disney as one of the "few companies in this country that deserve to be protected." What he didn't tell reporters was that he thought the company "was in desperate shape." Referring principally to Disney's film business, Eisner judged that "from the time Walt died till the time we came in—which was I think eighteen years or something like that—it just atrophied." The parks reflected the malaise on the film side, since they contained no attractions based on Disney movie characters (so-called intellectual property, or IP) created after Walt's death.

But once Eisner settled in and started talking with the people at WED Enterprises, he said, "I immediately noticed that this was the candy store. This was the sandbox. This was the place that you could really not only have a good time but [engage in] a lot of free thinking and history. It was like being with a group of people who had just come through therapy

and now we're back to being off Prozac. They were ready to go. And it was fun."

Wells was also a WED fan. "Frank was just a terrific enthusiast," Eisner said. "He particularly liked [WED] because it was ours. We weren't impeded by agents and lawyers and articles and industry." Except for Disney, "nobody was in this business" at that time, not in any significant way. Universal Studios had gradually been adding attractions since its modern studio tour had opened on the lot in 1964, but twenty years later it remained chiefly a series of staged demonstrations of live-action special effects experienced by guests stuck on a tram. The Six Flags organization continued to grow by acquiring existing parks—including Magic Mountain, north of Los Angeles, in 1979—but had not built a new park since the Six Flags in St. Louis in 1971. In any case, Six Flags parks survived on the appeal of their thrill rides. The storytelling, emotional engagement, and meticulously designed environments that grounded every Disney park were minimal at Six Flags sites. Meanwhile, parks without the corporate deep pockets of Six Flags were dying across the country and around the world. As Eisner put it, "we had a period of time when we were playing in the sandbox without a lot of noise."

As the corporate raiders had believed Walt Disney Productions to be undervalued, Eisner believed a day at a Disney theme park was undervalued. Walt Disney had kept prices low at Disneyland to maximize attendance, calculating that guests would spend more money once inside the park, on the attractions, food, merchandise, and other experiences of their choice. The well-known A-through-E ticket booklets had been discontinued in June 1982, a year after the first all-inclusive daily passport had been introduced. Annual passports followed in September 1982 at Walt Disney World and in June 1983 at Disneyland. The new system was streamlined and popular, but Eisner and Wells believed park guests would pay more. They raised the admission price six times in their first three years.

Eisner also knew the parks needed work. "You couldn't walk through the theme parks and not recognize that they lacked contemporary development," he recalled. "But when Frank and I walked down Main Street

for the first time, Frank turned to me and said, 'There's so much here. There's so much we can do.'"

The beginning of the Eisner/Wells era "was a very exciting time, actually," recalled Imagineer Tom Morris, who had joined WED in time to work on EPCOT's Journey Into Imagination. "As much as we liked the previous management, we had fresh new eyes now and a fresh approach. I think the thing that really energized us was renewed enthusiasm for quality and for pushing the envelope and not just repeating ourselves."

To underline that this would be a new era, WED Enterprises would also get a new name. From January 1986 onward, it would be known as Walt Disney Imagineering—a change that broke with the past at the same time that it continued to honor both the organization's founder and the philosophy he lived by. "There's really no secret about our approach," Walt Disney had said in 1965. "We keep moving forward—opening up new doors and doing new things—because we're curious. And curiosity keeps leading us down new paths. We're always exploring and experimenting. At WED, we call it Imagineering—the blending of creative imagination with technical know-how." Now, finally, the Imagineers would be working in a division whose very name spoke to their mission.

III. MISSIONS IN MUSIC

On Michael Eisner's second visit to the Imagineers, he brought not only Frank Wells, but also a different kind of expert: his thirteen-year-old son Breck. It wasn't as crazy as it sounds. The Imagineers had known for years that they needed to reach teenagers if they wanted Disney parks to expand—or, indeed, to survive. Space Mountain had been a ripping, zipping success, but it was just one step in the continuing effort to broaden the appeal of the Disney parks beyond families with small children. Getting teenagers and young adults to come to the parks, and to keep coming back, would require more than one roller coaster in the dark. It would require a healthy dose of cool. And in the early 1980s, there was nothing cooler than *Star Wars*.

With that in mind, Imagineer Tony Baxter had developed and pitched

an attraction called Star Tours, based on the fantasy universe of the *Star Wars* movies, the third of which—*Return of the Jedi*—had been the runaway box office champ of 1983. *Star Wars* characters were everywhere in the early 1980s: at toy stores, in video arcades, at fast food restaurants, on T-shirts and lunch boxes—you name it. Everywhere, that is, except in the minds of some Disney studio executives, such as board chair Ray Watson. As Baxter recounted: "I remember pitching [Watson] the Star Tours idea and being asked, 'What's an R2-D2? I don't know what that is.' And I said, 'Well, you know, the cute little robot.' 'Oh, well, I've never seen those films,'" Watson responded. It made Baxter's heart sink: how could a Hollywood studio board chair not know about *Star Wars*? Not even have seen the movies? "I thought, 'What's going to happen [to us]?'" Baxter said. Imagineering seemed to have hit a wall of obliviousness.

Then Eisner and Wells showed up. As Baxter recalled, Eisner's second visit to Glendale was less than a week after his first. It was a Saturday, so his son wasn't in school. "I don't know anything about this business yet, but I will learn," Eisner said. "In the meantime, Breck loves amusement parks, so I want you to take him through whatever you have."

"I remember thinking, 'My career depends on a thirteen-year-old?'" Baxter said. "And so I pitched up Star Tours and he says, 'Dad! That is so cool!' And Michael says, 'Okay, we're doing it. What's next?'" Baxter's next idea was for a super-sized log-flume ride incorporating characters from *Song of the South*, the 1946 Disney movie last seen in a 1980 rerelease. "And I thought, 'Well, this will be harder for a thirteen-year-old boy, because it's Brer Rabbit and whatnot.'" So Baxter didn't pitch the characters; he told Breck about "the steepest hill in the world" and the unique dip drop in total darkness on the inside of the ride. Breck responded, "Dad! That's even better than Star Tours!" And Eisner said, "Okay, we're doing it. What else do you have?"

Baxter was tapped out, at least for one morning. But Eisner was jazzed about the flume ride. "He goes, 'So, we'll open Star Tours next year and the flume ride the year after.'" That's when Baxter had to break it to his new boss that "it takes about five years to do something like Splash Mountain. And Michael just hit the roof. He looked at Frank and

he says, 'Get Coppola, get Lucas, get who's hot now, get Michael Jackson. Bring him in. We've got to do something, and we've got to have it done and we'll open it at the park in a year. We've got to show the world this place is waking up and there's change afoot."

And that, Baxter said, "was the start of Captain EO, and it was there [in Disneyland] in about eighteen months. So we went from a very sleepy period for about three years there to so much work we didn't know how we were going to do it all. All in that one Saturday. It was an incredible day."

As Tom LaDuke put it, Eisner and Wells "not only gave everybody an emotional boost—they then challenged everybody. They immediately started turning on some pretty significant projects—a lot of it based on Michael's connections to the entertainment industry to bring outside content and brands in, like Captain EO with Michael Jackson."

His reputation had waned considerably before his death in 2009, but in 1984 Michael Jackson was the musical equivalent of *Star Wars* in both success and ubiquity. His album *Thriller* had come out November 30, 1982, and spent a record thirty-seven weeks at number one on *Billboard*'s album sales chart. In March 1983, Jackson's moonwalking performance on NBC's *Motown 25* television special attracted nearly 47 million viewers, and by the end of 1983, his album was not just the best-selling record of the year, but of all time, with 32 million copies sold (a number still less than half its eventual tally). *Thriller* took home eight Grammys in February 1984 and continued to sell so well that it became the best-selling album for the second year in a row—a feat no other solo performer had previously accomplished. If any living person could attract young people to Disney theme parks, that person was Michael Jackson. He was admired, talented, magnetic, and unencumbered by all the baggage that would later weigh down his public image. He was the personification of youth and energy and, in a word, cool. He also loved everything Disney.

Captain EO would bring Jackson into Disneyland in an elaborate 3D movie to be directed—as Eisner had suggested on that Saturday with the Imagineers—by Academy Award–winning director Francis Ford Coppola. The rest of the crew was equally A-list: George Lucas was the producer,

Oscar winner Vittorio Storaro (*Apocalypse Now*) consulted with Disney cinematographer Peter Anderson on lighting, James Horner was the composer, and the script was by Rusty Lemorande, who had produced *Yentl* with Barbra Streisand and directed a feature called *Electric Dreams*. The set designer was John Napier, a Tony Award winner who had created the sets for *Les Misérables* and *Cats*; the choreographer was Jeffrey Hornaday (*Flashdance*). Jackson wrote and performed two original songs, and acting opposite him in the cast were Angelica Huston and comedy stalwart Dick Shawn. It was a film production team of a caliber unmatched by any Disney film since at least *Mary Poppins*—even if the goofy science fiction plot was concocted chiefly to accommodate the songs, dancing, and 3D visuals.

Silly though it was, the story outline was created by a small team of Imagineers, who conducted a four-day brainstorming session in February 1985. "We were asked to come up with some concepts to go with three elements," Imagineer Rick Rothschild told the *Los Angeles Times*. "The elements were George Lucas, Michael Jackson and 3D." The Imagineers pitched three different ideas to Eisner, Lucas, and Jackson on February 14, and the group selected one that was then titled "The Intergalactic Music Man." The title Captain EO came from Coppola, who said it was from the Greek word *eos*, meaning "dawn." As Eisner had insisted, Captain EO was fast-tracked. Production began in June in Culver City, California, at Laird International Studios (the former home of Selznick International Studios) and wrapped in August. The next year was spent on the visual effects and preparing the venues.

The animation effects were done at the Disney studio, but the cinematic special effects were farmed out to Lucas's Industrial Light and Magic. The camera and projection systems used were created by the team at the Disney Machine Shop, in collaboration with the Imagineers. "Part of the reason that 3D had disappeared was that it was painful to watch," remembered Tom Fitzgerald, "so we invented the camera rig that would allow us to do state-of-the-art seventy-millimeter 3D." The system would be used for several later 3D attractions, replaced only once digital technology supplanted film. To house the show at Disneyland, WED designed

a new theater to replace the open-air Tomorrowland Stage adjacent to Space Mountain. The new seven-hundred-seat Magic Eye Theater would be outfitted with lasers and "smoke" generators to produce what came to be known as a "4D" experience, meaning a 3D film supplemented by physical effects felt or seen by the viewers.

Soon-to-be-Imagineer Jon Snoddy, sent to Glendale as a consultant, worked on the project for ILM. "I was really fairly unfamiliar with Imagineering until I came there, and I was blown away," he said. "I found a lot of people that thought a lot like me." The Imagineers, he observed, had a shared history of growing up feeling isolated, like "this nutty person that saw things no one else saw and didn't talk about it too much. And then they come here and we all finish each other's sentences, because there is this curiosity and this intensity and this love for quality and for story that just permeates everybody."

Word of the top-line talent in Captain EO leaked in July 1985, perhaps because the filming had caused Michael Jackson to miss the massive two-continent Live Aid concert on July 13. An early report estimated the cost of the seventeen-minute film at more than $10 million, including the construction of the Magic Eye Theater in Disneyland, although later budget estimates climbed to $20 million, even $30 million. (Some of the cost was borne by the attraction's corporate sponsor, Eastman Kodak Co.) Originally set to open in March 1986, but delayed due to technical glitches at Magic Eye Theater, the finished attraction opened Thursday, September 18, at Disneyland. It had started showings a few days earlier in EPCOT, pushing the 3D film *Magic Journeys* out of the Journey Into Imagination pavilion, and it would debut in March 1987 at Tokyo Disneyland.

The *Los Angeles Times* dubbed Captain EO "the most expensive and most ballyhooed short subject in film history" and reported that "Lucas stuffed more special effects into these 17 minutes than there were in two hours of *Star Wars*." A preview event was held at Disneyland September 13, with a small army of photographers and journalists invited to cover the promised celebrity parade. Eisner and Wells "wanted these [new attractions] to be something that is written about in magazines and newspapers, not

just incidentally another new thing," Imagineer Tom Morris observed. The added attention had an impact at Imagineering as well, he added, creating "a renewed excitement level at Imagineering."

There was certainly excitement to spare at the Captain EO premiere at Disneyland as thousands of guests strained to get glimpses of some famous faces. Michael Jackson did not appear—although Eisner joked that the singer was somewhere in the park, disguised "as an old lady, an usher, or an Audio-Animatronics character"—but Janet and LaToya Jackson came instead. Jack Nicholson escorted Anjelica Huston, who joined Coppola and Lucas to cut the ribbon "opening" the show. The *Los Angeles Times* report on the event included quotes from park guests declaring the 4D film presentation "brilliant," "outstanding," and "genius." The celebration was taped for an NBC-TV special that aired two days after the attraction was opened to all Disneyland guests.

Captain EO wasn't the Imagineers' only strategy to lure young people to the park. A year before the Jackson film debuted, an outdoor theater space called Videopolis had opened in what had been a vacant meadow near "it's a small world." The venue was intended to reconceive the dance hall with banks of video screens and without alcohol or parental disapproval. The theater "literally happened in less than one hundred days from the time [Eisner] said, 'Do it,' to the day that it opened," recounted Imagineer Tom LaDuke. "Which was unheard of for us as far as speed." The high-tech space initially featured seventy TV monitors surrounding a five-thousand-square-foot dance floor and a stage ninety feet wide— as well as raked bench seating that would accommodate 1,500. It was essentially an amphitheater, and it hosted occasional concerts as well as dance nights. At the same time, the park introduced a forty-dollar "Videopolis Pass" that offered passholders park admission after six every night throughout the summer.

Within two years, Videopolis was a staple of nightlife for Orange County teenagers, as well as teens from farther afield, hundreds of whom would fill the bleachers each evening, waiting for the dance floor to open. It was a closed-circuit *American Bandstand* every night, minus Dick Clark, plus Mickey Mouse. The party did not last long, however. Videopolis

closed as a dance club in late 1989, a decision made in part as a result of some isolated incidents of youth violence in or near Southern California theme parks. A gang shooting in the Disneyland parking lot in March 1987 had left one fifteen-year-old dead, prompting Buena Park Police to offer anti-gang training to Disneyland security guards. The downside to becoming a hub for teen nightlife was that not all the teenagers who showed up just wanted to have fun.

Still, by the time it closed, Videopolis and Captain EO had helped accomplish Eisner's mission to bring young people to the park. "Michael and Frank were an amazing breath of fresh air," said Imagineer Bob Weis. "They saw Disneyland as a cooler place than we at the time they saw it. They thought this was right in the cultural vibe of today. And it paid off at Disneyland. The younger audience came. Those were big shocks to the system, which is exactly what they wanted to do."

IV. A NEW HOPE

As far as Tony Baxter was concerned, he grew up in a real-life Frontier-land, enjoying "an idealistic Tom Sawyer upbringing," as he put it. When he was a boy in the 1950s, he and his friends ran around the canyons and other rough, undeveloped land around San Clemente, California, about twenty-five miles south of Disneyland. They built forts and rode their bikes—and went home in time to watch Walt Disney on the *Disneyland* TV show. Soon after the park opened, his family moved even closer to Disneyland, and by the time he was ten years old, he could jump on his bike and ride right up to the main gate. It was, he mused, "almost like virtual reality for the fifties." If he could get a group of kids to ride up there together, or get a mom to drive them, that was even better. "It was really our extended backyard."

At home, he was still glued to Walt Disney's television show every week, especially when Walt visited WED Enterprises and "introduced us to people that worked at Imagineering—[to] John Hench and Harriet Burns, and [to] Claude Coats and Marc Davis and Rolly Crump." As he grew older, he realized that these were real people, and creating

Disneyland attractions was their actual job, essentially "having fun for their living." In high school, he learned as much as he could about the Disney attractions at the 1964–1965 New York World's Fair, far across the country. Then, in the summer of 1965, Great Moments with Mr. Lincoln opened at Disneyland, and his life changed.

"To see a human figure stand up and deliver a very inspirational speech" amazed the teenager, "and it was accompanied with all the theatrics of a Broadway show—the beautiful music, the cinematography that surrounded the introduction. It was first class all the way." He was so impressed, he recalled, "that I said right then and there, 'I've got to work for this company.'" As a seventeen-year-old, his options were limited, but he landed a job scooping ice cream on Main Street, U.S.A. in Disneyland. While studying landscape architecture and theater arts in college, he continued at the park, serving ice cream cones and working as a ride operator. "I had an opportunity to work pretty much in every land, on most of the attractions down here, which in the end became absolutely as much schooling as four years of art school," he said. "I would consider that my second schooling, and probably the most important." It taught him "what it's like to move people through an experience—how they react, how difficult it is to group people, what it's like dealing with people who speak different languages, what they appreciate, what they react to, what is repeatable over and over again. Why do people want to come back and ride something umpteen times? What are the special qualities that certain attractions have that others don't? All of this you would never learn in school."

One day, when Pirates of the Caribbean was still under construction, Baxter peeked into the attraction through an emergency exit—and was immediately spotted. "There was a wonderful man there who beckoned me to get out of the doorway and come on down and he would give me a tour." The man was Imagineer Claude Coats, who spent an hour and a half giving the young cast member a tour of the nearly completed attraction. "It was an amazing experience, and something I'll never forget," he said. (Years later, as an Imagineer himself, Baxter would offer the

same attention to other curious cast members—including a young Jungle Cruise ride operator named John Lasseter. "So never miss the opportunity to be nice to someone," Baxter advised.)

At age twenty-two, he finally got his shot at a job in Imagineering. He had his art portfolio and his attraction ideas—he had, for example, drawn a layout for a Mary Poppins attraction with flying carousel ponies, complete with maintenance access—but what made the difference was his "crazy marble machine." It was, he recalled, "this contraption that looked like the front of '[it's a] small world,' and it ran for four minutes." The Imagineers who saw it insisted he take it into the Model Shop at WED, which he did, giving demonstrations and answering questions for three hours. Baxter remains certain it was the marble maze that got him his job, because it demonstrated his ability to put art and engineering ideas together in a creative way—the very definition of an Imagineer. These days, when anyone asks Baxter how to get a job at Imagineering, "one of the things I tell them is 'create the impression that you stand out from all the other people who diligently want the same job and have similar artwork.'"

Baxter's first assignment as an Imagineer, in 1970, was assisting field art director Dave Burkhart on the 20,000 Leagues Under the Sea attraction in addition to installing Claude Coats' Snow White dark ride at the under-construction Magic Kingdom. He rose quickly through the organization, leading teams on new attractions, helping create the concepts for the Seas and Land pavilions in EPCOT Center, and leading the Fantasyland refurbishment. He was also in charge of the Journey Into Imagination pavilion, with its soon-to-be-iconic purple dragon, Figment. But by the mid-1980s, he recalled, "it became apparent to several of us younger Imagineers—who grew up with the wonder of Walt Disney on television and in the theaters, and coming to life in Disneyland—[that] Disney had lost touch. We weren't very popular on television. We did not have hit movies in the theaters." Disneyland, they believed, should be a place "where young people come fall in love, [surrounded by] their current popular culture." The young lovers "grow up and then

bring their children to experience what it was like to love Disneyland when you are young," and the pattern repeats. If the park didn't reflect the pop culture in the wider world, that cycle would be broken, which would put Disney at risk of irrelevance.

That was how Baxter came to propose the idea of bringing George Lucas and his *Star Wars* mythology into Disneyland. It would be the first time any park attraction was developed from intellectual property not created by Disney. Nevertheless, Marty Sklar supported the effort, and a meeting was arranged with Lucas. It was, Baxter recalled, "the best day of my life." Lucas told the Disney contingent that the *Star Wars* franchise was "number one," and so was Disneyland—meaning that "if he did anything in this arena of theme parks, it would only be with Disney, because this orchestration of two perfect things was important to him. So I came home with a sense of accomplishment."

That feeling was soon supplanted by the pressure to find an attraction concept worthy of both these "number ones." That was when Randy Bright mentioned having seen in London a complex simulator used to train fighter pilots and airline pilots at a company called Rediffusion Simulation Ltd. (RDL). Baxter flew to London to see this thing, got aboard the RDL simulator, and "realized I could feel what Luke Skywalker or Han Solo felt like in the *Millennium Falcon*. I came home and I said, 'That Achilles' heel of making this real is solved.'" The simulator placed the pilot trainee in an enclosed compartment that could then be rapidly tilted and pitched along multiple axes, mimicking changes in g-forces. The Imagineers would need to create a much larger passenger enclosure, but the principles of the technology could be adapted to the ride Baxter envisioned. When he got back to Glendale, "we went right to work then on acquiring our own model of the Rediffusion simulator." Disney Machine Shop craftspeople then began testing their own modifications of the device, rebuilding it to satisfy the Imagineers' needs.

Development stalled during the downsizing of Imagineering before Michael Eisner's arrival, but that fateful Saturday pitch session with the new CEO and his thirteen-year-old son got it moving again. "I had a communal experience there with Michael Eisner," Baxter said. "He knew

that I cared; he knew that I had passion . . . that we [Imagineers] weren't followers or yes-men, that we had a vision."

His vision dovetailed neatly with Eisner's. The new CEO planned to tap into his wealth of Hollywood and celebrity connections to inject currency and celebrity into the parks, whether via music or movies or both. "We didn't bring in Michael Jackson and George Lucas and outside directors Francis Coppola and other people because we wanted to," he recalled. "We had no choice. There was no IP [intellectual property] for the last eighteen years developed inside the company. So we did that—but that was a stopgap measure."

The Eisner/Wells approach to Hollywood talent and intellectual property was a seismic shift from Disney tradition, but Baxter saw something familiar in the team at the top. "They became as close to what I can imagine a Walt Disney and a Roy Disney would have been," he said, "because their skills were complementary and they impeccably trusted each other with filling in for what they each were lacking in."

In Kevin Rafferty's assessment, "Michael was a free-ranging cowboy, a loose cannon, and he was interested in everything. And Frank had this uncanny way of tempering him and bringing him back to reality and letting him know what would work and what would not."

"I don't even think they knew each other before they took the job," Bob Weis said. "But when you saw them, you would have thought they were friends for years. They were completely in sync with each other. They bantered back and forth. They called each other in the middle of meetings. They were energetic and they were together." Their partnership was also a union of near equals: like Eisner, Wells reported directly to the Board of Directors, not to the CEO.

Eisner saw his partnership with Wells a bit differently. "Nobody understood Frank, and nobody really understood me and we were definitely not Walt and Roy," he said, looking back. With Wells's Ivy League education and law degree contrasting with Eisner's more humble Midwestern origins, "everybody thought that I was the 'crazy,' so to speak, pushing creativity, and Frank was the suit. In fact it was the opposite. Frank was very impulsive, very enthusiastic, very charismatic. I was

considered all that, [but] I was much more conservative. The two of us together made a very good team."

Eisner's and Wells's enthusiasm for the flight-simulator-based Star Tours never wavered, and Lucas worked directly with the Imagineers on the ride narrative and effects. His ILM took on the making of the special-effects-driven four-minute film that would take passengers on a shuttle-like craft (called a StarSpeeder 3000) into an unexpected space battle while the modified Rediffusion simulator rocked and bobbed, piloted by droid RX-24, called Rex. To ensure the experience melded seamlessly with the *Star Wars* universe, the original voice of C-3PO, English actor Anthony Daniels, went to California to record the droid's dialogue for the attraction and also visited Imagineering to be filmed as reference footage for the Audio-Animatronics figure of C-3PO that appears in the attraction's queue area.

Baxter and fellow Imagineer Tom Fitzgerald led the Imagineering team. The pair "had a very close relationship already with George Lucas," observed Tom LaDuke, the attraction's effects designer, "and it made that interaction with ILM and George Lucas pretty seamless." The budget was constrained, but if the Imagineers needed more resources, "all we had to do was whisper in George's ear," LaDuke said. "If George wanted it, we got it."

LaDuke was that rare Imagineer who had grown up wanting to *be* an Imagineer, inspired in part by behind-the-scenes episodes of *The Wonderful World of Disney*. As soon as he could, he got a part-time job at Disneyland operating the rafts to Tom Sawyer Island and repeatedly asked for a job interview at what was then WED Enterprises. He was finally granted a quick meeting in the WED lobby with an Imagineer named Bud Martin from the special effects department. It lasted just ten minutes, but Martin sent him away with "a handwritten list of all the things I was going to need to learn." He stayed in Disneyland operations, went through management training, and finally got a shot at WED in the lighting and special effects department. Martin, his new boss, told him, "You're not here because you know anything about special effects. You hedged your bet and you got the management training and that's what we need."

LaDuke recalled, "I snuck in the back door, so to speak." EPCOT and Tokyo Disneyland were both gearing up, and the department went from about seven designers to more than 150 in the next few months. Most remarkably to LaDuke was that "Yale Gracey was still here. He did a lot of mentoring and we had some great opportunities to spend some quality time with Yale."

LaDuke survived what he termed "a dark time" of downsizing after EPCOT and Tokyo Disneyland opened, and the merger of his special effects department with Imagineering's Model Shop. He was twenty-nine when he got the Star Tours assignment, the enormity of which really sank in one day early on when he got a special delivery from Lucasfilm: "They delivered R2-D2 to my desk," he recalled, "a real R2-D2 from one of the films. In fact, it still was full of sand from wherever he was on the last shoot. All the model builders were standing there, staring at it, going, 'Is that the real—?' 'Yeah, that's the real deal.' And so the one at Disneyland that sat in the Star Speeder [in the queue area] was an actual, real R2-D2."

Star Tours was the first major application of a motion-based simulator in a theme park attraction, but the Rediffusion simulator was just the core of the experience. The ride would also need a new projection system that could withstand a repeated rattling on a kinetic vehicle to show Lucas's 3D movie, which served as the view from the Star Speeder's front window as it zipped through space and dodged enemies and obstacles. As they had many times before, the Machine Shop stepped up to the challenge.

"The Ballantyne seventy-millimeter projectors we were using in Disneyland and Walt Disney World were very robust, and I had no qualms about its survival in the Star Tours simulator," recalled Don Iwerks. "The problem was how to store the film in an endless loop. The outside back of the cab was the only surface available, as the entrance and exit doors were on the sides. We worked out a very successful system whereby the film from the projector—located at the front of the simulator—was transported on sprockets and rollers underneath the cab to the outside rear panel, where, under mild tension, the film was laced through a

multitude of sprockets and rollers and returned underneath the simulator back to the projector." It was, he judged, "probably the largest film loop in history, but it worked flawlessly" and remained in service until high-definition video projection replaced it.

"Putting a seventy-millimeter motion picture projection system on a moving base that was generating [multi-g] shock loads and not having the projector fall apart was a miracle," LaDuke said. The Machine Shop craftsmen were the "unsung heroes" of Imagineering, he added. "There were engineers and experts over there that already had decades of experience in camera system design and projection system design. They really did an astounding job."

This system also created a solid foundation for expanding the use of projection technology in a variety of attractions. Going forward, Tom Fitzgerald noted, "movies or media are going to become more integrated into the [theme park] experience—less 'come and sit in a standard theater and watch something,' more projection combined with sets and ride vehicles to immerse you in different ways."

The Star Tours experience utilized not just mechanical contraptions—the kind of thing Imagineers had mastered decades earlier—but also the complex electronics and programming that drove the simulator. Its movements were programmed second by second to match the visuals in the ILM-produced movie. The expanded talents of a new generation of Imagineers were asserting themselves. "We took that technology directly from the space programs," said Jon Snoddy, the Imagineer recruited from ILM. "No one had ever seen that. It was kind of crazy—the people that sold those devices, they were just amazed that we would do something so crazy with it."

Eisner's own first simulator experience was at Imagineering, along with Frank Wells—both of them nattily dressed in business suits. After climbing a rickety ladder into the boxlike ride vehicle supported by a metal armature, they strapped in and were jostled and tossed about for several minutes—no movie, no narrative, just *Star Wars* music playing loudly. Eisner came out of the experience elated, Wells feeling ill.

Eisner's chief feedback to the Imagineers: tone it down a bit. We don't want the guests to faint or upchuck. Modifications were made.

Star Tours debuted in Disneyland a few months later, on Friday, January 9, 1987, after a two-week preview run the month before, to work out any final kinks. The response to the opening was so overwhelming that Disneyland stayed open sixty hours straight, from that Friday's opening until Sunday's closing, to accommodate the demand to experience Star Tours. The wait time was sometimes as long as four or five hours, with the queue snaking out of Tomorrowland and down Main Street, U.S.A. "It's better than Space Mountain," one early rider told the *Los Angeles Times*. "It tempts your imagination. You begin to wonder what it would really be like."

The boost in attendance at Disneyland outlasted that marathon weekend. Star Tours combined with Captain EO and Videopolis boosted park attendance despite recent price hikes. Park revenue hit $1.52 billion in 1986, up 21 percent from the year before.

V. ROILING WATERS

But the Imagineers weren't yet done at Disneyland. That other pitch to Breck Eisner and his dad—a wet-and-wild flume ride—was also in the works. It was to be themed to the animated sequences from Disney's *Song of the South*, and in its length and the height of its final drop, it would immediately overshadow the milder, story-free flume rides that had become ubiquitous at American amusement parks. Michael Eisner briefly insisted it be called simply Splash, after the hit Touchstone film, with a life-size figure of Daryl Hannah placed at the bottom of the big drop. A young long-haired Imagineer named Joe Rohde was dispatched to talk the CEO out of it. "You can't really just interpose one story from another story and stick it in there," Rohde told Eisner in his first one-on-one meeting with the new CEO, "just like you couldn't take *Macbeth* and put it inside *Brigadoon*." Rohde recalled Eisner saying, "Well that totally makes sense. Why didn't somebody say that?" The flume coaster

still became Splash Mountain, incorporating Eisner's title, but with no mermaid in sight.

Baxter had conceived the Disneyland attraction in part to bolster the recently opened Bear Country—the future Critter Country—home of the Country Bear Jamboree. "Nobody was going out there," Baxter said. "Less than 2 percent of the whole population in Disneyland [would be] in this area at any one time." Also avoided by most guests was an attraction in Tomorrowland called America Sings, which had opened in the former Carousel of Progress theater in 1974, in advance of the American Bicentennial. The revue featured Audio-Animatronics figures of costumed animal characters performing snippets of popular folk tunes in four different eras and backdrops in the style of the Country Bear Jamboree. "It was past its prime," Baxter said, but it included "all these wonderful figures" created by the Imagineers.

So that was what was rattling around in his brain one day in the summer of 1984 when he was driving to work—singing animals, flume rides, the vacuum in Bear Country. Suddenly it came to him: "I know how we could save those figures from America Sings. We could put them out in Bear Country. And we could theme it to *Song of the South*, which is what this whole part of the park is about."

There was no hint of the film's racial minefield in the final Splash Mountain, which featured more than a hundred Audio-Animatronics figures, none of them human, along its winding channel. The show producer for the attraction, a recently minted Imagineer named Bruce Gordon, called it simply "the closest you'll ever come to riding through a cartoon come to life."

Despite saving money via the repurposing of the America Sings Audio-Animatronics figures, delays and problems in designing sufficiently lightweight flume vehicles had ballooned the budget from a reported $25 million to an estimated $70 million. (Along the way, it acquired a nickname within the theme park business: Cash Mountain.) Sneak previews finally began in early July 1989, some nine months after the originally announced opening date, and a dedication ceremony was

held July 17. Splash Mountain opened officially to the public the next morning.

Reviews were favorable, if muted. The *Los Angeles Times* praised the "top-notch" Audio-Animatronics figures, but ranked its "Imagination Quotient" below that of Pirates of the Caribbean or Haunted Mansion. The guests had no such reservations, however, and lined up by the thousands. Within a month, the *Times* was already reporting on a local boost in visitors as a result of Splash Mountain's debut.

Baxter tied the success of Splash Mountain and the other early-Eisner-era attractions to their adherence to the basic principles of Imagineering. "I don't design anything for the first ride, I design it for the twentieth ride," he said, "so you start to think, 'What is it that's appealing about something that I want to ride on it twenty times?'" To achieve that takes three qualities, he explained. The first was storytelling: the ride has to take you "to a place that you couldn't go without Disney." The second was thrill—or, as fellow Imagineer Eddie Sotto liked to say, "fear minus death equals fun." "Your greatest thrill experiences let you experience what it is to get almost to that point and then we pull back," Baxter said, "and especially here at Disneyland, because you know you're safe."

The third necessary quality "is the one that is more proprietary to Disney than anything, and that would be the emotional appeal of an attraction." As an example, Baxter cited Dumbo, which "is nothing more than a carnival ride that you'd see at every parking lot show that comes to a state fair," but which Disney transformed "with the emotional appeal of those little elephants out on the end. Kids will wait forty-five minutes to do something they could do at their hometown because of strictly the emotional appeal." Despite its ties to a controversial film, Splash Mountain checked all of Baxter's boxes: it existed in the fantastic world of Uncle Remus (as reimagined by Disney), amped up the thrills of the typical flume ride, and took guests through a joyous musical finale where the exhilaration from that big, soaking drop was magnified by dozens of Audio-Animatronics figures singing "Zip-A-Dee-Doo-Dah." It most certainly didn't need a mermaid.

CHAPTER 13:
HOORAY FOR HOLLYWOOD

"This was the [Imagineering] scrappiness that we said, 'Okay, we've got a project, we've got enthusiastic leadership, and they're giving us a tight schedule and a tight budget and we're going to do something with it." —Bob Weis

I. GETTING THE STARS TO SHINE

IN JANUARY 1988, Goofy set off a blast in EPCOT Center. The event was the formal groundbreaking for the Wonders of Life pavilion, but more metaphorically, the small explosion might have represented Michael Eisner's approach to the second theme park at Walt Disney World. The old rules were blown to smithereens. Eisner thought the ban on classic Disney characters in EPCOT Center was counterproductive and discouraged children from enjoying the park, so the Fab Five—Mickey, Minnie, Donald Duck, Pluto, and Goofy—were soon regular visitors to Future World, often attired in spacesuits. Classic Disney merchandise was added to the park's shops. Goofy's dynamite day was arranged in part to announce that he would be the mascot for the Wonders of Life, in keeping with the good-natured health spin of some of the character's mock-educational cartoon shorts, such as *Goofy Gymnastics*, *Tennis Racquet*, and *How to Dance*.

Among Disney fans, Goofy was a star, and he wasn't the only celebrity to be seen in the Wonders of Life. The pavilion, which opened in October 1989, focused on the human body, including fitness and

nutrition. Housed largely beneath a sixty-five-foot-high geodesic dome, it featured a Star Tours–like motion simulator ride through the blood-stream called Body Wars (featuring then-familiar actors Tim Matheson and Elisabeth Shue); an attraction about the nervous system that combined film and Audio-Animatronics figures called Cranium Command; and a fourteen-minute animation-plus-live-action film about birth called *The Making of Me*, starring comedic actor Martin Short. The central dome was mostly devoted to the Fitness Fairgrounds, a collection of hands-on, interactive displays, skits, and demonstrations urging guests to learn more about their bodies and their health. There were stars here, as well, such as tennis champion Chris Evert, captured on film for an exhibit called Coach's Corner.

The long-delayed Wonders of Life had taken shape thanks to Eisner's determination and a sponsorship from the insurance company MetLife. But in fact EPCOT had never stopped growing after its 1982 opening, the additions having been envisioned by the Imagineers years earlier. Morocco, first sketched by Harper Goff, had joined World Showcase in 1984, followed by the (so far) final national addition, Norway, in 1988. Norway's lead designer was John Hench, then in his late seventies and just as irascible as ever. Katie Olson was, along with the architect, in charge of the color scheme for the pavilion, and fondly recalled one approvals meeting with Hench regarding the imposing Akershus Castle at the front of the pavilion. "I'd painted it a very authentic, rather drab color, and John looked at it and said, 'Well, that's a boring color.' And he started pushing around the photographs. And he picked up a photograph of a pink wall in Norway, and he said, 'I think it should be that color.' I said, 'John, this is a twelfth-century castle in Norway. Twelfth century. Do you really think it would have been pink?' I said, 'I can't even imagine it having been pink.' And he goes, 'Well, if you can't imagine it, then you shouldn't even be on this project.' So if you go down to the Norway pavilion right now at EPCOT, it's a pink building."

Opening in between the two new national pavilions, in 1986, was The Living Seas—a pavilion Barry Braverman called "more experiential" than the other Future World attractions. Rather than Audio-Animatronics

figures, it had actual sea life: two thousand fish and marine mammals (a number soon increased) living in the world's largest saltwater aquarium, a nearly six-million-gallon tank with a Caribbean coral reef environment—although the reef itself was a reproduction, made of fiberglass, silicone, and urethane. Of course, there was also a scenic ride through an acrylic tube across the bottom, in bubble-like "seacabs." Braverman worked on the pavilion's exhibit area, called Sea Base Alpha, which contained numerous interactive stations as well as giant windows into the aquarium. "There was a lot of excitement in the company about interactive experiences, which hadn't been a big part of the repertoire of Disney Parks prior to that because of the capacity issues." More philosophically, Braverman said, Imagineers were wondering about their audience: just because they loved everything Disney, would they "go with us on this journey into these other places?" The answer was mostly positive. "There were some things that didn't work out as well as we had hoped and other things that were phenomenally well received," Braverman said. "Of course, over time we did more of what people liked and less of what people didn't like. And I think we ended up really carving out something."

As EPCOT Center expanded its offerings inside the park, Walt Disney World was increasing the number of themed hotels outside the parks, many of them just a walkway or boat shuttle away. And just as Eisner wanted stars inside the attractions—whether Disney characters, Hollywood actors, or sports figures—he wanted star architects.

Determined to exert more control over the building and running of the hotels—and all the other structures—on Walt Disney World property, Eisner set up the Disney Development Company to manage the company's holdings outside the theme parks. He was determined to hire the world's best architects—the stars of their field—to create striking new buildings that would "upgrade the level of our architecture and try to leave something behind for others," as he wrote in a memo to Frank Wells. In pursuit of that end, Eisner arranged meetings with Michael Graves—the architect who had recently completed a controversial expansion of New York's Whitney Museum—and Robert Venturi, a Philadelphia-based

architect who had designed that city's famous Franklin Court, a complex of historical sites and an underground museum adjacent to Independence Hall. Eisner and Wells invited the two high-profile architects to engage in a competition to design a hotel complex near EPCOT Center that would be built by developer John Tishman's company. Disney would supervise the design, but on Tishman's already-established budget. Also competing were noted hotel architect Alan Lapidus, who created the Broadway Crowne Plaza in Times Square—and the team at Imagineering.

In the end, the Imagineers' design was not in the running. Eisner said it "looked like a giant mountain, with all the parking in the middle. It was wonderfully whimsical—but totally impractical." The design selected was from Graves: a twenty-one-story building with a triangular core, like a flattened pyramid, topped by a giant bird bath-shaped ornament, and a twelve-story building with a curved roof. Eisner loved the buildings immediately but wanted a touch more fancifulness. Graves responded by adding a pair of giant swans to the shorter building and two giant dolphins to the wings of the triangular building. The hotels became the Swan and Dolphin—both opening, six months apart, in 1990. The buildings fulfilled Eisner's yearning for what came to be known as "entertainment architecture." As Graves later said in an interview about the project, "Michael didn't like those tall, all-glass buildings. He referred to them as 'refrigerator boxes.' He wanted the architecture to tell a story." Though neither Graves nor Eisner attributed this mandate to Imagineering, it was the core priority that continued to drive Disney's theme park design. Now it was shared by the company's CEO and had been applied outside the parks. It would expand from there.

II. DISNEY STUDIOS EAST

Michael Eisner's affection for stars—especially movie stars—soon found another outlet. Within weeks of the announcement of his move to Disney in the late summer of 1984, Eisner recalled, "I started [at Disney], and within a week, I said to the people at Walt Disney Imagineering, 'Get me those plans on the studio tour.' And we started."

Whether any such plans actually existed or Eisner was referencing a more ambiguous wish Walt Disney had expressed about a studio tour isn't clear, but Imagineer Bob Weis remembered Eisner raising the subject early in his tenure. On one visit to Imagineering, Weis recalled, "Michael said, 'You know, at EPCOT, you've got the energy business, you've got the transportation business, you have all these things, but you don't have the entertainment business. So why don't we have a pavilion at EPCOT that's about our business? Film, animation, what we do.'" Weis was assigned to develop an entertainment industry pavilion, including live-action film, animation, television, music—"the whole business." He sketched out his ideas and presented them to Eisner, whose interest in the project kept growing. He suggested expanding the footprint of EPCOT to add functional soundstages, so there could be a tour of a working studio. The more they talked, the bigger the plans became. "Very quickly it became obvious that this idea in his mind was a big idea and it was bigger than the real estate that EPCOT had available," Weis said, "and that it really should be something on its own piece of land. And that's how the idea of the studio tour evolved. But it began as an idea for an EPCOT pavilion."

Frank Wells recounted a similarly speedy evolution for the Imagineering concept. "When we first got the idea [presented to us], it was to build a smaller studio tour [as] another attraction at EPCOT Center. And I can remember Michael saying, 'It's fantastic. There's just one thing that's wrong with it. It's too small. This has got to be a real production facility as well as a tour. This is our next gate'"—industry shorthand for a new theme park. "And we walked out of that room and we knew it from that moment."

Eisner wasted no time in announcing that Disney would build a combination working studio and theme park at Walt Disney World. In February 1985, four months into his tenure, he told Disney stockholders that the company was planning to build a studio tour in Florida. There was a catch: still convinced that Disney had created no significant intellectual property since Walt's death, Eisner was concerned that the company didn't have enough new characters and stories to populate a

Hollywood-themed park. His solution was to make a deal with MGM, a studio not in the theme park business, to license that studio's name and well-known intellectual properties—including classics such as *The Wizard of Oz* and *Singin' in the Rain*. "We named the park Disney-MGM Studios in return for the use of their entire library, which was the best library in Hollywood," Eisner said.

At Imagineering, the idea of working on storytelling that didn't originate with Disney had long been unthinkable, but the Disneyland additions of Captain EO and Star Tours had been "big shocks to the system," Weis said. "And it paid off at Disneyland. The younger audience came. And we suddenly felt ourselves open to a much bigger world . . ." Despite the richness of Disney's animation lineage, he added, without MGM's properties, "I'm not sure that we could have ever carved out much of a studio tour, because it's hard to imagine at that time how small the Disney library of live action was."

There was also a certain circular poetry to joining Disney's name with MGM's. Walt Disney was creating his original feature animation classics at the same time that MGM was putting out live-action movies that defined Hollywood's Golden Age. The studio employed the best art directors in the business to create immersive sets on its famous backlot— while Disney's backlot existed only in the imagination of its animation team. Many years later, when Walt Disney was envisioning his family park, "the only parallel for what Disneyland was to be physically was a studio backlot," Imagineer Tony Baxter observed. So inevitably Walt turned to some of the same artists who had left their imprint on those classic MGM films to create the immersive experience of Disneyland— people like original Imagineer Herb Ryman, who went from working on sets for MGM period films such as *Mutiny on the Bounty* and *The Good Earth* to art directing *Fantasia* and *Dumbo* to designing Main Street, U.S.A., in Disneyland.

Many great set designers from 1930s Hollywood came to Disney, Fitzgerald noted, "not necessarily as architects, but as architects of surreal fantasy." Disneyland utilized "their knowledge of pushing together environments into tight spaces, where on one side you have a jungle

and on the other side you have a Western town. That was exactly what you do in the backlot." Now, the cinema history that connected MGM movies and Disney theme parks behind the scenes would be right there on the entry plaza—and peppered throughout the park. The Imagineers who would be turning classic films into Disney attractions already owed a creative debt to MGM.

The Studios project was envisioned to include a working backlot and soundstages, so it "also matched up with our new aggressiveness in making films," Wells said. "You could combine the production facility with a third gate"—a new theme park—"with a studio tour, to continue to entertain our guests in a completely different way." At a time when the studio was also determined to amp up its live-action filmmaking, he said, it was as if the Disney company had put all its ambitions into a computer, "popped the button, and the computer just exploded with the answer. It's a studio tour. That's what we've got. That's what all of this is about."

III. LIGHTING UP THE MOON

After the recent successes at Disneyland and EPCOT, the Imagineering team was energized. Michael Eisner and Frank Wells had established a "renewed faith in Imagineering," said Imagineer Tom Morris. He observed that working on Tokyo Disneyland, which closely resembled the Magic Kingdom, was "not very much fun to work on as a designer." But with the Disney-MGM park, "We were kind of given license to begin pushing the envelope—to make things not just very good or good enough but to make things excellent."

They had more ideas than they had money, in part because the park was initially conceived as a half-day experience. "It was, at the time, thought that people had an extra half day [at Walt Disney World] the day they came from the airport or the day that they went back to the airport or drove back," said Bob Weis, who was elevated to the creative lead for the studio project. "So you could have [full-day visits to] Magic Kingdom, EPCOT, and you could have another [park that took up a] half day. So it was going to be a little park, and we designed it as a little park.

And over time—after doing focus groups and demographics and things—it started to grow," Weis said. "Each time Michael came over to WED to look at it, he added another attraction or he added another idea. Or we were foolish enough to come up with another idea, and he always liked it. And as a result, what we ended up with is a park that is much bigger than I think any of us envisioned at the beginning."

The budget to build the studio park, however, did not grow. "It was a way lower percentage per guest of investment than EPCOT had been," Weis said. "But this was sort of the Imagineering scrappiness that we said, 'Okay, we've got a project, we've got enthusiastic leadership, and they're giving us a tight schedule and a tight budget and we're going to do something with it."

Where a castle beckoned guests forward from the gate in each of the Magic Kingdom–style parks, and the geodesic dome of Spaceship Earth captivated those entering EPCOT Center, the centerpiece of Disney's studio theme park would be a replica of Grauman's Chinese Theatre, Hollywood's best-known movie palace. Behind the facade was the park's most elaborate and star-studded attraction: The Great Movie Ride. It had evolved from its original role as the centerpiece in the Imagineers' proposed EPCOT pavilion to become a larger and longer experience at Disney-MGM. The ride combined all the Imagineers' many skills into one exciting experience lasting more than twenty minutes: Audio-Animatronics figures, film projection, and animation, of course, but also theater arts, as cast members acted out portions of the narrative; and the construction of grand, detailed sets. The movie scenes reproduced included not only films from Disney (*Mary Poppins*) and MGM (*The Wizard of Oz*), but also Warner Brothers (*Casablanca*), 20th Century Fox (*Alien*), and Paramount (*Raiders of the Lost Ark*, licensed from George Lucas's Lucasfilm, a hit just eight years old when the park opened). The only major studio not represented was, naturally, theme-park competitor Universal.

Guests rode through the scenes in rows of theater-like seats on moving platforms, similar to those used in EPCOT's Universe of Energy, each block of seats piloted first by a tour guide and later by an outlaw

or hoodlum who "hijacked" the ride after a shoot-out in either Gangster Alley or Western Town. Nearly a dozen films—more, if you consider that some segments represented full genres rather than single movies—were reproduced with Audio-Animatronics figures standing in for movie stars including James Cagney, John Wayne, Clint Eastwood, Sigourney Weaver, Margaret Hamilton, and others. The sets were deep and soaring, without the confinement of classic Fantasyland dark rides, and the experience was unified by the hijacking story line, which made the guests part of the story. It all ended with a film montage of familiar clips from dozens more movies that touched on every era and taste—a kind of take-away challenge to movie lovers to name all the films and stars as they flashed by. Applause at the end was inevitable.

Frank Wells was a big fan, telling a reporter just before the park's opening that the attraction had him "totally absorbed in everything that the movies stand for." He continued, "Kleenex is going to double its business on that. It is so nostalgic. It's so warm, and when you get to the *Casablanca* scene, I mean, no one's going to hold back. I mean, that is everyone's life in review in so many ways, and especially their movie lives." He concluded simply: "It's just a whale of a show."

The second anchor experience in the park was the Backstage Studio Tour, which took guests in a tram through a working production facility—where they could look through windows to see staffers working on costumes, for example—and elaborate, pristine outdoor movie sets, dubbed Residential Street and New York Street, meant to reproduce the feeling of a Hollywood studio lot. That was followed by a staged experience called Catastrophe Canyon, devised by the Imagineers. For the dramatic finale, the tram stopped in the canyon and seemed to experience an earthquake, as it might have been staged for a movie. A tanker truck exploded in flame and was then doused by a deluge of water from farther up the canyon. The post-tram "walking tour" through multiple soundstages began with a special effects demonstration re-creating a storm around a patrol boat in a water tank and ended with visits to a postproduction facility and a theater screening previews of upcoming

movies. The whole experience could take more than an hour, plus waiting time. Longer, if the guests lingered on the walking portion.

Imagineer Tom Fitzgerald, fresh off Star Tours, was on the team that developed the studio tour, focusing on the walking portion. Marty Sklar asked him to pitch in for about three weeks; he wound up working on it for three years. "As a writer, I found it challenging," he said. "As I recall it, every stop on this walking tour is two and a half minutes long. I said, 'Yeah, but not all stories want the same amount of time. I mean, you can spend an hour in special effects, but I'm not sure about sound effects or editing.'" Nevertheless, two and a half minutes it was to be. "And then there was a moment not long after where we realized that we're not going to be filming major motion pictures at the Disney-MGM Studios, that motion picture shooting was going to stay in California."

Unable to lure producers of big movies to the not-yet-built facility, Eisner came up with a plan B, Fitzgerald said. "Michael decided what we would do is we would film a series of [short] narratives with big movie stars—so that even though you couldn't see them on the stage, you could hear them talk about how movies were made." The result would be about ten short films to be shown at various points along the walking portion of the backstage tour. If Eisner could not lure stars to work at what he had hoped would be Disney Studios East, he could at least capture them in clever clips to play for park guests. Filming the shorts "was an incredible learning experience," Fitzgerald said. "We went all over the country shooting these things. We shot the first day on Warren Beatty's *Dick Tracy* film, and we shot with Pee-wee Herman down in Florida." Each little film illustrated a different craft in the filmmaking process, from acting and directing to matte paintings and special effects—such as putting Selleck and Carol Burnett together atop the Earffel Tower, the faux water tower with Mickey Mouse ears that would become the tallest structure in that park. The project had lasting benefits for Imagineering, creating a core media production team that became a permanent part of Imagineering. Future short films needed for theme park attractions could now be made in-house.

The hope that park guests would be able to spy on celebrities during the live-action production of major motion pictures remained unfulfilled, but the windows on the nearby The Magic of Disney Animation tour were never covered. There, guests could look over the shoulders of an actual Disney animation team at work: story artists, animators, clean-up specialists, ink and paint, and so on. According to Wells, Eisner was determined to make a working animation studio a part of the park, saying early on, "What more can we do to represent this company? What more can we do to make this a real Disney working studio than to have a real animation facility down there?" At first, the Florida animation cast members worked on shorts—an early effort was the Roger Rabbit–themed cartoon *Roller Coaster Rabbit*, released in June 1990 as the short preceding *Dick Tracy*—but Eisner envisioned a full second animation facility for Florida that could also produce features, and that hope grew to fulfillment over time.

In addition to the Backstage Studio Tour and The Great Movie Ride, Disney-MGM Studios also had more compact attractions, such as the Monster Sound Show and SuperStar Television, both of which picked audience members to help re-create scenes and effects, and live shows at the outdoor Theater of the Stars. There were shops—concentrated along Hollywood Boulevard, which connected the park gate to the Chinese Theatre—and restaurants, from an upscale reproduction of the famous Hollywood eatery The Hollywood Brown Derby to more casual and affordable joints such as Min and Bill's Dockside Diner. That sandwich-and-salad joint sat beside a large round pool named after Echo Lake, across the water from an ice cream shop in the shape of Gertie the Dinosaur. An attraction called the Indiana Jones Epic Stunt Spectacular! would be added a few months after opening, and Star Tours soon after that.

What had been created by the Imagineers was a realm of shared dreams. It inspired, Eisner said at the May 1989 dedication ceremony, "a state of mind that exists wherever people dream and wonder and imagine, a place where illusion and reality are fused by technological magic." It was, he concluded, "a Hollywood that never was—and always will be."

The new park even put a spell on Wells. He evoked the vivid episodes he had experienced while mountain climbing—"these kind of special moments that happen and you never quite know when they do. But if there was ever a magic moment in my life," he said not long before the park opened, "it was three nights ago when the board came down, and the studio tour, at least the outside of it, is getting very close to what it's going to look like. Hollywood Boulevard was lit—all those palm trees ran from the beginning right down to The Great Movie Ride. It was a beautiful night." Seeing the full moon, one of the cast members running the lighting took a spotlight and angled it toward the sky "so it actually looked like the studio tour was lighting the moon. And you want to talk about a magic moment? That was it. That's what being part of Disney is all about. It was wonderful."

The press seemed equally blown away. *Newsweek* put the park on its cover, and *Time* magazine published a positive advance review. As it had done with EPCOT Center, NBC-TV aired a prime-time special about the park. Opening day attracted stars including Bette Midler, Robin Williams, and George Lucas, as well as some three thousand members of the media from around the world. Regular folks poured in as well. "Within several hours of opening the gates for the first time," Eisner recounted, "we reached capacity and had to begin turning people away from the parking lots. In a month, the park's success had helped push Disney's stock up more than 20 percent. After three months, we announced our intention to double its size over the next few years, based on plans developed as part of our initial design."

The "half-day" park concept did not occur to most Walt Disney World visitors. Disney-MGM Studios "got the same basic volume of guests as the other parks were getting, and so it was inundated," Weis said. "The lines were long, and we couldn't expand it fast enough." Some proposals came together quickly, including a deal with Jim Henson's company to bring the Muppets into the park and a plan to build a completely new street, "Sunset Boulevard," out from the hub at the end of Hollywood Boulevard. The new thoroughfare would lead to a thrill ride unlike any the Imagineers had yet created, inspired by a hotel back in the actual

Hollywood. The Studios would keep Imagineering humming for years to come.

The park had been planned to serve an expected total of five million guests in its first year, but it was immediately popular enough to boost Walt Disney World attendance by five million in just the first six months. According to Eisner, operating income from all Disney parks hit $800 million for 1990—Disney-MGM's first full year of operation—which was more than triple the take from just six years earlier. Hollywood might not have been rushing to make movies at Disney-MGM Studios, but America was flooding into the park to enjoy what *Newsweek* had trumpeted as "Mickey's New Magic."

IV. THE DISNEY DECADE

Michael Eisner began the 1990s by announcing an ambitious agenda that would keep the Imagineers hustling for the duration. At a pair of news conferences—in California on January 12 and at Walt Disney World on January 14—Eisner unveiled plans for at least twenty-nine upcoming projects, ranging from new attractions at Disney-MGM Studios to a fourth and perhaps fifth theme park—plus new hotels, shows, and renovations. "The next ten years, we're going to do nothing less than reinvent the Disney theme park and resort experience, and not just here in Florida, but in all our parks and resorts," Eisner said at Walt Disney World, speaking the day after Star Tours had opened at Disney-MGM Studios. "By the year 2000, we expect to host over one hundred million guests each year in Disney theme parks and resorts around the world."

Eisner called the coming ten years the "Disney Decade," and at the California event he promised a major expansion of Disneyland, as well as the first steps in building a completely new theme park in Long Beach—or maybe in Anaheim, but not both. Later that year, the proposed $1 billion Long Beach park got a name: Port Disney. The company had acquired the land surrounding the popular *Queen Mary* cruise ship and historic Spruce Goose airplane attractions in 1988 when it bought the Wrather Corporation—giving the company ownership of the Disneyland

Hotel for the first time, among many other real estate assets. On the other hand, if the Anaheim plan prevailed, the new park would be adjacent to Disneyland, built on some of the seventy acres Disney already owned (including thirty acres of "backstage" area), some of which also came from Wrather. But there was something big on Eisner's list for both coasts: at the Orlando press event, he promised to start building a fourth Florida theme park before the end of the decade—although he would not say anything about what that new park would be. Disney's investment in vacation properties in Florida and elsewhere would also increase dramatically with new hotels and the launch of a "shared vacation ownership" program (which evolved into the Disney Vacation Club, debuting in late 1991).

Like any decade-long agenda, the plan featured as many items that never happened as projects that did. An attraction based on Disney's *Dick Tracy* movie would be scrapped when that film fell short at the box office, but the promised revamp of Tomorrowland at Disneyland went forward. Walt Disney World would indeed get a Splash Mountain, but not the announced Matterhorn-style roller coaster within a Swiss village inside EPCOT's World Showcase.

But whatever the scorecard on which of the many scattered seeds did and did not blossom, Eisner's dual press conferences broke considerable new ground in the history of Walt Disney Imagineering. Never before had the company announced so many new projects at one time, many of them still in early development. The fact that Eisner was willing to risk such immediate media scrutiny and future judgment on his success was a testament to his great confidence in his corporate team, particularly the artists at Walt Disney Imagineering. To that team Eisner would soon add the Oscar-winning high-tech special effects company Associates & Ferrin, installing its highly inventive founder, Bran Ferren, as the head of Research & Development. (The company had been consulting with Imagineering for several years.) By the end of the Disney Decade, the staff at Imagineering would number three thousand, a tenfold increase from the low point after Tokyo Disneyland opened.

One giant project in the works was not part of Eisner's January 1990

agenda, because it had been announced more than four years earlier. In December 1985, Walt Disney Productions had reached a preliminary agreement with the French government to build Euro Disneyland outside Paris, a deal finalized in March 1987. As the Disney Decade dawned, a team of Imagineers had been supervising construction in France for nearly two years. Mickey Mouse was finally going to have a permanent home in Europe—much to the dismay of certain French people.

CHAPTER 14:

AMERICANS IN PARIS

"Michael Eisner . . . had great ambition. . . . He wasn't just a typical CEO-type executive. He wanted to be part of the creative process, and Disneyland Paris was the mark that they were to make." —Eddie Sotto

I. KNOCKING ON THE DOOR

COULTER WINN vividly remembers his first day on the job, because he got schooled by John Hench. It was the late 1980s and Winn had had plenty of schooling already, having earned both bachelor's and master's degrees in architecture from UC Berkeley, where he had also studied art and history. Out of school for nearly fourteen years, Winn had recently been self-employed, running his own architectural firm in San Diego. Then a former colleague told him Walt Disney Imagineering was hiring. Intrigued, he'd gone to Glendale for an interview, and both he and Imagineering were smitten. Michael Eisner had just announced a jam-packed agenda of projects, and "I was told, 'You'll have work for ten years here.' I go, 'Sign me up.'" He moved his life north and reported for duty. Now he had been herded into the Imagineering cafeteria with about twenty other new hires. "And in come Marty Sklar and Mickey Steinberg, who were the creative and project delivery executives at the time, as well as John Hench," Winn recalled. "Now, John Hench is, you know, legendary—I mean, he started in the [Hollywood] studios in the 1930s."

Winn knows all that now, but at the time he had no idea who any of these guys were—or what he was in for. "John Hench asked, 'How many architects you got here? How many of you are architects?' And I go, 'I am.' I was the only one. He goes, 'Can you tell me Walt Disney's four levels of detail?' I go, 'I have no idea.' He goes, 'Well, why don't I tell you.'" And so he did.

"Detail level one," Hench said, is "you're out in the countryside, you're looking over the trees and you see the church steeple over the trees. Detail level two, you've walked into town and you've just come to Main Street. You can see the parkway, the median strip, the trees, the benches, fire hydrants. Detail level three, you're standing on the sidewalk and now you're looking at a fine house. You can see the color, the texture, the materials, the scale, the architectural style. Detail level four, you're actually going up to the front door, you've grabbed the door knocker and you're knocking on the door with the door knocker. You feel the temperature of the metal, the texture of the metal, whether or not it's been deformed, if there's paint on it, if the paint is slightly chipped. Most architects are really good about getting to detail level three. Here at Imagineering, we always have to get to detail level four, because we have to immerse our guests in our stories and make them so believable that the door knocker has to be completely real."

"I thought that was pretty good advice," Winn said, "and so, when we do a castle, even though it's really huge, I always remember that door knocker—regardless if it's the handle with the princess motif, or what that detail is, that's all part of it." No matter how big the project, "we really stress the details to get them right."

As the Imagineers worked on their fourth Magic Kingdom park, the castle was foremost in their minds. Ever since 1955, Winn said, when "you walk down Main Street in Disneyland, on your first trip to Disneyland, you see that castle. I mean, what's not to spark your imagination about everything being possible? It's just such a romantic icon. And then, every park has a different one." And in France, "you couldn't just do a regular castle."

That conundrum—how to bring Disney's unique fantasy world to a

country that had been the source of many of the company's best-known fairy tales, and at the same time adhere to Hench's mandate on detail— would define the creation of Euro Disneyland. Unlike the Japanese, who had wanted a near duplication of the Magic Kingdom–style parks many of them had already seen in the United States, the French had strong opinions about how Disney needed to adapt—or just go away.

II. BREAK A FEW EGGS

The Euro Disneyland project dated back to at least the mid-1970s, when Frank Stanek's study of possible sites for a new Disney park outside the United States had identified Europe and Japan as the top prospects. By the time Michael Eisner took the reins at Disney, Tokyo Disneyland was a roaring success, and Eisner wanted options for where to build the next international project. In the fall of 1984, he and Frank Wells heard a presentation by parks chief Dick Nunis and Jim Cora, who had directed operations, planning, and management in Tokyo. Their team had sifted through some 1,200 possible locations in Europe and narrowed the field to two countries: France and Spain. Wells told them to begin negotiations with both countries to see which might offer a better deal.

Eisner himself had his thumb on the scale in favor of the French, in part because in his youth he'd spent memorable vacations in Paris— "one of the most beautiful and romantic cities in the world." "My heart was with France from the start," he wrote in his memoir. The French site was 4,400 acres in Marne-la-Vallée, a farming community about thirty kilometers east of the center of Paris, accessible by an existing major highway and 30 minutes from both major airports serving the city. The two Spanish sites were near the sea and had longer summers, but Eisner judged the country "a geographical cul-de-sac"—far from the center of Europe and serviced by a separate rail system. Furthermore, Spain's development was well behind France's, with no national highway system and spotty telephone service. In Spain, Eisner believed, tourism would be limited to the six warmer months, while Paris was a year-round destination. France might experience a lot of rain and cold winters, he

judged, but most Europeans would be undaunted by weather conditions they were accustomed to. (Rain didn't bother the Japanese, either.) By fall 1985, the focus was on striking a deal with the French government. Among other infrastructure upgrades, Eisner wanted a promise that the Paris Metro subway system would connect to the park and that the country's high-speed train line TGV would drop passengers practically at the gate. He wanted a $700 million low-interest loan from the government and the sale price of the property set at the cost of farmland, not valued at its inflated Disney value. (The final price was about $9,680 an acre.)

With negotiations ongoing but both sides confident, Disney signed a letter of intent on December 18, 1985, with a final agreement still to come. The story led all the major newscasts in France that night. "We are hopeful that our current negotiations will result in a definitive agreement to bring Mickey Mouse and the Magic Kingdom to France and the European Community," Eisner said at the press event announcing the deal to the world. He told the *Los Angeles Times* that France "has been the leading market of the world for Disney after the United States." The park would be called "Euro Disneyland" in part because it was conceived as the playground for a continent, and in part because, as Eisner said later, "As Americans, the word 'Euro' is believed to mean glamorous or exciting."

Shortly after the Euro Disney announcement, in early 1986, Eisner had another new name to unveil: Walt Disney Productions would henceforth be known as The Walt Disney Company. The change, Eisner and Wells said, reflected the company's diverse business ventures better than the old name, which they said was associated chiefly with movies. It was another year before the newly named Walt Disney Company reached a final agreement with the French. It was signed on March 24, 1987, by Eisner and then French Prime Minister Jacques Chirac. "The Magic Kingdom," Eisner said at the signing, "will be brought to France intact. It will be different in that it will take advantage of, but have respect for the French culture." The theme park—built on former sugar beet fields—would be the largest in Europe. It promised to provide

an estimated thirty thousand jobs during construction and twelve thousand permanent positions in the park alone—plus staffers to manage the more than five thousand rooms in Disney hotels included in the wider development, called the Euro Disney Resort. (Phase One also included a campground, a golf course, and a clubhouse.) The initial budget of $2 billion would more than double before opening day, money that came from government and bank loans, outside investors, and other sources. Disney itself put in between $100 million and $200 million.

Construction began in August 1988. The French backlash followed soon after, as the nation's vocal left wing leveled charges of cultural imperialism. On October 5, 1989, Eisner went to Paris to celebrate the start of trading for stock in Euro Disney SCA, the public corporation set up to own and run the Euro Disney Resort. (Under French law, Disney could own only 49 percent, since it was a foreign entity, but Euro Disney SCA would also pay the Walt Disney Company licensing and management fees in perpetuity.) As the invited press looked on and shot photos and video, Eisner arrived in what he later described as a "little Disney car," driven by Mickey Mouse. As Eisner stood with Mickey, Pluto, and Donald Duck on the steps of the Paris Bourse, the French stock exchange, talking about the Euro Disney Resort, French communists in the gathered crowd suddenly began pelting them with eggs, flour, and ketchup. "Mickey go home!" they shouted. They tossed fake $500 bills in the air and declared Euro Disney the "dirty deal of the century." Although the demonstration overshadowed the celebration in media coverage, Eisner dismissed it as a theatrical reflection of French politics rather than public sentiment. "Who could possibly be against Cinderella and Snow White?" responded Robert Fitzpatrick, the former French professor from Baltimore whom Eisner and Wells had plucked from the presidency of CalArts in 1987 to become president of Euro Disney. Once the park opened, he told a reporter in 1991, all the critics "will be in the park with their kids, enjoying it."

But whether Disney had put enough thought and research into the cultural gap between France and the United States remained a much-debated question as the park was being built (and would emerge as more

concrete challenges after the park opened). "It's hard to imagine Europeans, especially the French, putting up with long lines and large crowds, but they might for a few days," a Florida professor of French literature told the *Orlando Sentinel* in 1991. He added that "some French employees may have a tough time understanding that a Disney employee has to smile and present a clean, well-ordered appearance." His observation corresponded to a popular joke at the time, suggesting that in France, all seven dwarfs should be named "Grumpy."

The onset of the United States–led Persian Gulf War in August 1990 further soured many French people on the prospect of an American theme park competing with local attractions for tourist dollars. By early 1991, a Parisian theater director named Ariane Mnouchkine had coined the phrase "cultural Chernobyl" to describe the project, a moniker that journalists and anti-Disney intellectuals loved to repeat in the months and years to come. (The USSR's nuclear plant disaster in Chernobyl had happened in 1986, so it was still a touchy subject, particularly in Europe, where radioactive fallout had reportedly drifted as far west as France and Spain.) "The French feel threatened because the cultural landscapes in France are changing too fast," magazine editor Leon Mercadet told a *Washington Post* reporter in 1991. "They sense France is becoming part of the American Empire. After decades of cultural penetration, we know culture is ruled by economics, and we in France have learned to be suspicious of whatever comes from America."

When Eisner showed up for a meeting with French President François Mitterrand along with Mickey Mouse, the Socialist president's staff denied entry to the costumed figure, evidently having decided, Eisner recounted later, that the President would not want to be seen with such a "frivolous character." Jack Lang, then the French Minister of Culture, declared haughtily that he would not attend the park's opening, tying Disney to the despised "America of clichés and a consumerist society." One French journalist summed up the gap between simultaneous French enthusiasm and disdain this way: "America gives us the same effect as ice cream: it makes us sick, but we keep asking for it."

But while major French magazines such as *L'Express* and *Le Point*

considered the influence of American culture in cover stories, the condemnation of Euro Disneyland was not universal. "This may come as a surprise, but I don't feel attacked either by an outside enemy or by a hostile foreigner," French philosopher Andre Glucksmann wrote in an opinion piece on the front page of the English-language *International Herald-Tribune*. In the *Washington Post*, Fitzpatrick traced the anti-Disney sentiments to "a small group, an arts mafia, who see anything popular, anything American, as endangering French culture." He added, "Don't think that's the French public view." Even President François Mitterrand, who had exiled Mickey from his office, turned out to have Disney fans in his family. "The President said that it was not his cup of tea," Eisner recounted, "but then his office called up and said, 'Can I have six tickets for my grandchildren?'" Eisner found the request indicative of his experience in France: a deep love for Disney combined with "typical French caution." In the end, he knew, the verdict would be determined by the success or failure of the park.

III. "AN EXTRAORDINARY WORLD"

Tony Baxter, the creative lead for the Paris park, was given a high standard to meet for Euro Disneyland. "Michael [Eisner]'s mandate," Baxter said, "was to create the most beautiful theme park. It was going to have his name and Frank Wells's on it. So, [they said,] 'We want this to be the most beautiful theme park ever.'" To which Eisner then added: "And you're going to do it for not a penny more than we spent in Tokyo."

This would be quite a challenge, especially when it came to the castle, which needed to be the most awesome attraction in this most awesome park. When it came time to select a designer to lead the Fantasyland team, which would include the castle, Baxter asked Tom Morris if he wanted the job. It was something of a leap of faith on Baxter's part, since Morris—fresh off Star Tours—"wasn't the castle guy or the storybook village guy," as Morris himself put it. "I was mostly working on Tomorrowland-ish things or Frontierland-ish things." He believed he got the gig in part because of a four-week trip through Western Europe

he'd taken a few years earlier, exploring every castle that struck his fancy. His extensive collection of detailed photos jump-started his team's design research for Sleeping Beauty Castle, which was known in French as Le Château de la Belle au Bois Dormant.

Baxter recalled that he and Morris "sat down together, and we thought of all the things that we've never done with castles before and decided, 'Let's see if we can do that.'" He continued, "We felt the most danger-ous thing we could do would've been to copy anything that was here in France, so we turned to the fairy tales. We looked at Eyvind Earle's incredible styling for Walt Disney's 1959 motion picture *Sleeping Beauty*, and we also looked to the French [through] their magnificent tapestries that were done in a very stylized way, where all the trees were squared and created in a very geometric form." The Imagineers also drew from one of Earle's inspirations: the book of hours Les *Très Riches Heures du duc de Berry*, a lushly illustrated prayer collection known as one of the premier examples of medieval illuminated manuscripts.

"All of that went into this design," Baxter said. "And I think what we ended up with is a castle that's at once Disney and at once out of a fairy tale and belovedly French all at the same time." With its nar-row, soaring turrets and its calculated asymmetry, it was a building that could exist only in the imagination—or in a Disney theme park—rising to more than twice the height of the original Sleeping Beauty Castle in California. Many of the details were subtle—for example, each turret was topped with a unique, hand-crafted copper weathervane. The sur-rounding landscaping—with striking, squared-off trees—was designed to evoke the flora of the famous Unicorn Tapestries, thought to have been created in France around the year 1600. The plants "reflect the rigid design sensibility that's in a tapestry," Baxter said.

The castle's greater size allowed Morris to create a more spacious inte-rior, designed to evoke the Gothic sanctuaries of classic French cathedrals such as Notre-Dame de Paris and Chartres, but with a fantasy overlay. In addition to the walkway leading to Fantasyland, the château had two more levels: a lower dungeon that housed an Audio-Animatronics fig-ure of a fire-breathing dragon and a balcony above that functioned as a

gallery for a set of meticulously crafted stained glass windows and hand-made tapestries, all commissioned by Imagineering for the castle. The castle's interior pillars became a prime example of what Morris termed "additive collaboration," which he described in Marty Sklar's book *One Little Spark!* as "not being afraid to make someone else's idea work or to enhance an idea of your own by incorporating others' ideas and designs into it." When Morris showed his early sketches to Eddie Sotto, the Main Street, U.S.A., designer had a suggestion: "Looks great," he said, "but have you considered making the arches under the balcony look like tree branches?"—which would pick up a motif used elsewhere in the castle. "It would have been easy to say 'yes, but' or 'no, this,'" Morris said, "but I had to admit it was a great idea and immediately incorporated it . . . because it was the best thing for the overall design and guest experience."

For the castle exterior, Imagineers developed a color scheme that would emphasize its verticality. "One of the tricks that John Hench taught me was if you want to make something soar, if you want to make it look like it's taller, you start by darkening the colors of the base, and as it goes up, you lighten the value of the color," said Katie Olson, who led color design for the château. "And we did that on the castle where we deliberately staged the color so as it goes up, it lightens." She added, "There's nothing more iconic for our parks than the castles, so if we don't nail the castle, I'm not doing my job. As you're looking down Main Street, you see the castle and you want that to be a very inviting, very welcoming, very reassuring view."

Other collaborators on the castle included the European artisans who worked on the tapestries and stained glass windows inside—the first time Imagineering had sought out local artists to collaborate on elements of a theme park. Their creations told the story of Sleeping Beauty, using characters and images from the Disney feature film. Paul Chapman, an eighty-year-old English master of stained glass, had worked on the restoration of Notre-Dame Cathedral in Paris before being coaxed out of retirement to oversee the eight window panels at Sleeping Beauty Castle. (Visible only from inside the castle, the artistic creations were "windows" in form but not function.) Chapman agreed to the commission, Baxter

said, because "all his life he'd been doing religious stained glass work and he wanted to do one last project that really made people smile." The thousands of brilliant shards in each panel included more than two hundred types of glass composed of different materials and colors, each piece bordered by lead. "They go together like a mosaic of color," Chapman told a video crew at the time, visiting the United Kingdom studio where the windows were created before being shipped to France. "There's no room for artistic interpretation [by the individual craftsmen assembling the images]. Everything has to be absolutely right. It must be drawn so that the painter gets an exact picture of what is expected of him."

The company hired to work on the tapestries dated back to the Renaissance, having been in business in the country's Aubusson region—famous for its tapestries—for more than five hundred years. The Imagineers also brought in European woodworkers and scenic painters from Italy. A company that had been in business for hundreds of years came aboard to create many of the glazed roof tiles for Fantasyland. "The shingles on the buildings are more colorful than shingles you would see in other villages," Morris said. "The lampposts integrate a higher degree of colored glass. The trees have wonderful, exotic, fanciful shapes to them. So everything is slightly out of this world. You've gone to an extraordinary world of your dreams."

Those dreams, Tony Baxter emphasized, were based on a lot of research into European culture. "I've never thought Disney was an American concept," he said. "It's a universal concept. One of the things we were careful to do was, we went all over the European continent to not just other theme parks, but to great gardens and to cultural places that the Europeans enjoy for leisure, and we found a consistency that was very similar to the type of things we did." Whether consciously or not, the Imagineering team was following in the footsteps of Walt Disney, who had been so inspired by the gardens of Tivoli in Copenhagen. The park's garden-heavy layout and all the customizing of attractions for a European audience—it all "grew out of our understanding and our exploration of culture here across the continent." That eventually even came to include Main Street, U.S.A.

IV. RETHINKING THE CLASSICS

Fantasyland wasn't the only land upgraded for Euro Disneyland. Both Frontierland and Adventureland, which had traded relative positions to the left of the castle, were enlarged, and the Haunted Mansion had moved into Frontierland. Renamed Phantom Manor, it was redesigned as a majestic but derelict Victorian home, its narrative reconceived to be a shade darker than the humor-focused Disneyland original. The revised story—about a mining millionaire, his beautiful daughter's tragic wedding day, and a mythical Thunder Bird that emerged from the wounded earth—corresponded to the imagined history of Thunder Mesa, the town depicted in the park's Frontierland.

"We discovered in our research early on that Europeans, especially the French, love the West, the Wild West," Imagineer Tom Fitzgerald said. "It's a piece of American history that is still very romantic to them today. So when you visit Disneyland Paris, you'll notice that the Frontierland is enormous. It's far grander than any of the other Frontierlands that we've created. It's got that sort of CinemaScope vista." Perhaps the most impressive vista in Thunder Mesa is from the front of the Phantom Manor. Set on a rise above the rest of the town, the mansion offered an excellent view of Frontierland's most dramatically reimagined attraction: Big Thunder Mountain.

Big Thunder Mountain Railroad had been a Space Mountain–era addition to Disneyland in Anaheim, the third in a series of mountain-themed roller coasters begun with the Matterhorn. It was Tony Baxter's first turn as the creative lead on a project. "It's quite a story," he said proudly, "going from scooping ice cream at Disneyland to being a designer of attractions there—because it didn't happen overnight." Taking on Big Thunder, he recalled, was "pretty scary. I had never done anything before [as lead designer], but it was also a park filled with everything that Walt Disney had led the initial effort on." That included the two most recent E-ticket additions to Disneyland, Pirates of the Caribbean and the Haunted Mansion, and even the not-yet-open Space Mountain, a concept Walt had signed off on but never saw developed.

"So Big Thunder was really the first major change where something differed [from Walt's vision]."

A runaway mine train roller coaster had first appeared as one of several attractions meant for Walt Disney World. Conceived by Marc Davis and intended for a mid-1970s opening in Fronterland at Florida's Magic Kingdom, it was shelved in favor of a second version of Pirates of the Caribbean, which early visitors to Walt Disney World had repeatedly requested. As a stand-alone attraction, the mine-car coaster "appealed to a new audience, an audience that was raised on speed and thrill," Baxter said. "And yet we still had the desire to keep it feeling like part of Disneyland."

Unlike its sister attraction, Space Mountain, Big Thunder Mountain Railroad was outdoors and needed to emerge organically from the twenty-year-old Frontierland. (It was to replace the narrow-gauge Mine Train Through Nature's Wonderland.) The challenge, Baxter said, was "to take a roller coaster track—which resembles a gigantic pile of spaghetti—and create the rockwork around it so it looks like the rockwork was actually there first." The towering peaks of Big Thunder were inspired by Utah's Bryce Canyon National Park, the theming by ghost towns left over from the California Gold Rush. A stretch of miniature buildings near the end of the attraction represented what was left of the town of Rainbow Ridge, and the trains zip through the bones of a dinosaur skeleton and past a goat with a stick of dynamite in its mouth.

The attraction opened at Disneyland on September 2, 1979, less than sixteen months after Space Mountain's debut at the park. A year later Big Thunder Mountain Railroad also opened in the Magic Kingdom in Florida, similar to the Disneyland version but themed to Arizona's Monument Valley. The Florida ride was adapted for inclusion in Tokyo Disneyland as well (dropping the word "railroad" from the name), opening in July 1987. For Paris, however, Big Thunder Mountain would get even bigger. "One of the neat things about doing something four times, like we have with Big Thunder, is each time you do it you can take a look at what it is we could actually make better," Baxter said, "and what we could improve in terms of making a more fun show."

Baxter had begun working on Big Thunder in his twenties. The Euro Disneyland version would debut twenty years later, and—working with chief Frontierland designer Jeff Burke—Baxter put those decades of added experience into the new ride. The three previous versions all included water features: a geyser, a shallow river into which the tracks briefly dip. But the fourth iteration put water front and center, situating the mountain and most of the track on an island in the center of the Rivers of the Far West. The queue and boarding station are on the "mainland," and trains duck through a tunnel beneath the river to get to the island, where they are pulled up a steep hill within a continuation of the tunnel, emerging into the open air at the top, where gravity takes over and the thrill ride really begins. Adding to the sense of danger, the track skirts the island's edge more than once, including one dip when it seems to splash down in the river (thanks to synchronized water jets along the track). At the end of the journey, the trains zip down into another tunnel, taking guests back to the station to disembark.

The mountain portion of Big Thunder Mountain in the Paris park reaches more than ninety feet into the air, nearly twenty feet higher than Sleeping Beauty Castle in the California park. The attraction's rock towers, with elements from both Bryce Canyon and Monument Valley, are visible for miles around, emerging from what was still mostly French farmland when the park opened, outdone only by the turrets of Sleeping Beauty Castle. It would be, Baxter judged, "the crown jewel of all the Big Thunders in the world, adding a lot of new surprises and fun to what is already a classic ride in our other parks."

Another classic attraction—Jungle Cruise—remained the centerpiece in Frontierland's neighbor realm, Adventureland. But that land also got a significant makeover for Euro Disneyland. Since Tom Sawyer Island had been eliminated by the placement of Big Thunder in the middle of the Rivers of the Far West, a new attraction was developed called Adventure Isle, which would be the exotic treasure-laden home for a lot of (unseen) pirates. The walk-through island combined the play areas, tunnels, and caves of Tom Sawyer Island with other classic Magic Kingdom elements, including the Swiss Family Robinson Treehouse (renamed

La Cabane des Robinson) and a resurrected version of Captain Hook's Pirate Ship—still landlocked but without the Chicken of the Sea restaurant inside. Also returning was a larger rendition Skull Rock, spilling water only from its mouth this time. The land thus merged imagery from three Disney adventure films: *Swiss Family Robinson*, *Peter Pan*, and *Treasure Island*.

Adventureland also gained "a major presence on the hub," lead designer Chris Tietz said. Previous entryways were "understated," he continued, while the hub entrance in Paris was marked by a dramatic gate resembling a Middle-Eastern city wall. With Euro Disneyland opening the same year as Disney's animated *Aladdin*, Adventureland's dramatic Bazaar, just inside that wall, took its inspiration from the stories that also introduced the boy thief: *1001 Arabian Nights*. "We wanted to give it a fantasy slant, something we could layer colors and texture and story onto," Tietz said of the Bazaar. Beyond the Middle Eastern marketplace, Adventureland combined elements from tropical islands, northern and central Africa, and the Caribbean. "We just tried to get as much fun into that land as we could."

The Caribbean section was anchored by the fourth iteration of Pirates of the Caribbean, its story line reordered to adjust for the Imagineers' cost-saving decision not to excavate twenty feet down into the water-laden French countryside, as the Disneyland original had done, but instead to take guests to a higher level at the start of the show, saving the waterfall drops for later in the experience. The new narrative "took the boats up at the beginning, into the fort to free all the pirates that are locked in the prison jail cells," Baxter said, "and then plunged people down into the city and then down again at the end [to tour the haunted caverns]. So we were able to capture the detail of the ride that made [the original in] Disneyland the most powerful of all the pirate rides—and do it for the price tag that we had to work with."

Baxter also wanted more impressive Audio-Animatronics for the attraction, "so we added a sword fight." It turned out to be quite a battle indeed. "The sword-fighting pirates was the most complex sequence we've ever tried to program," said Stan Abrahams, who worked in

Imagineering's Animation Development division. "These two guys nearly destroyed each other as they were being programmed. They'd tangle up their swords, punch each other, even tear the hair off of each other." The Audio-Animatronics figures eventually needed stronger arms and less destructive swords before they could be placed in the attraction. Once again, story needs were driving technological advancement, this time contributing to the forward leaps Audio-Animatronics continued to make.

The changes to what had always been called Tomorrowland were even more dramatic. "As Imagineers, when we start a project, the first thing we do is intense research," said Tom Fitzgerald. "We really try to understand our audience. What they love, what they know, their culture." They also wanted to make sure the new land wouldn't date itself in ten or twenty years—a problem with the original Tomorrowland. That was why, he continued, "we paid homage to Jules Verne, the father of science fiction by taking our Tomorrowland and giving it a steampunk retro look." In fact, it would not be called Tomorrowland at all: it would be Discoveryland.

"Innovation is really the key to what Discoveryland is all about," said the land's lead designer, Tim Delaney. "So instead of dreaming about the future, and calling it Tomorrowland, we decided to dream about discovering new ideas and innovations." Just as Fantasyland combines fairy tales from many cultures, and Adventureland blends various tropical locations, Delaney said, Discoveryland would become a "collection of different futures," recognizing that "man has always dreamed about the future." Along the way, the Imagineers would "pay tribute to some of the great European visionaries—people like Jules Verne and H. G. Wells and Leonardo da Vinci," as well as modern dreamers. "It's about many futures. There's actually a Jules Verne future. There's even a Michael Jackson and George Lucas future, if you will."

Some ideas for Discoveryland had their roots in designs for the abandoned Discovery Bay, the land developed in the late 1970s and intended for the north end of Rivers of America in Disneyland. (The plans had included Professor Marvel and his miniature dragon—characters now roaming Future World in EPCOT Center as Dreamfinder and Figment.)

Baxter was the lead designer on Discovery Bay, and he had styled the area after the works of Jules Verne and other Victorian-era science fiction—an aesthetic that in the 1980s inspired fresh retro-sci-fi works dubbed "steampunk." Jules Verne's aesthetic would be predominant in Discoveryland, Delaney said, "because he was a tremendous inspiration and visionary to us." It helped that Jules Verne was French, of course.

Guests' introduction to the land was a new version of the Astro Orbiter, this one called Orbitron Flying Machines ("Orbitron Machines Volantes"). Its planet-like orbs rotating a central spine were inspired by Leonardo da Vinci's drawings of the solar system, but it also had bronze decor honoring the Victorian gadgetry imagined by Verne. But the most extensive Jules Verne-inspired transformation would be the new Space Mountain, which would not welcome guests until 1995, after the park had been open for three years. Taking the longer name Space Mountain: *De la Terre à la Lune*, inspired by Jules Verne's novel *From the Earth to the Moon*, the attraction shared the conical shape of its three predecessors, as well as the concept of a space-themed roller coaster in the dark. But it was overlaid with a bronze-hued shell and featured a tubular launch cylinder along one spine of its sloped roof. The new catapult-style launch system was an homage to the giant cannon Jules Verne imagined propelling passengers into space. The detailing, inside and out—even encompassing a few props along the interior coaster track—consisted of elaborations on Jules Verne illustrations by Henri de Montaut and others, with geometric metallic shapes, banded cylinders, and variations on Victorian-era mechanisms of all sorts.

"This was the ultimate marriage of a story, a vision, and a technology," Delaney said. The catapult launch, he said, was a long-time aspiration of the Imagineers. "If you're gonna go to space, we might as well fire you off," he said. "Our ride engineers figured out how to do this. This is, in fact, the first incline catapult launch system ever created." Just as impressive was the creation of a synchronized musical score, piped into each ride vehicle through computer-connected speakers. Music by Steve Bramson, who had just scored the young Indiana Jones television series for George Lucas, was meticulously programmed to beats within the

attraction track—a first for any roller coaster. It also had three upside-down inversions, a Disney first. The Paris coaster immediately became the gold standard for Space Mountain attractions, and earlier iterations were eventually updated with new vehicles and musical scores.

At the mountain's base would be a walk-through model of Captain Nemo's submarine, the *Nautilus*, as featured in Jules Verne's novel and brought to life in the 1954 Disney movie *20,000 Leagues Under the Sea*, the design of which blended perfectly with the mountain above it. (The *Nautilus* had also been a feature of the never-built Discovery Bay.) The walk-through submarine would also open in 1995.

Perhaps it was fitting for a land devoted to great thinkers' visions of the future that the most arresting attractions of Discoveryland were yet to appear when Euro Disneyland opened. The only hints in 1992 of the Jules Verne dominance to come were the bronze color palette of Orbitron Flying Machines and the bullet-shaped airship floating permanently above the entrance to the Videopolis theater, a design reproduced from Disney's 1974 film *The Island at the Top of the World*. Star Tours opened with Discoveryland in 1992, as did Captain EO, Autopia, and two new shows: CineMagíque, in which live cast members interacted with filmed segments to tell the history of cinema from Harold Lloyd silent films to recent movies; and Le Visionarium, Imagineering's first Circle-Vision 360 movie to have a fictional narrative, about a Timekeeper who sends his "Nine-Eye" robot back into the middle of historical moments that included dinosaurs, Da Vinci, Mozart, and, of course, Jules Verne. For the full Jules Verne experience of Discoveryland, however, guests would simply have to come back . . . tomorrow.

V. BUILDING A LEGACY

Euro Disney's focus on sumptuous design extended beyond the Disneyland park itself. The development would showcase Eisner's continuing collaboration with some of the most celebrated architects in the world, some of whom were already at work with Wing T. Chao on Disney hotels in Florida. They included Michael Graves (designer of the Swan

and Dolphin, both set to open in 1990) and Robert A. M. Stern (the Yacht and Beach Club, also due in 1990), as well as Frank Gehry, Stanley Tigerman, and Robert Venturi. Eisner called them all together for a brainstorming session—a "charette," in architectural parlance—on Easter weekend in New York in 1988. "I just thought that Disney should be number one," Eisner said, "and in my tenure we built eighty buildings with the greatest architects around the world. We really set the style [for] entertainment architecture." Eisner cited the company's collaboration with A-list architect Welton Becket on the Contemporary and Polynesian hotels at Walt Disney World as precedent for his strategy to draw architectural stars into the Disney firmament. The only restriction, he said, was that the outside talent would not work on projects within the theme parks.

The first charette led to others, which Eisner recalled as "architects going around with wheelbarrows of plans and then meeting and discussing." Not all those who came to the inaugural New York gathering wound up designing buildings for Euro Disneyland, although Graves and Stern did, as did French architect Antoine Grumbach and American Antoine Predock. The architects at Walt Disney Imagineering also had an assignment: designing the five-hundred-room Victorian-style Disneyland Hotel that would spread out across the entryway to the theme park, blocking the view of the castle from the highway just outside the park. Arriving guests walked through a passageway in the center of the hotel to reach the park gate, where the castle would come into view, just as it does at Disneyland as guests emerge from below the train depot. Some of the consulting architects thought that was a terrible idea, but the Imagineers, Eisner said, "thought that the castle should be more of a surprise when you walked underneath the hotel. They won that argument. We had a big fight actually, almost a fistfight between Tony Baxter and one of the architects who would lose his commission over that issue. It was quite stunning."

In addition to the Disneyland Hotel from Imagineering, five other hotels would open their doors the same day as the Euro Disneyland park, each one representing a different style and geographic iteration of

American architecture and culture, all situated around a manmade lake. Graves designed Disney's Hotel New York, with an art deco aesthetic. Stern's firm did two complexes: Disney's Newport Bay Club, evoking New England (akin to Stern's Yacht and Beach Club in Walt Disney World), and Disney's Hotel Cheyenne, a cluster of structures, including tepees in the children's play area, meant to suggest an Old West town. Predock, who was based in New Mexico, created Disney's Hotel Santa Fe, described as Pueblo Revival style, and Grumbach borrowed the look of American National Park hotels for Disney's Sequoia Lodge. All together the six hotels offered more than five thousand rooms, ready on opening day.

With the hotels assigned to other architects, Eisner and Wells championed Gehry to design Festival Village, the French version of the Walt Disney World Village, the shopping, dining, and entertainment district. Gehry took the job, but his relationship with Disney was often contentious. "Getting involved with Disney and Mickey Mouse was not one of those things that anybody had any yearning to do," he said, recalling the many architects' collaboration more than twenty years later. "I think it was precarious for us." He enjoyed early meetings with some of his most celebrated peers, and he took the Festival assignment in part out of curiosity about how this unusual collaboration would play out. But he quickly soured on Eisner's fantastical expectations, recalling that he and Graves had walked out on one charette when the conversation veered too much into "different territory" from what he considered the art and function of architecture. "It was Hollywood, it was make-believe, it was cartoons," he said. "It sort of belied the seriousness of our architectural intentions." The collaboration was "a little bit out of sync to begin with, I think," he said.

Architectural critics were decidedly mixed on the grand hotels at Euro Disneyland, but the *New York Times* declared Gehry's design for Festival Disney a success. "With its lively signs and bold metal structure," Paul Goldberger wrote, "it's certainly the part of Euro Disney that manages to have the most architectural integrity." In the end, though, "I think architecturally, probably everybody felt a little bit compromised," Gehry said.

Everyone, that is, except Graves. "Not Michael—Michael went all the way. Michael became the favorite child of Eisner and company and could do no wrong." Graves also designed the company's corporate headquarters building on the studio lot in Burbank, completed in 1990. Known as the Team Disney building, it featured giant sculptures of the Seven Dwarfs in a line across the top of the facade, appearing to hold up the roof. The *Los Angeles Times* dubbed the structure "hokeytecture," while Gehry dismissed it as simply "embarrassing." Gehry himself was embarrassed by the addition of that Mickey Mouse statue atop one of his stainless steel Festival Disney columns. When he attended the opening ceremony for Euro Disney in 1992, he said, "there was Mickey Mouse, and I just left." He said he never went back.

VI. LET'S DANCE

The December before the park was set to open, the Imagineering Ride Development team was testing the steam locomotives, three of which were custom built for the park by a Welsh locomotive company. (A fourth would be delivered a year later.) "We'd alerted everyone to the fact that we were going to take the trains out, and away we go through the Pirates of the Caribbean tunnel to the Fantasyland Station," recounted Imagineer Mark Handon. "There we come to a grinding halt, because there's a contractor pouring colored concrete, positioned over the train tracks. He's just finishing up the train station platform. So we have a little conversation, and it's decided that they'll move their rig. Before they can do that, however, they have to clean out the concrete hose. To do this, you pump a foam ball through the hose, and it clears out the concrete. They're in the process of doing this, and all of a sudden, there's a huge explosion when the foam ball emerges. Six guys standing near the freshly poured platform topple backward into it. The hose is whirling wildly overhead, like a sprinkler gone wacky, spraying the trains, the station, and all twenty or so people in the vicinity with fresh, wet, sticky colored concrete. You can't wash concrete out of a beard or mustache—you have to cut it out."

That was one of many such stories shared just before the park's opening in Walt Disney Imagineering's in-house newsletter, the *WDEye*. Eddie Sotto related the story of overnight security guards breaking into a Main Street building in search of a stray dog they heard barking—and finding instead a speaker emitting a bark at regular intervals that the Imagineers hadn't thought to cycle off during the nighttime. There were, in short, as many stories as there were Imagineers hurrying to get Euro Disneyland open on time. Everything, it seemed, was behind schedule and over budget. The weather had been a persistent enemy of both speed and savings. Early in the construction process, Skip Lange, a field art director, observed, "Right now it's hot and dusty, and before that it's muddy—never in between."

One of the last tasks for the Imagineering team was the final painting of—well, almost everything. With many construction tasks running behind schedule, the time available for painting kept getting compressed, Katie Olson remembered. "You can't paint that building until almost everything else is complete, [so when] your time frame has been compressed, you are the one who's caught running"—sometimes literally, as she recalled at least once "running down Main Street, carrying paint." Tom Morris recalled tweaking scenery in "it's a small world" and painting handrails in Fantasyland in the middle of the night. "It's not just paint," Olson said. "You have to have the lighting installed. You have to have the audio installed. All of those people need to test [their installations]. All of the equipment—if it's a restaurant, [for example,] to support that restaurant operation—has to be loaded in. Their staff has to be trained. And everyone is still outside trying to finish that building. Or inside trying to finish that building. So it gets to be rather intense. Certainly the last few months on an installation, everyone is running around there ragged."

The final cost for the resort was a reported $4.4 billion, or double its initial estimate. Labor costs had been higher than expected, and just months before opening, a group of key contractors demanded more than $150 million in unpaid cost overruns. A settlement was negotiated, and Steinberg and his deputies wound up directly supervising many final

construction duties, as Disney had done at Walt Disney World. Steinberg, who did not have a high opinion of French work ethics or scruples, replaced many of the locals with Irishmen. He also handled the many legal battles that ensued as a result, but "we got it built," he said. "We opened on the day we said way back."

But there were many other financial fiascos along the way that were out of Steinberg's control. As opening day approached, for instance, Disney had to borrow $6.6 million to build 3,500 dorm rooms for many of the 12,000 cast members it would need to operate the park. Eisner's courting and coddling of leading architects for the resort's hotels and shopping areas had further blown the budget, as did the CEO's tendency to make expensive changes after plans were finalized. One day, for example, he ordered that more than a dozen wood-burning fireplaces be added to the hotels at Euro Disney. And he commanded the removal of two steel staircases from Discoveryland that he said blocked the view of Star Tours—at a cost of approximately $300,000.

"We probably spent too much money. We built too many hotel rooms," Eisner said long after he left the company, but the budget-busting had good intentions: "We were so enthusiastic about the reception we were getting and how quality a product we were delivering." In short, he summarized, "there was an economic issue. There was never a quality issue."

Opening Day was to be April 12, 1992, leaving several weeks for the Imagineers to work out any kinks before the summer tourism season kicked off. Eisner led a dedication ceremony on the evening of April 11, complete with mangled French. After a children's choir and some fireworks, Roy E. Disney read aloud his uncle Walt Disney's remarks from the opening of Disneyland. Then Eisner lifted a pair of scissors so large that resort president Robert Fitzpatrick, standing beside him, had to duck to avoid injury. With Fitzpatrick and Disney holding the foot-wide red ribbon in place, Eisner aimed his scissors, declared the park open (in French), and cut the ribbon. As fireworks once again lit the sky, a blinding light shone from within Sleeping Beauty Castle and Mickey Mouse emerged to beckon everyone into Fantasyland. The three

executives followed him into the light, and the ceremony ended. No one from the French government appeared at the ceremony.

Many of the Imagineers celebrated at the invitation-only opening night party—those who were not still in the park unboxing furniture or doing touch-up painting. As Tom Fitzgerald remembered, "We all walked along the routes by the hotels, and all the cast members were out applauding and cheering us on. And I personally remember standing with George Lucas in what was then Festival Disney and just talking about how amazing it was that [here we were in] the place where the fairy tales first started, [stories] Walt first tapped into his first films like *Snow White and the Seven Dwarfs*—how special it was that we would return to that place and bring something back from Walt to this region."

The next morning, a Sunday, when the guests came in, Baxter recalled, "what I saw on everyone's face was that enjoyment that I'd enjoyed as a small child at Disneyland." For a while, he stationed himself at the exit from Pirates of the Caribbean, hoping to glean the audience's reaction, despite his poor French. "I remember the pantomime of guests coming off the ride going, 'Mon dieu! Les pirates!' and I knew right away they were talking about those [sword-]fighting pirates, so it was really worth it to have gone that extra amount to put something wonderful like that into the ride."

Most of the guests whom Fitzgerald observed "were blown away about what they saw," he said. "There are amusement parks in Europe, but a theme park, a Disney theme park, was something very, very brand new." Since there was no equivalent to a *Disneyland* television series to educate the French in what to expect, "they had to learn it for themselves. They come thinking it's one thing—'It's characters'—and then they discover it's so much more."

That guests' process of discovery took time, so no matter how many moments of awe they experienced in the opening days, it was the annoyed minority that dominated media coverage. Many French adults were aghast that no alcohol was sold within the park, even in the table-service restaurants—a continuation of Walt Disney's prohibition at Disneyland

that had been maintained at each new Magic Kingdom. The Europeans also experienced sticker shock when they got to the ticket booths. Admission was set at 220 francs, or just over $40, for adults—a 20 percent premium over a day at Walt Disney World. On top of that, Disney souvenirs and meals were priced much higher than similar fare in Paris—$30 would get you one pair of Mickey Mouse ears or breakfast for a father and daughter at the Hotel Cheyenne. "We made our own mistake in thinking that we could match what we charged a guest in France as to what we charge a guest in Florida," Eisner reflected. "And that was just really stupid."

The first Sunday was damp and chilly, and there was an ongoing rail strike, and neither the weather nor attendance improved much as summer arrived. On June 26, a small army of French farmers drove their tractors to the entrance of the Euro Disneyland parking lot, protesting American agricultural trade policy and blocking hundreds of families and as many as seventy busloads of children from entry. The police did not intervene, and once the farmers got the press coverage they were seeking, they drove away. Disney officials said only, "This has nothing to do with us."

But it did, in fact, have to do with Disney, since the image of a haughty interloper had taken root in the national debate about the park. Who but an American company would attempt to regulate facial hair and forbid its employees from smoking in public, as Disney did its cast members? Disney quickly gave in on the park's alcohol ban, adding wine and beer to many menus—not a surprise to the Imagineers. "We kind of hedged our bets on that," Tony Baxter said. "We had taps and we had wine storage already built in, because a lot of us who had spent time in the culture over here knew that was part of the meal."

Not all French people were anti-Disney, of course—many Parisian shops celebrated Mickey Mouse's arrival with Disney decorations and Mickey Mouse toys—but the park suffered nonetheless, averaging a slack thirty-thousand visitors a day that summer, and just a fraction of that on rainy weekdays. The proportion of guests who were French was much lower than the company had hoped—close to a quarter, rather than half

the total—and visitors from several other Western European countries were discouraged from visiting France by unfavorable exchange rates. The ongoing recession in Europe and the United States didn't help. Hotel rooms sat empty, in part because of the depressed tourism market and in part because many hotels in Paris—just twenty miles away—were significantly cheaper.

In the first six months, the reported net operating deficit was 339 million francs, or nearly $70 million. In November, the shortfall led Disney to report its first quarterly loss in nine years (which the *Los Angeles Times* dubbed "a financial nightmare before Christmas"). The losses on Euro Disney, the company reported, amounted to $514.7 million—so far. To stanch the bleeding, Disney permitted Euro Disney SCA to defer for two years the payment of the tens of millions in management fees the French company was obligated to pay to the American one. (Royalty payments—including 5 percent of hotel, food, and merchandise revenue and 10 percent of admission and parking fees—continued, however.) The total lost in the park's first twelve months was a reported $930 million. The financial fallout would eventually erase many Imagineering projects from that ambitious "Disney Decade" list Eisner had unveiled just three years earlier. Fairly or not, Imagineering shouldered some of the blame for the cost overages, and the resulting budget contractions and strict oversight would have impacts for many years thereafter.

To save the Paris park, the company promised to cut costs and increase marketing efforts. Nevertheless, Euro Disney SCA ran out of cash in 1993 and might have had to file for bankruptcy if not for a last-minute investment from a Saudi prince and an agreement with more than sixty banks to restructure the French company's debts. Fitzpatrick was replaced as resort president by Frenchman Philippe Bourguignon, who (with Eisner's approval) reduced admission prices and some hotel rates and created a discount program for residents of the Paris area. Perhaps the most important change—certainly the most symbolic—came on October 1, 1994, when Euro Disney was officially renamed Disneyland Paris. When the change was announced, a Disney spokesperson explained that the company was seeking "to play much more than before on the

connection between Disneyland and the city of Paris." As Eisner put it, the word "Euro," for actual Europeans, "turned out to be a term they associated with business, currency, and commerce."

Within a year of the name change, the park reported its first quarterly profit. Its attendance soon surpassed 10 million visitors a year, and by the early 2000s it was the top tourist destination in Europe. "I think it just takes a little while to warm up to something that's new and fresh and something that may be a little alien," Baxter said. "I think that's why it works so well now. They've embraced it as part of their culture as well as America's."

Eddie Sotto was convinced that Disneyland Paris would be a success from the get-go. "The story I like to tell is something that really moved me [on] the opening night of the park," he said, recalling the invitation-only party that Saturday evening. "For five years I'm working on Main Street, and it's kind of an import from another culture. How do I know anyone is going to care about this?" Sotto was planning to film the Main Street Electrical Parade, so he found a spot and loaded his movie camera. Nearby, he noticed "a very fine-looking gentleman, and he's got a very beautiful lady with him in the Chanel suit with a pillbox hat and the whole thing." The gentleman was smoking a pipe—the height of sophistication, Sotto thought, and likely of a certain attitude as well. "So I go, 'Oh, great. This is our audience, pipe smoking.'"

As the parade approached, a cashier from one of the shops joined Sotto on the street.

"They turned the lights out on Main Street; only the parade lights come on. They are twinkling, the classical music that everyone in Europe knows is now blaring. The girl's got tears on her face as the light hits the castle and the fireworks go off." Sotto asked her if something was wrong. "She said, 'No, it's so beautiful. I live right here, and I never dreamed a foreign land can turn into this beautiful, beautiful place.' She was so moved, and I go, 'Wow.' And then I looked over, and I can't find the pipe smoker. I can't find his wife. Where is this couple?" Then he spotted them, behind the rows of parade gawkers, in a shadowy space between the crowd and the buildings. And what are they doing?

"They are waltzing in the dark to the music. And I thought, 'You know what? Maybe that's what exactly Europe needs. You have a class system, you have people that have to behave, that have to sit at the café. Then you have this thing, [this place,] where you get permission to be a child again. The world gets permission to be a child again at Disneyland. I think that's part of what motivated me as an Imagineer," Sotto concluded—"that you could deliver the child again. That's why you stay up till midnight making these things, because people can put the pipe down and they can just waltz, waltz in the dark."

CHAPTER 15:
PLEASURE AND RABBITS

"You know, I've always had a feeling that anytime you can kind of experiment or do anything, you ought to do it. You'll never know what'll come out of it. And I have that feeling today, if my boys come to me with an idea. If it sounds plausible to me, if it sounds possible, I try to go with them on the experiment because you'll never know what'll happen." —Walt Disney

I. THE THEME WITHOUT THE PARK

IN THE MID 1980S, the Imagineers spun a new story—one that was at first unrelated to any theme park attraction but later took on a life of its own, popping up in parks all around the world. The central figure in the tale was a fictional early-twentieth-century industrialist, inventor, and bon vivant named Merriweather Adam Pleasure. He built his Pleasure Canvas and Sailmaking company on an island in Lake Buena Vista, and it soon grew into a full complex of buildings, including the Pleasure family home. Merriweather was lost at sea in 1941, and his island fell into disrepair—until, the story continued, the Imagineers discovered and repurposed its structures.

The former family compound and business park became Pleasure Island at Walt Disney World. It was announced in 1987 and built in the next two years adjacent to Walt Disney World Village. Although it shared its name with the scary carnival that turned boys into donkeys in Disney's

Pinocchio, it was in fact an example of a growing category of complexes known as RD&E, for "retail, dining, and entertainment." More specifically, Pleasure Island was conceived as a magnet to draw younger adult guests (and locals, including many cast members) in the evening hours. Eisner wrote in his memoir, "From the time Frank and I first began visiting Walt Disney World, it had gnawed at me that there was virtually nothing to do at night. What happened, I always wondered, to those visitors who weren't satisfied to watch TV after dinner and go to sleep early?"

The Imagineers approached Pleasure Island with the same storytelling sensibility they applied within the theme parks. "Rick Rothschild and Chris Carradine and others worked closely on coming up with a story," recalled Imagineer Peggie Fariss, "and then that story informed the dining experiences and retail experiences." The Merriweather Adam Pleasure tale meant that Pleasure Island's Portobello Yacht Club had a backstory as the Pleasure family home; a country-western club called the New Armadillo had been their greenhouse; and so on. "I've referred to Pleasure Island as sort of a *Stand by Me* for grown-ups," Carradine told the *Orlando Sentinel*. "Five or six thousand people get together and discover adventure." They just needed to be twenty-one or older and pay the $14.95 admission fee.

Pleasure Island was in part the product of an Imagineering task force set up in the mid 1980s to look at "the business side of things, looking at the feasibility of new projects," said Fariss, who was part of this exploratory team. It had been formed during the slack period after Tokyo and EPCOT Center opened but before Disney-MGM and Paris geared up, and it imagined smaller Disney developments, outside the theme parks, and sought out contract work for other companies. The idea, Fariss said, was that the task force "kept a core group of people engaged in working on storytelling and place-making and encouraged Imagineers to think beyond just an attraction but also into the dining and retail [realms]."

One plan was for up to nine regional entertainment complexes across the country akin to the Walt Disney World Village (now part of Disney Springs). The concept was fueled in part by the popularity of the

mixed-use pedestrian centers developed by James Rouse, which included restaurants, retail, and amusements, such as movie theaters. Rouse had led the successful redevelopment of both Faneuil Hall Marketplace in Boston (1976) and South Street Seaport in New York City (1983). He had openly borrowed ideas from Imagineering's own place-making—he sent one Faneuil Hall designer to Walt Disney World for research—and now Imagineering was planning to return the compliment. The idea, Fariss said, was "to see if we could extend [Disney] storytelling into other aspects of our business"—and, perhaps, build standalone "Disney centers" around the country, not on Disney property. One such center was developed for but never built in Dallas, for example.

In the summer of 1987, Disney announced its intention to create such a development on forty acres near the Burbank studio to be called The Disney-MGM Studio Backlot. A kind of hybrid of the theme park in Florida with an expanded Walt Disney World Village, the complex would have included working studios for film, TV, and radio, as well as shopping, eateries, bars, a hotel, and attractions adapted from the theme parks. A version of the Great Movie Ride was one idea, along with a motion-simulator ride akin to Star Tours. It would be "unlike anything else in the country," Disney promised.

Rival theme park operator MCA didn't see it that way, however, and fought the development tooth and nail. MCA had apparently come to the conclusion that there was no way to stop Disney from building a theme park on its own land in Walt Disney World that would compete directly with MCA's planned Universal Studios Florida, but that it most certainly could halt plans to drain visitors from Universal Studios Hollywood, a fifteen-minute drive from Burbank. A citizens' group called Friends of Burbank, quietly funded by Universal, appeared to oppose Disney's plan, while MCA took on the development head-on with two lawsuits against the city of Burbank. For once, Disney buckled, scrapping plans for the Burbank Backlot complex, having concluded that it was too financially risky. "The economy took a turn and we thought, 'Well, maybe this isn't the right time to launch this idea,'" Fariss said.

Pleasure Island, however, finally launched one year behind schedule

on May 1, 1989, with six nightclubs—one of them of course named Vid-eopolis East—along with full-service restaurants, a ten-screen movie theater, the Imagineering equivalent of a food court, and quirky shops, such as a lingerie store beneath a giant neon-lit cutout of Jessica Rabbit. "That became almost like a formula for resort places," said Imagineer and architect Wing Chao, "because nowadays—forty years, fifty years later—you see many resort places, whether it be in the mountains or beaches—all these vacation spots have RD&E. So Disney, again, sort of created a model to show the world that you [need to] have the right mix of the venues in resort places, particularly in the evening." Plea-sure Island would serve not only visitors who didn't want to remain in the theme parks after dark but also locals and the increasing flow of businesspeople attending conventions in the area. "With the addition of Pleasure Island to the existing Disney Village, the combined venues and excitement, the place became a popular Retail, Dining & Entertainment (RD&E) destination," said Chief Imagineering architect Wing T. Chao. "This new day and night time 'destination' sort of became a 'model' for other seaside and mountain resort destinations which have emulated Disney by creating their own RD&E districts for their vacationers."

The unpleasurable side to Pleasure Island was that it was another project that went massively over budget, costing as much as four times original estimates, without immediately attracting enough of a clientele to justify the expenditure. Imagineering's creative backstory, expressed in architectural details, would amuse guests once they got there, but it wasn't the kind of hook that snagged the intended young adult clientele. To solve that problem, Eisner turned not to Imagineering but to his personal assistant. Thirty-year-old Art Levitt was a charismatic single man with a degree in marine biology and a love of nightlife whom Eis-ner judged to have "terrific promotional instincts and a willingness to take risks." Levitt added street games and outdoor shows (such as the limber and winsome Island Explosion dance troupe), seeded the crowd with models, brought in celebrity entertainers (Robin Williams was one surprise guest), and invented what would become the complex's signa-ture lure: a New Year's Eve celebration at midnight every night, with

a countdown and fireworks. The complex also hosted special seasonal events, from Mardi Gras parties to chili cook-offs. Pleasure Island even tested out a crowd-participation activity imported from Japan—something called karaoke. By 1993, Eisner reported, Pleasure Island was turning a profit.

The party didn't last forever. In the early 2000s, as its novelty faded and competition for its youthful audience increased, Pleasure Island's popularity began to wane, and renovations and the elimination of the admission charge didn't help. In 2008, Disney announced it would be closing the nightclubs, which were demolished over the next few years and replaced with restaurants with alluring water views. (The area eventually morphed into The Landing at Disney Springs.) The changes introduced daytime hours and opened up the area to families with children, who had previously been prohibited by the "twenty-one and older" policy. The RD&E concept survived and thrived—and the Imagineers were not done with Merriweather Adam Pleasure and his imaginary explorer friends—but such complexes in the future would cast a wider demographic net.

Pleasure Island was a case study in what could happen when Imagineers disregarded some of "Mickey's Ten Commandments." In particular, the complex seemed to stumble on Commandment Number One—"Know your audience"—and Commandment Number Two—"Wear your guest's shoes." The Commandments were written by Marty Sklar, he later said, "to explain and remind fellow Imagineers about the foundation principles on which our success has been built." They weren't intended for public distribution, but their wisdom was irrepressible, and they were included in a publication created for a momentous two-day workshop in April 1991 involving Imagineering's entire senior staff and titled "The Way We Do Business." Led by Imagineering president Marty Sklar and executive vice president Mickey Steinberg, the event gathered more than fifty Imagineering executives—vice presidents, directors, senior producers, and others—in the Hyperion Conference Room at Disney's Chastain Building, a ten-minute walk from Imagineering's Flower Street headquarters. The guest speaker on the first evening was Harrison "Buzz" Price, the research economist who had helped Walt Disney select the sites

for Disneyland and Walt Disney World, and the event ended with a panel discussion called "Where Are We Heading?"

The remarkable 146-page program for the workshop included bits of reassurance for the Imagineers—"There will be no massive 'airlifts' to staff [from Glendale to Paris] the last year of EDL [Euro Disneyland]"—and page after page of motivational and organizational adages and advice ("The people that are doing the work are the ones best suited to making the decisions"). Sklar—who had started his career with Disney as a writer—ended the advice and admonition section of the program booklet with this simple instruction: "Have fun—working here should be fun. If it isn't, something's wrong." One clear but unstated premise in the workshop materials was that no one Imagineering project was more important than any other: the Paris project might be glamorous and high profile, but lesser-known assignments also touched people's lives—even if that assignment was to create a trade show exhibit for Caterpillar Tractor (as Imagineering did in 1987).

But certainly the most often reproduced inclusion in the program was "Mickey's Ten Commandments"—a sage summary of the guiding principles of Imagineering (attributed to Steinberg but written by Sklar). Following numbers one and two were:

3. Organize the flow of people and ideas.
4. Create a "wienie" (Walt Disney's term for a "visual magnet").
5. Communicate with visual literacy (use color, shape and form to reinforce theme).
6. Avoid overload—create turn-ons (avoid too much detailed information).
7. Tell one story at a time.
8. Avoid contradictions—maintain identity (make sure the mission is clear and distinct).
9. For every ounce of treatment, provide a ton of treat (encourage guests to participate).
10. Keep it up (don't get complacent or neglect maintenance).

The commandments applied as much to entire theme park planning as to the smallest side project. Imagineers didn't do a lot of outside consulting, but they did work on contracts big and small for non-Disney clients they called "sponsors." In the mid-1980s, for example, while much of Imagineering was gearing up for Euro Disneyland, a smaller team was at work designing and constructing all the exhibits for the Gene Autry Western Heritage Museum. The 100,000-square-foot facility, originally budgeted at $25 million, opened in Griffith Park in Los Angeles in 1988. (It was later renamed the Autry Museum of the American West.) "It's themed to the Old West, the spirit of exploration and community, and utilizes a combination of film, dimensional effects and so forth," Marty Sklar said. "They came to us because of our experience with special gallery exhibits for the China, Japan, and Mexico pavilions at EPCOT Center." The museum's curator, John P. Langellier, called the Imagineering-designed exhibits "slick and compelling—these are some of the best ways to teach history today." It was just the beginning of an Imagineering-inspired revolution in museum and exhibition design that continues today.

II. HOLLYWOODLAND

Imagineering's long drought of new attractions based on Disney-created animated properties had lasted from 1958, when Alice in Wonderland debuted, until 1983, with the opening of the Disneyland dark ride Pinocchio's Daring Journey. Splash Mountain, inspired by *Song of the South*, followed in 1989. But both these rides hearkened back to movies from Walt's era, while the past thirty years of Disney animation—with the exception of 1985's *The Black Cauldron* being featured in the Cinderella Castle Mystery Tour attraction at Tokyo Disneyland in 1986—remained unmined. That was about to change—with the help of one of the Hollywood elite favored by Michael Eisner.

The Los Angeles royalty in this case was Steven Spielberg, who had served as executive producer of the 1986 animated feature *An American Tail*,

directed by former Disney animator Don Bluth—Spielberg's first venture into animation. The Thanksgiving release, which critics compared favorably to classic Walt Disney features, made almost twice as much money that year as Disney's own animated rodent release, *The Great Mouse Detective*, which had come out about five months earlier. Rather than dwell on this defeat, Eisner decided to team up with Spielberg.

One animated success behind him, Spielberg had developed an interest in the film version of Gary S. Wolf's 1981 noir-parody novel *Who Censored Roger Rabbit?*—a property Disney had been developing as a live-action/animation hybrid since before Eisner's arrival. Eisner invited Spielberg's Amblin Entertainment to produce the movie alongside Disney, marrying Amblin's knack for dynamic live-action storytelling with the skills of Disney's animators. The plot spoofed the recent detective film *Chinatown*, only this time imagining Toontown, where Hollywood's animated performers lived when they weren't mingling with live-action people at the studios or on the streets of Los Angeles. With a sexy cartoon siren (Jessica Rabbit), a salty detective hero, and a comi-cidal villain, it was—with the exception of *The Black Cauldron* (1985)—also Disney animation's first venture into PG territory.

Released by the adult-skewed Touchstone Pictures in 1988, the retitled *Who Framed Roger Rabbit* was a critical and popular smash. It became the second-highest grossing movie of the year (behind *Rain Man*), Touchstone's second most successful release to date (behind *Three Men and a Baby*), and the winner of four Academy Awards—including a Special Achievement Award for Richard Williams, the legendary independent Canadian animator Disney brought in from his home in England to direct the film's animation.

It was a natural next step to translate this massive success into park attractions, and the film's setting in pre-World War II Hollywood aligned it with the storytelling in Disney-MGM Studios, the Walt Disney World studios theme park. When Eisner announced his plans for the "Disney Decade" at the beginning of 1990, a number of Roger Rabbit–themed attractions were planned for the soon-to-open Sunset Boulevard area. A cluster of buildings inspired by the film's Toontown were to be anchored

by the Toontown Depot in a neighborhood dubbed Roger Rabbit's Hollywood. The two immersive rides announced for the development were Baby Herman's Runaway Baby Buggy Ride, inspired by the Roger Rabbit short *Tummy Trouble*, and the Benny the Cab Ride, a raucous spin in the talking Toontown taxi.

At Disneyland, the "Disney Decade" plans announced in early 1990 included Hollywoodland, a replica of elements of Hollywood Boulevard during the era of the 1930s and 1940s, along with the same Toontown rides announced for Disney-MGM Studios. (A second mini-land, the never-built Mickey's Starland, would have had attractions featuring the Muppets and characters from *The Little Mermaid*.) Scheduled to open in 1999, Hollywoodland would have been squeezed in between Main Street, U.S.A., and Tomorrowland, presumably built on former backstage property—the same space once imagined for Edison Square. It would have included the West Coast versions of The Great Movie Ride, since the Burbank development had been scotched, and SuperStar Television, the audience-participation show that dropped guests into classic TV scenes.

The plans for Hollywoodland were not long-lived. By May 1991, it had been axed from the Disneyland improvement agenda. Besides, Disney wanted to get Roger Rabbit into the park sooner than 1999. Thus Mickey's Starland was merged with ideas borrowed from the Roger Rabbit area envisioned for Disney-MGM Studios and became Mickey's Toontown—creating a home for both Mickey and friends and the characters from *Who Framed Roger Rabbit*. The new Toontown also borrowed elements from Mickey's Birthdayland, a temporary tribute to the mouse that had opened in Florida's Magic Kingdom in June 1988 to celebrate Mickey's sixtieth birthday. It included Mickey's Country House, a free-standing home in cartoon style through which guests could meander on their way to meet and be photographed with Mickey Mouse. A similar Mickey's House—plus Minnie's House—were part of Mickey's Toontown. Keeping most of Toontown's attractions either scaled down or technology-free, like the Mouse houses, was a necessary concession in getting the mini-land open as quickly as possible.

The one major attraction would be the home for characters from

Who Framed Roger Rabbit. Benny the Cab—actually it's his lookalike cousin, Lenny—remained the focus of the ride, which was briefly known as Toontown Transit before its final name was arrived at: Roger Rabbit's Car Toon Spin. "This ride grew out of, really, Disney technology," said Imagineering design lead Joe Lanzisero. "We physically went to one of our existing dark rides, which is a ride vehicle that runs along on a bus bar, and we looked at the teacups [in the Mad Tea Party], which are on a little post that spins around. We took a teacup one night off the teacup ride, put it on Pinocchio['s Daring Journey], and went through the ride to see how these two technologies would work together, and it was a marriage made in heaven."

Thus, the dark ride through the story of Roger Rabbit gained its twist: as in the Mad Tea Party attraction, guests could spin their vehicles by turning the wheel in the center of their "cab." The ability to control the ride vehicle, to a limited extent, reflected "the interactive age we live in," Lanzisero told the *Los Angeles Times*, putting an end to "the days of sitting in a ride vehicle and passively experiencing" the attraction. The spinning meant that riders might miss some of the storytelling, he noted. "We can't really tell full stories in these rides anyway," he said. "We create moods and feelings." To that end, the journey offered larger-than-life cartoon-inspired effects like shifting perspective—at one point the car seemed to be dropping from the sky—and explosions represented by massive word bubbles. It was, in essence, Roger Rabbit's Wild Ride. The Imagineers also upped their game in the developing art of queue theming, delivering their most immersive waiting area since Star Tours—a winding pathway through dimly lit Toontown streets and alleyways, augmented with character voices and interactive elements.

Built on the site of a former maintenance yard beyond the boundaries of the original park, Mickey's Toontown officially opened in January 1993—first new land in Disneyland since Bear Country debuted in 1972 (later dubbed Critter Country). Younger children loved its colorful opportunities to touch, climb, and crawl around. "They want to push every button," Imagineer Lanzisero told the *Los Angeles Times*.

Roger Rabbit's Car Toon Spin did not open with Toontown. Originally scheduled for the summer of 1993, it opened officially the following January, reportedly delayed because the new land was attracting capacity crowds without an E-ticket draw, so a winter opening was planned to draw guests back to the park at a normally slower time of year. At seven minutes' duration, Disney declared it the "largest and longest" dark ride that the Imagineers had ever produced; Gary Wolf, author of the novel that had inspired the movie that had generated the ride, declared it to be "mind-boggling." Exploring Toontown, he added, was like "walking through my own imagination." The land's popularity led to its later addition in Tokyo Disneyland, while what had been Mickey's Birthdayland at Florida's Magic Kingdom was refurbished and reopened as Mickey's Toontown Fair.

Disney didn't comment publicly on the cost of the original Mickey's Toontown, and in any case, estimates would vary widely depending on whether the development costs of the abandoned Hollywoodland and Mickey's Starland were added in. One report guesstimated the toll at about $100 million, or $30 million more than Splash Mountain had cost a few years earlier. But whatever the actual number, the high costs of Euro Disneyland, Pleasure Island, Splash Mountain, and Toontown were taking their toll. In 1992, The Walt Disney Company announced it would lay off 300 to 400 Imagineering staffers in August, out of a total of about 2,100 people. It was the company's biggest downsizing since Eisner's arrival, and a spokesperson blamed "Disney Decade" project delays on the sputtering economy. For Eisner's most ambitious post-Paris project, however—the company's first theme park in the northeastern United States—the blame game would have plenty of prospects.

CHAPTER 16:

THE BATTLE OF DISNEY'S AMERICA

"Lots of things I've started and if I just felt it wasn't natural, if I got too deep, I've abandoned it, the thing, and started something else. You can tell when it's wrong, you know." —Walt Disney

I. DISNEY'S AMERICA

IMAGINE THIS: when you enter the park—a park that never existed, except in concept art—you walk onto streets that represent a time one hundred years earlier than Main Street, U.S.A. in Disneyland. At a time when the country was beginning to crack along a divide between North and South, the mid 1800s streets of Crossroads, U.S.A., are neither Union nor Confederate, with shops and places to eat (and guest services) in a blend of pre-Civil War architectural styles. There's even a working inn amid the hustle and bustle, with suites tucked away throughout the town. If you're not staying at one of the hotel's 150 rooms but you'd like to get off your feet, you can catch one of two 1840s-era steam locomotives that will take you to some of the park's eight other Territories, as the "lands" here are known.

Skip the train ride, for now, and stroll to your right and you'll find yourself traveling another fifty years back in time, to a Territory called Presidents' Square. The buildings here are Colonial style, reminiscent of Liberty Square in the Magic Kingdom. Indeed, that The Hall of Presidents is replicated here, still housed in a facsimile of Philadelphia's Independence Hall. Beyond President's Square lies the Territory called Native

America, offering glimpses of American Indian life along the East Coast from about 1600, just before the first European colonists arrived, through the early 1800s. Here you can explore a Powhatan village as it existed in Eastern Virginia in colonial days, populated by Algonquian Indians. Stop and admire some of the authentic works of Native American art here, and keep a look out for Pocahontas, daughter of Chief Powhatan—and the heroine of Disney's 1995 animated feature. An amphitheater offers live shows on a Native American theme. Check your park schedule for showtimes.

There's an E ticket–level attraction here as well: the Lewis and Clark Raft Expedition. (Never mind that the explorers' journey took place from 1803–1806, nearly two hundred years after Pocahontas died.) With pounding rapids and churning whirlpools, the thrilling outdoor Expedition takes guests in circular, spinning, splashing rafts through western tableaux from the Mississippi to the Pacific Ocean, evoking the USA's relentless expansion in the 1800s. (You may be reminded of Manifest Destiny—the idea that European colonists were designated by God to rule the continent from coast to coast—but the Imagineers have long since dropped this theme, given its uncomfortable implications for the residents of Native America.)

After your raft ride, leave the woodsy Powhatan Village and stride past the grassy parade grounds on the shore of Freedom Bay, the lagoon at the center of the park. A finger of the bay stretches past the Indian village toward the Expedition rafts, but there's a bridge across the water that leads to the Civil War Fort that juts out into the bay. Here you'll view the armaments of the day and take in a CircleVision-360 movie that re-creates scenes from the war itself. Even more impressive, floating in the bay are meticulous reproductions of the ironclad ships, the *Monitor* and the *Merrimac*. Come back after dark to watch these ships reenact a naval battle, or check the schedule for Civil War reenactments that take place daily on the vast meadow adjoining the fort. The battlefield is ringed with trees that barely shelter the opposing tent encampments, each side protected by cannons. For guests, grandstands are provided for clear viewing of the regularly recurring skirmishes.

If the battle scenes on field and film are not sobering enough, you'll

also find an exhibit about slavery here, intended to be more disturbing and agonizing than anything previously included in a Disney park. There's a small ray of hope in the re-creation of a portion of the Underground Railroad, which leads you from the slavery exhibition to freedom.

You'll experience another significant temporal shift as you leave the fort and walk the pathway away from Freedom Bay toward the Territory called Family Farm, which plops you down in agricultural America at the time of the Great Depression, although without the abject poverty or the Dustbowl. Want to know how your food is grown, how to make ice cream, or how to milk a cow? Interactive demos give even the most citified guest the chance to get in touch with their roots . . . and leaves and fruits. Depending on your timing, you may enjoy a country wedding, a barn dance, or a farmland buffet. There's another train station here, if you'd like to take a break and circumnavigate the park.

Otherwise, as a farm family might have done at the time, you will next visit the State Fair, just a short walk along the shore of Freedom Bay from the Family Farm. When you reach the fair, you will have gone halfway around the lagoon, so walk up to the water and gaze out toward President's Square, across the water from you. You can get an even better view of the park from the State Fair's sixty-foot-tall Ferris wheel or from the peaks of its wooden roller coaster, in the classic style of Coney Island. For those who prefer something less kinetic, a live show about America's favorite pastime, baseball, featuring cast members portraying some of the game's greatest players on a regulation-size diamond.

To get to the next Territory, still situated in the middle of the twentieth century, take the pathway to Victory Field, representing America from just before World War II through to VJ Day. As the name suggests, it's a sprawling airfield, with hangers and aircraft to explore. As in the Civil War fort, you can learn about the daily lives of soldiers, but here you can participate as well. Early virtual reality technology will allow you to experience parachuting from a World War II era airplane or operating tanks and other weapons in combat.

After the thrills of Victory Field, step back several decades as you head back in the direction of Crossroads, U.S.A., where you started. On this

side of the Crossroads streets is the Territory called Enterprise, themed to the Industrial Revolution of 1870–1930. Indeed, "Industrial Revolution" is the name of this area's top-tier attraction, another high-speed roller coaster—this one running through a turn-of-the-century steel mill, barely dodging a shower of molten metal as you reach the end of the ride. Surrounding the indoor coaster is a factory town that highlights the innovators and inventions that transformed the nation between the Civil War and the Second World War.

Now you're almost where you started, but there's one more stop. Sandwiched between Enterprise and Freedom Bay is the small Territory called We the People, which covers the same turn-of-the-twentieth-century period as Enterprise. The architecture is inspired by Ellis Island, and the narrative encompasses the millions of stories belonging to the families of the immigrants who filled many of the factory jobs of the country's mushrooming industries. Lightening this sober subject is a laugh-filled but respectful film about immigration that stars the Muppets. After the movie, you can enjoy a meal from the nearby ethnic food market and food court.

Have you missed anything? If you're ready to go, now's the time to stop by the early nineteenth-century shops in Crossroads, U.S.A., for your late-twentieth-century Disney's America souvenirs, or maybe a corn dog or candy for the road. Or perhaps you're checking in at the park's nearby hotel, a lavish lodge and complex themed to the Civil War era. It's the only Disney hotel that's within the circle of the park's railroad. Not far away you'll find a separate water park, a twenty-seven-hole golf course, and a campground. And if you leave Disney property, more history is nearby, as the actual Manassas Battlefield from the Civil War is just four miles down the road.

And that, in short, is one key reason Disney's America was never built.

II. INSIDE AND OUT

Disney's America was far from the first major Imagineering project that reached deep into the development process before it was shut down. There were smaller projects, like the Burbank satellite site for Disney-MGM

Studios in the 1980s, as well as full resorts. One of the earliest dead ends was the plan for a moderately sized theme park in downtown St. Louis called Riverfront Square, a project developed by WED Enterprises from 1963 to 1965 under the supervision of that most famous Missouri native, Walt Disney himself. Covering two city blocks just north of the planned Busch Memorial Stadium and west of the Gateway Arch, then under construction, the complex would have been five stories high—plus deep basements—essentially rethinking Disneyland as a multilevel building, a kind of Galleria of Imagineering. Riverfront Square would borrow ideas from some Disneyland attractions—the soon-to-open New Orleans Square and Pirates of the Caribbean; the in-development Haunted Mansion; the Fantasyland dark rides—as well as offering new rides and shows, plus shops, theaters, and restaurants. One early idea was to adapt the Jungle Cruise as an indoor attraction based on the Lewis and Clark Exhibition—called simply the Lewis and Clark Adventure—with boats winding around an indoor river past scenes from the explorers' journey along the Mississippi, Missouri, and Columbia rivers.

Asked to come up with attractions that would both fit the enclosed space and honor local history and geography, Imagineers proposed a Matterhorn-style roller coaster through what would appear to be Mississippi river caves, and a Native American canoe ride past landscapes from the Minnesota origin of the great river, downstream to St. Louis. They briefly considered a dark ride themed to a huge St. Louis fire in 1849—an idea Walt nixed, as he did an attraction inspired by the Missouri bank robberies of the James Gang. None of these ideas was extensively developed, but many provided germs of ideas that would bloom in later attractions, actual and proposed, such as the river journey redesigned for Disney's America.

A March 1964 presentation of Walt's Riverfront Square proposal to St. Louis city officials reportedly went well. But the plan fell apart a year later over money: Disney wanted the city to provide an installation-ready structure, while the city would agree to pay only for the shell, leaving the cost and construction of floors and walls and other interior spaces entirely to Disney. Walt was unwilling to invest the additional millions.

In any case, Disney didn't really need the St. Louis location: by then, Project X was just a few months from a public announcement and Walt's attention had shifted to Florida.

The Riverfront Square project did not collapse because of external opposition, but adamant activists played a big role in Imagineering's next great unbuilt complex: the Mineral King project that was the original source for the Country Bear Jamboree. Just a month after the public revelation of Disney's preliminary plans for Walt Disney World, the United States Forest Service announced that it had accepted Walt Disney Productions' bid "to build and operate [a] $35 million Alpine Village in [the] High Sierra," as the *Los Angeles Times* reported on December 18, 1965. The deal—initiated by the Forest Service but eagerly adopted by Disney— gave the company three years to come up with an acceptable plan for the site, a glacial valley in Sequoia National Forest. Known as Mineral King, after the mining camps that once dotted the landscape, the pristine valley was 227 miles north of Los Angeles and about 100 miles east of Fresno with elevations starting at 7,400 feet above sea level. If the plan for Disney's Mineral King Ski Resort was accepted by the Forest Service, the company would earn a thirty-year lease on the site. Disney envisioned 2.5 million visitors a year by 1976. While just a quarter of the number of guests Disneyland was then attracting, it was a staggering number for a wilderness area that previously counted visitors in the hundreds.

Mineral King was part of Sequoia National Forest, but it was sur- rounded on three sides—west, north, and east—by Sequoia National Park. A ski resort in a national park would be unthinkable, but it could be an acceptable addition to a national forest. According to an account by Nathan Masters for KCET's "Lost L.A." series, the Imagineering proposal "envisioned an 'American Alpine Wonderland' on the floor of Mineral King Valley: a five-story hotel with 1,030 rooms, a movie theater, general store, pools, ice rinks, tennis courts, and a golf course. Twenty-two lifts and gondolas would scale the eight glacial cirques above the village, leading to ski runs four miles long with drops of 3,700 feet." There would be a chapel and ten restaurants or cafés, one of them at the top of the slopes—elevation 11,000 feet. A base camp restaurant would

offer a recurring Audio-Animatronics show starring those Country Bears. To eliminate auto traffic in the valley, a multistory parking garage at the gateway would hold 3,600 cars, and guests would ride a cog railway up to the hotel. The total cost was an estimated $35 million—plus the cost to build a year-round road to the site, which was then accessible only by a winding mountain track that was impassable in the winter. The $25 million road project, which included a six-mile stretch through Sequoia National Park, was to be handled by the state of California, using state funds and federal grants and loans.

Walt Disney approached the Mineral King project as a potential guest: he was a skiing enthusiast and had enjoyed his role as director of pageantry at the 1960 Winter Olympics in Palisades Tahoe, then known as Squaw Valley. The Matterhorn at Disneyland stood as concrete testament to his love of the mountains. "The company's entire approach has been based on the absolute necessity to preserve the site's natural beauty and alpine character," *Disney News* magazine reported in the Spring of 1966. It added that "the area's natural character will be preserved by camouflaging ski lifts, situating the village so that it will not be seen from the valley entrance, and putting service areas in a 60,000 square foot underground facility beneath the village.

"Mineral King," said Imagineer Frank Stanek, "was a beautiful mountain." While serving as business and project manager for WED Enterprises, Stanek visited the valley and hiked from the base camp at 7,000 feet elevation to the top of one of the surrounding mountains, which he estimated at 10,500 feet. Some of the people he was with skied down, he said, "and while they were doing that, I decided to hike the entire mountain, and I was glad I did that."

But the Mineral King valley's natural beauty had other fans, as well— those who preferred a forbidding access road and an annual visitor count of about 24,000 instead of a hundred times that number. The Sierra Club opposed the development from the moment it was announced, and "for more than ten years petitioned federal officials, penned letters to the editors, and staged 'hike-ins' to save the solitude of 'the King' from the planned resort," Masters reported. The protests went on long

after Disney himself died in 1966, kindled in January 1969 by Forest Service approval of Disney's resort proposal. Opponents organized demonstrations outside Disneyland in Anaheim, and the Sierra Club initiated lawsuit after lawsuit, until the case finally reached the Supreme Court in 1972. There a slim 4–3 majority decided that the Sierra Club lacked the standing to sue, rather than ruling on the merits of the case. That same year, California governor Ronald Reagan killed plans for the upgraded access highway, promising unspecified "alternate access methods" instead. It was a major blow. When legally mandated environmental studies delayed the project further, Disney moved on. In 1978, the Mineral King site was added to Sequoia National Park, forbidding any such development. Despite its loss in court, the Sierra Club eventually got its way.

Having realized by the early 1970s that Mineral King might never happen, Disney began looking at developing a ski resort elsewhere. With the help of the United States Forest Service, the company focused on Independence Lake in Northern California, a site at just under 7,000 feet elevation about twenty-five miles west of Reno, Nevada. Plans for a year-round resort there, announced in July 1974, included fourteen ski lifts, hotels, restaurants, shops, an ice rink, tennis courts, boat rentals, and more—enough to serve a million visitors a year.

Once again, Stanek did an onsite evaluation. "I may be one of the few people that has ever skied Lake Independence," he recounted. A four-person contingent from Disney flew with a Forest Service rep in a helicopter to the peak of one of the mountains surrounding the lake. Stanek skied down through the virgin snow, an unforgettable experience. But it was one Disney fans would never get to share, as the Independence Lake project "was endorsed by the Forest Service and the two local counties, but unfortunately, the newly elected Governor Brown did not lend his support," Stanek said, "and the project never was able to get off the ground." Once again, a seemingly endless impact study stalled development, and Imagineering quietly suspended all planning work in December 1975. A little more than two years later, Disney made the suspension public and, it turned out, permanent. After thirteen years of

investing time, money, and Imagineering prowess in two elaborate year-round mountain resorts, it was over. Only the Country Bears survived, with Teddi Barra belting out "Heart, We Did All That We Could"—perhaps the sentiment of all the Imagineers who worked on the ski resort projects for so long.

III. WHO CAN TELL AMERICA'S STORY?

The battle over Disney's America, in the 1990s, became the most prominent public fight over any development in the history of Imagineering. "There was no project during my first decade at Disney about which I felt more passionate than Disney's America," Michael Eisner wrote in his memoir, *Work in Progress*, "and none that ran up against fiercer resistance." It's not surprising that war metaphors are regularly invoked in discussions of the failed theme park, because the nearby battlefields played such an important role in the debate at the time.

Eisner and the Imagineers began the project with innocent enthusiasm. Imagineering senior vice president Bob Weis was the lead Imagineer on Disney's America, as he had been on studios project. He recalled that "Michael had been very interested in the idea of Disney as a storyteller in American culture and history. And he had seen at EPCOT with American Adventure that we were good at that. He thought that Walt had a history of covering American stories in television movies and things like that. And so Michael thought there was the potential of a new park that could be based on American history. And we all liked the idea [at Imagineering]. We all thought it would be a fun thing to do."

Eisner gave a similar account of the idea's germination. "I still like the idea of Disney's America," he said long after leaving the company. "The idea was that most or a lot of kids in school don't know anything about history. They don't know anything about the Founding Fathers, and this would be an entertaining way of educating in a place that has a lot of tourists."

Eisner had been inspired by a 1991 visit to the Revolution-era history park at Colonial Williamsburg, in Virginia, about two and a half hours

south of Washington, D.C. The site for Disney's America was even closer to the nation's capital, near Haymarket, Virginia, less than forty miles from central D.C. and conveniently close to Interstate 66, the primary east-west expressway in the area. There Disney's development company found 2,300 acres owned by Exxon, which sold Disney an option on the property, guaranteeing the company the right to purchase the land once additional property was acquired and plans for the park were created. The ultimate goal was 3,000 acres, and the real estate team bought options on a dozen more adjacent parcels. (The theme park would be less than 200 acres; the rest of the land would be used for complementary developments.) As in Florida twenty-five years earlier, no one knew the identity of the prospective buyer. Unlike in Florida, even local and state politicians were not immediately briefed on Disney's plans.

By his account, Eisner first met with Weis and the Imagineering team on a Sunday in January 1993. The park, he told them, "should be built around a small number of emotionally stirring, heart-wrenching stories based on important themes in American history." He wanted to make sure there were "elements that are fun and frivolous and carefree alongside ones that are serious and challenging and sobering." The plans needed "to capture the country in all its complexity." The Imagineers went to work, with just ten months to create a preliminary plan for a park unlike anything they had ever built, with attractions that would touch on some of the most sacred, most contentious, and most delicate moments in U.S. history.

Imagineer Steve Kirk, who worked with Weis, remembered early enthusiasm for the project. "I really liked the idea of popularizing American history," he said. The Imagineers' goal was to come up with a park that "re-created historical American venues or places with story lines that would actually educate people at the same time as entertaining them." It was "a very laudable, wonderful" project, he believed, "and we came up with, I thought, a very nice menu of attractions and experiences"—such as those described at the opening to this chapter.

Disney announced its plans with a press conference at Haymarket on November 11, 1993, in front of 150 media representatives. The

company distributed an elaborate brochure with full-color renderings and upbeat descriptions of the Territories and proposed attractions, and Weis brought some scale models to show the press. Not long before the announcement, Disney had secured the support of departing Virginia governor Douglas Wilder, an African-American Democrat, as well as incoming governor George Allen, a white Republican who had won the gubernatorial election on November 2; both attended the announcement event. Sarah M. Turner, leader of the Haymarket Historical Commission, told the New York Times, "I think it will be fine. . . . I think almost anything out here would be an improvement, because it's so dull."

Turner turned out to be in the minority among preservationists, at least judging by who was most vocal after the announcement. A month after the press conference, the *Washington Post* published a critical editorial by Civil War historian Richard Moe, president of the National Trust for Historic Preservation. Moe warned that the theme park would generate uncontrollable sprawl for miles around—ugly businesses and housing to serve and house Disney's millions of visitors and thousands of cast members. It would, Moe predicted, wind up "devastating some of the most beautiful and historic countryside in America" if state and local officials didn't act to control it. The article also raised the unsubstantiated possibility that the magnetism of Disney's America would reduce visitation and revenue at nearby historical sites from the Manassas National Battlefield a few miles down the road to D.C.'s Smithsonian Institution, as well as presidential homes such as Mount Vernon and Monticello. By Moe's estimation, "collateral sprawl" from Disney's America would threaten sixteen nearby battlefields, seventeen historic districts, and ten towns.

Moe's armchair speculations were among the first salvos in the historian wars that engulfed Disney's America for nearly a year after the public announcement. Weis had inadvertently given opponents fodder right off the bat, at the November 1993 press conference. "This is not a Pollyanna view of America," he said. "How can you do a park on America and not talk about slavery? This park will deal with the highs and lows. We want to make you a Civil War soldier. We want to make you feel what it was like to be a slave or what it was like to escape through

the Underground Railroad." The quote—often truncated and taken out of context—quickly became a favorite target of opponents, who argued that any Disney attraction that replicated a slave's experience would be insensitive at best and grossly offensive at worst. Eisner, who gave an interview to the *Washington Post* in December 1993 to insist that the park "is not about slavery," continued to defend Weis years later. "He was fine in saying that, and it was the truth and was a very good exhibit," Eisner said, adding that "the Disney Imagineers have done a lot of work in the Museum of Tolerance [in Los Angeles]. . . . So it's not that everything at Disney is singing and dancing and silly."

The news media turned opponents' attacks and Eisner's counters into a spectator sport, eagerly recounting every snipe and salvo and generating hundreds of articles, political cartoons, TV news segments, and opinion columns. "As development fights go, the battle in Haymarket could be epic," the *Los Angeles Times* intoned gleefully in January 1994, accurately predicting that "every twist and turn of the project would receive national and even international attention."

Disney consistently cited the local economic benefits of the park—particularly jobs and tax revenues—but it was an argument that many wealthy residents of Northern Virginia saw merely as another reason to oppose the development. A small group calling itself the Welcome Disney Committee, consisting chiefly of small-business owners in the Haymarket area, pointed out that a Disney park was preferable to the chaos of gradually encroaching suburbia—better for the tax base, too. But the organization's talk of "a better way of life for the working person and businesses of all kinds" did not resonate with national news media fixated on higher-profile personalities and grand speeches about the ownership of America's historical legacy.

Disney signed up two historians to advise the Imagineers: Columbia University professor Eric Foner and James Horton, an expert in African-American history at George Washington University. Weis and some other Imagineers also flew to D.C. to meet with representatives of the Smithsonian Institution, the Washington Indian Leadership Forum, and other prominent figures who could provide both valuable input and

public support. It was a late attempt to replicate the expert panels that had worked so well in the creation of EPCOT Center, but many of the nation's best known history scholars quickly lined up against the project, supported, Eisner said, by many of the rich landowners who had vast estates in Northern Virginia.

Historian Richard Moe co-founded a group called Protect Historic America and recruited as its chairman David McCullough, president of the Society of American Historians. "We have so little left that is authentic, that is real, and to replace it with plastic history, mechanized history, is a sacrilege," McCullough said on May 11, 1994, at the group's first press conference. "Would we, in the name of creating jobs, make splinters of Mt. Vernon?" A best-selling author—his *Truman* had won the Pulitzer Prize and topped sales lists in 1993—McCullough was an eloquent and well-known antagonist, with a voice many Americans remembered fondly from his authoritative narration of the 1990 *Civil War* documentary series on PBS. Among the twenty-nine additional experts who made up Protect Historic America were Shelby Foote (another star historian from *The Civil War*) and historical novelist William Styron.

Eisner later cited three realms of powerful opposition to Disney's America. First was the "Washington establishment, [which] thought, 'Why would Disney of all places come to Washington with a Disneyesque theme park? How arrogant of Disney to think that they could educate,'" an attitude that he noted ignored the company's decades of educational films, television programs, park exhibits, and other efforts. This contingent presumably also included historians, protective of their own role as interpreters and spinners of history. What Eisner did not acknowledge was that Disney had inadvertently given such doubtful historians fodder for their opposition by glossing over World War II for the Meet the World attraction in Tokyo Disneyland. What might the company do to smooth over American history's many rough patches?

To try to convince leading scholars that Disney could in fact animate and relate historical narrative with both accuracy and drama, Eisner invited a group of historians and curators to Walt Disney World to hear about plans for the park firsthand. There the academics took in

the multi-media show with Audio-Animatronics figures: The American Adventure in EPCOT Center. But the spectacle of Benjamin Franklin conversing with Mark Twain—born forty-seven years after Franklin died—did little to win them over. They found the show dated and felt it omitted vital aspects of the American story. They were more impressed with The Hall of Presidents in the Magic Kingdom. Eisner thought he'd won over some of the participants, but the visit did not shift the debate as he had hoped. The fact remained that most historians weren't concerned so much with the quality of Disney's dramatizations as with the very notion of turning history into an amusement product, whether education was a corollary result or not.

The second front Eisner saw lined up against Disney was less vocal but just as powerful: those rich landowners. The park, Eisner noted, would be in "a place that is next to where Katharine Graham lived." Graham was publisher of the *Washington Post*, and her family had owned the newspaper for decades before it went public in 1971. Graham wasn't alone: a lot of rich D.C. elites had farms and retreats in the area, which they didn't want to share with millions of Disney fans. As the *Los Angeles Times* reported at the time, "horse breeders, environmentalists and owners of big country estates off the remote gravel and dirt roads that bisect western Prince William County are bracing for a fight to preserve their rural lifestyle." The acronym NIMBY—"not in my backyard"—peppered news reports.

The third front, Eisner said, was geographic: Disney's America was just minutes from the Manassas National Battlefield, where two bloody Civil War battles were fought—dubbed the First and Second Battles of Bull Run by the Union Army. In Eisner's view, Manassas was "not really close but they, the media, made it seem close. So that was a problem." Indeed, many opponents used the proximity to imply that the theme park was defiling a sacred site, despite the fact that the land Disney had targeted had no particular historical significance. "I'd say that my post analysis of [Disney's America] was that the land became more of an issue than the park," Bob Weis said, years after the battle was lost. "The land was in a place that people didn't want a park, and there were a lot of

people who didn't accept the idea that it was a place to build a resort. So it almost didn't matter how good we got at the ideas because the land was always going to drag it down. If it had been in another location maybe the world would have turned out differently."

Weis continued to believe that Imagineering could play a productive role in bringing history to life. "I do think the idea that Imagineering could play a role in the preservation and communication of American history is still a good one," he said. "And it's interesting—the museum world and the historian community at that time were against the project. Subsequent to that, the museum world and historian community have become much more immersive and much more interactive—the way we are. And in fact we do a lot of pro-bono consulting with museums and things. So I think the world went that way. It's another one of those things where maybe Michael was ahead of his time."

The controversy grew so prominent that Congress decided to step in. In June 1994, the Senate's subcommittee on Energy and National Resources heard testimony from both proponents of the park and the opposing historians. Disney sent Peter Rummell, president of Disney Design and Development, who offered general reassurances but declined to give any details about what the park would contain, and Mark Pacala, senior vice president and general manager of Disney's America, who promised the company would "stop building immediately" if planned capacity limits were reached. Virginia governor George Allen also testified in support of Disney's America. The historians, McCullough and James McPherson, fell back on the common tactic of equating the Disney site with the nearby Manassas battlefield and claimed the park would desecrate hallowed ground. The five-hour hearing resulted in no action from the Senate, but it was one more stage from which the debate could reach its most avid audience, the news media. Five hundred spectators filled the committee room, and one senator—Ben Nighthorse Campbell, Democrat of Colorado—obliged the circus by wearing Mickey Mouse ears. (He was attempting to express his opposition to having the hearing at all.)

Another D.C. media spectacle was organized a few months later, as an

estimated three thousand protestors opposed to the park staged a peaceful march from the Washington monument to the Capitol on September 17, complete with the expected chants of "Hey hey, ho ho, Disney's got to go!" Disney publicly raised the white flag on September 28, 1994. The surrender had little to do with the debate about historical purity and everything to do with money, Eisner said. Since the announcement just ten months earlier, the projected cost of the park had increased by 40 percent, estimates of potential revenue had decreased, and the opening date had been pushed back by two years. The "coup de grace," Eisner said, was not the persistent drumbeat about endangered battlefields and insensitive exhibits but rather "new weather reports." Disney's budgetary projections had assumed the park would have to be closed for four weeks every winter, but the new information increased the minimum closure time to at least eight weeks. With that, "the finances started to fall apart," Eisner said. "And between all of those things, we walked away. Now the piece of land that we wanted has a shopping center on it"—a result that inspired no outrage at the *Washington Post*. "We were in the wrong place at the wrong time with the wrong people," Eisner concluded. "And the people we were fighting had control of ink, the newspaper, and it was every day, every day they were after us and I just didn't have the stomach."

Making the announcement about abandoning the project, Rummell said the company would continue to work on a history park in another location, but it was an empty promise. The war over Disney's America had been waged at the same time Eisner was dealing with the near bankruptcy of Euro Disneyland, recovering from quadruple bypass heart surgery in July 1994, and an economic slump that meant both Walt Disney World and Disneyland had to lay off cast members to trim costs. Captain EO was shuttered in EPCOT Center in mid-1994, just months after the first child sexual abuse accusations were made against Michael Jackson. (Disney said the closure had nothing to do with the allegations.) The "Disney Decade" Port Disney theme park in Long Beach had been scuttled a couple years earlier, while plans to expand in Anaheim remained uncertain. Just as Disney's animated feature division was enjoying a renaissance with the 1994 megahit *The Lion King*, Imagineering

seemed to be plagued with hurdles at every turn. Caution would be the watchword going forward.

In the long run, Weis believed, Imagineering gradually earned the respect from some of the same realms that had opposed Disney's America. "A lot of architects and a lot of even cultural historians that we've met with who used to think of Disneyland as gingerbread now see a deeper meaning to what we do—that there's a real cultural significance to the kinds of places we create, experiences we create, and how many different generations go to them." he said. "It's really a fundamental way of physical storytelling. It's not an aesthetic of gingerbread. It's a much deeper thing that we do, and I think that's why a lot of us do it—because we see that it has cultural significance."

Such delayed victories may be small comfort to the Imagineers who worked for months or years on projects like Mineral King and Disney's America. Struggles against entrenched opposition—standing on what they believe to be historical, environmental, or other high grounds—are distinctly short-term battles in an industry that functions on much longer time lines. For developments on newly acquired land, the mountain of bureaucratic hurdles and government approvals is another impediment, often used by opponents to slow any progress. Defenders of such Imagineering projects, from inside Disney or among its allies, may muster worthy arguments about economic and educational benefits, but they tend to avoid restating Imagineering's founding mission: creating happiness. Facing perceived threats to history or natural resources, mere happiness may seem a dubious value. Imagineers know differently, but when wars of approval are raging, they rarely get to speak for themselves.

For those who don't understand what the Imagineers were hoping to accomplish with Disney's America, Steve Kirk suggested a comparison to the success of Lin-Manuel Miranda's stage musical about the founding fathers. "What *Hamilton* did so successfully with taking contemporary media and rap music and dancing . . . they really got people interested in [American history]—something that I never thought would happen again," Kirk said. "I thought it was wonderful." The sad truth, he added, was that "*Hamilton* worked and Disney's America never got a chance."

CHAPTER 17:

GOING UP

*"Success is really about many, many failures and that we want
to make sure that we have a culture that we don't judge. . . .
We plan to fail many, many, many times because we are
experimenting. We are trying things that we don't know if it will
work or not. If we are above 50 percent hit rate on our smaller
projects, we're not trying hard enough."* —Jon Snoddy

I. THE STORYTELLING SKILL SET

UNDER THE LEADERSHIP of Michael Eisner and Frank Wells,
Imagineering's Research & Development department had
grown to a team of forty—having been a crew of just four in
1987, when it was called the Technology Applications department. In
the early 1990s, it was led by a former R&D innovator for General Elec-
tric named Dave Fink, an adventurous man who once taught himself to
assemble and pilot a hot air balloon as a GE promotional tool. Fink had
joined Imagineering in 1987, after five years of serving as the GE liaison
to the Horizons pavilion in EPCOT Center, of which GE was then the
sponsor. In 1992, his Imagineering bio described the R&D department
as it was then constituted: "Dave leads a staff of highly qualified sci-
entists, engineers, and technicians, as they discover, define, apply and
develop new technologies for Disney attractions and facilities. The areas
on which they focus include imaging, animation, audio and computer

systems, special effects, ride and transportation systems, advanced technology research, and materials evaluation and application."

The wording of that list may have evolved over the years, but all those concepts dated back to the insatiably curious Walt Disney himself. Imagineer Tom Morris recounted Ray Bradbury's comparison of Walt to "the man who jumped on his horse and rode off in four different directions." Bradbury said that image "reminds me of Walt because he was just excited about these topics—nature, and the environment, and ecology . . . space programs and our friendly atom and Mars and beyond." Walt loved to visit the research and development labs of leading American corporations, always in search of the latest "cool shit," as the Imagineers at the time put it. In many ways, WED Enterprises began as Walt's personal R&D lab.

Frank Wells shared Walt's hunger for learning and for new experiences, always looking for the next leap forward. In addition to his ambitious mountain-climbing agenda, he eagerly sought out challenges that let him test unfamiliar technology. As a young man on a Rhodes scholarship to Oxford University in England, he and a friend purchased a private plane with the goal of flying to South Africa. They crash-landed in eastern Africa—unhurt—before giving up. While at Disney, Wells commuted in a Pontiac Fiero that had been converted to run on electricity long before Detroit was considering mass production of such vehicles. "I once took the calculated risk that I would make it to and from the beach. I ran out of electricity on the way back in," he told the *Los Angeles Times* in 1992. "It was close enough to a friend's house. I coasted into his driveway, plugged the car into his washing machine outlet, and came back the next day to pick up the car."

Wells, recalled Imagineer Bruce Vaughn, "spent a lot of time over at R&D. He was very interested but he never came in saying, 'Hey, I'm gonna lead the way on this.' It was more like, 'Tell me why this is actually true. Convince me that this is actually what we should do.' He came in skeptical every time, but he would listen."

Wells was closely involved with the recruitment of a prominent technology innovator from the East Coast to lead R&D at Imagineering, the

media-savvy Bran Ferren. The son of two well-known painters, Ferren described himself as "what happens when you grow up in the art world and are interested in science." He attended MIT but left before graduating and began doing lighting and special effects for theater productions and nightclubs. By the time he was twenty, he had created special effects for concerts by the 1970s progressive rock trio Emerson, Lake & Palmer. He later did the same for Pink Floyd, Paul McCartney, and others as well as working on TV commercials.

At age twenty-five, he founded his own entertainment effects company, which he modestly dubbed Associates & Ferren, in East Hampton, New York, where he had attended high school. He took his talents to Broadway, working on effects and sound for *Evita*, *Cats*, and *Sunday in the Park with George*—the last of which was the first New York musical to utilize projection mapping, a technology that would transform Disney theme parks some years later. Ferren also applied his high-tech artistry to movies, starting with the hallucinogenic sequences in Ken Russell's *Altered States* (1980). He went on to do special effects for *Little Shop of Horrors*, *Star Trek V: The Final Frontier*, and even the bucolic *Places in the Heart* (they needed a tornado).

Ferren wasn't just utilizing the latest technology—he was developing it. His company made strides in robotics, invented audio and optical systems, and even refined how sunglasses were made. Director Paul Mazursky, who worked with Ferren on his film *Tempest*, called him "a Renaissance man, a figure from another time. . . . If you crossed Robert Oppenheimer and Monty Woolley, you might get Bran."

Ferren liked that there was no single answer to the question *So what do you do?* "It's like never having to grow up," he told the *Los Angeles Times* in 1989. "If you can be gainfully employed but no one knows exactly what you do, people will say you're a genius." By then, Associates & Ferren had a staff of forty, a number that could more than double during busy periods. The company worked for clients in business sectors that seemed to have no overlap, but Ferren saw a common thread in all his work: "I take ideas, which often deal with intangibles, and translate them into tangibles," he said. "I know how art and technology can intersect." He

also knew, like the future Imagineer he was, that the technology needed to be "transparent," that it should disappear within the show.

Imagineering called on Associates & Ferren more than once for a consultation, first for an attraction called Toontown Transit, pitched for the Disney-MGM Studios at Walt Disney World. Ferren and his team mocked up an impressive mobile projection system for the Transit ride, which would have provided the view from the windows of a moving Toontown bus. Although the Transit bus idea was scrapped, Ferren had impressed the Imagineers, and he was brought in again to help produce a complicated projection effect for another E ticket–level attraction. Over the course of these and other collaborations, Wells and Eisner saw an opportunity to bolster Imagineering's R&D department through one strategic investment. So in 1993, Disney bought Associates & Ferren for a reported $20 million, and Ferren became senior vice president of Creative Technology for Walt Disney Imagineering. The East Hampton research facility became the biggest campus for Imagineering's R&D department—which by the end of the decade would also have satellites in Florida and in Cambridge, Massachusetts.

"Based on our work, they looked at the company and said, 'Wow, we've never seen a company that looked so close to Imagineering,'" recounted Vaughn, who became an Imagineer by virtue of working at Associates & Ferren. He readily embraced Imagineering's mission. "I became in love with this sense of immersive storytelling versus passive storytelling, where the people are in it," he said later. "That first trip down there [to Glendale], I understood, 'Okay, these people aren't fooling around. These are truly artisans and artists and designers and storytellers, and they get it.'"

Storytelling had always been vital to Ferren, motivating many of the innovations he had worked on. "I eat, live, and breathe story," Ferren said in a 1997 speech to the Association of Computing Machinery. He argued that "every time a significant storytelling technology has been introduced to the world, it changed the course of civilization—or rather we change the course of civilization with it." That included language, writing, the printing press, radio, television, animation, and computers.

If you looked at computers as being "a storytelling tool rather than an information processing tool or a simple communications tool," he said, "it becomes a lot clearer as to where it needs to go."

Storytelling, he continued, "is such a compelling thing that if you do storytelling well in computers, it will let you solve a great deal of those other, I think, simpler problems."

"Walt Disney used to follow technology by becoming friends with the head of, say, Westinghouse, and visiting the plant floor," Eisner told *The New Yorker* in 1997. "I've got Bran Ferren."

II. TERROR AND TECHNOLOGY

Daniel Jue grew up on the opposite side of the country from Bran Ferren, in San Francisco, but his life's path was similarly influenced by his family's older generation. In Jue's case, it was his grandfather—one of the first Chinese Americans to produce his own films in the United States and the builder and owner of a movie theater in Chinatown. The theater often showed the Disney animated classics—much to the enjoyment of young Daniel. Naturally Jue's grandfather had books about filmmaking in his home, so it was there that Jue, as a boy, would flip through a copy of Bob Thomas's classic *Walt Disney: The Art of Animation* whenever visiting his grandparents. "He had a love and a very great respect for Walt Disney," Jue said of his grandfather. A budding fan himself, Jue finally got to visit Disneyland on a "magical and amazing" school trip when he was in fifth or sixth grade—although at the time it never occurred to him "that there were actually people who built Disneyland."

Building turned out to be Jue's ticket into Walt Disney Imagineering. After studying theater at UCLA, a friend and mentor who loved Disney suggested Jue apply to work for the company. Jue landed a job with the Disney Stores, at their newly created design center, in 1988. "This was a group of about forty people or so, in a warehouse in Burbank, and we designed, built, and installed all of the thematic elements for the Disney Stores." Michael Eisner had opened the first Disney Store in 1987 at the Glendale Galleria, and it had succeeded so remarkably and so fast that

many additional locations soon followed. There was a lot of work for Jue's construction team, on which he started as a scenic carpenter—so much work, in fact, that Disney soon farmed out the scenery building to a vendor. "I ended up in the design office, designing the show set pieces," Jue said.

That skill set took him to Imagineering in 1990. The building of Euro Disneyland was in full swing, absorbing so many existing Imagineers that "they needed a lot of people to backfill—to keep the development of the other parks going," Jue recalled. Imagineering was crazy busy and maybe just a little bit plain crazy. "It was haphazard. It was not an organized company. It was very much like a group of people just getting [on], doing the work. There was a huge amount of activity in different buildings." As a show set designer, "I could relate to my project team, but I didn't really have a good understanding of the company holistically. But it was exciting because we were all creating new, amazing projects." The downside, he said, was "for about two years probably every project I worked on got cancelled. So that wasn't so fun."

The first major attraction to which Jue was assigned that wasn't cancelled was also one of Imagineering's biggest attention magnets to be added to an existing park. Jue joined a team led by Kevin Rafferty, at the time an ambitious young designer hoping to develop that one big attraction that would take his career to the next level. Rafferty knew that the theme park known today as Disney's Hollywood Studios still needed an anchor—a "wienie"—for the far end of its new Sunset Boulevard, to draw guests north from the park's central hub. He also knew that other Imagineers had floated the idea of a haunted hotel with a free-falling elevator tied to an unsolved murder—a concept dismissed by Eisner as insufficiently compelling. But Rafferty couldn't get the idea out of his head. One day, brainstorming with Steve Kirk, a new concept hit him—a "Tower of Terror," themed to *The Twilight Zone*™. He quickly put together a proposal for Marty Sklar, the president of Imagineering, who gave him the green light to take it to Eisner and Frank Wells.

Following the wisdom of John Hench, Rafferty had added a fresh twist to the previously uninspired elevator-in-freefall idea. "What sold

that idea was the ride system," he said. "The idea that the ride vehicle would behave differently than what you'd expect. So when it got up to *The Twilight Zone*™ time, the elevator car actually traveled horizontally across the floor into another shaft." It would be, he added, "the first time that a ride vehicle started out as one thing and became something else—really appropriate to the story." Using freshly created concept art and the theme music from popular anthology series on a cassette player, Rafferty made his presentation to Eisner and Wells. "I remember Michael saying, 'Frank! Did you hear that? The elevator—it doesn't just go up and down, it goes that way!'" The men also liked tying the experience to *The Twilight Zone*™, which Wells termed an "iconic" property. (Indeed, for a show that ended twenty-five years earlier, in 1964, *The Twilight Zone*™ remained remarkably visible in the 1980s, with a TV reboot and a feature film as well as reruns of the original and VHS releases.) "Everybody knows what *The Twilight Zone*™ is," Wells said at the meeting, Rafferty recalled. Then he looked at Eisner: "You know, all it takes is money, Michael. Do you want it?" And Eisner responded simply: "Let's do it. This is a home run."

The green light, Rafferty said, was "kind of scary, because we didn't know how we were going to do it." Solving all the technical challenges would take years—and the assistance of Associates & Ferren, which worked on the attraction's projection effects. The Tower project also transformed how set designers like Jue did their jobs. "That ended up being the first project where we decided to draw everything in Auto-CAD," Jue said, referring to the popular computer-aided design (CAD) software, which had transformed commercial drafting in the mid-1980s when its creator, Autodesk, released a version that could run on personal computers. "Before then, everything was drawn by hand."

Research for Tower of Terror involved road trips—mostly to learn how not to design a freefall attraction. Zero-gravity thrill rides already existed at many American amusement parks, including Six Flags Magic Mountain, north of Los Angeles. Rafferty took some of his Tower of Terror team on a research trip there to experience the theme-free ride, called Freefall. Like most such rides, it was outdoors and resembled a vertical roller coaster with a single drop. Guests were strapped into a

four-seat vehicle resembling an oversized Ferris wheel gondola, which was ratcheted up one side of a tower, shifted to the opposite side, and dropped along a parabolic track bending from the vertical back to the horizontal—leaving riders on their backs until the car was rotated for unloading. Tower of Terror reimagined the vertical drop as an elevator in freefall, largely in the dark, and without leaving riders even briefly on their backs, which no elevator would do.

Rather than starting the mechanical design from scratch, Jue said, "we switched to using an elevator development company to design us an elevator that would fall." The firm had a stellar reputation for safety but was game to help the Imagineers develop a system that appeared to break the main rule of elevators: don't let it fall. In fact, the mechanism created for Tower of Terror avoided any freefall. Instead, it used a pair of electric motors to pull the elevator cars down the equivalent of thirteen stories at a speed greater than gravity would have provided.

"We're good at developing technologies here but we're also good at misusing other people's technologies," said Imagineer Dave Crawford. "They usually are frightened out of their minds because they've done everything in their power to do a certain thing and not put people [in certain situations]"—say, a plummeting elevator. "It's kind of the magic of what Imagineers have, is seeing the potential in everyday objects to deliver these interesting guest experiences."

To get to the tall elevator shaft, the cabin holding the riders traveled horizontally—as Rafferty had pitched—from the smaller vertical shaft where loading took place. "That was a trackless system," Jue said, "to have a cabin move out of an elevator into another elevator, which I believe was very, very innovative. Basically, it's two different systems that the guests are riding, not to their knowledge." The Tower was Disney's first use of a trackless ride vehicle, a technology pioneered by Ferren's R&D department that would become vitally important in years to come. Also innovative was the drop sequence: all riders experienced one long drop plus lesser drops, but the order and duration was randomly generated by computer for each vehicle. Guests could never predict their exact experience, compounding the thrills.

The attraction was elaborately themed, a stunning draw for the park that immediately overshadowed the water tower with mouse ears previously designated as the Studios' icon. The ruined "Hollywood Tower Hotel" borrowed exterior architectural elements from the actual Hollywood Tower, an eight-story art deco apartment complex in Los Angeles built in 1929, as well as the Mission Inn in Riverside, California, and other early-twentieth-century landmarks. At ground level, the queue wound through a beautifully designed lobby closely modeled on the interior decor of Los Angeles's 1920s-era Biltmore Hotel—although Disney's version was covered in the dust and cobwebs appropriate to a haunted hotel. Antiques and in-jokes were placed carefully about, some barely visible to the guests, such as the sheet music for a 1932 novelty song titled "What! No Mickey Mouse? What Kind of a Party Is This?," which Herbert Hoover had adopted for his (unsuccessful) reelection campaign.

The Tower's backstory was elaborate, with Michael Sprout's script describing a 1939 lightning strike that scarred the hotel and transported five elevator passengers into another dimension. "It's maybe a little ghoulish," Sprout said just before the ride opened, "but we knew many of the park guests would be staying at hotels, so elevators are something they're going to have to face every day." To record introductory narration ostensibly spoken by *The Twilight Zone*™ host Rod Serling, the Imagineers hired an impersonator named Mark Silverman—who as a boy had tape-recorded the narration on Disneyland rides so he could teach himself to recite them from memory. Hollywood director Joe Dante (*Gremlins*) directed the video that provided the backstory in the pre-show, in keeping with Eisner's vow to work with the best in the business.

Although the elevator drop took place inside, the Imagineers wanted incoming guests to be able to see what they were getting into. So the window into the top of the taller elevator shaft served a dual purpose: it allowed the screams of dropping riders to waft out into the park, both beckoning and warning other potential victims, and it gave those already aboard a view of just how high they were before the drop. The concept and design were finalized fourteen months before opening, as construction began. The structure required 150,000 cubic feet of

concrete, 1,500 tons of steel, and input from 150 or more Imagineers. The tower was 199 feet tall—about twenty stories—the tallest structure in Walt Disney World at the time and just twelve inches short of needing an FAA-regulated blinking red light on top to alert airplane pilots.

Eisner had bet big on the tower, spending an amount of money that could have financed two or three Hollywood megamovies at the time—an amount at least double the reported budget for Disney's 1994 megahit *The Lion King*. He had gambled against the advice of his own CFO, Richard Nanula, on the basis of sheer instinct. "Tower of Terror seemed to me so special that it was worth the investment—in part because the Disney-MGM park very much needed an additional thrill ride to round out its offerings," he later wrote.

Whatever the cost, the reception was worth it. *The Twilight Zone*™ Tower of Terror opened as part of the new Sunset Boulevard area at the park on July 22, 1994, along with the revamped 1,500-seat Theater of the Stars hosting the popular three-year-old show *Beauty and the Beast—Live on Stage*, many new shops, and a complex of food stands called the Sunset Ranch Market. On opening day, the *Orlando Sentinel* called the attraction the longest, fastest, and steepest thrill ride at Walt Disney World, declaring that it "distills the essence of every roller coaster into The Drop—a single gut-grabbing plummet that steals the superlatives from every other thrill ride at Walt Disney World." Park visitors lined up by the thousands. Eisner judged it "a spectacular ride that seemed certain to have a huge impact on attendance"—a belief supported by a 15 percent increase in visitors over the next four months.

The attraction proved so popular that plans were made to duplicate it for other parks—some of which had yet to be announced when the original Tower opened. (The copies would omit the vehicles' horizontal travel in favor of keeping the cars within one of three vertical shafts.) Just as important, many of the Tower's technological achievements would be vital to ride design at Imagineering for decades to come.

The Tower was actually the second major new attraction to be added to the Studios, since Muppet*Vision 3D had opened three years earlier. That show had been fast-tracked by Eisner to augment the park as quickly

as possible. The speed was possible since the attraction chiefly involved existing characters and existing technology: 3D filmmaking, Audio-Animatronics figures, and a few cast members in costumes. The one new twist was the first computer-animated Muppet, a character called Waldo who seemed to buzz around the auditorium.

Muppet*Vision 3D was the equivalent of a solid hit, but *The Twilight Zone*™ Tower of Terror was a blockbuster. At the same time, Imagineering had another blockbuster in the works for the opposite side of the country that would transform Adventureland in Disneyland.

III. HITTING ONE OUTSIDE THE PARK

Future engineer and Imagineer Ed Fritz spent his boyhood skiing the moderate slopes of Michigan every winter and anxiously waiting to be old enough to drive. "I grew up with hot rods," he recalled, and he lived in a house with "cars parked all over the garage and cars torn apart all over the lawn. I wanted to drive when I turned sixteen, and the only way that was going to happen is if I bought a car that didn't work and put it together." Planning ahead, Fritz bought a junker at age fifteen—a 1974 Chevrolet Nova that he turned midnight blue with paint acquired by a friend who worked at the Cadillac plant. Through trial and error and a little help from friends and relatives—his father was a mechanical engineer—the Nova was ready to roll when he hit the magic birthday. After that, "It was all about cruise night on Saturday, working on your car all week, and then getting ready for Saturday again."

It seemed preordained, then, that Fritz would study mechanical engineering at the University of Michigan, then go to work for a custom automobile design outfit called Triad Services. He worked in the shop building cars and on drafting assignments before being promoted to the engineering department. He was still a junior member of the team when Disney called. More precisely, an electrical engineering company based in Ohio called to ask for help with a Disney project. Imagineering was developing an electric vehicle for a top-secret new attraction, but the Ohio company needed Triad to take over the design of everything

mechanical: the chassis, the wheels, the steering, the suspension. "So they talked us into helping on this job," Fritz recounted, "and I ended up getting assigned to this project to figure out the steering system and help design the ride. It turned out to be The Great Movie Ride."

So down to Florida he went. "I didn't know anything about Imagineering or what it even was. I just came down and developed and tested this ride. And they said, 'Hey, you did a great job with that. We've got another problem over here—this flipping truck thing over at Studios.'" That was for the Indiana Jones Epic Stunt Spectacular! "And then I got done with that and said, 'Okay, nice knowing you, see you later.' And I went back to Detroit and starting working on cars again."

But Imagineering was not done with him. In late 1989, the head of ride engineering at Imagineering called. "He said, 'Hey, we've got this idea to build this vehicle with crazy motion based on an off-road [experience,] and my department has aerospace people and train engineers. I need an automotive engineer who can figure out this to make this vehicle work." A lifelong Michigander, Fritz was not immediately convinced. But he flew to Glendale, and there were all the Imagineers he had met in Florida. It seemed like a cool project, a close collaboration between engineering and Bran Ferren's R&D department, so he let himself be talked into taking the job. "I thought it was a two-year gig," he said. "I told my wife, 'We'll be out of California a couple of years—we'll surf or whatever and we'll come back to Detroit—all good.'" And he never lived in Michigan again.

The ride that changed his life was the Indiana Jones Adventure. Led by Tony Baxter, the team working on the attraction had previously worked on Star Tours, and "we wanted to take the next step" with motion simulator technology, Jon Snoddy recalled. The question the Imagineers posed to Ferren's souped-up R&D department was: can we put a motion simulator on a truck and drive it around during the simulation? The idea was simply expressed—"let's re-create that off-road vehicle experience"—but immensely complicated to execute. The only path forward, Snoddy said, was for R&D to "build something, try things, build some

more stuff. Try things and keep iterating until you get a combination that is right and then launch a project around that."

Despite the expected budget-busting costs, Michael Eisner was an early supporter, Baxter recalled. For one thing, the show would tap into an extremely popular intellectual property, already in use in a stunt show at Walt Disney World, and it would mean another collaboration with Indiana Jones creator George Lucas, the executive producer of *Raiders of the Lost Ark* and its sequels. More important, Eisner argued, was that Disneyland should always be considered "the supreme repository of new thinking." The attraction would be the first to put a motion simulator on a chassis and, like Tower of Terror, each ride would be randomly customized by a computer, with changeable starts and stops, different sound effects, and other variables. "If there's an explosion near your car, that may not happen to the car behind you," Baxter said. "The point of all that was to make it unpredictable." It would be more immersive than, say, Pirates of the Caribbean, where "you're a passive observer to what's going on around you," Baxter said. "Here, it's happening to you."

In some sense, the concept echoed the first Imagineers' intentions with the Snow White and Peter Pan dark rides, which originally cast the guests in the title roles rather than depicting the protagonists within the attractions' scenes. But riders had not understood why they weren't seeing Snow White and Peter, and the Imagineers gave in and added the heroes to their rides. Rather than having a role in the story, guests became largely unacknowledged viewers, a standard that had been maintained through the decades for rides as diverse as Pinocchio's Daring Journey and Splash Mountain. Now the Imagineers would borrow a lesson from Space Mountain—the story belongs to the guest—and apply it to an existing intellectual property, Indiana Jones.

To hone the mobile motion simulator technology, in 1991 the Imagineers built a full-scale mock-up track in a warehouse in Valencia, thirty miles northwest of Glendale. There they put what they had dubbed their Enhanced Motion Vehicle through its paces again and again and again, getting every bump and skid and turn just right. The test

riders—including, on at least one run, Eisner and Lucas—and computer programmers who were fine-tuning the motion just had to imagine the jungle roads and rickety suspension bridge that would be built around the track in the final ride.

Every jolt and apparent slide created by the simulator was intended to "amplify the experience," Baxter notes, "but we [have to] hide all that. Where you board, and once you're locked in the seat, you can't look underneath and see all the electronics that are going on to give you that experience—because you're really gliding through on glass-smooth flooring through that whole experience, but you'd never know that from what you feel above that motion base."

"We knew from the get-go that that was going to be a breakthrough attraction," said Daniel Jue, who was a show set designer on the Indy team. "Using that ride system that has a motion base and makes you feel like you're hopping over stones or going down a set of stairs, and being able to tell a dynamic story in that way—I'm very proud of Indiana Jones."

The team's collaborators were numerous. Veteran Imagineer John Hench created some concept art that helped sell the attraction to Eisner. Computer animators who had worked on the wildebeest stampede in *The Lion King* helped create the thousands of bugs that appear to be creeping all over the walls at one point. Researchers from the University of Utah who were developing better prosthetic limbs consulted on the Audio-Animatronics Indiana Jones figures. And, of course, Lucas was instrumental in honing the storytelling.

Surveying Indiana Jones fans, the Imagineers knew that the one story element that came up again and again was the giant rolling ball that nearly crushes Indy in a cave in the first movie. That scene was, as Imagineer Tom Fitzgerald put it, one of those "aspirational moments, physical moments in [the movie] that you would love to step into.'"

More easily aspired to than executed, Baxter knew. "I thought, 'Well, how are we gonna do that?' Ride vehicles have to proceed in a forward motion. They can't back up. They can't escape from something that's coming at you." Then one day Baxter was sitting in an automated car wash, where he noticed, "as this room is moving around my car, it made

me feel that my car was moving forward rather than the room was moving backward, and I said, 'There's the answer!'"

Imagineer Dave Durham, who designed the programming for the complicated vehicle motion, compared Disney attractions to magic tricks. "Magic is all about misdirection and making you think one thing when something else is really going on. Every single one of our attractions does that," he said. "The whole rolling ball scene is the room moving backward while you're moving forward. You have to remember, the ball's also coming forward and it's also bouncing and it's also turning while the room is moving. The whole room is moving. All the lights and speakers and Indy, that's all gotta move with it. When you come to that scene, it's already moving in the opposite direction—toward you, which makes it look like you're going faster than you really are."

Creating the sound effects and making sure each was perfectly coordinated with each vehicle's individualized experience required extensive R&D. "We had to create some new technology in order to pull it off," said Imagineer Joe Herrington. "At that point in time, you could only create basically a linear [audio] track"—which would not work with the Jeeps' changing speeds and unpredictable starts and stops. The solution was a custom-made digital controller that used a constant wireless feed of data from each vehicle—speed and location—to sync specific sounds in real time. Each effect—a tire screech, a braking squeal, an engine vroom—was coded and assigned to certain positions along the track and certain motions of the vehicle. "So suddenly you had a soundtrack that could follow the vehicle precisely, no matter what it was doing, or if it stopped. No big deal. Let it stop and we'll do something there."

The coordination of sound and movement needed to be perfect to avoid what Herrington termed "sensory conflict." For example, if the sound effects tell the rider that the vehicle is moving fast and making a right-hand turn but the car's motion says that's not happening, he explained, "Your ears are saying you're doing this but your eyes are saying no, you're not." The immediate conclusion is simple: "This isn't real." Not only does that ruin the storytelling, it can have physical effects. When the sound and image were just a few frames out of sync in early

tests of Star Tours, Herrington recalled, "we got people sick—just like that—because their eyes were saying this is what I'm doing and their ears were saying no."

The Indiana Jones Adventure would take up a lot more space than was available in Adventureland, so the actual ride was built in what had previously been part of the parking lot. An estimated five hundred Adventureland trees were tagged and relocated, and the Monorail was closed for a time while it was rerouted around the huge ride. Riders reached the boarding area through a labyrinthine queue that began in a jungle enclave adjacent to the Jungle Cruise. It apparently directed guests into the halls of an ancient temple but was actually taking them under the Disneyland Railroad tracks and beyond the previous perimeter of the park. The waiting area was the most elaborate the Imagineers had yet designed, with engravings in a letter-replacement code (early on, the initial sponsor, AT&T, provided a decoding card) and archeological elements that begged to be touched and tugged—sometimes resulting in audio or other effects.

"While you wait in line, you'll be seeing booby traps and hidden rooms and chambers that you'll uncover and archeology work going on," Baxter said at the opening. "And this all builds up the story and really increases what will happen on the ride. When it's done, you'll be through an hour-long experience."

Publicity for the new attraction was in high gear by January 29, 1995, when Disney had arranged for a halftime show at Super Bowl XXIX titled "Indiana Jones Adventure: Temple of the Forbidden Eye" and featuring 790 singers and dancers and A-list performers including Tony Bennett and Patti LaBelle. It aired in 150 countries and was seen by an estimated eighty-three million Americans. The advance word paid off: the ride was quickly embraced by guests when it opened officially March 3. Disney expected 24,000 riders a day and wait times of two to three hours. "This is not a ride for kids of all ages," Eisner said at the opening event, alluding to the forty-eight-inch height requirement—eight inches taller than the Star Tours limit—which banned most children younger than eight. A reporter for the Spokane, Washington, *Spokesman-Review* took his whole

family on the ride four times and called it "a blast." The *Los Angeles Times* declared the attraction "Disneyland's first true heir to Pirates" and also reported that Imagineers had "toned down the jostling level twice."

According to the *Times*, some of the seventeen ride vehicles had quickly developed cracks in their undercarriages—repaired during a brief weekend shutdown just weeks after the opening. But fixing stuff, making it work smoothly over and over, is at the core of what Imagineering does. "Imagineers are problem-solvers, that's what we do. That is our job," Durham said. "All we get all day long are thousands of problems. Most problems, people just give up because they're too hard. At Imagineering, we just don't give up."

IV. THE CRASH

One key creative force was missing from the ceremonies marking the debut of both *The Twilight Zone*™ Tower of Terror and the Indiana Jones Adventure: Frank Wells.

The same adventurous spirit that had led Wells to return to the R&D section of Imagineering over and over had taken him with a group of friends for a heli-skiing expedition in the Ruby Mountains of northwest Utah in the spring of 1994. The idea was to take a helicopter up to an otherwise inaccessible slope and ski down in powdery snow untouched by any other skiers. But somehow snow got into the engine that afternoon, causing the helicopter to crash into a remote mountainside, killing the pilot, a documentary filmmaker named Beverly Johnson, ski guide Paul Scannell, and Wells, who was just sixty-two years old. Johnson's husband and filmmaking partner, Mike Hoover, survived the crash. Like Wells, Johnson and Hoover were avid mountain climbers, and their documentary short on the subject, titled *Up*, won an Academy Award in 1985. At the time of the accident, Wells was on an Easter ski vacation with his son, who was not aboard the helicopter.

"There are no words to express my shock and sense of loss," Michael Eisner said in a statement released with news of Wells's death on April 3. "The world has lost a great human being." Eisner had lost the best

collaborator he had ever known or would ever know. He was left alone in the middle of the battle over Disney's America, the expansion of what we know today as Disney's Hollywood Studios, and continuing debate over what and where the company's next U.S. theme park should be. Weeks earlier, Euro Disney had dodged a bankruptcy filing, and plans for the long promised second gate at Tokyo Disneyland were in the works. And all this was apart from the usual bustle in other divisions of the company, including the film studio, Disney Channel, and so on. But among the many Disney cast members directly affected by the Wells tragedy, the Imagineers might have felt the loss most deeply.

At Imagineering, "We saw Frank Wells as our mentor, our biggest cheerleader, our best friend in the business," Bob Weis said later. Weis had left Imagineering to start his own design firm just before the accident, and he got the news in Florida in the middle of the night from his sister, who still worked for Disney. "I had traveled with him a lot to Tokyo, and he had been such a great friend to Imagineering that it devastated everyone."

Imagineer Wing Chao was home that Sunday night when a colleague from Imagineering called and told him to turn on the television news. "I was shocked to see Frank's picture on the screen and was saddened to hear about the accident," he recalled. "Of course, I was very sad because we were all very close working with Frank on a regular basis. And he was truly an amazing executive." Wells was also a personal friend to many Imagineers, inviting Chao and others to his house for dinner or to ride horses on his private ranch. "It was very sad that we lost him. It was not only a huge loss to the company, but also to me personally."

So many people poured in from around the world to attend Wells's memorial service—from Hollywood, from New York, from all over—that many Disney cast members couldn't even get into the cavernous soundstage where it was held. Weis traveled from Florida to attend. Imagineering "had a lot of projects in flight at the time," he remembered. "And the tone [around the company] changed a great deal. The enthusiasm waned and I think things became much more measured, more analytical. The chemistry wasn't there the way it had been. There were

certainly great projects that came out of that era [after Wells's death], but I think it became a lot more business-like. The heady days of the two of them being this great, fun, visionary leadership of Imagineering seemed to be over after Frank died." Without Wells to help them navigate and to provide balance for Eisner, the Imagineers faced stormy seas ahead.

CHAPTER 18:
SYNERGY

"Darkness ripples through Imagineering in different times and in different ways. There was a time where we were encouraged to forget who we were. . . . Our theme park days were over." —Tom Morris

I. AFTER FRANK

SO WHAT WAS an Imagineer doing standing atop the marquee of a doomed movie palace in New York's Times Square? It was 1996, and Eddie Sotto was at the RKO National Theatre on Broadway, looking down at all the tourists and New Yorkers rushing by.

Standing with him was Roger Goodman, vice president for special projects at the ABC television network. Goodman liked the views from the top of the marquee, a New York panorama that would be inherited by the second-floor news studio of ABC's flagship morning show, *Good Morning America*—a project on which Sotto and his fellow Imagineers were now working. On the first floor would be a second, multipurpose studio, where musicians could perform or the show's hosts could interview celebrities with crowds of onlookers on the sidewalk on just the other side of a glass wall. "We could get maybe two hundred people under a marquee and it wouldn't matter if it's raining," Goodman said to Sotto, according to a *New York Times* article.

In a previous era, none of this might have involved Walt Disney

Imagineering. But as the Pleasure Island and Gene Autry Western Heritage Museum projects had demonstrated in the 1980s, Michael Eisner saw Imagineering in part as a design studio that could create dramatic, enveloping spaces in any number of contexts. If Disney needed an attention-grabbing environment, Eisner turned to the Imagineers.

Sotto's *Good Morning America* studio assignment dated back to July 1995, when the Walt Disney Company announced it had reached a deal to acquire the conglomerate that owned the ABC television network, called Capital Cities/ABC, in the second-largest corporate merger in history at that time. As part of the $19 billion deal, Disney got not just ABC but also the leading sports cable TV network, ESPN, as well as additional cable networks, a publishing group, local television and radio stations, and other assets.

Now Eisner wanted to show off his new acquisition within the glass house of a high-tech Times Square studio. The ABC project required not only the pizzazz of a branded, attention-grabbing exterior but also solutions to the kinds of high-tech questions Imagineering faced daily. For example, how did one design huge panes of glass that would be bulletproof, soundproof, nonreflective, and variably polarized so the amount of light permitted could be carefully calibrated depending on the time of day and the weather? Such were the challenges in creating a television studio that would be versatile and welcoming and seamless. It was quite a different set of problems from designing Main Street, U.S.A., for Disneyland Paris, but now Sotto would at least be able to say he'd had a hand in designing the millennial equivalent of Main Street at the heart of New York's most famous crossroads. "The building is like a mirror, a looking glass," Sotto told the *Times* reporter. "The metaphor is media as architecture."

"Disney wouldn't do something average," Sotto continued. "Michael [Eisner] has a special place in his heart for Times Square. It's part of the overall corporate strategy."

It was a whole new world for Imagineering, and for Disney.

The period after Frank Wells's death had been tumultuous for The Walt Disney Company. Just three months after the memorial service in

a Disney soundstage, Eisner had quadruple bypass heart surgery after recurring chest pains revealed major blockages of his coronary arteries. He was incapacitated while the Disney's America fight was at a crucial juncture. As Eisner recalled later, "Right at that time, Frank died. Right at that time, I had open heart surgery. And right at that time we bought Capital Cities/ABC."

After the embarrassment of the Disney's America defeat, the ABC acquisition was considered a grand slam. Stock in both companies rose when the deal was announced July 31, 1995. That was in contrast to the economic challenges the company was facing elsewhere. As Eisner summarized in his memoir, "Well, let's see, this past year we've had Disney's America . . . Euro Disney's restructuring . . . tourist shootings and Hurricane Andrew in Florida . . . fire, floods, and a giant earthquake in California . . . not to mention certain executive changes. . . ."

This last was a reference not just to Wells but to the sudden departure of Jeffrey Katzenberg, who had come to Disney with Eisner a decade earlier to run the film production division, including animation. After Wells's death, Katzenberg had pressured Eisner to give him the number-two job, which Eisner did not want to do. There were many reasons for that, but among them was another business headache: while *The Lion King* animated feature had been a blockbuster in 1994, Disney's live-action movies were mostly losing money. Refused the promotion he wanted, Katzenberg left in the fall of 1994 to cofound DreamWorks SKG with Steven Spielberg and David Geffen. A year later, Eisner hired Michael Ovitz as the new Disney president; Ovitz had built Creative Artists Agency, where he was chairman, into Hollywood's most powerful agency, and had openly been seeking to run a major movie studio. Ovitz's tenure at Disney was rocky at best, and he was forced out after just sixteen months. Very costly litigation related to the departures of both Katzenberg and Ovitz would drag out for years.

Imagineering was unmoored in the middle of this corporate tempest. The initial financial losses at the recently renamed Disneyland Paris (which became profitable less than a year after the rebranding) had cast a shadow over discussions about building yet more theme parks from

scratch. The death of Wells, a crucial ally, was an injury that did not heal. "I made a big mistake," Eisner said later of hiring Ovitz, who never bonded with the folks at Imagineering, if indeed he thought of them at all. The constant in the mid-1990s was Eisner, heart surgery notwithstanding, and he kept the Imagineers busy not only with theme park attractions and planning but with a peculiar assortment of other projects, of which the *Good Morning America* studio was just one among many.

II. A FAILED QUEST

Not every item on Michael Eisner's a la carte menu of projects for Walt Disney Imagineering in the 1990s was far removed from theme parks. The success of the extensively themed Typhoon Lagoon water park, which had opened in June 1989 in Walt Disney World, had led the company to plan a second freestanding water park on the property. Typhoon Lagoon had an elaborate backstory that informed its theming throughout, and the second park would need to be just as creative.

Typhoon Lagoon had been the inspiration of veteran Imagineer Randy Bright, who had served as show producer for The American Adventure in EPCOT Center. His concept was that a freak storm had tossed the elements of a seaside resort hither and yon—including stranding a shrimp boat atop "Mount Mayday." The mountain would house numerous water slides, and the typhoon tale would guide the meticulously haphazard appearance of the park's facilities and attractions. It wasn't all show, though: Typhoon Lagoon also included one of the largest recreational wave pools in the world, with swells large enough for surfing. The park was regularly filled to capacity, turning away guests.

The second big water park, Blizzard Beach, was inspired by Imagineer Eric Jacobson's extensive collection of snow globes, scattered about his Imagineering office as mementos of his travels. Like Typhoon Lagoon, the narrative involved a freak storm, this time a blizzard, which led to the speedy creation of Florida's first ski resort—until temperatures returned to normal and it morphed into a water park instead. Blizzard Beach even

had a chair lift up "Mt. Gushmore," which guests could ride to get to the start of a variety of water slides down the "slopes." For opening day, April 1, 1995, machines dumped tons of snow near the entrance and hundreds of foam snowballs were blown into the crowd.

The next year, Walt Disney Imagineering grew in a way none of the Imagineers was expecting: in May 1996, Imagineering merged with the Disney Development Company, the division Eisner had created ten years earlier to acquire and manage real estate holdings and to oversee the design and construction of Disney hotels and administrative buildings. Peter Rummell, the head of DDC since 1985, was named chairman of the newly combined entity, which took the name Walt Disney Imagineering because, as Imagineering noted in its official history, "the Imagineering name is so powerful and so unique." The upside to the merger became apparent when, in June 1997, Disney purchased the Glendale property that had been Imagineering's home since 1961: the hundred-acre-plus Grand Central Business Centre.

The downside also became quickly evident, as Imagineer Tom Morris recalled. In the wake of Frank Wells's death, "Michael [Eisner] seemed a little unsure now of things in general or how to wrangle things. So actually Michael was taking a tighter fisted approach to things, and so budgets were clearly going to be less. I'm all for doing more for less. Sometimes you can do something better if you do it a little faster and are a little more resourceful. But this was drastically less—like, no theming. Theming became a bad word. IP [intellectual property] was a good word; interactivity was a good word. So whatever you did, make sure you have a lot of IP, make sure it was interactive, using the latest technology. But all of that theming stuff—just [use] the minimum amount needed."

Morris saw the change in direction as a reaction to the high cost and initially low returns of Disneyland Paris, the most extensively themed park in Imagineering history to that point. Paris, he said, "became somehow the easy thing to point at. It was like the shiny object for black crows, right?" Eisner's mandate to make Paris Disney's most beautiful park became the scapegoat for the theme park division's economic challenges.

"It was that red herring," Morris said. Executives could point to "all that theming that we put on the buildings and in the shows and everything."

The budgetary restrictions would have repercussions for years, but the merger with the Disney Development Company was also expressed in the assignment of teams of Imagineers to work on more projects unrelated to Imagineering's core theme park business or its more recent work on Disney hotels. Some were akin to the Pleasure Island development of the 1980s, expansions and redesigns of Disney's RD&E—retail, dining, and entertainment complexes. In September 1997, after more than two years of work, Disney Village Marketplace in Walt Disney World became Downtown Disney, with a sixty-six-acre expansion on the west side that included shops, restaurants, and a 1,671-seat arena that would serve as a permanent home to a new Cirque du Soleil show. (*La Nouba* ran from the end of 1998 to the end of 2017. A new show, *Drawn to Life*, replaced it starting in 2021.)

The Downtown Disney expansion also included a five-story 100,000-square-foot structure to house a new endeavor, dubbed DisneyQuest. It was intended as the pilot for a chain of entertainment centers, a sort of hybrid of indoor amusement park and video arcade, using early virtual reality and scaled-down motion-simulation technology. Announced in August 1997, DisneyQuest was a project of Disney Regional Entertainment, a new division of Walt Disney Parks and Resorts that hoped to bring Disney amusement centers to locations around the world. But within Imagineering, some version of the idea had been kicking around for at least ten years. The idea was to bring "exciting Disney entertainment and recreation" to urban centers, Carl Bongirno said back in 1987. But the concept didn't really take hold until the mid-1990s, when video arcades with VR experiences became a hot concept. Perhaps most notably, DreamWorks SKG and Universal Studios—both rivals to Eisner-era Disney—had teamed up with the video game maker Sega to form Game-Works, which started opening arcades in March 1997.

DisneyQuest was to debut at Downtown Disney in June 1998, then in Chicago a year later. A site was also selected in Philadelphia for a five-story 80,000-square-foot location. Eisner promoted the coming

Disney VR experiences during one of his introductory segments for *The Wonderful World of Disney* on ABC, speaking, he told viewers, "from the Virtual Reality Studio, where Disney Imagineers are creating a whole new world of storytelling." There followed a blocky 2D computer-animated sample of a VR experience based on *Aladdin*—an excerpt from one of the DisneyQuest attractions, called Aladdin's Magic Carpet Ride. Other interactive games were based on Disney's *Hercules* and the Jungle Cruise in Disneyland (think inflatable rafts on a motion simulator). The most popular offering would turn out to be CyberSpace Mountain, in which guests could design their own roller coaster on a computer terminal, then ride the hills and loops they'd selected via a motion simulator pod. In keeping with Morris's assessment of the company's priorities, DisneyQuest was jam-packed with intellectual properties and interactivity and light on theming. The exterior was a windowless box, the interior a mall-like multilevel arcade with a few Disney character busts and colorful signage. The quality gap between its attractions and ambience and, say, the Indiana Jones Adventure was immense.

That was also true of another Imagineering-led regional venture of the mid 1990s, called Disney Fair. The $30 million traveling show, housed in three massive circus tents, featured an elaborate forty-minute stage performance that pitted Disney characters, in the form of shaped balloons, against Captain Hook, who wanted to pop them. (It was titled "Mickey's Great Inflation Celebration.") A second tent housed a kind of video arcade and amusement center—with more inflatables—and a third tent was the gift shop. The idea was that Disney Fair would set up at existing state fairs around the country, charging an additional admission fee for its approximately two-hour Disney experience. Disney Fair opened for a test run at the Washington State Fair in Puyallup in September 1996, followed by the Arizona State Fair in October. Attendance was so low and the costs so high that Disney Fair made no more U.S. appearances. The next year, the traveling show was rebranded DisneyFest and shipped to Singapore, where it debuted in October 1997—and met a similar fate. The planned Asian tour was cut short.

Disney Fair and DisneyQuest were not what most Imagineers had

signed up for. "I think darkness ripples through Imagineering in different times and in different ways," Morris said. "There was a time, though, where I think we were encouraged to forget who we were. It was probably some time after we opened Disneyland in Paris, and the appetite level for theme parks from a management standpoint seemed to be waning. And I remember hearing, 'We're not doing any more theme parks now. We're no longer going to be a theme park company. We are entertainment, retail, dining and real estate development, and other things.'" The decay of executive support had eroded Imagineering's central mission: except for some smaller second gates, Morris believed, "our theme park days were over. That was heard through the halls." In addition to the DisneyQuest project, the Regional Entertainment division also developed a sports-themed restaurant and entertainment center chain called ESPN Zone that combined restaurants with arcades and, in some sites, television or radio studios. By the end of 1999, there were ESPN Zones in Anaheim, Baltimore, and Chicago, and a half-dozen other cities followed. "So that's where the attention was going," Morris said. The Imagineers were told, "'Okay, the theme park business is mature now.' That's the term that they would use. 'It's a mature business.'"

In retrospect, it might have been Eisner's indifference to Disney Regional Entertainment, more than his support, that doomed the enterprise. He did not attend grand openings of the division's locations and he gave DisneyQuest just two paragraphs in his 1999 memoir, noting that the entertainment centers were "conceived by Imagineering . . . [in] collaboration with leading software developers." But a *Chicago Tribune* article also published in 1999 suggested Eisner disliked the venture from the beginning. According to reporter David Greising, when Eisner first saw Imagineering's DisneyQuest plans in 1995, "the mercurial chief executive had a strong gut reaction. 'Kill the project,' he said. 'Why should we go forward with it? So what if we can make money?'" The article went on to say Eisner approved the idea only when more of Disney's own content was featured.

Chicago's DisneyQuest opened with some fanfare in June 1999 but was never successful, its patrons apparently coming to a conclusion

similar to Greising's: that it was a "place where you pay $16 for three hours of standing in line interrupted by a few minutes of modestly enjoyable distractions." It closed a little more than two years later, in 2001. (The Philadelphia site was abandoned in the middle of construction, while the Downtown Disney flagship survived until 2017.) Several ESPN Zones lasted somewhat longer, but just two locations remained by 2010, when Disney Regional Entertainment was dissolved, and all were closed by the end of 2018. Apparently the Regional Entertainment division had matured into obsolescence.

CHAPTER 19:
UNCHARTED WATERS

*"When we consider a new project, we really study it—not just the surface idea, but everything about it. And when we go into that new project, we believe in it all the way. We have confidence in our ability to do it right. And we work hard to do the best possible job." —*Walt Disney

I. LEAVING PORT

THE INITIAL DESIGNS suggested a certain ignorance of Disney's self-image, an assumption that a Disney cruise ship should sail far past whimsical and on toward silly—and beyond. Among the more conservative ideas was a supersized yacht with giant sails stretching hundreds of feet fore and aft from a cantered mast at midship. Then there was the ship that looked like a floating preschool playground, with giant flowers—or maybe they were starfish—on the smokestacks and a line of cartoon fish flying above a fake blue ocean inexplicably painted just above where the actual waterline would be.

One sketch seemed to express a clueless infatuation with the elegant Swan and Dolphin hotels at Walt Disney World by imagining a huge goose head on a curved neck in place of a bow masthead and the bird's tail at the stern. And if those touches weren't goofy enough, there were also the four ducklings that encompassed the smokestacks, with the notation that they would "toot a horn when docking or leaving port." An excess

of color was common to the sketches, as on the design labeled "Tropical Print," which featured grand flowers painted along each side of the ship, tip to tail, and a repeating series of red cabanas pictured on the upper decks. A design dubbed "Beach Party" imagined a different design for each lifeboat, all of them reminiscent of discount gift wrapping paper: polka dots, stripes, checks, bubbles, and the like.

Perhaps the most ridiculous of all—and the most blatant attempt to suck up to Michael Eisner—was a design titled the "SS *Mighty Duck*." Except the duck it resembled was a *Sesame Street*–worthy rubber ducky, with a molded-plastic-style head on the bow of the ship and a matching tail at the stern. In between, the entire ship was bright yellow. It might have made a terrific 99-cent toy, but a $400 million cruise ship it was not.

These were among the ideas generated by a call for designs for what would be Disney's first two cruise ships, and they were awful. Some of them were also "pretty hilarious," as Wing T. Chao, the Imagineer in charge of finding the perfect ship design, put it. Chao had asked European naval architects to submit ideas, and as Eisner recalled later, "they delivered us ships that looked like Las Vegas casinos. They were horrible. I said, 'I'm out of here. You have to develop a ship that looks like a ship.'"

But Chao wasn't daunted. He had set his sights on one of the best ship designers in the business, a Norwegian named Njal Eide, and he wouldn't take no for an answer. Eide (pronounced "Eddie") had already designed a number of elegant, modern cruise ships for Royal Caribbean, starting with 1982's *Song of America*—at the time, the third-largest cruise ship in the world. He was the man who had invented the multistory central atrium, and Chao wanted to see what he could come up with for Disney.

"So we went into his office, and we shared with him our program," Chao recounted. The company wanted two 2,500-passenger ships with design elements that evoked Disney "in a very subtle way." They needed to be distinctive, not looking like the Love Boat, which Chao described as a "white shoebox—like a building floating at sea." Eide listened politely and said simply, "I really do not usually participate in competitions," Chao recalled. "I am very busy. Thank you for coming." Chao wasn't

so easily brushed off. "We wouldn't leave," he said. They sat drinking coffee and talking on through the dinner hour—until Eide finally gave in as nine p.m. approached. "He said, 'Look, I'm hungry. I need to go home.'" To which he added, "Okay. I will participate."

Getting the world's hottest ship designer to contemplate what a Disney ship might look like was a vital step forward in a journey that had begun years earlier with a Big Red Boat. After Walt Disney World had opened, the company noticed that a significant number of guests were coming to the parks before or after embarking on Caribbean cruises, mostly leaving from ports near Miami, more than three hours away from Orlando. By the mid-1980s, some ships were set to start cruising from Port Canaveral, just an hour east of Walt Disney World. One such ship belonged to a newer cruise line called Premier, which offered mostly three- and four-day itineraries on a twenty-year-old ship called the *Oceanic*—which the young company had painted bright red from the promenade deck to the keel. Putting an exploratory toe in the cruise industry waters, Disney partnered with Premier to present, several times a year, Disney-themed cruises on the Big Red Boat that could be packaged with Walt Disney World visits for weeklong land-and-sea vacations. Premier provided the ship and all amenities; Disney provided its classic characters and themed activities. Catering to families with children—including child-care, kid-friendly menus, and play areas—was an innovation at the time, and it attracted a multigenerational clientele that had previously avoided cruises.

The partnership seemed to be going well, but Disney started hearing complaints from passengers who thought the Big Red Boat wasn't up to the company's standards. Among other things, "they thought the food quality was not there," Chao said, "and the cabins were somewhat small and not accommodating for their family needs."

"We've got to look into this," Eisner decided, so he booked a Premier cruise vacation for himself and his family. His assessment was immediate and merciless: "It was such a dump." Eisner went back to California determined to make a change. The licensing agreement with Premier was locked in for several years, but Eisner started exploring a new partnership

with a higher-class cruise line. "So we went to all the big companies," he recalled. "And they all insisted that they have to have gambling," which could not go on under the Disney banner. Just as important, "the rooms were too small for my liking, and there weren't kids' areas."

As the end of the licensing agreement with Premier approached in 1993, two business plans were presented to Eisner: find a new partner, which would be a lot less expensive, or go it alone. "After hours of discussion," Chao recalled, Eisner said, "Look, I know perhaps signing a lease with another company will be easier and a faster way to continue Disney's cruise experience for our guests. But these are not Disney ships; these are not Disney experiences. Now, if we want to get into the business, let's do it right. Because we are Disney. We should give our guests the proper experience."

And so, Chao continued, "That was the decision. Then he turned to me and said, 'Wing, now let's go find the world's best naval architects to help to design Disney ships.'" (Premier, meanwhile, made a new deal with Warner Bros. to feature Looney Tunes characters on its Big Red Boats. The company declared bankruptcy and ceased operations in 2000.)

Disney announced its intention to launch its own cruise line on May 3, 1994, hiring Arthur Rodney, the former president of Princess Cruises, as the new venture's president. The cruises would begin in 1998, the company promised. Disney would be on its own in an industry it didn't know well and couldn't join under existing assumptions. But Eisner approached the cruise industry the way Walt Disney had approached amusement parks: he was happy to benefit from their experiences, but he planned to turn the business on its ear, shake it up, and transform it in ways only Disney could. Sacrosanct beliefs would be discarded, and common practices completely retooled. The Disney Cruise Line was to be a disrupter that others would soon be scrambling to imitate.

"We were told that you had to have gambling, because that's where you made the money," Eisner recalled. "We couldn't have gambling even if we wanted it, because we owned a baseball team. And in that era you couldn't be in gambling if you owned a Major League Baseball team." In

any case, Eisner didn't believe a ship needed a casino to make money. Disney would plot its own course. And that would start with a striking boat design. Walt Disney Imagineering was charged with a lot of the interior design, but the exterior and the mechanical and architectural elements that made a ship functional required an expert. After the disastrous first batch of colorful, ridiculous sketches, all of them rejected, Eisner was asked what it was he wanted in the next round. He answered that he had no preconceived ideas but that the designers should think "classic on the one hand and also modern."

As the date approached for Eisner to review another set of designs, Chao had still not heard back from Eide. "Then about a week before the second meeting, I got a package. And I opened it up and it was from Njal Eide—and there it was, a sketch of a ship. I looked at it and I said, 'That's it. That is a Disney ship.'" That sketch would become the *Disney Magic* and *Disney Wonder*.

II. THE ARCHITECT

Growing up in Hong Kong, Wing T. Chao always loved Disney movies—animation, live action, didn't matter. "I loved the stories," he recalled. "I loved the cinematography. I admired Walt Disney as a person and the Disney company as a creative company." When the time came for college, Chao chose the University of California Berkeley, and a visit to Disneyland was at the top of his wish list. He and his sister, also a college student, drove down to Anaheim one day and arrived at the park by eight a.m. the next morning. "When the gates opened, we couldn't wait to get in to try every attraction available. We stayed until midnight. We wanted to be the last to leave. Actually, I didn't want to leave, because it was so much fun, it was so special. And I said, 'Wow, it would be so wonderful if I could work for this company someday!'"

At UC Berkeley, Chao earned both his bachelor and master's degrees in architecture, then worked a couple of years at architectural firms in San Francisco. Wanting to learn more about large-scale projects, he went back to school, this time at Harvard, to study "the integration of resort

projects and vacation experiences." Coincidentally, Chao was developing his ideas for richer vacations at about the same time that Walt Disney World was getting ready to open. With more than twenty-seven thousand acres to develop—an area the size of San Francisco—the Disney company needed people like him who could see the big picture. Recruiters came to Harvard, and Chao was one of their top candidates. "At that time, I had four other offers," Chao recalled. "I didn't know which one to pick, because I had never been to Orlando. I said, 'Is there a Chinatown in Orlando?'" The recruiter laughed and asked "Why?" "I said, 'Well, I like hamburgers, but not every day.' He said, 'Can you cook?' I said, 'Well, I guess I will have to.'" Chao took the job and moved to Florida in August 1972. "So that was the beginning—not knowing that I would spend my entire career at Disney."

Chao joined the team working on the master plan for the Lake Buena Vista community, which was to include hotels, a shopping village, golf courses, recreational amenities, and—eventually—more theme parks. When Michael Eisner and Frank Wells came to Disney in 1984 with an eye to further Walt Disney World expansion, Chao was the man they came to with their ideas for a new hotel. "We'd already done some sketches for the Grand Floridian Hotel," Chao recalled. "Eisner looked at it and he said, 'Every Disney hotel should have a story. It should have architectural character.'" Chao agreed and explained: as the Contemporary served as a backdrop for Tomorrowland and the Polynesian echoed the themes of Adventureland, the Grand Floridian would expand on the turn-of-the-twentieth-century narrative and architecture of Main Street, U.S.A. "Michael and Frank said, 'Great. Let's go.'" The main feedback from the executives was: make it bigger. So Chao's five-hundred-room hotel grew to nearly nine hundred rooms.

Chao's experience in developing hotels at Walt Disney World foreshadowed what would happen a decade later with the cruise line. The company began by working with corporate partners with extensive experience and wound up opting to go it alone. The Grand Floridian was to have been a fifty-fifty venture with Marriott Corporation. But the Imagineering team thought they could handle everything solo and set out to

prove it to Eisner by building two model hotel rooms in Imagineering's warehouse in Tujunga, California, twenty minutes north of Burbank. As Disney was poised to sign with Marriott, Chao and the Imagineers raced to finish their model rooms. With just two weeks' cushion, they brought in Eisner and Wells for an all-or-nothing assessment of their work. "When Michael and Frank came to see it, those two rooms, they said . . . 'It's so beautiful! Is it going to be like this?' We said, 'Yes.' So, on the spot, in that moment, Michael decided that we will design and build our own hotels. He said, 'We will learn. We will make our mistakes, but it will be Disney.'"

Eisner and Wells thereafter gave Chao the staff and resources he needed to supervise the design of the Grand Floridian and all future Disney property hotels, not only in Walt Disney World but also about 40,000 hotel rooms around the world. Imagineering would supervise both the architecture and the interior design—each light fixture and the carpet design, the furniture and marble patterns—as well as the ambience, the background music, and the cast members' costumes. Essentially, Chao said, every hotel was a movie set. The philosophy was simple: "We are in the theme park business. So our guests during the day spend eight to ten hours in our theme parks. At night when they go back to their hotels, we want them to continue their journey in a themed resort. They will immerse themselves, whether it be in a period in time or a geographic location, like the Wilderness Lodge. It's a 24/7 experience."

Those two rooms in Tujunga also set the stage for the panoply of world-class architects who would work with Imagineering's in-house designers. Eisner's idea was "Let's go out and hire world-class architects to work with the Imagineers," Chao said. The first collaboration, with architect Michael Graves, produced the Swan and Dolphin in Walt Disney World in 1990. The nearby Yacht and Beach Clubs by Robert A. M. Stern soon followed. Then in 1992 came the Victorian-inspired, Imagineer-designed Disneyland Hotel at the gate of Disneyland Paris, with a pastel color scheme designed by John Hench, and six additional diverse hotels by noted architects not far away—all situated according to the resort's master plan. In Walt Disney World, Peter Dominick's

Wilderness Lodge opened two years later, then Stern's BoardWalk Resort. Many others would follow. Over the years, Chao's team and their collaborators would create hotels across the globe, each built to encapsulate its own narrative of time and place.

In the early 1990s, Chao also led planning for the eventual construction of a planned city in Walt Disney World. It would not be precisely the EPCOT that Walt Disney had once imagined, but it would be a permanent residential town with its own city center and amenities created from scratch—which was, after all, "the spirit of EPCOT," Chao said. Situated on the southern tip of the property, which was unlikely ever to be useful for theme park or resort development, the town that came to be named Celebration involved a who's who of noted architects: Graves and Stern, plus Jaquelin Taylor Robertson, Robert Venturi, Philip Johnson, Charles Moore, Graham Gund, Cesar Pelli, and Denise Scott Brown. To encourage a sense of community, the houses would have front porches, and garages would be accessed from a service alley rather than facing the street. "The garage clicker," Chao said, "is the most antisocial invention in America. Because in the morning when you leave your house, you get into the car. You back your car out of the garage, you click it. You drive off. You wave to your neighbor but you don't talk to your neighbor. And when you come home, you click the garage door and you drive into the house. That's it."

The first residents would move into Celebration in the summer of 1996. Suburban real estate development was not part of Disney's business, Chao notes, but "if we do something, we want to do it right, do it better—otherwise why should we do it?" It was the same philosophy Chao and Disney carried into the cruise line venture.

III. THINKING IN CUBIC INCHES

Njal Eide's sketch for a Disney cruise ship dispensed with rubber duckies and muumuu fabric patterns in favor of exactly the classic yet modern silhouette Michael Eisner had hoped for but been unable to put into words. When Eisner first saw it, Wing Chao recalled, he said, "That's

the ship." Unfortunately, the initial design was all Eide had time to contribute, which necessitated the hiring of two other nautical design firms—YSA Design from Norway, and Tillberg Design from Sweden—to turn the sketch into actual architectural plans, as well as additional technical consultants for the interior spaces. All would coordinate with the Imagineering design team assigned to the project.

There were many aspects of Eide's vision that set the ship apart from its contemporaries, Chao noted, starting with his inclusion of two smokestacks. "All that you need technically is one," he said, "because the engine room is in the back of the ship—the aft, as they call it. So if you look at all the ships floating today, one stack. But if you look at other ships during the '20s and '30s, [they have] at least two or three or four." In those days, with the engines burning coal, the more funnels, the more burners, and the faster a ship could go. That's no longer true, but Disney liked Eide's more symmetrical profile, even though the forward smokestack wouldn't be functional. "We don't need it for any technical reasons, but it does give you the balanced look of the ship," Chao said. "Secondly, we brought back the portholes. Thirdly is the paint colors. Again, the old ocean liners would have the black hull and the white paint for the upper decks. The stacks were painted various colors, and so we painted our two stacks red." The fourth color in the design is a gold bending toward bright yellow, used for a strip along the top of the hull and for the lifeboats. "Now, if you add up these four colors—the black, white, red, and gold—guess what? That's Mickey Mouse's colors." Mickey has red shorts, yellow-gold shoes, white gloves, and black ears, limbs, and nose. "It's very subtle, but there's a story behind it. On the one hand, it brings the classic look of a ship. On the other hand, it's modern Disney."

Other classic features of the ship were more nautical. Chao noted that the bow was elongated and tapered and the stern was curved, giving the *Magic* and *Wonder* "a very aerodynamic look, like a super yacht." On most cruise ships, the bow is short, but "it's really not the right proportion. So, again, at Disney we want to do it right. When you have certain height, you want to have a certain length. It gives you that much more elegant look, hugging against the ocean." Most of these alterations

to what was standard cruise ship design in the 1990s came from that first Eide sketch, "and then Imagineers, working with YSA Design and Tillberg—we took it to the next step."

What went inside was just as important to Disney, even though it was a new realm for the Imagineers. Previous Imagineering projects outside the theme parks—whether Downtown Disney, the ABC studios, or the Anaheim stadium—were still "architecture in place," former Imagineer Bruce Vaughn noted, "with the same broad tools and challenges that we have building theme parks. There's physics to the world of a cruise ship, the amount of space you have. Everything has to be encompassed within the hull." Imagineering would also be working for the first time with "a different set of contractors and outfitters. All of those were brand-new for us. And those were pretty significant challenges."

As Chao pointed out, once the exterior dimensions were determined, and the interior zones established—cruise ships are divided into safety zones to quickly contain fires or other mishaps—that was it. There was no give and take on available space. "Within each zone, we have to use every cubic inch. That's a challenge, because we can't say we want two more feet in this direction. There's not two more feet. That will be the ocean. So that was the exciting part about designing a ship—thinking cubic inches, not cubic feet."

The deck that would have been dominated by an adults-only casino on other ships would be devoted to family activities on the *Magic* and *Wonder*. "In many respects," Vaughn said, "Disney invented the family cruise business. Others had attempted it, but if you don't design for that, you're not going to succeed. And that's where we are different. We are designed specifically for families, multigenerational families."

Chao noted that before Disney, cruise ships typically had a single all-ages children's area, "but we said, 'Look, different age groups will have different interests.' So we designed spaces and programs tailored to age brackets. This way the kids can meet their new friends and play with them among their age group." For younger children, a space called the Oceaneer Club would have a pirate theme, with slides resembling planks, barrels turned into tunnels, and organized activities with kid-size

costumes. In that space, Imagineers lowered the ceilings "so that it would feel much warmer and intimate," Chao said. For slightly older children, the Oceaneer Lab would be dotted with computer games, programmed with animation workshops and other activities, and guarded by a Buzz Lightyear statue. The ship would also have a babysitting center for children up to age three, to allow young parents a romantic evening or a worry-free walk on the promenade deck. Parents of older children could send them to the onboard movie theater or the Oceaneer areas without worry that they'd get lost.

For the ship's main entertainment space, the Imagineers knew they needed to serve the needs of Disney's entertainment team as well as the guests. The standard at the time was a lounge two decks high, with the higher floor becoming a balcony above the stage and small dance floor below. "So we said, 'We are Disney. We want a theater that can do mini Broadway shows.'" By this time, the stage adaptation of *Beauty and the Beast* had opened on Broadway and plans were underway to renovate the New Amsterdam Theatre on 42nd Street to house *The Lion King*. So the Imagineers stated their design demands to the shipyard: terraced seating for at least nine hundred people, a deep pit to allow scenery to rise onto the stage, and no columns in the middle of the theater. "It took us two decks for the pit," Chao said. "And of course you have the proscenium, and then you have two decks for all the props hiding above that. So five decks alone for the stage." It had never been done before, and the initial reaction of the shipyard, Chao said, was of shock. But they figured out how to do it. "They had to put in a lot of huge trusses, holding up all the other [decks] above the theater. But in the end, when the guests walk into the theater, they think they're in a land-based theater, not on a floating ship."

The Imagineers decorated the theater luxuriously, inspired by the ocean liners of the 1920s and '30s, with art deco flourishes. They used "a lot of red and gold colors," Chao said, "so it's very royal, regal, and glamorous." Layered on this classic look were the modern touches of fiber optics, embedded into the ceiling to come to life at the finale of each show. "That's the Disney magic."

The Imagineering magic extended to the dining halls—of which there would be three, rather than the one huge restaurant other ships offered. Guests would rotate among the eateries during their cruise, and their assigned waitstaff would rotate with them. The most dramatic of the three would be Animator's Palate—a pun on "palette," the board on which an artist mixes paints. It was a nod to Disney's "core business," Chao said. "Walt Disney started by doing sketches of Mickey Mouse in black and white on a pad, right? So what we did here for this restaurant was that when the guests enter the restaurant they will see the black-and-white sketches from our Disney movies. As the guests sit down, everything you see—the tables, the surrounding walls—it's all black and white. But as they go through the meal for the night, the colors will evolve. The ceiling will have colors. The walls will have colors. And the screens in the frames on the walls will have [clips from] our animation features. And they'll all come alive with full color, because, after all, that is the evolution of the whole animation industry."

It was the quintessential immersive Disney experience translated into the language of the cruise ship industry. "It completely changed everything," Eisner said of the Imagineers' work. "It became a family ship. Imagineering did what they do." Like a proud father who can't conceive that a favorite child would ever fail, he added, "I mean, it was not hard."

CHAPTER 20:
CREATURE COMFORTS

"I was really, really terrified [at the start of developing Disney's Animal Kingdom Theme Park], because it's an incredibly new, different, scary, ambitious thing to try to do—a really arrogant thing to try to do. We have a whole business that already knows what it is. The Disney Company knew what it did. . . . It had [an established] product, and here we want to do something that we know nothing about." —Joe Rohde

I. A PITCH WITH TEETH

THE LEOPARD WAS a bit jumpy, so Joe Rohde invited the Bengal tiger into the conference room instead. There sat the leadership of Walt Disney Imagineering and The Walt Disney Company—Michael Eisner, Frank Wells, Marty Sklar, and four others in seven chairs, no other furniture. In front of them was Rohde, a young, self-confident Imagineer who was presenting concept art as part of his pitch for a new animal-themed park in Walt Disney World. Then, Rohde recalled, "the door opens behind me and this tiger walks into the room. Now, he's on a little chain, but—really.

"I barely see this tiger, out of the corner of my eye," Rohde recounted, "sitting over there while I keep talking." What Rohde *can* see is the faces on the powerful men in front of him, none of whom had been expecting a four-hundred-pound predator to stride in from the hallway. They were

not really hearing what Rohde was saying at that moment. "The tiger sits down, scratches his chin, gets up, walks out of the room," Rohde remembered. "That's it. And I keep going with the presentation."

What Rohde had been saying was this: "When you see an animal and you don't know what stands between you and that animal—that's an exciting moment." Point taken.

"That was a pivotal moment," Rohde recalled. An animal-themed park "was not on anybody's plan to be made. And there was significant skepticism, and I would even say opposition to the idea." Rohde's team had been working on the idea for about a year and didn't have authorization yet for capital outlay—hence the pitch meeting. They had been focusing on the fantasy side of the animal park, and they had begun to hear a whisper campaign that they attributed to the finance and strategic planning teams, along the lines of "What's so exciting about animals? What makes animals so interesting?"

Engaging in that debate verbally, Rohde thought, "was a real trap, because it's very subjective. Like, 'Well, I think that animals are interesting.' 'Well, I think that they are not'"—repeated in an inconclusive loop. "You can't prove it on paper," he thought, so "we are going to have to bring an animal into the room." They considered the following: a Madagascar chameleon? Too small. A monkey? Too uncontrollable. A baby elephant? Wrong vibe. "So we settled on a leopard. Because once people see a leopard, we don't have to convince them that being around animals is exciting. We don't ask any permission. I do not tell Marty; we do not tell anybody."

Rohde's team contacted an animal trainer who worked on movies, and he agreed to provide a leopard at the designated time and place. Once the executives had taken their seats, "the animal guy shows up and says, 'I brought the leopard. But she's really jumpy, and I would be a little nervous about bringing her into a room full of people. So, I brought this tiger and he's really mellow. You can have the leopard if you want, but I advise the tiger.'" The leopard? Or the tiger? Rohde quickly opted for the Bengal tiger and went in to start his presentation.

"So, I would never do this today, but I was younger and more naïve,

and we did it," he noted. After the meeting, everyone had a tale to share. "Go to Frank Wells and you are going to get a story about, 'You should have seen Michael's face when the tiger came into the room.' Go to the finance guy and he's going to talk about the strategic planning guy. Go to Marty, [and] he's going to talk about Michael. Everybody has a story about a very exciting encounter with a wild animal—and that's the story." Thus, the stunt had the desired effect: "What this does is it shuts down cold the whole argument of 'I wonder if animals are really exciting.'"

Eisner recalled the incident a bit differently: "It was awful. We're sitting here having this creative conversation and they bring in this live tiger, which frightened everybody. They think it worked. It didn't work with me. But then again . . . that tiger coming in, of course, I remember in great detail." And what he remembered was, "I couldn't wait to get out of the room."

So, capital authorization remained in the future, but as a result of the meeting, "we got permission to keep working," Rohde said. "That's all that we were looking for. Every three months, we had to apply for another tiny little amount of money to keep like six people working. That's what this was. Six people. Sometimes eight." It was a number that would continue to increase, like a tiger's appetite.

II. THE KID WITH THE HAIR

Joe Rohde was born in California, but he grew up in Hawai'i, an ocean away from Disneyland. Surrounded by the beauty of the landscape and a unique cultural richness, he didn't need a theme park. He identified as "just a country boy from a small neighborhood in Hawai'i"—the old Makiki neighborhood of Honolulu, best known as the place Barack Obama was born. Makiki is in the hills above Waikiki Beach; as the elevation increases, its homes and apartment buildings and local businesses give way to undeveloped mountain landscapes threaded with trails and streams for boys to explore. Rohde grew up with an abiding respect for the island's stories, people, and traditions—a rootedness he would carry into his work at Imagineering.

He also loved animals. "When I was a little boy, I used to collect almost any little critter I could get my hands on—bugs, frogs, fish, lizards," Rohde said. "I had this little miniature zoo of containers spread all around the outside edge of the house." In short, he added, "I was fascinated by animals. I have a great picture of me holding a huge cane toad. That was my pet—a cane toad the size of a cantaloupe."

This grounding in the reality of Hawai'i's flora and fauna was counterbalanced by an early exposure to the contrivances of the film business. Rohde's father, Martin Rohde, was a cinematographer who worked on everything from the Elvis Presley movie *Blue Hawaii* to news footage of a Hawaiian visit by President John F. Kennedy. "I became really familiar with this disparity between how real something could look and how kind of fake it was," he said. When Rohde was about eleven, his father's work moved the family to Southern California, where the boy found himself "on soundstages and backlots and movie ranches"—such as the Fox Ranch, where Martin Rohde was a second unit cameraman on the original *Planet of the Apes*. "I could wander around [the sets] as long as nobody was shooting. It was a great time to be young and to have this privileged access to this world of illusion. That was a super formative experience."

It was also a good lesson for a future Imagineer. "This idea that one thing can just become another thing," Rohde said. "That thing that I thought was rock—that's really made of fiberglass. That thing that I thought was a plaster wall—that's really made of canvas." With intimate knowledge of the practical magic of movie sets, "my very first trip to Disneyland was already halfway about the imaginary world that it presents and halfway about, 'Oh, how did they do this?'"

He didn't visit the park often, however, in part because his family didn't have a lot of money and in part because he felt out of place. "You have to remember that I had long hair—kind of a hippie. I imagined I would not be super welcome in this environment."

Rohde assumed he'd follow in his parents' footsteps—his mother was an actress—and get into the movie business. Cobbling together grants, scholarships, and work, Rohde went to school at Occidental College in Los Angeles, got a degree in art history, and wound up teaching theater,

set design, and art history at a high school in the area's San Fernando Valley—where the father of one student was a Disney executive. When the Disney man saw Rohde's stage sets, "he came into my little classroom, and he's like, 'You're wasting your time here, kid. You should be working for Walt Disney Imagineering'—which I had never heard of." After a year or so of shrugging off the idea, he put together a resume and portfolio— and landed a new job. "I got a very entry level job in the model shop, and that was the beginning of my career."

It was 1980, and the Imagineers were busy with EPCOT Center. Rohde's first assignment was to join the Mexico pavilion team, which included Herb Ryman. "In my early years, Herb Ryman was sort of a mentor," Rohde said. "I was over at his house a lot. And Herbie, of course, traveled all over the place, and it became clear how much of the work that he did was based on his experience of the real world—which was another thing that I was not necessarily prepared for. From then on, I was sort of hooked on this idea of research as the foundation of what the work could be."

Rohde survived the downsizing before Michael Eisner arrived and joined the team working on the Norway pavilion, the last addition to the World Showcase to open in EPCOT Center. Rohde also became a favorite of the new CEO within weeks after Eisner's arrival, when they met to discuss the theming of what would become Splash Mountain. Eisner liked Rohde's look—his long hair, his youthful demeanor—and turned him into a de facto spokesman for Imagineering. As Rohde recalled, Eisner and Wells would regularly ask for "'that talking kid—the one with the hair. Put him in front of the cameras.'"

What Rohde got out of it, he said, was "some weird freedom to push on these ideas that are kind of unusual. Because I've become this character all of a sudden." It also illustrated a necessary component to success at Imagineering—apart from talent. "An Imagineer has to be a combination of an artist and some kind of strategist," Rohde said. "Somehow you are more than a personal artist. You have a creative thing and you have a way of integrating that into a huge, complicated enterprise that involves hundreds of people."

The precursor to the animal park was Rohde's design for the Adventurers Club, a nightclub that opened at Pleasure Island in May 1989. Many elements that would become central to Rohde's creature-park pitch were present in the nightclub: a travel theme, artifacts and photographs from non-Western destinations, a backstory about the building's previous incarnations, a style of architecture that seemed at once authentically exotic and fully imagined.

Soon after the opening of the club, Rohde accepted the challenge of developing an animal-themed park for Walt Disney World. "There had been the tiniest bit of noise about an animal project," he recalled. "I was a young designer with not a lot to my name. So, I took on the project. Really as a way of showing what I could do, as a workshop."

The project had a key supporter—at least in theory—in Eisner, who recalled that he "loved the idea from the beginning." For one thing, competition for tourists had heated up around Orlando—Universal Studios Florida opened in June 1990—and "we thought if we had a fourth theme park we could keep more people at Walt Disney World," Eisner said. "They wouldn't be going to our competitors." Eisner wanted the fourth gate to be "something interesting and something new" and had been impressed on family visits to the San Diego Zoo, which had pioneered cage-free animal exhibits.

Still, he thought, none of the many zoos he'd been to with his family around the world "did what I thought you could do with Imagineering." Eisner had also been on African safaris and liked the idea of blending the San Diego model with much larger and more authentic habitats. He believed the animal park "had the potential to be to old-fashioned zoos what Disneyland became to amusement parks—a quantum leap."

Rohde met with Eisner, who said, basically, "People love animals and people love Disney. If Disney did something with animals, people would love that. We have the Magic Kingdom. We should have the Animal Kingdom." And that unrefined nugget was what Rohde had to take back to his team. The initial questions they addressed, Rohde said, were fundamental: "What is in the idea of animals? What is in the idea of Disney?

Where do these things cross over each other? How could that become a place that is not a zoo? Disney had not done anything of this scale with live animals. I was really, really terrified, because it's an incredibly new, different, scary, ambitious thing to try to do—a really arrogant thing to try to do." Arrogant or not didn't matter at first, though, because no one paid much attention to Rohde's little six-person team. "We were working out of a little tiny trailer [on the Imagineering campus]—not even one of the big trailers. We were nobody."

Looking back, Rohde saw his chief asset in developing the park not as his design or artistic skills but the liberal arts education he'd gotten at Occidental College. He was a voracious reader and a habitual synthesizer of seemingly unrelated concepts. "I know ideas," he said. "I know how ideas fit together. I know how to study. I know how to learn things. I know how to teach things. I know how to communicate. So I could take an idea that was almost nothing and do the research to make it be something, communicate it to a group of people, understand when it fit together and when it matched—and get the thing moving."

Development began about a year before Rohde put the executives face to face with a tiger in a Disney conference room. His proposal blended three concepts into one: a traditional theme park with entertaining attractions, an EPCOT-style emphasis on dramatized education, and live animals presented in a way that would not bring to mind the word "zoo." "It took a lot of design to figure out how something like this could be done in a way that the company would be willing to take the chance," Rohde said.

Even Imagineering executives doubted the park would ever happen. Rohde recalled more than one memo—though he doesn't remember who they were from—saying, basically, "'These people are doing an excellent job of working on this project that's not on the five-year plan and we have no intention of building. And yet they show real aptitude and real design skills. Let's get them off of this thing and put them on something that we are building.'" His response was rapid and concise: "I would be like, 'Nope, we are working on Animal Kingdom.'"

III. INVISIBLE DESIGN

The hurdles Joe Rohde and his team of Imagineers faced were many, but he cleared them all, one by one. Amid what he called a "lack of clarity" after Frank Wells died, he put together another pitch and won over Dick Nunis, the head of theme park operations, with a one-on-one presentation of his concept. Nunis became a key ally. Then, with a mountain of economic analysis, he also earned the support of Judson Green, a Walt Disney Company financial executive who had been named president of the theme park and resort division in 1991. The final step was the all-important capital authorization, which Michael Eisner signed.

As contractors started clearing the land, and the design team grew, another hurdle emerged as someone on the company's financial side balked at authorizing a civil engineering contract worth tens of millions of dollars. At the time, Universal was forging ahead with its own new Orlando theme park, Islands of Adventure—and that project was hiring away Imagineers. Rohde appealed directly to Eisner, saying, "If you do want to do it, you better say yes pretty quick. Or you won't have the people left to do this job." The second capital authorization request was approved—for slightly more money—but the instability left Rohde flustered. "Once we did have the money, I was really, really terrified," he said. "For about a year, while we built it, I was really, really horribly nervous. And then once you start to see it go up, you know, then you are like, 'Whoa, this is cool.'"

The planning for Disney's Animal Kingdom Theme Park involved more research trips abroad than any project since EPCOT's World Showcase. Rohde's ragtag team of Imagineers took six trips to Africa, exploring on their own and joining packaged family tours that ranged from luxury excursions to discount safaris. They learned that undeveloped wild areas could not be easily visited, and that the safaris that did exist were often chaotic and poorly managed. In one incident, forty or fifty vehicles converged on a single tree after a leopard was reported to be perched on a branch. The Imagineers knew they could provide better encounters—for both animals and guests—within their proposed park.

The highlight of one trip was the hippopotamuses, Rohde said. "One surged out of the water with a snort and chased our boat, mouth open." He added, "That evening was the first time I have felt the exhilaration I expected from Africa. Fifteen-foot crocodiles and massive, hostile hippos crashed through the water. As sunset drew on, the animals became more aggressive. We wanted to capture that same feeling in the park." Equally dramatic stories came out of research trips to Asia, including visits to festivals in Bhutan, river rafting in Nepal, and elephant trekking in Thailand.

In Rohde's view, the designers needed these immersive trips to make Disney's Animal Kingdom authentic rather than idealized. Rohde had been a world explorer for years, disappearing to Nepal or Indonesia for weeks at a time, cut off from coworkers and friends back home. His goal with Disney's Animal Kingdom was to create for park guests a sense of place that approximated the reality he knew so well of being in East Africa or the jungles of Asia.

"It's not an idealized world," Rohde said. "My chief challenge was not the financial group of the Disney Company; it was the Imagineers. It was people who had been trained for at that point thirty years in a premise of what design looked like—very sweet and very idealized and very purified.

"To change their minds was the hardest thing about the job," Rohde confided. "It took time, and it took research. By sending people to these real places, they could see with their own eyes the honesty of what these places really were. Once you go to Africa, once you go to India, to the Himalayas, now you have your own vision, and that vision is true. You saw it with your eyes. Once you get through that barrier, now you have a group of people who know exactly what they're doing."

The Imagineers returned from their journeys not only with animal stories but with design ideas—sketches of buildings and landscapes, photos of local art and African architecture. "We sent a couple of our chief art directors to Africa on a research trip," Rohde said, "and they came back with thousands and thousands of photographs and sketches of things tourists never photograph. We'll photograph the way in which the local people mount electrical wire to a wall. We'll photograph the way in

which they patch a leaky window. Nobody covers this stuff. It's not in a book. It's not in a movie. You have to see it with your own eyes—on top of which," he continued, "there's something when you stand in a real place that isn't visual at all. It's the feeling of that place, and you never know what that is until you take people and you put them there."

It was a new kind of storytelling for Imagineering—not fanciful, but something grounded in the day-to-day culture of the locations being replicated. These would not be fantasy lands, or periods of history, but lands selected to showcase the animals' contemporary habitats: "Africa" and "Asia" (most of which would open in the park's second year), and an area blending science and whimsy called "DinoLand U.S.A." The park would have its own form of storytelling—but not a linear plotline. "That's not the way I think about story," Rohde said.

"Story is like a mathematical equation," he continues. "It's a nested series of assumptions that sit tight on each other and they build from the biggest idea in the middle to millions of ideas at the outside edge that are all little, tiny details." The story that would unify Disney's Animal Kingdom, Rohde said, was about "the intrinsic value of nature," which put the emphasis on the landscape rather than the buildings. "So all the architecture at Animal Kingdom is succumbing to the forces of nature." The goal was to "try to get you to believe that everything you see was the result of some kind of history—to avoid the sense of, 'Oh, what a clever thing those designers did.'"

Walls were designed to appear to be crumbling, signs to be weathered, walkways to be cracked, drainpipes made of copper instead of stainless steel, so over time they would develop a natural green patina. Thickets of entangled wires were nested atop power poles, with twisted strands connecting the poles to the buildings in a chaotic and seemingly hazardous web—a common site in African towns. The poles typically held real light fixtures, but the masses of wires were only for show—more than four miles of unplugged electrical wires, by Rohde's estimate. "It's one of those things you just wouldn't even begin to imagine unless you've seen it," he said.

The realism was in service to fictional locales. The African village

of Harambe "is not a replica of a place you could exactly go," Rohde noted. Similarly, the kingdom of Anandapur, represented in the park's Asia section, "isn't on earth somewhere. We made it up so that we could push together all the habitats of these [Asian] animals into one place." By avoiding references to specific places, histories, and religious creeds, the Imagineers buffered the park against the churn of geopolitical events, as time and conflicts inevitably erode culture, change borders, and remake landscapes.

The grandly scaled animal habitats—"a place where animals can live a good, full life," as Rohde put it—were just as carefully conceived as the human areas. And every bit required landscaping: plants that would evoke Africa and Asia and yet thrive in Central Florida. Thinking ahead, Disney bought an entire tree farm early on, cultivating thousands of trees in accelerator planters across four years, transforming seedlings into adult plants rather than breaking the budget buying full-size trees at the last minute. Plantings were supervised by landscape designer Paul Comstock, a second-generation plant guru with a past as a rock drummer. He termed the park's landscaping "promiscuous and harlequin," meaning both realistically lush and pleasing to the eye.

The tree farm provided only a portion of the vegetation required. In addition to the 100,000 trees, imported or transplanted, Comstock needed 1,800 species of ferns, mosses, and perennials, and 350 types of grasses. Like the park's other lead designers, Comstock traveled the world to find many of his materials, visiting ecosystems as diverse as those of Botswana and Tasmania, and at one point shopping for vegetation from the back of an elephant in Nepal.

In the end, the park would require some 4 million plants from six continents, along with 1.5 million cubic yards of imported earth to keep them nurtured. The only in-place survivors were about forty oak trees in a grove along the eastern edge of the park. Otherwise, every stem and leaf visitors would see were put there by Comstock and his team. "The most important elements in building a Walt Disney Imagineering landscape have to do with creating an ambiance, screening out the outside world and then supporting the show," Comstock said. "And the show that we

want to give here is an exaggerated sense of open space. We're using the color tones generated by the grasses to fool the eye, that what they're actually looking at is a lot larger space than what they are in."

Previously, the park site had been forest, pasture lands, and swamp. "The cow pasture actually had to become verdant rain forest and planted savanna," said Imagineer Jeanette Lomboy. "Much of [the landscape work] was actually going out and getting plant specimens and trees and allowing those trees, that plant canopy, to grow in, so the animals had a natural habitat to live in. If you stand back and look at Animal Kingdom today, you can't believe that it was anything else."

IV. WILDLIFE AND DEATH

As the park took shape, Joe Rohde was aware of the path Imagineering was about to enter. "Disney had not done anything on this scale with live animals," he said. "So we were very concerned about critical responses." Rohde believed Disney was just as concerned about animal welfare as the activists who would be scrutinizing the project, but it fell to Imagineering to translate that concern into action. As the company had done with EPCOT Center, prestigious advisors were recruited—"all the way from people of the ASPCA through to zoo people and conservation people," Rohde said. "And we took great care to follow their instructions with the design and with how we spoke about product."

The company established the Disney Conservation Fund in 1995, three years before the park opened, giving out grants totaling $1 million a year. The effort was a necessary step in working with the people who could help populate the park with living creatures. "You don't get animals unless you are prepared to do something on their behalf," Rohde said. "It took some time, slowly making the broader company familiar with this idea that we were going to work on something that was going to have to have a mission."

The plan for selecting animals to be included in Disney's Animal Kingdom was never intended to imitate Noah's Ark, or even the San Diego Zoo. "We freed ourselves from a kind of catalog-like obligation

that many zoos have," Rohde said. "We made a commitment at the begin-
ning that we would limit ourselves to portraying those animals and places
where we could make this idea clear that animals are land. Land is ani-
mals. You need these things together or you don't get either. We didn't
set out, for example, to say, 'Here are all the species of big cat in the
world.' But rather, 'Here is a place where people and tigers live together
and find a way to live.' It's a different story"—not a zoo and yet not like
any existing theme park or safari park.

Rohde had been talking to a zoologist named Rick Barongi since
1990. Barongi was an expert in animal care and habitats and worked for
the San Diego Zoo, as well as consulting for a couple of U.S. safari parks.
After consulting during early development, he accepted a full-time posi-
tion on the Disney team in 1993, becoming general manager of animal
operations for Disney's Animal Kingdom. (He also oversaw the care of
creatures already at Walt Disney World: The Living Seas in EPCOT and
at Discovery Island in Bay Lake, Disney's only zoological park.)

Barongi's job at the new park, Rohde said, would be both to find and
acquire its animal population and to "help imbue people with the sense
of the value of conservation and seeing animals in a landscape, not really
presented to you like an object for your consumption, but presented to
you as they live in the world."

Barongi knew what he was getting into by joining the Disney park
project. "We are being held to a higher standard, and that's the way it
should be," he told the *Orlando Sentinel* shortly after taking the job. "The
whole world will be watching us, and I look forward to that."

Disney's Wild Animal Kingdom was officially announced on June 5,
1995, three months after the five-hundred-acre site had been cleared
for construction. (The "Wild" was dropped the following February, in
part to differentiate the park from the defunct television series *Mutual of
Omaha's Wild Kingdom*.) The announcement freed up both the Imagineers
and the conservation advisory board set up on the park's behalf to dis-
cuss their role and to defend the park against anticipated criticism.

Opposition arose quickly. By late 1995, animal rights activists had orga-
nized to block the plans for Disney's Animal Kingdom—and to promote

their own visibility in the media by piggybacking on Disney's high profile. Two Florida-based groups had organized small protests at the entrance to Disney Village in Walt Disney World. A California group called the Performing Animal Welfare Society, or PAWS, had called for a boycott of all Disney theme parks. People for the Ethical Treatment of Animals (PETA), with a half-million members worldwide, had asked travel agents not to book visits to the park and promised additional actions.

"The activists are riled about the company's latest project," the *Orlando Sentinel* reported. "They think it's cruel to use animals for entertainment, and they can't see why Disney doesn't just stick to robot creatures and make-believe."

Disney countered with its own animal-welfare experts, including Michael Hutchins, director of conservation at the American Zoo and Aquarium Association, who argued that the new park would "make conservation a household word." The American Society for the Prevention of Cruelty to Animals, whose president was one of Disney's advisors, made a similar argument.

Disney found another powerful ally in Dr. Jane Goodall, the legendary chimpanzee researcher and conservationist who had become an internationally recognized celebrity by visiting late-night television talk shows with chimps in tow and appearing in several TV documentaries about her work in the jungles of Tanzania, which she had begun in 1960. "I completely dislike an organization being discredited when it's doing the right thing, or really trying to do the right thing," said Goodall, who had been brought into the Disney circle by Barongi. "And very often, by working with an organization that's trying to do the right thing, it will do it even better."

Goodall met with Rohde and the other Imagineers in Glendale and also visited the theme park in the months before it opened. She was comfortable speaking out, she said, because she was convinced that "Animal Kingdom was doing it right. And when Animal Kingdom is doing it right, it's good for the animals. And so it's not just standing up for Animal Kingdom, it's also speaking out for the animals."

Rohde was grateful for Goodall's support: "It was just really

meaningful to be thought well of by someone of [her] prominence." But he was also realistic about her motives. The efficient running of a theme park, he noted, "[is something] Jane Goodall would not necessarily care about. But actually executing conservation in the world she does care about. So we had to get to the point where we had a conservation organization [the Disney Conservation Fund] and a clear plan of what we're going to do with it before there was an appropriate reason for her to be involved."

Goodall's work was supported by a small grant from the Disney Conservation Fund, but that came later and did not influence her initial support. She was genuinely moved by what she saw at the park. "The whole design of Animal Kingdom was taking into consideration the animals as well as the people," she said. "That was nice. I remember when I went there and the elephants had arrived. Having four bull elephants able to submerge at the same time in a pool was magic because the elephants need water, and most zoos either didn't realize or couldn't afford [to provide it], or didn't care. So those were the kind of things that made it special for me."

Goodall was a supporter of Disney's Animal Kingdom in private as well as in public. "I know many, many people who've been to Animal Kingdom—some of whom disliked zoos—because I said they should go and have a look. And they've been impressed. And so there's no question. Animal Kingdom has made a difference, and it is still making a difference and it exemplifies the importance of having all these millions of people moving through it."

V. WHERE WILD THINGS ARE

Animals were, of course, everywhere in Disney's Animal Kingdom. They greeted guests in The Oasis, and their portraits adorned the Tree of Life. Some smaller creatures had habitats in the Tree of Life garden, accessible via paths at the base of the structure, and animals were portrayed by actors in the theme park's live shows: *Festival of the Lion King*, in a barely developed area called Camp Minnie-Mickey, and *Journey into Jungle*

Book, in DinoLand U.S.A. In the Africa sector, a trail was mapped out called Gorilla Falls that would take guests past the habitats of gorillas, hippos, and meerkats and introduce them to tropical birds. (A similar trail featuring tigers would have to wait for the full opening of Asia in 1999.) Some creatures wandered the park in the company of trained keepers, and a regularly performed trained birds show called *Flights of Wonder* was open in the small section of Asia that debuted with the park. A visit to Conservation Station—a working research facility and educational pavilion accessible via a short train ride—might offer glimpses of animals getting checkups from the park's veterinary staff.

But the most dramatic animal encounters in the park were to be from the tram-like vehicles that drove through the spacious habitats along what the Imagineers had dubbed the Kilimanjaro Safaris. This was the grandest E ticket–level attraction on the premises, a twenty-minute-plus ride through more than one hundred acres of scrupulously reproduced facsimiles of African forest, wetlands, and savanna, with a knowledgeable driver who could deliver both fictional narrative—about unseen poachers prowling the bush country—and insightful information about whatever animals made themselves visible along each circuit. Giraffes, elephants, and rhinos were usually too big to miss and often favored areas not far from the track, such as deep pools for bathing, but whether guests would glimpse cheetahs, antelope, crocodiles, lions, or the many other beasts living in the vicinity depended in part on chance and the time of day.

The Imagineers did make an effort to lure animals out into the open and closer to the safari road with the strategic placement of salt licks, shade trees, watering holes, even air-conditioning machinery hidden in the scenery—all in consultation with the animals' expert keepers. Many of the animals were also fed with stashes of food that appeared in different places each day, requiring them to search their habitats to locate their meals or other treats. But whether and when the animals felt like a bath or breakfast or a blast of cool air was beyond the control of any human. The plan was not to deliver a certain number of sightings per trek, Joe Rohde said, but to create "one big experience about adventure, about being someplace where you don't know what's going to happen."

This was accurate to what an African safari would be like, said Mark Penning, a Disney veterinarian from South Africa who joined Disney's Animal Kingdom team while Imagineering was still acquiring its one thousand original inhabitants. "In the Bush Belt in Africa, you just don't know what's going to happen next. That's what's so beautiful about it. You may go out on a drive in the wild and not see a big, charismatic [animal] at all. But the more you look at the little ones and the more that you appreciate what's out there, then you start seeing the links between the different animals. And that's what we want to do with our guests here. We want them to see this beautiful place and these beautiful animals, and to feel, 'Wow, it's my responsibility to make sure that my grandchildren and their grandchildren can still get to see places like this.'"

Most of the animals in Disney's Animal Kingdom were acquired from some of the more than two hundred licensed zoos in the United States, and most of those were born in captivity. Federal regulations discourage importing live animals, most of which need to spend six to nine months in quarantine before they are permitted to continue to their final destination. As a result, said Steve Castillo, a curator and animal office manager who started working on the Kilimanjaro Safaris a year before the park opened, populating Disney's Animal Kingdom savanna was a combination of fulfilling the Imagineers' aspirations for certain species and seeing what animals were available within the United States. The animals needed to be found about a year before their habitat was finished. Then Castillo and others would figure out the logistics of safe transportation to one of several Florida sites outside Walt Disney World to house them in quarantine for forty-five to ninety days, depending on the animal, before they could be introduced to the park. The quarantine was in part to allow the animals to become acclimated to Florida weather.

Despite the need to isolate the lions from, say, the tasty wildebeests, and the crocodiles from any animal without wings, the Imagineers wanted to preserve the illusion that the safari vehicles were traveling through uninterrupted wilderness. A few gates would be necessary along the road, but no fences were to be visible to visitors. "There are indeed boundaries all over the place," Rohde said. "But we don't want you to

think about those boundaries, right? We want you to think about the land. If you were to fly over in a helicopter and look down, there's fences and there's walls and there's moats and all kinds of stuff that you don't see, because we've worked them into the design. That way you're free to focus on the big idea: animals and land."

"We worked very hard on our sight lines," Rick Barongi said. "When you're looking at an elephant, even though there is a dry moat area between you and the elephant, that disappears. The elephants are so big, we make their habitats a little higher than your vehicle. So, they really look like they're much closer than they really are."

The landscaping of the savanna was "very, very accurate" to African terrain, Penning said. "That is where I am from, and I can tell you that this is what it is. Even the grasses are the same grasses that you would see out on the savanna. Once a guest has been through here, and goes to Africa, they are going to say, 'Wow, those Disney folks, they've got it right.'"

A key difference from the African savanna was that the animals were provided secure shelter as well as grasslands to wander. "We need to be able to bring them indoors whenever we want to," Penning said. "We are in Florida; we get hurricanes here. So all of these animals have air-conditioned bedrooms that they come to at night. They're all trained to do this." As an example, he cited the park's two dozen crocodiles: "We ring a bell and they are all inside in fifteen minutes. It's incredible." The nighttime accommodations were not only for the animals' safety and comfort but to give the veterinary staff an opportunity to examine them. "We can weigh them. We can see who is eating and who is not eating. We can get voluntary blood samples from them. We can do ultrasound looking at the heart function, lung function." The animals have, Penning said, "an easy, cushy life. Predators are all somewhere else, where they can't get at you, and you've got lots to eat and great care and you can run the savannas and do what you want to do. It's a very cool place for animals to live."

In a way, the Kilimanjaro Safaris fulfilled a long unrealized dream of Walt Disney's. When he had originally conceived the Jungle Cruise for Disneyland, more than four decades earlier, he had envisioned living

animals along the ride: actual bathing hippos and elephants rather than the Audio-Animatronics variety. But the logistics of controlling and caring for hungry, unpredictable African beasts proved too daunting for that era's Imagineers, who were creating a park from scratch in about a tenth of the time—and in less than a fifth of the space—of Disney's Animal Kingdom. Now there would finally be a Disney theme park attraction in which thirty-some guests boarded a vehicle for a narrated journey into the wilds to see living animals in re-created habitats—albeit in an open-air truck rather than an open-air riverboat.

The realism of the safari was countered by the E-ticket fantasy attraction in DinoLand U.S.A., called Countdown to Extinction. The ride utilized the Indiana Jones vehicles and technology and followed an identical two-level track, but with an entirely new narrative and all new surroundings. As with It's Tough to Be a Bug!, it was shaped in part by a computer-animated feature in the works. Disney's *Dinosaur*, due out in 2000, would be the company's first CG movie created in-house by Disney animators. The dino hero of the film, an iguanodon named Aladar, and its villain, the T. rex–like Carnotaurs, make appearances along the way, although the ride's narrative was unrelated to the film. *Countdown to Extinction* had actually been considered as a title for the movie, and the attraction was renamed simply DINOSAUR after the movie's release. It was just one of many changes, additions, and revisions the park would undergo in its first few years.

VI. RAPIDLY FORWARD

A remarkable parade marked the dedication ceremony for Disney's Animal Kingdom—and it was not the March of the ARTimals held daily in the Safari Village for the first year. No, it was a parade of Imagineers, for the first time recognized en masse at a park's opening celebration.

With no space inside the park large and open enough to hold an event with more than a hundred performers and many hundreds of invited guests, Disney's Animal Kingdom dedication unfolded on a temporary stage in the parking lot. Roy E. Disney was the first speaker. "The

Walt Disney Company owes a lot to animals," he began. "Back in the 1930s when other studios spoke figuratively about their stables of stars, we meant it literally. Our featured players back then were two mice, two ducks, and two dogs." He also talked briefly about Disney's animated features, from *Snow White* to *The Lion King*, as well as his own work as a young man on forty of Disney's True-Life Adventure documentary films, shown on *Walt Disney's Wonderful World of Color*. "These films," he said, "proved that animals don't have to be cute to be compelling, that dramas don't have to be scripted to be stirring." He finished his remarks by saying, "I want to call forth the people who really made it possible, the designers from Walt Disney Imagineering. They're the ones who transformed a pasture into a kingdom."

Then came the March of the Imagineering-nimals, led by a beaming Joe Rohde. Many Imagineers had flown in cross-country from Glendale for the event, joining the dozens of Imagineers who were already on-site, working on the last-minute polish before the park opened. As Lebo M—the South African singer and music producer responsible for the African arrangements on *The Lion King* soundtrack—sang "Welcome to Our World" in Zulu and English, the corps of Imagineers paraded past the seated guests, smiling and waving, finally out from behind the scenes.

Michael Eisner's remarks were less personal than Roy E. Disney's—"Nature is perhaps the greatest storyteller of all"—and ended with the now-obligatory reading of the dedication plaque installed at the park's entrance: "Welcome to the Kingdom of Animals, real, ancient, and imagined; a kingdom ruled by lions, dinosaurs, and dragons; a kingdom of balance, harmony, and survival; a kingdom we enter to share in the wonder, gaze at the beauty, thrill at the drama, and learn." Eisner also introduced the eleven members of the advisory board who were present, as well as Jane Goodall.

"I remember so well the opening," Goodall said. She particularly recalled Eisner "standing up thanking everybody. Then he says, 'Of course, we have Jane Goodall, well known around the world for her wonderful work with gorillas.' And there's a sort of groan from all around"—since those seated near Goodall in the front row well knew

she had dedicated her life to the study of chimpanzees. "Afterwards, I met Michael and I said, 'How could you have done that?' He said, 'Well, I thought it was wrong,' but he showed me the notes he'd been given by whoever did his speeches and it actually said what he had said. So he scribbled on it, 'I'm really sorry, but you do gorilla-sized work.' I still have that little card."

The real opening was at seven a.m. the next day: April 22, 1998, which was the twenty-ninth annual Earth Day, the worldwide celebration of environmental stewardship and conservation. Many of the first day's guests had arrived before dawn, and the park reached capacity at nine a.m., and was closed to new entries.

Eisner reported that "the ratings from guests are the highest we've received for any park in our history," and early press reviews were favorable. "The $800-million park is both bold and familiar, but also dramatically different from its Walt Disney World predecessors," the *Los Angeles Times* opined. "But this is not the Magic Kingdom with animal acts." The *New York Times* reporter "found Africa and its safari truck ride to be the high point of a day's visit (along with that creepy bug film)." He noted that although there was "no knockout, gotta-be-seen spectacle . . . the park is an appealing addition to a destination that already draws people from around the globe."

The biggest change in the first year was the opening of Asia in March 1999. The Maharajah Jungle Trek, with its ruined palace theme, was a walk-through attraction that took guests through an aviary and past habitats for giant fruit bats, tapirs, Komodo dragons, and tigers. The opening also added a new thrill ride, the Kali River Rapids. The working title had been Tiger Rapids Run, but no animals would be visible along the way, and Imagineers feared more dashed expectations. The new name evoked Kali, a four-armed Hindu goddess who vanquished evil and protected the innocent.

The attraction revived a concept that had been developed for Disney's America, and like the never-built Lewis and Clark Raft Expedition, it promised an exciting, splash-filled journey through rapids and past whirlpools. The imagined setting was India's Chakranadi River, starting

with a gentle float through pristine wilderness, with jasmine and ginger scents infused in the mist, then speeding up as the surrounding forest became blighted, felled by illegal logging—locking into the park's overarching conservation narrative. Getting the final drop exactly right—it needed to feel "like the bottom has dropped out of the river," Rohde said—led the Imagineers to reengineer the effect the summer before the park opened, leading to a four-month period of testing and adjusting that delayed the attraction's debut.

Disney's Animal Kingdom attracted six million visitors in the eight months of 1998 it was open, while admissions at the other Walt Disney World gates fell slightly, since some guests skipped one or more of the other parks in favor of the newest one. (It would take time to convince guests to stay that extra day.) The opening of Asia would ease crowding at Disney's Animal Kingdom. As theme park trade magazine publisher Gary Slade told the *Orlando Sentinel*, "The other Disney parks are very good at absorbing people—like sponges. But at Animal Kingdom, it's like the people didn't have enough to do." Presciently, he added, "They probably still need one more section down the road somewhere." The *Sentinel* speculated that the new land could be "the long-rumored Beastly Kingdom, a section based on mythical creatures"—fulfilling the promise of the dragon seen in the Disney's Animal Kingdom, five-creature logo and mentioned in the dedication plaque. But the mythical creatures that would displace Camp Minnie-Mickey would be a different kind of winged beast, from newly minted myths still ten years in the future.

Theme park pundit Slade credited Kali River Rapids with getting "visitors off the park's streets and into lines," but the Imagineers had an opposite goal: get guests out of the lines and into the park. To do that, they were developing the world's first virtual queuing system, which they dubbed "FastPass." It wouldn't eliminate the wait time for walk-up guests, but those who planned ahead and understood the new system could gain access to a second, much shorter line at an assigned time later in the day. The goal was to respond to the most common Disney theme park visitor complaint in the 1990s: wasted time due to long, unavoidable lines.

Beginning in July 1999, at each of the park's three most popular

attractions—Kilimanjaro Safaris, Countdown to Extinction, and Kali River Rapids—an area was set up consisting of a half dozen or so small electronic kiosks with a design appropriate to that attraction. The devices would read the barcode on a guest's admission ticket and issue a small, printed FastPass voucher assigning that guest a one-hour window in the future to join a special, shorter queue for the selected ride. A set number of FastPasses were programmed to be handed out for each five-minute interval, and when that number was exhausted, the one-hour return window automatically shifted back five minutes—until all FastPass admissions for that attraction were exhausted for the day.

The FastPass system was developed as a collaborative effort between Imagineering and the park's Operations team. The engineer behind the system was Greg Hale, who then oversaw the Electrical and Controls Engineering Department for Operations. "We actually went into the ride-control systems, looked at the capacity of every ride in real time, and have a computer system that knows that capacity and allocates a portion of the capacity to each FastPass issued," Hale said in an article published by the International Association of Amusement Parks and Attractions (IAAPA). The introduction of the FastPass in 1999 made many visitors happy, but behind the scenes, it was likely that other news made more of an impact on Disney's Animal Kingdom cast members: More than fifty mammals were born there in 1999, including a gorilla and four hippopotamuses. The park had become a sustained habitat for its animal residents, and its success would bring better lives to the animals' counterparts in the wild through the conservation programs Disney's Animal Kingdom helped to fund. Rohde believed that macro view trickled down to every guest experience. "We hear this a lot," he said. "People come here expecting a theme park experience because they're at Walt Disney World. And they do get a theme park experience. There are rides. There are attractions. There are Disney characters.

"But they get more," he added. "And they sense almost immediately that there is more. So the classic thing we [hear is,] 'I came for this, and I got more. I got back something real, something I can take away.'"

As Eisner phrased it, "Rather than guiding and directing experiences,

as we did in our other parks, we would encourage visitors to come to the Animal Kingdom to explore and discover for themselves."

In Jane Goodall's opinion, that exploration would inevitably lead to observing animals who were comfortable and well taken care of. "The important part is that it's not just looking at animals, it's looking at animals in the right kind of habitat. I mean, obviously everybody knows they're not wild. But that is less important than making it good for the animals, which is what Animal Kingdom has done." The takeaway, she added, is that "people also get educated as to the plight of these animals. So you look here at a group of elephants, you're seeing how they interact with each other. You're seeing the tenderness with which the adults will caress an infant." That's the kind of lesson no other theme park in the world could impart.

CHAPTER 21:

STATE OF THE FINE ART

"Walt set a standard early on with the Imagineers. There was a standard that surprised people. A standard that enabled people to come in expecting something and then giving them something even beyond that. Beyond really their own imagination. So they left thinking, 'Wow, either only Disney could do that,' or asking, 'How did Disney do that?'" —Bob Iger

I. IMAGINEERING GOES NORTH

ON A TREE-SHADED BOULEVARD in Montreal, Quebec, sat a majestic mansion, one of the last survivors of the opulent homes of wealthy residents that once lined Dorchester Street in the late 1900s, each nestled within a spacious garden. Lawn and trees still surrounded Shaughnessy House, as it was known, but the greenery had been pushed back by the construction of a 130,000-square-foot modern building that now enveloped the three-story home on three sides, an impressive structure reminiscent of New York's Metropolitan Museum of Art. Designed by Peter Rose—one of Canada's leading architects in the late twentieth century—this was the Canadian Centre for Architecture. But on this particular night, in June 1997, the parklike setting had become a temporary outpost for Walt Disney Imagineering.

Here Imagineers, academics, Disney fans, and art critics had all gathered for the opening of an exhibition titled *The Architecture of Reassurance:*

Designing the Disney Theme Parks, curated by Karal Ann Marling, a professor of art history at the University of Minnesota. Marling listed her specialties as, among other things, aesthetics, Christmas images, clowns, Elvis, theme park architecture, and Walt Disney. She had been working for years with Nicholas Olsberg, the architectural center's chief curator, and Marty Sklar, the creative head of Imagineering, on creating this exhibition and a corresponding book—both scholarly and coffee-table-worthy. The project "would look behind the multiple myths of Disneyland, in order to trace the impulses and mechanisms that made it and changed it," as Olsberg wrote in the book's foreword.

It also brought out the usual naysayers. From Montreal, the traveling exhibit moved to the Walker Art Center in Minneapolis, where, on opening night that September, little girls in princess outfits had to pass by protestors from a group calling itself the Northern Artists Front.

After once joking that he didn't want to talk about the Imagineers for fear other companies would steal them away, Michael Eisner had agreed to this extensive examination of the history and accomplishments of Walt Disney Imagineering "as a cultural phenomenon," as Olsberg put it. Marling and her research team got unprecedented access to The Walt Disney Company's archives while the company "assiduously distanced itself from the content and argument of the exhibition and of the book," Olsberg wrote.

"For a long time, many years in fact, *The Architecture of Reassurance: Designing the Disney Theme Parks* could never have happened," Sklar wrote in a five-page essay published in the book. Museums didn't consider the Imagineers' art "legitimate," he wrote, and Disney was hyper-protective of their original drawings and other works and determined not to reveal the secrets behind its theme parks' magic. But Sklar was proud of his association with great artists and Imagineers such as Herb Ryman, John Hench, and Harper Goff, and he wrote confidently of Imagineering's achievements and process. Walt Disney's brilliance in bringing together top talents to rethink architecture as storytelling and entertainment at WED Enterprises Sklar noted compared with Italy during the Renaissance—except that da Vinci and Michelangelo were world famous, while Ryman and

Hench were unknown even to the 1.2 billion people who had visited Disney theme parks since 1955. The exhibition and book, he hoped, "will suggest to you that the people, the process, and the projects represented in these spaces constitute a body of work perhaps unequaled in its impact on people around the globe."

The exhibition was full of the Imagineers' colorful concept art, detailed design drawings, and photographs, of both models and completed attractions. It even included some WED/Imagineering projects that were never built, such as Thomas A. Edison Square—the GE miniland envisioned for Disneyland in 1957 that later inspired the Carousel of Progress. The $50 book, which was published for the exhibition's opening, flip-flopped the title to *Designing the Disney Theme Parks: The Architecture of Reassurance*, thus giving the Disney name top billing. It offered five deeply researched monographs—the longest, by Marling, was 150 pages—that presented and scrutinized the work of the Imagineers in thoughtful but accessible prose and with considered attention to both historical influences and cultural context. It concluded with a Q and A with architect Frank Gehry, talking about his experience in designing Festival Disney for the Paris resort.

The combination of the traveling exhibit and the book, with their imprimatur of sophistication—in 1998, the show opened at the storied Cooper Hewitt National Design Museum in New York City—inspired further sober consideration of the Imagineers' accomplishments in high-toned publications such as *Artforum*, *Artnet*, and *Harvard Design Magazine*. Disney's theme parks had been the subject of academic and cultural critiques many times over the decades, often unkindly, sometimes incomprehensively. But *The Architecture of Reassurance* was not just a respectful analysis and meticulous history—it put Walt Disney Imagineering in the same league as Gehry and other twentieth-century master builders who were hailed for adhering to a coherent point of view and rigorous standards. As a highly visible, serious academic undertaking, Marling's project accorded Imagineering a gravitas and recognition previously withheld by most self-appointed guardians of good taste and artistic merit.

At the same time, by some estimations, Walt Disney Imagineering was then working on a new theme park that would be its most artistic accomplishment to date.

II. AN IDEA FLOATS TO THE TOP

Steve Kirk went to college at the California State University, Long Beach, and graduated with a degree in illustration. Problem was, he recalled, "I wasn't very good." But his brother Tim had a friend named Rolly Crump, the former Disney animator and then-former Imagineer, who was now based in Florida and working on attractions for Busch Gardens and other non-Disney parks.

Crump hired Tim and Steve to help with one of his Busch Gardens assignments in 1975; then Crump rejoined WED Enterprises in 1976. "He said, 'Hey, they're hiring people over at Imagineering. Why don't you go over and take your portfolio?'" Steve Kirk recalled. He did just that, and he met Imagineers Tony Baxter and Tim Delaney as they reviewed his work. Even though Kirk thought his art unremarkable, "I had an imagination that actually came up with wacky stuff, and so I think that's what appealed to them." He got a job offer and considered himself lucky. "Today," he believed, "I would never have qualified." He thought the job would be temporary; he stayed twenty-five years. (His brother Tim joined Imagineering four years later, in 1980.)

One of Steve Kirk's first assignments was working under the supervision of Baxter on the development of Discovery Bay—the proposed land that inspired the Verne theming for Discoveryland in Disneyland Paris, and Figment the purple dragon for the Journey Into Imagination pavilion for EPCOT. Kirk also worked on The Land and the Wonders of Life pavilions, then on the studio tour portion of what we now know as Disney's Hollywood Studios.

As Kirk gradually took on more and more responsibility at Imagineering, Disney was working with the Oriental Land Company on the long-planned second Tokyo park. The original Tokyo Disneyland "was doing gangbuster business and they wanted to have a new product

to put right next door," Kirk said. Masatomo Takahashi, president of Oriental Land Company, announced the company's intention to build the second gate at an April 1988 press conference marking the fifth anniversary of Tokyo Disneyland. But what this new park would be took years to determine.

Just as Michael Eisner had been certain something with "Disney and animals" would make a great park (but didn't have any idea what that would look like), Takahashi was set on "a second Disneyland"—yet was open to the Imagineers' ideas on what that would entail. In 1991, Imagineer Bob Weis convened a core group of Imagineers, including Kirk, to brainstorm a completely new approach such a park. "We took a weekend and came up with the idea of doing a series of seaports," Weis said. "And the concept was, you could do something that was like Disneyland, but the water [theme] would make it totally different. So it would satisfy Michael's concern about it being different but also Oriental Land Company's idea that it should be very much like Disneyland."

The idea was called Tokyo DisneySea, a park divided into lands and full of storytelling attractions, like Disneyland, but structured around seven ports of call, some realistic, some fantastic. As recounted by Imagineer Craig Russell, one of the project managers for the park, Weis, Kirk, and a few others "sat down in a very tight group, came up with an idea, and built an amazing tabletop model." They took their pitch to Tokyo and, "to Disney's shock, Oriental Land Company said, 'That is the park we're gonna build.'"

"When Takahashi-san saw the new concept for Tokyo DisneySea, even in its very rough form," Weis said, "they saw something that complemented Disneyland, that was thematically cohesive the way Disneyland is. [They saw] adventure stories that they could relate to. Characters that they could relate to. And the tone of the entire negotiation from then on was positive and forward."

After several years of secret development at Imagineering and discussion with Oriental Land Company, Tokyo DisneySea was officially announced to the worldwide press on November 26, 1997—just six months before the opening of Disney's Animal Kingdom Theme Park.

The Tokyo DisneySea opening wasn't expected until 2001, but a press release teased the park as featuring "exotic ports and daring voyages [and] offering a rich world of thrilling rides, themed dining and unique shopping." For the Imagineers, Tokyo DisneySea would be the first opportunity to create a brand-new fantasy-themed park since the original Disneyland. The official groundbreaking was October 22, 1998, the same day the name "Tokyo Disney Resort" was introduced to encompass both Tokyo theme parks, as well as the hotels and shopping areas on Oriental Land Company's bayside property.

A press conference also shared more details about what Tokyo DisneySea would include. "It had a lot of Disney intellectual property in it, but it was all fresh—it was all new," said Kirk, who was named senior designer on the project. "We looked through the Disney intellectual properties and thought, 'Okay, what hasn't been used someplace else?' Well, Little Mermaid, Aladdin. We've always wanted to do a really serious Jules Verne land, and so that was thrown in the hopper. Another one was Indiana Jones—perfect for a tropical delta type [attraction]. And how do we stitch these different IPs with each other and allow enough elbow room to add others? How do we put them as addresses along a body of water in seven different lands—seven seas?"

Whatever the solution to these challenges, Tokyo DisneySea was in no way to be a secondary park. "They definitely wanted equal weight," Kirk said. "They wanted equal quality; they wanted as much intellectual property as they could get." However deeply the Japanese guests might love Disney, though, Oriental Land Company executives "weren't rabid about it having to be Mickey Mouse or Donald Duck or Cinderella. They were saying that it has to have equal Disney quality in it. And so they weren't adverse at all to coming up with things from scratch as long as it was liberally laced with the Little Mermaid and with the other IPs that they could identify with Disney."

Best of all, the construction would be fully funded by Oriental Land Company, with Disney's cost limited to about $100 million for design and development. It wasn't a blank check, but it was a very large one.

III. A VERY RICH PARK

Tokyo DisneySea's seven ports of call were not created to correspond to realistic geography—say, one for each major ocean—but to themes the Imagineers could envision with striking architecture and engaging attractions. The lands would blend cultural themes with history and, of course, fantasy, tied to the leading intellectual properties selected for the park. They would also all be linked by water—what project manager Craig Russell called "this huge 42-million-gallon swimming pool." It took the form of an irregular liquid loop that circled the central land mass and changed character from harbor to marina to river to coastline depending on what land was adjacent. Indeed, what made DisneySea unique among all Disney parks was its location on Tokyo Bay, Steve Kirk asserted, with just a monorail track and a seawall separating the edge of the park from the open ocean beyond. "It's not like a lake with waterfronts around the perimeter," Kirk said. "One flank of that whole park looks out onto the actual horizon of the Pacific Ocean."

The water theme began at the park's entrance, where in place of the courtyard at the foot of the train station in Disneyland, guests would enter through DisneySea Plaza, with a central circular pool, over which hovered a giant blue-and-green Earth, dubbed the AquaSphere, seemingly held aloft by a column of water.

From DisneySea Plaza, a passageway led to Mediterranean Harbor—the first land, inspired by the Italian ports of Venice and Portofino and architecture characteristic of Tuscany. Arriving visitors had an immediate and awe-inspiring view of Mount Prometheus, the 189-foot-high volcano rising from Mysterious Island, the park's Jules Verne-themed central land, across the waterway from Mediterranean Harbor.

Heading to their left, guests would next reach the American Waterfront, a land consisting of two re-creations of sites from along the Eastern Seaboard of the United States in the early 1900s. On one side of the water was the New York Harbor section—where the Sailing Ship *Columbia* sat docked, a stationary reproduction of a steam-powered ocean liner

from the 1930s. (With red smokestacks and a black hull, the resemblance to the permanently docked *Queen Mary* in Long Beach, and to Disney's own cruise ships, was more than coincidental.) Across the water from New York Harbor was the Old Cape Cod section, in the style of a New England fishing village and anchored by a red-and-white striped lighthouse inspired by the one in Quoddy Head State Park in Maine, at the easternmost point of the United States. (Steve Kirk's brother Tim was one of the Imagineers assigned to the American Waterfront. Tim Kirk called his brother "the best creative leader I've ever worked with.")

Continuing a circuit of the park from Old Cape Cod would lead guests to Port Discovery. The Tokyo DisneySea land was retro-futuristic, with a design and attractions inspired, like Mysterious Island, by the works of Jules Verne. Across the water from both the Old Cape Cod section and Port Discovery was just a fringe of trees along the park's border—and the view of Tokyo Bay itself. The Monorail track along the park's perimeter had been lowered to give guests a clearer view of the aquatic expanse beyond. "Towards the ocean, we're making a show statement," Kirk said. Disney parks always took into account their environment, he noted, "but that one to me really takes its name seriously. Tokyo DisneySea is on the sea."

The two American Waterfront sections and Port Discovery were placed closest to the ocean in part because they would require less landscaping that would be endangered by salty sea breezes. Indeed, the tall trees along the seawall were fitted with sprinklers at the top. "So every time a salt wind comes through, they turn the sprinklers on to rinse all the salt off the trees," said John Sorenson, the park's chief landscaper. After years of working on site planning and landscape architecture, Tokyo DisneySea was Sorenson's first time supervising a park's horticulture, so he asked the legendary Disney landscape architect, Bill Evans, to consult.

"I went to him and said, 'Bill, I have no idea what the planting [should be] in Tokyo, so would you please help me?' And he said, 'Yeah, I'd love to do that.' He was well into retirement, and so he would enjoy coming to Imagineering to spend time. He came every Thursday, and we spent the whole afternoon together." Sorenson got not only valuable advice on

what plants would be appropriate for different parts of the park, he got to hear "all these great stories about building Florida, about building EPCOT, about Walt.

"I'd ask him a question and he would just depart on to these great stories," added Sorenson. "And then after a long time he would say, 'I bet you thought I forgot what the question was.'"

The landscaping was more extensive in the next land past Port Discovery. Lost River Delta was on the opposite side of the park from the entrance, and around a bend from the side adjacent to the bay. "Tucked back behind large buildings," Sorenson said, the area had "a microclimate that was sheltered from the ocean." Introducing an adventure theme, the lush Lost River Delta imagined a Central American archaeological site in the 1930s—providing a home to the Indiana Jones Adventure, housed in a life-size Aztec pyramid, as well as correspondingly themed shops and restaurants.

On the opposite side of the river from the pyramid in Lost River Delta, on the "island" side of the water, sat the next region, Mermaid Lagoon. Entirely untethered from real geography or history, the fantasy-themed area was designed to evoke King Triton's palace from *The Little Mermaid*, its bright colors and seashell-themed architecture in stark contrast to the shady jungle of Lost River Delta.

The final land on the perimeter of the park, a trail away from Lost River and a bridge away from Mermaid Lagoon, was the Arabian Coast, built to resemble a Middle Eastern harbor in the timeless realm of *One Thousand and One Arabian Nights*, best known as home to Aladdin and his friend Genie.

The Mermaid and Arabian areas were this park's answer to Fantasyland, Kirk said. "We thought there was no reason to reinvent that model of what makes a Disney park. You want something that's for the kids, a Fantasyland—or two, in the case of Tokyo DisneySea. You want something that has an action-adventure angle, like Lost River Delta and Mysterious Island—Indiana Jones and Jules Verne," which would appeal to older children and young adults. "You also needed something—especially in Japan—for the middle-aged and older crowd who just want to walk

around, see a live show, do some shopping, have a nice dinner, and get out of downtown Tokyo." All these markets overlapped, Kirk added, "but I think we hit those three notes pretty well." Also overlapping all three demographics were "the die-hard Disney fanatics who are looking for Hidden Mickeys in every bit of architecture and are in love with the big five characters." Unlike with the opening of EPCOT, Mickey, Minnie, Donald, Pluto, and Goofy would be residents of Tokyo DisneySea from the outset.

Still, the park's centerpiece and pièce de résistance was a new creation for Imagineering: the volcanic Mount Prometheus, on the park's central land, Mysterious Island. The name came from Verne's 1875 novel *The Mysterious Island*, a sequel to his *20,000 Leagues Under the Sea* but not as well known. Lincoln Island in Verne's novel was set beneath a volcanic peak, but the impressive Mount Prometheus was a creation of pure imagination—an amalgam of Lincoln Island and Vulcania Island from *20,000 Leagues*, both of which were secret bases for Captain Nemo's submarine, the *Nautilus*—as well as a good dose of Imagineering innovation.

It had been part of the Tokyo DisneySea plans from early on, and it had "a huge presence in the park," Kirk said. Visible throughout Tokyo DisneySea, the mountain was designed to match exactly the height of Cinderella Castle at Tokyo Disneyland. Its surface required approximately 750,000 square feet of carved concrete rockwork, and an enclosed harbor at its base included the *Nautilus* itself. Still, Oriental Land Company asked for more from its volcano.

"There was one meeting where Oriental Land Company said, 'Yeah, what does it do?'" Kirk recalled. "And we go, 'What you mean what does it do? It's a volcano.' And they said—I'm paraphrasing—'Yeah, but it's gotta do something.'" As in the Verne novel, if a volcano is introduced into the narrative, it had better erupt. "So we thought, 'Okay. What can we do? Let's put seven giant gas cylinders at the top for flames.' There is an elan2 [liquid nitrogen] generator for 'smoke.' There's a huge array of lighting up there. It has to work together in the same space and it has to be programmed. So during the day it rumbles, then it goes off a little bit and then it has this climax at the end of the day with a huge eruption."

To create the lava flow down the slopes of the mountain—utilized only after dark—the Imagineers used rear-lit fiberglass, an effect developed by Imagineering's R&D department.

What Oriental Land Company wanted, Oriental Land Company got. It was paying the bills. Among theme park projects, "Tokyo DisneySea definitely was an anomaly when it comes to the relationship between a money schedule and creative," Kirk said. "Because the money was coming from someplace else." Which is not to say that Imagineering was profligate. "Our management in Imagineering had a very conscientious attitude about not gratuitously spending money. If there was a field change that the creative team felt should be made, then we had to make our case both through our own management and at [Oriental Land Company]," Kirk said.

Some Imagineering suggestions were rejected on both fronts, but each revision or budget debate was a three-way discussion. Kirk found himself sometimes arguing in favor of laying out more up front to reduce costs later—as in, for example, the domes in the Arabian Coast. "They're actually gold leaf. And our management naturally said, 'That's ridiculous. Just use gold paint.' Oriental Land Company representatives said, 'That's ridiculous. Just use gold paint.' Then we brought their maintenance people into a field meeting and said, 'Well, what do you think?' Because I knew the answer, and the answer was, gold leaf will last forever. You will never have to put a scaffolding up, get it repainted, and so forth and so on. Do it right, now—even though it's extra money—and you're saving money in the long term."

The three-way collaboration was "very civilized," Kirk said. "Everyone knew this had to be a home run first time—that if word got out with the Japanese public, who were so in love with Tokyo Disneyland, that 'They're doing this mediocre park next door,' we were sunk. And so I think the money was spent really wisely."

As had been the case with Tokyo Disneyland, the Oriental Land Company wanted detailed documentation, both to track expenditures and to make sure every detail was executed on-site precisely as it had been conceived by the Imagineers. "Of all the color boards [showing design details] I've ever been around in any project or development,

these were the most," Kirk said. "The renderings were very developed; the models were very, very beautiful. It wasn't a gratuitous design. It was simply that we cannot be ambiguous with [Oriental Land Company]."

The fabrication was done partly in Japan and partly in Glendale. The Audio-Animatronics figures and a lot of the sets for inside attractions were created in California, but the exterior architecture had to be made in Japan. That meant providing exacting design plans to the local manufacturers and builders—including hundreds of rockwork samples, for instance, and meticulous instructions on aging and grain reproductions. "You could not cut corners and make assumptions," Kirk said. With its weathered surfaces, whimsical character architecture, and extensive ornamentation on almost every building, "it was a very rich park."

IV. COMING ATTRACTIONS

Tokyo DisneySea would contain two major attractions repurposed from other parks. One—the Indiana Jones Adventure—was technologically similar but with a new narrative. A fresh subtitle—Temple of the Crystal Skull—replaced Temple of the Forbidden Eye in Disneyland, which reflected a new narrative that involved Jones's search for the Fountain of Youth.

The queue was also re-themed, and a Central American guide named Paco, who spoke Japanese, replaced John Rhys-Davies's Sallah as host. The surrounding Lost River Delta was entirely new, and designed to resemble the dark jungles of Central or South America rather than the upbeat Adventureland at Tokyo Disneyland next door. "We thought, 'Okay. Let's let Tokyo Disneyland be more of *The Jungle Book*—you know, cheerful bright colors, a [Walt Disney's Enchanted] Tiki Room kind of look,'" Tim Kirk said. "'Let's make our Lost River Delta way more edgy and adventure-based.'"

Less dark but still distinctly adventure-centric was the Mysterious Island attraction 20,000 Leagues Under the Sea. The concept would be familiar to longtime Disney fans, inspired as it was by the 1959 Submarine Voyage in Disneyland and the more elaborate 20,000 Leagues Under the

Sea submarine attraction in the Magic Kingdom, which had run from 1971–1994. On Mysterious Island, the familiar submarines were replaced with Verne-styled capsules that resembled large Ferris wheel gondolas, suspended from above, with bubble windows that simulated submersion without actually going into the water. The Tokyo DisneySea story line was similar to the Magic Kingdom attraction, beginning with a ship grave-yard, climaxing with an attack by a giant squid (replacing Florida's North Pole segment), and ending up in Atlantis, whose mermen help return the capsules to Nemo's base. As in Discoveryland in Disneyland Paris, a full-size model of Nemo's own *Nautilus* submarine was docked outside, although the Tokyo DisneySea version could not be boarded.

Most of the other attractions in Tokyo DisneySea were unique to the new park. Some provided relatively straightforward transportation, such as the narrow-gauge elevated DisneySea Electric Railway that ran from the American Waterfront to Port Discovery and back, or the DisneySea Transit Steamer Line, with its shuttle-size boats making clockwise jour-neys around the park's waterway.

Others were new concepts that resembled earlier ideas, such as the Blowfish Balloon Race in Mermaid Lagoon, a kind of Dumbo ride for the undersea set, or the Arabian Coast's Caravan Carousel, a double-decker merry-go-round housed beneath an impressive golden dome. Interactive walk-through attractions included the kiddie-friendly Ariel's Playground in Mermaid Lagoon and the Galileo-meets-EPCOT displays of Fortress Explorations in Mediterranean Harbor, which was connected to the mys-terious Society of Explorers and Adventurers invented for the Adventurers Club at Pleasure Island. (The display set the stage for the addition of a re-themed Tower of Terror attraction that would be added in 2006.)

The two-person Aquatopia boats in Discovery Bay, which resembled a Jules Verne edition of Autopia, looked simple enough, but the attraction actually utilized the groundbreaking technology first used in the Tower of Terror: trackless navigation. The patented system, which eliminated the guide rail common to previous Disney dark rides, had been per-fected for an attraction called Pooh's Hunny Hunt at Tokyo Disneyland, opening in September 2000. One goal of the Hunny Hunt's trackless

system, recalled Imagineer Daniel Jue, was to allow for the "different ride vehicles floating around the 'river' going through the Hundred Acre Wood to have a different ride experience depending on which vehicle you were in."

The five-seat "hunny pots" traveled from room to room in groups of three, and each pot would forge a different path. "In Japan that's very important because we have a very high repeat audience there," Jue said. "So it was important for us to develop a ride system that could give our guests different experiences every time they went. And what we learned from that was that a trackless ride system was actually a very great tool to tell a story and to get intimate moments as well as group moments. You could join three vehicles together and they could all see the same thing, or they could run off and go to a different location and see individual different things."

The top secret tech used a network of sensors in the vehicles and along the route, which communicated wirelessly with one another and with a central processor that controlled the motion of all the honey pots in use at any given time. Each pot could follow a separate route in each segment of the ride, so the differences were unpredictable and innumerable. It was a variability similar to the Indiana Jones Adventure experience, but freed from a single track. "I still think that it is an incredibly innovative attraction," Jue said of Pooh's Hunny Hunt. "We pushed [the technology] to its limits. We created a scene where you actually bounce with Tigger and the entire room bounces around you to the rhythm of 'The Wonderful Thing About Tiggers.' Then we had those vehicles go into another scene where it wasn't just a set of three vehicles, but a set of six vehicles in one very large scene and they dance through Heffalumps and Woozles into Pooh's nightmare. And then we then added a [seventh] trackless show vehicle that has characters in it and is choreographed with your six vehicles."

"Getting Pooh's Hunny Hunt opened is like sending a probe to Jupiter," joked Dave Durham, the Imagineer in charge of the ride's incredibly complex programming. "We were coming up with a way to program these multiple vehicles—nobody had ever done that before." Further complicating the work was the need for each set of three honey pots to move

through each room, and have time for the room to reset, all in thirty-to forty-second intervals, before the next "hunny pot" trio moved in.

Once the vehicles were functional and the computer control system was set up, Durham's team needed eighteen months to program the ride in real time, and in a real space. Since the attraction building was not ready that early, and no single space near Imagineering in Glendale was big enough to house a full-size mock-up, the team worked on one room at a time. In an anonymous warehouse near the Burbank airport, they decided they could put tape on the floor to represent the walls and obstacles in the attraction's first room and run the trio of vehicles through their paces until the programming was perfected. "Then they're going to rip up all the tape and put the tape down where scene two would be," Durham said. "Then, we're gonna program scene two. We're gonna rip up all the tape and put down new tape. We're going to do scene three.

"If we do it perfectly, then all these scenes should perfectly blend together at the edges," observed Durham. Some of Durham's coworkers were doubtful this system would work, but Durham went boldly forward. "It took us a year and a half, and then we went to Tokyo, dropped it in [the completed building], and it worked almost perfectly the first time."

The lesson, Durham concluded, was that "Imagineers are problem-solvers. That's what we do. That is purely our job. Whether it's how to best replicate a Wild West street using today's materials and building codes, or whether it's how do you not run [a Hunny Pot] into a door at full speed, we're problem-solvers. Most challenges, people just give up because they're too hard. At Imagineering, we just don't give up."

Tokyo DisneySea utilized a modified version of that trackless system for Aquatopia in Port Discovery. "That was a little bit different," Jue said. "That is a field of water, and these hovercraft-type vehicles travel through different areas of the pond." The utility of the trackless system "was to enable different vehicle motions that you couldn't do on a track—like go backward, go forward, spin on a dime, do spirals." Imagineering's trackless vehicle navigation system would become increasingly important and complex in the decades to come.

Also brand-new for Tokyo DisneySea—and not based on any existing

Disney IP—was Sindbad's Seven Voyages in the Arabian Coast. The dark ride resembled both "it's a small world," in that it utilized boats and doll-like Audio-Animatronics figures, and Pirates of the Caribbean, in its darker story line that summarized the mythical nautical journeys of its title, including the slaying of monsters and the looting of treasure. Indeed, the story line was so dark that the attraction was closed in 2006 to give the Imagineers a chance to brighten it up. It reopened in 2007 with a newly beardless Sindbad, an added tiger cub sidekick, and a fresh Alan Menken song, "Compass of Your Heart," sung in Japanese. The revised attraction was re-titled Sindbad's Storybook Voyage, a family-friendly name that evoked the original kid-centric boat ride Storybook Land in Disneyland.

The *Aladdin*-specific attraction in Arabian Coast was the Magic Lamp Theater, in which a live cast member portraying a magician conjured and then interacted with Disney's frenetic Genie, who appeared as larger-than-life 3D animation. As in It's Tough to Be a Bug!, audience members wore 3D glasses and the action on the screen was presented as happening within the theater. It was the first 3D representation of Genie, and to make sure the character was true to the film, the Imagineers worked with Eric Goldberg, Genie's original animator, and a team of Disney CG animators in Burbank—all of whom learned just enough Japanese to create the carefully timed illusion of conversation between the live magician and the animated Genie.

The most elaborate new attraction in Tokyo DisneySea was another Jules Verne narrative: Journey to the Center of the Earth. It borrowed technology from a Walt Disney World attraction that was in development at the same time as Tokyo DisneySea called Test Track, which opened in March 1999 in the building previously occupied by the World of Motion pavilion in EPCOT. To create the attraction, Barry Braverman recalled, Imagineers visited the GM proving grounds in Milford, Michigan, where GM executives told them, " 'If you can take this energy of what it is like to test a new vehicle and translate it into a ride, you've got something.' And we did. And it was a great project."

It was also a notoriously delayed project, first announced for the spring of 1997 but repeatedly pushed back. Imagineers wanted to

faithfully simulate the swerves, sudden stops, and other challenges consumer vehicles must master before being manufactured for market, including reaching a speed of sixty-five miles per hour. Imagineer Brad Ferren of R&D was determined "to avoid subtlety at all costs," as Test Track concept designer Kevin Rafferty recalled, determined to make the experience "different from anything we've ever done. Faster. Smarter. Better." Those goals were achieved, but only with a lot of stops and starts.

By the end of 1998, however—nearly two years before Tokyo DisneySea's scheduled opening—most of the kinks had been ironed out and the attraction was ready for a soft opening, allowing park visitors to be the final test drivers in the three months before the official opening. That meant the Tokyo DisneySea team could repurpose the technology without reinventing the wheel, so to speak.

The Journey to the Center of the Earth narrative combined Verne's two best-known stories, imagining that Captain Nemo had burrowed so deep into his mountain lair that his tunnels had connected with the fantastical realms at the center of the Earth. The attraction's six-person vehicles were designed to look like mining bulldozers, with plow-shaped prows as if ready to burrow through rock. The story referenced elements of the novel, as the cars at varying speeds through caverns of luminous crystals and a mushroom forest, then dodged a cave-in and powered through lightning on the shore of an underground ocean. The finale was an encounter with a lava monster—one of the largest Audio-Animatronics figures Imagineering had ever done—before rushing back to the surface in an apparent eruption of Mount Prometheus.

The lava monster is "really pretty creepy—really, really scary," Kirk said. "I mean, you're there and it's hot and it's steamy and there's lava and he's going to eat you. And you get out of there." But there was no way to be certain of that effect before the attraction was actually built. Journey to the Center of the Earth was developed at a curious time in ride software development. While complicated programming was necessary to run the show so each vehicle's journey was perfectly timed to the special effects and other vehicles, the attraction was modeled the old-fashioned way. "There was never any [animated] computer modeling like

it is today, which is incredibly sophisticated," Kirk said. While they used some static early modeling software for the sets, computers couldn't pre-visualize the ride experience in real time. For that, a detailed miniature had to be built. "A little snorkel camera would go through a large-scale model. I know we did that for the Sindbad ride, and for Journey to the Center of the Earth."

The challenge with a snorkel camera gliding through a scale model, Kirk said, is "you just don't know what it's going to feel like. You don't know what the vehicle is doing. You can say what you want it to be, but you just don't know what the ride system can deliver. We did mock-ups for Journey to the Center of the Earth that were really wonderful and fun. But you had to intellectually piece together that string of visceral experiences."

Kirk said he had long identified three stages in the proving of a ride experience, separated by months if not a year or longer. First was the modeling phase. Then came "walking through a mock-up of the sets themselves. Almost all the set work for all the attractions was done by Imagineering in different warehouses around the [Los Angeles area,] where I could walk through to see the rough lighting and see the sets that were available. At least you could get an idea."

Step three, Kirk noted, "is when you're actually going on-site and you can ride before opening," when the Imagineers go through the attraction again and again, tweaking the vehicle programming, the sets, the lighting, the audio.

Nowadays, he said, Imagineers in the early stages of development "could do a computer model of the whole thing." They could watch it at their desks, adjusting each segment as needed—minus the snorkel cameras.

What the computers of the time could provide were static 3D design models, which would render point-of-view images from any given spot in the park, and from any height off the ground. The detail was lacking, Kirk said, "but we could solve a lot of visual intrusion issues and [predict] the Tokyo Bay view. Computer modeling, he continued, was "the biggest technological breakthrough that ever really leveraged our design team" during the creation of Tokyo DisneySea. It allowed the designers "to figure out as I'm walking inside the park, when I'm walking around

a corner, what do I see in front of me? When do I see the Indiana Jones pyramid? That kind of thing. These were not sophisticated models, but they were definitely incredible design tools and way better than the old-fashioned snorkel cameras."

One structure that was modeled in the computer in detail was the sprawling Ambassador Hotel, which fulfilled the Disney's America plan for a luxury hotel within the park. "Initially we didn't have any hotels in the Tokyo resort," recalled Wing Chao. "But later on we added three hotels, and the second one was the MiraCosta, part of Tokyo DisneySea. It was integrated [into the theme park]," straddling the entry passage from DisneySea Plaza and stretching out in both directions, with two wings that served as the upper stories of the buildings along the Mediterranean Harbor waterfront. (Inside the park, the lowest floor was used for retail shops and restaurants.) The wing to the left of the entry passage connected to a semicircular section that looked out on a Venetian gondola ride. "It's an Italian theme [hotel]—part Portofino, part Venice, part Florence. And so the architecture really has various facades"—depending on whether it was viewed from the gondolas, the waterfront, or the hotel's own beautifully landscaped entrance outside the park.

Many hotel guests would have twenty-four-hour views within the park, whether looking over the gondolas or facing the dramatic landscape of Mysterious Island and Mount Prometheus. And the Imagineers knew what those views would look like, because the park and the hotel had been created as computer models before they were built. That meant an Imagineer could tell the computer to place a virtual camera in, say, a fourth-floor hotel room window facing Tokyo Bay and see whether the sight lines cleared the park. The five-story hotel also served as a berm, blocking views from the park toward Tokyo Disneyland and parking facilities.

Kirk relied on the modeling software, but he wasn't entirely convinced about its accuracy until he actually crossed the bridges on-site, just before the opening, and the views of Tokyo Bay were exactly as predicted at every point. That's when he thought, "Phew! That's a few billion dollars well spent."

CHAPTER 22:

TAMPERING WITH THE FORMULA

"You can't fool people. . . . They can tell when things are being shortchanged or you're not paying attention to the details and putting the quality into something. Walt used to say, 'If you do a good job, they'll pay for it.' And I think they started seeing that we weren't doing that good of a job anymore." —Kim Irvine

I. ECONOMIES OF SCALING DOWN

JACK LINDQUIST, who had taken a stand against Disney characters in the new EPCOT Center in the early 1980s, had spent the early 1990s as president of Disneyland. He was a marketing guy, but Marty Sklar had considered him a good friend and an ally. Lindquist had lobbied for the expansion of Disney's original theme park and for a second gate on the Anaheim property—both causes that were key to the future of Walt Disney Imagineering. A month after he retired in 1993, the Imagineers honored him with a window on Main Street, U.S.A., above City Hall. It read: "J. B. Lindquist, honorary mayor of Disneyland. Jack of all trades, master of fun." Then the Imagineers settled in for anxious months awaiting the announcement of who would replace their longtime colleague overseeing Disneyland on the operations team.

The answer came in November 1994: Paul Pressler, a former marketing executive at Kenner Parker Toys, makers of *Star Wars* action figures and board games. The man who would take on the job of leading the

ten-thousand-plus Disneyland cast members had never been inside a Disney park until he joined the company seven years earlier. He had first run licensing for Disney's consumer products division before landing the top job for the Disney Stores chain in 1992, where his success—fueled by the demand for toys related to *Beauty and the Beast* and *The Lion King*—had impressed Michael Eisner. The Disney CEO hailed Pressler as a "talented, creative business executive," and the *Los Angeles Times* dubbed him "a self-effacing, energetic Disney devotee known for a rare combination of business acumen and artistic inventiveness."

Walt Disney Imagineers and many veteran Disneyland employees would soon have a different opinion. Unlike Lindquist, Pressler was not a friend of Sklar's. "Initially, we had issues," Sklar told the *Los Angeles Times*. An early conflict was over the window displays along Main Street, U.S.A., which Pressler wanted to fill with the most popular merchandise and the Imagineers wanted to maintain, as they had since 1955, as displays where the inventory served to reinforce the narrative of each store. As the *Times* reported, "The Imagineering division looked at how the stores fit into the theme park while Pressler's approach relied more on what works at a store in a shopping mall." Sklar said they "worked out these issues," but Pressler's reputation among Imagineers never recovered.

"Paul came from a merchandising background, and so merchandising became a whole focus of most of what he did," said Imagineer Kim Irvine. "So, the park changed dramatically under his leadership." Pressler installed his own hires—"he called them his world-class leaders"—at the heads of the food, merchandising, and operations divisions at the park, displacing people who had been there for years with "all these different people that didn't understand our tribal knowledge. They didn't get it. They didn't know why guests came here." They didn't know, Irvine added, "that you couldn't mess with it so much that it became a different beast."

Pressler explained his personnel changes with a comparison to Walt Disney Imagineering. "We had really good operations people, but we didn't have creative people that [could do] what Imagineering does for rides," he said. His new team was "going to help envision products that

are going to be unique and different," including in the park's food service and retail sites.

Pressler had been Disneyland president just two months before WESTCOT—planned as a West Coast version of EPCOT—was scrapped, but he insisted his mandate from Eisner when he took the job was not to stall a second Anaheim theme park, but to build one. It's just that WESTCOT was not that park. "It wasn't a creative issue," he said. The plan had been "phenomenal," he judged, but impractical, bringing in more people than the infrastructure could handle and costing more than the company felt it could recoup. Anaheim's second gate needed to be "scaled back to a level that the company felt we could move forward prudently and make money."

The company's focus for the project was as much or more about upgrading Anaheim as it was about a new theme park. The resort plan, Pressler said, needed to include funding for improvements to the area surrounding the parks—even if the local government wasn't contributing much to the face-lift—meaning there would be less money to build a second gate. "The vision was for us not only to build a second park, but how could we transform Anaheim into a resort destination. How do we put [in] beautiful tree-lined streets and how do we improve the infrastructure in parking? How do we get the other hotels to upgrade their facilities to make this more of a destination as opposed to kind of a one-day trip? So that was the mandate. And we found a way to make all that happen."

After WESTCOT was discarded, Eisner asked Imagineering for new proposals. "Michael and I assembled the Imagineers," Pressler recounted. The brainstorming "charette" would stretch over three days in Aspen, Colorado, and it was held with an uneasy sense of urgency. "The window of opportunity to do this was fairly small," said Barry Braverman, one of the Imagineers at the charette. "We had one more shot to figure out an idea for the second gate that would make this whole thing work."

The funding for the resort project was still substantial, but much of it had been designated for a new hotel, the shopping complex, a parking deck, and other infrastructure upgrades, leaving a smaller slice for Imagineering to work with. It was clear, Braverman said, "this second park

was going to have to be austerely budgeted"—limiting not only its size and scope but the Imagineers' creativity. By Braverman's recollection, Pressler and the strategic planning team told the Imagineers to think of something "much smaller than Disneyland, much fewer attractions. But it's a piece of something big."

Knowing that Imagineering was going to have to import assets from Walt Disney World that could be re-created and repurposed for an Anaheim park, Braverman proposed something relatively modest. "Actually, I was not the only one," he said, "but I did pitch the idea of a park themed around California, because I thought that would be a cool thing to do. I figured the California theme—with Hollywood and the beach and the farming and the great wilderness of the High Sierras—would give us a lot to work with, a lot of places to put things. Because we knew we weren't going to be able to invent every ride out of whole cloth."

There were other park proposals from the Imagineers meeting in Aspen—focusing on sports, the oceans, and Route 66, to name a few— but the California pitch was the one Eisner liked. He also liked bits and pieces of the other proposals, so the Imagineers cobbled together a hybrid that came to be called Disney's California Adventure (which notably dropped the apostrophe "s" in 2012 and became what we simply call today: Disney California Adventure). Braverman was asked to drop what he was doing in EPCOT and focus on the proposed Anaheim park. "What we wanted to do with California Adventure," Pressler said, "was not just celebrate the state and all of its cultural blend and history—and certainly the movies was part of that—we wanted to make it more immersive. A little bit more like EPCOT in innovations where it wasn't just about riding rides. It was about immersing yourself in the lifestyle and the culture, particularly around the workplace and a lot of the history."

By the time Disney California Adventure was conceived, Tokyo DisneySea had been in the works for about four years—not counting the years that the Oriental Land Company patiently waited for a plan they could embrace. Yet the two parks were expected to open around the same time, in 2001. The official announcement of the park's name and theme wasn't made until July 1996, and even then Disney shared more

about its plans for a 750-room luxury hotel—the Arts and Crafts–themed Grand Californian—than it did about the attractions planned for the park. A statement teased that experiences would range from "the glamour of Hollywood to the exhilaration of soaring above Yosemite Valley."

"We really haven't decided what will go in the park," Judson Green, president of Walt Disney Attractions, told the *Orlando Sentinel*. "It's at a very conceptual stage right now."

"We had to do this thing from the start to finish in five years," Braverman said. "And we didn't even have a site to start with, because it was a parking lot." A new parking facility had to be built off-site, with shuttles to Disneyland; then the existing lot needed to be cleared. Utilities had to be laid. Some of the deals struck with local governments for planning and funding of infrastructure as part of the WESTCOT negotiations would carry over to Disney California Adventure which saved some time. Still, Braverman said, "it was a very fast-paced project and very constrained in lots of ways."

For one thing, Braverman's park team had to coordinate with the designers for two adjacent projects: Downtown Disney, the new outdoor shopping and restaurant concourse, and Disney's Grand Californian. "There was no, 'Well, Downtown Disney you do your thing and we'll do ours.' No, because they were right on our edge." Like the Hotel Mira-Costa at Tokyo DisneySea, the Grand Californian would serve as the border and berm along one edge of the park, with many rooms offering views inside an area of the theme park dedicated to California's forests and mountains—meaning plans for a fringe of tall trees had to be scaled back to preserve the hotel guests' sight lines. "It was constant negotiation like that all the way along to try to make sure that all the pieces had their due," Braverman said.

The contrast between the DisneySea and California Adventure projects was immediately apparent at Imagineering. Housed in different buildings on the Glendale campus, they might well have been in different worlds. With Oriental Land Company funding DisneySea, it seemed like the sky was the limit, while the self-funded Disney California Adventure needed to build on budget about half that of the canceled $3 billion

WESTCOT. The DisneySea team created at least a dozen rides and shows that had never been seen before or had been substantially reconceived. Disney California Adventure would have just a handful of thrilling new attractions—and a lot of space filled with lower-cost, lower-appeal sites such as dueling bakeries (sourdough vs. tortillas!) and miniature farm fields. The DisneySea team was immersed in architectural detail, endless varieties of surface textures, and how to build a mountain the size of the Disneyland castle. Disney California Adventure would have undistinguished pavements, scaled-down architecture, and no real "wienie" to anchor the park. (Its sole mountain would top out at 110 feet, with an outcropping shaped like the head of a bear—the symbol of California.)

DisneySea team members got to fly to Tokyo to work on a park with ocean views. Disney California Adventure Imagineers were transforming a parking lot in Orange County with a backdrop of hotels and power lines.

"We were working on two different tracks," said Marty Sklar. "One was for Tokyo DisneySea, and we had a different kind of budget for Disney California [Adventure]. There were a lot of people at that time that had a difficult time going to lunch together—one group had a large budget, the other group had a very tight budget. And so there was this feeling that they were kind of underprivileged."

Braverman acknowledged the disparities but said his team members were committed to the project as it had been conceived. "One criticism that some people raised was, 'Well, why do I want to go to a park about California when I'm in California? I can see the real thing.' I said, 'Yeah, but you can't go to all these places in one day, and you can't have experiences that are distilled and presented through Disney magic.'" The park, he continued, wasn't intended as a textbook but as a celebration of "the California dream, manifested in the dream of Hollywood, of stardom, the dream that's represented by the beach and surfing and all of that. The dream of flight, of aviation. The dream of agricultural bounty. All these things that became areas and lands of the park were embodiments of the California dream. And that gave us a lot of leeway."

Disney California Adventure abandoned the hub-and-spokes model prevalent in previous Disney parks and offered, at opening, just three

lands and a small plaza. Everything to the left of the entry was the Holly-wood Pictures Backlot. To the right, guests would walk through Golden State, a land that combined smaller themed areas called Bountiful Valley Farm, Pacific Wharf, the Bay Area, Grizzly Peak Recreation Area, and Condor Flats, which resembled Edwards Air Force Base in an earlier era.

Golden State was home to two of the park's three E-ticket thrill rides, one of which—Grizzly River Run—was similar to Kali River Rapids in Disney's Animal Kingdom Theme Park, but with two steep drops instead of one. Farthest from the entrance was Paradise Pier, a Disney dream version of the seaside amusement parks along the coast of California, with a mile-long roller coaster called California Screamin'—the park's third big thrill—Disney's first midway, the 150-foot-tall Ferris-like Sun Wheel, and several smaller-scale rides.

Eisner was a big supporter of the layout, Braverman said. He liked that the park's backlot section would provide a home for Muppet*Vision 3D and other elements from the Disney studio park at Walt Disney World. He liked that the park's farm could incorporate the It's Tough to Be a Bug! attraction from Disney's Animal Kingdom. The park might not have everything in it that the Imagineers would want, Braverman acknowledged, but team members were fully committed to "trying to build a foundation for what could come later. And, of course, we left a lot of land available. So my mantra for my team was, 'Fill the page. Let's not sit around and grouse about what we don't have to work with. Let's fill the page with what we do have to work with.'"

A park just over half the size of Disneyland—at fifty-five acres—would be expected to attract about half as many visitors, possibly for about half a day each. "I think that we estimated the first-year attendance would be about five million," and the lower ride capacity would match that attendance, Pressler said. He liked to paraphrase a famous quote from furniture designer Charles Eames about how restrictions could fuel creativity: "I have never been forced to accept compromises," Eames said, "but I have willingly accepted constraints."

Imagineers, Pressler believed, would "be able to find a way to bring Disney quality, Disney creativity in a tighter budget, to make the economics

of the park work. The idea was, this is the box, this is the envelope, this is the dollars we have; how can we be the most creative that we can be?"

Eisner also channeled Eames. "Often financial control creates more creativity," he said. "People think if you put a financial box around a creative person you are inhibiting them. I think the opposite. I think what you're doing is you're forcing a person to be even more creative. To do really great things within a reasonable budget."

II. SOARIN' AND CRASHIN'

If Disney California Adventure was to be a virtual tour of the Golden State, its entrance would serve as the virtual postcard you could send home from your travels. Letters nearly twelve feet high spelled out "CALIFORNIA" across the plaza in front of the turnstiles. Immediately beyond the entrance, the Imagineers reproduced one of the state's best-known icons. "We needed a gateway to California," said Imagineer Tim Delaney, creative director for the park. He snapped his fingers: "Golden Gate Bridge. We'll open up [with] our picture postcard, lead to the Golden Gate Bridge and the only thing we need beyond that is the other image that draws people to California, and that became our sun icon."

Beyond the miniaturized bridge—its proportions distorted to fit a stretch of monorail track—a short stretch of shops led to a big disk, clad in super-reflective titanium, hovering above a modest fountain meant to look like a breaking wave. This was Sunshine Plaza.

"When I finally sold this idea to Michael Eisner," Delaney recalled, "instead of getting congratulated, everyone said, 'Aaah, it's great. You're two years behind. Catch up.'"

Some Imagineers weren't buying it. According to Kevin Rafferty, the entry experience—and the park in general—had abandoned "our fundamental design principles of theme park design. There were all these visual cues that were kind of contradictory. You know, there were great big California letters. There was a stylized Golden Gate Bridge that was kind of foreshortened and was kind of fake and suggested that this wasn't a real place. And the first statement that you saw when you walked into

the gate was the sharp sun. Frankly, you could have seen that at a shopping mall in Newport Beach [California]. It's like, why is it here?"

The Imagineers' decision not to build a berm around the park to block views of the surrounding utility poles and non-Disney buildings also came in for some criticism. Imagineer Tom Morris attributed that choice to mere contrarianism. "We were going to just do the opposite because we haven't tried that yet and we like to do new things," he said. The Imagineers told themselves a berm wasn't needed, because "what you see on the outside of California Adventure, it's California. It's just another part of California—[part of] the scenery. That sounds good, except it . . . doesn't really work."

It was a lesson in rule breaking, Morris noted. "We need to break rules, 'cause breaking rules is fun and you do discover new things when you break rules. But you have to have rules in place before you could break them." With Disney's California Adventure, he continued, "we were just trying some wacky stuff that either wasn't appealing, the guests had no interest in, or, sometimes, they were appealing but weren't operationally feasible."

There was one attraction in the park that was appealing, feasible, and admired by all: Soarin' Over California. The original concept was to replicate a hot air balloon ride, but that soon evolved into re-creating the sensation of hang gliding over many of California's most scenic landscapes, from coastal surf to Yosemite peaks to Disneyland itself. The mechanics were conceptualized by Imagineer Mark Sumner when inspiration hit over one Thanksgiving weekend. At his home, using the materials at hand—an Erector Set—Sumner built a small model of a system that would load riders in three parallel rows on the ground level of a huge theater, then lift all three rows in an arc so that the front row became the highest of three stacked rows. Riders would be safely belted into seats, but their feet would dangle, as if in a hang glider. The illusion would be completed by an enormous concave screen, eighty feet across, like a dome on its side, so that the view from the swinging seats was completely taken up by the high-resolution film clips.

To test the mechanics, Sumner and his team utilized a Star Tours

simulator mechanism that Imagineering had stored in a Glendale warehouse. With the cabin removed, the Imagineers used the remaining platform to create a mock-up of the hang glider system, with a wind machine to blow air onto the test subjects' faces and a film of the ocean in front of them. "When they would dive down towards the water," Sumner recalled, "probably seventy percent of the people would pick their feet up so they wouldn't get their feet wet. We're saying, 'This is gonna work. We think we can pull this off.'"

"In some ways I think Soarin' is the twenty-first-century version of Circle-Vision," said Tom Fitzgerald. Instead of a 360-degree view on a series of rectangular screens with seams between them, "how about we take you into the screen where you see no edges, and you really feel like you're flying?" The Imagineers dispatched filmmakers in helicopters to fly through elaborately choreographed mini narratives at different California sites: surfers at Malibu Beach, rock climbers and hang gliders at Yosemite Falls, rafting on Redwood Creek, hot air balloons rising over Napa Valley, fireworks over Disneyland, and so on. The film was shot in high-definition IMAX format at forty-eight frames a second to be as sharp and immersive as possible, and appropriate scents were pumped into the auditorium so riders could smell the oranges and the pine trees. Wind machines provided the sensation of moving through the air.

Even Paul Pressler enhanced the narrative. "My one tiny little contribution creatively was when you flew over the [Palm Springs] golf course. I said, 'Wouldn't it be great if a golf ball came flying at you?'" With a touch of animation added to the live-action footage, Pressler's golf ball joined the show. "Those were the most fun days of working with the Imagineers and finding creative solutions and engineering solutions to bring these things to life," he said. "That was a real joy."

The ride system was a masterful combination of imagery and motion—including the impression of motion that wasn't happening. "We were concerned, 'Do we need to tilt this thing side to side to give people the sense of banking around a river bend for example?'" Sumner said. "What we found out is, visually, we could pull that off—we really didn't need to bank it. In fact, I've had people sit next to me on the attraction

and swear that we're moving this thing side to side and we're not. The other important thing that we did learn was that adding a little bit of pitch, which is swinging like you would on a child's swing, just a few degrees makes a big difference."

"It involves not only a new ride system, but also some really breakthrough ideas in projection technology, programming, and so on," Braverman said. "It really is, probably, the most ambitious thing we were able to pull off [in Disney California Adventure]."

For Dick Nunis, it was a filmic triumph foreseen by Walt Disney. He recalled Walt's first experience with Circle-Vision 360 in 35mm—upgraded from 16mm. "I thought it was fabulous. We could hardly wait for Walt to come in and see it. He stood around and looked at it, and he said, 'Roll it one more time.' Then he folded his arms and at the end of it he says, 'It's pretty good.' Then he said, and this is classic Walt, 'Someday, the technology will be where we'll have the picture all around us. All the sides, and no screen.'

"Well, today we have Soarin', Nunis reflects. "And in my opinion, that's the dream that Walt would be more proud of than anything." Bob Iger, president and COO of The Walt Disney Company when California Adventure opened, called Soarin' simply "one of the greatest attractions the Imagineers have ever created." In years to come, it would be repeated and refined at three more Disney parks, in both cases becoming one of the park's most popular attractions and also later introducing an updated Soarin' Around the World attraction.

The California Screamin' roller coaster on Paradise Pier was its own collection of technological marvels, largely disguised to resemble a mid-twentieth-century amusement park staple. But riders would immediately notice a difference. Rather than being ratcheted up a tall slope to allow gravity to supply the vehicles' speed, the cars began at ground level and were catapulted from zero to fifty-five miles per hour in four seconds, launched up the first, tallest hill by a magnetic force created by 5,000-amp motors. To guarantee that fully loaded coaster trains would travel the same speed as empty cars, thus reaching the end of the journey in carefully choreographed intervals, the Imagineers placed linear induction motors

along the track—similar to those used twenty years earlier for the Houston airport WEDway. Connected via computer to sensors along the track, the motors could adjust each vehicles' speed by increasing or decreasing the magnetic forces provided along the way by additional motors.

If Soarin' and Screamin' were the apex of Disney California Adventure, then the nadir was a black light dark ride called Superstar Limo, in the Hollywood section of the park. The ride placed guests in six-seat purple "limousines" and took them past various Hollywood tableaux, dotted with barely animated 3D caricatures of then-current celebrities, including Cher, Drew Carey, Regis Philbin, Whoopi Goldberg, and Tim Allen. The crowds and journalists and police were mostly represented by flat cutouts and cartoonish murals, and the sets were an assortment of mostly two-dimensional comic book renditions of Los Angeles locations rendered in garish colors.

The failure was partly a result of last-minute changes made to the attraction's original concept. The limos were supposed to have been speedier vehicles careening through Los Angeles, trying to escape the paparazzi in a race to meet up with Michael Eisner in time to sign a contract with Disney. But the death of Princess Diana in Paris on August 31, 1997—in a high-speed limo accident that may have been caused by paparazzi—put the brakes on this idea. There was no time (or budget) to replace the attraction, and it was the only grown-up ride in the Hollywood area that could be ready to open with the park. (Muppet*Vision 3D was nearby but was a stationary show and targeted a younger audience.) So the vehicles' speed was reduced, and the mention of *paparazzi* eliminated. The storytelling was essentially lost, breaking a foundational principle of Imagineering.

The saga of Superstar Limo has become a cautionary tale within Imagineering, according to Imagineer Bruce Vaughn. "Everybody can tell you the story. The original was probably too self-referential about Hollywood, 'cause it was a paparazzi ride and you're catching celebrities as they're taking out the trash and things—I mean, really. But you could see in a pitch room how that could be funny. But then you end up with Princess Diana dying right midway while the project is being

installed, and suddenly paparazzi are a really bad theme. Well, you're almost done [building the ride]. What are you gonna do? So now it turns into, you're gonna be a star. But all the figures are kind of grotesque. It just didn't work. What should of [been] done was stop [and ask], is this good enough to open with?"

Vaughn did not fault the Imagineers in charge of the project as much as he did dysfunction within Walt Disney Imagineering at that time. "The culture wasn't really listening to each other," he said. Even within a team working on the same park, "They would just go into these little pods of 'This is my land' or 'This is my attraction, and I've lost touch with my peers.' There was no sense of, 'Hey, wait a minute, is this good enough?'" That failure to collaborate effectively may have contributed to Disney California Adventure's overall incoherence—it certainly helped doom Superstar Limo, which closed just eleven months after the park opened.

"As had happened with those transit boats at Animal Kingdom," Vaughn points out, "guests waiting in long lines developed certain expectations, and they felt shortchanged, perhaps wondering whether Disney magic was fading. "The guests don't lie," Vaughn said. "Their reaction to what we create is the Disney brand at the end of the day."

III. A CREATIVE CHASM

Dancers in ocean blue and sunshine gold bounded across the stage set up outside Disney California Adventure on February 8, 2001. Some displayed fifteen-foot banners emblazoned with aspirational words such as "imagine," "celebrate," "explore," and "brilliance." At the end of the dance, the big blue disks that had been lined up against the backdrop were rolled away to reveal letters spelling out CALIFORNIA—the plaza postcard effigy, which had been incorporated into the temporary stage.

Whether it was the chilly weather or the relatively scaled-down nature of this dedication ceremony—no band, no singing, no children, just one Disney character—the speeches were brief and stiffly delivered. Roy E. Disney talked about his father and uncle and the dreams associated with California—a repeated theme of the brief celebration—and Michael

Eisner read the park's wordy dedication plaque, standing next to Mickey Mouse. This plaque differed from those that had gone before it by honoring anonymous people from history: "the native peoples, explorers, immigrants, aviators, entrepreneurs, and entertainers who built the Golden State." Rather than a parade of Imagineers, the special guests at this opening were Art Linkletter, eighty-eight, and Buddy Ebsen, ninety-two, who had both taken part in the opening of Disneyland forty-six years earlier, as well as some original Mouseketeers. The one Imagineering representative onstage was Marty Sklar. He was recognized along with Dick Nunis, who had retired as chair of Walt Disney Attractions in 1999, not for their decades of leadership but because they had been original Disneyland cast members in 1955.

To mark the opening, the *Los Angeles Times* published a glowing profile of Paul Pressler, who had risen from his 1995 appointment as president of Disneyland to become president of the company's theme park division in 1998, and then chairman in 2000. Then called Walt Disney Attractions, the division had been renamed Walt Disney Parks and Resorts in 2000. It oversaw all theme parks and hotels, both sports teams, the cruise line, and regional entertainment sites, chiefly the two Disney-Quest locations and ESPN Zone restaurants. Parks and Resorts brought in $6.8 billion in revenue in 2000 and employed more than two-thirds of the company's 120,000 cast members.

Regarding Disney California Adventure, the *Times* article noted that "Pressler's management of Disney's $1.4-billion backyard investment has spurred another $3 billion in public spending to make massive freeway improvements, enlarge the adjacent Anaheim Convention Center, build a 10,000-space parking garage and give the entire district a unified, landscaped look." The groundwork for that public investment had actually been laid by negotiations for the WESTCOT project, which began while Pressler was still running the Disney Stores.

The news buried in Pressler's recent resume was that Walt Disney Imagineering was also now part of Parks and Resorts. Imagineering had previously been part of The Walt Disney Studios, essentially reporting to Eisner himself. In 1998, when Pressler became president of Walt Disney

Attractions, Imagineering began reporting to him. The business side now officially ruled over the creative. "I had Walt Disney Imagineering reporting to me," Pressler said, but "I didn't envision running it, nor did I run it. Marty [Sklar] ran Imagineering. So my goal was really to help support Marty. What I tried to do was to bring a little bit more of why do the business people and the operators make the decisions that they make. How do we integrate the creative into that decision-making?"

Pressler may have considered himself hands-off, but many Imagineers did not. Looking back at the period that produced Disney California Adventure, Imagineer Joe Rohde judged it "probably the bleakest era that I could think of, because it was the most dominated in a forceful way by this: 'We're the business guys. We know this; we have data here. The data says this. We're following this data. You're doing this because that's what it says here. This is math.'"

The interference with Imagineering went beyond budget constraints, according to a report in the *Los Angeles Times*, which dubbed the new park "Michael Eisner's Fantasy Resort." Reporter James Bates wrote in September 2000 that "the $1.4-billion theme park has carried his imprint everywhere. . . . The sunny colors? Eisner chose them. An acre devoted to farming? Eisner's idea. The slope of the water rafting ride? Eisner ordered it scarier. The Craftsman-style drapes and wallpaper in the new 750-room Grand Californian Hotel? Eisner's choice. The location of pegs where hotel guests will hang their coats? Don't ask."

Bates summed up the situation succinctly: "For Eisner, California Adventure offers a challenge Disney hasn't always met: can the company build a popular theme park without busting a budget?" The goal was to "prove that financial discipline can coexist with theme park creativity."

The experiment was not an instant success. The park opened with about a third as many attractions (including shows) as Disneyland had in 2001: twenty-two, compared with sixty-three. But admission prices were identical: $43 for adults and $33 for children ages three to nine. The press was lukewarm, and guests complained that there wasn't enough to do and very little to hold the attention of children. After a slow summer, chef Wolfgang Puck pulled his pricey Avalon Cove seafood restaurant out

of the park. Attendance, projected at seven million for 2001, was just five million for those first eleven months, while the twelve-month total attendance in Disneyland was more than twelve million.

"There are some good things in the park," said John Lasseter, the writer-director of Pixar's *A Bug's Life* and *Cars* and represented in Disney California Adventure by Cars Land and Pixar Pier. "Soarin' was phenomenal. Screamin' was a great roller coaster. But it fundamentally didn't work really as a Disney park. Because when you walk into Disneyland, you know you're at a Disney park. When you walked into Disney California Adventure, it felt like it could be anywhere. I kept walking around going, 'Oh, no. This is—,' 'Oh, they didn't—.' It's like they didn't want to spend any money on the place-making."

Given the park's size and number of attractions, most guests could see all they wanted to see in a one-day visit—and some left disappointed by that accomplishment. The allure of theme parks, Tom Morris pointed out, lies in part in being so jam-packed that you have to leave some things for another visit. "What you don't see and what you don't go on is just as important as what you do go on. It's alchemy."

Kim Irvine put it bluntly, "You can't fool people. You know, they can tell when things are being shortchanged or you're not paying attention to the details and putting the quality into something. Walt used to say, 'If you do a good job, they'll pay for it.' And I think they started seeing that we weren't doing that good of a job anymore."

Imagineering legend John Hench provided the most biting assessment. When asked what he thought of the new park, Walt Disney's old friend reportedly answered, "I preferred the old parking lot."

Those who visited both Disney California Adventure in Anaheim and Tokyo DisneySea, which opened six months later, were particularly struck by the creative chasm between the two parks, built by Imagineering at the same time. "We all look at it now and say California Adventure didn't have enough of the rich place-making," said Imagineer Bruce Vaughn. "This was the shocking thing to me, too. I had been to Tokyo DisneySea, which was well funded by Oriental Land Company and is a masterpiece of place-making."

Vaughn continued, "It lacked a little bit of character and warmth, but that was by the directive of Oriental Land Company. They wanted a park that was completely different than the Magic Kingdom—something more sophisticated and more adult. But the quality and richness is unbelievable. At the same time, we're building California Adventure—same culture, Imagineering. And you end up with great things like Soarin' . . . And at the time there's an attraction that's Superstar Limo."

Braverman believed his team took the blame for many decisions they didn't make. "I think that the park is beautiful," he said. "Obviously there was disappointment in the attendance levels in the early days and lots of less-than-positive press. [But] I felt like we were being judged on criteria that were really unfair in terms of the task we were given."

The initial admission pricing was also out of their hands. "The way in which the two parks were offered to the public probably could have been done in a way that would have given California Adventure [the time needed] to come along as the little brother of Disneyland and grow into a full-blown park. But we didn't have that opportunity from some people in the press."

Braverman acknowledged that some of the Imagineers' choices meant to differentiate Disney California Adventure from Disneyland park were exactly the sticking points in visitors displeasure: the initial absence of Disney characters, the "avant-garde" theater artists who appeared in the place of parades, and the effort to have the park "skew a little older," which slighted families with small children. As a result, some guests "weren't finding [in Disney California Adventure] what they expected from Disneyland. So that disappointment—I understood that. But over time we tried to respond to those things. Fortunately for us, there are Act Twos in our theme park business."

The attempt to fashion Act Two began within months. During the first summer, admission prices were lowered for Southern California residents, and the Main Street Electrical Parade was brought out of retirement. Disney characters were introduced in a Goofy-themed show and elsewhere. Avalon Cove was replaced with a more affordable eatery, offering meals with greetings from Mickey and Minnie and other

characters. Then came the events of 9/11, and visitation hit a new slump that lasted well into 2002. One year after the opening, Pressler declared himself "a proud father" and promised he wouldn't give up on the park. Then, a few months later, he quit Disney to become CEO of The Gap Inc. clothing store chain.

Some plans for the park that had been dismissed as too costly under Pressler suddenly seemed imperative. Imagineers had wanted to include *The Twilight Zone*™ Tower of Terror attraction in the Hollywood area, but the budget and rushed schedule wouldn't allow it. Now it was green-lit—but would still take years to build. (It opened in May 2004.) Once Superstar Limo was permanently parked, that space was also available, but it took the Imagineers until December 2005 to completely re-theme and rebuild the dark ride as Monsters, Inc. Mike & Sulley to the Rescue! (The limos became taxis, the celebrity figures redressed as monsters, the cartoonish sets replaced with more dimensional scenery.)

One criticism that could be addressed more quickly was the lack of attractions for small children. Using It's Tough to Be a Bug! as the anchor, a new area for tykes opened in October 2002. It was called Flik's Fun Fair, after the ant protagonist of *A Bug's Life*, and the combination of the Fun Fair, It's Tough to Be a Bug!, and the Bountiful Valley Farm was renamed "a bug's land."

Pixar's Lasseter worked on the project with Imagineer Kathy Mangum. He saw "a bug's land" not only as a hub to amuse small children but as a way to counterbalance the slim place-making in the rest of the park. "At Disneyland, Walt Disney created something that no one had seen before. He took you to another place and another time and everything about it was authentic," Lasseter said. "You went through a portal into another place, preventing anything from the outside world to intrude in your vision. When Disney California Adventure opened, they didn't adhere to those things. So it just didn't feel authentic. So when we had the opportunity to do "a bug's land," Kathy and I said to ourselves, 'We're going to make it immersive.'"

The idea, he said, was "to make the guests feel like you're the size of an insect"—a perspective Pixar animators had experienced through

a tiny, mobile "bug cam" that recorded the world from a bug's point of view. To share that feeling with guests, Imagineers designed an environment that riffed on the change of scale. Walking through a discarded cereal box simulated the classic Disneyland tunnel entrance, while the benches appeared to have been constructed from giant Popsicle sticks, still stained fruity colors. Light poles were topped by lightning bugs.

"We wanted everything to feel authentic—like the insects built it," Lasseter said. Just as the forced perspective of Main Street, U.S.A., took guests back to a kind of child's-eye view of the world, Flik's Fun Fair created an ant's-eye view. "We did these huge clovers—translucent, just like the movie—and we put them all over," Lasseter said. "We had one four-leaf clover in the land and didn't tell people where it was."

The new area included four "kiddie rides," each themed to *A Bug's Life* character and seemingly inspired by a similar attraction in Disneyland. Flik's Flyers was a circular Dumbo-style "balloon" ride. Francis's Ladybug Boogie resembled the Mad Tea Party. The miniature Heimlich's Chew Chew Train was a scaled-down version of the Casey Jr. Circus Train, with added candy-scented effects. And Princess Dot's Puddle Park was a flat area dotted with embedded waterspouts reminiscent of the recently opened Cosmic Waves fountain in Tomorrowland—but with a giant garden hose theme. Surrounding the attractions were living plants, selected for their oversized leaves and stalks—"and as they grew, the scale even got better," Lasseter said.

"a bug's land" might have represented baby steps for California Adventure's long road to profit and popularity, but it was an acknowledgment that ignoring a crucial segment of the theme park audience was not a good idea. And while the choice of this story world might have been convenient, since It's Tough to Be a Bug! was already open and space nearby was available for the added rides, it also foreshadowed the future: California Adventure would eventually become the most Pixar-infused of all Disney's theme parks.

CHAPTER 23:

STRUGGLE AGAINST INERTIA

"If it doesn't come out the way I feel it oughta come out, I'm sick. I'm disappointed. It's because we didn't do it, and I say, 'Why the heck didn't this come off? What was wrong, you know? Where were we wrong to start with basically on it?'" —Walt Disney

I. HONEY, I SHRUNK THE THEME PARK

WITH THE OPENING of Disney's Animal Kingdom Theme Park in 1998, Walt Disney World now had four parks. In 2001, both Disneyland in Anaheim and Tokyo Disneyland opened a "second gate." In 2002, it was Disneyland Paris's turn. Just after this second French park opened, Imagineer Bruce Vaughn, the head of R&D, arrived in Paris for a press event within the resort's original Disneyland Park. He had not worked directly on the new park and was looking forward to a private, guided tour.

Peter McGraw, a fellow Imagineer, escorted Vaughn into the new facility, which had a theme similar to what we now know as Disney's Hollywood Studios. It was after-hours, so only a few cast members were left in the park. Vaughn and McGraw walked into what the former took to be the backstage area and continued for about ten minutes.

He was confused. Why did it take so long to get to the "onstage" area where the guests would be? "I was like, 'When are we gonna be in the park?'" Vaughn recalled. "And he turned to me and goes, 'You're in the

park.' And he pointed at the Armageddon marquee—an attraction over there—and I'm like, 'I'm onstage?' He's like, 'You're onstage.'"

Vaughn was floored. The surroundings looked like the backstage area at other parks: "a bunch of gray warehouses." McGraw explained, "Yeah, it's supposed to be like a studio." Vaughn's response: "Oh, God. You gotta be kidding me."

But it was not a joke or a mistake. It was Walt Disney Studios Park, the long-awaited sister park to the opulent—and finally bustling—Disneyland Paris. And it was a disaster. As Vaughn put it, "California Adventure looked great compared to Paris's second gate."

The intention to build another park next to Euro Disneyland had been announced by early 1992, even before the success of the first Paris park had been secured. Disney said it planned to invest $3 billion in a park called Disney-MGM Studios Europe, set to open in 1995 or 1996, along with thirteen thousand more hotel rooms. "I think Michael and Frank were very excited about the public reception to Disney-MGM Studios [in Florida]," recalled Bob Weis. "And I think it gave them this interest in, Does this concept have legs internationally? So that's when we started looking at it as a possible second park for Japan and as a possible second park for Paris."

But when Euro Disneyland failed to meet attendance and revenue projections and came to the brink of bankruptcy, this Phase II development was put on indefinite hold.

Still, there was a contractual obligation to open a second park, or control of the land on which it was to sit would be reclaimed by the French government. Once the renamed Disneyland Paris started to turn a profit, in the mid-1990s, the plans for Disney-MGM Studios Europe were revisited. Dropping MGM from the name—as the Florida studio park would do in 2008—it became the Walt Disney Studios Park. It would open in March 2002, becoming Disney's third new park to debut in just thirteen months.

The park was based on "this idea that people wanted to go and see how entertainment is created, how movies are made," Vaughn said. Unfortunately, "the reality of filmmaking is that unless you are there at

the very moment they are shooting the stars or doing stunts, it's a lot of hurry up and wait—quite boring. I used to be a special effects camera-man, so I know. There are moments of excitement and the final product is exciting, but the actual process isn't as glamorous as people think."

The experience with Disney-MGM Studios at Walt Disney World had already demonstrated that the idea that a theme park could also be a bustling movie studio was impractical. That changed the "studio park" concept from watching filmmaking into creating "a false sense of what was going on behind scenes," Vaughn said. It was a "slippery slope" that led the designers to settle on a backlot aesthetic that would be authenti-cally drab—not considering that they were shirking the place-making that was a core tenet to Imagineering. "People really want to be immersed in the stories" at a Disney park," Vaughn said. "They don't want to be in a studio that isn't really an authentic studio."

The Walt Disney Studios Park reminded Vaughn of a story John Hench used to tell about Walt Disney. Hench looked around the origi-nal Disneyland before it opened and said, "'Walt, this is way too much detail. The guests won't get it. You're wasting money. You're wasting effort.' And Walt said, 'Don't underestimate the guest. They won't be able to tell you necessarily why this feels good, but it's because of all this detail. They won't be able to point to that filigree or the fact that that's real brass or these seats are actual leather and tell you that, but they will know the difference. They will feel it.'" Whether they would return to Disneyland would depend on exactly that undefined feeling. The detailing that Walt loved "clearly wasn't the priority here [in Walt Disney Studios Park]. It was almost like people forgot that the business we're in is the guest experience [one]. It became, 'The business we're in is architecture and building places.'"

At sixty-two acres—only about half of which was initially developed—the Walt Disney Studios Park was technically a little bigger than Disney California Adventure, but it offered even fewer attractions when it opened. The park was roughly U-shaped, with the entrance at the bottom of the U. The entry, which resembled a classic Hollywood studio gate, led to a rectangular plaza named after pioneering French filmmakers the

Lumière brothers, with a small Sorcerer Mickey statue at the center of an unremarkable fountain. To the left of the plaza was the 130-foot-tall "Earffel Tower"—a larger version of the faux water tower with Mickey Mouse ears designed for Walt Disney Studios Park.

Guests then entered Disney Studio 1, a building resembling a soundstage that served as this park's Main Street, with shops and food service sitting behind brightly colored storefronts intended to look like the flat sets they were. Beyond lay the park's center, marked by a reproduction of the *Partners* sculpture of Walt Disney holding hands with Mickey Mouse. To the right was the Art of Disney Animation pavilion; the Dumbo-like Flying Carpets Over Agrabah, with 16 two-seat "carpets" circling on spokes in front of a flat, painted backdrop; and a theater presenting a stage show celebrating Disney animated features titled *Animagique*.

To the left of the hub was almost everything else. The park held firmly to its theme, with most attractions related to filmmaking: another stage show, celebrating live-action films, called *CinéMagique*; a stunt show named Moteurs . . . Action! Stunt Show Spectacular; and a special effects demonstration inspired by the movie *Armageddon*. An extensive Studio Tram Tour track took up most of the top section of the park on both sides. The trams steered guests past faux movie sets, past props that had never appeared on film, and through two special effects demonstrations—Catastrophe Canyon, reproduced from Florida, and a burned-out London street scene from the little-seen Disney dragon movie *Reign of Fire*. The park's only thrill ride was a more abstract rendition of the Rock 'n' Roller Coaster Starring Aerosmith, which had opened at what we now know as Disney's Hollywood Studios in Orlando in 1999. Early plans to include French versions of Honey, I Shrunk the Audience and The Great Movie Ride had been abandoned.

Apart from shops and restaurants, that was it for the Walt Disney Studios Park. A dedication ceremony officially opened the park on the cloudless morning of March 16, 2002, with Roy E. Disney, Michael Eisner, and Euro Disney CEO Jay Rasulo holding clapperboards rather than cutting a ribbon. (No French citizens spoke at the event, although Rasulo, an American, addressed the crowd in French.) As the three men

snapped their clappers closed—flanked by Goofy and Mickey Mouse—cloth shrouds dropped away from the outer gates, and a few hundred guests entered the park. In the wake of Tokyo DisneySea, the studios splash was minimal. Major U.S. media outlets barely acknowledged the opening. Not even ABC's *Wonderful World of Disney* featured the new park.

The park was, observed Imagineer Daniel Jue, more of a business move than a creative one. "It was part of the contract that we had to actually develop something really quickly, and so it was done as quick and as cheap as possible."

As Tom Morris noted, theming cost money, "so when we started to develop the second park for Paris, it was like, 'It's got to be a studio park. Make it industrial. All of the money will go inside the show but not outside. It's not going to be about place-making, it's not going to be about highly immersive environments. You'll go into these shows and the shows will be a promotion of our films somehow. So we'll get our film product into it. They'll be interactive, but all of that rockwork and stonework—medieval and Western and Gothic and all of these things that Magic Kingdom park is all about—we don't do that anymore.'"

Ever since the death of Frank Wells, Morris said, Eisner "seemed a little unsure of how to wrangle things in general. So Michael was taking a tighter-fisted approach."

Opening in the troubled economic and travel climate after 9/11, Walt Disney Studios Park seemed more of a burden than a boost to Disney's Paris resort. The development as a whole—both parks and the surrounding resort area—went from profitability in 2001 to a $66 million loss in 2003, while combined attendance sank from 13.1 million in 2001–2002 to 12.4 million the next fiscal year. By mid-2004, the Euro Disney company that owned the resort had gone back to its banks—just as it had ten years earlier—to negotiate another refinancing deal to avoid bankruptcy.

For years, the Walt Disney Studios Park seemed largely forgotten. And when it was brought up, it often had scorn heaped upon it. A typically nasty Disney-centric blog post called it "Disney's most disastrous theme park ever; a park that dispensed entirely with immersion, fantasy,

and romance in favor of blistering blacktop, industrial backlots, metal lighting rigs, electrical poles, and big, boxy, tan show buildings." Like California Adventure before it, the Studios Park was slated for upgrades and additions, but with the Paris resort's finances perilously close to insolvency, it took much longer.

And also like Disney California Adventure, the first enhancements were Pixar-themed. In 2007, the Animation Courtyard was joined by the Toon Studio, with an indoor roller coaster called Crush's Coaster, themed around the *Finding Nemo* sea turtle, and *Cars Quatre Roues Rallye* (Cars Four-Wheel Rally), a more elaborate Mad Tea Party ride themed after the 2006 feature. The biggest new attraction, also echoing Disney California Adventure, would be *The Twilight Zone*™ Tower of Terror, opening at the end of 2007.

Even so, the park struggled to attract more than 2.5 million visitors in 2008, about a fifth of total for the same year to visit Disneyland Paris. It would be almost three more years later that Walt Disney Studios Park got its next infusion of fresh attractions. First, Imagineering had other parks to augment.

II. A STRUGGLE TO MAINTAIN

Walt Disney's theme parks needed all the new thrills they could get in the early 2000s. While Tokyo DisneySea was an immediate hit, Disney didn't own the park and received only licensing fees and revenue percentages. The two new parks it owned, in full or in part—California Adventure and, through the Euro Disney company, the Walt Disney Studios Park—performed at far below projections and weren't paying for their own construction costs, much less contributing to the company's bottom line. A recession beginning in early 2001 was compounded by the terror attacks of September 11, 2001, both of which hit the travel and theme park industries hard, and the economy stayed soft well into 2003. Perhaps it wasn't surprising Paul Pressler had jumped ship in 2002, leaving his replacement as the parks division chief, Jay Rasulo, the former head of Disneyland Paris, holding the bag. "We continue to

be in a period of multiple uncertainties," Rasulo told the *Los Angeles Times*. "We think the comeback will be slow in 2003."

Morale was low at Imagineering. After opening three theme parks in eighteen months, the number of active projects had dropped precipitously. Layoffs were inevitable, and people were let go at all levels. By the end of 2002, *Wired* magazine reported that Imagineering had been forced to "slash its ranks by half, from 3,000 employees in the late '90s to roughly 1,500 today."

"Disney is in a bear trap right now," said former Imagineering executive Larry Gertz, who spoke to *Wired* magazine after he left Imagineering in early 2003. "They're incredibly investment-averse. But the problem is, if you don't fund the Imagineers to constantly come up with something new, you lose a big piece of what the brand means—which is that you go to the Disney parks to see stuff you can't see anywhere else." He continued, "When I started, the mandate was, 'Don't think about cost'— you can't put a price tag on innovation and the brilliant execution of ideas. If you do, you may miss the best idea. These days, the approach seems to be to start with a spreadsheet and work magic from there, which is very hard to do."

The downsizing also shrank Imagineering's 11,384-pound dinosaur. A longtime Hail Mary project of Danny Hillis's in the R&D division, the twelve-foot, eleven-inch robot was known as Dino. The goal was to create a full-scale triceratops-like dinosaur that could walk around and respond to its environment without a human controller. Most such ambitious projects began with scale models and worked their way up to life-size, but Ferren and Hillis decided instead just to build the thing and solve each problem as it arose.

Dino would be a massive R&D experiment, yielding technological innovations in artificial intelligence and robot mechanics, but it was chiefly intended just to prove such a thing was possible. Imagineer Frank Mezzatesta took over after Ferren and Hillis left, and by early 2001 a skinless, skeletal Dino was indeed able to walk around the project's work space, a cavernous warehouse near the Burbank airport. Within its massive frame were fifty-five batteries, at least a dozen electric motors, laser

sensors, and a gyroscope to feed positioning information to the onboard computer, which could then shift the legs as needed to stand, walk, or even dance (a little). Still missing were sensors and software to detect and respond to obstacles (like people and walls), as well as a global positioning system.

The Dino project was never completed, at least not in the way that Hillis had originally intended. According to Imagineer Jon Snoddy, the Imagineering R&D chief who counts the Dino project team among his dear friends, "it was one of those things that probably was trying to reach too far in one step. It was a massive project. . . . Massive device. This amazing giant aluminum skeleton. You want to reach, but if you reach too far it gets riskier and riskier and riskier."

While a different group of researchers might have started small, "they said, 'Well, let's just try to go all the way there in one step.' And they didn't quite get there. I'm sure they could have refined it, but it was kind of a moment where they said, 'Let's go another direction.' And so that team went and worked on some other things."

As for Dino, he evolved, and shrank. By 2003—the fortieth anniversary of Audio-Animatronics figures—he had become Lucky the Dinosaur, who made his first public appearance on August 28 at the Natural History Museum of Los Angeles. More precisely, Dino had been shelved and some of the lessons learned from Hillis's experiment were adapted for use in a more manageable eight-foot-tall green Segnosaurus. Lucky walked on two feet instead of four, and his two smaller front legs were permanently attached to the handle of a flower cart he pulled behind him. The flower cart both stabilized the biped and contained the heavy batteries and the onboard computer. That freed Lucky's body to be similar to Imagineering's traditional, stationary Audio-Animatronics—a bundle of motors and hinges and wires and controls attached to a versatile skeleton on the inside and mobile limbs and expressive features on the outside.

A few days after his unveiling at the museum, Lucky appeared in Disney California Adventure for what Imagineering referred to as play-testing, accompanied everywhere by a human handler. He then returned to Glendale for another two years of research and refining.

Lucky's first extended run in a theme park was from May to July of 2005 in Disney's Animal Kingdom. The Segnosaurus traveled everywhere with a human companion dubbed "Chandler the Dinosaur Handler." Lucky could walk on his own, interact with guests, snort and make dino noises, and move his mouth and eyes. He could even sign an autograph—a flowerlike doodle—by holding a pen in his mouth while his companion held the item being signed. Unlike Dino, Lucky was not fully autonomous, requiring input from a human operator. But he was the first freestanding Audio-Animatronics figure in Imagineering history.

Did that mean that the Dino project had been a failure while Lucky succeeded? Does that question even matter in the spirit of Imagineering? Phantom Boats, the Alien Encounter, even Superstar Limo—every misstep in Imagineering history was also in some ways a step forward.

"When I took over R&D, one of the first talks I had with the group was something I called 'Building a Culture of Failure,'" Snoddy said. "What I meant by that was reminding us that success is really about many, many failures and that we want to make sure that we have a culture that we don't judge. We expect to fail, we intend to fail, we plan to fail. We plan to fail many, many, many times, because we are experimenting. We are trying things that we don't know if it will work or not. If we are above a fifty percent hit rate on our smaller projects, we are not trying hard enough.

"So we really do try to make sure that everything we do is based on a lot of quick failures." The play-testing phase is specifically designed to figure out what needs work on a given project, he noted. "We will go to the park, take over an area, [and we] will present it in front of people. And then we realize immediately that, 'Oh, this is not working.' And then we readjust and make it better and better. Almost everything we do is filled with failure, is born in failure. It is something that we are able to learn from. It's just a part of how we design."

As for Lucky the Dinosaur, his journey wasn't over. After his stint in Disney's Animal Kingdom, he was next going to Disneyland. In Hong Kong!

CHAPTER 24:
THE END OF THE RAINBOW

"I think the biggest damage was the mindset that there's a new formula: 'Let's build a park for half the budget. Let's deliver half the product and let's ignore all these wonderful things Walt had created.' . . . It's always more difficult to recover than it is to do the right thing in the beginning." —Tony Baxter

I. GATEWAY TO ASIA

IMAGINEER WING T. CHAO first saw the site that would become Hong Kong Disneyland from a helicopter. It was August 1998, and a small contingent from Disney was visiting the city in search of a location for a second Asian Disneyland. Chao, who had spent years leading Disney's negotiations for the park, had boarded the helicopter along with the city's secretary of planning, and they'd taken off to tour what little land was available. Hong Kong Island was a combination of closely packed buildings, steep hills, and preserved parks, but there was hope something might be found in the New Territories, the mountainous peninsula extending from the Chinese mainland north of Hong Kong Island—or perhaps on Lantau Island, to the west of the main isle. Mostly what they saw, though, were countless skyscrapers, compact urban development, and hillsides so precipitous that even a perpetual housing crunch couldn't conquer them.

"After an hour or so of a helicopter ride, we couldn't find any piece

of land that is flat, that is within easy access to the highway, with the metro station nearby," Chao said. "And also a piece of land without any visual intrusions or high-rise buildings in the background, because in the Magic Kingdom of Disneyland, we don't want to see any existing buildings outside in the real world."

Just when Chao was about to give up hope, the secretary of planning pointed down. "How about here?" he said. "Look down here." Chao followed his gaze. "I looked down. I said, 'Well, I don't see any land. I see water.' He said, 'Well, if you like the location, we can reclaim it for you.' So we landed the helicopter and went into the office and looked at the map. Penny's Bay was a very strategic location in North Landau Island, where the government was building an airport. And they were building two major bridges. So, it would be a strategic location, and that body of water does not have any existing buildings nearby. So for the first time, Disney selected a site that was a body of water and not a piece of land." The groundbreaking for Hong Kong Disneyland would have to wait at least a couple of years—until there was actual ground to break.

Chao sold the idea to Disney management, who agreed it could work if Hong Kong would take responsibility for reclaiming the land. "And the government did—within two years. Record time. They reclaimed five hundred acres of land and created the pad to build Hong Kong Disneyland."

Imagineer Tom Morris joined the Hong Kong team as creative director during the land reclamation project. The site was on the northern tip of Lantao Island, a short stretch of water away from the mainland part of the city. "I believe it was in early 2001," Morris said of his first trip to Hong Kong, "because I remember going on a boat and seeing the float—this little buoy out there with a float on it—and being told, 'That's where the castle is going to go.' And I was like, 'This is really amazing.' We started designing it in 2000, and it opened in 2005—so kind of on a typical five-year theme park schedule."

Disney had been exploring the possibility of a theme park on mainland China for some time, and Hong Kong had been on Disney's short list for possible international park locations at least since the early 1990s.

Research had shown that the mainland Chinese patronized many "so-called theme parks," said Andrew Kam, later the managing director of Hong Kong Disneyland, "but at best I would probably call them amusement parks rather than theme parks."

Other locales also on the list for a second Asian park were Singapore, Thailand, Indonesia, and the Philippines, plus Australia. "But we went to Hong Kong first," Chao remembered. That was in 1992, and the territory was still under British control. "We had a meeting with the British governor. He was cordial and gracious. We said, 'We would like to come to Hong Kong and'—typical Disney—'we have a list of criteria. We need a piece of flat land. The price has got to be right. And easy transportation.'" And no nearby skyscrapers to loom over the park.

The governor smiled, welcomed them to Hong Kong, said he'd be happy to help—"but you have to pay market price." Real estate prices were going up, up, up at that time, Chao said, and land in "downtown Hong Kong . . . it was in the millions and millions of dollars per acre." That was not going to work, and the governor didn't much care. "The British did not have any incentive to give us any land, because they are leaving in five years," Chao said. "So we left Hong Kong and said, 'Okay, we will come back after the handover.'"

In 1997, the British yielded authority over Hong Kong to the Chinese. A new local government was formed, under the authority of the People's Republic of China—a new potential partner in the park venture.

But Disney could not immediately return. The company had angered the government of the People's Republic in 1997 by agreeing to distribute Martin Scorsese's *Kundun*, a film about the early life of the exiled Dalai Lama, considered a Tibetan separatist by the Chinese. Business ties were cut, films were blocked from distribution, and Disney's Shanghai film dubbing studio was shut down. Michael Eisner called in Henry Kissinger to help smooth things over, and Eisner and his wife attempted to make nice by attending a state dinner for the president of the People's Republic, Jiang Zemin, at the White House.

The furor died down only after *Kundun* came out and failed at the box office both in the United States and abroad. The talks with the Chinese

government over Hong Kong Disneyland began less than a year later. "We were able to negotiate the deal with the Hong Kong government in record time—thirteen months," Chao said.

The Chinese government had incentives to make the park happen. A financial crisis had gripped many of the nations of Southeast Asia beginning in 1997, which by 1999 had led to a precipitous decline in tourism in Hong Kong. A Disney park in Hong Kong could help both the mainland and the city, where tourism was thought to be one of the best paths to recovery from the financial crisis.

Disney had its own long-term motives, according to Bill Ernest, president and managing director in Asia for Walt Disney Parks and Resorts. "The Walt Disney company was interested in Hong Kong as kind of a gateway to Asia—and a gateway to China ultimately," he said. "So it was kind of a win-win. We get a beachhead into China and the [theme park] is a win for the local economy."

The final agreement was announced on November 2, 1999. Attempting to strike a balance between the Tokyo deal, in which Disney had no ownership, and Paris, in which Disney invested a small amount up front but wound up responsible for hundreds of millions more to keep the park afloat, for Hong Kong Disney would partner with the Hong Kong government, sharing ownership and costs. Disney would invest a reported $316 million toward the design and construction of the theme park—a fraction of the cost of most of the parks it had built to date.

The Hong Kong government's equity stake in the park was a reported $419 million, making the ownership division 43 percent to 57 percent in favor of the government. With the Hong Kong government's also extending about $1 billion in loans and shouldering the cost of the land reclamation and related improvements in transportation, utility, and other infrastructure, one media report pegged the total cost of the project at $3.6 billion.

In just two years, often working twenty-four hours a day, the government reclaimed five hundred acres in the former Penny Bay, filling in an expanse between two mountain ridges and demolishing a bayside shipyard, which the city government had purchased and shut down.

The reclamation used marine sand brought to the site from the bottom of the South China Sea. The sand was compacted to make a solid building site, and a top layer of fertile soil was put down to allow for landscaping—although how much landscaping there would be was a topic of some debate.

From the beginning, the concept was to build a smaller version of Disneyland. "We came up with all kinds of options that we felt might be perfect and collaborative," recalled Imagineer Doris Woodward, who was on the creative team during the negotiations. The park would honor Disney's "storytelling legacy, but yet [with] enough of something new that could excite our guests in Hong Kong. Hong Kong's a very global, upscale environment with a texture that is extremely connected with Chinese heritage." The city blended high finance and urban density with still-thriving mom-and-pop shops and buildings from the 1800s, resulting in what Woodward called a "colorfulness [that was] quite influential to how we ended up thinking about our concepts for the Magic Kingdom."

Annual visitation was projected at five million—less than half the total at Disneyland Paris or either park at the Tokyo Disneyland Resort. Disney expected a third of visitors to come from Hong Kong, a third from mainland China, and a third from other Southeast Asia countries. Expectations were tempered in part by recent industry failures and missteps in the region. As the *Los Angeles Times* put it, mainland China was "littered with failed theme parks," many of them backed by U.S. or other foreign investors. Hong Kong was more "freewheeling," the report continued, but "the Chinese cities of Shanghai and Zhuhai remain in the running" for future park locations.

At one point during initial planning during the late 1990s' era of restricted spending, Tom Morris recalled, the Hong Kong project "was not even going to be a Disneyland. It was going to be a Disney park in Hong Kong—like a half-day park, a three-hour, four-hour park that might have elements of a Disneyland in it. At that time, we were talking about doing a castle that was flat, done like [the Disneyland facade] "it's a small world"—stylized with a series of flats. And no rivers, because water

is expensive and water doesn't pay the bills." Also on the chopping block? "All of the flowers and all of the plants and all the landscaping," Morris said. The thinking was that "people are coming to see Disney characters, to go on a few rides, to see some entertainment. And they are coming to see IP'd stories that are in conjunction to our film product. And all this other stuff—no, we're not going to have that."

II. LEARNING EXPERIENCES

The castle at the center of Hong Kong Disneyland was not made out of flats. In fact, it was a near duplicate of Sleeping Beauty Castle from the original Disneyland. And that prohibition on landscaping and water-ways? It did not come to pass. In fact, the park would eventually become known for its landscaping diversity.

At first, though, Hong Kong Disneyland was like a dream version of Walt's first park—familiar yet oddly altered. Sure, there was the iconic entrance plaza and railroad station, but once through the tunnels and into the park, it was different in subtle ways—and not just because the English language signs included Chinese translations.

"There's things in that Main Street that used to be at Disneyland [in Anaheim] that aren't at Disneyland anymore," Tom Morris said, "so you get this weird kind déjà vu when you walk in certain areas." The view toward the castle, unhindered by tree—since those in Hong Kong were still young—included a mountain backdrop unique to Hong Kong. Then, once you got to the central hub, you realized that Frontierland was entirely missing, seemingly swallowed up by Adventureland. It seemed Indiana Jones and Tom Sawyer hadn't made the trip, while a new circu-lar amphitheater with a thatched roof had risen in Indy's place, hosting *Festival of the Lion King*, the show introduced in 1998 in Disney's Animal Kingdom Theme Park. The Rivers of America had been merged with the Jungle Cruise, the boats for which now circled an island where the tree house attraction sat. Rafts crisscrossed the Jungle Cruise waterway to take visitors to the tree house, while Audio-Animatronics animals

dotted the shorelines. No paddle wheeler or sailing ship navigated this narrower river.

Tomorrowland was still on the opposite side of the park, and there sat the Orbitron, essentially identical to the recently installed Astro Orbitor in Disneyland, and beyond that was Space Mountain—the only thrill ride in the initial plan. But Tomorrowland, too, was more compact, as if the structures housing the PeopleMover, Carousel of Progress, and Mission to Mars had been disintegrated, and the other buildings had huddled in closer for comfort. In place of Star Tours was Buzz Lightyear Astro Blasters, a version of Buzz Lightyear's Space Ranger Spin from the Magic Kingdom. There was also a spot for Autopia, which in this park extended to a track on the other side of the Disneyland Railroad berm, but it was still under construction.

Fantasyland layered on another disconcerting level to this phantasmal Disneyland. Passage through Sleeping Beauty Castle led to a familiar-seeming plaza with a carousel at its center and Dumbo the Flying Elephant beyond. The Mad Hatter Tea Cups were spinning far off to the right, sheltered by a canopy-like roof. But the attractions on either side of the plaza were different and included none of the original dark rides. In place of Peter Pan and Mr. Toad was the Many Adventures of Winnie the Pooh, duplicated from the Magic Kingdom. On the other side of the plaza, instead of Snow White and Cinderella, was a single attraction, Mickey's PhilharMagic, a theater offering a superwide 3D film accompanied by some physical effects that had been introduced in the Magic Kingdom in 2003, in the space once occupied by the Mickey Mouse Revue.

The only major Hong Kong attraction new to a Disney theme park was a twenty-five-minute live show called *The Golden Mickeys*, housed in an auditorium just past the train tracks beyond the Mad Hatter Tea Cups. *The Golden Mickeys* was not created for Hong Kong Disneyland, though—it was a musical revue introduced on the ships of the Disney Cruise Line in 2003. The park's only truly brand-new offering was Fantasy Gardens, a landscaped area near the Tea Cups dotted with small pavilions that would

be "the most elaborate Disney character meet-and-greet location at any Disney theme park in the world," according to a press release.

From Fantasy Gardens, you could walk just a few steps to board the Disneyland Railroad—at the only train station other than the Main Street depot—and ride back to the front of the park, passing no Grand Canyon diorama and no dinosaurs. Then this dream of a surreal and scaled-down Disneyland was over. Other than shops and restaurants, that was the sum of what was planned for the Hong Kong park.

It was a project on which "it was very challenging to be a portfolio leader," Morris said, "because it was a job that was inevitably going to fail because of not putting all of the ingredients that you need to put into a Disney park. Not scaling it and sizing it to what the audience's expectation is going to be is not going to go over well with the public." He was left with the choice of disappointing guests (and the media) by keeping it small or disappointing Disney executives by going over budget. It was a lose-lose proposition.

Nevertheless, Morris chalked up the three smaller parks—Disney California Adventure, Walt Disney Studios Park, and Hong Kong Disneyland—to a learning experience for Imagineering. "It was something that needed to be tried and experimented with," he said. "The curiosity from a senior management level had been there for years and years and years. It was like, 'Do we overdo it in our parks?' They wanted to test that, and we saw how far that went—and it wasn't very far. Part of the essence of going into a Disney park is being a little overwhelmed. So when you leave, your feet are a little tired. And you didn't get to see everything, so you want to go back. We were disappointing our guests with kind of watering down the formula. Yeah, you can go on all the rides, and you only have to wait fifteen minutes for each of them, but you weren't satisfied."

The park attractions were not exactly cut-and-paste reproductions, since the layouts needed to be adapted to different spaces, and the scripts translated into the local languages. "We actually use three languages here," explained Managing Director Andrew Kam. "We use Putonghua [commonly called Mandarin] for the mainland guests, which account for

about forty-five percent of our total attendance, and we use Cantonese, obviously, for our Hong Kong local market—Hong Kong local guests account for thirty-three percent of our attendance—and for the remaining quarter of our guests from Southeast Asia, we use English to service them." The waiting area for the Jungle Cruise, for example, was eventually divided into three queues, one for each language, so guests could be matched to a cruise host in their preferred tongue.

Disney tried to be sensitive to local customs in other ways as well. A feng shui master was brought on board by Chao to advise the land use planning—before the land reclamation—to make sure the orientation of the park followed traditional Chinese beliefs about the flow of energy, or qi. The master was shown Disney's layout, and he suggested rotating the entrance by twelve degrees for better qi, to ensure maximum prosperity. He also recommended putting a bend in the walkway from the train station to the main gate, to prevent good energy from sliding quickly out past the entrance and down into the sea.

In the Crystal Lotus, the upscale restaurant within the park, a virtual koi pond—with CG fish that responded to guests' footsteps—joined four other feng shui elements: water, wood, earth, metal, and fire (also virtual).

Other nods to local beliefs were incorporated into the two hotels on the property. One ballroom was designed to measure 888 square meters, since eight is a lucky number, while the hotels eliminated fourth floors—skipping from the third to the fifth—since the word "four" in Cantonese sounds like the word for "death." Disney "kept the consultant kind of on board for three or four years during the construction," Morris said. "They'd bring him through every now and then and make an adjustment if needed."

There were learning experiences during construction. Ian Price, the Imagineer overseeing construction, arrived in Hong Kong from Paris. "In Europe—whether it be Germany, Italy, Spain, France, the U.K., the Netherlands—there is a great pool of talent that you can call upon, especially to do the more complicated themed rides. That didn't really exist here in Hong Kong, so we had to start from scratch in some cases. There

were classes set up with a local construction training board—to take plaster as an example—to show how to do theme plaster. They've been a plasterer for ten, fifteen, twenty years. They were used to doing things a certain way. [We had to] try to get them to change the way they plastered a wall. We didn't want to have something flat and straight and true, we wanted it all ripply and bumpy and to look as though it was old. So there was a lot of weeding out all of the people that couldn't get it."

Price's team also brought in supervisors from Paris and the United States who had worked on previous parks. "Those people then managed to train and teach other people locally how to perform those tasks." The hope was to have the best local workers stay on permanently as Imagineers to look after the park and its future growth.

Other challenges, such as the weather, were highly specific to the location. "Florida's nothing compared to Hong Kong," which Tom Morris recalled as having "ninety-nine percent humidity, ninety-nine percent of the time. It's often over ninety degrees, and then they get ninety-nine inches of rain a year. Florida gets thirty-three, and in California we get ten if we're lucky. It rained a lot. So just thinking when you're out in an environment like that, and trying to organize your thoughts and give direction, you know, is just kind of a physically taxing situation."

The park's smaller scale meant "always making sure that whatever it was that we were doing was delivering," Morris said. "Every restaurant, every shop, every space, delivered. Anything we built out there, it got all the loving care that any Disney facility, any Disney park that we ever do gets."

III. FIFTY YEARS ON

In December 2002, Mickey Mouse, Marty Sklar, and a small band of Imagineers dropped by the city council chambers in Glendale, California. Mickey was dressed appropriately for the occasion in his sorcerer's apprentice garb, complete with flowing red robe and tall blue magician's hat emblazoned with a silver moon and stars. Mickey and friends had been summoned there by Glendale mayor Rafi Manoukian,

who presented them with a proclamation declaring December 16 to be Walt Disney Imagineering Day in honor of the organization's fiftieth anniversary. Manoukian then directed Mickey to a seat at the council's table on the dais. The mouse briefly presided over the council before departing with his Imagineering colleagues.

"We really were the beginning of, not just the Disney theme park business, but the entire theme park business," Sklar told the *Glendale News-Press*, a weekly publication of the *Los Angeles Times*. "Essentially, we're the largest design firm around the world, located right here in Glendale"—Imagineering's home since 1961. "We do everything from the blank sheet of paper, right through to construction." The newspaper reported the then-current Glendale workforce of Imagineering at 1,100, occupying "more than a dozen buildings that make up the company campus." Worldwide, Disney put the figure at 1,600 Imagineers, down from a peak of 2,500 in the late 1990s.

For the most part, the Imagineering anniversary was a low-key affair, with little recognition in the press. There was a concert to mark Imagineering's birthday in Glendale in August, and the company issued some collectibles for Disney fans—pins, a limited-edition lithograph. But Disney's efforts would be chiefly directed toward a different anniversary: the fiftieth of the Disneyland park, in 2005.

That didn't stop the Imagineers themselves from celebrating, and a grand banquet in late 2002 was held to mark the occasion, hosted by Sklar. Standing up to make a toast, he referred those attending to the crystal flutes on the banquet tables, custom etched with the logo created for the occasion: Sorcerer Mickey waving his wand in front of a big numeral 50, above the words "Walt Disney Imagineering / Est. December 1952." Sklar began, "You should all have champagne at your desks"—and corrected himself—"at your *table*"—as the room erupted in laughter. "Oh, that's a Freudian slip," he went on. "You didn't know you were gonna work tonight, did you? Fifty years. You've come a long way, baby. Here's to fifty more, but one year at a time. We all soar together or we fail together. And now, the sun never sets on the operation of a Disney park around the world. You should all be very, very proud of

that. We toast you to the next fifty. Hear, hear!" Applause and drinking followed.

Sklar had been with Disney for forty-seven of Imagineering's fifty years, most of that time working with the Imagineers. He had been the organization's lead creative executive since 1974, although his specific title changed periodically. The *Los Angeles Times'* coverage of the fiftieth anniversary consisted of a lengthy profile of Sklar. Calling him "a sorcerer in his own right," reporter Richard Verrier recounted his career from his first meeting with Walt Disney through Project X to "Mickey's Ten Commandments" and the just-opened Flik's Fun Fair in Disney California Adventure. "When Marty says something is good, it's almost like Walt says it's good," Imagineering president Don Goodman told the newspaper. Others compared Sklar to Jiminy Cricket (the conscience of Imagineering) and Yoda (as unflappable as the Jedi master in *Star Wars*: Episode V: *The Empire Strikes Back*). Verrier noted that "Sklar's job is a balancing act of developing new and often expensive attractions while holding the line on budgets that have grown tighter in recent years as Disney's profit and stock price have declined. His most important role, though, is as anchor to a company sometimes accused of drifting from its roots."

The profile was published the same week that Walt Disney Imagineering had announced the elimination of more than twenty jobs from the Research and Development division. With the opening of Walt Disney Studios Park in Paris in early 2002, the only park still in the works was Hong Kong Disneyland. After that, work would continue on expanding the smaller parks and adding attractions at the larger ones, but the only hope for a fully new project consisted of highly preliminary talks with China about a Shanghai park.

There would be, in short, something of a lull. Many other divisions of the company were also struggling, and the company's stock—worth nearly $32 a share in early 2000—had cratered below $13 a share just two months before the Imagineering anniversary banquet. It began creeping up again as 2002 became 2003, but the damage to Michael Eisner's reputation as chief executive officer had been done.

Eisner spent the years from 2003 to 2005 in a battle for control of The Walt Disney Company, with Roy E. Disney leading the calls for his resignation. Books have been written about this so-called "Disney war," and the shrunken state of Imagineering and its recent theme park creations was only one issue among many. Roy and his allies had been upset by both the Jeffrey Katzenberg and the Michael Ovitz departures in the 1990s—and the hundreds of millions of dollars they had cost the company—and with the continuing oversized compensation paid to Eisner while Disney's stock price had been trending mostly down after a peak in 1998.

Opposition to Eisner was also focused on his alleged micromanagement and a resulting "brain drain" of talented creators and executives departing Disney. The film studio had many more bombs than hits, and the animation division hit a slump after 1999, generating a string of money-losing features (save for 2002's *Lilo & Stitch*) that hit bottom with the 2004 critical and box office disaster *Home on the Range*. Perhaps most distressing, in the animation realm, Pixar Animation Studios had announced it would end its distribution deal with Disney, just as Pixar properties were proving invaluable in rejuvenating Disney's theme parks. Among other issues, Pixar chief and Apple founder Steve Jobs had never forgiven Eisner for his accusation that Apple profited off Internet piracy.

"My belief was that Michael kind of lost his sense of direction about what the company was or where it should go or what it should stand for," Roy E. Disney said in 2007. "Pixar was doing more for Disney than Disney was doing for Disney for a long time there. One needs to recognize those things and be grateful. Instead, we get into a fight."

ESPN remained successful, but the ABC network produced one disappointing season after another—having turned down hit series franchises, including *CSI* and *Survivor*—and Eisner refused to settle on a succession plan should he leave the company. When Roy E. Disney attempted to hold Eisner to account on all these failings, the CEO fought back. In the fall of 2003, Eisner and his allies on the company's board of directors arranged to eject Roy from the board and from his positions as the company's vice chairman and chairman of Walt Disney Feature

Animation. Rather than being forced out, Roy quit and started the "Save Disney" campaign to oust Eisner, the man he had helped recruit to run the company two decades earlier. In his resignation letter, Roy said Disney under Eisner had become a "rapacious" and "soul-less" company that put stockholder value at risk by "always looking for the quick buck."

With the stock depressed, there was also another hostile takeover attempt—as there had been just before Eisner was hired—this time by the Comcast cable empire, hoping to secure a merger with a content-production company. There was talk that Comcast, with no interest or experience in the tourism business, would sell off Disney's resorts and theme parks—which would have severed Walt Disney Imagineering from its parent company. Opposition to Comcast's offer was the one thing that united Eisner and Roy, but the Save Disney forces argued that one of the best ways to boost the stock and rebuff Comcast was to replace Eisner.

"It's time for new blood," Roy said. Roy's arguments connected with both Disney fans who owned small amounts of stock and with institutional investors who owned millions of shares, and an unprecedented 43 percent of shareholders withheld their support for Eisner's reelection to the board at the company's March 2004 annual meeting. Eisner held on for about a year longer but decided to save face—rather than risk being removed—by announcing he would leave a year before his contract expired. Bob Iger became CEO-elect in March 2005 and took over much of the day-to-day management of the company until Eisner left on September 30, 2005.

In his resignation speech, Eisner's continuing fondness for Imagineers and the parks was clear. "I can only conclude by telling you what I am doing next," he said as he wrapped up. "I'm going to Disneyland."

Indeed, Eisner had held on just long enough to preside over not just Hong Kong's opening, but the fiftieth anniversary celebration at Disneyland. It had taken years to prepare for the eighteen-month celebration, largely because of the years of cost cutting that had taken a toll on maintenance, beginning in the mid-1990s. "Disneyland needed a lot of work to bring it up to the standard that it deserved," Sklar said. "A lot

of us were very concerned that the fiftieth anniversary would come and the park would not look the way it should, and it wouldn't function the way it should."

Before Paul Pressler left abruptly as head of Walt Disney Parks and Resorts in September 2002, Sklar and the design staff at Walt Disney Imagineering had complained repeatedly about specific instances of shoddy maintenance in Disneyland. Even after Pressler left, the protégé he left behind—Disneyland Resort president Cynthia Harriss—stonewalled the Imagineers. A pet peeve of Sklar's was that Pressler and Harriss had shut down the Submarine Voyage attraction in Tomorrowland in September 1998, reportedly to save $3 million in maintenance costs. For years, the submarine lagoon—a prominent piece of park real estate—had sat empty. Sklar even had to fight to preserve the eight submarine vehicles in storage. (He won that battle.) Still, no money was allocated to develop a new attraction for the abandoned lagoon. By the time of Imagineering's fiftieth anniversary, parts of the park were in desperate need of repair, with attentive guests noting the peeling paint and rotting wood along Main Street, U.S.A., the first thing as they entered the park.

Then, in late 2003, Harriss left—following Pressler to The Gap clothing company—and Jay Rasulo, now the head of Walt Disney Parks and Resorts (as the division was now called), picked Matt Ouimet as the new president of Disneyland Resort. Ouimet, a well-liked manager with fourteen years' experience within The Walt Disney Company, selected Greg Emmer as his deputy, with the title senior vice president of Operations. Emmer had been a Disneyland cast member in his youth, thus elevating to the park's management an executive with hands-on park experience for the first time in nearly a decade. Ouimet and Emmer set about working with both Imagineering and the operations staff to address the Imagineers' long list of maintenance failings at Disneyland, determined to spruce up the park in time for the fiftieth birthday celebration.

Sklar had nothing but admiration for Ouimet and Emmer, who could often be found inside the two theme parks—what Sklar termed "management by walking around." Their clear dedication to not just the

parks but to the people who worked there also rebuilt the morale of the Disneyland Resort cast members, Sklar said—another long-neglected bit of maintenance.

"Fortunately," Sklar said, management had changed "early enough so that we could bring Disneyland up to where it was pristine, if you will, when the fiftieth anniversary came along." The point, he added, was not just to celebrate the past but to give the impression that Disneyland also had "a wonderful future, because we all love it and [want to ensure it] has the same loving care it had when Walt Disney created it." Sklar estimated the cost of the rejuvenation at close to $70 million. The public response suggested it was money well spent.

Dubbed the Happiest Homecoming on Earth, the party lasted from May 5, 2005, until November 30, 2006, and was a great success. On May 4, some fans camped out in their cars to be among the first to enter the park the next morning. By the time the gates opened at 8:30 a.m., thousands of people had lined up. Once inside, they saw five gold crowns on the turrets of Sleeping Beauty Castle, along with jewels and bunting, as well as golden accents everywhere: on lampposts, on ride vehicles, on cast members' badges.

Disney reported that more people entered the park by 11:30 a.m. than had attended the first day in 1955. Diane Disney Miller was there with her husband, Ron Miller, sharing the stage with Michael Eisner, California governor Arnold Schwarzenegger, and others. Art Linkletter, who had been with Walt Disney fifty years earlier, co-hosted the official ceremony in front of the castle, joined by Julie Andrews, LeeAnn Rimes, Christine Aguilera, and others. There was a seventy-piece live orchestra and a small army of Disney characters. The occasion was also a happy reunion for many early Imagineers, including Don Iwerks, Blaine Gibson, Harriett Burns, and others.

The park's rejuvenation by the Imagineering had not been merely cosmetic. A whole new attraction, Buzz Lightyear's Astro Blasters, had recently opened, and the classic Jungle Cruise sported new effects and landscaping, while Space Mountain was still closed for renovations. (It reopened in July, after two years of work.) Ouimet was ecstatic, telling a

Los Angeles Times reporter, "It's kind of cool that something that was created fifty years ago still resonates today."

The celebration boosted not only the morale of Disney fans—it improved spirits at Walt Disney Imagineering. "The fiftieth was really a fun opportunity because it was such a big anniversary," Kim Irvine recalled. Irvine worked on creating the golden crowns for the turrets of Sleeping Beauty Castle and other anniversary touches, enjoying old-fashioned Imagineering brainstorming sessions with Sklar and the rest of the team. "We just had a lot of fun developing that [celebration,] and it was received so well, I think it's going to be a hard one to beat."

CHAPTER 25:
THE IMPORTANCE OF CHANGE

"Our guests want everything to stay the same, just as they remember it the first time they ever came, but that's really not a good idea because things become stale. Walt wanted all of these attractions to be updated. Again, relevancy. He kept saying, 'We've gotta keep this thing live and fresh and new.'" —Kim Irvine

I. A MORE PERFECT UNION

IT WAS THE FIRST-EVER character parade at Hong Kong Disneyland, and it helped point The Walt Disney Company toward the future. On opening day in September 2005, CEO-elect Bob Iger stayed in the park after the dedication ceremony to watch the musical cavalcade, dubbed Disney on Parade. The fifteen-minute show was a typical Disney assortment, providing a capsule history of the studio's animated fare, from black-and-white Mickey Mouse shorts through the mid-century feature classics, which were represented by a moving castle housing the most beloved Disney princesses. Alice from *Alice in Wonderland* got her own float, then the time line fast-forwarded to *The Little Mermaid*, quickly followed by a *Toy Story 2* float with Buzz, Woody, Jessie, and the gang. Mickey Mouse returned with the other classic costumed characters on a double-decker bus to wrap things up.

"I was watching float after float and character after character come by, which is wonderful," Iger recalled, "and it hit me that the collection

of characters really came from two eras. The first was the great Disney animation era, which started back in Walt's day and continued really up to *The Lion King* in the mid '90s. And then there was the Pixar era that started with *Toy Story* in 1995 and continued all the way to 2005. The characters in the decade that had just passed were mostly from the Pixar films and all the others were from the older Disney films." In fact, the mermaid Ariel and her undersea crew were the only Disney studio characters in the parade who had debuted in the previous fifty-three years.

In the decade just past, Disney parks had featured enduring parades and shows based on *The Lion King*, but subsequent features from Disney animators were rarely represented. Those few movies that had a park presence had had their stories grafted onto attractions invented for other properties. For example, ExtraTERRORestrial Alien Encounter in the Magic Kingdom had been re-themed as Stitch's Great Escape!, representing *Lilo & Stitch* (2002), the studio's only bona fide animated hit so far in the twenty-first century. Disney's other recent animated features, from *Fantasia 2000* to *Home on the Range* (2004), were not visible in the parks once their initial promotional pushes faded. On the other hand, Pixar-based attractions were popping up everywhere. Three parks had variations on Buzz Lightyear's Space Ranger Spin, two had It's Tough to Be a Bug!, and EPCOT had Turtle Talk with Crush, inspired by *Finding Nemo*. Disney California Adventure would soon feature Monsters, Inc. Mike & Sulley to the Rescue!—and more Pixar attractions were in the works.

"What struck me," Iger said of his Hong Kong Disneyland epiphany, "was that it was so important for us to continue to create great characters at Disney. They shouldn't all come from Pixar." This was particularly important since Pixar had announced a year earlier that it would cut ties with Disney and look elsewhere for a distribution partner. "It was the intention of both companies to go their separate ways," Iger said, "and I thought, 'Well, what would happen if we failed to make great animation? What would happen to our parades? What would people think of, not only Disney, but all the experiences that Disney had to offer?' And so the sense of urgency that I felt that day and the concern that I had about the

challenges of figuring out how to make great animation was very much on my mind as I left Hong Kong and went on three weeks after that to actually become CEO."

Iger worked quickly to mend fences with Steve Jobs, the chairman and principal stockholder of Pixar and the CEO of Apple Computer. Then on January 24, 2006, Iger revealed that Disney had struck a deal to acquire Pixar Animation Studios for $7.4 billion in an all-stock deal. He cited his mission "to return Disney animation to greatness," but the company would also be able to mine Pixar movies to refresh its theme parks with popular new characters and stories.

For his part, Jobs cited his relationship with Iger as motivation for making the deal, trusting Iger's promise to maintain Pixar's unconventional company culture and preserve its unique creativity. In a CNBC interview at the time the deal closed, Jobs made his trust in Iger explicit, saying that Pixar was "buying into Bob Iger's vision of where Disney is going. He understands the importance of animation." In the *Los Angeles Times*, Iger tied the success of the Pixar deal to a single phone call with Jobs, in which he popped the question and waited anxiously for a reply. After a moment, Jobs responded simply, "It's not the craziest idea in the world."

Iger knew that a major acquisition was a good way to bring in new talent who might well benefit the greater company. Iger himself had come to Disney through its 1996 acquisition of Capital Cities/ABC, where he had then been president and COO. He had spent most of his career at ABC in New York City, working his way up the ranks from weatherman to lead the network's entertainment division before ascending to the presidency in 1994. But he had always had an affinity for Disney and fondly recalled as a boy "watching the *Mickey Mouse Club* on a small black-and-white television set and [being] not only enthralled with the show and the Mouseketeers, but the other shorts and different kind of forms of storytelling within it." He remembered watching Walt Disney talk about the creation of Disneyland on television and "dreaming of one day being able to go there." But he was an East Coast kid—a graduate of Oceanside High School on Long Island, New York, and then Ithaca

College in Upstate New York—so his first visit to the park had to wait until he was out of school.

As his pursuit of Pixar underscored, Iger was intent on both preserving and enlarging the Disney brand. "What I've tried to do as CEO is to create a real balance between respect for our heritage and the need to innovate," he said. "I think what we have as a company is so unique because the heritage is so special—the heritage that was Walt, the heritage that was the Nine Old Men, the heritage that was the beginning of Imagineering, the opening of Disneyland, those great films, the television show about building Disneyland. You could look in so many directions and find this rich heritage, which actually has application today. It's still warm. It's still inviting. It's still entertaining, and there's no need to discard it and there's no need to be disdainful of it. There's also, I think, no need to be reverential to it, because if you revere something you don't want anything to change and might as well relegate it to a museum case and leave it as it is. I did not want to do that. I did not want the values of the past and us valuing the past to get in the way of us being in our present and creating our future."

Iger regularly cited three guiding principles as the core of his leadership philosophy at Disney: fresh, high-quality creative content, technological innovation, and international expansion. All three were also vital to the future of Walt Disney Imagineering, which needed new and popular intellectual properties to create blockbuster attractions that would endure for decades, technological innovations to ensure groundbreaking state-of-the-art experiences for park guests, and international markets to fill both existing and future parks with enthusiastic Disney fans.

Moving forward in all these ways, Iger argued, was also in keeping with the philosophy of Walt Disney himself, who opened Disneyland by saying that the park would never be finished. From its very inception, "the company never stood still," Iger said. "Walt wasn't about creating something and leaving it as it was—including Mickey Mouse. Over the years, Mickey changed because Walt knew that times change. So that's really the message that I sent [as CEO]. I have huge respect for who Walt

was and what he created, what he meant to the company. Really what he means to me because . . . he made it all possible for us. He gave us this unbelievable canvas to paint on."

II. FORWARD, BACK, FORWARD

As the Pixar acquisition was being announced in January 2006, Walt Disney Imagineering was allowing cast members to preview test runs on its own most recent attraction—in many ways, an expression of two of Bob Iger's guiding principles: innovative technology and brand-new content. Expedition Everest—Legend of the Forbidden Mountain in Disney's Animal Kingdom Theme Park was unlike any of Imagineering's previous mountain adventures. It might have resembled the Matterhorn in its snowy crags, but it was a couple of generations removed—"plussed," as Walt would have said—in mechanics, electronics, and place-making. It was Disney's first coaster in which the trains reversed direction mid-ride, running backward at high speed for nearly a minute before revers-ing again to complete the journey in forward motion. It required an unprecedented menu of mechanical and programming innovations to accomplish, and it was planned and constructed using state-of-the-art proprietary imaging software.

For all its high-tech twists, however, the Imagineers' first priority was that it told a story that fit comfortably within the park. "We were a little worried because the ride itself is a thrill ride," said Joe Rohde, again the lead designer. "So it would be very easy for an attraction like this to slip over into fantasy and get silly in a park like Animal Kingdom, which is so grounded and so rich in authentic detail. It's a ride about going to see the Yeti—a story about a legendary creature that turns out to be real. So we really needed to create a realistic world for it to be real in." That included not only the theming within the attraction but also the village surrounding its entrance.

Rohde was already steeped in Himalayan mountain culture, having been "going back and forth to the Himalayas for twenty-five years," he said. He took four additional research trips, along with other Imagineers,

for the Everest project. "All together we probably spent half a year in the Himalayas. It was pretty extensive. The whole village that surrounds Expedition Everest is more or less drawn from the Tibetan and the Nepalese Himalayas." The people there have an "extremely detail-oriented tradition of carving and sculpture," Rohde said, which would have been "difficult for us to do without help from the people who live in that region." Nepalese artists were commissioned to construct much of the exterior detailing of the buildings—including a mandir, or Hindu temple tower. The artists' work helped hide the mandir's interior steel frame, built to withstand Florida hurricanes.

The catch was that the village in Disney's Animal Kingdom needed to look a couple of hundred years old. So after receiving, say, the gorgeous window frames commissioned from Nepalese wood carvers, polished to a mirror finish, the Imagineers "took them and laid them out in the rain for about a half a year and let them soak up water and split and open up cracks," Rohde said. "And then we would take them with a crane and drop 'em, so we would break all the pegs inside the window so we could twist it." Then came the chiseling with a jackhammer, and the wire brushes on a drill, the sandblasting, and the treatment with sticky tar—"trying to get them to have this look of something so old that all the varnish is starting to actually oxidize and burn off of it. You know, it's got to look like a 200-year-old window that's been sitting out in the weather in the mountains."

Knitting together the story of the Himalayan village and the narrative of a technologically complicated thrill ride required Rohde's leadership, Imagineer Daniel Jue remembered. "There are a lot of technical challenges that I had to deal with—with the ride system and with the mountain and how we were going to build it." The narrative was not one of those challenges, he said, "because Joe had a very clear vision about the story. Getting that clarity, which Joe is brilliant at, is really a key to the success of many of our projects. It's when we don't have that clarity that people start to drift and make inconsistent decisions that get us into trouble."

The mountain of Expedition Everest was 200 feet tall, besting the Tower of Terror by six inches. Imagineers created two dozen clay models

of the peak before scanning the final shape to create the computer model. The physical construction within Disney's Animal Kingdom was the usual collaboration among Imagineering's full arsenal of artists: designers, engineers, computer programmers, rock sculptors, and so on. But perhaps the most remarkable technological innovations were happening back in Glendale, where proprietary new software, developed within Imagineering, had revolutionized the planning process. The Imagineers dubbed it "4D," since it not only created a 3D image of the project—everything from the internal superstructure to the coaster tracks to the craggy surface of the mountain—but also depicted its progress through time, the fourth dimension. The software also allowed the Imagineers to predict conflicts between the different construction teams and adjust to avoid them.

The 4D software was created by an R&D team led by Imagineer Benedict Schwegler and two researchers from Stanford University. It had been developed over three years beginning in 1998, with the California Screamin' roller coaster in Disney California Adventure as its test project. By the time Expedition Everest was underway, 4D was also in use as part of the top-to-bottom renovation of the original Space Mountain in Anaheim, set to reopen in 2006. With The Walt Disney Company's blessing, word of the Imagineering software spread throughout the construction industry, and Disney had licensed it to contractors working on architect Frank Gehry's complex Walt Disney Concert Hall in downtown Los Angeles, as well as for the building of hospitals, malls, pipelines, and the port of Miami. (It was so successful that the Stanford researchers Martin Fischer and Kathleen Liston negotiated a deal with Disney to set up their own separate company, called Common Point, to continue to hone and license the software—with Disney keeping the right to use the software, which it had paid to develop, for free.)

But as always at Imagineering, all the technological breakthroughs were behind the scenes, hidden from the guest experience. Many lower-tech mechanical tricks and innovations helped cloak the nuts and bolts and elevate the story that Rohde had developed for Expedition Everest. Guests were said to be boarding a steam locomotive for a journey through

a Himalayan pass—a terrain Rohde personally knew well—and the coaster trains were made to appear steam-powered with puffs of water vapor rising from a front "smokestack" and from beneath the loading platform as the vehicles arrived and departed. The Imagineers developed a new system to tug the trains up the steep first hill in the manner of a traditional roller coaster but without the telltale clacking sound that would spoil the steam train illusion. The team added to the story as much of Himalayan culture as they could, drawing from Rohde's deep knowledge of the area. The first section of track took riders through the ruins of a temple, its walls covered in drawings of the mountain's mythical Yeti—whose handiwork they would soon see. In short order, the vehicle was brought to a stop for six seconds near the peak—the track in front seemingly torn up by a large creature—while the platform beneath the train quietly flipped upside down, redirecting the vehicle backward through a series of curves and hills at up to fifty miles per hour. (As soon as one vehicle cleared the rotating platform, it flipped back to connect to the uphill track on which another train would shortly arrive.) A second stop in the Yeti's cave home allowed for another track switch. Riders then barreled forward and, finally, encountered the Yeti himself in a cavern just before reaching the terminus.

The Audio-Animatronics Yeti was to have been the Imagineers' most impressive creation on the attraction—not counting all the largely invisible computing and engineering feats. It was twenty-five feet tall, weighed ten tons, and was kept balanced on its two enormous legs by a structural boom invisibly connected to its back. It could move five feet forward and back, and it roared and lunged—until it didn't. Iger officially opened the ride on April 7, 2006, but within several months, the Yeti was frozen in place. The heavy creature's repeated motions threatened to weaken the concrete support structure holding it up, so Imagineers were forced to turn off the animatronics, leaving just the audio. To compensate, the Yeti's cavern was fitted with strobe lights to give the illusion of movement. (On social media, the creature was soon dubbed "Disco Yeti.") Fixing the problem vexed the Imagineers for more than a decade, without a workable solution. "It's not an issue of maintenance access," Rohde

said on Twitter in 2020, complimenting the maintenance team as equal collaborators with the designers. "It's an unexpected and unforeseen set of issues, very complex, with no easy or timely solutions as of yet."

Such concerns were among the factors that led to a major restructuring of Imagineering three years later, in 2009. With the retirement of Imagineering president Marty Sklar, Bruce Vaughn and Craig Russell took over leadership of Walt Disney Imagineering in 2007 as chief creative executive (Vaughn) and chief design and project delivery executive (Russell), and the position of Imagineering president was (temporarily) eliminated. (Imagineering president Don Goodman, who had previously run R&D at Imagineering, became executive vice president for Resort Development, overseeing the company's real estate developments with Wing T. Chao, who was executive vice president of Master Planning, Architecture, and Design.) Two years later, in 2009, Vaughn and Russell oversaw an additional restructuring that replaced the ever-changing project-based teams with a portfolio system, assigning permanent creative leadership to each specific property: Anaheim, Orlando, Tokyo, Paris, and Hong Kong.

The goal, Vaughn said, was to "take a global view of the product." The organization, he said, had begun—unconsciously, perhaps—to prioritize its physical creations above the less tangible experiences of its park guests. "And it struck me and Craig as, well, that's not right. That implies to me that an Imagineer builds architecture and places and things and that's what we're proud of." Individual Imagineers would "know the guest experience is so important, but if you're not designing with that in mind—if you're not designing with, 'Oh, it's to bring people together; it's to make people happy; it's to create immersive worlds of fantasy and bring those to life for the guest'—then you become too self-referential and you're a bit arrogant about what your product is."

He continued, "At the end of the day, what we Imagineers do is create the venues for the guest experience. It's less about the parade going down the street and more about the faces of the guests watching the parade. That's what the reward is. Every Imagineer knows that when they go to the park and look at it. But you have to reinforce that that's the

product." The portfolio structure, Vaughn and Russell concluded, would give Imagineering's creative leaders an ownership and intimacy with specific properties, keeping them better connected not only with the guests but with the Operations team within each park—"our front line," he said, "all these cast members out there with these badges on, interacting with the guests." Portfolio leaders would "know this resort better than anybody and think of it holistically—think about the hotels, think about the entertainment, think about the attractions, think about the place-making, think about everything about it and then come back with ideas about what needs to get done." The new management structure at Imagineering would be crucial in the several upgrades and expansions then being developed for Disney parks in the coming years.

III. HARRY AND JACK

Bob Iger's epiphany at the opening day parade at Hong Kong Disneyland was part of a much larger battle for the most popular intellectual properties on which to base theme park attractions. The competition had ramped up in Michael Eisner's last years as Disney's CEO, particularly when Universal Orlando opened a second theme park a short drive from Walt Disney World, called Islands of Adventure. Among the up-to-the-minute cultural touchstones it included were Dr. Seuss's The Grinch (in anticipation of the holiday 2000 release of Universal's live-action feature film based on *How the Grinch Stole Christmas*), Marvel super heroes (including The Incredible Hulk Coaster and a dark ride with 3D effects called The Amazing Adventures of Spider-Man), and *Jurassic Park* (the basis for a dinosaur-themed flume ride). Less current were a collection of cartoon characters from King Features Syndicate, such as Popeye and Dudley Do-Right. Still, it was an impressive opening day variety pack—and it would soon become even more formidable, with the addition of a young wizard and his story-rich universe.

On May 31, 2007, Universal Orlando announced it had struck a deal with Warner Bros. to open The Wizarding World of Harry Potter within

three years. After some delays, Universal's park-within-a-park opened a little more than three years after it was announced, in June 2010, within Islands of Adventure. It was perhaps the most formidable challenge yet to Disney's dominance of the Florida theme park industry, but it was also a threat that came as no surprise, since Warner Bros. had been shopping the rights for years—including a failed attempt to interest Disney in the Potter property. Universal planned two phases of Wizarding development, and the 2010 debut included facsimiles of both Hogwarts Castle and Hogsmeade Village (a shopping arcade).

The next phase was to be an equal-size second Wizarding World land next door, within its Universal Studios park, set to open in 2014. The new area would be chiefly a re-creation of the books' Diagon Alley, with live performances and an even more impressive centerpiece ride.

"Universal—with Harry Potter and Diagon Alley—has really given us a run for the money, and rightly so," said Imagineer Tom Morris. "Those are beautiful projects. Beautiful place-making. Some wonderful shops and restaurants and great merchandise. The merchandise itself is wonderful, and the experience of buying the merchandise is really fantastic. That's an area where we now need to catch up with the competition."

Catching up included leaning into the search for new intellectual properties to layer into the existing parks. While the offerings from Walt Disney Animation Studios features thinned out, not every new story had to come from Pixar. As the twentieth century evolved into the twenty-first, Imagineers began to infuse classic park attractions with fresh themes and characters from previously underutilized properties. For example, there was one treasure trove of spooky characters that had not been seen in the parks before: Jack Skellington, Sandy Claws, Sally, and all the other Tim Burton creations from the 1993 stop-motion animation feature *Tim Burton's The Nightmare Before Christmas.*

The introduction of the film's narrative at Disneyland had its roots years earlier with a different take on the holiday: the decision to decorate "it's a small world" for Christmas. "Back in the early '90s, we were asked to reconceive Christmas," recalled Imagineer Steve Davison. "We had a

big board of just big ideas, and one of the ideas was creating 'it's a small world holiday.' And lo and behold they went for it, because it was a very simple idea—put Christmas and kids together. So we just kind of blindly went into it."

What happened next became a pattern whenever the Imagineers tinkered with longstanding attractions: the Internet "just blew up," said Davison, who summarized the complaints posted on social media platforms as "They're attacking our sacred ride!" The only previous top-to-bottom holiday overhaul of an existing attraction had been the Country Bear Christmas Special, an overlay within the Jamboree attraction in the Magic Kingdom in 1984, before social media existed. The Country Bears' popularity had been waning by then, while tampering with the iconic "it's a small world" would require a more delicate balance: "Everything we did was very true to what the ride was, but for me it really needed to scream it was different—like, 'Wow, this is a whole new ride.'" With new music, holiday costumes and decor, new or modified Audio-Animatronics, and new lighting, "it was just going to be like this explosion of holidays really hit this ride," Davison said.

With great trepidation, Davison and his team—including Kim Irvine, who had worked on "it's a small world" when it was first installed—went to the park in late 1997 for the opening of "it's a small world holiday," feeling terrified about what the throngs of people waiting outside would think. "The first thing we did was turn on the eighty thousand lights that were on the front," Davison said. The music started up: a mashup of "Jingle Bells" and the traditional "it's a small world." The crowd reaction was immediate: "Everyone just cheered, because it looked like Oz. And everyone started going in—and the great thing is, everybody that went in came out with huge smiles. It really kind of reinvented the attraction in two ways. It was great for kids again, but it was great for all those parents that had gone on it years before. They went on it again and saw everything that they loved but they saw it in a whole new light. All the people that were so negative on the Internet by the time they went on it were raving about it. I was very proud of that, because it was such a gamble and it really paid off."

The lesson, Davison said, was that even classic intellectual properties could be turned into must-see attractions again—as long as the Imagineers focused on what was unique about the properties in the first place. The success of "it's a small world holiday" "had a lot to do with the fact that only Disney could do this. Anybody could go and put lights up on a facade they had in any of their parks, but nobody had a ['it's a] small world.'"

The popularity of the seasonal version of "it's a small world"—which immediately became an annual event—opened the door to a similar overlay at the Haunted Mansion. That idea, however, was not as easy to sell to Imagineering management and Park Operations. It took three years of pitching. "The idea of putting holiday [theming] into the Haunted Mansion is crazy," Davison said. "We kept going to meetings going, 'Look, holiday at the Haunted Mansion!'" Eventually, the team was inspired to add characters and storytelling elements from Disney's long-neglected *Tim Burton's The Nightmare Before Christmas*, a Halloween movie with a Christmas theme—or maybe the other way around. "The Jack Skellington spin on it is what sold it. Because I can go to marketing and say, 'You can market it from September all the way through January.' And to them that was gold, because with one giant product you are now cornering a market that they could never get."

Disney had been skittish about whether Burton's *Nightmare* was family-friendly from the beginning, releasing it under the Touchstone label, rather than branding it as a Disney movie. It had won over critics and earned an Oscar nomination for Best Visual Effects (the Best Animated Feature category did not yet exist), but it had previously been overlooked by Imagineering because "it had a very niche market," Davison said. "When we started, the franchise wasn't that big. To me it was interesting, because again the Tim Burton piece of it was fantastic. The style of it was amazing. The characters were amazing. And the idea of coming in and having this crazy character kind of just land his sleigh on the Haunted Mansion by accident—and everything that he put in, all the guests loved. That was kind of the point of view of it." Working with the Park Operations' entertainment division on the overlay, the Imagineers

had a ball, taking the existing Haunted Mansion sets and adding spidery Christmas trees and singing, snow-capped jack-o'-lanterns and creepy snow angels. "It was the craziest thing ever," Davison said.

One bold idea was to change out the incantation in the séance room, replacing the musical instruments Madame Leota had conjured for decades with giant floating Tarot-inspired cards depicting "The 13 Days of Christmas." (The gifts included "rings of power," "telling tea leaves," and "mystic mirrors.") Leota Toombs, the original face of Madame Leota, had passed away in 1991, but Davison had a plan. "Steve Davison came to me and asked if I wanted to do Madame Leota," recalled Kim Irvine, Toombs's daughter. "I'm kind of shy and I didn't really want to do it, but I didn't want anyone else to do it either. I wanted to keep it in the family." Davison wrote the new incantation, and Irvine submitted to the indignities of having a cast made of her face—the thick layer of alginate, the straws in her nose, and all. Irvine sat quietly while the Imagineers spread the goo and waited for it to harden, thinking about when she was sixteen and her mother came home after that same uncomfortable procedure. "Remembering all of her stories and then actually reenacting it all was pretty amazing," Irvine said. Once the casting was done, she sat with her head absolutely still and performed Davison's new text (although the voice was ultimately provided by frequent Disney voice-over actor Susanne Blakeslee).

As it turned out, the cast of Irvine's head may not have been needed. "Our faces are so much the same, the life mask [within the crystal ball], they don't have to change them out. They're able to just project on the same face—so we play a dual role."

How Disney fans would react to this tampering with a classic was again a concern, Davison said, but "my big philosophy has always been, 'If you're going to do it, do it big.' We totally dressed that ride out, from the very first piece when you walk in, to the last piece when you leave. It's just full of decor." At opening night in 2001, with the media on hand and guests clamoring to get in, Davison felt his unfounded "it's a small world" Holiday terrors returning: what if they were disappointed it? He

stewed in the attraction control room, confessing his concerns to a technician. "He goes, 'Go ride the elevator. Just act like you're a guest, go ride the elevator, and you'll have your answer.' When we got to the bottom of the elevator, people were just screaming. And then I knew: 'Wow, it did work.' This crazy, crazy idea that nobody was really asking for."

Suddenly *Tim Burton's The Nightmare Before Christmas* was no longer a niche market. Disney spent millions of dollars to have Industrial Light and Magic turn the original film into a 3D feature and released it in theaters every fall from 2006 to 2009. "And the wildest thing now is that the Jack Skellington merchandise is huge in the parks," Davison said. "You see it everywhere. And a lot of that's because of Haunted Mansion Holiday. It was fun. That's what I love, it's just to dream crazy. How crazy can you be?"

IV. ANOTHER JACK

Rewind ten years, and the letters page of the *Los Angeles Times* was aflame with Disney fans angry about modifications to another classic Disneyland attraction. "I'm saddened to see Disneyland stoop to measures like this in a misguided effort to avoid offending anyone," wrote a reader who identified himself as a former cast member. How, asked another letter writer, "can Disneyland officials be so insensitive"? "I was outraged," one woman ranted. "I think the changes are ridiculous. What do you think pirates did for a living?"

The occasion for the tempest was a January 1997 announcement that Pirates of the Caribbean in Disneyland would shut down for two months to alter the tableaux that suggested village maidens were being chased for the purpose of sexual assault. "We listen to our guests, and our guests have raised some concerns about that scene," a Disneyland spokesman told the *Times*. "Our fans are a blessing, and sometimes not so much," said Kim Irvine. "I love their feedback, but it's also very difficult to please them, and to convince them that they need to trust us." Many guests, she added, "want everything to stay the same, just as they

remember it the first time they ever came. But that's really not a good idea because things become stale. Walt wanted all of these attractions to be updated. Again, relevancy. He kept saying, 'We've gotta keep this thing live and fresh and new.'"

The fresh additions to Pirates were not major. One pursued maiden would now carry a tray of wine, while another was replaced by a flock of chickens, chased by a pirate with a net. The idea was to suggest the pirates were peckish rather than lascivious (a change that prompted the *Times* reporter to get comments from a weight-loss clinic). A woman hiding from the pirates in a barrel—peeking out, then sinking back down, presumably to preserve her virtue—was replaced by a cat.

Second-generation Imagineer Kim Irvine defended the impulse to update Pirates and other classic rides. "Since most of these attractions were actually created in the '50s and '60s and '70s, you know, times change," she said. "And we have to look at things a little bit differently. And sometimes that means we make some small tweaks to our attractions." The 1997 alterations to Pirates of the Caribbean were minor, the ride reopened, and fans soon lined up by the hundreds to see what was new. The furor was essentially drowned out by the enthusiasm of park guests, who wanted to see if they could spot all the changes.

"Pirates of the Caribbean has become the standard by which our guests measure every other attraction," Marty Sklar told the *Los Angeles Times*. "But it's not a museum piece either. We want to keep adding to it and improving it like everything else." Of course, despite the stated goal of taking sexually suggestive scenarios out of the ride, the renovation left untouched the attraction's most dramatic depiction of the exploitation of women: the bride auction, with its terrified plump woman on the block and a siren in a red dress primping for the would-be slave buyers. ("There are no current plans to change that," the spokesman said.) Another twenty years would pass before that narrative was rewritten.

The cat in the barrel had a shorter life span.

By early 2006, the letters page of the *Los Angeles Times* had been supplanted by social media as the place irate Disney fans again expressed their fury over tampering with Pirates of the Caribbean. This time the

motivation seemed more clearly commercial. In 2003, Disney's Johnny Depp movie *Pirates of the Caribbean: The Curse of the Black Pearl* had been a box office smash, landing among the four top-grossing films of the year and selling an estimated fifty million tickets in the United States. The sequel, *Pirates of the Caribbean: Dead Man's Chest*, was due out in July 2006. As the attraction had inspired the original movie—which included many visual tidbits lifted from the ride—the movies would now saturate the attraction. Pirates closed in March for the refurbishment, reopening in late June, a week before the release of *Dead Man's Chest*.

The changes included the addition of three Audio-Animatronics renditions of Depp's Captain Jack Sparrow throughout the ride—one of them replacing the cat in the barrel, as Sparrow seemingly scoped out a nearby pirate who had been given a treasure map and magnifying glass. A figure of Geoffrey Rush's Captain Barbossa now commanded the pirate ship shooting cannons at the fortress in the lagoon scene (when music from the film could also be heard). Bill Nighy's spectral Davy Jones, from the second film, appeared as a projection on a waterfall that served as a curtain that disappeared to reveal the room housing the battle. Other updates to lighting and special effects were more subtle but updated classic Imagineering innovation with new technology, such as the new digitally projected lightning bugs, which replaced the practical bug effect that had been crafted by Yale Gracey. Similar modifications were made to the Pirates ride in Walt Disney World, which reopened in early July.

Some longtime fans were predictably irate. "It's about as weird and inappropriate seeing Johnny Depp in this ride as it would be if Charlton Heston was written into the Bible after starring in 'The Ten Commandments,'" one seethed to *The New York Times*. Jason Surrell, a Walt Disney Imagineer tapped to write a book about the adaptation of the attraction into the movies, said the changes simply played to some guests' anticipation. "You have an entire generation of guests who come there for the film series," he said. "Younger fans expect to see these movie characters in the attraction."

Imagineer Kathy Rogers, who oversaw the changes to the ride at both Disneyland and the Magic Kingdom, told the *Los Angeles Times* that the

revamp "strengthened the classic." "I cannot imagine how anybody can see this attraction and walk off and say, 'Boy, they did something they shouldn't have.'" To another reporter, she added, "We have such reverence for Marc Davis's storytelling. . . . This is not about making it the movie ride." Despite that, Rogers noted that Davis's original story line in the harbor scene had been rewritten, although in a way guests might not notice. Rather than just sacking the city, she explained, Barbossa's crew was now attacking in an effort to capture Jack Sparrow. Still, she added, the new figures "look like they've always been there. You're not saying, 'Oh, they put that movie thing there.'"

Rogers also acknowledged the work of original Pirates sculptor Blaine Gibson, saying that Valerie Edwards, who sculpted the new figures, was a protégée of Gibson. "Our characters in here are very caricatured," Rogers told the *Orlando Sentinel*. "We actually did tweak the characters of both Barbossa and Captain Jack Sparrow in this so they live in our world, because our world is not the real world." When the two modified Pirates rides reopened, once again the complaints of originalist fans were outweighed by the attraction's renewed popularity, and by theme park guests who found the updated ride to be just dandy. "It looked so authentic to me. I loved it," one Florida visitor enthused. As for the new figures, "I thought they were real people," she said.

A dozen years later, Pirates of the Caribbean was subjected to one more revision. That "Take a Wench for a Bride" banner left untouched by the 1997 changes finally came down in 2018, and the women who had stood for auction for fifty-one years were freed. The announcement of the changes was made in early July 2017, during a period of increasing outrage over sexual harassment against women—a movement that would take the name #MeToo the following October. The sultry redhead in the scene was recast as a member of the pirate crew, leading an auction for the booty looted from the town.

Later that summer, Imagineering suffered two significant losses: Marty Sklar passed away at the end of July, and X Atencio died in September. It was a double blow to Imagineering, as both left vacancies in the organization's creative history that no one else could ever fill.

Sklar's forty-eight years with WED Enterprises and Imagineering, and his wise, benevolent leadership were unlikely ever to be equaled. His creative instincts were perhaps second only to Walt's own, a fact his fellow Imagineers acknowledged with the Main Street, U.S.A., window they designed for his retirement in 2009. It read, "Main Street College of Arts and Sciences, Martin A. Sklar, Dean." Along the bottom of the window, which would forever speak to Sklar's impact on generations of Imagineers—some of whom he would never meet—it read, "Inspiring the Dreamers and Doers of Tomorrow."

V. NEW SIGHTS FROM BELOVED BOATS

Marty Sklar's efforts to save the boats idled by the 1998 closure of Submarine Voyage in Disneyland did not go unrewarded. "We had searched for something that we could tie this part of my childhood onto," said Tony Baxter, who had adored the Submarine Voyage when he was twelve and then, as an Imagineer, searched and hoped for a new intellectual property that could revive the attraction. "We had hoped *Atlantis: The Lost Empire* was going to do good." If Disney's 2001 animated feature had been a hit, that would have justified the time and effort needed to refurbish and re-theme the Tomorrowland classic. Instead, the movie underperformed at the box office and even failed to get a nomination for the first year of the Best Animated Feature award at the Oscars. In short, Baxter said, "it didn't do it."

Two years later, another underwater feature swam straight to the top: Pixar's *Finding Nemo* was the second-highest-grossing film of the year in the United States (behind *The Lord of the Rings: The Return of the King*) and won Pixar its first Academy Award for Best Animated Feature. "When *Finding Nemo* came out, it was a home run," Baxter said. "So we knew right away that if we could create some way of merging the Pixar animation—which shouldn't work underwater at all—with an underwater experience, what a winner that would be."

"The moons were in alignment when the movie *Finding Nemo* came out," added Imagineer Kevin Rafferty, who wrote the script for what he

dubbed the Finding Nemo Submarine Voyage, a name that stuck. "It just seemed like a natural fit."

Baxter started a quiet campaign to win support from the new Disneyland president, Matt Ouimet. Imagineers refitted one of the old Submarine Voyage vehicles in the style of *Finding Nemo* and left it in the attraction lagoon, where Monorail riders could take photos to share online. "I knew it would get buzz," Baxter said. As he recounted to writer Arthur Levine, Baxter next had the Imagineers build an attraction mock-up and invited Ouimet for a test run. "I really didn't want to like this," Ouimet said, in Baxter's retelling. "It's fantastic . . . but, it's going to be *so* expensive."

Making the new attraction work would require a lot of that new technology that Bob Iger emphasized. Each submarine would seat forty people, facing two directions beside forty separate portholes stretched along the sides of eight 52-foot-long vehicles. The show needed to accommodate all these separate perspectives with a unified and synchronized narrative, including cycling animation clips that would have to be shown with new projection technology. (The system would not need to be waterproof, however, since most of what riders viewed was, in fact, in a dry space beyond the layer of water immediately outside the subs.) "We built a section of the sub out of foam core and we invented some technology to allow us to go from seat to seat to seat to see what we would see and what we would hear [at each moment during the ride]," Rafferty said. "We designed the script accordingly to where if you heard what was happening in the front seat, it would make sense to you in the last seat coming up to it. So it was quite challenging."

Baxter credited Pixar creative chief John Lasseter with helping the Imagineers solve this narrative puzzle. "He was our guardian angel. He saw us through the difficulty of making something that is physically impossible to do, doable. And every aspect of that was reinventing technology for the twenty-first century." One change was replacing the vehicles' former diesel engines with electric, which were recharged at the loading dock by induction technology that did not require wires or other physical contact. "The sound system on board is synchronized with

animation that's running out in the ride that shouldn't be in sync with it and yet it is, and it's synchronized to move through all the seats along the sides. It's absolutely brilliant."

"As simple as that ride seems," explained Glenn Barker, a media designer for Imagineering, "there's an eight-channel sound system. Each porthole has a speaker above it so you get that sound with your image and as you are floating by. We pan the sound down through those eight channels from one end to another." As a result, each seat along each side hears Dory say, "Nemo, where's Nemo?" at the same time the animation of Dory is visible from the porthole. The audio team also added a subwoofer to each submarine, "so we can get the big explosions and all of that."

One of the things Baxter was most proud of in employing all the new tech to revive the subs is that "it's all invisible and at the service of having a great time visiting your friends in Nemo's world." As Baxter put it, "people don't realize how complicated [the submarines] are, and you don't want them to know. You just want them to go on and think they are really out there, [saying to themselves,] 'These are real fish. They are talking to us.' People come away going, 'Wow, how do they do that?'"

There were no social media snubs this time around. Guests took to the new ride like fish to water. "People were just so happy to see that attraction come back to life," Rafferty said. "I remember we invited a couple of our Pixar pals down, and Jonas Rivera, who produced Inside Out, came down. And I remember he sat next to me and he was just like bawling—like, 'You guys brought this back. This is so cool.' So bringing new life into a classic attraction was really fun."

The next renovation mission, though, would take the Imagineers through rougher waters—adding more than Christmas to "it's a small world." The resulting dustup was perhaps the most prominent fight since the Disney's America dustup over what the Imagineers should and should not be trusted to do.

The project began benignly enough. By the fall of 2007, the boats in "it's a small world" had a problem. They got stuck periodically, grounding out on the bottom of the channel in which they traveled,

reportedly in two spots, one near the Canadian Mounties and another by
the Scandinavian geese. The standstills were infrequent but more than
once resulted in embarrassing evacuations within the attraction itself,
stranding other riders behind the stuck craft in immobile boats until
the blockage was cleared. The Internet was abuzz with the theory that the
increased weight of the average Disneyland patron was the problem, but
Disney said the issue was simply a result of four decades of repairs to the
boat channel that had built up layers of fiberglass patches and reduced
the water's depth. The plan was to replace the "it's a small world" armada
with lighter vessels and to upgrade the channel to add an additional inch
of water depth. It would take ten months, starting in January 2008.

The closure would allow other upgrades as well. Permanent fixtures
would be added to make the addition of the holiday overlay simpler, for
example, and any figures or costumes that were reaching the end of their
life span could be refurbished. But then news leaked of changes that went
beyond maintenance: doll-like figures representing Disney animation
characters would also be added to the show, along with a small section
that would be a direct tribute to the United States. The idea, said Imagi-
neer Kim Irvine, chief designer on the project, had come from Hong
Kong Disneyland, where Imagineers "had just finished their "it's a small
world," and they had incorporated a little Disney doll in each scene in
their attraction. So Marty [Sklar] called me and said, 'I think it would
be fine if we did this at Disneyland. They're really cute and would make
a fun addition. We haven't done anything new in ['it's a] small world' in
quite a while.'"

Irvine, who had worked with Mary Blair and knew her style, designed
the figures for Disneyland. "So we took each one—Cinderella and Alice
in Wonderland and such—and turned them into something that looked
more like the toys [in the attraction]. So instead of Cinderella being
in her ball gown, she's in her little scullery maid outfit," with toy-size
mice representing the film's Jacques and Gus alongside her. Alice was in
her pinafore with a toy White Rabbit. Each character was then strategi-
cally placed in the national area that corresponded to the origin of the
story: Cinderella in France, Alice and Peter Pan with the British dolls,

Pinocchio in Germany, Aladdin in Arabia, and so on. "Once we started working on them, and I could see them transforming into something that fits seamlessly into it, I felt more comfortable with it."

The details were not originally shared with the public, and the push-back on what information was available was immediate and alarmist. Despite everyone's apparent acceptance of the holiday overlay, which was much more intrusive than the character introductions would be, certain fans and former Imagineers took to the media to condemn the plan. "I think when people first started hearing that we were doing this, it was difficult for them to imagine because they thought it was going to be Donald in a hula skirt and Goofy in a sombrero," Irvine said. "I totally understand why they didn't like the idea, because that would sound bad to me, too."

Mary Blair had died thirty years earlier, but her son Kevin penned a letter to Disney that he said represented the entire Blair family and the wishes of their lost matriarch. "The Disney characters [in and] of themselves are positive company icons, but they do NOT fit in with the original theme of the ride," he wrote. "They will do nothing except to marginalize the rightful stars of the ride 'The Children of the World.' This marginalization will do nothing but infuriate the ride's international guests and devoted Disney fans." The family also opposed the "tribute to America," he continued, citing the same marginalization argument. "Furthermore," Kevin Blair wrote, "ripping out a rainforest (imaginary or otherwise) and replacing it with misplaced patriotism is a public relations blunder so big you could run a Monorail through it." As a former Imagineer himself, he added, "I cannot believe someone from Imagineering was paid to come up with such an idiotic plan as this." He concluded, "The desecration of Mary's art is an insult to Mary Blair, her art, and her memory, and to the entire Blair Family itself."

The unfiltered anger of opponents to the changes made it "probably one of the worst controversies" to engulf Imagineering, in Irvine's view. Disney tried to calm concerns with two open letters in response to Kevin Blair's, one from Sklar and another from Disney's chief archivist, Dave Smith, both of whom had known and worked with Mary Blair. Smith

reminded the complainers "that Walt Disney never intended Disneyland to be static" and that "the Disney Imagineers have continued to follow his dream, frequently adding and changing things in the park to give today's guests the best possible experience." Sklar also cited Walt's intentions, and sought to put Blair's contributions to "it's a small world" in context: "Mary Blair's illustrations were, of course, the spark. But this was one of those great Disney 'team efforts,' and many Disney legends joined her: Marc Davis; Blaine Gibson; Rolly Crump, Harriet Burns and numerous others," as well as songwriters the Sherman brothers.

Sklar wrote that reports of great changes were either exaggerated or untrue: Mickey Mouse would not be making an appearance, the rain forest scene would not be removed (it was repositioned to make room for the USA dolls), and the world's children would not be marginalized. "We are not turning this classic attraction into a marketing pitch for Disney plush toys (rumors to the contrary)," he wrote.

Looking for an ally from the WED days, Irvine invited Alice Davis, Marc Davis's widow and the designer of the original costumes from "it's a small world," to lunch. Over their meal at a restaurant, "I showed her all of the designs," Irvine recalled. "At first she was like, 'I don't think we should be touching anything in that ride.' But when she saw them, she went, 'These are really cute. I want to help you design these costumes. I like these.' And she actually had a lot of input into the costumes."

Irvine was convinced the modifications were in the spirit of the first Imagineers. "Any changes that we make are always done within the original intent. And I mean that across the whole park. We love Disney just as much if not more than the guests. I mean, we grew up here, so it means everything to me to make sure that the original stories [remain as they were,] laid out for us by the original Imagineers." Change was built into the DNA of Disney theme parks, she added, "but it needs to be as good, if not a lot better than what was there before. You can't take away."

Still, the online vitriol had Irvine spooked. "While this was happening, I was afraid to go out on the street at night," she recalled. "It was really serious, and people were very upset about it." Her trepidation continued on opening day in February 2009, when she stood outside the

attraction watching guests go in to experience the refurbishment for the first time. She was incognito, with no name tag or other indication that she was a cast member. Her mind was soon eased. "I'd hear people come out and go, 'That's cute.' 'Yeah, I really like that.' 'Hey, did you see the Peter Pan flying above?' You know? And they like it."

The experience reminded her of an earlier, less prominent renovation. "The same thing happens with everything you do," she said. "The first time I changed the [Disneyland] castle a little bit, I was working with John Hench. We added little squirrel downspouts and added a stained glass window and just added elements to it that made it more interesting. And the idea that we were putting things on the castle [some guests] were very upset about. So we had an annual passholders day right at the time the castle was being worked on, and I set up a table out in front and had John Hench's drawing of the downspouts and a little mock-up of the stained glass window. And they'd come over and say, 'What are you doing to our castle?' I'd explain to them, and then they'd go, 'I like that. Thank you, okay.' And they'd go. So it's really just letting them know that we are always doing the very best that we can to make sure that we keep things looking and feeling the same."

What to change, and when and how, is a permanent challenge for Imagineering, dating back to the first months of Disneyland, when both the Tomorrowland Boats and Canal Boats of the World needed upgrades. But revamps weren't always contentious, as Imagineering's next big project would demonstrate.

CHAPTER 26:

EXPAND AND DELIVER

"We're dealing with something that was just fundamentally broken and needed fixing. Right in our own backyard—or Disneyland's own backyard. And so I just decided, let's do it." —Bob Iger

I. A NEW ADVENTURE

THE YEAR 1923 did not begin well for twenty-one-year-old Walt Disney. His Kansas City, Missouri, studio, Laugh-O-gram Films, lost its one big client, and its few employees soon deserted. Nearly penniless, Walt ended up sleeping in the Laugh-O-gram offices and spending a dime once a week to bathe at the nearby Union Station. Finally, he threw in the towel, declared bankruptcy, and used what little money he had to buy a first-class ticket on the Santa Fe Limited train to Los Angeles, where his older brother Roy was in a veterans hospital, recovering from tuberculosis.

Although talking motion pictures were still years in the future, Hollywood had already established itself as a dream factory, and young Walt made a tour of the studios, trying to land a job. He had no luck, although he did get to watch some silent films being made, soaking up the tricks of the trade. But he soon returned to animation, working in the garage of his uncle Robert Disney, in whose home he was renting a room. In October he landed a contract for the "Alice's Wonderland" project he had developed back in Missouri, about a real little girl who has adventures in a completely animated world. Walt convinced Roy to

join him in his new business, and together the two founded that October what would become The Walt Disney Company. The year ended much more happily than it began.

It's that era of hope and growth that Walt Disney Imagineering wanted to capture along Buena Vista Street, the idealized vision of 1920s and '30s Los Angeles that replaced both the gateway to Disney California Adventure and its Sunshine Plaza after an extensive, park-wide refurbishment project that began in earnest soon after Bob Iger took over as CEO. Although the boulevard took its name from the address of the Walt Disney Studios in Burbank, on the other side of the Hollywood Hills from Los Angeles, Buena Vista Street was a dreamscape of the Disney brothers' early years in their adopted home. While casual visitors might not be able to identify the names and histories of the architectural landmarks the Imagineers re-created, they would nevertheless be immersed in the story of that era of Los Angeles—so vital to everything that followed at The Walt Disney Company.

When guests first enter a Disney theme park, Kevin Rafferty explained, "they want to go to another place and another time." Sunshine Plaza's kitschy take on California—with its caricature of the Golden Gate Bridge, blazing sun sculpture, and beach-themed pop songs—didn't accomplish that, in part because it evoked no particular era and in part "because the music that you heard walking into that park was the same music you could have heard in your car driving to the park. There was nothing special about it. I think the addition of Buena Vista Street—as far as the storytelling and the place-making—was huge. Because even though we made up Buena Vista Street, we didn't make up the story of Walt arriving in California—with a suitcase and a dream." It was, he judged, "a great theme for the park."

Rafferty continued: "It's okay to make-believe, but it's not okay to fake-believe. It's our job to make make-believe believable. Buena Vista Street was an entry statement. It was an era that people can understand. It informed what the sound of the music would be, what the costumes would be, and what the things would be in the [shop] windows. It was

a comprehensive, solid story that delivered on the believability. It was sincere. It was truthful."

It's that kind of storytelling that many thought the original California Adventure lacked. When the park opened, "the glue to hold the thing together, the depth of immersion—wasn't there," said Tom Staggs, who was president of Parks and Resorts for The Walt Disney Company at the end of the expansion project. "The amount of Disney DNA that was built into the park fell short, and we realized that. And I think that it took some courage to say, 'It's time to go in and fix it,' because that's a big bet."

Bob Iger had not had any significant involvement in the original design of Disney California Adventure, but its rejuvenation was high on his list when he took the Disney Company's top job. He believed there were "a lot of things that were great about it," but after four years of unremarkable attendance, it was clear that "it didn't live up to the expectation of a Disney theme park."

As steward for the company's shareholders, Iger felt obligated to run the numbers, and the resulting financial analysis concluded that the enormous outlay needed for a makeover would most likely be a bad investment. "I ended up essentially ignoring that," Iger said, then modified his assertion, adding, "I listened to it, but I decided not to take it into account when the decision was made to try to fix it, because the problem was too big for us image-wise—sitting right next to Disneyland."

"Disney California Adventure did not have the sense of place or warmth or just the Disney bubble that Disneyland had," said Bob Weis, who had left Walt Disney Imagineering in 1994 to run his own design firm. He returned in 2007 as Imagineering's executive vice president, lured back by the offer to lead the California Adventure upgrade. "When you put something that doesn't have that [appeal] right across the plaza from Disneyland, it just feels discordant. So people weren't comfortable there. And so you found that the guests didn't really like the place—and I don't even think the people who worked there liked the place very much, and nobody wanted to stay there to dine or to shop. They just wanted to come, do the Tower of Terror, Soarin'—you know, those main

things—and then go back to that richness of experience and optimism that you feel when you walk around Disneyland."

Weis rejected the phrase "renovation project." He told his team, "We have to look at it as a campaign"—an effort not to reject everything that had come before but to layer on top a blanket of conviviality that would win affection from both guests and cast members. Weis and his team quickly identified some priorities to give Disney California Adventure a "richness of place." The park needed more landscaping, for one thing, and it needed to get its tongue out of its cheek. "The language used and graphics were kind of insincere and jokey, and some of the attractions had kind of weird humor," Weis said. "It just didn't feel like it had the earnest warmth that Disneyland presents."

The place to start in adding sincerity to the park was right at the front. So almost exactly ten years after the entry plaza was first opened, it was closed. Building Buena Vista Street would be a risk, Weis said, "because that's a lot of money to spend on something that's not an attraction. But Bob Iger had the vision, I think, and also the personal analysis of the place to say, you've got to do these things because they're bringing the experience down. We said, 'We've got to redo the first act. It has to have a Walt connection and it has to be worthy of being across from Disneyland.' And he really went with us." Iger's approach, Weis said, was "if it's not great, it's not worth us doing."

When the plan to overhaul Disney California Adventure was announced at a press conference in October 2007, the decision to tie the park to Walt Disney's personal history was front and center. Jay Rasulo—Staggs's predecessor as Disney Parks and Resorts Chair—declined to characterize the six-year-old Disney California Adventure as a flop, saying that the revamp would consist of "incremental investment" rather than a full-scale renovation. The park would be expanded by twelve acres, but "bigger and more expensive is not necessarily the answer," Rasulo said. "You want people leaving thinking, 'Wow, only Disney could do that.'"

As John Lasseter observed, "This pendulum swings back and forth at Imagineering"—the ruling philosophy oscillating between an emphasis

on fiscal discipline and an emphasis on the artistry of the guest experience. "There's a time period in which it's kinda controlled by how much the budget of something [can be] and the schedule, and that is the most important thing. The things that are created during that time are not the things that last forever. It's like, 'Oohh, could've been better.'" When the pendulum again favors creativity, the Imagineers go to work to shore up their legacy.

Years later, Iger would summarize his ambitions for California Adventure in six words: "Big ambition. Big risk. Sweeping change."

II. PLAYING THE CLASSICS

A key goal during the rehabilitation of Disney California Adventure was shifting the park's emphasis from the second word in its name, California, to the first: Disney. To that end, three opening day attractions were revamped or replaced. The zippy little roller coaster that had been called Mulholland Madness became Goofy's Sky School, its dips and sharp turns now representing the graceless flying of student pilots rather than the twists of a Hollywood Hills road whose name meant nothing to many people outside of Los Angeles. Similarly, the citrus-grove-inspired decor of the Orange Stinger—on which riders sat in swings that twirled around a central pillar—was replaced with imagery from the 1935 Mickey Mouse short "The Band Concert." The ride was dubbed Silly Symphony Swings, and each ninety-second spin was accompanied by sprightly classical music.

The most extensive California-to-Disney transformation, apart from Buena Vista Street, was the addition of a ride called The Little Mermaid ~ Ariel's Undersea Adventure, a dark ride that supplanted *Golden Dreams*, the fanciful seventy-millimeter film about California history that starred Whoopi Goldberg. The exterior of the building retained the grand columns copied from San Francisco's Palace of Fine Arts, but the theater auditorium was gutted and replaced with a series of projected and Audio-Animatronics scenes from the animated film, which guests rode through in clamshell-shaped vehicles while snippets of the movie's

familiar songs played. The idea, Weis said, was simply to "take one of our fantastic classic stories and bring that to life and immerse people in it"—a goal that the largely glowing reviews and long lines suggested had been achieved.

But the Imagineers were not done with their Disney makeover. A new show envisioned for Paradise Bay, the lagoon adjacent to Paradise Pier, reached back to Walt Disney's television days. Conceived by Steve Davison, vice president of Parades and Spectaculars, World of Color would be the first nighttime outdoor show in Disney California Adventure, and it would be the grandest expression of the new direction in which the Imagineers were taking the park. "Basically, Bob Iger said to me, 'You have to relaunch this park,'" Davison recalled. Iger continued, "'World of Color is the first thing out of the gate, and it has to show the world that California Adventure is going to be newly spectacular.' No pressure."

The idea was simple: keep the park filled until closing by giving it an anchor show, that must-see event that would keep the park and its restaurants bustling after dark. Previously, Bob Weis noted, "There was no nighttime scene. After sunset, you never saw anybody in Disney California Adventure, and we wanted it to have a vibrant nightlife."

The mandate from the Park Operations team, Davison recounted, was something of a challenge. "Basically, they said 'It can't have any people'"—but it needed to combine water, music, and lights in some fashion that would keep viewers in awe for nearly a half hour. Davison's team soon settled on a theme evoking Walt's 1960s TV show, *Walt Disney's Wonderful World of Color*. That, he said, "was a fantastic idea for us because it kind of gave us this palette to paint from. It just literally started us thinking about how we take water and paint with it—how we can do it in full color like no one's ever done before."

As the idea grew to include advanced laser and projection technology and hundreds of individually programmable water jets, "I never thought we would sell it. I thought, 'It's a fun idea, [but] it's so expensive, nobody will ever touch it.' And we had a great meeting with Bob Iger, and the first words out of his mouth were, 'When can we have this?' That's when

fun becomes terror, honestly. Because you develop something and you see it in your mind very clearly, but now you have to execute it." From that point until the 2010 debut, it took three years to design, install, and program the show, including draining the lagoon to build underwater electrical vaults and to install the water jets as well as the projectors and lighting towers that would need to emerge from underwater at showtime.

Once all that infrastructure was installed came the make-or-break moment. "The first time we ever turned it on, when I first walked out there, and they go, 'Watch this.' And they turned on the big giant grid of 800 fountains and it just was like candy on the lagoon. You just feel great. You feel like a little kid going, 'Wow, we have something really great.'" For the next three months, night after night, the Imagineering team programmed the show, one second and one water jet at a time, adding layer upon layer upon layer. With so much going on at once, Davison said, "there's so many things hidden in these shows that if you don't look where we're telling you to look, you'll see all these little things going on that really kind of capture your imagination in a whole new way, if you see a show once or ten times. And a lot of people will come and go, 'Wow, when did you add that to the show?' And I'm like, 'It's been there since day one.'"

The final show included almost 1,200 fountains, shooting up to two hundred feet in the air, as well as fire and fog and projections on walls of water, all set to classic Disney music, starting with the Sherman brothers' "Wonderful World of Color" theme song. Lights on buildings around the bay were also synchronized with the show. Music, dialogue, and clips of animation were incorporated from *The Little Mermaid*, *Fantasia/2000*, *Pocahontas*, and many classic Disney features, as well as from Pixar movies such as *WALL·E*, *Up*, and others. Mickey Mouse, naturally, was the star of the grand finale. "You put your heart and soul into it," Davison said of the multiyear project, "and you just hope that everybody sees it and really falls in love with it."

His nerves were jangled before the official opening, but he need not have worried. As he recounted it, "The great thing is that everyone

cheered. Everyone was so enamored with it and totally got it and really loved it. The music was spectacular, the visuals were spectacular. And it really was over the top."

"Nobody believed that anyone would ever go to Disney California Adventure at night, and World of Color completely turned that around," said Weis. "The energy here was just something that you could feel—and not just cast members had changed. Everything had changed. People wanted to be here. People dined here. People stayed here. There were triple shows of World of Color. And people were waiting. And all of a sudden, you had that kind of vibrancy that you feel at Disneyland."

III. THE RUBBER HITS THE ROAD

Kevin Rafferty readily described himself as "a car nut." Automobiles, he said, "have always been my thing, ever since I was really small. One of my first memories was getting a little pedal car for Christmas when I was a little tiny kid, which was phenomenal. I remember driving my little pedal car into my room and fighting with my mom because I didn't want to get in bed. I wanted to sleep in my little pedal car all night." When he was a little older, he started building model cars, anxiously await-ing each September, when designs from carmakers' new model lineups would become available. "I just love the design of cars, the functionality of them, the horsepower, the art of them. Everything about them." He grew up loving road trips with his family—more so after his father spon-taneously traded in the family station wagon one afternoon for a sleek new Pontiac Bonneville convertible, even though the back seat got a lot more cramped for young Kevin as luggage spilled over from the limited trunk space. As a young adult dishwasher at Disneyland in the 1970s, Rafferty hung out with fellow cast members (including his future wife) in the parking lot, dreaming up new rides for the park. Years later, as a leading Imagineer, one of his most cherished possessions was the green 1956 Corvette he called Sandra Dee.

So in 2004, when Barry Braverman asked him to "come up with something big," something to "bring more Disneyland DNA into Disney

California Adventure," it was natural for him to focus on California car culture. He researched the history of automobiles in Disney shorts and features—from "Susie the Little Blue Coupe" to Herbie the Love Bug—and created a pitch for a new 1950s and '60s–themed area he called "Carland." After many months of development work, news from Pixar Animation Studios (still two years away from becoming a part of Disney) turned Rafferty in a new direction: John Lasseter and his team were working on a movie called *Cars*. It seemed as if the wheels of the universe had aligned. Rafferty headed to Northern California with his Carland plans and concept art to meet with Lasseter.

Lasseter, too, grew up immersed in car culture, in part because his father was manager of the parts department at a Chevrolet dealership. As his responsibilities at Pixar grew, Lasseter stopped directing features after *Toy Story 2*—except for *Cars* and *Cars 2*, both developed from original stories he cowrote. The first film had been shaped in part by Lasseter's recollection of a road trip along the legendary Route 66 from Chicago to Los Angeles—a journey that ultimately inspired *Cars*. So he had definite ideas in mind when he sat down with Rafferty to review the sketches for Carland. "Initially the idea that the Imagineers came up with was a traditional Disneyland-like land that is one idea that you have many different stories within," Lasseter recalled. "There was going to be a ride of Susie the Little Blue Coupe, Herbie the Love Bug and then a ride for *Cars*. And I remember looking at the drawings, and I go, 'You know, I'm sorry, you guys. If I was [a park guest,] I would want to go to Radiator Springs"—the desert town that the main characters in *Cars* call home. "That's what I would want to see. I would want to go and visit this town and be in this environment, to be in Ornament Valley.'"

Imagineer Kathy Mangum recalled that "Carland was sort of a blend of different Disney-based car stories, like Goofy [learning] about driving and Radiator Springs Racers [inspired by *Cars*] and a few other things, but it didn't have that cohesive story line beyond that it was about cars in California. Then *Cars* the movie hit big, and the characters were so loved that it became really natural, or sort of obvious to take Carland and turn it into Cars Land. That then gave us the hook for creating Radiator

Springs, the town. A lot of the same elements are in this land that were in Carland, as far as number of attractions and numbers of restaurants and retail locations, but now they're based in one story line. And it actually became a stronger idea because of it."

The full evolution from Carland to Cars Land took until 2008, by which time Bob Iger had taken over as CEO. Bob Weis had also returned to Imagineering to captain the California Adventure expansion, after seven years running his own design firm, which consulted on theme parks, museums, and other projects. With *Cars 2* in development, both Bobs supported the single-story theme, Lasseter said. "Bob Iger was all for it. And it became one of the very first lands that Disney had done on a major scale that had one story in it."

Having Lasseter on the team was vital, Weis said. "We do a lot of work with *Snow White* and great movies that are old. And the people who visualized them have been dead for decades. And here's the creator [of *Cars*], directly working with the creative and technical teams. He loves every part of it—everything from how the mechanical system is going to work to the design of the rocks."

Lasseter's connections to Disney theme parks went back to his own youth, when he started his Disney career as a sweeper in Tomorrowland in 1977. He made sure that Kathy Mangum and her design team followed in his tire tracks on a research trip down Route 66 to look for ideas "for the buildings, for the streets, for the plants, for the food, for every aspect," Lasseter said. "Everything went on to feel like it was authentically, truly Route 66—like you were there. We want people to feel like you're not in Disneyland, you're not at Disney California Adventure. You have been truly transported to Radiator Springs."

Except that this would be a theme park in sunny Southern California, not an animated movie. The characters in *Cars*, for example, don't need shade; Disney California Adventure guests do. "They're not just watching [the movie]," Mangum said, "they're actually walking in it, they're riding in it, they're touching it, they're sitting in it. So to provide more shade, you see more trees here than what you see in the film. We put the buildings a little closer together. We've got railings. We've got

pathways. We've got extra signs; we have to do menu boards. But all that had to feel authentic to the film, and the film is authentic to Route 66, so there were a couple layers that we needed to really consider as we went full into design."

One issue that Cars Land partially solved was California Adventure's lack of a berm to shut out the outside world. To make Radiator Springs as immersive as any land at Disneyland, the Imagineers built "not just a mountain—it's the mountain range," Mangum said. "It's Ornament Valley." Rising to a height of 125 feet, the reproduction of the Cadillac Range—mountains that resemble classic cars' tail fins—required 300,000 square feet of hand-sculpted and hand-painted plaster.

As they had done for decades, the Imagineers started with physical models, a smaller one of just the mountains first, then one at an eighth inch to a foot that included the entire Cars Land, which allowed them to check sight lines. Once perfected in foam, that model was scanned and enlarged to a half inch to a foot, "and that model actually became our construction document," Mangum said. The final model was scanned and rendered in a computer at full size to allow the engineers to determine the positioning and bend of the thousands of tons of structural steel rebar that would serve as the mountains' skeleton—"a huge, three-dimensional jigsaw puzzle." The skeleton was then covered with wire mesh and a three-inch-thick layer of plaster that had to be sculpted by hand. The whole process took two years.

Leading the rockwork team was Imagineer Zsolt Hormay, the artist who had carved a chimpanzee at Disney's Animal Kingdom Theme Park to honor Jane Goodall. "My background as a sculptor helped me transition into the world of rockwork," he said. "We have artisans from all over the world, because this is such a specialized trade. It's hard to find people who have enough experience and understand the beauty of rocks." To create the magic, the cement was sprayed on wet and had to be carved with customized tools at exactly the right moment as it hardens. "It's a marriage of understanding construction, yet being able to focus on the artwork," Hormay said.

From certain angles, Lasseter observed, "it seems like you're fifty

miles away from the rocks. It just grabs you and takes you immediately to a different place."

Cars Land was set along either side of a 525-foot concrete path styled to represent Route 66. The twelve-acre area included three food service locations, such as Flo's V8 Café; three attractions; and three retail shops, such as Ramone's House of Body Art. Each site was developed with its own story in mind.

"Inside each of the shops, each proprietor—Ramone, Flo—they have their own music," Mangum said. "We really tried to get into the heads of the characters and say what music they would listen to, how they would decorate their offices, what they would have on their walls. This was information we didn't get from the movie. We had to get to know these characters, and I think we did." The first ride guests encountered was Mater's Junkyard Jubilee, a "whip"-style experience in which guests rode in two- or three-person trailers pulled and gently flung from side to side by a "baby Mater"–style tractor in front, following a figure-eight path.

The second attraction was another Imagineering learning experience. For Luigi's Flying Tires, riders sat at the center of nine-foot-wide horizontal tires, hovering on a layer of air created by a floor grid of more than 6,700 vents. As Rafferty described it, it was a kind of giant air hockey table populated by faux-rubber pucks, an homage to the long-gone Flying Saucers attraction at Disneyland, which opened in Tomorrowland in 1961. "When I was a kid, that was one of my favorite things," he recalled. Indeed, the bumper-car-like ride was beloved by many Disney fans but plagued by so many breakdowns that it was the park maintenance team's biggest headache for its five-year run. Convinced they could improve on the Saucers technology for the Luigi's ride, the Imagineers placed eight powerful fans in a deep chamber below the floor to power the vents lifting the tires. "Human beings standing down there are just dwarfed compared to the big channels of air that go through the holes," Rafferty said.

Cars score composer Michael Giacchino provided eight Italian-style songs with a "kind of Louis Prima snap to it," as Lasseter described the music—"like an Italian festival." In the Imagineers' test runs, he said, it

was "such a fun ride. You know, bumper cars these days, for safety, you can't bump very hard. What's so great about this is that you bump people, and there's this big cushion, the tire, and it works perfectly."

As Rafferty described the experience just before the attraction opened, "When you sit there and you feel that air coming up and you feel your tire rise up, it's magical."

The problem was, it never worked for guests quite as intended. As with the Saucers from the '60s, riders were supposed to be able to direct the vehicles' movements by shifting their weight. But in practice the tires never moved as much as the guests would have liked, and the slow loading and unloading led to long wait times for a ride many found disappointing. After a little more than two years, Luigi's Flying Tires followed Superstar Limo into retirement.

Tony Baxter saw a deeper lesson in the Flying Tires having gone flat, and it was in the difference between a giant tire and a miniature flying saucer. "In the case of both those rides, they were modest experiences," he said. "They float and people have a little bit of leeway to move them around. But for everybody living in the '60s, getting to fly on a flying saucer, that's a bucket list item. Whereas, to go on a Luigi flying tire isn't. So if the ride doesn't deliver as much as it should, then it falls back on what emotional connection is there, and it's very thin in the case of Luigi. It doesn't have that compelling quality that needs to be at the base-line." The most successful attractions, he said, combine great emotions and thrills and "take you to a place that you couldn't have gone without Disney—all three of those things working. I think that's where we score the best."

But Luigi did not disappear with his tires. The Imagineers turned failure into success by shifting to a Disney-specific technology that delivered the thrill of the new: trackless navigation. Without losing the Luigi's Tires theme (and the tire store queue area), the attraction was replaced just a year after it closed with Luigi's Rollickin' Roadsters, which utilized the trackless system within a completely new format—a dance routine. In each running of the Roadsters, twenty miniature cars with one or two passengers performed a choreographed ballet that involved spins and

near misses and other fancy maneuvers. The ride cycled through five different Italian tunes, and the cars' paths changed from run to run. "Some of the technology we used to deliver dancing cars was originally designed to control undersea robots that work at a depth of fifteen thousand feet under an oil platform," Rafferty said. "So whatever it takes to get us there, that's what we need to do." It was definitely a case of making Italian lemonade from a bushel of flying lemons.

Cars Land's most heralded triumph was the Radiator Springs Racers—in part because it was at least two types of Disney ride combined into one. "Radiator Springs Racers was something I really wanted to see Imagineering start doing," Lasseter said, referring to pushing the boundaries of storytelling on a thrill attraction. It also built on some hard-earned Imagineering knowledge. The long, problematic development of Test Track for EPCOT had eventually produced a ride system that could be adapted for the centerpiece attraction in Cars Land.

The ride story was divided into four segments, experienced by guests in six-seat vehicles styled to look like Radiator Springs residents, complete with eyes on their windshields. On the initial outdoor outing through scenic Radiator Springs, guests experience a beautiful drive through the pine trees, underneath an arch, revealing a beautiful waterfall, all with music scored perfectly to the geographic highlights. The cars then entered a dark-ride section, encountering Audio-Animatronics renditions of characters and incidents from *Cars* and ending up in either Luigi's Casa Della Tires (for a tire change) or Ramone's House of Body Art (for a new coat of paint).

The Imagineers came to refer to the anthropomorphic vehicles dotting the story as "Automatronics," and despite being cars, Autopia designer Bob Gurr observed, they were every bit as warm and appealing at Disney's classic attractions, in part because they were part of a "thorough, thorough story. You have animated figures that look like a '48 Hudson, and that '48 Hudson is just as much a character as the pirate." Radiator Springs Racers was "extremely thorough in all its technical and show details," Gurr said. "All that's traced back to that 1966 pirate ride design that Walt led us into."

After interacting with the "Automatronic" cars in the shops, the ride vehicles paired off for a rapid outdoor race at speeds up to forty miles per hour, the winner of which was selected at random. A slower final dark segment takes the cars through Tail Light Caverns, where they wind up on a single track again for disembarking. It was a lot to fit into one linear attraction with a single vehicle—a lot of shifting gears, so to speak.

"In Radiator Springs Racers, we literally needed the rubber to meet the road," quipped Rafferty. "This is such a sophisticated attraction and we wanted the ride vehicles to present themselves as real cars, as real automobiles. They had to be believable." The first suggestion from the ride engineers, given the story outline, was to adapt a roller coaster system, "where the vehicles themselves were above the track by a couple of inches—which meant that the wheels would not be perceived as turning because they wouldn't be touching the ground. But why create a 300,000-square-foot, hand-sculpted, hand-painted Ornament Valley backdrop and then fake the wheels? It was just unacceptable. So we adapted the Test Track system where real rubber tires, real car tires, are actually touching the surface of the road." The tires weren't powering the vehicles forward, but the gritty road surface ensured that "when guests are out in the land, they see those real rubber tires going around like real cars do." Unremarked by the riders would be the 300-horsepower motors in each vehicle—and the license plates, where what appeared to be random letters and numbers were actually the initials and birth dates of the Imagineers who worked on the ride.

In short, the attraction had a lot of moving parts. "If you could see everything it took to run the attraction all day long, your head would . . . *boom*," Rafferty said, mimicking an exploding brain. One small example of Imagineering magic: "When you go around the curve around Willy's Butte, we kind of cheated [the angle of] the track a little bit so that you would feel the g-force a little bit more—it's actually kind of a forced curve. So even though you're going like twenty-seven miles an hour, it feels like you go at about a hundred."

One tool the Imagineers had in the creation of the Radiator Springs Racers that had not been available to those working on Test Track in the

mid-1990s was 3D computer modeling that had been combined with virtual reality technology to create a kind of full-scale VR walk-through preview. The space where this happened was called the DISH, for Digital Immersion Showroom—also referred to as the DISney Holodeck, a reference to the holographic rec room from *Star Trek: The Next Generation*. A cruder version of VR tech had been used to preview Pooh's Hunny Hunt and Mission: SPACE, but DISH had its origins with the mock-up created to figure out the timing of the Finding Nemo Submarine Voyage in 2000. "We realized that by creating these virtual simulations of the attraction that would give us great power and flexibility to explore what the guest experience was going to be like from every single vantage point," recalled Mark Mine, director of Technical Concept Design at Imagineering. "So that would really help us to do a better job at telling the story."

The Nemo experience led to the formation of Mine's team at Imagineering, and that group created the DISH. "The DISH is a virtual reality theater," Mine explained. "Some people call it an immersive projection theater or a cave environment." An Imagineer would stand inside, wearing 3D glasses and a "bowler hat" that was actually a tracking device, reporting the occupant's exact position and orientation to the DISH computers. Computer-generated imagery was projected onto the walls— 3D renderings of the familiar computer models that had been in use for many years. But these renderings responded instantly to the occupant's movements, which "allows us to draw the pictures so that they look correct from that vantage point. It's exactly like those chalk [sidewalk] drawings, where if you stand in just the right place, it looks like there's a big pit opening up on the ground in front of you. It's the exact same thing except that we're doing it sixty times a second, so as the person moves around the room, we update the picture so that everything looks three-dimensional and you get the ability to look around objects as you move your head back and forth. It gives you a very natural understanding of the space and a good sense of how big things are, how far away they are, and what sight lines are to objects."

Before construction began, Imagineers could come to DISH and

"walk down the main street of Radiator Springs in the virtual world," Mine said. "We use this for evaluating the layout of the land, and the sizes of the buildings. We have another simulation which is a detailed simulation of the Racers ride itself."

DISH was a considerable improvement on trying to approximate the perspective of riders using handmade scale models, Mine said. "We've been doing physical models for sixty years to help us design our attractions, and we've done a lot of stuff where we squat down at the eye height of the guest or bring in a little tiny camera to get a good sense of what it's going to be like on the ride. But it's hard to get a very exact sense of what it's going to be like to be there." Inside DISH, he continued, "we can take you and put you inside the ride vehicle. And you get to ride through the ride. You're moving at the speed that you're going to be moving in the final attraction, and you see exactly what you see in the final attraction. So it's a real great way for us to let the designers walk in the shoes of their guests and see what the guests are going to experience. We use that to make sure we've got the timing and the story beats in the ride all worked out."

But DISH was for finding and solving early design problems, not for final tweaks to bring all the elements together. In the final months of building the Radiator Springs Racers, Rafferty and fellow Imagineer Joe Herrington rode through the four-minute attraction over and over, providing hands-on attention. "I know it's started to get real when Joe and I sit in a vehicle to design the soundscape—to integrate the soundscape into the showscape, if you will," Rafferty recalled. "And one night, about two o'clock in the morning, a little bit of rain was coming down and Joe had his heavy-duty laptop with his Pro Tools rig from which we are installing the audio. And he looked over to me and said, 'Hey, Kev, this is our seven hundredth ride-through.' And I said, 'Seven hundred times?' It felt like maybe only two hundred to me. But then from that moment on I started counting. So before opening day, Joe and I rode through that attraction 7,084 times." In between rides, they'd work on honing the precise sound effects they wanted. The thudding sound of Guido working under the car to change the tires, for example, was actually Rafferty on the Ornament Valley construction site, banging a chunk

of rebar against the fiberglass case of Herrington's Pro Tools rig. "A lot of stuff like that happens in the field that you don't expect, but it really makes the show great," Rafferty said.

The variations in the attraction experience were included in part with annual passholders in mind, Mangum said. "In Anaheim, we have so many guests that come here really frequently, and we were thinking of them for Cars Land: what could we build that they would want to see over and over and over and maybe the experience was slightly different every time? In particular, in Radiator Springs Racers the finish is always random. You never know who is going to win. Doesn't matter what color your car is, what side of the track it's on, you don't know, it's random." It took at least two rides to see both Luigi's and Ramone's garages—and the later addition of Luigi's Rollickin' Roadsters offered dozens of experiences, depending on the song, the dance sequence, and the particular vehicle the guest selected. Such variations were "really a reaction to knowing that these guests are frequent guests, and we want them to feel something different and a different level of excitement every time they get on that ride and every time they come in this land."

The creation of Cars Land was particularly personal for Rafferty. "If you walk down the street in Radiator Springs and you see the courthouse at the end of the street, that's about where I used to park my car when I was a kid and dream about creating attractions. It's just cosmic. I've always had a relationship with this particular piece of property at the corner of Katella and Harbor [boulevards]. It's just always been kind of my dream place, and now it's all solidified because it's in Cars Land."

His work in the California Adventure expansion also underscored a central principle of Imagineering, Rafferty noted. Many of the attractions that most amaze and amuse the guests are the ones that the Imagineers have no idea how they're going to accomplish when they first envision them. A Mr. Potato Head who can remove and replace his ear? An Audio-Animatronics Mater who talks to riders in Radiator Springs Racers while the guests move forward and Mater moves backward? Rafferty didn't know how either effect could be accomplished when he pitched them to stunned colleagues: "Jaws hit the floor." But when there's a challenge

worth accomplishing, he said, "everybody kind of rallies around it and figures it out."

Not every unlikely brainstorm becomes a finished illusion. "When we're designing an attraction, we start out at thirty thousand feet and kind of hone in on it," Rafferty said. "Sometimes you have to throw out the things you love to get the attraction to where it needs to go. So there's a lot of stuff on the cutting room floor, so to speak, and oftentimes where it ends up is not exactly the way you kind of envisioned it at the beginning. It kind of reminds me of the old Imagineering joke about, you know, 'How many Imagineers does it take to change a light bulb?' 'Does it have to be a light bulb?'"

IV. "ON POINT"

The rehabilitation of Disney California Adventure was revealed to the public in phases. The schedule was determined in part by the time necessary to do the work and in part as a strategy that let guests know steady progress was being made—and to keep them coming back to check out the changes. "People have watched this transformation happen a little bit before them," observed Tom Staggs, the chairman of Parks and Resorts by the time of Cars Land's 2012 debut. "They've seen the construction walls and they've heard the rumors and they saw the Cadillac Range peeking up from behind the walls. Every little bit of those glimpses seemed to get people more and more excited."

The new features in Disney California Adventure debuted over the course of Bob Iger's early years as CEO. World of Color and Silly Symphony Swings in 2010; then Goofy's Sky School and The Little Mermaid ~ Ariel's Undersea Adventure opened in mid-2011. But the biggest reveal was saved for last. Buena Vista Street and Cars Land were unveiled together with great fanfare on June 15, 2012—the final pieces in a complicated jigsaw puzzle that had officially taken five years but had in some ways been in the works since the park first opened in 2001.

The former Sunshine Plaza had been closed off since August 2011, and for ten months guests were redirected along a temporary path

behind and around the Soarin' building to enter the park. Now, finally, they could follow in Walt Disney's footsteps into the Los Angeles of the 1920s and '30s. The Imagineers had developed Buena Vista Street by re-creating three of the architectural icons that came to define that period of Los Angeles—the originals all built while Walt and Roy were establishing their company as the top animation studio in Hollywood. The Carthay Circle Theatre movie palace, with its striking Gothic octagonal bell tower, opened in 1926. Nine years later and a couple of miles to the northeast arose the Pan-Pacific Auditorium, its quartet of aircraft-like towers soon hailed as an art deco masterpiece. In between and another seven miles to the northeast, the Glendale-Hyperion Bridge was built across the Los Angeles River in Atwater Village, opening to traffic in 1929, just a year after the birth of Mickey Mouse.

Now the Pan-Pacific's four towers soared over the Disney California Adventure entry plaza, where the giant letters spelling out C-A-L-I-F-O-R-N-I-A had stood a decade earlier. (The new entrance had in fact opened in July 2011—installed in just one night.) Guests entering the park now passed under a scale reproduction of the Hyperion Bridge, over which the Monorail ran, to continue their stroll down Buena Vista Street. At the far end stood the eighty-nine-foot-tall Carthay Circle bell tower, a faithful reproduction of the exterior of the movie palace where Walt Disney's *Snow White and the Seven Dwarfs* had premiered in 1937—and twelve feet taller than Sleeping Beauty Castle in Disneyland. (Inside the Carthay Circle was a two-level high-end restaurant and cocktail lounge, rather than a theater.) In between the entrance and the Carthay Circle, Buena Vista Street was packed with references to Walt's early life: a gas station named after Oswald the Rabbit; a shop named for Walt's father, Elias; Mortimer's Market, acknowledging the name Walt had originally given to Mickey Mouse; a 2719 street address borrowed from the original Hyperion Avenue location of the Disney studio—and much more.

Those guests who were patient enough could ride the length of the street on one of two Red Car Trolleys, faithful reproductions of the Pacific Electric transports that once connected downtown Los Angeles

to nearby counties—and which Disney fans would recognize from the movie *Who Framed Roger Rabbit*. The trolleys had stops at the entry plaza and at Carthay Circle, not far from a new statue of a young Walt Disney posing with Mickey Mouse, titled *Storytellers*. Trolleys then turned to continue up Hollywood Boulevard into Hollywood Land (formerly known as the Hollywood Pictures Backlot).

If one thought of California Adventure as a movie, Bob Weis explained, then Buena Vista Street was the opening reel. "If you get Act One right, you're ahead. If it's wrong, maybe you can recover, but you might not. And I think this park never recovered from a bad Act One. People just didn't come in with a sense of heart. So the brainstorm of completely tearing out the main entrance and coming into a world that Walt might have seen when he first came to Los Angeles—seeing the red cars moving—[was to take you to] a completely different place, immersing you in all the sound and music and everything about that era. It really was intending to take us emotionally into this park as the first act. So by the time you get to the other things—whether it's Cars Land or Hollywood or any of the other lands—you really feel you've been taken [to another] place."

Guests might not have a deep connection to that era of Los Angeles, but "this audience particularly in California, has this emotional tie to Walt. For a lot of people here, Walt was gone before they were born, and they still have that emotional connection from the years of going to Disneyland and being connected with the company. And so that interest has tended to hold that relationship and that emotion from people as they go down the street. And remember, not only do they enter [via Buena Vista Street], but it's also the last act, the last thing you see. It's the welcome in and kiss goodnight. So it has to be really perfect."

Staggs felt that connection well before opening day. "What makes Disney parks so special is not that we build great physical things," he said. "It's that those things allow people to have these shared moments, create these memories, that they want to come back and do again and again. I walked California Adventure and Cars Land and Buena Vista Street during construction many, many times and went to testing the rides and

I kept thinking as I was doing it, 'I can't wait to do this with my kids. I want my three boys to ride this. I want to come here with my wife and sons and get them to see this and enjoy it.' When that's the barometer and that's the feeling that you get, then you know you're on point. That's what the Imagineers are really trying to capture—the place you want to visit, the place you want to share with people you care about, the place you want to come back to again and again. That's the essence and the heart of the place."

The multiyear effort, Staggs emphasized, was "a collaboration across our organization. So if you walk into Cars Land or Buena Vista Street, every piece of it has been thought of from the ground up with all areas of our company brought to bear. So the Imagineers worked closely with folks who thought about the merchandise, the folks who thought about the costuming, the people who thought about food and beverage—so we could make the whole thing a truly immersive experience and have all the experiences hold together and add up to this thing that is much, much bigger."

The expansion and renovation of Disney California Adventure, Weis said, was "a huge change for the better. And Cars Land added not just a fantastic property, ride, place—all those things—but the perception of Disney California Adventure as a park became much grander because the whole park felt bigger. Not just Cars Land." With Buena Vista Street and World of Color, "suddenly you have a park that feels good when you come in. It has a great nighttime, it has landscaping, it has new attractions, but the whole place feels a lot more like a Disney park. And that's the sense of optimism people feel."

He continued, "When you talk to people, it's interesting, because they all compliment Cars Land and they all compliment World of Color and Buena Vista Street. But they also say that there is something about the whole vibe that changed. And that's what had to happen. It just had to be brought into its own, relative to the unbelievably high expectation we have of Disneyland right across the plaza. The entire resort has changed its economics. Everything works better. Disneyland works better because not so many people are crowded into it, because Disney

California Adventure actually gets the linger time that it deserves. The resort works better, the Downtown Disney area works better. It was just an exponential change in everything about the Disneyland Resort."

The Imagineers were proud of their years of work and now faced the difficult final stage of the creative process: the 300-person Imagineering team had to put their pencils down, split up, and move on. "We all love working together," Kathy Mangum said just before the Cars Land debut. "We love working on something that's amazing. We get energy from it. We get a kick from it. It defines who we are. A lot of our team members already know that they're going to go into a deep depression when Cars Land opens—it's hard to let go. We know we're supposed to let go. We know we have an opening day, but you've lived with it for about ten thousand hours of your life, if you've been on it for about five years, and that's hard to just walk away from. So you see such a passion and emotion. We are tied to this. We don't build it and walk away and not think about it again. This is *us* out there. It's not individual, but it's all of us out there. It's Disney."

"After the land opened, I just had this tremendous separation anxiety," Kevin Rafferty said. "I just hated to walk away from that. When I went back to work at Imagineering in Glendale and I was sitting in traffic one day, I happened to look out my window and I looked up at the clouds and—I'm not kidding—there was a cloud in the very shape of the Radiator Cap Butte. I mean you can't make this stuff up. It was almost like this cosmic connection. It was just . . . it was fantastic."

CHAPTER 27:

PROJECTING THE FUTURE

*"The big dynamic in our lives really is change. Walt Disney
had one foot in the past and one foot in the future, because
he loved the nostalgia and he loved the technology and
what it enabled. That marriage is still very, very strong
and it lives here at Imagineering."* —Marty Sklar

I. MAPPING THE WAY

IN EARLY 2013, the vengeful demon Mara had a surprise for riders
familiar with the Indiana Jones Adventure at Disneyland. For eigh-
teen years, the Buddhist entity had been instructing guests at the
beginning of their journey never to look into his eyes and then getting
angry whenever someone ignored his command—meaning, every time
a jeep approached. His voice had cried out, "You looked into my eyes!
Your path now leads to the Gates of Doom!" while the eyes in his golden
mask flashed with strobe lights. But now the god had been transformed,
his face displaying not just flashes but a fully animated warning of the
doom he promised. In one of three variations—each themed to one of
the attractions' three doorways to danger—his eyes opened suddenly and
acid seemed to drip down from his forehead, eating away at the gold.
In another, his face would suddenly start to crack with age as his eyes
became vacant black sockets. In the third, his face appeared blue instead

of gold, and his anger seemed to bring on a storm as lightning flashed across his cheeks amid threatening swirls of bright colors.

Mara, it seemed, had been possessed by Madame Leota. More than forty years after the debut of the Haunted Mansion, the inspired projection magic crafted by Yale Gracey and Don Iwerks using a rigid polystyrene plastic head had been upgraded with new digital technology, and it was quickly becoming the go-to effect for creating mesmerizing public displays, whether theme park attractions or corporate promotions. Start-up companies with names like Pixel Rain Digital and BartKresa Studio were offering to create dramatic events for corporations in which entire buildings could come alive with colors and images and moving pictures. And it had all started with a spirit medium in a crystal ball and some singing busts in a Disneyland "graveyard."

Occasionally known as the Madame Leota effect, the technology came to be called projection mapping—although the mapping was in fact done well in advance of the projecting. The central idea had changed little from Gracey's day: project moving images onto unmoving yet irregularly contoured surfaces. But the "mapping" portion had become as sophisticated as 3D computer graphics and scanning technology could make it. In January 2011, Disney debuted its first major projection mapping spectacular in the Magic Kingdom at Walt Disney World, a short nighttime show titled The Magic, the Memories and You!. The backdrop was Cinderella Castle, and the images included both Disney characters and PhotoPass images of park guests taken earlier that same day, in keeping with the Let the Memories Begin marketing campaign then in full swing. (At Disneyland, a show with the same name and content was projected onto the facade of "it's a small world.") It was just a taste of what was to come in the years ahead, as nearly every large structure in a Disney park—the Tower of Terror, the Tree of Life, Grauman's Chinese Theatre—became a screen for images, animations, and effects both new and classic.

For the Imagineers, the ability to rejuvenate attractions like Indiana Jones Adventure was both another example of keeping things fresh and timely, and a chance to fulfill old, unrealized dreams. Charita Carter, one of the Imagineers who developed projection mapping within

Imagineering, said Tony Baxter's original, early 1990s storyboards for the attraction had included some "pretty sweeping changes" focused on when Mara got angry—beyond what the technology of the day could produce. "At the time we used the tools that were available, which was lighting and some atmospheric effects. But with the onset of projection mapping, we realized there's an opportunity to go back and really push that art. So now when you go in and you see those different manifestations of Mara and the different paths that the guests can take, you've got something that's very sweeping and compelling and animated. The vision was always there."

Carter led Walt Disney Imagineering's newly set up Scenic Illusion Group, which was started not with a particular attraction in mind but with the goal of honing tools that could be applied to any number of experiences. "[Our] overarching focus was to take a look at our dark rides and how to approach them differently," Carter said. "We had paint specialists, and we had lighting designers, and we had visual effects artists, and we had projection specialists. That's what brought us to this idea of projectors. How can we use them in new ways?" That question led the group to projection mapping and an effort to apply its increasingly sophisticated effects to guest experiences. Their first breakthrough was called "high dynamic range scenic projection." According to Carter, "This is the idea where you paint a set and you take a picture of that set that you project back onto it, and you get this amazing, very saturated, very immersive-looking environment." The team tested their idea in the lab, then brought in designers—who immediately wanted to find places to put the new effect to use.

An early test case was Snow White's Scary Adventures at Disneyland, in which two scenes were refreshed. "One of them was the transformation scene of the hag to the witch and the other one was the finale scene with the dwarfs going up the hill [toward the witch]," Carter said. The improved lighting and effects were considered a success and paved the way for the more elaborate changes on Indiana Jones.

Also revamped was the classic Peter Pan's Flight. Like Snow White, the opening day attraction from 1955 had been substantially revised in the 1983 renovation of Fantasyland, including the addition of animated

figures of the story's hero. (As with Snow White, the original attraction had been conceived as a voyage from the point of view of the main character, who was therefore not depicted in any of the ride's tableaux.) As part of the sixtieth anniversary celebration of Disneyland in 2015, Peter Pan's Flight closed early in the year for refurbishment. The changes were principally the addition of lighting and special effects, such as animation on the clock tower, pixie dust made of laser particles, and an explosion of countless fiber-optic stars in the skies over London and Never Land. The idea, said creative director Larry Nikolai, was to make guests feel like they were "floating in space over the island." He added, "This is one of our guests' favorites that they run for in the morning. We have a heavy obligation here to make sure that the magic stays intact."

Speaking just before the attraction reopened in the summer of 2015, Nikolai added, "I've experienced this attraction since I was a little kid. Then bringing my kids through after the '83 enhancement, and just marveling at how they had made it so much better, but still respected the original. And now we get to do the same thing. That's what excites me—just being part of this, that's been part of my childhood."

The Scenic Illusion Group was also instrumental in creating a walkthrough attraction called Pirates of the Caribbean: The Legend of Jack Sparrow at Disney's Hollywood Studios, which opened officially in December 2012. The show served as a kind of workshop for the Scenic Illusion Group's development of new projection effects—part of the process rather than an endpoint. Set in a theater dressed with pirate props, the various scenes included dancing skeletons, mermaids, a Kraken attack, and a floating skull that talked. Sparrow himself also appeared, in a life-size projection, and fought Davy Jones—a scene that turned out to be a teaser for a completely new Pirates attraction then in early development. The audience was encouraged to participate through repeated chants and a recitation of the pirate oath.

"We took an existing soundstage there and did basically Captain Jack Sparrow's man cave and this really fun walk-in experience," Carter said. "That really kind of opened up the door to do the very first theatrical

show that the company has done, and that was in Tokyo DisneySea." The original thirty-minute musical *Out of Shadowland* debuted in July 2016 on the Hangar Stage in the Lost River Delta area, with three original songs sung by a live cast accompanied by a Cirque du Soleil–like acrobatic team. The story and songs—about a young girl who enters a fantasy world when separated from her scouting group in a forest—were augmented by special effects created by projection mapping: animated shadows, floating orbs, a waterfall, a burning forest, and so on. The finale was a battle with a glowing, skeletal dragon, represented by a giant puppet operated by three black-clad performers and enhanced by both black light and projection effects. The show, Carter said, was a collaboration between Imagineering and the park's creative entertainment team and utilized all the tools and techniques Scenic Illusions had been developing. It was another stepping-stone, closing in 2019. By that time, projection mapping was in use throughout the parks, most visibly in the many and varied nighttime shows.

Steve Davison—the director of Disneyland Forever, created for the park's sixtieth anniversary, and other nighttime shows—recalled that his involvement started as a means of storytelling. "I never set out to do parades or spectacles in the sky," he said. "You kind of just end up there because your heart leads you there. A lot of stuff comes to me by accident." In the case of fireworks shows, the accident happened back in 2000, when Davison's boss asked him to direct a new pyrotechnics show for Disneyland. He responded, "I don't do fireworks. I never studied fireworks. I didn't know anything about fireworks." It didn't matter, his boss said, because "we don't want a fireworks show. We want a story. We want a story in the sky."

The narrative he wrote, about a little boy and Tinker Bell in his backyard, became the fireworks show Believe . . . There's Magic in the Stars, which ran from 2000 to 2004. "I was meticulous about color," he recalled. "When I looked at fireworks, to me they were actors. You're an angry firework or you're a beautiful firework or you're a luscious firework. I mean, they each had personalities that were different. And what I found was that when you started to group these things together,

people reacted totally differently." For example, "if you did this kind of blue swirling pieces with silver and you played the music of *Cinderella* and they all looked like dancers, it transported people in their minds. And it was a whole different philosophy." And the show, he noted, "was a smash. I mean I didn't even realize how big it was." A Christmas variation was quickly ordered up—and ran for more than a decade after the non-holiday show had been replaced.

Then came projection mapping technology, which had continued to evolve at a rapid pace. "A lot of people around the world had started doing it, but they were doing it on big, flat buildings," Davison said. "And we're like, 'Well, how do we do it on a castle?' That really was the best place to do it." Carter's Scenic Illusion Group took on the assignment, scanning the contour of the building with laser technology, stitching the many scans together within their software, then figuring out where to place the projectors and how to mask off the light beams so that they filled the surface of the building without bleeding out into the sky beyond. "We have projectors at all sorts of different angles projecting on every inch of the castle," Davison said. What guests see, though, is one seamless effect that "keeps transforming magically in front of your eyes."

Projection mapping shows at the parks that did not include fireworks could be shown on most nights when weather conditions forbid pyrotechnics. Plus, once a building had been minutely scanned and rebuilt within a 3D graphics program for one show, that same computer model could be reused for every subsequent projection mapping show. Both those merits were, of course, in addition to the visceral guest experience, which involved not just images and fireworks but precisely timed musical accompaniment. Citing "Let It Go" from *Frozen* as an example, Davison noted, "I've done it in a water format. We've now done it in fireworks, and now we're doing it in video projection, where the video now launches into fireworks. It's a multi-media production now. That to me is fantastic, because you're now blurring the lines of everything that we've done and everything that we've learned over the years. So now when you watch a show, sometimes you have no idea what you're looking at. It could be projection with lasers on top to make it more

three-dimensional, but it's also shooting through water planes to give it a whole different level of effect."

The Imagineers could imagine quite a lot through projection mapping technology—not just for outdoor spectacles but also to update indoor attractions with sharp new effects that were relatively inexpensive to implement but vivid in impact. What guests might perceive as an attraction's total overhaul could often be accomplished with minimal changes to the existing structures. The technology quickly became integral to the design teams working on attractions for Disney parks throughout the world.

"You have to build the best technology you've ever built in your life," said Jon Snoddy, who joined Imagineering for the first time in the late 1980s, working for Dave Fink. Snoddy credited Fink with creating a formal R&D team at a time when the company's technological innovators were scattered among different Imagineering projects, as well as the Machine Shop, the Camera Department, and outside contractors. Snoddy left Disney for fifteen years, then returned to lead Imagineering's R&D department after Bran Ferren's departure. There he found "the same spirit, that same energy, the same freedom, the same high expectations, and the same collaboration" Snoddy remembered from the Fink days. R&D, he noted, is "a long process." The core philosophy at Imagineering was, "Let's invest long-term and make sure that every time a new project starts, the most advanced technology available is at their fingertips."

He continued, "We really must be at the absolute state of the art, and then you have to make it invisible. If somebody walks out of one of these [attractions] saying, 'That was an amazing machine. That was an amazing robot. That was an amazing simulator'—we've failed miserably."

II. THE SKY'S THE LIMIT

The exponential advancement of projection mapping technology, in the second decade of the twenty-first century, seemed to trace out a kind of Moore's Law curve for theme park attractions. The famous hypothesis of

Intel co-founder and microchip pioneer Gordon Moore, first expressed in 1965 and revised in 1975, was that the number of components in one integrated circuit would double every two years; it's a projection that seemed to hold true for more than forty years. In the world of theme park design, Moore's Law was interpreted more broadly—suggesting that the technology underpinning the latest attractions would advance so quickly that designers would always be struggling to remain at the cutting edge.

"The acceleration of technology is happening so quickly that it's hard to keep up with it," said Imagineer and Concept Technical Director Tom LaDuke. "When you build a theme park and it takes up to three or four years to get it open, and you have to specify equipment eighteen months into the design, it's pretty sure guaranteed that what you install will be obsolete in the real world. The bar is higher, because cool illusions are becoming ubiquitous. That's the challenge—staying nimble enough to stay ahead of the technology curve."

"Time frames are really unpredictable," Jon Snoddy said. In the R&D division, he continued, "we try to set reachable goals. We take the problem and break it into pieces and we'll look for something that can be done in a few months or a year and then see how it works, see where we are. Other things are kind of ongoing. We believe that if we use machine learning and artificial intelligence and advanced robotics, we can build a character that you can have a conversation with. Well, that's not the kind of thing you say and then tomorrow afternoon you produce it. It means that you're interacting with scientists around the world. It means that you're bringing a lot of people in-house. You are doing a lot of experimentation. You're taking things to the park to test them. It's a multi-year process. Let's invest long-term and make sure that every time a new project starts, the most advanced technology available is at their fingertips."

The R&D team hosted briefings for the designers and other Imagineers each month on both the latest breakthroughs and incremental progress. Some R&D investigations of the latest tech might go on two months and lead to a dead end. On the other hand, "You have timescales

that are forever," Snoddy said, referring to the team's regular "excursions out into the frontiers" in search of new technology that might be useful.

In general, he continued, "We have two sized projects here. What we call big projects are often multi-year projects. They are expensive, and because of their scale, they need professional management, and they can last anywhere from a year to even three or four years. Then we have a lot of what we call small projects, and those are intentionally not closely managed. Approving them is instantaneous. You go to your boss and say, 'Hey, I have this idea,' and it really doesn't much matter what it is. I make a point of not approving those myself. I don't even want to know what they are, because I don't want them to be limited to the kinds of things that I might like. I want them to be completely bottom-up." That attitude, he said, had "always been a hallmark of this organization. It is a group of smart people that are driven by ideas. They come out where one or two people are talking in the hall—they get an idea, they get a little bit of money, they buy some parts, and they build something. And often those things can be done in a week, in a month, in a couple of months—really fairly quickly." The goal, Snoddy said, is "to go from an idea to a thing as quickly as possible. You have a picture of it in your head, and I have a picture in my head, and those might be very different. But as soon as we build something, instantly we are seeing the same thing. Instantly, there is consensus—and that consensus might be that it's a bad idea. That's okay, because it lets us fail and fail quickly and get on to the next thing."

The Imagineers in R&D are an eclectic bunch. "We kind of pride ourselves on having a really wacky diverse group of people here," Snoddy said. "It's not the kind of organization where you hire super-narrow specialists that are brilliant at only one thing." Being one of the best in the world at one thing will get someone in the door, he added, "but the thing that gets you hired is the breadth. Everyone here, you can pick any topic and they can converse on that topic. They are people very connected to their industries but also all sorts of industries. They are active in local theater, local art. They do installations and exhibits. They build things.

This is a group of people that love ideas, that love to see something new come into existence. They are very hardworking. You have to throw them out [of the office] sometimes."

Steady advancement is not good enough. Progress needs to keep up with whatever the theme park equivalent of Moore's Law might be. "If you need just to improve things a couple of percent, to move the needle a little bit—you don't need R&D. Projects can do that," Snoddy said. "What we have to do is look for those leaps—those things that are not obvious. Those things that don't fit well into the established literature and the established way that that discipline is done."

Breakthrough technologies do not emerge from mere problem-solving, said R&D's Ben Schwegler. "If you were to go up to the best carriage maker [in the late 1800s] and ask them what their problems are, they would say, 'Oh, you know, I've got a problem with my horse, and he always trips on the little crossties.' That guy doesn't tell you he wants a car. So, the one thing that we have learned here is, yes, we come up with great technology, but until you change the business, the way you do business, then you leave most of the benefit of the technology on the table."

On the design side of Imagineering, thinking outside the box is a chief goal during the "Blue Sky" phase of any project—as in "the sky's the limit." "During the Blue Sky process, people are just dreaming, [and they] really have no constraints," said Bob Chapek, who succeeded Bob Iger as CEO of The Walt Disney Company in 2020. "There's a point for dreaming, and that should be completely unbridled."

"Blue Sky at Imagineering is always incredible—I love it," said Imagineer Chris Beatty. "You're just throwing out crazy ideas, but at the same time we're problem-solving." The fundamental question is always "What kind of ride experience do we want [the guests] to be taken on?" The answer to that will start to focus the discussion. The process is "organic; it's very natural in how it evolves. You'll put down a story idea or a layout and you can fall in love with it—but you can't be held to it. You have to be able to cast it off at times and look at the problem differently." As Blue Sky shifts into the practical-design phase, in almost every case, "We have some amazing ideas we'll never build."

The more mundane word for Blue Sky sessions, Wing T. Chao pointed out, is "brainstorming." The idea is "just dream. We just write ideas down on three-by-five cards [and pin them] on the walls. And then we discuss, we caucus." While the goal is to set the creative bar as high as possible for each project, Blue Sky does not mean the team should imagine a limitless budget and infinite timeline, Chao added. Cost and scheduling "always have to be in the back of our mind. So as we dream, we want to make sure that in the imagination portion, we don't go too far out for too long."

Some Blue Sky sessions are targeted to solve a particular problem—say, what should replace Superstar Limo? What should an E-ticket *Cars* attraction be like? "Then, every once in a while, we do what we call un-targeted or open-ended Blue Sky," said Charita Carter. "There's no particular need that has been articulated, and we come up with our own parameters for coming up with an idea." Other sessions focus on needs brought to Imagineering from the Operations team. "The parks are really good about articulating what it is that they need, and then we take that information and we come up with just really compelling ideas," Carter said. "Oftentimes, we'll come up with something that they were not anticipating at all, but it is so intriguing to them they might even decide to change direction."

The partnership with Operations, she noted, became more integrated after Imagineering joined the Parks and Resorts division of the company, uniting the two teams under one corporate banner. "Way back when I started with Imagineering," Carter recalled, "we did not report to our Parks and Resorts group, so we gave out a lot of ideas and then the parks kind of came in and shopped [through] what we had come up with to see what fit. As we've moved into one unit and one organization, I think that partnership has really grown. So it's really an exchange going back and forth."

The Park Operations team can help Imagineering anticipate the evolution of guests' expectations. "You've got to constantly evolve the product as far as how people consume the entertainment," said Bruce Vaughn, the onetime head of R&D who became chief creative executive

of Imagineering in 2007. Guests, he said, are beginning to look for more role-playing and agency. Their expectations are being shaped and reshaped almost daily by the proliferation of new technology in other areas: social media, video games, streaming entertainment, interactive . . . everything.

"Our audience has also evolved," said creative executive Chris Beatty. "What they've come to expect, what they can experience at home [on game platforms], the adventures they can go on without ever leaving their house. It's a very daunting task for us to be able to not just keep up with it, but exceed and keep surprising our guests, keep our guests asking the question, 'How in the world did Lumiere just—it's a candlestick. How did he just come to life on the mantel?'"

One twenty-first-century challenge was what Vaughn called the "erosion of patience." By 2012, by one estimate, Americans were spending thirty-seven billion hours a year waiting in line, whether in their cars, at fast-food restaurants, at airport security, or any of the countless other first come, first served situations built into modern life. They didn't go to theme parks in order to add to that total; they went to be entertained. Waiting couldn't be designed out of theme parks, but the downtime could be transformed. "People don't like to wait in lines anymore, so we're working on plans that have no queue lines," Vaughn said. "People will still be waiting but they just won't be standing in queues. They'll be doing other things."

As nice as it might be for guests to be excused from lines by digital reservations, or by activities themed to the attraction they're awaiting, those changes caused other headaches for the Imagineers. "Queue lines are a very efficient use of space," Vaughn said. "You stack people in—they get very tight—and now you can fit more people in your park. It's just a really bad guest experience and the tolerance for it is getting less and less and less and less." As the play action inside Toy Story Midway Mania addressed park guests' preference for agency and interactivity, the Mr. Potato Head barker outside served as a queue line entertainer, along with cast members strolling about in Toy Story character costumes.

In the rest of their lives, park visitors—especially younger people—are

used to the rapid gratification of an on-demand world. How would parks evolve to meet these new expectations? "You don't sit there and say, 'Well, this is how we've always done business and this is all we know.' We've got to change," Vaughn said.

Snoddy expanded on those thoughts. "We are living in a pretty amazing time where everyone carries around what literally was a super-computer a couple of decades ago," he said, referring to the iPhone and other smartphones, which had become ubiquitous by the 2010s, as well as iPads and other tablet computers guests often carried into Disney parks. "Every day children use them, and so it is inevitable that that will start to shape more and more the in-park experience. People use [smartphones] in queues now. We now sell a lot of tickets with smartphones. People use it to get around."

The MagicBand—a miniature computer, battery, and radio transmitter contained in a watch-like bracelet—was introduced in the summer of 2013 and replaced not only paper FastPasses but also most paper tickets and hotel room keys for Disney properties. Each unique MagicBand could be linked to a guest's smartphone or tablet through the My Disney Experience app, which then also kept track of park tickets, dining reservations, and FastPasses. Guests were encouraged as well to link a credit card to their MagicBands, which could then be used to make purchases.

"You can order food or just walk up and the food will appear automatically because of things like MagicBand and our personalization technology, and we'll be pushing more and more and more of that," Snoddy said. The ultimate goal is to "make the lines and hassles and things that detract from the experience go away and make it a more seamless experience." But however quickly guests adopt and even adore FastPass+ or the MagicBand, no such innovation is an endpoint, he noted. "It will continue to evolve. Those platforms are not permanent. We continue to look for the next thing and the next and the next and the next. We have a number of active projects that will extend the functionality and then add to it."

The name MagicBand is, of course, no accident. Magic is what Disney promises at all its parks, whether in its ticketing and queuing

technology, in its nighttime spectaculars, or in its attractions, from Peter Pan's Flight to the latest thrill ride. It's up to Imagineering's R&D division both to keep applied science at the forefront of current trends and to keep it hidden from view. A favorite quote for many R&D Imagineers is an observation science fiction writer Arthur C. Clarke made in 1973: "Any sufficiently advanced technology is indistinguishable from magic." That simple but resonant assertion "is actually a vision statement for our department," said Imagineer Dave Crawford. "Our job is not about technology. Even though that's what we work with almost every day, it's not about the technology. It's about the experience." For example, he continued, "We still use fiber optics everywhere. Smoke and mirrors. But [what matters is] our ability to reinvent the way it's presented by scaling it up, scaling it down, figuring out a way to trick guests into believing it again—believing something they've seen before, to believe it again."

III. OFF TO WORK WE GO

The years 2011 and 2012 laid down several major milestones for Walt Disney Imagineering in addition to the opening of Cars Land and Buena Vista Street at California Adventure. The Disney Cruise Line completed its phase-two expansion, launching its third ship, the *Disney Dream*, in 2011 and its fourth, the *Disney Fantasy*, in 2012. Both ships had interactive and other new-tech features to charm modern cruisers (SEE CHAPTER 19). The August 2011 opening of Aulani, A Disney Resort & Spa, on the Hawaiian island of Oahu, marked the first time the company had built a hospitality destination that would not serve any of its parks. The resort, with more than eight-hundred rooms and time-share villas, was designed by a team led by Imagineer and former Hawai'i resident Joe Rohde. The Imagineer blended elements of native Hawaiian culture with Disney influences and characters in an approach similar to his work on Disney's Animal Kingdom Theme Park. "I like the idea that several of the projects that I've been involved with have a non-entertainment payback within them," Rohde said, citing both the conservation program

linked to Disney's Animal Kingdom, and the immersion of Aulani guests in authentic Hawaiian language, art, music, and culture.

In Walt Disney World, the focus was on Fantasyland, which unveiled the results of a three-year makeover in 2012 and 2013. In the largest expansion since the Magic Kingdom opened, "New Fantasyland" significantly extended the footprint of the storybook area, growing from ten acres to twenty-one, including the space previously occupied by Mickey's Toontown Fair. To double the Dumbo ride's capacity, the repositioned attraction now featured two flying elephant carousels and an interactive waiting area in the form of an indoor playground. Guests were notified when it was time to ride via a pager assigned to their party.

The most sweeping addition was Belle's Village, a mini-land themed to the 1991 animated film *Beauty and the Beast*. It included a retail shop, a counter service restaurant called Gaston's Tavern, and a tall mountain capped with a miniature reproduction of the Beast's castle. Inside the mountain was the high-capacity Be Our Guest Restaurant, where lunch was ordered at a computer terminal with a "magic rose," then served at individual tables. The wireless-location technology within each "magic rose" directed the servers to the correct party in cavernous dining rooms designed to resemble the ballroom and west wing of the Beast's castle. (It was also the first eatery in the Magic Kingdom to serve alcohol.)

The creative director for New Fantasyland was Imagineer Chris Beatty, who said the expansion was the realization of one of Walt Disney's goals for Disneyland: to have guests join "journeys with animated characters." That was particularly true of the mini-land's supersized meet-and-greet experience with Belle, called Enchanted Tales with Belle, the entrance of which resembled Belle's cottage from the film. The multi-scene experience began in Belle's father's workshop and continued—on the other side of a magic mirror—in a wardrobe room in the Beast's castle, where some guests were chosen for roles in a brief reenactment of the story of *Beauty and the Beast*. The final room—the castle library—introduced Belle in person, who played herself in the impromptu skit, narrated by an Audio-Animatronics figure of Lumiere with all the non-performing

guests seated on padded benches. Belle then posed for photos with the actors. One travel blog declared it "surely the prettiest and most elaborate meet-and-greet station in Walt Disney World."

But Belle's Village was not the finale of the renovation. For that, guests waited another eighteen months for the opening of a new roller coaster called the Seven Dwarfs Mine Train—a new kind of "scary adventure" that grafted some aspects of the classic dark ride onto a runaway mine train experience. While much of New Fantasyland was princess-centric, the new coaster added new dimensions of action and thrills to the fantasy.

The ride was divided into three segments—two stretches of coaster hills and curves separated by a visit with the Dwarfs at work in their mine, with glowing jewels all around and the characters singing while they worked. Like the Lumiere narrator in Enchanted Tales with Belle, these Audio-Animatronics figures did not have mechanical facial features but instead had their expressions created through projection mapping: fully animated faces of the Dwarfs—created by Disney animators—were projected from inside onto the figures' translucent, contoured faces, making them resemble their original animated selves more than ever. It was Madame Leota times seven, disembodied no more, and in full color, a generational leap forward in projection technology.

"This was the first time we've done a full 3D design and delivery process on any of our Audio-Animatronics figures," said Imagineer Ethan Reed. "It's enabled us to do things with characters that we've never been able to do before, like working with Walt Disney Animation Studios."

The Los Angeles Times called the Seven Dwarfs figures "the most lifelike in the industry." The ride, wrote reporter Jerry Hirsch, was "part of a drive by theme parks to keep their attractions relevant in an age when video game graphics have outpaced anything Walt Disney imagined decades ago." "We wanted to create a family experience that would bring to life the dwarfs in a way that we could not have done before," Bruce Vaughn told the Times. "Snow White has a deep history with the company, and we didn't want to lose that." A theme park reporter for the Orlando Sentinel noted, "All the parks toss the word 'immersive' around, but I was

buying into it there." The interactivity extended to the Mine Train queue area, which included jewel-sorting video games, wooden water spigots that played musical notes when triggered by guests' hand movements, and other elements.

The mine train vehicles added another new sensation, as each car swung gently from side to side during the ride. "You saw [the mine cars] kind of swing back and forth in the animated classic," said Imagineer Pam Rawlins, the show producer on the attraction, in an online interview just before its opening. "Our ride guys thought that was a perfect opportunity to bring [guests] this new ride technology—the first of its kind. . . . It sits on a cradle and it rocks back and forth as you bank and turn on the rolling hillsides."

IV. IN THE MANOR OF MAGIC

An expansion was also in the works for Hong Kong Disneyland, which had opened in 2005 as the smallest Disney park and had been gradually growing ever since. Autopia opened there in 2006, along with an interactive show called Stitch Encounter that allowed guests to talk with Stitch in a fashion similar to Turtle Talk with Crush. The revised "it's a small world" opened in 2008, including the Disney character dolls that led to the later update at Disneyland. From 2011 to 2013, three new lands were added to the park.

The first to open was Toy Story Land, with rides targeted to young children and props and theming tied to the Pixar films (*Toy Story 3* had been released in 2010). It had not been Imagineering's first idea for expanding the Hong Kong park. "We were going to do a land based on snow," Tom Fitzgerald recalled. Called Glacier Point and focused on a North Pole outpost, it would have been an intentional contrast to another planned expansion, an area called Grizzly Gulch, planned for a 2012 opening and themed to the American Southwest. But Disney's local partners, including representatives of Hong Kong's government, didn't think the Arctic theme would resonate with Chinese guests. That left the Imagineers with a gap and little time to fill it. In part to avoid

starting from scratch, they decided to adapt Toy Story Playland, already in the works for Walt Disney Studios in Paris. "It works really well here for a bunch of reasons," Fitzgerald said. "For many of the Hong Kong locals who are familiar with [the Pixar films], they love those characters and they know those worlds. If you've never seen those movies—if you're from south China and you've come here—visually it communicates on a very simple level. It's just big toys and just a fun environment to be in. If you get the stories, it's just a plus."

The Imagineers debuted their most innovative new attraction—designed from scratch and exclusive to Hong Kong—in May 2013. Mystic Manor, the centerpiece of an expansion area called Mystic Point, would utilize as many new tricks as the Imagineers could manage. "Hong Kong is a very dynamic city," said Ian Price, director of project management for Hong Kong Disneyland. "Technology is forefront—you just have to go downtown and look at all the stores, [with the] latest technologies on the shelf, literally the day it happens, so as Imagineers we have to try to keep up with that technology, working with the R&D Department back at Imagineering, who come out with new and incredible things all the time. We're constantly trying to give the local market that new technology, that special wow factor, because they appreciate it so much."

Mystic Manor, said Imagineer Joe Lanzisero, would take the concept of the Haunted Mansion back to the "grand illusion hall" that had been Walt Disney's original concept for the Disneyland attraction—"like a ride through a magic show. Yale Gracey and all those guys were brilliant taking mirrors and lights and creating ghosts that appear and disappear." Researching the local culture suggested that the kind of ghostly attraction that connected with guests in the United States would not work in Hong Kong. "The Chinese have a very different way of thinking about the afterlife," Lanzisero learned. "Singing, happy ghosts really wasn't what they thought of." Rather than feel constrained, the change in perspective gave the Imagineers a sense of liberation. And they turned away from the Haunted Mansion to a newer backstory they had invented for the Tower of Terror in Tokyo: the fictional Society of Explorers and Adventurers (S.E.A.).

The S.E.A. had been introduced at Tokyo DisneySea, where the tower attraction had been redesigned as a Moorish Revival hotel, said to have been owned by S.E.A. member Harrison Hightower III (images of whom resembled Imagineer Joe Rohde). Hightower's story was then linked retroactively to the defunct Adventurers Club in Disney's Pleasure Island (designed by Rohde), which the new lore recast as a chapter of the S.E.A. For Hong Kong, Mystic Manor was said to be the home of another S.E.A. member, Lord Henry Mystic, who had a mischievous pet monkey named Albert and a magical Balinese music box. The "Doom Buggies" of the Haunted Mansion, which advanced steadily on a linear track, were replaced with "Mystic Magneto-Electric Carriages"—trackless vehicles in the tradition of Pooh's Hunny Hunt and Aquatopia. The cars were said to have been an invention of Lord Henry's, weaving the ride system into the storytelling.

"Actually starting from scratch and really developing a brand-new project and developing brand-new characters to me personally, as a designer, that's the most exciting thing that we get a chance to do," said Mark Schirmer, who was co-lead with Lanzisero on Mystic Manor. "One of the things that we did in this concept was to go back to our roots, our Disney roots, and say, 'What made Disneyland in Anaheim great and unique as a theme park? It set itself apart. Our mandate was to go back to that immersive storytelling and what Walt ultimately created at Disneyland. We said, 'You know, we only have five minutes on this ride. It's a fairly short time to tell a comprehensive story. We need our characters to resonate immediately with the guests." For Mystic Manor, that included both the stylized Lord Henry, the explorer, and Albert, his pet monkey, who would really be the star of the show—an immediately and universally appealing imp with an oversized head and big, soft eyes.

Albert became the attraction's main character because "we knew that the monkey had a very special place in this culture," Lanzisero said. "The monkey king is essential to a lot of their literature, and a lot of their stories are about the learning that the Monkey King goes through. So we chose to use the monkey as our surrogate. He's us, going through the ride, and he's made some choices and his choices have their consequences."

It was time, Schirmer said, for the Hong Kong park to have "something that was unique in the Disney repertoire that they could call their own. And certainly they wanted something that was uniquely Chinese and a tip of a hat to their home culture." The attraction would celebrate the nation's art, with a final room themed as a museum dubbed the Chinese salon. To accommodate guests who spoke several different languages, "We actually dialed back the dialogue [in favor of] more of a visual storytelling. We limited the audible dialogue between characters to our first scene, our pre-show, and our last scene."

Visual storytelling meant top-notch special effects, and once again, projection technology became the principal device to create "the most grand magic show that we could use the most up-to-date technology," Lanzisero said. The use of super-high-resolution projectors and computer mapping would blur the line between what was a physical set and what was a projected image. Lanzisero's team had discussed adding a 3D component, with the riders wearing 3D glasses, but he nixed the idea. "There's something about when you're in a real environment—you're not looking at it through glasses, and it's happening around you. The effects make it look and feel like you're inside a 3D CG movie."

As often happened at Imagineering, the technology had advanced just when the Mystic Manor team needed it to pull off their best illusions. "One of the main story points was the fact that Lord Henry Mystic finds this music box. There's supposedly a curse on this music box—when you open the music box and the music is played, it could turn inanimate objects into animate objects. The idea was to create a visual representation of the music, almost like a pixie dust, like you would see if you did a CG movie," Lanzisero said. How to create this sparkle effect floating in the air was the subject of some extensive experimentation. "We went through a whole variety of mock-ups just trying to get this musical dust a physical manifestation. I remember one was, we took literally Christmas tinsel and shot lasers on it and had this whole series of wires and things that pulled it up and pushed it around the room. It all looked lame." At the same time, the special effects team at Imagineering was working

with outside researchers to create a CG laser-generated image of floating pixie dust, such as Tinker Bell might generate. "They showed us this mock-up, and I said . . . 'That's our music dust. That's perfect.' That was an incredible breakthrough moment."

"We actually created, as part of the storytelling, almost this third character called the music dust," Schirmer said. "So that music dust, that visual element, travels through [the show]. It's basically foreshadowing or pulling us forward through the different scenes." The music dust was created using a laser particle projector, a state-of-the-art device for which Mystic Manor would be the world premiere. "We were actually able to develop that with some cleverly placed show sets that actually lets it illuminate and appear that it's in the middle of the room." By projecting laser particles onto a mobile, invisible scrim—a flexible, transparent mesh that dropped from the ceiling—the Imagineer magicians could make the music dust dance and travel throughout the space of each scene, delivering a definite "wow factor."

Combined with an advanced version of the trackless vehicle system that allowed more complicated maneuvers, Lanzisero said, "it's like all of a sudden we had this giant toy box of things that allowed us to present something like we couldn't have presented before." To guide the trackless vehicles, more than two-hundred RFID tags were installed in the floor. Each unique radio frequency identification tag communicated its position wirelessly to each vehicle, keeping them on course. The vehicles could start and stop, turn 360 degrees, and proceed at varying speeds. The flexibility allowed the Imagineers to vary the duration of their special effects and to direct riders' attention more proactively—unlike with a continuous-track system, on which every section is viewed for the same amount of time. "That allowed us to think about the ride experience more like a movie, where each of the scenes individually could have a beginning, middle, and end and then each of the scenes could build on the previous one so that the whole experience would have a beginning, middle, and end with a real sense of build and a real sense of being able to tell a story." The vehicles were dispatched and unloaded individually,

but they traveled through Mystic Manor in groups of four, with each car in the group tracing a different path through each room, so guests could have different experiences on repeated visits.

The special effects, even without the 3D glasses, included "4D" effects, such as bugs swarming into the vehicles—another projection illusion. Some elements were nods to other Disney attractions, such as an appearance by Trader Sam from the Jungle Cruise, singing busts such as those in the Haunted Mansion, and a supersized statue of a Polynesian god reminiscent of Walt Disney's Enchanted Tiki Room. The latest in projection mapping technology was combined with previously perfected effects such as fog, black lights, lasers, Audio-Animatronics, and more.

The seamless blend kept guests guessing about how any single effect was created. That was particularly true for the final scenes, beginning in the Chinese Salon—a finale that Lanzisero and Schirmer decided to scrap and rebuild late in the process. What they had, they believed, wasn't yet knocking their socks off, so they asked for and were given the time and resources necessary to reconceive it. The result was Mystic Manor's most awe-inspiring blend of all the elements already introduced, including characters that emerge from artworks, more 4D effects, and a wall that appears to be blown out, all accompanied by a surrounding swell of music. "You're only in that scene for about thirty-five to forty seconds total, and to have that amount of effects happening in there is really unique to our product."

The icing on this technologically rich cake was human rather than technological: Danny Elfman, the ideal composer for an attraction in which music was central to the story. Elfman's agent had seen a sneak preview of the attraction at the D23 Expo in 2009, and brought the composer together with Lanzisero and Schirmer. To woo Elfman, the composer for *Tim Burton's The Nightmare Before Christmas* and countless other movies, "we actually had a full, walk-through show model that was done," Schirmer recalled. "That really gave him a great basis for what our storytelling was, how we were going to move through the space, and how he could ultimately compose the music."

Elfman's answer was immediate: "Yeah, I'll do the music for you."

Lanzisero was thrilled: "His musical style—we call it 'scary fun,' and that's the whole tone of this attraction."

As it happened, Elfman was a lifelong Disney fan, having loved the Haunted Mansion as a kid, long before it took on the *Nightmare* holiday overlay (a version of the attraction he had not experienced before taking the gig on Mystic Manor). "I liked the idea of possibly doing something that could be into the subconscious of children of many generations to come in the same way that this [Haunted Mansion song] got into my head," Elfman said. "When I started writing it, I started writing it as if it were a movie or a show or anything. I just wrote a version of a tune and I broke it into a number of variations"—the quiet variation, the boisterous variation, and so on. He was so in sync with the Imagineers' vision that his first stab at a theme was immediately approved. "That always makes a project really special, when a first idea, a fresh first idea was the right one," Elfman added.

The process was far from over, however. As the Imagineers finished each room along the ride, they would ask for additional variations: an Egyptian version, an arrangement with more Polynesian-style drums, and so on. Once they started stringing it all together, things really got complicated. While the riders would hear just one continuous soundtrack, in fact each room's music had to cycle as vehicles left and new cars entered, and each room's sound had to overlap with the rooms on either side of it. The puzzle, Elfman said, was "how the music for each room interfaced with the next room with four cars [passing through at slightly different times]."

Elfman had composed pop songs, movie soundtracks, theater music, and even a Cirque du Soleil score—but he'd never written music that had to overlap with itself before. It was not an option to install separate speakers in each vehicle, because the Imagineers "wanted it to be all live in the room," Elfman said. "They wanted it to feel like the sound and the music was coming from the objects themselves." A month or so before the attraction was to open, Elfman arrived in Hong Kong. "We spent weeks, every day, going room to room, banging it all out and remixing everything live on the spot [on a laptop computer]. We'd ride each of the four cars and listen to that mix and then make notes: 'Well, it was

working for Car One. Not so good for Car Three and Four.' We'd shut the ride down, make adjustments, bring the ride back up, and ride 'em again. And then we'd start it up again the next day."

Most important to the Imagineers was that Elfman understood "this whole idea of creating a hummable theme," Lanzisero said. It was the hallmark of so many classic Disney attractions, including Pirates of the Caribbean, "it's a small world," and Haunted Mansion. "You walk out with that central music theme humming through your head. Danny got that immediately." As he added variations for each room, the result was "this really interesting tapestry of music that supported the story in his style, which was exactly the tone we were going for." The addition of Elfman to the team "was like all the planets converging for us."

The final attraction checked a lot of boxes. "We wanted to build something that's popular for the young adults, exciting but still suitable for families," said Emily Tso, specialist, operations administration, for the Hong Kong Disneyland Resort. "And I think the ultimate point is we wanted to build something that's unique to Hong Kong—something that [Chinese] people can show off to their friends from other parts of the world."

Opening in May 2013, Mystic Manor got rapturous reviews from both Disney bloggers and theme park business insiders. Hong Kong Disneyland fans were "amazed with all the different special effects," Tso said. "Queuing up with the guests a couple of times, I could see a lot of people coming back for their second or third ride. At the soft opening, I actually saw people requesting which vehicle they wanted to ride on, and it created a separate queue by itself. So that's pretty amazing."

Considering "the theming, the level of detail, and the technologies that we're using within that attraction, it's second to none," said Andrew Kam, managing director for Hong Kong Disneyland. The attraction would go on to win Best New Attraction at the Theme Park Insider Awards in 2013. It was a good year for Disney at the awards, with Tokyo DisneySea, Disney California Adventure, and Disneyland in Anaheim taking the top three slots in the Best Theme Park category. DisneySea and Disney California Adventure took the top two spots in

the Best Restaurant contest, for the Sailing Ship *Columbia* Dining Room and Carthay Circle Restaurant, and another new Hong Kong Disneyland attraction, Big Grizzly Mountain Runaway Mine Cars, took third place in the attractions category. Grizzly Gulch had been Hong Kong's second new mini-land, opening in 2012 and evoking a nineteenth-century mining town. It was the park's equivalent to Frontierland, with a bear-shaped rock formation reminiscent of Grizzly Peak in Disney California Adventure. The Gulch's only ride, the Runaway Mine Cars, was similar to Big Thunder Mountain in theming—with the addition of Audio-Animatronics bears—but also borrowed technology from Expedition Everest, including a segment where the trains ran backward.

In terms of number of attractions, Hong Kong Disneyland remained one of the smaller Disney parks, but the three new lands helped boost attendance to 6.7 million by 2012, an increase of 13 percent over 2011. "The word on the street and the word of mouth with our consumers is that this park is very balanced," said Bill Ernest, president and managing director for Asia for Disney Parks and Resorts as Mystic Point opened in 2013. "It's family-driven, it's young adult–driven, it's a park that celebrates the festivals and the seasons." Repeat business from mainland China increased, and the park reported its first profit in 2012, seven years after opening. Another change, Ernest said, was that cast members had begun to consider their work in the park as a career option, rather than just a temporary job. "I think the future is very bright. Now we've got the DNA. Now we've got the balance."

V. A TOTALLY WACKY ADVENTURE

The decision to build a *Ratatouille* attraction at the Walt Disney Studios Park in Paris was one of the first of its kind to veer from the park's original concept. As Bruce Vaughn, then Imagineering's chief creative executive, put it, "In no other place do you see such an evolution of the design aesthetic of a Disney theme park. The studio park was an attempt to take people behind the scenes in Hollywood. What we've learned over time is that that sense of artifice actually doesn't resonate well with our

guests. So when we went on to create Ratatouille, we decided to not show them how the movie is made, or go behind the scenes. We said, 'We want to take you to the place'—much like we did with Cars Land at California Adventure. [We will] take you into this world of *Ratatouille*."

The attraction was not the first major addition since the park opened in 2002. That honor went to *Un Saut dans a Quatrième Dimension* (*The Twilight Zone*™ Tower of Terror), which opened in late 2007 as part of the Hollywood-themed Production Courtyard. Toy Story Playland opened in 2010 with three smaller, all-ages rides. The *Ratatouille* attraction, coming a few years later, would fill in a lot of missing pieces of the park's identity puzzle. It would use the latest technology to create an exciting experience, rather than to reveal the secrets of filmmaking. And it would be original to the park and set within a fully realized mini-land.

Just as Radiator Springs in Southern California was a fantasy rendition of America's nearby desert Southwest, the Ratatouille area would be a whimsical twist on Paris, in that city's own suburbs. The plaza outside the attraction entrance was carefully conceived to evoke Paris and yet remain a fantasy realm, with a statue of Remy the rat at the pinnacle of the central fountain and rat figures designed into the details. (The Imagineers even invented biographies for the square's imaginary human residents, expressed by the carefully selected decor behind the windows to apartments that didn't actually exist.) As with the Radiator Springs Racers in Cars Land, the actual attraction would be populated with characters and incidents from the film that did not necessarily follow the film's story line. Unlike the Racers, which was built with all practical effects in real spaces, indoors and out, the *Ratatouille* attraction would rely in part on 3D animation, with riders wearing the necessary specs, to accomplish the sense of peril and immediacy the Imagineers had in mind.

The notion of making an attraction based on Pixar's *Ratatouille* "really started when the film came out in Europe," said Tom Fitzgerald, Imagineering's creative director for the *Ratatouille* project and creative executive for the Disneyland Paris Resort. "It was such an enormous hit in France and in Europe. It was like a phenomenon—and not surprising, because it's such a valentine to Paris and gastronomy and to the

architecture of Paris." Rewatching the movie with an eye toward a theme park experience, "the scene that got us started was ironically the first scene that was animated for the *Ratatouille* film, where Remy falls through the window of Gusteau's restaurant." The rapid-fire chase through the kitchen that ensued seemed like "a great idea for a ride. We could shrink you down to the size of a rat and you could see the world from that perspective. So that's where we started."

The attraction, he thought, should be the spiritual successor to Mr. Toad's Wild Ride in Disneyland. "It is just a crazy fun thing, and it's been a favorite since the park opened. And then *Ratatouille* came along and we saw that scene and it's like, that's Mr. Toad's Wild Ride—that gauntlet of Remy going through the wheels [of the serving cart] and the footsteps and almost getting stepped on and then going into the restaurant [dining room]. It was a gauntlet ride—just a fun, crazy adventure."

What it would not be was a re-creation of the film itself, a choice that "speaks to where we've evolved our design aesthetic over time," Vaughn said. "We decided along the way that we didn't want to do what we call 'book report' attractions. We didn't want to retell the story from the movie. There are, obviously, familiar elements, because you want to have people have that emotional connection back to the movie, but it's a scene that doesn't happen in the movie. You are, literally, one of the rats trying to get to dinner with Remy. And it takes place in a time [outside] the movie, because Remy has his restaurant"—as at the end of the movie—"but you're still in the [Gusteau] kitchen; Skinner is still around. We sort of twisted the story, bent time a little bit." In the film's narrative, Gusteau's restaurant, run by Skinner, is closed down before Remy gets his own bistro; in the attraction, both eateries coexist, and Skinner's kitchen staff from the film are all present. It was a kind of alternative rat history, combining the movie's "greatest hits," as Fitzgerald put it.

As is often the case, the Imagineer had a scene-by-scene story for the attraction before he knew for certain what technology would bring the special effects to life. "We tried to do a version where we didn't use 3D media early on. We spent about a year, I think. We couldn't make it work because we couldn't get the physical effects to interact with us enough.

We couldn't physically hit you with a mop or a champagne cork. There are things that you could do with the illusion of 3D that you cannot do physically, and in the end we had to let go of that version and go to 3D." It would be the Imagineers' first attraction that combined 3D media with trackless vehicles—and once again, projection technology would be crucial to creating the guest experience Fitzgerald had in mind. The 3D projections in particular "really opened up the door to us, because now in one scene you could go from the rooftops of Paris, fall [through the skylight] and finish in the kitchen. You could go through a lot of real estate. If we had to physically take you through the journey that you go through on this virtually, the show building would be the biggest show building we've ever built. So it gave us an interesting way to cover more ground and go to more places. The story line didn't change much from then on."

Fitzgerald considered the *Ratatouille* attraction the most challenging writing assignment he'd taken on at Imagineering. "The challenge with Ratatouille was we had a show that had to communicate in French and English and it's a ride that has high capacity, which means the scenes are going to be relatively short. So I had to be very concise and I had to figure out how to have the characters be bilingual." Most of the dialogue in the scenes is said once in French, once in English.

"We actually had to record American actors for the English and French actors for French and make them sound like they were the same person." (That decision would become crucial when the attraction was duplicated for EPCOT in Walt Disney World, opening in 2021. Since the soundtrack already included an English translation, it did not have to be rerecorded. Even if U.S. guests didn't understand the French, the presence of the language was consistent with the theming and narrative of the attraction.)

The original co-writer of *Ratatouille*, Pixar's Brad Bird, who also directed the film, had creative input to the attraction, as did John Lasseter. They viewed an early attraction model and approved the "alternate universe" take on the story line. Once the decision was made to use 3D media, Pixar animators were recruited as well. Bird insisted the Imagineers work with as many of the original *Ratatouille* animators as

possible. The film's production designer, Harley Jessup, consulted on the look of the animated sequences.

But however perfect Pixar's scenic design and animation might be for the projected media, the Imagineers never let go of the idea of creating detailed, giant-size props and Broadway-worthy sets. "What we're doing is a theater where there is no proscenium," Fitzgerald said. "You're actually invited onstage and you get to move through it. We wanted to blur the line between what's virtual and what's real." The surrounding props would help convince riders that they were in a real space, making them "much more willing to suspend disbelief."

Also keeping the experience fresh from scene to scene were the variety of the projected media. "The screen shapes and sizes are different," Fitzgerald said. "Some are rear projections. Some are front projections. Some are shadow projections. Some are Pepper's Ghost projections"—the spectral mirror effect used so extensively in the Haunted Mansion. "We just keep mixing it up so you don't get a conscious feeling of, 'Oh, I get what is going on.' We don't want that to ever happen. We want you to just be wrapped up in this gauntlet of 'Oh my gosh and now we're here! Oh, now this is happening to us!' Just have that roller coaster experience."

An early step in creating that experience, Fitzgerald explained, was called "The Jellybean Experience." "Once we have the plans of the ride, we [create] a digital plan view of all the vehicles in the building." The rat cars were represented in the computer model by "these little circles"—they looked like jelly beans—"and you program when you think they will move, and you can watch them go from scene to scene. It shows when doors close and when the next group [of vehicles] comes in and when the door opens and they go out. So on a screen you can watch the whole ride work." After the attraction was built, the technician assigned to the control room during operation would have a similar bird's-eye computer mock-up showing exactly where each vehicle was at every moment to make sure that they do what they should be doing.

The next model shifted from the virtual world to the physical world. To work out the flow of the show, the Imagineers built a scale model of the attraction layout. It was big enough, Fitzgerald said, that "we could

actually ride through on little stools." The mock-up helped the team work out sight lines and perspectives and the scale of the props. The Imagineers started honing in on the precise timing and the length of each scene—crucial information for their animating partners at Pixar. "Once we had this sort of timing chart, then we actually started making animatics of the scenes"—rough animation—"and doing scratch-track dialogue and then reviewing, reviewing, reviewing. We built full-size screens for every scene in the show down in Glendale. We felt that it was critical, because we were going to be producing the show in the States and then delivering it at the end to Paris. With the resolution and size of the scenes that we were doing, we had to do our homework." The mock-up remained in place, updated as needed, for more than a year, and the Pixar artists could bring down their animation to see it in the context of the attraction. "And we would review it and do notes and then they'd go back and do the next iteration and bring it down—we'd review it, do notes."

The vehicles—six-seat cars shaped like rats—were guided by Imagineering's patented trackless technology. That allowed the Ratmobiles to start and stop and speed up and slow down and spin, just as in Mystic Manor. Also as in the Manor, the vehicles traveled through the show in groups—three this time, rather than the Manor's four—with each car in the pod tracing a slightly different path. "They're wireless vehicles," Vaughn said, "so there's a lot of communication going on between the vehicles and the environment, and we wanted to give each one of those a unique personality. So, they're not just going in a line, each vehicle doing the same thing."

The presence of up to eighteen 3D-bespectacled guests in three moving vehicles all watching the same projected media from shifting perspectives made the rendering of the Pixar animators' work incredibly complicated, since the effectiveness of 3D media depends on the exact angle from which it's seen. As the Ratmobiles moved through each scene, the ideal viewing spot needed to shift as well, which meant making subtle changes to the 3D effects. Solving each clip for what's called the "moving eye point" required a lot of math and practical testing. "We went out to a warehouse way out in Ontario, [California,] out by the

[Ontario] airport, and we built the first of the projection domes" that would be used for the final attraction, explained Chrissie Allen, the executive producer of the ride and creative producer of the Paris resort. The projection mock-up, along with Ratmobile stand-ins, allowed the Imagineers to figure out how to manipulate 3D images to place a "sweet spot" within each Ratmobile. "We spent about a year in Ontario testing that with moving objects before we even brought in the Pixar animation," Allen said. The tests also helped them figure out how big the animated Remy should be relative to the vehicles.

Solving for the variables of the moving eye point is "really complicated stuff," Fitzgerald said. "Way over my head. It's very easy to say, 'Yeah, and then we fall through the roof, we go through the kitchen and come out through the refrigerator.' But it took the team months and months and months to get it right."

A third ride mock-up was built in a warehouse in Detroit, Allen said, where the Ratmobiles were manufactured. "We had an entire model of the track. And the vehicles did the choreography for up to nine months to a year before we even brought them [to Paris]." Visits to the Detroit mock-up fell during one winter, she recalled, "So, back in Detroit in the middle of the night, forty degrees outside, we would sit with our iPads in our laps and imagine riding around on the vehicles as they did this choreography." The mock-up had no projections or props, so the testers used iPads synched to the vehicle movements to display computer models of what riders would see—"kind of like watching on an airplane screen a movie that's going to be thirty or one hundred feet wide and one hundred feet tall."

To further enhance the riders' immersion in the experience, each vehicle was fitted with "scamper motion"—an individual vibration, even at rest, to make the car's movements seem more like the scurrying of a small animal. "We wanted these [vehicles] to be rats, and we wanted to have some personality, so we asked for more features [than in Mystic Manor]," Fitzgerald said. The rats would go forward and back, and spin, and tilt forward—to make that fall into the kitchen more vertiginous—and they could change order, so the same vehicle in the pod wasn't always the

first to leave a scene. The movements were all to service the story, "so you really would get the sense that these were characters, that they have life.

It was crucial that riders remained "not quite sure where the media ends and where a set begins," Fitzgerald said. That meant that the Imagineers' lighting lead, Joe Falzetta, had to watch all the iterations of the animation as they arrived, because he would need to match the look of each scene with the lighting he designed for each set. Falzetta also consulted directly with Pixar's CG lighting designer.

Once the attraction was constructed in Walt Disney Studios Park, all the Imagineers' planning and the Pixar artists' animating was put to the test. Pixar would provide three rough versions of each clip, providing slightly different solutions for the moving eye point problem. "During the middle of the night," Fitzgerald said, "we came in when they weren't cycling vehicles and looked at it and confirmed which of the three options was the perfect one and then go into rendering"—the time-consuming process by which powerful computers create high-resolution final animation from the rougher versions used for animation and design. To make sure the huge, projected images remained crystal clear, the resolution had to be as high as possible—so the animation rendering required "huge, huge, huge files. At the start of the project [Pixar] told us that the few minutes of animation that make up the ride take as long or longer to render out than the entire *Ratatouille* feature film. That gives you another sense of why it was important for us to do our homework early—because you couldn't at the last minute come in and say, 'Re-render everything.'"

The operations team for the Disneyland Paris Resort had asked Imagineering to create a restaurant as well as an attraction for the new mini-land, so the Ratatouille experience continues at the end of the ride, where guests seamlessly find themselves invited to eat in Remy's actual restaurant. "We knew we wanted to do something with food because *Ratatouille* is all about the rat who dreams of becoming a chef," Fitzgerald said. He resisted the suggestion that they re-create Gusteau's restaurant—after all, the high-end restaurants of Paris were just up the road. What the Imagineers could create that guests couldn't find in Paris was Remy's rat-scale restaurant, seen at the end of the movie, populated by the tiny

chef's rodent friends. That, Fitzgerald thought, would be really fun: a restaurant in which the diners are imagined to be rat-sized, with giant plates separating the booths, a chandelier made out of a huge colander, and chairs seemingly made from the wire cages that top champagne bottles. The restaurant was an extension of the ride, which ended with the Ratmobiles arriving in Remy's miniature bistro.

"The fun piece for us is that we get to do a scale change," Vaughn said. The effect began in the ride's queue. The entry to the attraction was styled as a Parisian theater, "but very quickly as you move through the queue, you are shrunk down to the size of a rat." Much of the queue reproduced a Pixar-inspired landscape of Parisian rooftops, first at human scale, then at rat scale, setting up the drop into the kitchen that kicks off *Ratatouille: L'Aventure Totalement Toquée de Rémy*, as the ride came to be called (translated roughly, "Ratatouille: Remy's Totally Wacky Adventure"). "It's the kind of experience that we think triggers that sense of the imagination and the child within everybody," Vaughn said.

The triumph of the attraction was not in the honing of complicated projection effects, nor in the creative physical tricks, but in making the entire assortment of technology invisible. *Ratatouille*, Wilson said, embodied "the magic of being in a well-done attraction—you are transported to somewhere else for just a brief period of time, and you get to enjoy an experience that you wouldn't otherwise get to enjoy. From the moment you walk into this land, you feel yourself enveloped 360 degrees by practically a scene out of the movie—it's supported by entertainment, it's supported by music, it's supported by lighting. The sensation on the ride vehicles [is one of being] completely immersed." It is, in short, "about being delighted."

Walt Disney Studios Park still had growing to do. But by the year *Ratatouille: L'Aventure Totalement Toquée de Rémy* opened, the Disneyland Paris Resort—with its two theme parks, Disney Village shopping complex, hotels, golf courses, and other offerings—was *the most visited destination in Europe*. In 2014, the two parks together welcomed more than 15 million guests. (That was about twice the count for the Eiffel Tower.) The year marked the beginning of a steady climb in attendance at the Studios Park, culminating in 2017 with its first year topping 5 million visitors.

CHAPTER 28:

AN EMOTIONAL CONNECTION

"I once asked John Hench, 'What does this all mean? What's the deeper meaning of all this?' And he said, 'The meaning of the parks is very simple. It's "you're going to be okay." ' " —Bob Weis

I. A SHAKEN NATION

IT WAS THE park-wide announcement that Disney hoped it would never have to make: "Ladies and gentlemen, your attention please. We have just experienced an earthquake. Please move away from the buildings to an open area. Please be assured that the park has been designed with earthquake safety in mind."

It was just after 2:46 p.m. on March 11, 2011. An undersea earthquake had hit from an epicenter forty-three miles east of Japan's main island. With a magnitude of at least 9.0—an intensity considered "catastrophic"—it was the largest earthquake ever recorded in Japan. It shook the entire country, including the Tokyo Disney Resort, where some seventy thousand guests were enjoying a sunny Friday afternoon at the two parks. The PA announcement that followed the earthquake was the first step in Oriental Land Company's disaster management plan. It was especially crucial at Tokyo DisneySea, just a seawall away from the water, because more deadly than the quake itself were the resulting tsunami waves, swells of water up to thirty-three feet high that rushed out from the epicenter in every direction. Between the quake and the tsunami, more than fifteen thousand people in Japan lost their lives that day and

thousands more were reported missing. None of those were at Tokyo Disneyland.

"Oriental Land Company's response to that earthquake was superb," recalled Imagineer Daniel Jue. "They took care of our guests in ways that were completely beyond what I would say is standard, and they took what they had learned about Disney service and Disney care to another level. No one at Tokyo Disney Resort was injured during that earthquake. The only complaints that we got were about seasickness, because the earthquake was very rolling."

When the quake hit, all the resort's attractions were shut down and guests were ushered or directed out into open areas. Built to withstand even strong temblors, the buildings sustained no significant structural damage. That was not the case elsewhere around Tokyo Bay, where many neighborhoods constructed on reclaimed land, as Tokyo Disneyland had been, were badly shaken. Oriental Land Company had spent considerable extra time and money to compact the area's platform fill—pressing it down to increase its density. The process had considerably reduced the dangers of liquefaction, when loose earth acts like a liquid during a quake, a phenomenon that destroyed buildings, cracked pavement, burst buried water pipes, and caused manhole covers to pop up in other areas along Tokyo Bay.

Little of that was seen at Tokyo Disneyland. The resort did experience some minor flooding, and some parking lot pavement was left cracked, shifted, and covered with patches of standing water. With parts of the parking areas unsafe and public transportation shut down—and no certainty that aftershocks wouldn't make things worse—some twenty thousand Disneyland guests had to stay overnight in the resort. Oriental Land Company provided food, water, blankets, and, where needed, heaters. *New York Post* travel editor David Landsel was visiting Tokyo DisneySea at the time of the quake and reported his experience as it was happening via Twitter. "More than 30,000 people in park at the time," he wrote. "All ended up outside on the ground waiting for shaking to stop." The mood of the guests around him was good. "Our neighbors here in the cafe are group of schoolgirls eager to practice English. Lots of laughs." For those

stranded in the parks, he reported, cast members passed out tea, cookies, chocolates, and pork buns. By evening, when temperatures dropped to around freezing, he said the entry plaza to Tokyo DisneySea had been transformed into a tent city. "What a bizarre (and wonderful) place to be trapped!" he observed. Disney's Steve Davison was also in the resort during the earthquake and posted photos of minor damage on social media.

The thousands of guests stuck in the parks, Jue said, "were all taken care of and brought back home safely." It was immediately clear that the parks would be closed the next day, and on Saturday, Disney said it expected the closure to last at least ten days. By then the magnitude of the disaster at the flooded Fukushima Daiichi nuclear power plant was becoming clear, as was the devastation and loss of life throughout the country. It would have seemed disrespectful to open the parks while the country was still burying the victims, assessing the damage, and dealing with one of the world's most horrifying cases of contamination by radiation. The closure stretched on for nearly five weeks.

As the park's twenty-eighth anniversary approached, the time seemed right to reopen. Disney and Oriental Land Company announced Tokyo Disneyland would reopen on its birthday, April 15. For every guest who visited that day, Both companies would donate 300 yen (about $3.60) to the Japanese Red Cross. The news was treated as a rare bright spot in a dark time, and by the time the gates were scheduled to open at eight a.m., ten thousand people had lined up outside. Disney characters ventured out into the waiting crowds, waving and hugging as they were greeted by shouts of "Mickey! Mickey!" Then the turnstiles started spinning again, and fans rushed into the park. The area known as World Bazaar was lined with cast members, neatly turned out in their uniforms, waving at all the visitors. Some cast members were noticeably moved, wiping away tears of happiness. Guests were equally elated. Indeed, the whole country seemed to be celebrating, as the reopening became a big story over Japanese media and throughout the world.

"We repaired things to offer our guests dreams and peace again," Kyoichiro Uenishi, Oriental Land Company's chief operating officer, told a Reuters reporter. "The timing was right today." (Tokyo DisneySea

remained closed until April 28.) There were signs of the disaster's impact, both literal—a placard at the entrance offering condolences—and subtle, such as the non-functioning fountains and the dimming of many lights, part of the park's efforts to conserve energy during the power shortage. The park's daily schedule was also reduced by four hours, closing at six p.m. But the dimmed lights did not dim spirits. "There's been so much bad news," said Daisuke Ishidoya, a twenty-nine-year-old restaurant worker from an area of Japan directly affected by the tsunami. "I really needed a bit of cheering up." A young father escorting his three-year-old daughter, dressed as Cinderella, on that first day back said simply, "It was pretty lonely without the park."

"There's a period after any disaster in Japan where they are in mourning," Jue said. "After 9/11, the president can come out and after a period of time say, hey, we're back on our feet. Everyone, go back shopping, right? And, the country feels like, okay we can get back to our business. In Japan, no one announces that. But there's just this natural period of mourning where all business dinners are canceled. No one goes out to parties. Areas of Tokyo that were typically lit up and bright and active were dark. I do feel that the opening of Tokyo Disneyland was the first step to tell everyone, hey, it's okay. We're back to normal and you can come back. And it showed to me that Tokyo Disneyland is not our park anymore. It's Japan's park, and they own it. And so that day with cast members and with guests it was a greatly emotional day. We had people running to hug Mickey and thank him." As an Imagineer, Jue said, holding back tears, "you go, 'This is what we do.'"

The reopening of Tokyo Disneyland was comforting to a rattled nation regardless of whether people actually ventured out to visit the park. While the five-week closure had reflected the nation's mourning and individual isolation immediately after the disaster, the reopening represented hope and unity. If Disneyland was the "architecture of reassurance," then Tokyo Disneyland, with its actions during and after the earthquake, was reassurance in action. The smooth disaster response and attentive care of guests on March 11 had a lasting impact. "That told all of Japan that Tokyo Disney Resort is safe," Jue said. The fact that the

resort reported so little damage, Jue added, "was a testament to not only the Walt Disney Imagineering design, but to the quality of construction and quality of [Oriental Land Company's] maintenance."

Guests responded by continuing to fill the park. Attendance at the combined parks did dip in 2011, but by less than would have been expected given the weeks-long closures and national crisis. By 2012, attendance topped 2010 levels, and the resort reported more than 17 million guests for the first time in 2013. "Our guests came back in droves," Jue said. "Even when Fukushima was still leaking, and people would not go outside. They would not go visit the beaches or the [city] parks. They would carry radiation meters to check the parks. But they know that they will be safe, and they will be taken care of at Tokyo Disney Resort. So a significant point in time for the resort was that earthquake. Tokyo Disneyland had to open for the country to begin to heal."

II. LEARNING AND RECHARGING

The cultural and emotional weight given to the reopening of Tokyo Disney Resort after the tsunami was just the latest chapter in a story that had begun with the original Disneyland. On the most literal level, Disney's parks were shrewd business ventures utilizing established intellectual properties with built-in popularity. They were constructed and sold on a solid foundation of market research, and they thrived because of the company's marketing prowess. Disney parks presented a collection of short stories that seemed to emerge from a single author, and the addition of Pixar properties to the mix tended to strengthen that impression rather than dilute it. Imagineering, with its six-decade history of place-making, may have made occasional missteps, but it had also proved itself adept at course correction.

"You've probably heard this a dozen times, but I think it always goes back to the story," Imagineer David Wilson said. "When you walk into our parks, you enter somewhere else. If you're an adult who has a lot of problems in your life, or if you're a family with children, you walk into any of our parks and you immediately let your guard down." That

immersion, he continued, "allows serious businessmen to wear Mickey Mouse ears and allows people to do things that they would never normally do, because we've created an environment where you're basically transported. Pirates of the Caribbean is a perfect example, because in Pirates—I mean, you know you're not a pirate, you know you're not in a pirate ship, but for a few minutes you'll suspend your disbelief, and you will enter that world and you will be marveled by the environment that is created and by the music and by the sensations and by the story. That's the magic of being in a Disney park. It's the magic of reading a good book."

For May 2015 at Disneyland in Anaheim, the "even bigger" offerings were new high-tech shows to mark the park's upcoming sixtieth birthday—part of a sixteen-month event dubbed the Diamond Celebration. Imagineer Steve Davison, executive, Parades and Spectaculars, was once again in charge of the new shows. The man behind the dramatic World of Color in Disney California Adventure had two things planned for the next Disneyland birthday celebration. He brought in the Paint the Night parade, introduced the previous September in Hong Kong Disneyland, and he supervised the creation of a new fireworks spectacle, called Disneyland Forever. The new show, a tribute to the songs, stories, and characters from Disney's and Pixar's films, required the installation of at least twenty-five new projectors to overlay animated images via projection mapping not only on Sleeping Beauty Castle and "it's a small world" but also on the Matterhorn (dressed as a volcano at one point), mist screens along Frontierland's Fantasmic viewing area, and buildings along Main Street, U.S.A. Projection technology was also integral to the parade, animating the faces of some characters on the floats. Over in Disney California Adventure, the World of Color show was revised to feature a tribute to Walt Disney's conception and creation of the Disneyland Park.

As the *Los Angeles Times* reported on May 22, the celebration's opening day, "Sixty years after Walt Disney opened the Anaheim theme park powered largely by gas engines, electric motors, pulleys and gears, Disneyland is jumping into its seventh decade with heavy use of laser mapping,

high-definition projectors, LED lights and infrared technology to tell Disney's classic stories." The new technologies gave the Imagineers "the flexibility to upgrade its attractions primarily by installing new software instead of having to tear out steel beams, mortar and plywood," the *Times* reporter noted. As former Imagineer Bob Gurr told the Times, "It's like a movie house. You just change the movie every once in a while."

"Disneyland—and Disney Parks in general—are places where you can go and they get better every time you go," said Imagineer Tom Morris. "They defy entropy. They are not getting old, and that makes you feel youthful. Maybe you'll somehow by osmosis get some of that magic on you, and you will defy all of the things that time and age bring because Disneyland is better than it was when it opened. It's better than it was forty years ago, thirty years ago, twenty years ago."

That special bond between guests and parks was particularly strong in Tokyo, Daniel Jue observed. "It is a much higher, a much greater emotional connection that [the Japanese] have with Disney and our Disney parks than I have witnessed anywhere in the world, even domestically," said Jue. "It is almost as if Tokyo Disneyland fills a need that they are missing in their daily lives. At Tokyo Disneyland it is perfectly acceptable to dance on the streets, to sing with a parade, and to smile and to have fun and wear funny hats. What Tokyo Disneyland does is it gives people freedom to express themselves. That's why I love Tokyo Disney Resort, because I see that our guests are emotionally connected to what we're doing, and they are living the happiness that we are trying to produce."

CHAPTER 29:

AUTHENTICALLY DISNEY,
DISTINCTLY CHINESE

"One of our challenges on this project . . . like anytime we go into a new market, is really trying to teach our culture, our history—the Disney tradition. . . . It all started with one man, one man with two daughters, that cared so much about their happiness, sitting in a park wondering, 'How can I make this more fun for more people?'" —Doris Woodward

I. DESTINY AND DETERMINATION

"I GUESS DESTINY CAUSED me to land at the right place at the right time and meet the right people." Doris Woodward was looking back on her long career at Imagineering—a career with its origins in a young girl's talent for drawing. Her mother was Chinese, her father European and Middle Eastern, but both had been born and raised in Shanghai. They married there and moved to Hong Kong before Doris was born. She grew up in the city under British rule but immersed in Chinese culture and driven to pursue creative endeavors—drawing, singing, modeling. When it came time for college, she decided to apply to an art school in the United States. "I could probably draw my way through," she thought, "and it should be pretty fun."

She enrolled at the California College of the Arts in San Francisco and scored internships during her junior and senior years in the

graphics department at San Francisco's small M. H. de Young Memorial Museum—her first step toward Imagineering, though she didn't know it at the time. The work prepared her for her first postcollege job—creating graphics for the Marine World/Africa USA theme park along San Francisco Bay. It was a small park, "kind of a mom-and-pop," she recalled, "but dealing with all kinds of storytelling. In their way, it really taught me how to understand and expand my design role into themed sets and environments, not just graphics." Without planning it, she had built a resume that fit right in with WED Enterprises, then working toward the opening of EPCOT. So when a friend's suggestion led her to Glendale— to interview with Marty Sklar, John Hench, and Rolly Crump—"they felt that I would be a wonderfully suited artist to join their team."

She loved Imagineering from the start, feeling she was "surrounded by a group of incredibly talented individuals who have a higher purpose." It was 1979, and while Walt was gone, many of his original creative team were still working with Imagineering. "So I was very fortunate that I got to work with [many] of them—and they were hilarious people. They were supportive and extremely talented. I was incredibly fortunate to learn from the masters the whole aspect of storytelling and collaboration." Woodward's first major assignment was working on The Land pavilion, a team led by Crump as the art director. "I couldn't have asked for a better boss to teach me the art of design and the art of entertainment." Many projects would follow over the decades, she said, but "EPCOT clearly was the foundation that brought me to where I am today as an artist, as well as an individual."

She went on to work on projects that grew into enormous successes (Disney's Hollywood Studios and Disney's Animal Kingdom Theme Park) and others that never came to be. Destiny kicked in again when the company decided to investigate the options for building a theme park in Asia. Woodward was assigned to the creative team and "traveled all over Asia in search of what would be the right entry point for the company to have a Magic Kingdom," she recalled. "Of course, Hong Kong being my home and where I grew up, it was very natural for me to think that would

be the right place. And luckily, as it turned out, it was." Along with fellow Imagineer Wing T. Chao, Woodward worked to educate the Imagineers in Chinese culture to make the park more appealing to its prospective guests. (Hong Kong Disneyland may have begun as one of WDI's smaller efforts—a "lift park," as Woodward termed it—but the advantage of starting small in a new country was that the expansion projects could be better tailored to the market, as Disney and WDI's learned more about their Asian visitors.)

Starting small would not be the plan for Disney's second Asian resort, a project in which Woodward would eventually play a key role. But getting there took more than a decade—longer, if one counted overtures made to Frank Wells in 1990 by Zhu Rongji, the then-mayor of Shanghai, China's largest city. Wells had visited China but never entered into formal negotiations. Michael Eisner met with Zhu Rongji in October 1998 in Beijing, after Zhu had risen to become Premier, ranked as China's number two official. During the meeting Zhu mentioned he had set aside land for a Disney park in Shanghai when he had served as the city's mayor. Eisner expressed an interest in developing a Shanghai resort, and Bob Iger then began to lead on the Shanghai project, with the first phase of negotiations beginning in 2001. Once Iger took over as CEO in 2005, a park in Shanghai became central to the "international expansion" pillar of his three-prong formula for Disney's success. Iger had begun pursuing the plan in earnest after he became the head of Walt Disney International in 1999, making dozens of visits to the country. A second Asian resort would be "big in terms of capital investment, but extremely meaningful in success," Iger said. "So that's one thing that I typically ask: could it be a big needle mover? Otherwise, a big risk isn't worth it."

To learn as much as possible about these potential Disney consumers, Iger spent many days on his visits to China gauging their mood and learning their habits, often taking casual walking tours of Chinese neighborhoods. One day, wandering through a neighborhood of small one-story homes—some of them so small that one building contained just a bedroom and bathroom, with the kitchen and living room next

door—Iger and his Chinese companion, a Disney executive based in China, encountered an elderly woman. She was sweeping the street in front of her home and invited the two men in for tea. "We walked into her little living room and there was, first of all, a postcard of the Statue of Liberty on her small refrigerator," Iger recalled. "And I noticed on top of the refrigerator was a stack of Disney books. It was actually a very meaningful moment, because she explained that she was a grandmother and that those were the books that she read to her grandchild. There was a connection between her and Disney that was very special to her— even though she knew very little about Disney. She had no idea what Disneyland was, but she had a real understanding of Disney characters and she recalled seeing *Snow White* when she was a girl. And it was touching to me, because it suggested that there was a passion for Disney. There was a connection that Chinese people were making to not only our characters but who we were. And it just opened my eyes to the fact that if we did it well, we could be welcomed in China, by the people of China, in a very, very heartfelt way."

The Shanghai park would be built in partnership with the local Shanghai government and the oversight of the central Chinese government, making the negotiating process more complex. "I think time in many respects has been our ally," Iger said, "because as the negotiation wore on, China developed more and more"—increasing the likelihood of success. There were starts and stops, a brief flirtation between Shanghai and Universal about a park, which went nowhere. Once Iger became CEO, he said, "I gave the negotiating team a mandate, which was, 'Let's get this done.'" For more than two years, a small team of Disney negotiators lived in China for two or three weeks a month, hammering out the agreement with the government point by point by point.

The negotiators were working with a rough master plan for the resort developed by a team of Imagineers led by Bob Weis. They sketched in not just the theme park but also the hotel, recreation, shopping, and entertainment districts. The idea was that "by the time they finished negotiations, we'd have a design we felt pretty good with, and then [the Imagineers] could go off and start the real design and the real

construction," said Andrew Bolstein, who was the operations representative on the team and later the senior vice president of operations for the Shanghai resort. "That was kind of the beginning of traveling through China and really trying to understand the culture and the people."

The "travelers" visited Chinese amusement parks, hotels, retail and dining complexes, and entertainment districts. "We met with the operators and did a lot of observation," Bolstein said, "just seeing how they do everything from queueing to dining to shopping, what types of attractions they like and don't like." Imagineers met with academics, culinary experts, marketing and merchandise concerns, as well as with potential guests. They asked focus groups about Main Street, U.S.A., and restroom preferences. They quickly learned that China had plenty of amusement parks but no real theme parks that offered the kind of immersive experience Disney provided. Shanghai Disneyland would have a lot of competitors but no direct competition.

Finally, in January 2009, Disney and Shanghai submitted to the central government a joint proposal outlining the financing and legal considerations for the resort. The new Disney resort would be built in Pudong, a district east of central Shanghai, not far from the airport. The theme park would be the main draw within a larger resort that would include two hotels, a retail, dining and entertainment district, a recreational lake, and other features. It would be co-managed by Disney, which would hold a 43 percent stake in the park, and the Shanghai Shendi Group, a conglomerate of government-owned companies with a 57 percent interest in the development. The budget for the entire project was $3.59 billion, with an opening date initially set for 2014. The agreement finally gave Walt Disney Imagineering the green light it had been waiting for.

By that time, it had been nearly four decades since Woodward had left Hong Kong for college in the United States. She had been back to Hong Kong and had visited China many times over the years, but she had lived her entire adult life in the United States. After Disney's Hong Kong deal was signed in 2000, she had left Imagineering—after twenty-one years—and moved with her family to Vermont, where she worked

remotely as the creative lead for a California-based design company and emphatically noted, "we had a fantastic life." Then she got an email from Imagineer Bob Weis, whom she had not spoken to in nine years or longer. "He teased me with the idea of perhaps coming back to work on the Shanghai project." Woodward and her family had been contemplating a return to California, where their younger daughter wanted to attend art school, and news of Woodward's possible relocation had reached Imagineering. "I heard you're coming back," Weis said. "Let's get together and chat about Shanghai."

"The next thing I knew, I was back at Imagineering," Woodward recalled. "I could see the challenges were there because there weren't really any Chinese members on the team," she said. "Mainland China is very different from Hong Kong with attitudes more traditional, more classic." Working from Glendale, "there would be challenges from the standpoint of understanding the Chinese culture and not taking the stereotypical point of view."

The mandate for the Shanghai park was a Magic Kingdom tailored to the Chinese market, but the expectations were a sea change from Hong Kong Disneyland. "It was the bigger, the better—the wider, the higher, the more unique, the unusual," Woodward said. The idea was simple but challenging: build a Magic Kingdom, but make it a Disney park unlike any before it. "We were asked to go for the limit, think out of the box, but maintain an attitude and integrity that is still of a Magic Kingdom."

"I've seen the best of times and I've seen the worst of times," Weis said. "I've seen when Imagineering was held in very high regard by Disney's management and I've seen us be seen as trouble." With Iger now settled in as CEO, Weis judged it to be "one of the absolute best times, if not the best time I've ever seen. And I think it's in large part because Bob set the company's standard, which is quality. He just said there's no compromising quality on any level. So if it's not good enough, we're not doing it. When you present something to Bob and it's not as good as it should be, he sees it immediately. And there's no compromising innovation—that's the culture."

This would be Weis's second Magic Kingdom in Asia, since he had been on the Tokyo Disneyland team in the 1980s. It was during that project that he first traveled to China, soon after the government had first permitted visitors from the United States. "It was 1983," he recalled. "I went to Beijing. I went to Shanghai and a few other cities, but China was so transformatively different from the way it is now." Weis had been asked to lead the Blue Sky effort on Shanghai while still overseeing the construction phase of the Disney California Adventure expansion. It was a lot to take on, he said, but "I thought about it and I thought back to that trip in 1983 when I went to China and thought, there is no way I could turn this down. Even if it's going to be crazy in this time period— the last year of the expansion of Disney California Adventure—I gotta do this project. It goes back to my Tokyo roots of working overseas doing a project in a culture that none of us really know very much about. So I had to take it on."

Weis put together the team that would begin forging ahead on concrete plans for a park that had actually been in the works for years. "It does have a long history," he acknowledged, but the design specifics of the park had evolved over the years. "We really started the design from a fresh perspective a couple of years before the deal was signed." The Shanghai team at Imagineering had grown accordingly, and the focus became a 2009 presentation to get an approval from Disney's corporate board of directors.

Iger set up an event for the board at the Imagineering offices. Led by Weis, "the Imagineers put up [concept art] on big screens—imagery all around—in one of the big rooms at Imagineering," Iger recalled. "And I remember the feeling in the room, because there was sort of a 'holy cow' moment for the whole board. 'You're going to build that?!' Everything looked big, and of course the Imagineers have a great way of making everything look romantic. The board was blown away." Steve Jobs had joined the board as part of the Pixar acquisition a few years earlier, and he was at the unveiling. "And Steve turned to me, but audible to the whole room, and said, 'Only Disney could do this.' It was great. It's a

nice validation—made us all feel good." The board approved, and the Chinese government followed suit in November 2009.

The groundbreaking ceremony in Shanghai was April 8, 2011—an event Bolstein recalled as an early test of Disney's ability to coordinate with the local government and Chinese consultants. Disney took the lead in organizing all aspects of the event—though the event was the first time post-negotiations that Disney partnered with the Chinese—to handle the logistics of getting a bevy of local dignitaries together with Disney executives and hundreds of guests—all of whom were expecting "a real Disney show in a tent on a piece of pavement that didn't exist thirty days earlier in the middle of a giant dirt pad. So it's like making magic out of nothing. And the show itself was beautiful." Two children sang "When You Wish Upon a Star" in Chinese and an array of Disney characters bounded onto the stage—Mickey Mouse, Goofy, Princess Jasmine, and others—all wearing China-inspired clothing. "It was kind of a goose-bump moment, because we put a lot of effort into it and you know, now it's done. We've got a lot of work to do." Bolstein laughed at the memory. "Now all that empty dirt out there has to get going. So that was a mean-ingful day for sure."

Iger shared the spotlight that day with the city's then-mayor, Han Zheng, and Shanghai's Party Secretary, Yu Zhengsheng. It was at that ceremony that Iger unveiled the company's guiding vision for the park: "a destination that will be authentically Disney and distinctly Chinese." He later explained, "I wanted to convey to the world that we were build-ing something that was going to be a Disney theme park experience but that would resonate culturally in China—that we're going to be extremely mindful of entering China with a great deal of respect for the people of China and its culture. Deep down, that's what I wanted us to build, too. It was truly what I wanted the experience to be."

The phrase "authentically Disney, distinctly Chinese," which Iger came up with while working on the press release, would be repeated end-lessly in the coming years, in media reports, opinion pieces, and even academic dissertations. Among Imagineers, the saying came up so often

that it became an acronym: ADDC. "It was so resonant," Iger said. "It said so much about what we were building. And that became the mandate for the Imagineering team that designed it. And everything we did thereafter creatively in the park was authentically Disney, distinctly Chinese."

II. FROM THE GROUND UP

Shanghai Disney Resort would be an enormous and unprecedented project—not just in scope but in building a vast and sophisticated park in a country with no comparable construction or design history and a limited or absent understanding of what Disney represented. "The big challenge of Disney going to any foreign environment is, we can't do it all ourselves, so we have to reach out and find the resources necessary to get any project done," Bob Weis said. A growing number of international Imagineers would be based in Shanghai, while Imagineering also recruited Chinese Imagineers—"not consultants, not advisors," Weis said, "but Chinese Imagineers who join the company just like the rest of the Imagineers, who become a permanent part of what Imagineering is about. And we need to be willing to learn from them. It's a two-way learning experience." To find talent, Imagineering scoured Chinese theater academies, film studios, and art schools in search of designers and art directors, immersing the new recruits in Disney history and design seminars. In the United States, Weis even posted a notice on a Chinese community board at Craigslist, thereby discovering "two of the finest Imagineers we have on Shanghai." In Glendale, the Imagineers were tutored by Chinese experts on language, the arts, food, and culture. It was "like a cultural exchange program," as Weis put it.

To do the actual building, "we brought on a series of big international creative contractors that have done things like we're doing," Weis said during the construction. "Nothing like the scale of what we've done, but they've done projects in Singapore and other projects in Asia that require the kinds of skills that we have, and they're going to bring in a combination of international and Chinese talent."

Local contractors, Walt Disney Imagineering soon learned, followed "very different practices," said Imagineer Ali Rubinstein, who would become creative director for the park's castle. "They are fantastic at building giant skyscrapers. I mean, you can see the big, beautiful buildings [of the Shanghai] skyline from Pudong, and they're very, very fast and very efficient. But themed construction is kind of a new thing here. Our level of storytelling isn't typical when you're building a giant skyscraper."

The first construction challenge was keeping the whole park from sinking. The location in Pudong was "swampy, mucky land a lot like Florida," Rubinstein said while the building was in its early stages. "And so if we build buildings just on the ground, they'll sink. So literally there are piles that go into the ground ten, twenty, thirty meters down—thousands and thousands of them, for every little structure that we have, from a small food and beverage kiosk all the way to the castle, which has hundreds and hundreds of piles. It's an amazing amount of infrastructure that's going in to support what is next, which is doing all the vertical construction."

The construction contracting strategy was "a complete flip from Hong Kong, where most of what went into Hong Kong Disneyland came from the U.S. or other parts of the world," Weis said. For Shanghai, as much as possible would be built in China. "The only exceptions were our most sophisticated Audio-Animatronics figures and certain kinds of specialty materials that only could be manufactured in other places. And most of our very sophisticated ride systems were built by vendors that we knew around the world. But everything else is made in China and made at the quality level that we demanded. That was a gigantic effort."

To educate their local partners, the Imagineers in China created physical models and samples of everything: every type of rockwork, every facade, every design embellishment. The scale models were presented to the contractors with a simple message: "This is what the final product has to look like." A drawing, Weis noted, can be open to interpretation;

a scale model is not. "You want to be collaborative and cooperative, but you also want to be demanding."

The Imagineers not only had to guide the construction contractors carefully, they had to recruit and train artisans to accomplish the more artistic work, most from China but also from about fifteen other countries in Europe and Asia, Rubinstein said while the work was still being done. "Some are extraordinary experts that have come in and just blown us away with their skill sets right off the bat. Others have maybe struggled a little bit more, but that's typical. We found some incredible new talent here that we're going to be able to grow that will stay here and carry on Imagineering when we're all gone."

A case in point were the Chinese artists trained in concrete sculpting by rockwork production designer Fabrice Kennel, producing surfaces that would be indistinguishable from rock or wood or other materials when finished. He started with a team of five or six and wound up training more than a hundred—passing along skills that he himself had learned in the field, working on theme parks in Europe. "There is no special school for this work, so we just learn ourselves," he said. The training was hands-on, in a designated rock-sculpting training area, with reference photos and finished samples. Kennel would demonstrate how to set up and then work the gradually hardening concrete, how and when to add soil and sand, and how to shape and add texture and patterns. Once trained, he expected the workers not only to produce perfect surfaces, ready for painting, but also to have fun, to "play with it, so at the end it looks real."

The Chinese trainees ranged from sculptors with masters of arts degrees to plasterers with no formal training. "What I encourage the people [in training] is, don't hesitate," he continued. "The best work is always when you do it fast and right the first time. It's almost like a sketch—it's got this freshness, this fragility, and you don't feel the work, you don't feel the labor in it. You can patch, but it feels like a patchwork. It has to look like nobody has done it."

Overseeing the construction for Imagineering's creative team was

Woodward, who had relocated to Shanghai for the duration. She started off as the creative director for the central castle and other parts of the park, as well as the "the mouth, eyes, and ears for the team back home." The other creative directors would also eventually relocate to China, but whenever Weis was not on location in those early days, Woodward acted in his stead, supervising the creative aspects of the overall resort. It was her job "to make sure that it all carries through—the quality, the continuity, the concepting—through all the vendors."

At the same time the seedlings of a theme park began to break out of the mud, Disney was planting the seeds for sustainability. A tree farm had been started to grow the plants that would be needed to landscape the park, with particular attention to matching the trees to the soil and enriching the soil to nourish the trees. A small water treatment facility was built to test techniques that would then be scaled up for the final, full-size water-treatment plant. Energy plans were developed around a sophisticated, highly efficient system called CCHP, for Combined Cooling, Heating, and Power. All this work was overseen by Ben Schwegler, chief scientist for Imagineering. "What I'm really interested in is, what are the interactions of the built environment—that's the roads, the buildings, the earthmoving machines, all of the infrastructure—with the natural environment? How do the buildings that we put there help or harm the natural environment, and what can we do with the designs to either mimic the natural environment—or make it not worse? Under the best circumstances, how can we actually improve the natural environment in a way that makes it healthier and happier for humans?"

The tree farm was just one example of that work, as Schwegler's team measured air and water quality and analyzed the soil—"all of the elements that make up sustainability," he said while the park was still in progress. "Behind the scenes, there's a huge effort to make sure that the planting of the trees, the choice of the trees, is well-grounded in plant nutrition, in soil biogeochemistry, as we call it—the interaction of the microorganisms, the soil itself, and the mineral part of the soil." The tree farm recruited "the best people we can find throughout China, the best people

we can find throughout the world, to help us understand what really is going to make the trees as happy as the guests, if you will. Plants breathe just like people breathe, so we have to take a lot of care to make sure that the plants can breathe." Referring to the dirt surrounding him as he spoke, he continued, "This soil is very carefully balanced between the organic fraction and the mineral fraction. It can hold fertilizer really well." In layman's terms, he added with a smile, "It's good dirt. We like to think of it as happy dirt."

The point was not just to have healthy trees throughout the park but to invest the principles of sustainability in as many aspects of the resort as possible. "We wanted to look at all of the energy flows through the park and all of what we call the material flows through the park." A CCHP system managed all the conduits of energy—heated air, electricity, hot water—together, and giant tanks were built to hold the huge volumes of water that would be integral to energy production and distribution. "What you want to do is make the production of electricity and hot water and cold water as efficient as possible. And the way that we decided to do that here is to combine the production of electricity together with the production of hot water and chilled water." In the CCHP system, the heat created by generating electricity would be used "through a process called 'absorption chilling' to produce cold water. So we do both cold water and hot water from the same source and at the same time that we produce the electricity." The system tripled the energy efficiency of the theme park. "The goal here is to start with energy and then build out [the efficiency] to all the other infrastructure elements. And that, we think, is a real blueprint for sustainability overall in China—and for the rest of the world, for that matter."

To improve air quality for the future, Disney's CCHP did not burn the coal commonly used in energy production in China but rather vastly cleaner natural gas. That choice of fuel, along with the efficiency of the operation, "gets us to the point where we produce far, far less pollutants than any other comparable type of installation [in the country]. Later on, when we know a lot more, we can make it even cleaner."

III. A NEW KINGDOM

To anyone familiar with other Disneylands around the world, Shanghai Disneyland would have been familiar in many ways—and yet entirely different. It was as if Disneyland were a creature whose DNA had remained largely unchanged but whose physical characteristics had greatly evolved. The park would deviate radically from the tried-and-true Magic Kingdom formula—changes that had complete support from Bob Iger and other top executives, as Bob Weis recalled. "Every time we had an initial creative meeting, they always opted on the side of invention. Every time we said, 'Well, we're thinking this is kind of outdated; we should do a completely new version,' they always said, 'Well, of course you would do that. There's no way we would do the old version again. It was great for its time; now we need to take it into the next century.' I think it reflected the fact that people realize that China is no longer emerging—China is here. Shanghai is a happening place for fashion and design and so many things, so we realized we had to put our absolute best foot forward."

The park was, as Iger had promised, authentically Disney, down to the shade of the bricks and the sweep of the arches in the building that straddled the walkway just beyond the turnstiles. Here was a clock tower rising above a Victorian brick edifice, and just like in Anaheim, guests passed beneath it through wide, arched tunnels to reach the street beyond. Yet it was not a train station, for there was no train here, and the boulevard to which it beckoned was not Main Street, U.S.A., but a wider, more fanciful lane called Mickey Avenue. It still led guests toward a dramatic castle in the distance, but rather than being a reproduction of Marceline, Missouri, circa 1900—to which Chinese guests would have no nostalgic connection—this downtown was pure fantasy. With more whimsical architecture and brighter colors, Mickey Avenue was said to be the home of Mickey Mouse and his friends. The shops and restaurants were themed after Disney and Pixar cartoon characters: Chip and Dale's Treehouse Treats, Mickey & Pals Market Café, Remy's Patisserie. There was a "bank" owned by Scrooge McDuck, a Minnie Mouse meet-and-greet opportunity at the Sweethearts Confectionery, and so on. The theming

borrowed elements from Toontowns and even Disney California Adventure. At the far end on the left rose the iconic octagonal clocktower of the Carthay Circle Theatre, this time welcoming guests into the park's largest retail shop, Avenue M Arcade.

Mickey Avenue was shorter than Main Street, U.S.A., in other Disneyland parks, and it didn't have a cross street at its midpoint. Instead, it opened up into a Y shape at its terminus, the two arms wrapping around the most dramatic Shanghai Disneyland area of departure from its predecessors: Gardens of Imagination. Rather than having a simple hub plaza, "we actually turned it into a land," said Doris Woodward, to whom Weis assigned design supervision for both the gardens and the castle. The gardens retained a hub-and-spoke design, offering pathways to the lands beyond, but the area was supersized, becoming a destination in itself rather than just a transient picture spot. It sported expanses of water, walkways, lush plantings, and even attractions.

The setting would appeal to Chinese guests, who "really have respect for nature," Woodward noted, but just as important, it provided an alluring oasis for the older generation in the family groupings particular to early twenty-first-century China. "This is something I think our senior management didn't really think about in the beginning," she said, "but this market is what we call the 4-2-1—four grandparents, two parents, and one child"—a result of China's long-standing one-child policy. (The policy was relaxed in 2015, just before Shanghai Disney Resort opened.) "The notion was that whole guest group travels together, a family unit of seven, and we need to appeal to all the people on the team." For the younger children and older adults, the gardens offered both the traditional Dumbo attraction and a *Fantasia*-themed carousel—the first time those attractions had been located outside of Fantasyland. "That provided a very simple enjoyment for the older generation without having to feel that they would go on [more challenging attractions]." Teenagers and younger adults could head off to seek thrills while the grandparents and younger children were occupied in the Gardens.

"Bob Weis had this idea that it would be kind of like Tivoli [Gardens, in Copenhagen]," recalled John Sorenson, the Imagineer who

supervised landscaping across the park and served as creative director for the Gardens of Imagination. "It's our hub, but it became much, much bigger. It has some of the highly ornamental quality that we often have in Fantasyland and this little lake that's reminiscent of Tivoli, and it's just kind of fanciful and whimsical. And it's a place where we can showcase a lot of planting, but it also is the center of the outdoor entertainment." The size of the Gardens of Imagination thus had a highly practical explanation as well as an aesthetic one: it provided much more viewing space for the nighttime spectacular, which would combine music, projection mapping on the castle, and fireworks. With that in mind, Sorenson said, "there was a very specific need for where there could be trees, where there couldn't be trees, and where a lot of people had to gather. So it is the most open space [in the park]." The Gardens of Imagination were, in Sorenson's words, "a park within a park—this wonderful tapestry of space and the lake and different kinds of plantings and these little neighborhoods, and it has a grand scale to match the grand scale of the castle."

Towering over the Gardens, Enchanted Storybook Castle would be the largest fairy-tale castle yet built in any of the Magic Kingdom–style parks. But while the scale of the castle would draw the eye—and media attention—from the get-go, it was the scale of what surrounded it that made this park unique. Covering 963 acres at Grand Opening on June 16, 2016, Shanghai Disney Resort was larger than Disneyland Paris, the previous record holder among the Magic Kingdom–style parks. The size had an aesthetic role: this would be the Disney park with the most open space and landscaping apart from Disney's Animal Kingdom. While the animals had reign over much of the terrain at Disney's Animal Kingdom, in Shanghai the openness was a gift to the guests. In a populous country, this park would be a respite, a place where up to eighty thousand guests could roam on a busy day.

Beyond Mickey Avenue and the Gardens of Imagination, the themed areas would have breathing room as in no other Magic Kingdom. Fantasyland, for example, was arranged around a lake and featured a spacious Alice in Wonderland maze—themed to the Tim Burton movie,

a big hit in China, rather than the animated feature. Throughout the park would be wide walkways, green buffers, and room for expansion. "This is the park that strays the most from the original design concept of Disneyland," Iger said. "It doesn't have a Main Street. It doesn't have a Frontierland. It has some of the same elements—like Tomorrowland, certainly, and Fantasyland and the castle—but it has many different elements that we haven't built anywhere. And that's very purposeful."

Despite the differences—and in part because of them—Bruce Vaughn liked to think of Shanghai Disney as a project similar to the original Disneyland, believing "the more things change the more they stay the same." Just as in Anaheim in 1955, the park was to be constructed on a largely rural plot not far from a giant metropolis, and it would be the nation's first Disney park, built by a crew who for the most part had never worked on a project anything like this one. For Imagineering, Vaughn continued, "We've held to the tenets that Walt put to the original Imagineers to innovate relentlessly, not just in the obvious ways but in technology. There's so much that's new in this park as far as the ride systems, special effects, and stories that we're telling, but also in just how the park is laid out and how the resort is being thought of."

Research guided all the Imagineers' decisions about which of the various Disney attractions would be included. Some thirty focus groups underlined what American guests brought with them to Disney that the Chinese did not, particularly nostalgia for America's own past. The Old West and steam trains did not move their emotional needle. On the other hand, the younger Chinese were relatively well versed in Disney movies such as the Pirates of the Caribbean franchise and *The Little Mermaid*.

The final vision for Shanghai Disneyland would include both proven successes and previously unseen creations. The park would blend some of Imagineering's greatest hits with epic new works—attractions reminiscent of past smashes but entirely fresh. In Tomorrowland, Space Mountain was supplanted by a bright, indoor-outdoor *TRON*-inspired roller coaster. In a new land called Treasure Cove, a reconceived Pirates of the Caribbean attraction was driven by an original narrative and served by all of Imagineering's latest immersive technology. Some of the attractions

from the opening day of Disneyland in 1955 would appear in forms similar to their original incarnations—Peter Pan's Flight and Dumbo, in particular—while other classics were omitted in favor of more recent innovations. Adventure Isle—this park's take on Adventureland—had a rapids ride but no Jungle Cruise. Fantasyland had The Many Adventures of Winnie the Pooh, but no "it's a small world." In Tomorrowland, guests could enjoy a laser-shooting ride called Buzz Lightyear Planet Rescue but not Astro-Jets. Nor did the Imagineers limit themselves to updating Magic Kingdom–based attractions. In Adventure Isle, Soaring Over the Horizon would extend the Soarin' franchise that began in Disney California Adventure, while the raft ride was akin to Kali River Rapids at Disney's Animal Kingdom.

New attractions were an imperative, Weis noted, since filling a state-of-the-art theme park with copies of attractions from previous parks wasn't really feasible. "Anything that's over ten years old, our technologies evolved [beyond], and we now know what guests liked and didn't like. There's so many things that you see and you want to refresh that it's hard to just take anything off the shelf. I know people get frustrated with Imagineering and say we like to redesign everything, but it's really true."

While their on-the-ground research had guided the Imagineers' decisions about which attractions to update and which to eliminate, the focus groups left one question unresolved: how Chinese should the park be? "We're trying to strike that balance," Weis said, "between Chinese influence and traditional Disney."

Nowhere was that balance more dramatically expressed than in the Gardens of Imagination. With no precedent guiding them, Woodward and her team had a true blank slate, and they set out to encapsulate the park's unification of Disney and Chinese traditions in a singular work of art: the mosaics of the Garden of the Twelve Friends.

The Friends were Woodward's ingenious fusion of the twelve signs of the Chinese zodiac with corresponding characters from Pixar and Disney animated films—all depicted in large, oval murals handmade with

thousands and thousands of tiny glass tiles. The long walkway where the murals were displayed was at once a photo spot, an art gallery, and a primer about Disney stories. Guests would know the twelve signs of the zodiac as well as Americans knew the twelve months of the Gregorian calendar. And as they walked along the Garden of the Twelve Friends, Shanghai guests would see those familiar zodiac icons linked to Disney and Pixar characters: Remy from *Ratatouille* (The Rat), Thumper from *Bambi* (The Rabbit), Mushu from *Mulan* (The Dragon), Kaa from *The Jungle Book* (The Snake), and so on. Each mural was just under seven feet wide and four feet tall, in a sculpted oval concrete frame.

Woodward's goal wasn't a series of movie posters but an awe-inspiring display of craftsmanship. She had settled on mosaics to render the images because tile was something nearly indestructible, in all kinds of weather. The technique also had the appeal of being "a totally different medium that we haven't really done before," Woodward said. Disney and Pixar artists, adhering to the source imagery for each, designed the murals, but local mosaic artists would be needed to bring them to life. The process would involve cutting colored glass tiles into tiny pieces that would become the pixels building the overall image. Every tiny section—an eye, for example, or even eyelashes—required the precision trimming and placement of dozens of fragments.

Woodward considered a number of Chinese companies to create the artworks before selecting a Shanghai company. She visited their factory, met with their art directors and tile cutters, and liked the artistry of their work. She explained the need for absolute fealty to the character designs and even brought the craftspeople videotapes of the movies and shorts that featured the animals. "To create a final piece that is Disney," she reasoned, "they had to understand and believe in us and believe in our characters and understand the subtlety of them. So that took time." Indeed, it took some nine months just to render the test mural: Remy, in the *Ratatouille* restaurant kitchen, with his many gradients of fur color, copper pots full of simmering sauces, and the Eiffel Tower seen at sunset through a window in the background. "It was not easy," she recalled,

but after nine months, "I have to say it almost brought tears to my eyes, because that Remy was absolutely fantastic. It was gorgeous."

Their Remy was also blue, rather than gray—a change necessitated by the fact that the tile factory didn't manufacture any glass tiles in shades of gray. "So it was their artist's eye that actually translated [the gray shades] to what they thought would be the right color combination for Remy." Woodward sent an image of the mosaic off to Pixar, with a detailed explanation, hoping for their approval. "And I got the email back, and they loved it."

The company went on to produce all twelve images, ahead of schedule, about one every two months, capturing "the essence of each of the characters, but in another form," Woodward said. One by one, the Chinese artists had translated animated movie figures into familiar emblems of Chinese culture, ink and paint and computer pixels into a distinctly Chinese art form. It was a long process, but Woodward had been certain it would all come together as soon as she got that first thumbs-up from Pixar for the Remy mural. "It was a wonderful moment because I was able to go back to those artists and explain to them that they actually created a new twist on something that was so dear to us and that it was received and accepted. At that point we were one family."

IV. TOWERS OF IMAGINATION

How do you build a fairy-tale castle when its visitors may not know any of the fairy tales? "Historically, we've always called our castles after a princess name," said Doris Woodward, the original lead designer for the castle. "This was the first time we thought, 'You know, maybe we should think about this. Maybe we call it the Storybook Castle.' And by doing that, we're actually able to present all the princesses, which was a whole new concept for us, and it really excited our entire design team." The result would be "the biggest, the widest, the tallest of all our six Magic Kingdom castles." It would be, at almost two hundred feet tall, more than two and half times the height of the original Sleeping Beauty Castle and a smidge taller than the Cinderella Castles in Walt Disney World

and Tokyo Disneyland. It was, as Woodward described it, "just a giant spaceship of a castle."

What came to be known as the Enchanted Storybook Castle began as a kind of collegial design competition within Imagineering. "We had a number of designers, some of whom had worked on the Paris castle and other castles, and we all did a little mini charette," recalled Imagineer and architect Coulter Winn. "We took a day, and we all came up with schemes. And the person that came up with the most compelling scheme was Doug Rogers." Rogers was an Imagineer, but he had previously been a production designer for Disney's CG-animated Rapunzel feature, *Tangled*, on which he had worked on the film's castle. His idea was to design a castle more like a French château—a romantic Renaissance edifice on a rock base—rather than like a medieval fortress. The iconic Mont-Saint-Michel, on the coast of France, was a major influence.

"One of our challenges was to really make it approachable." said Mario Huerta, the Imagineer who served as architect for the building, working closely with Winn on the final design. The Shanghai castle would be warmer and more welcoming, inviting guests who may not previously have known the stories of the many Disney princesses it represented to come inside and get acquainted. A walk-through attraction on the third floor, dubbed the "Once Upon a Time" Adventure, would share many of the princesses' tales with immersive and interactive elements. Guests would also be able to meet the princesses in a full-size restaurant on the second floor, with five dining rooms, each themed to a different princess. Easily accessible meet-and-greet locations would be designed into the Fantasyland side of the castle.

The accessibility of the castle also pleased Imagineering's Chinese partners, who "really wanted the castle to be more endearing, as a place where people actually live," Winn said. "In this case, almost all of our princesses live here. We've joked that it's become a sorority house because we have twelve princesses right now and probably more will move in."

To research châteaus, Winn flew to France, sketching and photographing possible details: a double helix stairway at Chambord, the cloister at Mont-Saint-Michel. "The team then got together and really

started to look at synthesizing all of the various elements from our castles and how we can incorporate them into the biggest castle that we'd ever done." The large restaurant on the castle's second floor would keep the structure wide for about a third of its height, delaying the typical tapering toward the pinnacle. In addition to sketches, Winn and the castle team created their initial designs as 3D models in a computer. Every element of ornamentation was individually modeled, so they could fly turrets around or swap out finial designs to test different profiles. The 3D computer model also facilitated individual tagging of each of more than two thousand separate elements, which would allow tracking through the various factories in China that would produce them. "Every single piece is designed and nothing is bought from a catalog," Huerta noted. Finials, railings, crests, doors, and on and on—"everything is unique and based on an original design that we worked on in Glendale."

There were also all the features guests would not see: subterranean dressing rooms for the stage performers and a basement maintenance facility for the boats from the Voyage to the Crystal Grotto ride, which guests boarded in Fantasyland for a round trip that included a show of colorful fountains in a cavern beneath the castle. There were elevators, shrouded doors, hidden stairs, and secret passageways most guests would never see, as well as plans for a fourth-floor VIP suite and a private terrace that could be used by Disney executives for special occasions. In the public area inside the castle, the Chambord double helix stairway would be re-envisioned for the great central rotunda, as the entry and exit stairs for the "Once Upon a Time" Adventure. On sunny days, the vast chamber would be dappled by the multicolored light beaming through the castle's many custom-made stained glass windows. For the exterior, the designers started to decide on textures and colors, and how the structure would appear to emerge from the sculpted rocks at its base.

The outside, too, would have hidden features: a mobile telephone network tower, turrets from which speakers could emerge, 502 strobe lights that could be programmed so that when the projections hit the castle during the nighttime spectacular, it would become a kind of magical star field. During the day, the front of the castle would never be in

shadow. "All of our castles face south-southeast," Woodward noted, with the exception of the castle at Tokyo Disneyland, which faces northwest. "The reason for that is because we never want any of our guests to be in the shadows with their photo taking. So they're always in sun and they'll always look beautiful in all of the shots."

It would be a huge castle, with a huge team of Imagineers working on it. There was a team in Glendale, creating the final design documents. Those would be handed over to the field team in Shanghai, which would then share them with the general contractor and make sure every little detail and instruction was correctly implemented. Some adjustments had to be made in the field, of course, particularly to the colors selected in Glendale. "Every site is different," Winn said. "The sky color's different in Shanghai than it is in Florida—it's a very gray sky—so you really don't know exactly what color [the castle] is going to be until you're in the field. I was always pushing for a bit more saturation if they need to really make it read, because you don't want the towers to just disappear against the pale sky."

Helping the castle to shine in the sun would be the gold finials atop each turret. Each was covered in twenty-four-karat gold leaf, a finish "that has held up for centuries all over Europe. So we're pretty confident that it's going to hold up well [in Shanghai]," Ali Rubinstein said, despite the city's frequent rain and often chancy air quality.

Rubinstein had taken over as executive producer and creative director of the castle when Woodward's other responsibilities grew. "When she handed off the castle—handed off her baby to me, I first thought, 'Wow. Uh-oh, what am I going to do? This is huge.'" But Rubinstein also recognized "a great opportunity" when it came knocking.

Part of that opportunity was to work as part of a triumvirate of women leading the development of Fantasyland: herself, fellow creative lead Lori Coltrin, and producer Jodi McLaughlin. "I think having three women lead the team provides a very different kind of dynamic," Rubinstein noted. They were just three of a historic number of women in leadership positions on the Shanghai team, from Woodward on down.

Rubinstein's road to Shanghai had been a long one. She had started

her career as a lighting designer in theater, then shifted into scenic design. That led her to the film industry, where she became a set decorator. She also worked on design at non-Disney theme parks, before joining Disney as a production designer. At Imagineering she was on the Tokyo DisneySea team and the expansion of Hong Kong Disneyland. "I've since moved into creative directing and show producing, and I get to touch everything—all the disciplines. I get to touch rockwork, and I get to touch paint, and I get to touch lighting, and I get to touch show set, and I get to touch animation. I get to do all this cool stuff every day."

On an average day during construction, however, Rubinstein's job was more chaotic than cool. There were conference calls about everything from design to budget to staffing; hundreds of emails to answer; the review of various drawings and mock-ups ("that's the fun part"); and, of course, going out in the field to see what was taking shape that day. On site, there were samples to review—paints, carvings, etc.—and the resulting discussions with the architects, the paint leads, the carving leads, and others. And all that was before moving on to what Rubinstein called the "show building," where the sets and Audio-Animatronics figures for the Crystal Grotto boat ride were coming together. After that, there might be a meeting about topiaries or scheduling details—or whatever the crisis of the moment might be. By the time she got back to base, there would be another hundred emails to answer. Some days were more nerve-racking than others, such as when a turret was lifted into place. Each tower was painted on the ground, then raised by a crane and fitted into the structure. Because each is so high, "it would be really hard to get back to them. So we have to get it right the first time."

For all that, Rubinstein kept her focus on the big picture. "Story plays a part in every single decision I make," she said, whether she was considering the placement of pipes or looking at a carved bunny. The Enchanted Storybook Castle was a culmination both for her career and for Imagineering's long history of castles. "This castle has a very eclectic look," she observed. "There are multiple finishes, multiple styles of architecture. We've pulled from different time periods. We've pulled

from different specific castles in Europe, and we've pulled from specific castles in our lands." Saturated with storytelling—various design details evoked each of its princesses' stories—it was also freighted with high expectations and "a lot of hype," she noted. "It's going to be seen throughout China. It's the most impactful piece of architecture I've ever worked on, and I'm not even an architect. It's completely intimidating and terrifying and exciting."

Fulfilling the "authentically Disney, distinctly Chinese" mandate were many prominent design elements, including the ornament atop the tallest tower. "The finial is topped with a peony, the flower of China," said art director Leia Mi, who designed the finial. "This is our nod to the Chinese culture. I'm very emotional [seeing that], granting myself a bit of pride." The peony had a burst of stars beneath it, representing Disney. Mi also designed the castle's second-highest finial, in the shape of a crown. It was decorated with symbols for all twelve Disney princesses, situated above a "Chinese lucky cloud and magnolia flowers, the city flower of Shanghai. So it's like a combination of a lot of lucky Chinese symbols and Disney symbols," Mi said.

Mi was born and grew up in China. Her father took her to see the original *Lion King* movie when she was nine—the first animation she had seen in a movie theater. "It blew my mind away," she recalled fondly, "and since then, I decided when I grow up, I need to be an artist working for Disney to create something as beautiful as *The Lion King*." She moved to the United States to study animation at the Savannah College of Art and Design in Georgia, and while still in college earned a spot as a finalist in the Imaginations design contest sponsored by Imagineering. That led to an internship at Imagineering, working on both Cars Land and the Blue Sky development team for Shanghai Disneyland. "Because I was one of the few Chinese employees on the team, my biggest challenge was, they always asked me, 'Hey, do you think Chinese people like this? Do you think Chinese people like that?' So basically I was speaking for 1.3 billion people!" she said with a laugh. By 2014, she was back in China, one of the art directors for the castle, visiting a local factory to check the

manufacture of her designs and supervising installation at the construction site.

One of the sites she visited regularly for six months was creating a traditional relief-style jade carving for the Fantasyland side of the castle, where the princess meet-and-greet area would be. Under the supervision of Rubinstein, Mi created the design for the large mural, which depicted the Enchanted Storybook Castle sitting atop a mountain with a Western-style village below it and a Chinese-style pine tree lower still, in the foreground. It was an image that would be at once familiar to Disney fans and those who grew up with Western fairy tales, rendered in a style that would be at once familiar to Chinese guests who grew up with that country's traditional arts. It was an invitation for each to decipher the culture of the other.

The Imagineers settled on a Chinese factory with twenty years' experience to execute the carving. Mi made several visits a week to check their progress during the six months or so it took from initial computer modeling to completion. It was a long, slow process, especially to execute "all the fine details of the castle on the jade. It requires a lot of very detailed hand carving." But the time investment was worth it, Mi said: "The factory [that] worked on this jade piece has been in this industry for twenty years, and they said they have never seen anything as beautiful as this before." Mi eagerly anticipated the experience of Shanghai Disneyland guests as they approached her design. "When people see this art, I want them to imagine, 'Oh, who lives there in the village? And who lives there in the castle?' I want them to create and imagine stories of their own."

V. EVERYTHING OLD IS NEW AGAIN

Bob Weis was excited to bring Pirates of the Caribbean to Shanghai Disneyland. "I grew up going to Disneyland in Anaheim, and I remember the first time I went on Pirates of the Caribbean, I couldn't believe this world and this immersive experience," he recalled. "One of the things I said early on in the Blue Sky process is, 'I want to bring some of the

classic attractions to China.'" There was a problem, though. When Weis and his team brought many of their Chinese partners to Anaheim early in the development process, the guests did not enjoy the classic Pirates ride. "They said, 'Wow, this is slow. I felt like I was looking through little windows and the action was out there somewhere, but I wasn't in it.' They want to be *in* the ship battle, not *watching* the ship battle." The Chinese also found the Audio-Animatronics figures rather old-fashioned. "Everything we see is colored by nostalgia," Weis said, "by the fact that we grew up with this thing."

The Pirates of the Caribbean that many Chinese audiences knew was the film series with Johnny Depp—inspired by the original attraction, to be sure, but not much reflected in it. To bring Pirates to Shanghai, and to put the guests inside the ship battle, the attraction would have to be completely reinvented. It would need not only an updated narrative, but state-of-the-art storytelling and technology. "China is a huge, amazing place," Weis mused. "You can't just phone it in. This needs to be the biggest, the best that Disney can offer."

The reinvention grew to encompass more than just the Pirates attraction. In Anaheim, the original attraction was the centerpiece for New Orleans Square, a context that would be meaningless to most Chinese. The ride had also made sense in Adventureland—its home in the Magic Kingdom, Tokyo Disneyland, and Disneyland Paris—but even the most recent of those Pirates iterations was already nearly twenty years in the past. What made sense for this narrative in the twenty-first century? The question dovetailed with the Imagineers' decision to scratch Frontierland from the Shanghai plan, after research showed it did not resonate with potential guests. (China's history was long and rich, but it did not include gunslingers, saloon pianists warbling Stephen Foster songs, or rivers traversed by paddle wheelers.) With Frontierland omitted, the Imagineers decided to create a new land to surround their re-envisioned Pirates, inspired not by America's past but by the attraction's and movie franchise's larger storytelling world. "We decided in this park to divide Adventureland into two sections," Bruce Vaughn said. "Pirates has

become such a strong brand for us that we wanted to dedicate more than just one attraction to it."

In Shanghai, "it made more sense to focus on the Caribbean, so we invented a place called Treasure Cove," explained Luc Mayrand, the Imagineer who served as executive creative director for the land, the first in any Disney park inspired entirely by the Pirates mythos. Treasure Cove "gave us a chance to put in all of the cultures that came together and met in the middle of the Caribbean. That's why the village is so rich. There's Dutch, Spaniards, and Africans, Middle Easterners, and indigenous people—and all these things all together in one place." As Treasure Cove evolved, Mayrand knew he wanted to merge "the real, the imaginary, and the new"—that is, actual Caribbean history, characters from Disney's Pirates movies, and new story lines exclusive to the park. In addition to the new Pirates attraction—plus shops and a restaurant—there would be a comedy-infused stunt show inspired by the movie franchise, called Eye of the Storm: Captain Jack's Stunt Spectacular, and a multilevel walk-through reproduction of a wrecked ship, called Siren's Revenge, as well as the water-spouting Shipwreck Shore play area. A loading area for the Explorer Canoes connected Treasure Cove to its sister land, Adventure Isle.

The Pirates attraction itself would take its inspiration from both the film franchise and the original Pirates ride, but it would tell "a whole new story," Mayrand said. "It's not a re-telling of the movies. We wanted to tell the equivalent of a ten-minute-long movie that is really three-dimensionally happening around you. It acknowledges you sometimes. It knows you're there. You're part of the story and there's no interruption."

Weis set goals for Mayrand's team: "We need to control the boats. We need to be able to have Johnny Depp talk to you—not to just anybody—and so the boats had to be controlled in the water. They had to be able to go twice the speed, go backward, turn like a camera on a dolly so you [understand] things as you go through. So it really required a complete reinvention of the way that we think about Pirates, creatively, but also how we do it technically."

There was a lot about Pirates of the Caribbean: Battle for the Sunken Treasure that fans of the original attraction would recognize.

The vehicles were once again multi-bench boats, to which a pirate skull overhead issued words of warning as the ride began. Boats passed by the land's table-service restaurant—Barbossa's Bounty—situated in a courtyard shrouded in perpetual twilight, before entering caverns populated by skeletons in decaying pirate garb. Three of them were locked in a subterranean jail, forever doomed to beg a skeletal dog for the keys. A ghostly captain stood at the wheel of a ship, facing a fierce wind amidst flashes of lightning. But when that skeleton unexpectedly morphed into Depp's Captain Jack Sparrow, the attraction veered spectacularly from the classic story line. Sparrow addressed the riders directly and sent them down a dark chute on a quest to find Davy Jones's sunken treasure in an undersea world of sharks, giant squid, ghostly pirates, and ship carcasses. Jones himself, as an Audio-Animatronics figure, soon made an appearance, followed by a fierce battle between his fleet and Sparrow's, back on the ocean's surface. The ride vehicles passed between two ships, towering above on each side of the guests, cannons blazing, as other pirate ships battled and exploded on the ocean in the distance. The guests' boats then turned to enter Sparrow's galleon as it was sinking, where Jones and Sparrow engaged in a climactic sword fight with a fiery finale that propelled the riders, backward, back to safety.

Despite its complexity of execution, the story was lean and easy to follow, even for riders who didn't understand the Mandarin language in which the characters occasionally spoke. It borrowed elements of the original Pirates attraction and characters and situations from the movies, but it followed its own course—a narrative designed to provide as many high points as possible, according to executive producer Nancy Seruto. "We started with epic moments. Could you do a battle between two ships that you're caught in the middle of? Could you do a whirlpool? Could you take people under the water? And then how do we knit together a really clear story from the characters of the film in a very concise way? Your story line has to be just a few beats, even though you're creating something epic. So we created basically a three-act play around this adventure. It was a whole new experience."

Immersing riders in nine minutes of awe-inspiring and finally

ferocious storytelling required Imagineering's most complex combination yet of mechanical and projection effects—props, Audio-Animatronics figures, lighting effects, and real water on the one hand, and giant, photo-realistic animated sequences and projection mapping effects on the other. "We referred to it as a white-knuckle job from day one," Seruto said.

With its trackless vehicles propelled and controlled by underwater magnets, the attraction took lessons learned and technology perfected from Mystic Manor and Ratatouille and applied them to the water world of Pirates—submerged gold, flying cannonballs, swordplay, and all. "When you say, 'I'm going to seamlessly merge the physical world and the media world,' all kinds of things come into play," Seruto said. "The media becomes an extension of the physical world. That perspective and that scale all have to work together. The lighting has to work together. The color. You don't want it to look like a movie screen at the end of the [two battling] ships. You're the center of the action. So if a cannonball is being fired at the ride vehicle, you want it to come right at the ride vehicle. The coordination of all the design trades and all the technology trades to make that work required a lot of precision."

The Imagineer in charge of that precision for the attraction's extensive projected media was producer Amy Jupiter, whose history with Imagineering stretched back to the early 1990s, when she was an intern at The Walt Disney Company. One of her lowly duties then was to document the trademarked products used in Disney films. That required the use of a color photocopier, and the only one at the studio was in the Imagineering building in Glendale. During her brief visits there, she longed to join their work, fascinated by the coalescing of so many different creative disciplines. Her family had been contractors, helping to build New York City, going back several generations, so she had grown up fascinated by the interdisciplinary teamwork and the mechanics required to make the things people take for granted. "When I think of Imagineering," she said, "we are 90 percent a construction company, and it's the rest of that 10 percent that brings spirit into our attractions."

Jupiter began her Hollywood career with a focus on filmmaking, learning her trade at the Disney studio, as two college internships led

her to a full-time job. Her interests came together when Imagineering decided to set up an in-house filmmaking group during the development of what we now know as Disney's Hollywood Studios, which needed a lot of original movie footage for its Studio Backlot Tour. It was just a taste of what was to come. She worked at Imagineering for a while, then left to continue her filmmaking education with other studios' productions, came back, and left again. Along the way, she worked on the media within Imagineering attractions at Walt Disney World, Disneyland Paris, Tokyo DisneySea, and Disney California Adventure.

"Film at a theme park has the ability to transport you to different worlds," Jupiter said, if it's artfully merged with "the physical experience of the attraction." Even as digital media eliminated physical from the workflow, media creation was still referred to as "filmic storytelling," in part because the storytelling principles remained unchanged. Digital cameras and projectors simply made the storytelling "more stable, more reliable, more repeatable," she said.

Jupiter needed all her digital tools when her third stint with Imagineering began just as the new Pirates attraction at Shanghai Disneyland was moving into production. To create the giant, high-resolution, high-frame-rate images of the undersea world and the sea battle, Jupiter worked with the special effects team at Industrial Light & Magic in Northern California, which conjured and animated all the photo-real and seemingly life-size creatures and pirate ships. She also interfaced with the Imagineering design team to ensure that the imagery would blend with the physical sets and Audio-Animatronics figures.

From the specialized projection mapping that animated the faces of two Audio-Animatronics pirate figures in stockades, to the titanic images on domed screens stretching overhead, hundreds of digital projectors would be at work, both creating high-resolution imagery and enhancing the built sets and props. The goal was to keep the guests fully engaged in the experience, never considering the mechanics and programming necessary to create it. "That is the trick of illusion design and using multi-media inside of an attraction," Jupiter said, "to really free the guests from their own minds so that they can be in their imagination."

Pulling off the propulsion system was another challenge. The use of a trackless system wasn't new, but "there had never been a boat ride that was a magnetic propulsion system and nothing to this scale," Seruto explained. "In water rides, traditionally, the water moves the vehicle. But you don't have sophisticated control. You sped it up by pumping more water and you slowed it down by stilling the water. But you really can't program and do a highly timed and dynamic show." The magnetic system would allow the Imagineers to start and stop the vehicles, alter their speed, turn them in any direction, and even run them backward. It was, in short, "a very new thing." The team built mock-ups and tested components, but they couldn't be certain it would run smoothly until the ride building was nearly finished, the track filled with water, and the actual vehicles put in place. "It felt like an 'all-up test,' which is a term they would use in the space program when they would just fire off the rocket. You didn't know until you knew."

Meanwhile, the Imagineers utilized the latest computer graphics technology to preview the attraction, for the first time turning to video game driver–software, known as a game engine. The software allowed them to program the experience with music and media and other effects to approximate the ride-through experience in real time. While still in Glendale, the gaming engine allowed them to go forward, back up, and make changes as they went along. "We were able to put ourselves in that world as the guest, and time everything that happened to us along the way," Seruto recalled. "We were able to preprogram the show, which was huge. It would have taken us months had we started from scratch onsite. So I think in my lifetime it's the first time where the tools we have match the ambition of what we create."

Much of the media was to be projected onto giant domes, creating the effect of surrounding the guests without the need for 3D glasses—at least, that was the theory. The experience would be at such a massive scale that even the best computer modeling programs couldn't fully reproduce the riders' perception of the blend of media and physical effects. "There was no way to really test it in full scale without building something that was ginormous," Seruto said. "So you had to find ways of testing the

components of it and then adding it up in your own head to make sure it was going to work. Unlike smaller-scale projects, [where] you can get that 100 percent confidence in a mock-up, in Pirates you had to take a few leaps of faith that all of this was going to add up."

The projected media were created by ILM in California, but the sets were built in China—including those imposing ships at war that the attraction vehicles pass between partway through the ride. The Imagineers figured the three-story-tall ships would be carved by robotic arms, programmed to follow the contours of precise 3D computer models. "And then we got to Shanghai and the vendors started building it their own way," Seruto recalled. "They used our model to build a giant steel frame and then started rolling in wheelbarrows of clay. Wheelbarrow after wheelbarrow of just red river clay. And by hand, just kind of throwing clay at the [steel frame] and then patting it down until they had covered something the size of a building with red clay. And then they proceeded to carve it. I never ever imagined that that would be the way that that ship was going to get built in my wildest dreams. But two weeks later a ship is emerging from this mountain of clay that's stunning—beautiful. And because it was done by hand, it just felt like opera. It had so much passion and artistry in it that I don't think it ever would have felt that way had we done it robotically. It would have been accurate but it wouldn't have had that artistry that really made it sing."

Many of the Chinese artists and construction workers used simple tools, Seruto noted. "You really never saw power tools. You didn't see people with leather tool belts with screw guns in them. It was all hand tools—and a lot of tools just made out of rebar. So to think that we built this park out of hammers and tools just manufactured on the spot out of rebar and grinders and just a few simple things—it still amazes me. I still don't know how we did it. It was literally handcrafted."

The construction of Pirates was further challenged by the weather. Shanghai is not Orlando or even Hong Kong: winter is bone-chilling, and the Pirates ride box was too big to heat during the build. "That building is two soccer fields. It's massive," Seruto recalled. "And then in the winter, there's not heat in it yet and it's filled with water and it's a

damp, cold, dark place and we were working three shifts for many, many months towards the end. And the night shift was a tough shift in that environment, especially the winter before we opened. It was a really cold winter. And we were in there with Industrial Light & Magic working on media. I thought, 'These are the biggest names in visual effects in the world and we're asking them to come and work in this freezing building.' And they were so great. They were such good sports. We would bundle up. As many winter clothes as you could put on your body, we had on our bodies. For weeks on end, really. But you know, you look at that screen and you forget how cold it was."

Another contributor from California was Bob Iger, who would show up every couple of months, according to Seruto's recollection of things. "He came quite often. And he would just show up so excited and you just couldn't wait to share with him what you had done. He was like a kid. I loved taking him around." That included escorting the CEO on a flimsy inflatable raft, long before the ride vehicles were installed. "So we putted him around in a little rubber boat. And then everybody wanted to go on the rubber boat. They were doing rubber boat rides all night long. It was great. No matter what condition things were in, he always could see that it was going to be great and you knew he was behind it." On each visit, Iger would make two or three observations about things he thought needed tweaking. "It was never dictatorial. It was like, 'It could be this or it could be that, but it needs overall to deliver something it's not delivering.' In two seconds his note will be so right on—and that's a weak spot I've been staring at for two years. And he would just zero in on it. I don't know how he does it."

By the time opening day was within view, the Pirates project had been in the works for more than five years. So the Imagineers tried to mark the progress being made by celebrating momentous achievements along the way and compiling on one backstage wall a gallery of all the workers who had contributed, which grew to 1,500 photos. Not long before the opening, the group also performed what had become a tradition with each new Pirates ride: the water ceremony, which required water from each of the existing Pirates attractions across the world. Mayrand collected

some of the samples himself, visiting Disneyland with Kim Irvine to fill a vial from the original Pirates of the Caribbean. Colleagues from Walt Disney World, Tokyo, and Paris filled their vials and shipped them to Mayrand—a nod to the water ceremony performed at the opening of "it's a small world" in Disneyland. After the water samples reached Shanghai, Mayrand recalled, "We had this really, really fun little ceremony where we took these bottles, brought them into the attraction, got on a boat, and then poured just a tiny bit of water from each one of the Pirates of the Caribbean attractions in the world into the flume there. [Fellow Imagineer] Ric Turner said that when we did that, it gave the attraction a soul. It made it connected to all the other rides in the world, and somehow from that day, it wasn't a ride anymore. It wasn't an attraction. It was just a place, right? That was a real magical moment there."

VI. A NEW ADVENTURE

The sister land to Treasure Cove, connected by both paths and a waterway, came to be called Adventure Isle. As Bruce Vaughn described it, it was to be "an exotic place that is really not set in any geographic location or time"—maybe China, maybe not. While unique to Shanghai Disneyland, the realm had "all those classic elements that make up the best Adventurelands in our Disney parks around the world: an iconic mountain with real waterfalls and a sense of a jungle environment." Indeed, Adventure Isle was the most naturalistic environment in the park, featuring twenty-five thousand square meters of hand-crafted rockwork and lush, leafy landscaping. Plus, it was the only land in Shanghai without any pre-existing intellectual property. Its story was created from scratch—from the ground up, in a literal sense, since some of the land's topography, including the mountain, was locked in before its narrative was locked down.

The Imagineers charged with creating Adventure Isle, led by Stan Dodd, the land's executive producer and creative director, knew that while it might be physically adjacent to Treasure Cove, the two lands needed to be distinct in both terrain and storytelling. Dodd sketched

out some early ideas in 2011, and as his team grew, they consulted with a variety of experts, including scholars at the Smithsonian and National Geographic. One contingent of designers flew to South America to research pre-Incan Andean cultures, in search of "a kind of exotic culture that a lot of people weren't that familiar with."

Meanwhile, some of the architectural underpinnings of Adventure Isle had already been settled by the spring of 2012—a necessary step to keep construction on schedule—so Dodd's team developed their narrative with "some physical constraints," he recalled. By May, the story had largely come together, and the geographic elements of Adventure Isle took on a richer narrative overlay. Adventure Isle would be a kind of lost world, home of the Arbori people, who were, as Vaughn put it, "reminiscent of tribes from South America or China or other places but really creations from our own imagination." The Arbori had lived in peace, undisturbed by the rest of the world for a thousand years—until 1935, when their land was discovered accidentally by an expedition from the League of Adventurers. (The League was similar to the Society of Explorers and Adventurers mythology, which linked attractions in Tokyo DisneySea and Hong Kong Disneyland, but this was a separate secret organization.)

The mountain looming over the land was dubbed Apu Taku, or the Roaring Mountain, named for both the sound of the great waterfall cascading down its face and the growl of the mythological Guardian of the Water, which the Arbori believed accounted for the waterfall's roar. This dinosaur-size crocodile-like beast was called Q'aráq (pronounced "croc"), and the falls and the river below were said to be his realm. "We find art representations [of Q'aráq] throughout the land. Whether it's petroglyphs, geometric art, or dimensional sculptures, this beast is represented everywhere," Dodd said. All in all, he concluded, Adventure Isle would be "one of the best storytelling experiences we've ever created anywhere."

At the base of the mountain was Camp Discovery, dedicated to exploring the territory of another mythological Arbori creature, Q'ai, a fanged cat. In fact, the camp was a series of hiking trails and rope courses

to challenge and amuse guests, winding past waterfalls, through caverns, and past an interactive excavation site. Camp Discovery was conceived as a sort of playground for older children and adults, said Andrew Bolstein, in a country where the ratio of adults to small children in a family would often be six-to-one: four grandparents, two parents, and one kid. "We have this really big young-adult focus we want to try to deliver," he said. "We've never done anything like it in any Disney park."

On the opposite side of the mountain from Camp Discovery sat the Arbori tribe's "celestial observatory"—which was, in fact, a new twist on the Soarin' attraction called Soaring Over the Horizon in Shanghai Disneyland. It used the same ride mechanism introduced in Disney California Adventure but with a new film that replaced California sites with a variety of familiar landmarks across the globe. The film utilized both newly shot helicopter footage and CG effects, and new scents were matched to the destinations: rose blossoms during a Taj Mahal flyover, a sea breeze in the South Pacific, and so on. (An essentially identical film, called Soarin' Around the World, also debuted in EPCOT and Disney California Adventure once Shanghai Disneyland opened.)

The attraction most anchored in the Adventure Isle mythology was called simply Roarin' Rapids, which updated the ride technology from Kali River Rapids at Disney's Animal Kingdom in the service of a new story. The rafts were said to be transportation to an archaeological camp downriver, but they veered off course due to a fallen tree and wound up inside the Roaring Mountain. There, a massive Q'aráq, as an Audio-Animatronics figure, roared and snapped at the guests before they returned to the open air, floated past a whirlpool, and careened down a steep drop on their way to the disembarking area. "We've done raft rides in a couple parks before," Bolstein said, "but we've never done it before with an indoor show scene, which adds a level of theming and complexity."

The giant Q'aráq was "about the size of a bus," Dodd said, and its biting, lunging head was the size of a small car. It even had its own breath scent. It took a village to create this dragon: not only the designers and the vendor doing the fabrication, but also ride engineers and safety

and maintenance experts from the Operations team. (Like all complex Audio-Animatronics figures, this would need a regular maintenance routine to keep it running smoothly.) "We put a lot of energy into the head, and we worked with a vendor to really develop a lightweight head that would give us all the movement that we wanted. We wanted it to be as close as possible so that when the guests are coming into this scene on the raft it's as if this creature is literally going to be in the raft with them." Dodd compared the appearance of Q'aráq to the monster reveal in a horror movie. "I think we did a good job of setting up the anticipation for the actual encounter with this creature so that you don't really ever see exactly what's happening until it ultimately is right in your face."

Throughout the long creation of Adventure Isle, Dodd kept in mind the original Imagineers. "I remember watching the [*The Wonderful*] *World of Disney* [as a boy,] about transporting Pirates down to Disneyland in the midsixties to get that thing open [on time]," he said. Those Imagineers, he believed, had "a drive, a vision that says, We're going to do this. We're going to be innovative. We're going to push ourselves.' At the time it was Walt who was in the driver's seat, [but] I think that's still what we do today. You get a lot of smart people together and you keep at it till you figure it out. When I step back and look at Adventure Isle today—in terms of just the carving work on the mountain, the theme painting, even those traditional kind of disciplines for us—we've taken to the next level. I think it's one of the best environments we've ever created anywhere in the world."

VII. LIGHTING THE WAY

When Scot Drake was in junior high in Southern California, he tried to convince his parents to buy him a bunch of hundred-year-old bicycle frames someone had listed for sale in the local giveaway newspaper. He thought he could refurbish them as custom bikes and then resell them at a profit. "My dad knew better," Drake recalled, "even though he loved working in the shop with me. That was definitely an overwhelming project to try to take on." He didn't get to redesign those bikes from

the distant past, but he did get to design bikes from the future in his role as the creative director in charge of Tomorrowland in Shanghai Disneyland.

An inventor, tinkerer, and artist for as far back as he could remember, Drake was particularly fascinated by vehicles, shifting from bicycles to automobiles as a student in transportation design at the Pasadena Art Center College of Design. He originally planned to be a car designer but fell in love with entertainment design in college—the program included everything from film and television to museums and theme parks—and landed an internship with Walt Disney Imagineering. After graduation, Drake worked for Universal's theme park division and in museum design until Imagineering called to invite him back full-time in the late 1990s. As an intern, he had worked on the first DisneyQuest project, and Imagineering was now staffing up to complete the Chicago location.

One memorable assignment during his early years at Imagineering was the opportunity to use his transportation design experience to propose ideas to Bob Gurr for the Mark VII Monorail upgrade at Disneyland. Once the new monorail was installed, Drake was able to invite his family for an inaugural ride. "The highlight of that project was getting to drive the monorail—drive my own design down around and through the resort."

Drake spent many years assigned to the Blue Sky team at Imagineering, during a period when Blue Sky was something like a department, rather than a phase each project's team went through. So he was both primed and a bit overwhelmed when Bob Weis asked him to head up the Tomorrowland team for Shanghai Disneyland. Rather than adapting previous incarnations, this Tomorrowland would start from a clean slate. It was, he said, "a designer's dream—to get to develop what a Tomorrowland could be for an entirely new market. The design of this land is really about hope and optimism, and that's the core value from the very beginning of the very first Disneyland."

The assignment took him back to his childhood visits to the original Anaheim park. "You didn't sleep the night before, and you slept the whole ride home because you were exhausted by how much fun you were

having. Tomorrowland was always the place we experienced at the very end of the day. All the lighting, the optimism. I felt like I was in space when I would go to Space Mountain, when I'd go to [Mission to Mars]. These stories and journeys definitely stayed with me into design school. I've always been kind of passionate about futurism and design and innovation, and I think those are core values that I picked up from going to the original Tomorrowland in Anaheim growing up."

Drake and his Tomorrowland team started, he recounted, by "traveling to Shanghai to talk about the optimism that the Chinese feel for the future. It is very close to the optimism that Walt tapped into in the fifties when he built the original Tomorrowland." Drake spoke with futurists of "every imaginable type, whether it was someone in robotics or architecture or storytelling" to make sure this new land reflected the latest, best-informed visions of tomorrow.

The most recent Tomorrowland built by Imagineering had been the one in Hong Kong Disneyland, which featured Space Mountain, an Orbitron, Buzz Lightyear Astro Blasters, and Autopia, along with shops and restaurants. Both Space Mountain and the Orbitron had also anchored Discoveryland in Disneyland Paris, a park conceived two decades before Drake started work on Shanghai. It was time for a fresh start. This new version would have little overlap with previous incarnations. The relatively new Stitch Encounter, introduced at Hong Kong Disneyland in 2006, would be reproduced in Shanghai, and there would be an interactive Toy Story attraction, called Buzz Lightyear Planet Rescue. But both Space Mountain and the Orbitron would be represented only in spirit, by new attractions that resembled their predecessors but did not repeat them. The Orbitron was replaced by a sixteen-arm Dumbo-style ride called Jet Packs, in which pairs of riders, with their feet dangling, could control the height of their two-seat vehicle as it circled a central sphere accompanied by upbeat music.

Space Mountain was harder to walk away from. "There were a lot of obstacles to getting Shanghai done," said Bob Weis. "And there are sometimes obstacles that we put in our own way. We'd say, 'We should lift Space Mountain, because we know it. We know how to build it, we know

how much it costs. It's popular.' And the attractiveness of doing that is so strong to everyone, especially when you're really busy and you're trying to do a big, challenging project. Take this one thing and just repeat it."

But as easy as it would have been to talk themselves into a fifth Space Mountain, the Imagineers kept coming back to what they knew about Shanghai. For such a forward-looking city, even an updated version of a nearly forty-year-old attraction just wasn't good enough. "A big part of this challenge was trying to celebrate what the possibilities could be in the future and to make it dynamic over time," Drake said. "Shanghai is a place that's reinventing the future every day."

At the same time Drake was at work conjuring a Tomorrowland worthy of Shanghai, Disney was conjuring a future for one of its own classic properties: *TRON*, the 1982 film that had first introduced movie audiences to grand-scale computer-generated animation in a narrative context. *TRON: Legacy*, set in the same world nearly thirty years later, was set to come out in 2010, and the two films together sparked Drake's imagination, as well as his design sensibilities.

"The original *TRON* film set a design aesthetic that had really never been done before, and it was iconic instantly. The idea of a Lightcycle and what that turned into in the *TRON: Legacy* film was happening right at the time that we were trying to invent what this land could be." The movies fed into Drake's passion for vehicle design—"you can't have a vision for the future without really cool vehicles"—an area where he believed Imagineering was unsurpassed. He envisioned a new kind of roller coaster that would allow guests "to sit on a Lightcycle and launch into that ultra-stylized world. And the design team and engineering team really just ran with that as a concept to try to make the most sophisticated ride vehicle that we've ever done. The amount of storytelling when you're on that bike—you feel like you're right in the middle; you're a main character of that story." To achieve that goal would require not just a new ride vehicle but sophisticated onboard audio and lighting, so that "you become immersed in this vehicle as you get launched into the grid."

What came to be known as the TRON Lightcycle Power Run would reimagine the digital bike race from the original movie, with guests

seated on their own Lightcycles—linked in double-width trains of four-teen bikes—representing the blue team (Jeff Bridges' team) racing against the opposing gold team, which appeared to be running in parallel to the blue through high-definition projections. "We decided that if you really wanted to do TRON you had to be on a bike," Weis said, "not in a ride vehicle that felt more like a roller coaster. [We wanted] to put people on an immersive scooter where you're completely open all the way around you—like you're on a motorcycle, with the wind all around you."

The TRON plan did raise a few eyebrows, since the original film, however respected by critics and beloved by some viewers, was consid-ered a box office disappointment. "Many people were asking us about TRON, you know, why would TRON be a great experience for this park?" recounted Howard Brown, Imagineering's senior development executive for the Shanghai Disney Resort. "We find inspiration in many ways to create great guest experiences."

Whatever the reputation of the film, however, the richness of the story with which it imbued the ride was important, Weis noted. "Space Mountain is a great Disneyland concept, but it doesn't have a real strong connection to any story line."

Unlike Space Mountain, with its thrills cloaked beneath a ribbed cone of mystery, TRON Lightcycle Power Run would explode out into Tomorrowland. The first curves after the coaster's rapid launch were on a track outside the ride building—beneath a color-shifting canopy that looked especially impressive at night. The bike trains zoomed along at sixty miles per hour above two levels of Tomorrowland walkways. Seeing the bikes flying by overhead, Weis thought, would "completely blow peo-ple away. Plus, people will know, don't put your grandmother on it unless she wants to do that. It will clearly communicate what the experience is."

"You're always pushing for the most innovative rides and attractions," Drake said, but "innovation is not the goal. It's just what we do—pushing the envelope and making sure that how we deliver this story and experi-ence is as good as it can be." The storytelling began with the pre-show, when guests learned that they were being scanned and digitized to bring them into the computerized realm of TRON. As in Space Mountain,

the queue line passed over the boarding area—tantalizing guests with a bird's-eye view of the experience they were approaching. "Those are just the story drivers to get you in the spirit," Drake said. "When that thing launches from zero to sixty in four seconds, you're going to feel this TRON experience more than you ever have."

The Imagineers utilized "every trick that we know," he said, including set design, props, lasers, lighting effects, projections, animation, and black light. There were LEDs programmed to run in sync with each vehicle and with the corresponding projections, precisely programmed to account for moving eye point, just as in the Ratatouille attraction. But "the key ingredient to what we do is to integrate our facility design with our ride design and our show so guests don't see the difference between those elements."

The choice of the TRON Lightcycle attraction, with its array of lighting effects both inside and outside the building, was in part a tribute to Shanghai. "The lighting is really the lifeforce of our land," Drake said. "There are so many LEDs in downtown Shanghai, and that skyline is amazing and beautiful. We're not trying to compete with that. We're really trying to make a choreographed story that sets a mood for the land. It's about this energy that's surging through [Tomorrowland]." The TRON pavilion would be "dynamic architecture in form and in function. We talked a lot about the shape language of this [curve of track outside the building] being like the tail of a dragon. Everything is big. All of our set pieces are big. Our signage is big. TRON was always something that set a new bar for the aesthetics and how this sci-fi world could and should look."

The TRON Lightcycles would not be the world's first bike-like coaster vehicles, but the goal was to make them "the most sophisticated ride vehicle we've ever done," Drake said. Drake researched the existing motorbike roller coasters at non-Disney parks, determined to have riders seated in a motorcycle position with a secure but unobtrusive safety harness. Beginning with a Dutch vendor's existing bike-like vehicle, "we spent a lot of time redesigning that restraint, making it [blend with] the TRON aesthetics and beefing up the whole vehicle—adding all the

technology of onboard audio, onboard lighting—so it becomes a character in the overall experience." Mock-ups were made and revised in Glendale and made and revised in the Netherlands, where the bikes were to be built, "trying to get the form factors right, making the restraint as safe as possible [but] completely hidden from the guests." In the end, Drake judged, "it's a beautiful bike just on its own. I want one in my living room."

The production designer on Drake's team was Shawn Tuohey, who had raced motocross bikes for ten years. "Actually being in that [bike-riding] position instead of sitting in a vehicle really intrigued me," Tuohey said, "so my heart's been in it from the get-go." Tuohey often served as the liaison between Drake in Shanghai and a manufacturer in southern China. Each land in Shanghai Disneyland had selected two vendors—one ride vendor, creating the core elements of the attractions, and one show vendor, manufacturing the land's sets and other decor. And everyone worked with the general contractor hired for the construction of the entire park. It was a lot to coordinate, and the digital communication tools were crucial. "I can take a photo of something and email [Drake] real quick and say, 'Is this what you're looking for?'" Tuohey said. "And really quickly he'll respond back and just say, 'Can you change this or change that?' and the vendor keeps moving."

"Cross-global design is happening on an epic scale on this project," Drake said during the construction phase. "We have architects in New York. We have a design team in Glendale, a production team in Shanghai, and we're all communicating every day." Because of the time differences, the emails never stopped. The buses that took Imagineers back and forth to the work site had Wi-Fi, and Disney had issued iPads to team members so they could keep working even in transit. "The digital communication tools have been great," Drake said. "We have collaborative tools [through which] we can look at the same screen, be sketching over things, sending things back and forth. We have virtual models that we're sharing." The two teams shared a virtual wall where they could post designs and environments for discussion across multiple time zones and

countries, "so that we're all seeing and saying the same thing and so it's one vision that we're all carrying through."

As construction wound down, Drake began to see in real life the vision his team had set for themselves years earlier. "We painted a big picture long ago, five years ago, of what this could be, and then you dissect that and you break it into individual pieces," he said. "It's not until this assembly of all of these parts come back together that you really get to stand back and see that each one of those pieces creates a much bigger story."

As Drake waited for the rapidly approaching opening day, he contemplated what the wider impact of Shanghai's Tomorrowland might be. "The huge opportunity here in China is to inspire the next generation," he said. "What we're building is just the spark, right? What their imagination fills in after that, that's the true genius of the original Disneyland. When we would walk through Tomorrowland as kids and we saw that rocket, we weren't seeing a fiberglass and steel rocket. We were seeing space travel. And that's what we're trying to hint at with all of these stories that we're telling—that the possibilities are endless. And if we can inspire the next generation, I can't wait to go to the next Tomorrowland."

VIII. OPENINGS AND ENDINGS

When the deal to build Shanghai Disneyland was signed in 2009, an opening in 2014 was envisioned. By the time of the 2011 groundbreaking ceremony, that had been revised to 2015. The final opening date was June 16, 2016. There was no single reason for the postponements—there were thousands of them. Every step along the way had involved surprises, unanticipated challenges, extended training periods, and schedules stretched to guarantee the quality that both Disney and the Chinese wanted to see on opening day.

There were exceptions, Doris Woodward said. For the Wandering Moon Teahouse, a quick service restaurant, the Imagineers wanted classic Chinese paintings and brought in local artists who specialized in

exactly that. "We didn't have to spend that much time with them. They knew exactly what we wanted after we gave them the subject matter, and off they went." Such experiences were gratifying but rare. "We should've engaged [in training] much earlier, because it takes time to learn about our requirements," Woodward said, "everything from a particular kind of painting technique to a particular end result look and finish."

Insufficient training time was just one of many factors in the rescheduling of opening day. Even experienced Imagineers could not have fully anticipated the grueling conditions that endured during the long construction period, including seemingly endless clouds of dust and the 110-degree heat in the summer, plus the challenges of communicating complex directives through translators. It sometimes just seemed otherworldly, impossible, and unending. Then, eventually, an endpoint came into view.

When the June opening date was announced in January 2016, the explanation for the delay was that Disney and the Shanghai Shendi Group had decided to invest an additional $800 million to add more attractions to meet the anticipated market demand, bringing the investment to $5.5 billion for the full Shanghai Disney Resort through the Accelerated Expansion Plan, which was announced in April 2014. Once that opening date was locked in, everyone set to the task. As Howard Brown recounted, the Chinese contractors promised him their support by saying, "You know, in China, we don't really know how to run a marathon, but we really know how to sprint." The last six months would be one long sprint to the finish.

"I think having an end date was galvanizing for the team," said Fantasyland producer Jodi McLaughlin, "especially for a lot of people that have been here for three or four years. When there's that light at the end of the tunnel, then it becomes more achievable—even though the road is very difficult and bumpy. Having that date was one of the most important things for the team to really rally around and come together."

"We got more done in a short period of time than even we thought was possible," Bob Weis said of those final months. "It was everything from the contractors to the final programming of the attractions, the

shows, the live entertainment, the planting of the final landscaping. There was so much compressed into a relatively short period of time that I think we were all kind of astounded that we got through it. It was very difficult, it was busy, it was twenty-four hours a day." Three months before the opening, Mickey Avenue was crowded with contractors, Imagineers, and even parade floats. As workers finished the shop interiors, touched up the final graphics, hung light fixtures, installed paving, and planted the final landscaping, they would occasionally stop and look up to see Mickey Mouse passing by. "They had to practice the parades as construction's going on around them," Weis said. "It was a wild scene."

The work zone parade rehearsal was indicative of a larger transformation: the gradual handoff of the park from Imagineering and its contractors to the Operations team that would run Shanghai Disneyland forever after. During the months before the opening, "everything's happening simultaneously," Andrew Bolstein recounted. Just like owners inspecting a newly built home, he said, the Operations cast members would find things that needed attention, consult with the Imagineers, and bring back the contractors for final fixes. Operations also had to figure out how many people it would need onboard every day to run the park and find places to train them—and feed them—that didn't interfere with the final construction touches.

Bolstein was the general of a small army that had been recruiting cast members for months at job fairs and elsewhere. They needed a crew of ten thousand ready for opening day. "We just wanted to make sure that we really found people that would be positive, outgoing individuals that would deliver the world-class service that we wanted to deliver," he said. Some hires had service experience in retail, restaurants, or hotels, but none had worked in a Disney theme park. They needed to be trained not only in their specific duties but in "participating as part of the show, and delivering those types of welcomes and greetings in the show language of a different themed land." Bolstein found an old college not too far from the park that his team transformed into a Disney University, where the thousands of incoming cast members sat through Disney Traditions classes and participated in role-playing to learn how to respond to guests

in a Disney-appropriate manner. Then, as locations inside the park became available, training would continue onsite. For those assigned to Sweethearts Confectionary, the Minnie-Mouse-themed shop on Mickey Avenue, for example, "you could show them a picture, you can explain how you are one of Minnie Mouse's friends, but until you actually see the space and Minnie Mouse is actually standing outside delivering the meet-and-greet, it doesn't make sense yet."

Ali Rubinstein described the final months of construction as "a war zone. We all come together in this extraordinarily stressful situation with a single goal in mind. It is something that nobody will ever be able to describe—the emotional ups and downs, the bonding. I think when you go through an experience this intense with so much expectation, so much at stake, and so much reward waiting for you at the end, it just automatically draws you together. I mean, you have to come together or you won't survive."

"You go home at the end of the day and say, 'How are we going to do this?'" Woodward said. "But the next day comes, you take a deep breath. The show must go on, and you start again."

"We all shared the stress," Bob Iger recalled. "The eyes of the world were on this." Iger himself visited the site sixteen times in the final six months. "I was completely strung out. I had nothing left in the tank. The pressure [was] on us. We had the board, we had senior executives, we had investors, we had the press. We had to tour, wine and dine everybody. We had the government. We had the Imagineering team and the construction team and we had this thing that we had to open. It was quite something."

"I am pretty philosophical about stress," Bob Weis said, "because we're not paramedics, we're not rocket scientists, we're not flying airplanes. We're building happiness." Still, he added, "it was a heroic project really from start to finish."

As had been done at Hong Kong Disneyland, a soft opening period invited select guests into the park before the grand opening. The test runs began May 7—six weeks before the opening. A small number of guests came that first day, with the daily number gradually increasing as

the weeks went on. "The first day of trial ops, the Imagineering group were finishing up final touches," Bolstein recalled. "It's all the things you always heard about in the old days at Disneyland in 1955, or EPCOT in 1982—making sure landscaping is done, the attractions are tested and finalized, and the food's getting into location. On that day we opened at 11:30, so we had the morning to still have time to push through. But it was exciting. The guests arrived early that day—mainly our own cast members with their family and friends. It was one of those moments you tear up on, because we had the rope [in place] and we had thousands of guests already lined up and very excited. So we were all there taking photos, taking selfies with the guests. And then the announcement comes, the rope drops, and everybody takes off. My own wife and kids were right there at the front, so it's a pretty special moment. You finally see kids in the park and families and everything. And that was really what we were pushing for—to say it's here, it's open, and guests are using the place, and so life begins."

Until that park preview period, Ali Rubinstein observed, "we had never had anybody set foot there other than us and our construction workers. We didn't really know how the guests were going to react. And as it turned out, they were overjoyed. People were crying. People were obviously laughing and smiling and it was certainly a memorable moment."

"You spend so long working on something and birthing a project like this," said Stan Dodd. "And then when you're there and you see the first guest come through the gate [during the soft opening] and you start to see the expressions on their faces, particularly of the children—or of the elderly and everybody of every age in between—and they're just taking it in and obviously reacting in a very positive and emotional way to what you created—it's wonderful. I don't know how else to describe it. It's an incredible feeling." Dodd also experienced the park as a guest on one of the preview days, waiting in line outside the gates for an hour and a half before opening with his children and his sister's family. The trial operation period is crucial, he said. "Anytime you start to put thousands and thousands of guests into the environment, you begin to learn the adjustments you have to make, whether you need to adjust pathways or

add lockers or add additional graphics or change seating arrangements. There are countless things that come up, and we're used to that."

It was the first preview of a park in the era of smartphones and social media, so guests' reactions were evident instantaneously even to people not there that day. "People see Soaring for the first time, and it goes all over WeChat, and the next day [during the preview period] the gates open and everybody runs to Soaring because everybody's heard about it on WeChat," Weis said. (The wait time for Soaring stretched to five hours at one point during the soft opening.) "Or everybody's heard that the turkey legs are incredible and you gotta go there first because there's a line for them." (The wait for turkey legs? Up to ninety minutes.) "The guests know more about the park when they arrive than they ever have before because of that mobile communication, and so it's a very different experience to how they move around—because they know what they're looking for without looking at a guide map. They already know where they're going."

President Xi Jinping would not be attending the formal opening ceremony at Shanghai Disney Resort, but Iger had met with the Chinese leader twice in Beijing—including a headline-making one-on-one in 2014, since it was rare for a Chinese president to invite an American business executive for a solo chat, much less at the Great Hall of the People, the seat of China's legislature. What was truly unique about the meeting is that Xi normally met groups of CEOs from various industries, never with executives of one company. Both men issued upbeat statements about cooperation, but the most moving moment of the meeting went unreported. Iger had learned that Xi's father, a revolutionary leader, had visited Disneyland in 1980. He tasked his staff with finding a rare photo of Xi Zhongxun taken inside the park. Once located, the photo was freshly printed and framed and presented to Xi Jinping as a symbol of their ongoing partnership. "I could tell he got very emotional about it," Iger said. "He didn't cry but tears welled up in his eyes. And he said to me at the time, 'My interest in Disney is not rhetoric, it's from the bottom of my heart.' I had never heard a Chinese official echo anything like that, injecting their emotions into a discussion. It was a big deal."

The Chinese people similarly opened their hearts to Disney. Half a million people visited Shanghai Disneyland in the preview weeks before its official unveiling on June 16. And they not only embraced Soaring and turkey legs, but elements of Walt Disney's own theme park philosophy. "We have trained our cast members to collect trash whenever they see it," Bolstein said. "That's very standard Disney culture. But we actually find our guests sometimes finding other people's trash and picking it up and putting it in the trashcan. And that's when you know maybe we've hit a nerve here."

On the Thursday of the official Grand Opening, guests lined up hours early in orderly queues, despite intermittent rain. The showers tapered off enough by the time of the dedication ceremony to allow a gold-robed choir to perform "When You Wish Upon a Star" in Mandarin on the steps of the Enchanted Storybook Castle. Iger's remarks—in addition to echoing Walt Disney's words from the opening of Disneyland in 1955, now being translated into Mandarin—seemed to reflect on the Imagineers' long efforts and steadfast determination. Opening day, Iger said, was "a celebration of creativity and collaboration, commitment and patience—a triumph of imagination and innovation." Iger also read a letter from President Barack Obama, while Chinese Vice Premier Wang Yang shared a congratulatory message from Xi. Wang then joined Iger and Han Zheng, who by this time had already risen to become Party Secretary of Shanghai, to cut through a ceremonial red and gold ribbon. A troupe of red-and-gold-clad dancers soon appeared and performed to prerecorded music, joined by many of the Disney princesses to whom the castle was dedicated, and then by Mickey and Minnie Mouse and other classic Disney and Pixar characters. For the finale—underlining the park's Chinese character—several hundred cast members from all areas of the park hustled out along a raised walkway at the foot of the castle to wave at the crowd as a burst of fireworks briefly lit up the facade.

The park was declared officially open just before noon, and lines of waving cast members along Mickey Avenue welcomed the first regular guests—the long-expected three-generation families, as well as cliques of single young people, corporate groups, and thousands more, sporting

umbrellas, ponchos, princess costumes, and Mickey Mouse ears. Many sprinted off to get to the rides they'd already heard about on social media.

Reflecting on the opening sometime later, Iger cited the TRON Lightcycles as representative of the long journey to 2016. "You know, we saw that attraction being built for so long, meaning both the early design concepts and ride technology and pre-vis [aka digital previsualization] and virtual riding of it in Glendale, all the way through to seeing the steel go up and ultimately seeing the vehicle cycle through without people on it—and then getting on the vehicle for the first time with sandbags sitting up behind us to make believe there are other people on it. The thrill of being shot out of the building for the first time, you know, was the thrill ride of a lifetime. This is what we wanted to deliver. There were just so many great moments that I experienced in those early days." On opening day, he concluded, he was "really tired but so thoroughly exhilarated as well. It was the highest high that I've had in this job."

In its first year of operation, more than eleven million people visited Shanghai Disneyland, exceeding all predictions. "It took a lot of will in order to get [the park] done, but we pushed it over the finish line," said Bob Chapek, who took over as chairman of Disney Parks and Resorts in early 2015. "And the end product is absolutely fantastic."

For many Imagineers, the high of the opening was followed by the disorientation of arranging to move back to California after years in China. Some had relocated their families to China, including Tomorrowland design lead Scot Drake, whose wife and two young daughters had been with him in Shanghai for most of his three years there. The Drake family had grown by one since their arrival, with the adoption of a Chinese-born son. Working on the park, he said, "was incredibly meaningful on a designer level, on a cultural level, on a personal level—being able to share that with my family and bring them over. We adopted my son over there, so Shanghai, China—that park is a very special place for all of us now."

For Woodward, opening day was "bittersweet. From a woman's point of view, it is like your baby is finally born and now you walk away." She had been through this before, as far back as the opening of EPCOT,

and every time "it was very hard to leave." Her involvement in Shanghai Disneyland had lasted longer than with any other park, and it had been quite a journey. "I mean, how can you not be proud? With all of the challenges we had, or all of the insane points of time where we think it's not being done—[and then] you look at it literally today and you go, 'It is done, it's there.' I mean, the castle—it's phenomenal to think that four years, five years ago it was dirt. And it wasn't done by a bunch of elves overnight. I mean, it was literally these Chinese workers who got it [done] with all of us there."

That included the newly recruited Chinese Imagineers—many of whom would remain in Shanghai, at least for a while, to continue working on the park. "As perfect as everything looks [on opening day]," Woodward said, "there's still some work to do."

The details of the experience had evolved, but even in Shanghai—especially in Shanghai—the Imagineers' chief motivation remained the same as it had been sixty years earlier. As Chinese Imagineer Chan Nga Kwan put it, "it's very simple, it's one thing. We are creating something happy and joyful. No matter how many challenges that we're facing—time, money, schedule, whatever, right?—we should always bear in mind that we are creating joy for people."

CHAPTER 30:

THE MARVELS OF THE UNIVERSE

"I did not have a clear way of understanding how Avatar
was even possible to do [in a theme park]. People love
the movie, but is it feasible? Can we do it? . . . What
about this is a smart idea?" —Joe Rohde

I. FIVE THOUSAND NEW FRIENDS

THE STARK EXPO was open for business. On display were samples of Stark Industries creations from across the decades, including iterations of Tony Stark's Iron Man suit and Captain America's shield, in rooms with names like Hall of Legacy and Hall of Mobility. For guests visiting the expo, the finale would be a test run of the Iron Wing Mark VIII, a forty-five-passenger drone shuttle piloted by Stark's AI assistant, Jarvis, across the towers and bridges of Hong Kong on the way to view the Arc reactor atop the Stark Tower in the city's Kowloon neighborhood. Unfortunately, the planned scenic excursion became a wild ride when HYDRA robots attacked, and the Iron Wing and its passengers had to join Iron Man himself in a battle to save the city—before returning to land safely back at Hong Kong Disneyland.

When the Iron Man Experience officially opened in January 2017, it was the culmination of another kind of journey. Bob Iger had spearheaded Disney's acquisition of Marvel Entertainment more than seven years earlier, in a $4.3 billion deal announced in August 2009 and finalized on New Year's Eve. Coming four years after the purchase of Pixar,

the Marvel pact was another step along one of Iger's three parallel paths toward Disney's future: own the best-quality intellectual properties. And by debuting Disney's first Marvel-inspired attraction in Hong Kong, the Iron Man Experience also furthered Iger's international strategy: only one Disneyland in the world hosted the Stark Expo, and it wasn't in the United States.

The ride's location seemed particularly poetic, since Iger's decision to bring Marvel's super heroes into the Disney family could be traced back to that opening day parade at Hong Kong Disneyland in 2005. The impact of Iger's epiphany continued to ripple across the years, and to shape the agenda at Walt Disney Imagineering. The first decade of Iger's tenure as Disney's CEO was an intense period of enriching the company's cache of intellectual properties and in turn expanding the scope of what could serve as the foundation for Imagineering attractions. By the time Cars Land opened, Pixar properties were well integrated into all the parks. Marvel—with what Iger termed its "treasure trove of over five thousand characters"—would not be far behind, nor would it not be the last new catalog of stories to transform the parks.

For the parks, the worlds of Marvel would complement existing Disney and Pixar properties in strategic ways. While both classic Disney characters and Pixar movies had a substantial adult fan base, they were often still perceived as family fare. Disney's library in particular was richer in princess stories than in adventurous young men. The parks did have many rides inspired by Disney's classic male protagonists, but they were often cute animals (Dumbo, Winnie the Pooh) or mischievous boys (Peter Pan, Pinocchio). In the past, when hoping to appeal to thrill-seekers—and thus, presumably, to most boys—the Imagineers had often created new stories from whole cloth. Attractions from the Matterhorn Bobsleds, Pirates of the Caribbean, and Haunted Mansion through Test Track, Kali River Rapids, and Expedition Everest—Legend of the Forbidden Mountain had offered excitement and chills without tapping any pre-existing characters or stories. Another Imagineering strategy for rides perceived as masculine had been to draw in tales and characters that were enormously popular but not originally from the

Disney family—everything from Tom Sawyer Island to the Indiana Jones Adventure to Star Tours came from creators outside the Disney fold.

Pixar had boosted the juvenile male quotient at Disney parks, with the Buzz Lightyear-themed mobile shooting galleries and the triumph of Cars Land, but Marvel was a treasure trove of grown-up male heroes (and a smaller number of heroines). Like classic Disney properties, Marvel stories also had cross-generational appeal. Many fans—including a number of Imagineers—had been drawn in as children by the original comic books and remained loyal as teenagers and adults. But as the global box office success of the first Iron Man movie had demonstrated the year before the Disney acquisition, plenty of adults and families were eager to enjoy the adventures of Marvel super heroes without any prior familiarity.

Properties like Marvel could be a game-changer, Imagineer Jon Snoddy observed. "Suddenly it's like, I don't think our audience is saying this is just for our kids. It's for Mom and Dad as well. These are properties that really go from children to adults, and it's going to change the way we approach the design of theme parks." Everything from the attractions to the character interactions could now speak equally to adults and to children. Fresh, cross-generational characters and stories from like Marvel could help shift the perception of Disney theme parks—the Magic Kingdom–style parks in particular—from realms of childhood and nostalgia into the repositories of beloved pop cultural figures. If the strategy worked, Marvel wouldn't be the last such acquisition to have its impact on the parks.

The first step in that tonal shift was the Iron Man Experience, announced to the public in October 2013. Development had its ups and downs, said Imagineer Alec Scribner, executive show producer on the attraction. "Fortunately, the president of Marvel Studios, Kevin Feige, is a huge Imagineering fan," Scribner said. "So he was just as excited about what we were doing as we were." Legendary Marvel mythmaker Stan Lee was also onboard—literally. He joined the filming of the attraction's safety video as one of the Iron Wing's passengers, seated next to a boy with an Iron Man mask.

For Imagineering creative director Ted Robledo, the chance to work on a Marvel-based attraction and to meet Lee was "a dream come true," he said. "I grew up a Marvel fan. I've been reading and buying comic books for a very long time. I date my vintage by the price of comic books, and that sat somewhere around thirty cents an issue [when I started buying them] and they're somewhere like three or four dollars now."

The Iron Man Experience would be a motion simulator ride; the elaborate exhibits that constituted the Stark Expo would be the immersive queue area. The attraction would use an updated version of the technology from Star Tours—an attraction noticeably absent from Hong Kong Disneyland, though present in four other parks. "A lot of ride engineers worked really hard to make this cabin work," Robledo said. "Even though it's based on a simulator type of ride that we've done in the past many times over, they actually started from the ground up to redesign a new cabin with more modern features and more comfort features as well as more reliability—and the fact that we're putting forty-five people in this Iron Wing, versus forty in our other simulator rides."

The new motion simulator cabins would be tossed about by electric actuators rather than hydraulics, Scribner noted. "Hydraulics tend to drift. You tell them to go to a certain location and they'll go there for a few weeks or months and then they'll start to drift"—requiring regular recalibration. "Electric actuators don't do that. They go exactly where you told them to go every time." The new system also used less electricity, in part because the electric actuators made the cabin considerably lighter, even with five additional passengers. The 3D film guests would view through the cabin windshield was created by animators at Industrial Light & Magic, while the Imagineers also added "4D" effects, including a rush of wind when the front window appears to break.

Robledo's favorite part of the attraction was not the technology but the storytelling. Early in development, the story line had been set in New York, where Stark Tower was seen in Marvel movies. But John Lasseter, in his role as principal creative advisor at Imagineering, suggested to Robledo that since the attraction was being designed for Hong Kong, a second Stark Tower could simply be plopped down in the middle of

that city. Robledo agreed immediately. "It's an authentically Iron Man super hero adventure that takes place in a real place—Hong Kong," he said. "That's something that we rarely do for our guests. The cool thing about this adventure is it starts in Hong Kong Disneyland, and you'll see that there is a battle that actually takes place in Hong Kong. So I'd call it the first self-aware Disney ride." It was a momentous shift. After decades of taking park guests to fantastic and faraway places, the Imagineers grounded the Iron Man Experience in the very spot where the riders boarded the attraction.

Stan Lee found the whole Imagineering philosophy to be in tune with an Iron Man story. "Anybody who goes to a Disney theme park to begin with loves color and spectacle and excitement and adventure," he said during a break in the filming of the safety video. "And that's all that Iron Man is—it embodies all of those things. I think the audience in Hong Kong will go crazy for this experience." In part a reflection of the massive Chinese audience for Marvel films, Hong Kong Disneyland attendance for 2017 increased by 3 percent over 2016, and the next year it went up another 8 percent, to 6.7 million annual visitors.

But Disney didn't wait for these attendance reports before cementing its commitment to enhancing the park further. In November 2016, just weeks before the Iron Man Experience opened, the company joined with its partner in the resort, the Hong Kong government, to announce a six-year, $10.9 billion expansion. The project was set to begin the next year and was more than half reliant on Marvel characters. Adjacent to the Iron Man Experience, and replacing Autopia (which had closed permanently in June 2016), would be a new Marvel zone, later revealed to have an Avengers theme, while Buzz Lightyear's Astro Blasters would be supplanted by another Marvel attraction, later announced as Ant-Man and The Wasp: Nano Battle! (which would utilize technology similar to Astro Blasters). The remainder of the expansion would be a new land inspired by the *Frozen* movies, to be built across the Disneyland Railroad tracks from Fantasyland. The plans foreshadowed Marvel-themed areas that would soon be announced for several Disney parks. As with the cinematic unfolding of the Marvel Cinematic Universe, Iron Man

had simply led the way for a much larger cast of characters arriving in his wake.

Another Marvel team landed at a Disney park just months after the Stark Expo opened its doors. Across the globe from Hong Kong, an entirely different set of heroes would be checking into a beloved Hollywood hotel—and completely transforming it.

II. THE POWER OF LAUGHTER

It was the shortest turnaround time for an E-level attraction in recent Imagineering history—just ten months from the announcement to the grand opening. Guardians of the Galaxy—Mission: BREAKOUT! was first revealed to the public in July 2016 at San Diego Comic-Con, and it opened in late May 2017. Part of the trick, of course, was that the attraction already existed, with different theming, under the name *The Twilight Zone™* Tower of Terror. But the Imagineers also accelerated all their usual procedures to warp speed. The 183-foot-tall tower was shrouded in giant scrims while the exterior work began, and the ride continued to run as Tower of Terror. Then it closed in January 2017 to allow the interior rehab to start. Just before Memorial Day, the scrims vanished and the Guardians attraction opened. To the public, it looked easy. Inside Walt Disney Imagineering, it was a year-long mad dash with countless sleepless nights.

The speed was by design. The question the Marvel creative team had for Imagineering soon after Disney acquired the company was simple: how fast could a Marvel-based attraction open at a Disney park in the United States? Bruce Vaughn, Imagineering president at the time, took Joe Rohde out to dinner in Disneyland to brainstorm ideas in early 2016, but nothing quite clicked. In Anaheim, the lack of space for expansion was a particular handicap. And if they annexed what little available acreage there was for their first Marvel attraction, where would they build the next one? Then Michael Colglazier, then president of the Disneyland Resort, stopped by Vaughn and Rohde's table, saying, "I really desperately need a major attraction to open for Memorial Day [in 2017]. We

should do a redo of Tower of Terror." The Hollywood area of Disney California Adventure was the least-visited part of the park; an attraction from Marvel, with its enthusiastic fan base, would change that. The Imagineers' brainstorming suddenly shifted gears: which Marvel super hero could best occupy the tower? Spider-Man? Dr. Strange?—*Was he famous enough?*—Guardians of the Galaxy? As it happened, *Guardians of the Galaxy, Vol. 2* was set to hit theaters in early May 2017. Maybe that was the answer.

Rohde left the dinner to walk into Disney California Adventure's Hollywood Land and look at the Tower, thinking, "You know, there are not many details on this building that make it look like a hotel. And if you took those details off, it zeroes out really fast to just being a big abstract mass—which means all I need to do is add back a certain number of details and I can really redirect what this thing even is." It didn't look like a spaceship. Maybe a launch tower? Then he recalled Taneleer Tivan, the Guardians' sometime nemesis, better known as the Collector—and *click!* That was it. Rohde quickly envisioned a combination power plant and fortress where the Collector kept his treasures—to which he had just added the Guardians. *Done!* It would be a prison-break story. Guardians of the Galaxy—Mission: BREAKOUT! was born.

The redesign could easily be story-driven, Rohde thought. "The character of The Collector is the character of the building. It needs to be nouveau-riche looking. It needs to be garish. It needs to express power. It needs to express value. It needs to express containment. We can do that, and we don't need to go to the movie. We can go to the comics. We can go to old Jack Kirby drawings. And then the character of the plot needs to be the character of the characters—irreverent, fast, humorous." Just as Marvel stories often did, the new attraction would weave together archetypal narrative threads: the keeper of a castle, a hidden treasure, a band of comrades, a great escape. Whether or not park visitors were familiar with the Guardians movies, the attraction story line would be clear.

Rohde particularly liked the irreverence of both the Collector and the Guardians—so different from the ominous atmosphere of *The Twilight*

Zone™ source material. "Tower of Terror is modeled to produce a sensation of fear," he reasoned. "It's a scary ride right? Dropping. Scary. This [Guardians] ride is not a scary ride. This is an irreverent ride. It's a comic ride—almost like a Warner Brothers Bugs-Bunny-in-the-scary-haunted-house kind of story. It's high-speed, zany comedy. So we need to change the emotional feeling of the ride." The new story line—about Rocket, the raccoon-like Guardian, escaping his enclosure to cause a power failure that would allow his compatriots to break out as well—was ebullient and humorous. It leaned more into surprises and action and less toward foreboding and frights. Ride engineers worked to have some of the ride's drops produce "more of a floating sensation," Rohde said. "That is a happy sensation—like when you take the baby and you throw him up in the air and you catch him and he giggles—a funny-scary feeling."

"We wanted to make it a giggle machine," said Amy Jupiter, then Imagineering's executive media producer, "an extended period of joy and surprise." Part of changing the mood was changing the soundtrack, the spooky theme making way for the kind of classic pop songs that filled the Guardians' movie soundtracks. Six songs, recorded from 1968-1980, were eventually licensed. From Steppenwolf's "Born to Be Wild" and the Jackson 5's "I Want You Back" to Pat Benatar's "Hit Me with Your Best Shot," the selections were both upbeat and, in context, tongue-in-cheek commentary on the story. "Finding the songs was really hard," Jupiter said, "because especially if you're just going to go up and down and up and down, it's got to be a driving beat." The six songs were paired with six narrative variations, randomly selected for each cycle of the ride, "so you never know what you're going to get. You're going to get something that always surprises you, and it's evergreen and we will be able to change it." The changing visual gags, seen briefly by riders during pauses as the lift traveled up and down, involved the Guardians grappling with various malevolent creatures or drones, or reacting to an unexpected cut off of the fortress's artificial gravity.

To figure out how to reprogram the tower's drops to fit the new story, the Imagineers had to do test runs while the attraction was still operating

as the Tower of Terror, Rohde said. "Which means you're there from midnight to four in the morning—week after week after week, testing ride profiles." Creating the new media needed was also fast-tracked, since it would require filming the actors who played the Guardians, decked out in their characters' costumes and makeup. That meant getting the shots needed on the set of *Guardians Vol. 2* before it wrapped in June 2016, an accommodation that director James Gunn welcomed. Since the attraction's story and ride flow had not been locked in place by then, Gunn shot more footage than the Imagineers could possibly use, hoping that the abundance of dialogue and imagined scenarios would be enough to populate the ride. And he kept things moving. "When you're directing for a ride, people are in a much different state than they are when they come in and see a movie," Gunn observed. "When they come in and see a movie, they're mellow. They're listening. In a ride, people are so amped-up and so crazy. You really need to move fast. You need to pound it home. Everything's more grand than it is in the movie. And the actors reflect that."

Gunn shot the footage of each character with an Imagineering-designed vertical array of seven cameras, which would allow the ride engineers to match the perspective seamlessly with the vertical motion of the ride's lifts. The film of the actors would also be merged with a healthy dose of CG animation, to create both Rocket and the attacking creatures and most of the sets in which the Guardians find themselves. The physical sets that would replace the Hollywood Hotel decor were constructed off-site, so they could be more quickly installed once the ride shut down.

The production barreled along so quickly, Rohde said, that "there are no design documents. There's no millions and millions of drawings. All that exterior architectural decoration literally went from my desk—'it needs to be a thing like this, with a thing like that'—to another desk to a working drawing to a vendor [for fabrication and installation]." The many peer reviews that typically marked the progress of an attraction had to be collapsed to two: one early on, before all the expenditures were locked in, and one not long before the opening. Even if they'd done additional reviews, the schedule left no time to respond to any

feedback. The show needed to go on by Memorial Day 2017. That was what Colglazier said he needed to give Disney California Adventure and its Hollywood section a necessary summer boost, and so that was what Imagineering would make happen.

Even before the public announcement, just months after the idea was first conceived, the Imagineers knew to expect pushback from fans of *The Twilight Zone*™–themed Tower. But they were betting the quality of the new show and the support of Marvel's massive fanbase would more than counterbalance the naysayers. From Disney's perspective, the Guardians were a perfect fit for Disney California Adventure, Jupiter observed. The park "really screamed for Marvel." Long-term plans would create an entire Avengers-inspired campus around the Collector's citadel, but the quicker transformation of the Tower of Terror would at least give Marvel "a toehold." The story essence of Guardians of the Galaxy— Mission: BREAKOUT!, Jupiter observed, was disruption. "Tivan just lands his Collector's fortress in the middle of Disney California Adventure, so everything had to be about disruption. If we were going to take and disrupt people's Tower of Terror, we were going to disrupt it with something really exciting. And so excitement and disruption became our thematics."

As was the pattern with the revamping of any existing Disney park attraction—even one open just twelve years—a vocal contingent of fans expressed their displeasure at the announced disruption. Within days of the Comic-Con announcement—which had been met with some audible "boos"—various "Save the Tower of Terror" petitions on *change.org* had attracted more than twenty-thousand signatures, boosted by a social media storm of anger in the spirit of "worst idea ever." "When you reimagine any attraction you're going to get some resistance," Jupiter said, "because we can't imagine anything different than the Disney attraction we love and know. And so in order for us to take any attraction that is beloved and then reinvent it or reimagine it, it has to be better. It has to erase every single expectation you ever had and [make you] forget the old attraction, so that you love this [one]."

Since three Towers of Terror still stood in other parks, including the

original at Disney's Hollywood Studios, it was unlikely that fans would forget the old attraction. But that didn't mean they couldn't also love the new one. Once the show opened, "I was so excited by the audience's response," Jupiter said, adding that riders' praise for the Guardians ride was "almost like an apology" for the online negativity.

Rohde too found guests had been won over by Guardians of the Galaxy—Mission: BREAKOUT!, particularly because of its contrast to the Tower of Terror. "The emotional feeling is different, and I think this is why people respond so positively to it—because it's kind of joyous. And that's very deliberate. It's kind of oddly exciting and joyful even though you're still just going up and down in the same elevator you were going in before."

III. HERE THERE BE DRAGONS

In narration matched with images of a verdant world, the speaker sounded like he was channeling Joe Rohde's thoughts about the philosophy of Disney's Animal Kingdom Theme Park. "It's hard to put into words the deep connection the People have for the forest," he said in somber tones. "They see a network of energy that flows through all living things. They know that all energy is only borrowed—and one day you have to give it back."

The words expressed a reverence for conservation and harmony with nature, but they belonged not to Rohde but to the fictional Jake Sully, the human hero of James Cameron's hit film *Avatar*. He speaks them soon after his avatar, a ten-foot-tall member of the Na'vi people native to an Alpha Centauri moon called Pandora, has proved himself to his distrustful fellow tribesmen by taming a dragon-like banshee. The avatar, on the back of the winged banshee, had spent several spectacular minutes of the film gliding and soaring across the colorful landscape of the lush and alluring planetoid Cameron imagined.

It was an awe-inspiring sequence, made more arresting when moviegoers enjoyed it in the 3D or IMAX formats available during its original 2009 release. Of course, Pandora—with its glowing plant life

and floating mountains—had been created for the movie almost entirely through computer-generated animation. Now Walt Disney Imagineering was planning to build Pandora — The World of Avatar out of steel and concrete and paint on twelve acres of Disney's Animal Kingdom. Now the dragons were finally coming in for a landing—in the form of Cameron's banshees. Pandora — The World of Avatar would be the first new land opened in Disney's Animal Kingdom since the Asia area debuted in 1999.

The idea to bring the mythology of *Avatar* into a Disney theme park was pitched to Cameron by Bob Iger and Tom Staggs, the recently appointed chairman of Walt Disney Parks and Resorts, over a Hollywood breakfast in the spring of 2011—less than two years after the Marvel deal. At the home of Jim Gianopulos, then the co-head of production at Fox Filmed Entertainment, the movie division of Twentieth Century Fox, the Disney executives met with Cameron and his producing partner, Jon Landau, just weeks after Staggs had hatched the idea. The Disney proposal was not an acquisition, as Pixar and Marvel had been, but a long-term licensing partnership, similar to the deal with George Lucas that had brought Indiana Jones into the parks. This time the goal was not just a new attraction but a completely new land, along the lines of the soon-to-open Cars Land—the first land Imagineering had created in any park based entirely on one existing intellectual property.

Presented to Cameron and Landau in broad strokes, the plan was already bigger than anything the men had envisioned. "I was dumbfounded," Cameron recalled. "I had heard various proposals from other companies about doing a ride or something like that. This wasn't a ride. This was a land. This was a place you could go and walk around. Yes, it would have ride attractions within it, but it was so much more fully fleshed out than anything I imagined. It was such a beautiful vision—and to put it in Animal Kingdom, which is such a celebration of the natural world already, to me it was a great move and it was so consistent with the themes of the movie."

Cameron was immediately interested, telling Iger, "Hey, I've got all these designers, these animators, these people who actually worked

on *Avatar*. We have all the CG assets and everything. Why don't we get involved with the Imagineering team? We'll stay out of your way. We're not going to try and tell you how to do a land. We wouldn't know where to begin. But we could be helpful and be a resource—maybe a little bit of the conscience of *Avatar*, if you will."

For Rohde, the creative director both for the park and for Pandora — The World of Avatar, Cameron's imaginary ecosystem was a natural fit. "Everything at Animal Kingdom is about a small set of ideas, and those ideas give rise to the attractions," he said. The first, overarching idea is that "nature is a value against which we can hold no other value higher." The second is wrapped up in the first, like the vines hugging Pandora's floating Hallelujah Mountains: adventure in the natural world has intrinsic value. "When we undertake an adventure, on the other side of that adventure, we're a better person. If we can do something we haven't done before, see something we haven't seen before, go somewhere we haven't been before, we're better people. And then the last big idea that this all involves is a call to action. *Avatar* is about these same values. So it fits really neatly into the mythology of Animal Kingdom, even though it's a science fiction adventure."

Cameron and Landau met Rohde on their first trip to Disney's Animal Kingdom. As Landau recalled, "Joe was talking so philosophically about Animal Kingdom and what it meant to him personally and what he thinks it means to the world and to the guests, and it was so in line with how we view *Avatar*."

The narrative of Pandora — The World of Avatar would not be *Avatar*'s story—humans clashing with the natives on an alien world—but an expression of the harmony of nature: sentient creatures, beasts, plant life, and land all bound together. It would be the spirit of the movie, rather than its plot. The dragon-like banshees were not window dressing but the mythological embodiment of man's partnership with the natural world— on Pandora, a banshee and its rider linked their nervous systems and remained partnered for life. It was also a fit metaphor for Imagineering's plans: the attraction would be the real-world avatar for a lush moon that had previously existed only through digital cinematic effects. To get

Pandora — The World of Avatar off the ground, to make it soar, would require a mind-meld between Cameron and his crew and the team at Walt Disney Imagineering.

The deal between Disney and Cameron's production company, Lightstorm Entertainment, was hashed out quickly and announced in September 2011. Iger focused on the global appeal of *Avatar*, which had grossed $2.7 billion worldwide, more than 70 percent of that total coming from outside North America. The planned opening of Pandora — The World of Avatar, estimated for 2016, was to follow the release of Cameron's two *Avatar* sequels, then set for late 2014 and late 2015 and expected to boost interest in Disney's new themed area. That part of the plan did not come to be, however. In 2013, Cameron revised his release plans, declaring there would be not two but three *Avatar* sequels, due in three consecutive Decembers, starting in 2016. *Avatar* 2 was later rescheduled for 2020, then 2022. Pandora — The World of Avatar would open several years before any sequel, and it would sink or swim based on its own appeal, and that of the one film from 2009.

Not every Imagineer immediately saw the *Avatar* project as a natural fit. As executive producer Lisa Girolami recalled of her first impressions, "We can envision something, but you don't really know if it's going to go over well. That was the biggest unknown for me. The movie had come out quite a while before. Were people really going to want to hang out on Pandora? Or were they really going to want to wander around and experience that whole land? I was a little nervous about, 'Would this be enough?'"

The first challenge for the Imagineers would be to create a fantasy realm as believable as the rest of Disney's Animal Kingdom. "Because of the live animals [in the rest of the park], Animal Kingdom is obliged to be very, very realistic," Rohde said. "There's really no stylization in Animal Kingdom—we can't idealize things because the animals are not going to be idealized. They live, they die, they have babies, they have flies, they poop, they do all this stuff right in front of you, because they're alive. None of that [corresponds] with the purified, idealized, beautified sensibility of a classic theme park."

The first step in grounding this fantasy realm in realism was to

remove Pandora — The World of Avatar from the narrative of the movies, establishing that this World of Avatar existed a hundred years after even the unreleased sequels. "In our story, this area used to be a mining camp, so it's under habitat restoration," Rohde explained.

Spoiler alert: after the events of all the Avatar movies, the native Na'vi people rule a peaceful Pandora where they mingle harmoniously with their human guests. As Cameron phrased it, it was "a time when Na'vi and humans could kind of embrace each other's cultural differences." The land would speak directly to park guests, Cameron said, because "the Na'vi represent that thing in us that we want to recapture, that we aspire to. They're kind of the embodiment of the best of us, the people who care about each other, care about the natural balance, respect nature, and so on."

The Imagineers developed two attractions as part of Pandora — The World of Avatar—actually three, by Rohde's count. "The land itself is an attraction. We expect people to interact with the land. It's this incredibly beautiful environment. The other two attractions are classic rides." The land would feature a sampling of the movie's bioluminescent plants as well as some of Pandora's floating mountains: giant rocks suspended above the ground as if by antigravity. (In the world of the film, the mountains were held aloft by a powerful magnetic field—not a configuration that Imagineering could duplicate.) The thrill ride, which came to be called Avatar Flight of Passage, would put guests on the back of a banshee for an aerial trip around the landscapes of Pandora. And the serene dark ride, Na'vi River Journey, would feature a grand, lifelike shaman figure with many gestures and detailed facial expressions that would extend the boundaries of Audio-Animatronics figures.

This time around, Rohde wouldn't be able to make research trips to the exotic location he was re-creating—unless visits to the Lightstorm offices counted. The collaboration with Cameron's team was a union of equals, Rohde said. "We're talking to people who understand animation, who understand engineering, who understand how to get an idea from conceptual to physical—not just a screen image, but physical, built things. And that's made it really easy for us to collaborate."

The Imagineers would add their knowledge of how to build permanent structures—as opposed to temporary movie sets—and how to envelop guests into a storytelling realm with which they may not be familiar.

For Cameron, Rohde's involvement "was a match made in heaven for Pandora." According to the director, "Joe is just a ball of fire, obviously. He and I clicked right away. He's got a lot of ideas, he knows how to marshal a team, he knows how to inspire a team and keep them on track, and he understands the minutiae of it right down to rolling out the blueprints and doing the CAD drawings and the structural engineering." Rohde could talk the talk, but he would need an equally committed team to bring Pandora — The World of Avatar down to earth.

IV. LEVITATION BY DESIGN

Most Imagineers trained for other careers and found themselves happily detoured to Imagineering. But Jeanette Lomboy was dreaming about becoming an Imagineer as a little girl. "I grew up right around the corner from Disneyland," she recalled. Her family visited on weekends, paying the then-low admission charge—just $1 when the park opened—and simply walking around to enjoy the atmosphere. "We would save up for the C, the D, and the E tickets," so the attractions were a rare treat. But that only sharpened young Jeanette's interest. "When I was a kid, I use to hear all my friends say, 'Oh, I want to be a doctor, I want to be this, I want to be that,' and I went, 'Wow, why would you want to be that when you can do something cool like create this magical world where people can walk around and have fun all day long with their family?'" Lomboy attended the University of California, Los Angeles and worked at Disneyland on weekends. Once she landed an internship at Walt Disney Imagineering, she was on her way—"living the dream."

She learned an important lesson right out of the gate: be prepared to let go. "My first project was with Disney's America. I could see myself going into the field and installing this [park]. Then, of course, six months into the project, like things inherently do, it got cancelled and I was heartbroken." To keep her job, it was up to Lomboy to convince another

Imagineering team to take her on, and for a brief time she thought her dream would end less than a year after it started. But she was able to stay on—working first on the millennium celebration at EPCOT—and work her way up. "It was an interesting time, and I was also one of the very few young people [at Imagineering] at the time, back in the late nineties. I got a lot of exposure, had great mentors, and had a lot of fun."

Within a few years, Lomboy had become the producer on Imagineering's first scavenger hunt–style interactive game, an EPCOT guest activity called the Kim Possible World Showcase Adventure, based on the Disney Channel animated series *Kim Possible*. "We originally set out to attract tweens, eight- to twelve-year-olds, and we ended up attracting seven- to seventy-seven-year-olds, because everybody wanted to try a different kind of attraction." The overlay, in which participants received a series of clues on portable devices called "Kimmunicators," was part of Imagineering's Living Character Initiative. Begun with Lucky the Dinosaur, the initiative sought to use a combination of technologies to add unique, interactive guest experiences to the parks, whether helping Kim Possible complete her mission or meeting a rat-sized Audio-Animatronics figure of Remy on a portable cart inside the Les Chefs de France restaurant in EPCOT.

Lomboy first worked with Joe Rohde when both signed on to the project known as Aulani, A Disney Resort & Spa, on the same day. "He was the creative executive in charge and I was his show producer," Lomboy recalled. She thought she'd be concentrating on interactive experiences at the resort, but Rohde had other ideas. Thirty minutes into their first meeting, he told her, "You know what? Forget just being in charge of that interactive attraction. I kind of want you to get into all of it." Their partnership quickly became close and productive. And it soon extended to Disney's Animal Kingdom and eventually to Pandora — The World of Avatar, with both of them working closely with James Cameron.

"When we sat down with Jim and his team, we learned that much of *Avatar* is based on real science," Lomboy said. "He's actually incredibly obsessive about making sure real science and real biology are integrated into his film—everything from animal design to habitats to how the world

works. I remember the day when Joe and Jim said, 'Gee, wouldn't it be cool if we did mountains that floated? We'll do the Hallelujah Mountains!'" While they couldn't create the entire range of hovering rocks seen in the movie, they quickly committed to having "rock chunks floating 160 feet in the air above the guests' heads." As was often the case with Imagineering projects, the "how" was yet to be figured out, but the team decided, "We're going to do it, and it's going to be stunning."

Whether there are hurricanes on Pandora isn't revealed in *Avatar*, but Florida gets more than its share. Floating mountains in Walt Disney World—dressed with synthetic plants and two miles of artificial vines—needed to withstand hurricane-force winds for a generation or longer. It took about a year to get across that engineering and architectural hurdle, Rohde said, involving physical models, digital models, and a lot of complicated engineering formulas. The solution "was to take the structural steel, which is holding these mountains up, and redesign the structural steel so that it appears to be nothing but limp, draped vines. So, when your eye looks at the mountain, it sees these drapey vines hanging here and clearly they are hanging from something. So your eye goes over to the obvious thing that is holding them up, which is this mountain. So then your eye says, 'Well, what's holding up the mountain?' And you look underneath and there is nothing—seventy-five, eighty, ninety feet of nothing underneath these mountains. Well, in fact, of course, it's these skinny little vines that are holding up the mountain, but your mind's eye won't let you believe that. It's like a classic magician's trick. Nobody has ever done this before."

The seemingly draped vines were in fact a series of steel arcs. To disguise their structural function, individual steel threads were separated from one another as much as their engineering permitted. That would give them a more fragile visual impression—while they were still able to counter not only gravity but also the unpredictable horizontal forces of hurricane-strength winds. The result was a complex truss holding the mountain in place, plainly visible yet disguised as environmental embellishments.

As Imagineer Zsolt Hormay observed, "It looks like confusion, but

every piece is designed, placed, engineered. That's what's amazing about it. Every piece."

The plants in Pandora — The World of Avatar required equal attention, both on the mountain and below it. "Down at ground level, most of the foliage that you see will be real foliage—although we have a pretty big menu of alien Pandoran plants [created by Imagineering]," Rohde said during the development phase of the project. "Once you get up onto the mountain, the problem with real foliage is that [as it grows,] it changes scale, it changes size, it accumulates weight, and it collects water. And so everything that you see as we go up the mountain will be a form of artificial foliage." The plants on the mountain would be steel mesh frames coated in automobile epoxies, paint, and plastic that could withstand the sun, wind, and rain for twenty years or more.

As for the Pandoran plants on the ground—their function was not only to re-create the biosphere of the film but also to light up the theme park after dark. Since its opening in 1998, Disney's Animal Kingdom had been on the early-to-rise, early-to-bed plan, typically opening at seven or eight a.m. and closing between six and eight p.m., depending on the season. With the addition of Pandora — The World of Avatar, a lagoon-based nighttime show called Rivers of Light, and some new stage shows, closing time could be pushed back, encouraging guests to linger after dark. "Wherever you see a Pandoran plant—all of those plants are actually electric lighting fixtures," Rohde said. "They all light up at night. They are all connected to a centralized show control system, so not only can we make them light up, we can send waves of illumination through all of the plants in the land." Projection mapping would add the mountains to the bioluminescent effects, and the sounds of Pandoran animals would be heard through speakers hidden throughout the landscaping (an audio effect that ran during the day as well). The idea was to create "a spectacular place to be as the sun goes down. As the shadow of those mountains falls out across the land, everything starts to glow and come to life."

All that planning and fabricating and programming, and so on, took more than a village, Lomboy said. "It takes an entire city." At the peak

period of designing and building Pandora — The World of Avatar, the team included hundreds of Imagineers in both California and Florida, plus the Lightstorm crew. Cameron's group was based in Los Angeles but extended to New Zealand, since Weta Digital (located in Wellington) had done the bulk of the computer animation that had created Pandora on-screen. "It's an effort that sort of spans many organizations and hundreds of people—by the time we're done, maybe even over a thousand people. And that's not even including us interfacing with our Operations team in Florida at Walt Disney World. So it's like conducting a concert, right? There's this entire symphony of people who are coming together, and they all have their part and piece to make the whole thing come to life."

V. RITES OF PASSAGE

Unlike Jeannette Lomboy, Ed Fritz didn't long to be an Imagineer as a kid. He wanted to build cars (SEE PAGE 355). When Imagineering called Fritz—for a second time—to help with the ride vehicle for Indiana Jones Adventure, Fritz flew out to California for an interview. "I knew everybody, because I'd run into them in Florida when I was working there, and I'd walk the hallways [of Imagineering] and say hi to everybody. And they talked me into moving out there," he recalled. "I told my wife, 'We'll be out in California a couple of years—we'll surf or whatever—and we'll come back to Detroit. All good.' And then, you know, one thing led to another and thirty years later, I'm still doing this."

When the Pandora — The World of Avatar project came along, Fritz joined early brainstorming sessions on the E-ticket attraction. "It was really Joe Rohde and I sitting in his office one day early on talking about what the rides might be," Fritz said. "Joe was throwing out ideas about, 'You're flying in one of those fan-jet choppers,' or 'How could you really fly around the land?' Well, flying on the back of a banshee—that's kind of the big thing in the movie. So we start talking about flying the back of a banshee. He kind of looked at me and said, 'Well, can you build a machine that is so smooth and fluid it feels like you're on an animal—to

make it feel organic?' And I said, 'Oh, yeah, for sure I could figure that out.' And as I walked out of the room, I remember thinking to myself, 'Did I say that out loud? Because I really have no idea how to do that.'"

"With ride systems, you imagine things the way you want them to be," said Lisa Girolami. "But if technology hasn't caught up, you make a decision that you're going to figure out the technology by the time the attraction or the land opens. And that's a big risk, because you make the best educated guesses you can, and everything changes along the way. The only thing that doesn't change is the date. You know that you have to open. But that's where that passion comes in. You never say die."

The attraction that came to be known as Avatar Flight of Passage presented three separate challenges. One was the visual media that would present the landscapes of Pandora—a more complex iteration of the films created for the Soarin' attractions that would be rendered in 3D, as in the Ratatouille attraction, to heighten the sense of immersion. The other two challenges were more mechanical: "One is the chair that you sit on, and the other one is the big machine that moves you around," Fritz explained. "We formed a team and started designing many different iterations of what that machine might look like. Is it a single level machine? Is it two levels? Is it two [riders] wide? Four wide? Ten wide? Five high? All these different configurations of what it might be, and weighing all the technical pros and cons of each of those choices. And we landed on something that's sixteen seats wide and three stories high. But we don't want to build a prototype that big, so we built a two-third-size machine that had all of the same sort of technical characteristics."

At the same time, the team started breaking down the requirements for the "chair" riders would mount—"Those chairs have a longer list of functionality than I can even remember," Fritz said. "We ended up building about fourteen prototypes of that chair—starting from literally a cafeteria chair on a piece of plywood all the way up to a fully functional prototype. So you start with the cafeteria chair, then it was a piece of plywood, and then some cardboard, and then some fiberglass, and then some better fiberglass, and then some steel—and it just evolved."

To work out the math and mechanics needed to create the ride

mechanism, the Imagineers first needed to establish their targets. How much movement was just enough? Defining the range of the "link chairs"—named after the Na'vi's biological connection to their banshees—was done primarily by feel. Working in a warehouse, the Imagineers attached an actual chair to a robot arm. "We sat in it, and we rode up and down. Twelve inches of movement? Twenty-four inches? Thirty-six inches? Forty-eight inches? We tried all these different ranges of motion to figure out what we thought was good enough to make the show believable. And we used the information from that testing to design the entire ride based on that."

"I think the most challenging thing was really to be able to fulfill the emotional promise of riding a banshee on Pandora," said Amy Jupiter, the executive media producer who worked on Flight of Passage. "It took us some time to translate what Jim had in the films [into] the dimensional universe."

Unlike many other attractions, in the which the narrative turns on something going wrong in the course of what seems a simple mission—Star Tours, for example, or Indiana Jones—Flight of Passage was always intended to be a worry-free celebration of this imaginary place, a kind of "Soarin' Over Pandora," as Cameron phrased it. "What we were selling there was an experience of beauty and being physically present in the world of *Avatar*," he said. "I saw it as more scenic and not hardcore action."

Each dip and turn of the banshee's flight had to be turned into movements of the link chairs and of the "big machine" in which they sat, together providing noticeable tilt on all three axes: side to side, back to front, and up and down. It was a tricky mix that needed to balance thrills and awe. "I felt early that the ride was too rough, that it was trying to compete with hardcore simulator rides for an adrenaline rush," Cameron said. "So I asked them to back off on that. I felt the visual experience of it with the big dome screen and the high-resolution projection of the 3D would be so compelling that you wouldn't want to just get kind of pounded through it. You'd want to take it in and enjoy it. So I think we met on a middle ground there. It's still got some good drops."

It also had the latest Imagineering 4D effects. Some were standard: a wind machine simulated soaring through the air, and odors of flora and fauna were occasionally piped in. What was new, though, was the simulation of riding a living, breathing creature. The Imagineers had long worked on ways to immerse guests in an experience, to extend the illusion of an attraction's environment to encompass the ride vehicle itself, whether with the boats of the Jungle Cruise, the "shrinking" Omnimover cars of Adventure Thru Inner Space, or the jeep-like vehicles of the Indiana Jones Adventure. But this was the first time riders would be melded with what seemed to be a sentient entity.

To pull off the banshee illusion, air bladders in each chair adjacent to the riders' legs inflated and deflated to reproduce a banshee's breathing, and the seat's movements were programmed to feel organic rather than mechanical. "It's a pretty remarkable experience," Cameron said. "I think it also sets a new bar for the next generation of flight simulator ride shows. It's amazing how quickly the mind edits out what's behind you. It's not like you feel compelled to look over your shoulder to see if Pandora's still there behind you, because you're so compelled by what's in front of you and what's coming and the creatures that pop up and the ones that fly by you and the ones that kind of fall in with you—and you get to study for a while—and then they peel away."

Jupiter worked with other Disney artists and with Cameron's team on the high-resolution, photo-realistic 3D animated film projected on a ninety-foot-tall domed screen in front of the riders. Much of the animation was based on performance-capture, courtesy of the facilities of Lightstorm Entertainment in Manhattan Beach, California. "What's really amazing is that we were able to put banshees on a stick and have our creator director and our designers actually perform the flight of the banshees," Cameron related. "And that provided our first ride profile."

The team working on the film used the same previsualization tools Cameron had used in planning his feature. Performance capture data was input into MotionBuilder, the 3D computer animation program used for *Avatar*. Cameron also provided to the Imagineers existing digital assets from the film—everything from digital leaves to floating mountains.

"It was like the two teams just merged," he said. "Because you could work at lower resolution [in pre-visualization] and change animation very quickly, change your flight paths very quickly. So it was a kind of fast prototyping loop. And then the ride programmers would work with [the revisions]. And everybody's running back and forth" between Manhattan Beach and Glendale.

The Lightstorm team also worked on building digitally the virtual sets the banshees would fly over—postcard-worthy landscapes, some of which did not appear in the original *Avatar*, such as an ocean filled with whale-like creatures. The new locations enhanced the potential for 4D effects. As the banshees flew through the tube created by a giant breaking wave, for example, riders would feel water droplets on their faces. Once both the visual storytelling and the corresponding ride programming were locked, the Lightstorm team could render the animation at the extremely high resolution that made the ninety-foot-tall images appear as real as, say, footage from a National Geographic drone. "That's when everybody's jaws are really going to drop," Cameron predicted. "That's when your eyes are going to bug out."

VI. ESCAPE FROM THE UNCANNY VALLEY

Avatar Flight of Passage would take guests soaring over Pandora in dramatic fashion, while the Na'vi River Journey would take them into the world at ground level and at a gentle pace, immersing them in the lush forest environment seen in the film and a bit of Na'vi culture. The floating vehicles were reminiscent of classic Disney attractions like Pirates of the Caribbean, "it's a small world," and Living with the Land, only this time the boats resembled supersized handmade canoes, appropriate to Pandora. Unlike those episodic attractions, the River Journey was an uninterrupted immersion in the land's flora and fauna, building gradually to an appearance by a Na'vi. Riders would begin in a cavern dotted with glowing mushrooms, then emerge onto the signature nighttime surface with bioluminescent life-forms all around them,

including many plants and creatures recognizable from the film and others created just for Disney's Animal Kingdom. Most would be physical creations, but some were brought to life with high-tech projection technology, which provided glimpses of stalking beasts through the foliage or cavorting creatures that appeared as shadows on giant leaves. As the boats progressed, music could be heard, getting louder and louder until a Na'vi shaman appeared—a smoothly gesturing and swaying Audio-Animatronics figure—singing and chanting in the Na'vi language. The boats then returned to the caverns and the boarding area.

The River Journey presented a separate set of challenges from Flight of Passage. Apart from the projection effects, everything in the dark ride existed in three dimensions, and where guests' eyes might linger during the leisurely tour was impossible to predict, leaving no room for cheating on any leaf or stalk. "There might be something you saw in the movie that we wanted to bring into our land but you only ever saw it from the front [in *Avatar*]," Lisa Girolami said. "So what does it look like as you turn around and look at the backside? What does it look like in three dimensions?"

To keep the experience as rich as possible, the Imagineers also invented "things that didn't exist in the first movie, in terms of sounds and different foliage and things like that." To keep the attraction tethered to the film, *Avatar* composer James Horner consulted on the music, and anything along the way that appeared to be Na'vi-made, such as the boats, would appear to have been constructed from natural materials—plant fibers and bones, for instance—since the Na'vi did not use metal of any kind.

To underscore bioluminescence within Pandora — The World of Avatar, "the look we went for is a black light look, because there are a lot of things you can do with black light. We wanted dark because we had a number of special effects that needed darkness," such as the projections, Girolami explained. "But then you have the constraints of UV light. Any time you paint [with luminescent pigments], if you're not careful, it can look kind of like a carnival ride with all these crazy colors. We needed it

to look realistic. We had to make this experience feel like nighttime on the moon of Pandora and not look like a midway somewhere."

But by far the greatest challenge of the Na'vi River Journey was the Shaman of Songs, which would expand the boundaries of Audio-Animatronics in realism, expressive detail, range of motion, and sheer size, since the Na'vi are ten feet tall when standing. Even seated, the shaman was an impressive figure who would have made the Pirates of the Caribbean look like the Seven Dwarfs, had they ever met. She was to be "ten feet tall and look completely alive," James Cameron said. The director was particularly focused on the shaman because of his lifelong affection for Walt Disney's original Great Moments with Mr. Lincoln. He had a vivid memory of first seeing Disney's Lincoln when he was seventeen or eighteen years old. "I was absolutely dumbfounded by it," feeling like "I was five years old. Part of your mind is saying, 'This is a robot,' but it doesn't look like a robot. It didn't occur to me that there were all these cables underneath the floor. I thought he was going to walk away at the end of it." He hoped the Na'vi shaman would have a similar effect on modern audiences. "There's something very powerful about that illusion that you're seeing a living being that can't possibly exist. It's mesmerizing."

To push the illusion of life to new limits, the Imagineers started with the face—and a senior research scientist named Akhil Madhani, a robotics expert whose previous inventions included the Black Falcon, a robot that could perform surgery under the guidance of a surgeon thousands of miles away. "Traditionally with animatronics, we sculpt an expression into the character because they just don't have that much range of motion in their faces," Madhani said. "We wanted a character that could express emotion." That required many more motors in the shaman's head, which was now possible with a move to electric actuators. "We can get motors that are the size of my little finger that thirty years ago would have been the size of my hand," Madhani said, "and it allows us to place them inside the face." The shaman's expressions were controlled by forty-two electric motors, each one acting independently and accurate to tiny increments. Dozens more controlled her long arms

and body, for a total of about eighty independent motors in that single figure.

But the closer the Imagineers got to the illusion of life, the more they risked creating something scary and unreal. "If the skin thickness is wrong, if the sculpt is wrong, if the placement of the motors is wrong, or if where you move them is wrong, it very quickly goes to, 'This is creepy.' It's deforming in the wrong way, and it doesn't look realistic."

"There's a challenge when you try to make an animated figure look realistic," Joe Rohde said. "When the figure is stylized, we accept a certain kind of simplicity. The closer you get to something that really looks real, you hit this thing called the uncanny valley, where it's just not real enough. Any mistake you make is really creepy. We've been able to come up with a figure whose facial expressions and movements are so realistic that it jumps the uncanny valley."

Lightstorm again contributed their expertise. "We were able to plug in, almost as a module, our way of capturing motion and performance [from human actors] that we had used to make the movie," Cameron said. That "became the front end for the programming of the shaman. So, it actually represents real human instinctive movement that's now being manifested through an incredibly complex machine."

Along the way, the Shaman of Songs even mesmerized her creators. "We created a robot, we programmed the robot. She did what we said. But we were watching her during what we call the reset"—when the figure reaches the end of her program and stops momentarily before starting over. "She goes through her motions, she goes to her reset, she stops, and she turns back to begin—and everybody goes, 'What was that? That did not look like a robot resetting. That looked like she just stopped what she was doing, thought of something, and went back to start again.'" The notion that the shaman might give the impression of having unspoken thoughts led Rohde to write a second script for her performance: "She has the script of the things she's saying and what they mean in Na'vi and an interior script of what she's thinking that doesn't always match exactly [what she's saying aloud]. So her facial expressions become really, weirdly human and believable."

VII. WELCOME TO OUR WORLD

The Shaman of Songs was not a character from *Avatar*, nor were the Na'vi seen during Flight of Passage. Pandora — The World of Avatar was just that: the world of the movie, but not the movie itself. Unlike Cars Land, which largely adhered to the characters and time frame of the Pixar movies, this new land extended the franchise. As the sequels slipped into an uncertain future during the five years Pandora — The World of Avatar was in production, the Imagineers had to acknowledge that many of the guests wandering into this fantasy realm would not be intimately familiar with its source material—either not having seen it, especially younger children, or not recalling its details from a viewing years in the past.

The storytelling needed to be strong enough to win over the neophytes and the dabblers as well as the fans. Cameron himself, Joe Rohde observed, would be "coming to a place that's richer and different and has things he's never seen in a world he invented."

Perhaps to avoid impeding the thousands of fans expected for the attraction's opening day—May 27, 2017—a modest dedication ceremony was held a few days earlier, on May 24, during the preview period for select passholders and invited guests. On dedication day, Bob Iger spoke during a brief celebration at the foot of the floating mountains, preceded and followed by a crew of eight (human) drummers performing Na'vi music. "Disney has been doing things no one thought possible for almost a century now," he said, "thanks to the visionaries and innovators that have gigantic ideas and great courage and the sheer will to deliver the impossible. And, of course, at Disney we call these people Imagineers, who turn bold ambitions into incredible experiences that only Disney can create."

With that, Iger turned to acknowledge "the creative and spiritual leader of this great land, Joe Rohde"—a rare personal tribute for an Imagineer during a theme park dedication. Cameron, the only other speaker, also thanked Rohde "and his incredible team of Imagineers" in his remarks, before making explicit the logic behind putting a fantasy realm within the studied realism of the rest of Disney's Animal Kingdom.

"This park, which is based on a deep respect for nature," Cameron said, was "the perfect place to connect Pandora to our world . . . [to] inspire us to understand and respect the natural world and our place in it."

The years of expectation and a months-long marketing campaign—including an ad during the 2017 Academy Awards broadcast that featured Cameron and an English-speaking Na'vi—drew both media attention and thousands of visitors to opening day, the Saturday of Memorial Day weekend. Fans gathered outside the park by the hundreds before dawn, and the lines just to get into the area for those without FastPasses grew to an estimated three to six hours—not including additional queue time for the two attractions.

The press coverage of the newly opened land suggested the Imagineers had communicated exactly what they hoped. Disney fan websites were ecstatic, and the hometown *Orlando Sentinel* headlined its next-day article, "Pandora Fans Offer Positive Reviews for Disney's Latest Creation." Even more cynical journalists were impressed. "Stepping into Pandora — The World of Avatar . . . is, as the creators surely intended, like entering another planet," reported *Vulture*, as part of a long, often critical July 2017 article. "Strange plants sit next to ones that you sort of recognize. You can hear odd animals rustle in the underbrush. At night, a bioluminescent forest comes to life, bathing everything in an ethereal glow. Your footsteps light up as you walk. Everything, it seems, is *alive*. And the attractions inside the land are just as immersive." Hard evidence of the land's success arrived a year later, with a May 2018 report that the opening of Pandora — The World of Avatar was responsible for a 15 percent increase in attendance at Disney's Animal Kingdom in 2017, compared with the year before. For 2018, the first full year for Pandora — The World of Avatar, attendance climbed more than another million, hitting 13.75 million for the year.

The teamwork of Lightstorm and Imagineering had successfully communicated Pandora's kinship to the other celebrations of nature and conservation in Disney's Animal Kingdom. Some pundits noted not just the land's connections to other areas of its Disney's Animal Kingdom home but also to some of Disney's most beloved theme park attractions

of the past, particularly those free from any confining, pre-existing story line. The *New York Times* observed that "the Pandora rides recall the Disney of old—the take-it-all-in scenes of Pirates of the Caribbean and the Haunted Mansion, where fans to this day still debate the ins and outs of the story." Despite the fact that half a century separated those Disneyland attractions from the creation of Pandora — The World of Avatar, and that none of the same artists were involved, the Imagineering aesthetic, the philosophy of storytelling and placemaking, remained unchanged.

As Rohde put it, "The strength of Imagineering really is Imagineers. The through line of Imagineering is the culture of Imagineering, and the center of that has to do with this devotion to the idea of story and that things have meaning." Throughout its history, Imagineering fostered a culture of collaboration in an effort to retain "this focus on an obligation to our guests that stays the same [across the years]. You know, Imagineering at one point had maybe four hundred people in it and—when I started—two parks. It's a completely different thing now, at one level of analysis. And yet it couldn't be a thing at all if it didn't have this through line of devotion to story, devotion to collaboration, and devotion to the audience."

A fourth pillar of Imagineering was less weighty than these other three: a devotion to fun. Perhaps the person most pleased with the Imagineers' five-plus-year effort to bring Pandora — The World of Avatar to life was James Cameron, who not only loved the result but thoroughly enjoyed the process. "Oh, yeah," he said, "threaten me with a good time. Put me in with a bunch of engineers and artists and creative people and take the constraints off and say, 'Go nuts!' You know, that's fantastic."

CHAPTER 31:

AMONG THE STARS

*"When we announced that Lucasfilm was gonna become part
of the Disney family, all of Imagineering was abuzz with 'Oh
my gosh, now we can go big.' But also, it went from, 'Oh my
gosh, look at all the things we can do,' to 'Oh my gosh, we
better get this right,' pretty quickly."* —Scott Trowbridge

I. BIG REVEALS

IMAGINEER CHRIS BEATTY vividly remembered one snowy Christmas morning in Ohio when he was just a boy, in the early 1980s. Excited and hopeful, he ran downstairs to find a stack of gifts under the Christmas tree, and he "just dug in—ripping the paper off the presents." He knew what he wanted: "*Star Wars* played a huge role in our life," he recalled, an obsession he and his friends turned into play with the help of toy action figures. That Christmas, "I remember the very first figure I unwrapped was the Darth Vader figure from [Episode V:] *Empire Strikes Back*. I can still remember the smell of the plastic, what that vinyl figure smells like today. It's powerful. And I remember taking all those toys and going out in the snow on Christmas morning and making a Hoth playset and bringing that world to life."

It was an experience repeated millions of times across the United States, if not the world, beginning after the release of the original *Star Wars* in 1977 and continuing without interruption for decades. By 2012,

there were six live-action feature films as well as several animated television series; dozens of home videogames; countless books, comics, and trading cards; and other merchandise from toys and clothes to tape dispensers and fishing tackle boxes. It wasn't just the licensing that had exploded—the mythology had grown exponentially since that first movie, and the fan base continued to renew itself generation after generation. Bob Iger estimated that the *Star Wars* universe in 2012 boasted more than seventeen thousand characters, thousands of planets, and two hundred years of existing history. It was the cultural equivalent of a perpetual motion machine—seemingly impossible, yet there it was, still spinning and spinning after more than thirty years. So Iger's deal to purchase Lucasfilm, the privately held company that owned the rights to this narrative gold mine, seemed something of a steal at just over $4 billion.

The October 30, 2012, announcement surprised many in Hollywood, since Lucasfilm was not known to be for sale, but it was not out of the blue. It came on the heels of George Lucas having announced his retirement. Five months earlier, he had hired Kathleen Kennedy, Steven Spielberg's long-time producer and a forty-year associate of Lucas, as Lucasfilm's co-chair. The goal was to have her run the company solo after Lucas bowed out. When Iger approached Lucas about a sale, using the post-acquisition successes of Pixar and Marvel as his primary arguments, Lucas told him, "If there is anyone I want to sell to, it is you," Iger recounted later.

The deal was the third and by some measures the most precious crown jewel added to the crown of Iger's strategy to expand Disney's intellectual properties with stellar acquisitions. Pixar and Marvel had impressive arrays of toys and other products, of course, as well as dedicated fans, but their long-term potential outside of the media of their origins remained somewhat unproven at the time Disney bought them. Lucasfilm, it seemed, had already conquered the universe—including Disney theme parks.

"Disney had a long history with Lucasfilm, going all the way back to Captain EO—and Star Tours, of course," noted Imagineer Scott Trowbridge, and that partnership had continued right up to the Lucasfilm acquisition. The year before Iger snapped up the company, Imagineering

had debuted Star Tours — The Adventures Continue, a complete over-haul of the popular Star Tours attractions, with more than a dozen extended new 3D film clips created by Industrial Light & Magic, the special effects and animation division of Lucasfilm that Disney would now own. (The deal also included Skywalker Sound and the rights to the Indiana Jones franchise.)

The Star Tours revamp had been announced in 2009 and in dis-cussion with Lucasfilm for several years before that. Opening in May 2011 at Disney's Hollywood Studios and June in Disneyland, the upgrade included not only the new media but also enhancements to the motion simulation system, a 4K-resolution digital projection system, higher-quality audio, and the promise of literally thousands of story variations, as the new visuals (and corresponding motion programming) were com-bined at random for each ride cycle. And that was just one attraction at two parks. (Paris and Tokyo would soon follow.) Now Imagineering would have the entire *Star Wars* universe as its playground.

The 2012 acquisition came at a crucial time for Imagineering. Proj-ects like the Star Tours overhaul and the several groundbreaking Shanghai Disneyland attractions, then in their early stages, utilized the latest technology to supersize guest experiences, but they remained rooted in well-established attraction templates. They were still motion-simulation rides (Star Tours — The Adventures Continue), boat rides (Pirates of the Caribbean: Battle for the Sunken Treasure), dark rides (Mystic Manor), and roller coasters (TRON Lightcycle Power Run). The next challenge for Imagineering was to draw upon emerging technologies to create completely new, fully immersive guest experiences that related stories in fresh, innovative ways. Pandora — The World of Avatar would soon represent the first steps in that direction, with its recreation of an alien moon's ecosystem to envelop guests. But the addition of the Lucasfilm portfolio called for an even greater leap forward—under the watchful eyes of a large and demanding fan base. Star Tours — The Adventures Continue, Shanghai's E-ticket attractions, and Pandora — The World of Avatar all blended mechanical marvels, digital programming precision, and projected media in pioneering, awe-inspiring ways. Now it was up

to the Imagineers to take these technological breakthroughs to their next level—and into a galaxy far, far away. It was a pressurized mix of beloved IP, audience expectations, and a kind of "can you top this?" imperative.

The response to the Lucasfilm acquisition at Imagineering was jubilation, Beatty recounted. He was in a conference room, where a small number of Imagineers had been told the news about fifteen minutes before the rest of the company found out. They would be the core group to start work on a new *Star Wars* project, much to their delight. Then they were asked to stay put until everyone else had heard, and they spent that time talking excitedly among themselves, along the lines of "it's going to be incredible—the possibilities!" They knew the rest of their coworkers had gotten the news when they heard "the cheering from all the other conference rooms and in the hallways. Every Imagineer on campus was just ecstatic about the possibility of bringing this land to life that fans had only dreamed about entering into for the past forty years."

"When we announced that Lucasfilm was going to become part of the Disney family, immediately all of Imagineering was abuzz with, 'Oh my gosh. Now we can do this. Now we can go big.'" recalled Scott Trowbridge. "It was really an exciting time, but also kind of a daunting challenge, because we also knew that we had to get it right if we were going to do something big with *Star Wars*. We had to do right by the fans; we had to do right by the fiction. We had to do right by the other creators that were working on *Star Wars*. It went from, 'Oh my gosh—look at all the things we can do,' to 'Oh my gosh—we better get this right.'"

Kennedy believed the *Star Wars* saga was a natural for an immersive land. "All of us [at Lucasfilm] have talked a lot about the crossover between film experiences and theme park experiences," she said. "A lot of the innovation that's going on inside of film is very well suited to emotional connections with audiences inside theme parks." Filmmakers who translate novels into movies, she noted, focus not on the exact narrative details but on "what is impacting somebody. What feeling are they actually taking away from the experience? And that's the same conversation you have about how you're translating something to a theme park experience."

For Beatty, the prospect of working on an expansive *Star Wars* project took him back to those days of posing action figures with his friends—an experience he considered integral to his career at Walt Disney Imagineering. "I think as Imagineers we always bring a sense of play and a sense of discovery to everything we design," he said. "And I think a lot of us tap back to our roots, growing up and the playfulness we had as kids, creating imagined worlds. It was no different for me. I remember building a place in my backyard to have my figurines have these epic battles—TIE fighters coming in, and X-wings battling. And my friends from down the street would bring all of their *Star Wars* figures, and we had these huge, huge epic battles."

Trowbridge, too, had his childhood history with the franchise. "I remember seeing *Star Wars* on the big screen for the first time and just being blown away by this fantastic environment and this amazing archetypal kind of mythological-level story," he said. "It just felt like such a completely thought-out universe. I remember thinking what a cool thing [it was] that someone dreamt up this whole idea and made it seem so plausible, made it seem so real yet so different from everything or anything that existed in our world."

But what would all the grown-up *Star Wars* fans at Imagineering invent to re-create that childlike sense of immersion in George Lucas's universe? And what could they create that would be both new and surprising to its legions of fans? After all, *Star Wars* devotees were a notoriously vocal contingent when they felt slighted. It fell to Trowbridge to figure all that out.

Trowbridge and his hand-picked *Star Wars* team worked for a year and half to come up with . . . something. "We really focused in on the ideation of it," he said. "What are the core ideas that we want to develop? What are the primary themes?" The team settled on a narrative crux of the *Star Wars* saga: self-empowerment and "what it means to be a hero—what it means to rise up above your station." To build those ideas into a theme park, they knew they had to create an environment that didn't already belong to someone else's story. Early discussions of recreating one or more environments familiar from the films were shelved. Imagineering's *Star Wars* saga would not be Luke Skywalker's, it

would belong to each park guest. "We wanted to build a place that was not reminiscent of a place we've been to" through the existing *Star Wars* mythology. "We wanted to build a place where we could discover our own story—a new story for us."

The attractions were not the first thing on the agenda. "We actually started with a pretty fundamental question: who do we want to be in *Star Wars*? What kind of a character am I going to play? If we're going to let people live their own story and we're going to become the protagonist, what kind of a protagonist are we going to be? From there we started to think about what kind of stories we wanted to tell that allowed people to express those perspectives and then to develop that into the kinds of experiences we wanted to have. And then the hard work begins of figuring out, how do we make that real?"

"The power in *Star Wars* is not the spaceships," Imagineer Tony Baxter said. "It's not the hardware. It's not the blasters and the lightsabers and all of that. It's Luke and Han and Leia and the adventures they had and how much we wanted to be them, wanted to be with them, wanted to emulate the things that they did. So the wish fulfillment of getting to go on that kind of a journey is what it was all about. We put one line in that original Star Tours experience at Disneyland that really encapsulated all of that: the pilot said, 'I've always wanted to do this!' as we went down into that trench shot [on the Death Star]. It was every kid's desire sitting in the theater eating that popcorn—'Wouldn't it be cool to be Luke Skywalker and get to do this?' So you've got to look for those moments."

"The Blue Sky process here at Imagineering is always exciting," Trowbridge said, "but you can only imagine sitting down at the table for the first time, [saying,] 'Okay, let's think about what we want to do with *Star Wars*.'" The Blue Sky period gave team members the chance to present ideas big and small for this new land on a daily basis. "I think that was my favorite part. Almost every day we had a new set of storyboards and we would get up and just pitch to each other. The energy was fantastic, and we had a group of people who sat at the table [saying,] 'I don't think we can do that.' 'I think we can do this.' 'We definitely can do that, but there's no way we can do that.' And you go, 'Okay, tomorrow we'll fix

this and we'll come back again.' So it was organic—and no two days were alike. We spent months and months just looking at different layouts."

Creating a new environment didn't mean banning all the iconic *Star Wars* elements. This nascent *Star Wars* land wouldn't be Tatooine or Hoth or Endor, which already had specific stories and heroes attached, but there would be lightsabers and Stormtroopers and X-wing fighters. "Our mantra was along the lines of, 'If you wouldn't see something in a [*Star Wars*] film, you shouldn't see it in this land.'"

This would be a new level of guest immersion. Cars Land put you in the world of the Pixar films, but you did not become a car, nor did visitors to Pandora — The World of Avatar encounter its ten-foot-tall inhabitants on the area's outside pathways. The *Star Wars* land the Imagineers envisioned would turn guests into inhabitants, interacting with their surroundings and with Stormtroopers and Resistance fighters and lightsaber salespeople, and so on, just as they would in a galaxy far, far away. "Our first guiding principle was to build a place that felt authentic and that you could really truly believe you were living a *Star Wars* experience," Trowbridge said. That would include not only the attractions and the buildings but the cast wardrobe, the merchandise in the stores, and the restaurants and food kiosks and the fare they served. The team wanted guests to be able to enjoy "a glass of blue milk you buy off of the farmer at the blue milk stand. All of that kind of [detail] comes together to reinforce your *Star Wars* story."

Trowbridge's team was thinking big—bigger than any previous Imagineering project short of opening a completely new park. They proposed to Imagineering leadership and Iger not one *Star Wars* land, but two, fourteen acres each, to be built simultaneously in Disneyland in Anaheim and Disney's Hollywood Studios in Walt Disney World. Both lands would be built "at a level of technology, a level of fidelity that might be above and beyond what anybody has been expecting," Trowbridge said. "That was a pretty big shift—going to two of these, with the same team and pretty much the same time frame. In fact, we actually accelerated the time frame a bit because we knew we wanted to get it open as quickly as we could."

Disney said yes, and Iger announced the two-park project to the world

at the D23 Expo in August 2015. The lands did not yet have a name, but each would be "a jaw-dropping new world," Iger promised, in front of a giant blowup of concept art that featured the *Millennium Falcon* coming in for a landing on a planet previous unknown in the *Star Wars* universe. As the Imagineers fretted backstage, wondering how the crowd of emotionally invested (and often vocal) fans would respond, Iger called the project the Disney Parks division's "largest single-themed land expansion ever." The Imagineers need not have worried: once Iger revealed that one of the two new lands would be "right here in Anaheim at Disneyland," the crowd was shouting and on their feet with enthusiasm.

The fourteen-acre Disneyland project would replace the Big Thunder Ranch and a good deal of backstage area beyond the original footprint of Disneyland. The construction necessitated an eighteen-month shutdown of the Rivers of America, Pirate's Lair on Tom Sawyer Island, the *Fantasmic!* show, and the Disneyland Railroad while the river and railway were rerouted. (All reopened in July 2017.) At Disney's Hollywood Studios, the land would absorb most of the former Streets of America, leaving the Muppet*Vision 3D attraction on a block-long Los Angeles-themed street renamed Grand Avenue.

After the 2015 reveal, Disney kept up the drip feed of information for the next two years, building awareness. Scott Trowbridge, for example, teased crowds at a premiere event for a ten-minute 3D film called *Path of the Jedi* that opened in Tomorrowland at Disneyland in November 2015, promoting the December worldwide release of *The Force Awakens*. Perhaps most prominently, Harrison Ford shared fresh concept art on *The Wonderful World of Disney: Disneyland 60* on ABC in February 2016. "Every year, we sort of added to the story," said Imagineer Robin Reardon, who joined the Galaxy's Edge team as executive producer in 2014. "But how we told the story was always really consistent: this was a place where guests are going to come in and write their own Star Wars story."

Reardon had begun her career at Imagineering during the creation of Disney's Hollywood Studios, but had been working elsewhere for many years when Trowbridge and Bruce Vaughn coaxed her back with two words: *Star Wars*. There was another lure to get her to return, she

recalled: the chance to work with a new generation of talent. "One of the things Bruce Vaughn dangled out there for me was that we had a group of young Imagineers [on the *Star Wars* project]. We've got to grow 'em up fast. They're ready, and they're going to be great." Also impressive to Reardon was the number of team members who were women. "Many of the programming and software leads are women," she noted. "The producers on the project are women. We have a technical director in the village who's got a chemical engineering background, and she's amazing."

On Imagineering's narrative team for Galaxy's Edge, the story lead was writer Margaret Kerrison, who immersed herself in everything *Star Wars* for years, making sure every detail of the land would fit within the canon, from the biggest moments in the attractions to the tiniest prop in the outpost market. "What's most important to me, as a storyteller, is how people feel when they walk into the land," she said. "We want our guests to feel encouraged to explore and discover every corner of Black Spire Outpost."

As the project progressed, Reardon noted, there were "more women onsite and in leadership roles than certainly there were when I started in the business in 1985—by a longshot. There was definitely a different dynamic, and I think that's great. There's a group of really young, talented women on my direct team—midtwenties to midthirties—an amazing next generation [of Imagineers]."

Although fortified with new and returning recruits, the Imagineering team wasn't going it alone—it was a partnership with their new coworkers at Lucasfilm. "Getting Lucasfilm on board [for creating an entirely new planet] was easy," said Beatty, who had become executive creative director for the *Star Wars* lands soon after finishing his work on the new Fantasyland area in the Magic Kingdom. "The entire Lucas creative team championed it from day one." Less easy to navigate were the nearly four hundred miles between San Francisco, where Lucasfilm was based, and Glendale, especially given the high degree of secrecy shrouding everything about the project. "The amount of secrecy and security around this project has been at a level I've never seen before. We wanted to have the ability to share stories and ideas, and we wanted to understand

where Lucasfilm and the writers of the [movie] franchise were taking the characters." *The Force Awakens* came out in late 2015, but the Imagineers couldn't wait that long to see where Lucasfilm was taking the story, since the park project needed to reflect the latest mythology. It was a highly secure two-way street, as representatives from Imagineering visited the film's sets, and the Imagineers shared their artwork with Lucasfilm, and each side kept the secrets of the other.

Deciding what the new land would be named "was quite an exploration," Trowbridge said. As the story developed, about a planet on the rim of the *Star Wars* galaxy—a distant, largely forgotten outpost populated by shady characters—the team brainstormed many naming options "and just kind of stared at them for a long time. We mocked up various versions in graphic form also, put them up around the office and lived with them for a while. It was important that the name feel like a real place, that it feel unique, that it speak to a broad audience of folks with various levels of *Star Wars* awareness, and that it speak to the promise of adventure and fun ahead." Before a name could be considered, Trowbridge related, it had to fulfill six criteria, established in early 2017:

- Lead with *Star Wars*.
- Communicate a place, not an idea or single experience.
- [Be] relatable and appealing primarily to mass, mainstream audience.
- Create intrigue and motivation to engage.
- Create sense of action / adventure / possibility.
- Provide a broad foundation to build around and on over time.

"We evaluated everything from the very utilitarian 'Star Wars Land' (boring) to the very story-forward name of 'Star Wars: The Lost Outpost' (mainstream audience may not relate)," Trowbridge noted. "We even took a shortlist of a dozen and researched them with potential guests to see how the names matched up with what we hoped they would communicate. In the end, one of the original candidates, *Star Wars*: Galaxy's Edge, just seemed like the best choice."

With a name, a narrative, and a layout set by the summer of 2017, everyone was looking forward to "that big reveal," Beatty said—the disclosure of the new lands' moniker and exterior design. "There's something kind of magical about that." Bob Chapek, then chairman of Walt Disney Parks and Resorts, revealed the *Star Wars*: Galaxy's Edge name to the world at the D23 Expo on July 15, 2017, and the Imagineers at the same time revealed a detailed scale model to share with the thousands of Disney fans on hand.

"We toiled in secret for a long time, coming up with what it should be and how it would work and what it would look like," Trowbridge said. A digital model or concept art viewed on a screen kept people at a certain distance, he noted, while "someone looking at [a model] can go, 'I want to go there. I can see myself being in that space.' We felt it was the best way to unveil this project."

For Beatty, the project conjured memories of playing *Star Wars* in his yard back home in Ohio. "And now, as an Imagineer, it's amazing because we're just building that play set at full size." He looked forward to being able to walk through the park and "imagine being that ten-year-old kid with his action figures in the backyard. It's just on a scale that's full size—and epic. It's really magical because you really are getting to live out your childhood dream and bring these worlds to life in a way that you could have never imagined when you were ten."

II. THE SMELL OF AUTHENTICITY

How do you invent an entire planet? While work on *Star Wars*: Galaxy's Edge overlapped with work on Pandora — The World of Avatar, the two teams faced different challenges. Much of Pandora already existed, at least in photo-real CGI form, while Galaxy's Edge would be set on a planet not previously included within *Star Wars* mythology, the world of Batuu. "This is a place that no one's ever seen before," Chris Beatty said. "So we had this balance that we had to find of old and new. It's not like Tatooine or Dagobah or Hoth, that we've seen in the franchise films, so it was important to go back to the very beginning and understand what

makes *Star Wars* . . . *Star Wars*. What's the DNA? What's the foundation that we would have to build as a team to bring this place to life so that when you walk in the gate for the very first time—when you walk through that [entrance] tunnel and the land opens up to you—you go, 'Of course this is *Star Wars*. I've never seen this place before, but it looks, it smells, it tastes like *Star Wars*."

The layout of the two lands would be slightly different, since the Disneyland plot allowed for three entrances and the Hollywood Studios site would have just two. All the entrances would be tunnel-like, so that Batuu came into view only as guests descended and re-emerged on the other side. "One of the biggest things I think we as a team are proud of are the cinematic reveals," Beatty said. "What we love as storytellers is not showing you everything at one time. What we like to do is [as you] come in, give you a little taste of it, a moment where you [think] . . . 'Just look at this building. This is the droid shop. This is incredible.' And then as you turn the corner, we open this amazing view up to you." As guests wander deeper into the land, each new reveal was designed to evoke awe and excitement. "We're always pulling you through the scene to a destination you just haven't seen yet. All these details start to come together to create those cinematic moments."

To imagine those scenes, the Imagineers consulted the Lucas Museum of Narrative Art, along with the Lucasfilm Archives, absorbing the early concept art George Lucas had commissioned from illustrator Ralph McQuarrie, drawings that determined much of the look of the original *Star Wars* trilogy. "As matter of fact," Beatty recalled, "we even had a board in our design studio that was sort of a test board. When you drew something, you held it up to this wall of all Ralph McQuarrie's work. And if it looked like something Ralph McQuarrie had a hand in, it got to go to the next round. If it didn't look like something Ralph had designed or developed, we threw it out. No matter how good it was, it had to be thrown out."

It was, Beatty said, "just an honor to be actually holding and touching [McQuarrie's] original sketches and really get to dive into design elements and motifs that I'd never seen before in books and little thumbnail

sketches Ralph had [made]. We started to put together a design bible, as I call it. It's like a patchwork quilt of elements that we don't know how they all go together yet. But you start to take a piece of this and a piece of that and kind of weave them together to craft a visual look at a place." The team also spent a lot of time absorbing both the films and the television series Lucasfilm had created over the years. "I've lost track of how many times we must have watched the original trilogy and the prequel trilogy," Trowbridge said, laughing at the memory, adding that he and his team also watched every season from the *Star Wars: The Clone Wars* animated series that had been released at that time. Of the show, he noted, " [Supervising director] Dave Filoni and the team had done some great work with George. They sat together for six years, six seasons, side by side, crafting the stories . . . so there was a lot of George in that saga."

The Imagineers also worked closely with Doug Chiang, the executive creative director at Lucasfilm. He had done design work on Episodes I and II, then left Lucasfilm for a while, returning to work as the concept artist for Episode VII: *The Force Awakens* and production designer for 2016's *Rogue One: A Star Wars Story*. He now oversaw *Star Wars* design for films, television, videogames, and theme parks. The guiding aesthetic of the franchise, Chiang said, was not what the average fan might assume: "George never considered *Star Wars* to be science fiction. He always thought of it as a period film. And so our approach was to design *Star Wars* as a period film." That became even more true as the decades passed and the then-futuristic technology Lucas had envisioned in 1977 became dated and was reimagined for the prequel trilogy, the later episodes, and Galaxy's Edge.

The prop team for Imagineering, for example, prioritized the acquisition of items from the late 1970s and early 1980s, which would better match Lucas's original production design. "When you think about *Star Wars*, it's not a high-tech galaxy," Robin Reardon said. "Most of the stuff—the screens and all that—are never anything after the seventies and eighties, so there's that particular look of the propping." The props for Galaxy's Edge were created under the leadership of Eric Baker, a props fabricator and art director with an extensive Hollywood resume. The props his team generated were a combination of found items that were

repurposed by Baker's team of prop artists, objects constructed from bits and pieces of found items—such as miles of cable and stripped-down seat-backs from an abandoned airliner—and props constructed from scratch.

"Eric and his team set off literally all over the world," Trowbridge said, "sometimes hand in hand with the set decorators and the prop folks for the *Star Wars* films and sometimes on their own. They went to Indian bazaars and strange artifact shops and airplane graveyards in the middle of the desert. Military surplus outlets to buy missile containers that we might find in the Rise of the Resistance area. So literally all over the globe scouring for the source materials. Then they brought it back to this warehouse [near Walt Disney World] and Eric and a dozen or so artists spent the next two years handcrafting these things—turning them into [props,] taking a piece from this and a thing from this and fabricating this and 3D printing that and putting it all together." The artists weren't just fabricators, Trowbridge said, they were "physical storytellers." For each prop, "they can tell you exactly what it does, how it works, who built it [within the *Star Wars* mythology]. They think all of those things through." Their work, he added, always adhered to "a kind of plausibility" that added to the believability of the land around it.

"One of the funniest things was to go to Florida and go to the prop shop and see all the stuff being built," Reardon said. "I mean, just bins of what other people would say was garbage that they were welding together and making into things. And you go . . . 'That's an evaporator!' And when those things started coming into the land, then it was real. Then it was—people lived here and it had a life. It had a heartbeat."

The Imagineers were eager to internalize the *Star Wars* aesthetic that Lucasfilm's Chiang understood so well. Under Chiang's supervision, Beatty recalled "just doing render after render and drawing after drawing and model after model until we got the shapes right, the forms right, the color palette correct. That process took us many years and was really labor intensive. But it was so rewarding, because you really got to understand why things have a certain look and feel to them."

The Imagineers did not confine their research to archives and videos. They also took research trips, both to the sets of *The Force Awakens*

during filming at Pinewood Studios in London and to the real-world locations that had inspired the original filmmakers. "We spent a lot of time in Marrakech [in Morocco] and Istanbul [in Turkey]," Beatty said. "We knew early on we wanted this land to feel mysterious and a little bit dangerous, and we wanted to have a sense of romance, a sense of history—that it was a place that had probably been conquered multiple times, [where] these epic battles had taken place. We kept coming back to Istanbul, to Jerusalem, to Marrakech and Fez in North Africa. That region of the world has a lot of that romantic kind of quality and a sense of amazing history."

The trips were about much more than architecture, Beatty related. "I remember standing in the Grand Bazaar in Istanbul and it's incredible actually to close your eyes, stand in the middle of the bazaar, and you hear the shopkeepers yelling at each other and yelling at patrons trying to get them to buy their goods. And you hear the call to prayer and you hear all these different people speaking different languages. And you can smell the Turkish coffee and you can smell the wet because it's been raining that morning. And the ground you're walking on—those cobbles have been walked on for a thousand years. And you hear the birds fly—even though you're indoors, there are birds, and you can feel them fly by your head, you can hear them. If you close your eyes, you could be in a *Star Wars* film. You could be on the planet Batuu, at Black Spire Outpost. And those moments were incredible because it gave us so much more than just the visual look of this planet. It gave us the feeling of this planet. It told us what it was going to smell like, what we were going to hear, what it would feel like, what it would taste like. And so we took probably over three thousand pictures during those trips—pictures of doorknobs and stones and rubble walls and weird plant life. Those details feed the team. When we come back, we give those pictures to the artisans for carving the rockwork. We give those pictures and stories to the painters, to the sculptors, to our set designers. It's invaluable to them because it's the guide that helped them bring this world to life. And then we put a little *Star Wars* on top of it."

Galaxy's Edge was a groundbreaking effort for Imagineering in

size and ambition, but Beatty saw its roots in one of Walt Disney's own expansion projects for Disneyland. "Of all the places within Disneyland, *Star Wars: Galaxy's Edge* feels probably most like New Orleans Square," he said. "Standing out in front of Pirates of the Caribbean—up on that elevated walkway, looking out at Rivers of America—you see the *Columbia* sailing by and the *Mark Twain* sailing by and you're hearing the jazz bands play and you can smell the restaurants all around you and the people are passing by. There's a sense of energy to it and a vastness and a grandeur to it. But then when you turn the corner and you go down [into] New Orleans Square, it compresses down and it's intimate and you feel almost devoured by that space. And there's amazing little details that you can't even comprehend when you step back and try to look at all of them. You just get lost in all those amazing little details. And then as you find your way down those little hallways and pathways and you can't really see where you're going—there's a sense of exploration."

To achieve a similar experience in Galaxy's Edge—that "sense of expansion and compression" as guests wander through, as Beatty put it—every detail needed to contribute to the story. That included not just every restaurant and shop, but every item sold anywhere, whether a custom-made droid or mass-market beverages. Coca-Cola, for example, agreed to new bottle shapes and label designs unique to Galaxy's Edge. "Everything wants to feel like you are immersed in this authentic *Star Wars* experience," Trowbridge said. "So we worked very closely from day one with our Operations partners, with our food and beverage partners, with our merchandise partners." All the vendors went through their own development process, in consultation with the Imagineers and Lucasfilm, to contribute to the story. "And then, of course, there's the place itself," Trowbridge said when the land was still under construction. "With an amazing amount of detail, every square inch of *Star Wars: Galaxy's Edge* has pretty much been hand built, or hand carved, or hand-painted, or hand laid. Every cobble in the cobblestone streets has been laid down by somebody with their own hands. It's truly an artistic labor of love to kind of make this galaxy feel believable—like it has a history, like it has a story to tell, and that it is a great setting for you to lose yourself in the world of *Star Wars*."

The story of Galaxy's Edge was in part conjured by the name given to the Batuu village the Imagineers had invented: the Black Spire Outpost. The once-vibrant trading post on the edge of the galaxy had become a haven for "the smugglers, the bounty hunters, the rogue adventurers looking to crew up, the people who don't want to be found—basically all the interesting people"—as Trowbridge described it during a panel discussion at the *Star Wars* Weekend in Walt Disney World a few months before the opening.

Since the Black Spire Outpost was an entirely new location, Beatty noted, "characters we've never met before can come and go, just as [the guests] can come and go—as adventurers here." The blank slate provided "the freedom here to story-tell and to be relevant and keep up with the films that are coming in the future. It's completely flexible in that way," a plasticity that recreating locations from one or more of the movies would not have offered.

Still, given the complexity of the *Star Wars* universe, and fan familiarity with every detail, the Imagineers' attention to story was intense. In the time frame of the *Star Wars* film saga, the Imagineers' Batuu existed during the time period of the final trilogy, when the Resistance to the First Order was at its peak. Apart from the attractions, which would insert guests into missions for the Resistance, the Black Spire Outpost presented its own stories. A ship parked above a restaurant named Docking Bay 7 Food & Cargo belonged to a newly minted character named Strono "Cookie" Tuggs, the former personal chef to Maz Kanata, the character voiced by Lupita Nyong'o in *The Force Awakens*. Blaster burns on one wall spoke of a big shoot-out between a shop proprietor and a scoundrel who tried to cross him. In a detail that would have pleased John Hench—an original advocate for storytelling pavements in Disneyland—droid tracks embedded in the concrete pathways, textured and painted to look like dried mud, indicated the passage of an R2 unit. In time Batuu would get its own novels and comic books, but when it opened its design would already contain references not only to most of the nine canonical films but also to the animated television series, *Star Wars* novels, and the upcoming 2018 movie *Solo: A Star Wars Story*.

Even the name of the village referred to an eons-old backstory, as Trowbridge revealed in a May 2018 story on the Disney Parks Blog. Those spires of rock that formed the backdrop for Galaxy's Edge were in fact not geological but biological: "Widely known for the petrified remains of its once towering ancient trees, the spires now stand guard across the river valleys and plains and have long captured the imagination of travelers to this planet. To the first settlers, these petrified spires became more than just landmarks; they became the heart of the outpost itself." Thus the name, the Black Spire Outpost, embodied in the darkest and tallest of the fossilized trees, standing 135 feet above the ground below.

"Being a creative director-art director on this project has been fantastic, because our job every day is to be a storyteller—a physical storyteller. We work with all these incredible trades people to tell all these little stories," Beatty said. Many guests, he noted, might never pick up on some of the narrative threads woven into the world around them, but that was fine, too. "We know the details are there. If the details were missing, you would know that the land was not complete."

"I think it creates a unique challenge and opportunity for Imagineers to re-create what was essentially on the screen into a real-world experience, a physical experience," Bob Iger observed. "For the guest, I think it raises the quality of the experience, because they're interacting with characters and they're experiencing a place that was magical to them in one form and they never believed they could ever experience. I actually think they're doing a great service to the guests by bringing them to these places, the outer edge of the galaxy."

By the time the land opened, Trowbridge, Reardon, Beatty, and the other Imagineers and Lucasfilm artists had created an experience for Disney guests as full of sensation as Beatty's time in Istanbul—and as transportive and detailed as Main Street, U.S.A. "So when you enter into the planet Batuu, especially when you enter into the marketplace, you'll be able to close your eyes and you'll hear in these apartments that surround you, up in the upper levels of the [bazaar], you'll hear aliens having conversations over droids being repaired. You're going to hear an alien mother and her son having dinner. You're going to hear a deal gone

wrong by two scoundrels who are hiding out in one of those apartments. And you're going to smell this strange ronto meat wafting through the market. You're going to hear strange creatures over at the creature cart to your right, screeching and crying and barking. You're going to hear patrons passing by. You're going to hear this otherworldly music—almost like a flute—pull you in and lead you through this space. And even with your eyes closed, it'll be *Star Wars*. You'll know where you're at, and it will be unlike any place you've ever been before."

III. RESISTANCE

The Imagineers knew that the attractions they created for Galaxy's Edge needed to be as immersive, authentic, and original as the land in which they would be situated. But in this case, the sky was not the limit. "The one thing that the team probably struggled with the most in Blue Sky, in coming to some sort of agreement on, is we could only build two rides," Chris Beatty said, "and we had probably five rides on the table that we really loved. And that was a tough, tough decision. You know, the planet, the look of the planet, crafting a new planet—not that difficult. We all agreed from day one on the direction we would go. When it came down to the two attractions, we were really, really torn. You had to have an attraction that had that conflict between the First Order and the Resistance. So we knew we had to have that epic tension, that epic conflict represented in some way. And so once we came up with Rise of the Resistance—and by the way, that was pretty early on—that attraction came to be, and we set it to the side."

The second attraction proved more difficult to settle on. "We knew we had to have the *Millennium Falcon*. You couldn't build a *Star Wars* land without the *Millennium Falcon*," Beatty said. But with just one more attraction slot to fill, the *Falcon*'s role kept changing. "It took many different forms early on. It was a ride; it was not a ride. It was a meet-and-play experience. It was just an icon; it was back to a ride. That's pretty typical of Blue Sky—things come and go. We'll circle around an idea and come back—and a lot of times you come back to the very first idea you had."

For a while, the idea of a *Millennium Falcon* ride was set aside while other attraction ideas were considered.

The most compelling question that remained in selecting a second attraction was, is there a way to create an immersive Jedi-themed ride? The obstacle was that during the development of Galaxy's Edge, the ultimate fate of the Jedi in the core *Star Wars* film saga remained unclear, since only the events of *The Force Awakens* were locked in, and any attraction they created needed to endure for decades—well beyond the completion of the third trilogy. The team asked themselves, "How would the Force be represented in the land? How would the Jedi be represented?" Beatty recalled. "That was difficult, because we only knew about Episode VII and [that part of] the story of Rey and Kylo. So it made it very difficult for us to base a ride around the Jedi and the Force—although we felt like it's such a key part to *Star Wars*. How do you craft the land without that element? I think we were clever in being able to bring pieces of the Force and the Jedi into the land in different ways, but a ride based around that was one of the most difficult things we left on the table in Blue Sky." If the option for a third Galaxy's Edge attraction ever presents itself, Trowbridge noted, "we have some great ideas to start with."

And so the Imagineers came back to the *Millennium Falcon*. Across *Star Wars* mythology, the ship had had many pilots, and it fit the Imagineers' developing themes, Trowbridge said. "It's aspirational. People want to fly on the *Millennium Falcon*. And so we were going to give them that opportunity—not just to fly on it but to actually sit behind the controls and operate the ship's systems or take on the bad guys with blasters and missiles and laser cannons and all that. So there were a few things that always felt like they wanted to be a part of this from the very beginning."

The attraction came to be called *Millennium Falcon: Smugglers Run*. The ride would put a crew of six people in the cockpit of Han Solo's ship as it sought to steal cargo vital to the Resistance while being pursued and attacked by forces from the First Order. It included an extensive queue area representing a full-size hangar and service area belonging to Ohnaka Transport Solutions, an interplanetary shipping company.

Guests in line also had unobstructed views from two levels of the full-size *Millennium Falcon* parked just outside.

"That's a hundred-and-ten-foot-long spaceship and it has to be built out of metal and has to withstand years of earthquakes and hurricanes," noted Doug Chiang. On top of the construction challenges, "we researched all the different versions of the *Falcons* that we built for films and there were a lot of different versions—different scales—and they were cheated for budgetary reasons or story reasons. There was never one consolidated design." While parts of the ship had been built full-size as sets for the movies, the whole ship had previously existed only as a computer-generated model or miniature.

This kind of set construction was new to the Lucasfilm team. As Chiang pointed out, "When we're designing for films, the sets are very temporary. We can cheat a lot, and we focus our energy into building what's going to be seen in front of the camera"—neglecting backsides and corners and rooms hinted at but not seen by the camera. Sets distant from the action could be thin on detail. Further, he continued, "The level of build is even more sophisticated. When we build sets for films, we can cheat with materials. Plywood can be painted to look like metal. For theme parks, metal has to be metal, concrete has to be concrete, because the guests are going to come in there and they're going to experience that set with all their five senses."

Whether approaching the *Millennium Falcon* or exploring a Batuu alleyway, "One of the great things about design for a theme park is that it's an unguided experience," Chiang said. "The whole set has to be realized, like what's 'round the corner or what's in the next room. Guests are going to explore this environment in its entirety. And so we have to think about things like, 'Okay, well, what's underneath that table?'"

For the *Falcon*, Chiang said, "we felt that it was very important that the version that's going to be at Batuu is the definitive one, the distillation of all the different pieces." In the movies, the ship's design had ranged in length from 88 to 118 feet. "So we basically took the average of that and created a 110-foot version." The most dedicated fans could

amuse themselves by comparing the details in the Galaxy's Edge ship to those in different film incarnations—thus the clear-shot visibility from the Smugglers Run queue.

"There were a couple of moments for me I went . . . 'This is really going to be something that people have never seen,'" Robin Reardon said. "One of those moments for me was building the *Falcon*. You look at all the detail that you get—all the history from the filmmakers—and there have been many *Falcons* and they're not all exact, but our fans, who are passionate, know every piece of it. Our production designer, Mitch Gill, deserves a huge shout-out, because he shepherded the bird from beginning. But one of the great moments for me was actually going to the vendor and seeing two *Falcons* [being] built next to each other, and it was like a Lego set. We built them all [at the vendor site], and then we took them apart and shipped them and then put them back together again. And so when it started coming together in the land, that was really the moment I think that everybody started feeling, 'Okay. This is the thing.'"

The preshow for the *Millennium Falcon* attraction, just before the boarding area, featured the space pirate Hondo Ohnaka, an alien character (in both senses of the word) introduced in the animated series *Star Wars: The Clone Wars*. The Audio-Animatronics figure of Hondo, who charged guests with their mission, was voiced by the original voice actor, Jim Cummings—better known to Disney fans as the voice of Winnie the Pooh. After this introduction, visitors were given color-coded cards that assigned them to a boarding group and ushered into a waiting area that reproduced the familiar main hold of the *Millennium Falcon*, where they could pose for photos at the Dejarik game board—holographic "space chess," if you prefer—made famous in the original *Star Wars* film. It was a kind of wish-fulfillment rare in what was essentially the end of a queue. Guests were also assigned one of three crew assignments: pilot, gunner, or engineer. For the purpose of the attraction, the cockpit of the *Falcon* had been enlarged from four seats to six, and each guest was assigned certain tasks to perform via buttons adjacent to their seats. The voice of Hondo narrated the experience and instructed the riders when to press the buttons to fire weapons, make turns, or launch the ship into hyperspace.

The projected images seen from the front window of the cockpit would not be the unchanging film clips used in both iterations of Star Tours. The high-definition animation would be responsive, to some degree, to the guests and their button-pushing, shifting the trajectory of the ship when a "pilot" ordered a tilt or a turn, generating laser blasts when a "gunner" triggered a weapon, and so on. (Of course, if the guests didn't press any buttons, or pushed the wrong ones, the programming would keep the journey on generally the same course, if less dynamically.) This was quite an ask for the technology team, Trowbridge recalled. "We knew we needed this to be near-cinematic-quality imagery, rendered at a high frame rate in real time. That was not technology that existed, until we partnered with our development partners Nvidia on the graphics card side, Epic on the Unreal game engine, and ILM [which was creating the photo-real CG-animated imagery]. We set off to develop that technology with a plan that said this should be possible by the time we need it in order to open."

The Imagineers were on their own time-limited mission with Smugglers Run, which needed to be ready to go on opening day. Months before opening, the complicated technology still wasn't working smoothly, Trowbridge recalled. It "almost worked" time and again as the Imagineers fixed one bug after another. "But all of that is the behind-the-scenes angst of making all that stuff work," he said. "We don't want anybody to think about that when they come to the park. When you're there and you're in the cockpit of the *Millennium Falcon* and you're flying around, blasting those TIE fighters, it just all feels real and believable to you. It just feels like *Star Wars*."

Unlike Star Tours or The Iron Man Experience, which crowded dozens of guests into a module for a shared adventure, for Smugglers Run, Imagineers wanted the riders "to feel like you were actually flying the *Falcon*, and we wanted you to feel like you were the only ones," Reardon said. There were, she noted, "operational challenges" to creating an individualized *Millennium Falcon* experience. "How do you separate six people and still deliver the capacity and get people so that they feel like they're the only ones there?" What she termed "that little magic trick"

took the Imagineers through a number of discarded versions that might not have worked as well.

The solution was to have not one cockpit but dozens. In fact, there were twenty-eight—four sets of seven arranged on four rotating turntables with their loading doors to the outside and the projection screens toward the center. Each cockpit had its own motion simulation, projection, and audio systems, so that guests in each of the modules on one turntable were experiencing the ride's narrative in staggered time frames. During the four-and-a-half minutes the adventure lasted for, say, Module I, the turntable made a full rotation, the six other modules were unloaded and reloaded, and Module I returned to the slot adjacent to the loading area. If the loading was delayed for some reason, extra messages from Hondo had been recorded to divert the guests while they were awaiting to disembark. With six guests in each module—a "single rider" line provided individuals to fill in empty seats when parties didn't add up neatly to six.

Millennium Falcon: Smugglers Run would open at the same time as Galaxy's Edge in both parks. The second attraction, called *Star Wars*: Rise of the Resistance, would open four to seven months after the lands' debut. "This is probably the most epic attraction experience we've ever built," Trowbridge said. "We wanted to give people an experience that put them in the middle of an epic *Star Wars* experience—kind of 'all things *Star Wars*' [put] into one mega attraction." The experience needed to combine "both visceral thrills but also story-driven thrills—and some humor, because humor is an important part of *Star Wars*. And so we started to think about, 'How do we take a story like this and make it real?' And ultimately that starts driving you towards some really bizarre and crazy options—like, what if we combine these three or four technologies? What if we take this thing but make it ten times bigger than it ever was? And ultimately we drive towards the least crazy of the crazy ideas but one that will accomplish the goals we want and to deliver the experience we want. The whole experience is almost like a three-act play that you move through. But that's the way we best felt *Star Wars* could come to life for people with that true sense of kind of epic spectacle."

The ride would combine cavernous sets, extensive projection and lighting effects, Audio-Animatronics figures, cast members acting out roles, and a soundtrack that included music, dialogue, and sound effects. Guests would walk through sections, get jostled about by motion-simulation technology, ride in skittering trackless transports, and finally experience a Tower of Terror–like controlled drop. The narrative, with eighteen separate scenes, would blur the usual divide between preshow and main attraction, and the full experience took almost twenty minutes. It was, in short, "the hardest thing we've ever done," Reardon said. "And the reason that I think that we can deliver it at all is because the team locked it pretty quickly in terms of what that experience was going to be, and then the next five years were about delivering that experience."

Taking a cue from The Iron Man Experience, both *Millennium Falcon*: Smugglers Run and *Star Wars*: Rise of the Resistance began their stories from within the surroundings outside the attraction: the Black Spire Outpost space port. The *Falcon* appeared to take off from exactly where it sat within Galaxy's Edge, and it dodged the giant petrified tree stumps both departing from and arriving back at Ohnaka Transport Solutions. Rise of the Resistance posited the existence of a secret base of the Resistance hidden within the outpost, where Poe Dameron's X-wing fighter has landed. Locating this covert encampment became the motivating force for the First Order villains who sought to interrogate the "Resistance spies"—otherwise known as the guests. Characters from the third *Star Wars* trilogy abounded: Rey appeared in the preshow; Poe Dameron communicated with the "new recruits" throughout the experience; Nien Nunb piloted the transport shuttle that takes guests into space, where they were captured by the First Order; and both General Hux and Kylo Ren—in projected and Audio-Animatronics figures—menaced the prisoners.

The ride-through part of the attraction began only well into the experience, after the guests had already seen a hologram of Rey, walked past Poe's fighting ship, flown into space, and visited both the vastness of a Star Destroyer hangar bay and a First Order prison cell. There General Hux and Kylo Ren appeared on a walkway above the captured guests' heads, ready to begin the interrogation. In an impressive new twist for

projection technology, the filmed images of Hux and Ren had corre-
sponding animated shadows that fell on the physical set, giving them a
greater sense of presence in the room.

When Hux and Ren were called away, the "recruits" were rescued from
the cell by Resistance fighters—costumed cast members—who seemed to
cut through the wall and directed guests to strap themselves into eight-seat
vehicles, identified as hijacked First Order Fleet Transports. Apparently
piloted by R5 droids provided by the Resistance, the transports were,
in fact, trackless vehicles akin to the rats in the *Ratatouille* attraction. In
pairs, the vehicles then scurried about the Star Destroyer, dodging those
trying to capture them and at one point stumbling across the starship's
bridge, where they eavesdropped on Hux and Ren. They were then
spotted and began the final chase through the Star Destroyer, includ-
ing passing huge cannons firing at Poe's forces and another encounter
with Kylo Ren, as an Audio-Animatronics figure. In perhaps the most
stunning effect, Ren's lightsaber pierced the ceiling overhead before the
transports were able to get away. Such effects often involved not just one
technology, but several, in what Trowbridge called "these amazing tech-
nology sandwiches"—lasers, projections, computer-generated imagery,
practical effects, and so on, all calibrated to be invisible to guests and to
be repeated every minute or so, every day of the year without fail.

All the high-tech visual thrills combined with the unpredictability of
a trackless vehicle to make for an exciting chase through a Star Destroyer.
Along with the initial walk-through segments, Rise of the Resistance had
a staggering eighteen scenes in all. But the Imagineers wanted something
even more spectacular for the finale. "I think one of the things that we
struggled with the most—and not in a bad way—was the finale for Rise of
the Resistance," Beatty said. "We had idea after idea coming to the table.
We knew it had to be something that no one had ever experienced before.
It had to be epic; it had to be an . . . 'Only Disney could do this!' kind
of a moment." Some of the discarded ideas were in the "You guys are out
of your minds" category, he said, "but sometimes that's where we have to
begin, to end in a place that [really works]."

"We knew that we needed a bit more visceral thrill," Trowbridge said.

"So we came up with the idea, 'What if we take that trackless ride vehicle and actually mounted to a motion-base experience like Star Tours?' for part of the experience. That way it's not just about zipping through this Star Destroyer but it's a moment of being very, very active in a simulated-motion environment. But then we thought that it's *Star Wars*—we have to have that extra-special moment. So then we said, 'Okay, let's take that trackless ride vehicle and put it on that motion base, and then let's take that whole motion base and attach it to a controlled freefall drop tower for that big moment of 'Wow!' and surprise and thrill that we all expect from *Star Wars* movies. And that is a crazy idea, but that's what we did, because we felt like that was the best way to bring *Star Wars* to life."

Thus it was that as the "recruits" awaited escape from the ship in their vehicles, with a view of the space battle outside in front of them, they experienced a Star Tours–like motion simulation followed by that unexpected Tower of Terror–type controlled drop. And soon the transports were once again sailing through the spires of Batuu and landing not far from where the Nunb-piloted shuttles took off.

"On a project like this, there's lots of things that can keep you up at night," Trowbridge said. In addition to its massive physical scale, "*Star Wars*: Rise of the Resistance is probably the most complex attraction we've ever, ever built from a technology standpoint. The way these different ride systems integrate and combine with each other—those kinds of things are really, really hard to do. And we're doing it for the first time. That's a lot of new technology, and it doesn't happen seamlessly and it doesn't happen easily. There are teams of people literally working 24/7 to [create] the software that operates it—the millions of lines of code that are required to operate a complex beast like this, the hardware systems, the mechanical systems, and electronic systems to integrate and to communicate with each other. You know, we set off on these projects believing that there is a solution to these things that have never been done before and that we will accomplish those solutions before we open. Oftentimes we're shooting our arrows of expectation over the horizon to an unknown spot because the duration of these projects is so long. We're betting on another generation of technology coming into existence

by the time we need it. And it's not a given that that's going to happen. We predict what the cutting edge of technology is going to be in a couple of years. And that's getting harder and harder to do because the state of technology changes and advances so quickly."

IV. OVER THE EDGE

Galaxy's Edge was set to open May 31, 2019, at Disneyland and August 29 at Disney's Hollywood Studios. The period before opening was the "big push—the mad dash to the finish line" typical of the opening of any new land or park, Chris Beatty recalled, speaking as the final touches were ongoing. "You're seeing painters just bringing all the details to life. You're seeing tons of set work being installed. The props team has arrived and they're starting to uncrate all these incredible props that will really just be the finishing touches on this incredible world that's being brought to life. All the trades are literally working on top of each other twenty-four hours a day, seven days a week to bring this place to a finish line."

Sounding like the true *Star Wars* fan he had been since he was ten, Beatty added, "Every day it's like Christmas because you get to come out here and you get to see it just getting closer and closer to that moment where we get to open this up to the guests and to the *Star Wars* fans from around the world."

Given pre-opening access to the land, reporters seemed to get exactly what the Imagineers were hoping to achieve. "A walk through Black Spire Outpost, the fictional *Star Wars* city at the heart of Galaxy's Edge, is a stroll along war-torn streets—blaster fire has stained the buildings—and Middle Eastern-inspired bazaars where the shops are cluttered stalls under tattered canopies," wrote Todd Martens in the *Los Angeles Times*. "Consider Galaxy's Edge a tweak to the Disneyland formula, one designed to make the park more palatable to generations weaned on video games and the sort of branded multi-faceted cinematic universes made famous by *Star Wars* creator [George] Lucas and Marvel." The land "feels like a different world," reported the *Orlando Sentinel*, a phrase reconstituted as "an entirely different world" by the Associated Press. Travel and fan blogs were

generally ecstatic—"simply incredible," "a true masterpiece of theming," and "visually arresting and just a ton of fun" were typical assessments.

More soberly, *New York Times* writer Brooks Barnes, a self-described Disneyland purist and "casual *Star Wars* fan," was impressed that "Disney had created an earthy yet otherworldly place that seemed to bridge everything in the *Star Wars* universe—movies, books, video games, TV shows"—thus affirming the Imagineers' decision to invent a fully integrated new planet rather than reproducing a familiar one that would have been more restrictive. Barnes quoted his adult companion for the visit as saying, "The sense of place they have created is unbelievable. I almost don't even care if there are rides."

Barnes's second companion, a nine-year-old named Sam, was intent on finding the lightsaber workshop, which Barnes described as a "retail showstopper," for its dramatized process of selecting and personalizing a lightsaber to purchase and take home. (Those who preferred to customize a droid could do so in the Droid Depot next door.) Young Sam also soon discovered Galaxy's Edge's unique augmentations to the *Play Disney Parks* app, a level of mobile phone and computer tablet interactivity that was a first for an Imagineering project. The app, the boy explained to his adult chaperones, "adds another layer of storytelling to Galaxy's Edge by turning smartphones into interstellar 'data pads.' . . . Sam quickly realized that he could use it to activate droids in the land; scan cargo crates to see what was inside; and translate shop signs written in Aurebesh, a *Star Wars* language. You can also use the app to interact with other guests in a game called *Outpost Control*, choosing to play for the First Order or the Resistance."

The online interactivity, Robin Reardon said, fed into "this notion that this is a living place and that you are visitors to this place or citizens of this place. It needs to feel like a real authentic place, so as we approached interactivity, it had to be that it felt like it was organic." To that end, new cast members working in Galaxy's Edge first participated in a four-hour training session that helped them to develop their Batuu-specific back stories, which they could share, as appropriate, in guest interactions. That kind of virtual and personal interactivity Reardon

speculated could be "the next frontier" for immersive theme park experiences. By encouraging guests to participate "at a level both individually and as groups with your friends, I think that we're starting to redefine what 'attraction' means. Maybe we don't have to just go in and get on a ride and do that experience and come out and go to the next one. How you create your own experience and interact with that environment is another kind of attraction. Virtual reality or augmented reality allows you to participate with the spaces that we're creating at a variety of different levels. The thing about theme parks is [that they] build places that you go into, complete environments that allow you to play make-believe. And the more tools that we can give you and opportunities that we can give you to play make-believe—I think it's an exciting opportunity."

Months later, the August opening day in Walt Disney World saw capacity crowds and queuing times of up to five hours. Some fans had arrived at three-thirty a.m. to be near the front of the line just to get inside at the promised six a.m. rope drop for Disney's Hollywood Studios. To ease the overcrowding Disney allowed some guests into the realm at four-forty-five a.m. Seventy-five minutes later, the line for *Millennium Falcon*: Smugglers Run reportedly stretched out of Galaxy's Edge all the way back to the park's central Grauman's Chinese Theatre. (The wait time had shrunk back to an hour and a quarter by evening—a tribute to the ride's high capacity.) By early 2020, the annual attendance numbers for both parks confirmed anecdotal impressions: Disneyland logged about the same number of visitors in 2019 as the year before, while Disney's Hollywood Studios saw a 2 percent boost.

Whatever the numbers showed, the enthusiasm for *Star Wars*: Galaxy's Edge was undiminished within the halls of Imagineering and The Walt Disney Company. Bob Chapek, the parks division chair who was soon to become Disney's CEO, recalled that he had seen "the first [*Star Wars*] movie on the first night that it opened back in Indiana where I grew up and had been a fan ever since." The achievement he saw in Galaxy's Edge was not just its two "jaw-dropping E-ticket attractions," but the land as a whole. "When you walk into the land, that conceit that you're on Batuu, a planet on the edge of what's known to anybody, is just so striking. And

everything is in story. So you don't feel like you're walking through a theme park about *Star Wars* or a theme park that takes place during *Star Wars*. What you feel like is you're on a foreign planet. And that to me overwhelms even the great E-attractions."

The project, he said, had pressed Imagineering to new heights of achievement, "testing the limits of technology" while still remaining grounded in operational concerns such as capacity and maintenance. "The ambition is so strong that we're inventing as we're implementing. And I think that's really important. That means we are pushing the outer boundaries of anything that we've done. Invention is hard, but that's what we do. We always want guests to walk away and say, 'How did Disney do that?' That's what we were searching for."

As intended, the *Star Wars* project was a sturdy third pillar in Imagineering's determination to surround guests with the experience of a single story. "Cars Land was obviously immersive," Chapek said. "That was a big step in that direction. I think Pandora took it up another step. Well, this just cubed all that."

Chris Beatty acknowledged both the forward momentum that Galaxy's Edge represented and its origins within the early Imagineers' philosophy of place-making. "I've been really privileged here at my time in Imagineering to work with some incredible Imagineers," he said. "My first office was actually right next to John Hench, so I got to spend almost two years at lunch every day with John, just kind of picking his brain. And I always like to say that, as a creative director, you become a little bit of all of those creative executives and storytellers that you've worked with. So for *Star Wars*: Galaxy's Edge, I was influenced a lot by the former Imagineers that I got to spend time with. And I was also really influenced by Disneyland itself." Those droid tracks in the concrete, it seems, were really the footprints of countless Imagineers.

CHAPTER 32:
EXPECT THE UNEXPECTED

"A lot of young people think the future is closed to them, that everything has been done. This is not so. There are still plenty of avenues to be explored." —Walt Disney

I. AN ABRUPT INTERRUPTION

IT ONLY TOOK SEVEN WEEKS for every Disney theme park in the world to close down. The closures began less than a month after a rash of severe viral pneumonia cases were first noted in Wuhan, China, at the end of December 2019. The medical emergency continued to mushroom in Wuhan until China's leader, Xi Jinping, sealed off the city on January 23. Two days later, the Shanghai Disney Resort abruptly closed. The suddenness of the decision, and the level of perceived crisis, could be inferred from the fact that January 25 was a Saturday, and Sunday had long been the resort's busiest day. The health precautions could not wait two days. By that time, the virus that came to be known as COVID-19 had killed a reported forty-one people in Wuhan, about five hundred miles west of Shanghai, and the government was determined to use lockdowns to prevent its spread. Hong Kong Disneyland—570 miles south of Wuhan—closed one day after Shanghai's. By mid-March, less than two months later, every Disney park had been shuttered. Disney Cruise Line ship departures were also canceled, and Disney resorts emptied out—then the hotels, too, were closed to guests.

The halls of Imagineering's headquarters in Glendale were also

abandoned, with half-finished models sitting on worktables, storyboards pinned to the walls, and all plans seemingly in limbo. "There was one day we were at the office and the next day we were at home," said Bob Weis, Imagineering's then-president, a few months later. What had been one office complex instantly became hundreds of home offices. "The meeting schedule was the same the next day. It was just all by video." In the subsequent weeks and months, many Imagineers were furloughed, meaning they kept their jobs and benefits but lost their paychecks. These Imagineers were legally forbidden from working on anything Imagineering-related, or even from talking with any colleagues still at work. Many of them would return, but for the moment they had been taken out of the creative loop as suddenly and as completely as if they'd been disintegrated by Thanos's finger snap.

The sudden isolation, displacement, and staff reductions were unprecedented and wildly disruptive—as they were in workplaces across the globe in early 2020. Every idea about how Imagineering functioned from day to day needed to be rethought. "When I took this job, I had this kind of simplistic view of leadership, which is: you've done a lot of this work for many years, so you're in a position to be able to lead a lot of people who do this work," Weis said. "And it turns out leadership is more like doing something you never thought you'd have to do, for situations you'd never thought you'd be faced with. And now it's a matter of trying to apply whatever knowledge and experience you have to a problem that's completely unknown."

One upside, he added, was that he saw some people more frequently than he had before, although via Zoom rather than in person. "But what I miss most is serendipity," he continued, speaking from his home office via Zoom. "I'm kind of an easily bored person, so I'm always walk-ing down the hall to see what's happening on the patio or in another building—with the idea that you'd run into somebody randomly [who says,] 'I was thinking about something you should know about.' That strange, serendipitous synapse that happens—'hallway culture,' Marty Sklar used to call it—that's what you don't have. Everything's planned down to the minute, so you don't just run into people. And you can't

touch anything. There's nothing you can feel—you can't step back from the wall and look at their drawings because everything's at the same scale. You're missing a lot. But in terms of can we function? Yes, I think we're functioning on some levels very effectively."

Imagineer Scot Drake—who was supervising a number of Marvel-related attractions being built in Disney parks around the globe—experienced a similar psychic dislocation during COVID-imposed isolation and furloughs. "When you're on these teams and been working with these people day in and day out, there's certainly a toll that takes when all of a sudden a whole bunch of people aren't working," he said. "Certainly we all miss that personal touch of wandering around the campus at Imagineering and just having those hallway conversations. You kind of realize there is a lot more to those than maybe you gave credit for."

In the first six months or so after the shutdowns, Weis said, he'd been able to meet other Imagineers in person in Anaheim just three times, each of which felt "gigantic—to be able to get in the car and drive to Disneyland and meet somebody. It's huge." Being in Disneyland on a sunny California day with no guests was a rare experience. "It's beautiful," Weis said. "They have continued to trim the trees and water the flowers and so on. So it's amazing to go there and walk around and there's nobody there except you. It's Disneyland in this kind of paused state, ready to go, ready for the guests to come back."

The park had been closed before. Until the 1980s, it was closed on Mondays and Tuesdays except during the summer and the year-end holidays—a practice Weis recalled from his early years with Imagineering, since the closures allowed for maintenance and installation work to take place in the open. Special events and severe weather accounted for a few closures across the decades, but before COVID, Disneyland had been shut down unexpectedly for full days only two times: the day after President John F. Kennedy was assassinated in 1963, and on September 11, 2001. The COVID closure would extend for more than thirteen months, the longest COVID shutdown at any Disney theme park.

Some of the Disney parks had begun to reopen in mid-2020, starting

with Shanghai on May 11. "A bunch of us that worked on Shanghai got together in the late evening when it reopened," Weis recounted. It was morning in Shanghai, and a local Imagineering team member was able to live stream the guests returning to the park—"and we're all as cheerful seeing it reopened as we were when it opened the first time. To see [the parks] closed is hard. To see them reopen is a symbol of optimism."

Capacity was restricted at the reopened Shanghai Disneyland Park— starting at a third the pre-COVID maximum—and attendance was managed via a timed reservation system. Guests were required to wear face masks and submit to temperature checks at the gate. Social distancing was encouraged by signs on the floors and pavements, and guests from separate parties were no longer assigned to share vehicles on certain attractions. Similar precautions were introduced at other parks as they reopened. Hong Kong returned in June 2020, then closed a second time from mid-July until September. Disneyland Paris reopened from mid-July through most of October 2020; then closed again until the following June due to a surge in COVID cases in France. Benefiting from Florida's less stringent COVID protocols, the Walt Disney World parks fared better, welcoming guests again starting in July 2020 with reduced capacity and COVID precautions.

But it wasn't the same. Not only did the shrunken attendance and face masks change the look of the parks, some guest benefits were curtailed or eliminated. New rules restricted "park hopping"—the visiting of more than one park on the same day—and FastPass+ was shut down. The nighttime spectaculars were canceled at all the parks, to prevent the gathering of large crowds, and some attractions that necessitated close quarters remained shuttered, particularly indoor shows such as Enchanted Tales with Belle, Voyage of the Little Mermaid, and Finding Nemo—The Musical. Even outdoors, Disney characters could no longer interact with the guests, appearing instead behind rope barriers, where they would wave to visitors taking selfies, with the characters framed behind them. For all that, though, the emotional power of the parks remained—the minting of happiness that had been the focus of Imagineering from day one. "It's a physical symbol of coming back after much trauma," Weis said. "People

get rejuvenated when they're there; there's a reassurance. Even if you don't go right now, there's a reassurance in knowing that you *can* go."

The last parks to reopen were the two in Anaheim, which welcomed guests again April 2021. Preparations for the reopening began weeks earlier. Cast members prepped and tested every system in the park, whether mechanical or digital. The horses that pulled trolleys down Main Street, U.S.A., needed practice runs. So did the dozens of miniature speedsters on Autopia, the rocket cars on Space Mountain, and the boats of "it's a small world," where prerecorded safety announcements in many languages played to empty seats. The stores needed restocking with fresh merchandise. And one cast member was assigned to take a step ladder, dust cloths, and a soft, clean paintbrush into Walt Disney's Enchanted Tiki Room to groom José the parrot and his many avian co-stars—gently, one at a time.

The park had been closed to visitors for 412 days, but it had never been entirely vacant. Maintenance crews had never stopped cleaning. The security team had never stopped patrolling; the guards had raised the American flag over Town Square in a daily ceremony each morning throughout the closure. And the Imagineers had been on the job. After rigorous health-safety protocols were established for those working in the parks, Imagineers had supervised the refurbishment of the King Arthur Carrousel, as well as revisions to the Jungle Cruise. They had overseen the installation of new special effects and other enhancements to the Snow White dark ride, which was renamed Snow White's Enchanted Wish. They had shepherded the continuing construction of the Disneyland version of Mickey & Minnie's Runaway Railway attraction in Mickey's Toontown, set to open in 2023.

Similar testing and preening went on in Disney California Adventure, which would also reopen on April 30. But the Disneyland Park was the focus of media and fan attention that day. It was not just the first Disney park; it remained the spiritual hub of the company's entertainment empire. For cast members and guests alike, its reopening was the antidote to the scourge of lost hope that had arrived with the pandemic. Walt Disney had said even before the park opened in 1955, "Disneyland . . .

would encompass the essence of the things that were good and true in American life. It would reflect the faith and challenge of the future, the entertainment, the interest in intelligently presented facts, the stimulation of the imagination, the standards of health and achievement, and above all, a sense of strength, contentment, and well-being."

The loyal Disneyland fans knew that feeling, that reassurance, as certainly as they knew the words to the "it's a small world" song, whether or not they'd ever consciously contemplated the deeper meaning of Walt's original theme park. By midnight before the reopening, hundreds of fans had already gathered on the sidewalks outside Disney property, determined to be among the first inside. Shortly before five a.m., cast members welcomed the waiting guests onto Disney property, to form socially distanced lines.

Inside the park, soon after the sun rose to illuminate the brilliant pink blossoms on the trumpet trees in the hub in front of the castle, a few dozen cast members gathered for one more flag-raising ceremony, hosted by Bob Chapek, who had become chairman and CEO of The Walt Disney Company in February 2020, just weeks before the spread of COVID across the United States would make headlines. "You can just feel the energy and the excitement all around us," he told the cast members scattered around Town Square. While not explicitly citing the Imagineers present, he certainly included them in his remarks. "We're not just another place; we're not just another theme park. We're something special, and we're something special because of all of you. Because you bring magic to the world, and our guests crave the Disneyland experience, because of your special brand of care and attention."

As the front gates finally opened at eight a.m., the guests passed under the Disneyland Railroad tracks on their way to Main Street, U.S.A. Their smiles beamed from behind their pandemic-mandated masks, their joy palpable in their energetic gait and their bright and roving eyes—some moist with what one guest called her "happy tears." The park, most of which opened an hour later, was restricted to 15 percent capacity that day, and at first it seemed that the cast members outnumbered the visitors. Main Street, U.S.A., was lined in some places three deep with people

wearing Disneyland name badges and the costumes of their trades—Main Street merchants, kitchen staff, PhotoPass photographers, blue-shirted security guards, and even a few executives in suits and ties. They all stood and waved to the returning guests and to the smartphone cameras held aloft, applauding and shouting friendly variations on "Welcome back!" and "Welcome home!" After more than a year away, everything was a photo op—the red-shirted driver of Disneyland Fire Dept. Engine No. 1, the waving cast members, and, of course, the castle gleaming in the sun. "Everyone's just had a tough year and we need the magic back in our lives," one young guest told a reporter. "And this is it."

There were new things to see in this revived and welcoming Disneyland—not just Snow White's Enchanted Wish but upgraded visual effects in the Haunted Mansion and the just-opened high-tech attraction *Star Wars*: Rise of the Resistance, which had been open less than two months before the park was closed. But many of the guests who made the effort to be among the privileged few on April 30 gravitated toward the familiar, wanting the comfort of knowing that their favorite experiences could be repeated in the way they remembered them.

That sense of going back in time—or possibly of returning to a beloved dream—was enhanced by the park's sparkling cleanliness. It seemed new again, as if its chaotic first day in 1955 could be rerun without the not-quite-set concrete, unfinished drinking fountains, and Autopia pile-ups. The more Disneyland changed, it seemed, the more it remained the same. Now, as then, news media recorded the opening, but this time it would also be captured by hundreds of smartphones generating thousands of social media posts. Now, as then, top Disney executives were on hand to gauge the guest experience, as Chapek was joined by executive chairman Bob Iger and other company leaders to greet visitors in front of the castle. Walt had bantered on-camera with Art Linkletter; Chapek and Iger exchanged small talk and posed for endless phone-camera selfies with longtime fans.

The cast members had changed; the technology had evolved; all the attractions had been either upgraded or replaced; and the average age of the park-goers had noticeably increased. But the two openings shared an

enthusiasm rooted in decades of Disney storytelling. The iconic image of a battalion of school children rushing into Sleeping Beauty Castle had been replaced by Instagram clips of bloggers narrating their slow journey through the tunnel; down Main Street, U.S.A.; and across that same drawbridge, yet the scenes were connected by an emotional resonance no mere amusement park could match. It was at once childlike and timeless. As Walt Disney said, Disneyland "has that thing—the imagination, and the feeling of happy excitement—I knew when I was a kid." Finally that feeling had returned.

II. LOOKING FOR RELEVANCY

Despite its reduced numbers and siloed offices, and the park shutdowns around the world, Imagineering was still pushing forward. They quickly pivoted and re-Imagineered new ways to keep their projects on track. Many plans were delayed—new attractions could not be debuted in closed parks—and construction was suspended for a while as the Imagineers, and the rest of the world, figured out, as Bob Weis put it, "How do you work in construction in today's world, where workers have to be safe and have to be a safe distance from each other?" Once health guidelines and face masks were firmly in place, the work resumed, providing a significant morale boost to the scattered Imagineers. "There's nothing more optimistic for Imagineering than to see more projects moving forward again," Weis said. For a while, at least, construction and upgrade projects did not have to be hidden and scheduled around park hours. When COVID hit, almost every Disney park was in the midst of some major changes, all of them addressing answers to the growing question: what did it mean in the 2020s to put the guest experience first?

Some projects checked more than one relevancy box. Indeed, the word "relevancy" itself had become a watchword at Imagineering in the twenty-first century. Across many years before the COVID closures, plans had been made and carried out to make changes to some decades-old attractions to bring the storytelling in line with current guest expectations. Carmen Smith, vice president for creative development at

Imagineering, had supervised this ongoing effort since 2010. Her team's work often began with strolls through the parks on what became known as "relevancy walks." The idea was for Smith and her colleagues, along with the cultural consultants they invited to join them, to look at every aspect of the park experience through the eyes of present-day guests, unclouded by nostalgia or tradition, and to see what could benefit from an update. The walks were particularly focused on cultural sensitivities but also looked at gender balance, generational bias, environmental concerns, and opportunities to utilize new technology—and at anything that seemed simply outdated.

"It's really about being relevant to our audience today," Smith said. "How do we connect with them? How do we look at what's existing in the park and those things that may now be considered egregious?" The relevancy team also looked forward, providing their expertise and, if needed, outside consultants who could address any questions raised by projects in development. The team arranged for regular guest speakers, seminars, and podcasts to reach out to all of Imagineering. "Everyone is charged with this responsibility, not just me," Smith said. "Everyone has ownership on the change that we want to see in our products and in our environment." The relevancy team extended beyond Imagineering, she noted. "We have partners across all of our parks around the world"—both cast members and invited experts, such as social and cultural anthropologists. The goal is "not necessarily to right the wrong," Smith said, but to answer the question, "How do we advance our story?"

One small example of the relevancy team's discoveries was the welcome plaque introducing visitors to Liberty Square, which opened in 1971. The plaque invited guests to imagine two-hundred years earlier, when the American colonies were on the verge of revolution. It read, in part: PAST THIS GATEWAY STIRS A NEW NATION WAITING TO BE BORN. . . . IT IS A TIME . . . WHEN GENTLEMAN PLANTERS LEAVE THEIR FARMS TO BECOME GENERALS. On one relevancy walk with some invited cultural anthropologists, Smith recounted, "we noticed that sign. PLANTERS are slave owners; they are considered a [social] hierarchy. So it was really quite astonishing that we have a sign welcoming PLANTERS into Liberty

Square." Most guests might not have made that connection—but some would have and would have felt the sting of a cultural insensitivity left over from another era. Noticing such not-quite-hidden missteps, Smith noted, only comes about "when you've got the right people walking with you. It's unfortunate, but we find things like that throughout all of our parks." (The plaque was quietly replaced.)

The Imagineers' work on what Smith termed "inclusive strategies and relevancy" began in the early 2000s, when Bruce Vaughn led Imagineering. The goal, Smith said, was "to take different approaches to making sure that our environment really reflected the world that we live in and that our experiences do the same. It has been a very long journey. We've made considerable strides. We have a long way to go. But we look at this work as not being separate and apart. It is how we do work." Along the way, teams of Imagineers had worked on reimagining the headquarters of National Geographic to be more inclusive of the many cultures its work tapped into, as well as helping to stage a celebration of the fiftieth anniversary of the civil rights movement in Birmingham, Alabama. "We had a team of about fifteen Imagineers that went back and forth to Birmingham, working with the foot soldiers who were part of the civil rights movement," Smith said. "And we're in contact with many of them to this day." Other efforts at outreach were open-ended, such as the steady stream of Imagineers who visited the Institute of American Indian Arts in Santa Fe, New Mexico. Such partnerships "heighten awareness of the communities we serve," Smith noted, as well as being exercises in team building within Imagineering.

The lessons learned were applied to Imagineering's creations, past and present, including the 2017 changes to the auction scene in Pirates of the Caribbean. Concurrent with those revisions was the conclusion of a years-long, ongoing discussion of how best to rethink Splash Mountain. The attraction had opened in Disneyland in 1989, based on the animated sequences of Disney's 1946 film about Uncle Remus, *Song of the South*.

The plan the Imagineers settled on was to replace the *Song of the South* theming with characters from Disney's 2009 animated film *The Princess and*

the Frog, which had introduced the popular Princess Tiana, the studio's first African American princess. Although not announced to the public, the concept had been in the works since at least 2016. Top company brass, including Bob Weis, Bob Iger, and Bob Chapek—as well as Josh D'Amaro, the newly appointed chairman of Disney Parks, Experiences and Products—were all involved with the decision to announce the Splash re-theming, which the company shared with fans and news outlets June 25, 2020. "We continually evaluate opportunities to enhance and elevate experiences for all our guests," Smith said in Disney's statement to the press. "It is important that our guests be able to see themselves in the experiences we create." The re-theming also made geographic sense, particularly in Disneyland, where the attraction was adjacent to New Orleans Square, in which Tiana already made regular appearances, since the city was her home in the film. (Splash Mountain at Walt Disney World was to be identically revamped, although Magic Kingdom lacked a New Orleans Square. Because of the unpredictability of the COVID pandemic, no projected opening dates were announced for any of the revised attractions.)

The plans for the new attraction were in keeping with other recent Imagineering creations, which evoked their source material without parroting it. The story line would be set after the ending of the movie, as Tiana and her alligator friend, Louis, headed to a Mardi Gras concert—the staging of which would replace the original "Zip-a-Dee-Doo-Dah" riverboat scene.

"It's a brand-new adventure," said Imagineer Ted Robledo, the creative lead on the project. "It's not a book report of the film. We're going to get introduced to a whole bunch of new, fun characters, but Tiana is front and center." Perhaps most important for present-day riders, "the guests will be participants in the story. They are not just passive viewers." Tiana and her friends would be addressing the visitors directly, involving them in the Mardi Gras story line. "We're not just looping around and around and looking at things."

"We are taking advantage of the Splash ride system," said Charita Carter, the project's lead producer and a longtime leader in both the

Blue Sky and Scenic Illusion teams. "We're not changing that. There's a lot of storytelling that's done with the ride system itself. And one of the things that we know that our guests love about what's happening there now is the fact that it's a musical. So we're going to take that to another level. The music is actually going to be a character in our story."

"We want to ensure that people know this is an African American woman with attributes that we all [share]," Smith said. "She's got an entrepreneurial mindset, and she is fun and happy and likes to see her friends do well. She wants them to help them overcome their fears." That driving force, Smith noted, "is the DNA of what makes our parks so successful. It's about hospitality. There's just no other place in the world where you feel that you're a king or a queen. Cast members make you feel that way, and that's what Tiana wants people to feel like."

At the same time plans were announced for Splash Mountain, less drastic revisions were being planned for another Disneyland attraction with relevancy issues: the Jungle Cruise. "There's probably drawers of ideas of what you could do to Jungle Cruise to make it more exciting and more of an E ticket–level attraction," said Michael Hundgen, Imagineering's executive producer for the Walt Disney World portfolio. "But it's classic. It's got a humor that is all its own. There's not a lot of attractions that can kind of pull off a campiness but also nostalgia. So we wanted to keep it classic, not too far from the [original] story. But there were problematic scenes that perpetuate stereotypes that we want to move away from, that don't resonate with guests today. Scenes that, in fact, put our guests and sometimes our skippers in uncomfortable situations. And this ride is kind of made by the skippers, right? A great cruise is made possible because you've got amazing cast members in front of it."

Replaced would be the figure known as Trader Sam, a head-hunter depicted as a dark-skinned African in Disneyland and as a plump Caucasian in Walt Disney World (where the Jungle Cruise was to be similarly updated). Two scenes near the end of the voyage that depicted an African village—with skulls atop spears stuck in the ground—and a native "attack" on the boat would also be revamped before the park's reopening.

The revisions also gave the Imagineers an opportunity to impose a

unifying story line on the attraction for the first time. Original Imagineer Harper Goff had wanted simply to take park guests on a journey through the tropical rivers of the world, one literally flowing into another as a boat captain provided interesting tidbits about each different ecosystem. The attraction was without any human characters until Marc Davis's additions in the 1960s, his humorous scenarios suggesting back stories but not connected to one another. The unifying thread became the captains' comic monologue, rather than what was depicted along the way.

"The amazing thing about the Jungle Cruise is, as classic as it is, it really doesn't have a strong narrative," said Imagineer Chris Beatty. "You're on this wacky adventure that somehow takes you to four different rivers of the world and across the globe. It's an amazing journey filled with amazing moments, but there's really no narrative thread that holds this whole thing together." The Imagineers had recently created the character of Alberta Falls to serve as the owner of the Jungle Navigation Co. Ltd. Skipper Canteen restaurant in the Magic Kingdom (which opened in 2015)—taking inspiration from one of the best-known jokes in Jungle Cruise skipper patter: "Now we're approaching the beautiful Schweitzer Falls, named after that famous African explorer, Dr. Albert . . . Falls." Recalled Beatty, "We'd already had a little bit of a backstory to Albert's granddaughter, Alberta Falls, although we never got to see her other than in a painting hanging in the Skipper Canteen." "Someone had to bring all of these amazing skippers together. Why not let that be Alberta?"

Depicted as the child of an English father and an Indian mother, Alberta became the proprietor of not only the restaurant, but the cruise company. The explorers stuck on the pole were her friends, visiting from around the world, each of them given a name and a backstory related to Alberta. Their story involved a wrecked boat (its aft half depicted in the hippo pool) and a jungle camp overrun by chimpanzees. Where Trader Sam once stood would now be Trader Sam's Lost and Found, in which the unseen entrepreneur sold all the items travelers had "lost" along the river—items now being repurposed by a group of mischievous monkeys. The goal, Beatty said, was to retain "a true Marc Davis kind of humor" and to "play up the fun, comical nature of the Jungle Cruise."

To help rewrite the skippers' jokey script, the Imagineers even brought in a former cast member who had been a longtime cruise skipper. "I think our writers have done a phenomenal job, and it's been a very inclusive experience," Smith said. The new scenarios and patter met the team goal of "making sure that we tell a story that people can laugh at and, number one, that keeps our guests in the story."

The idea was to update the relevancy of the Jungle Cruise in every way—resolving its problematic cultural biases, certainly, but at same time building the changes with the same eye toward storytelling and interactivity that any freshly minted attraction would display. The word "relevancy" covered a lot of bases and was intended to encompass Disney fans around the world.

"If you think about Imagineers' greatest challenge and what I think we've been successful at doing, it's that we create experiences that speak to a very diverse global audience," said Debra Kohls, Imagineering's director of communications and public affairs. "It's this idea that inclusion and hospitality merge to create an environment where everybody feels like they can be themselves, and that people that would never speak to one another outside of our parks, stand next to each other with the same joy watching the same parade come down the street. [It shows] what a uniting place our Disney parks can be, and the better job we can do to reflect the diversity of the world, the more inclusive we will continue to be. That is a continuous challenge—it will never be done. And we have to keep moving forward and being willing to make some maybe unpopular decisions amongst fans when we know it's the right thing to do."

III. MARVELS AROUND THE WORLD

The revised Jungle Cruise and Snow White's Enchanted Wish were not the only Imagineering projects to debut within the reopened Anaheim parks in 2021. Across the plaza in Disney California Adventure, the long-planned Avengers Campus had been just months away from opening in early 2020 when COVID-19 arrived and shut things down. "We were all geared up," related Scot Drake, the Imagineer who led the

Tomorrowland team in Shanghai and now oversaw Marvel experiences worldwide. "Whenever we did turn things around and reopen, we were going to have new content that we had already promised."

The Avengers Campus in Disney California Adventure would be the second multi-attraction area within a Disney park to be inspired by super hero characters—after Hong Kong's evolving Stark Expo—part of an ongoing effort by Imagineering to bring more super heroes and stories to the parks. "We had a lot of things to keep alive globally," Drake said. A second Avengers Campus was underway at the Walt Disney Studio Park at the Disneyland Paris resort—about a year behind Anaheim's campus—and in the works in EPCOT was Guardians of the Galaxy: Cosmic Rewind, which would become Disney's largest and most sophisticated fully enclosed roller coaster.

The additions would not only expand and update the stories and characters represented by Disney attractions; they would appeal to an audience who might otherwise forgo theme parks altogether: young adults. In one survey, a remarkable 62 percent of Americans ages eighteen to twenty-nine considered themselves super hero fans. While there were plenty of enthusiasts older and younger than that, people in their late teens and twenties were a crucial audience for Disney. They were too old for children's rides and yet mostly too young to have children who wanted to be taken on those same rides.

"When you think of things like *Star Wars*, like Marvel, I don't think our audience is saying this is just for our kids," noted Jon Snoddy, Advanced Development Studio executive and senior vice president at Walt Disney Imagineering. "It's going to change the way we approach the design of the theme park. It means that the interactivity—the interactions with the characters are going to not just be for little kids. It's really for everyone. When you think of [video] games, it seems like the coolest ones are often built around the properties that now are a part of the Disney family and so it gives us a real first step to the next generation of themed experiences and immersive experiences." Like video games, super hero experiences would bridge the generational divide between children and young adults.

It was not a coincidence, therefore, that some of the new Marvel-inspired attractions had replaced Pixar-themed rides. The Avengers Campus in Disney California Adventure occupied space previously devoted to the *A Bug's Life*-inspired It's Tough to Be a Bug!. In Hong Kong Disneyland, the 2019 debut of an expanded Stark Expo area of Tomorrowland featured an attraction called Ant-Man and The Wasp: Nano Battle! that took over the facility previously occupied by Buzz Lightyear Astro Blasters. Nano Battle followed the track of the former ride and utilized a similar, if updated, laser-gun technology, as guests fired at Hydra swarm-bots from their Omnimover vehicles. But the exterior of the attraction had been completely redesigned, the former toy-themed facade transformed into the sleek S.H.I.E.L.D. Science and Technology Pavilion, blending with the Stark Expo theme of the adjacent Iron Man Experience.

Because of the disruptions caused by the pandemic, the day that that the Quinjet was lowered into place by a construction crane in August 2020 took on a special meaning for the Imagineers, several of whom were watching from nearby, socially distanced and wearing orange construction vests, crimson hardhats, and protective face masks. It happened in "some of our darkest days," Drake said, "but it felt for the world like the Avengers had landed like heroes [to say], 'We're here. Everything is going to be Okay.' Not only did the site go from a construction site to a place of story, but for all of us, it became a moving experience—one of those once-in-a-lifetime kind of Imagineering moments."

A key component in the Marvel attractions—as it had been with *Star Wars*: Galaxy's Edge and Mickey & Minnie's Runaway Railway—was to make the guests part of the stories being told, to give them a role other than passive viewer. That meant connecting guests with the super heroes they already knew and loved, turning them into allies and collaborators, not just fans. "What we are working towards is this kind of connected universe, where we have these major lands—like in California and Paris—and we're continuing to build attractions around the world that tap into that infrastructure and that belief," Drake said. "And we have a lot of

content for how these characters make sense in our format and what we as guests are finally able to do alongside them."

Each Avengers Campus was also designed to be adaptable enough to become home to characters who had not yet appeared in Disney narratives but might show up five, ten, or twenty years down the road. It would be, Drake said, "this blank canvas—something that was flexible over time. We can put in new addresses, new modules, knowing that it was going to continue to grow." The Disney California Adventure campus was conceived with a backstory reflected within its design: the area represented an old facility that had belonged to Howard Stark—Iron Man's World War II–era industrialist father—that the Avengers had renovated for their own purposes. On top of those two layers, the Imagineers added a third. "We invented a new organization, the Worldwide Engineering Brigade, or WEB," Drake explained, "where all of these young geniuses are getting together—and one of them happens to be Peter Parker," aka Spider-Man.

The new attraction that would encompass the WEB narrative, in both Disney California Adventure and Walt Disney Studios Park at Disneyland Paris, was dubbed WEB SLINGERS: A Spider-Man Adventure, which updated the concept and technology of interactive rides from Buzz Lightyear's Space Ranger Spin and Toy Story Midway Mania! to Ant-Man and The Wasp: Nano Battle! Guests would be recruited into WEB and asked to help neutralize the manically self-replicating spider-bots that were taking over the Avengers Campus—only this time instead of shooting laser blasters, guests would be slinging webs from their bare wrists, just like Spider-Man. Combining sophisticated motion tracking, 3D animation, real-time rendering, and some motion-simulation, the attraction immersed riders in a series of battles against the spider-bots. Each took place in front of a large projection screen that was presented as a doorway to some part of the campus, and each vignette advanced the overall narrative. "So not only do we get caught up in the stories with the characters," Drake said, "but we're empowered to participate alongside them."

In EPCOT, the Cosmic Rewind attraction would place guests alongside the Guardians of the Galaxy for what the Imagineers termed a

"storytelling roller coaster" adventure. The pavilion once occupied by the Universe of Energy became the queue, preshow, and loading area, while a huge new building was constructed to house the coaster itself. "You could fit the entire Contemporary Hotel inside our showbox," Drake noted. The coaster vehicles for Rewind were a new concept for Imagineering, as each four-person pod could be programmed to rotate a full 360 degrees during the journey. The Imagineers dubbed the attraction the "Omni-Coaster," because of its Omnimover-like ability to rotate the vehicles to direct riders' attention to precisely timed projected media and other effects. "Just like TRON [Lightcycle Power Run] had us immersed within all of this technology and projection the entire journey," Drake said, "you're going to have projection and black light and all kinds of lighting effects all around you throughout this journey." For good measure, Cosmic Rewind would be Disney's first reverse-launch coaster. In short, "it's pretty spectacular."

As with WEB SLINGERS: A Spider-Man Adventure, the new tech for Rewind would be at the service of the story, which in turn plugged into the unique character of EPCOT. The narrative imagined that representatives from Xandar, the ancient home planet of lead Guardian Peter Quill's father, had created their own EPCOT pavilion, which would serve as the ride's queue and preshow area. "We're bringing in what we've dubbed the first 'Other-World Showcase' pavilion with the planet of Xandar," explained Wyatt Winter, senior producer on the project. "And so just like we've learned about the people and cultures around the world in World Showcase, we're now going to learn about Xandar. They've come here to show us their technology and help us as humans go to that next level of exploration and learning." The pavilion would be "this hybrid of real-world human science and Marvel science—trying to connect those two worlds and ease you into a full-blown, massive super hero attraction experience."

Perhaps the greatest leap forward in technology that the Imagineers debuted with the new Marvel-themed areas was not contained within an attraction but appeared spontaneously at unannounced intervals within the Avengers Campus in Disney California Adventure. It allowed

Spider-Man to soar up to sixty feet in the air above the buildings—a feat no stuntperson could be expected to accomplish safely time and again, day after day. It was dubbed *Stuntronics* technology.

In an unusual twist, Imagineering had unveiled the *Stuntronics* technology three years before it became part of Avengers Campus. They felt they had no choice: in order to test the *Stuntronics* figures, they had to be launched sixty feet in the air above the Imagineering campus in Glendale, and the flying test subjects would be clearly visible to people outside the walls. So Disney shared clips on social media and video websites to forestall uninformed posts from random observers. Less than a minute long, the video compiled a brief history of Imagineering's "flying robot" research, from tossing baton-like devices to the one-legged "stickman" to the animated mannequin seen soaring above the rooftops of Glendale.

Given their minimal theming and blank faces, the metallic figures of 2018 were remarkably expressive, appearing both determined and serene through posture alone. The *Stuntronics* figure began each flight with his legs back and arms extended, his body straight and leaning forward, hanging on to the cable that would launch him. Then the cable yanked him into a high arc and released him, and the robot took control. He could tuck into a series of somersaults, pose in the sky like Spider-Man with his arms extended dramatically and one leg bent, or perform a few flips with his body extended. Each flight ended with the mechanical acrobat tucking into a ball and landing in a springy black circus net at least ninety feet from where it started, dropping gracefully like a trapeze artist about to take a bow. Except in this case the credit went not to the performer but to his creators, who had spent years figuring out how to combine and compact the technologies necessary to make his stunt possible.

The initial idea, explained Imagineer Tony Dohi, was to free Audio-Animatronics figures from the ground, to create a "stunt robot—something that has a lot more action in it." Half a century earlier, having an Abraham Lincoln figure that was "capable of rising up from a seat and taking one step forward at the time was mind-boggling. Well, we've been working on ways to make a robot be able to move through the air and do the somersaults and flips like a trapeze artist or a true aerial performer.

So that requires an understanding of physics and being able to merge all the math to get this really, really specific movement into the control system for a figure that actually has to be entirely autonomous. He makes his own decisions as he's going through the air as to when to untuck, for instance, to slow down his rate of spin or when to curl into a tuck to hit the net in just the right orientation."

Much of the robotics research was done by Morgan Pope, a research scientist and mechanical engineer in Imagineering's R&D division. The team's research goal was simply expressed but about as complex and anything Imagineering had worked on previously, Pope said. "We have all these [figures] that are bolted down in the parks, but can we actually pick them up and toss them?" Early experiments he called "simple linkages," resembling hinged batons, designed "to see if they can hold up to being tossed around." The next step was more daunting: "How do you control an object while it's flying through the air?" In human acrobats, Pope continued, "the main controller that you have while you're in the air is the same one that an ice dancer has when they're skating. You can move your arms out to slow down and pull your arms in to speed up a spin. You can do a lot of stuff with your orientation. You can [determine] which way you're pointing when you land."

Pope's initial work on falling robots was done not at Imagineering but at a new division of The Walt Disney Company created by Bob Iger called Disney Research. "It brings together world-class scientists and engineers to literally develop the technology that the Disney company will need in the future," Jon Snoddy explained, calling its creation Iger's "greatest technical innovation" as CEO. "It has given us improvements in the ways our movies are made, improvements in the way our Audio-Animatronics figures are made, improvements across the board in the way all of our business units work." It was work by Disney Research that allowed *The Rise of Skywalker* to feature scenes with the late Carrie Fisher, and Disney Research that helped filmmakers to mitigate the electrical interference that had been causing artifacts within digital photography, reducing the need for postproduction cleanup. And it was Disney Research that pioneered the miniaturization and other tech needed to

bring to life the Shaman in the Na'vi River Journey. "I could go on and on," Snoddy said, adding to his list interactivity, precision projection mapping, and robotics.

It was at Disney Research that Snoddy saw Pope's early work and recruited him for Imagineering's *Stuntronics* technology team. Together with other Imagineers, the group "started making stuff that was driving towards some kind of an acrobatic [figure]," Pope said. "But we started very simply with a bunch of stick-shaped robots and eventually worked our way up to a pneumatic full figure and then finally these all-electric figures."

Dohi explained that a figure "like this actually has a pretty sophisticated sensor inside that knows its rate of spin and feeds that back to a computer and then that computer controls the motors on board." Key to their success was a device called an inertial measurement unit, or IMU, which could measure and report a body's orientation, speed, and other movement data by using some combination of accelerometers, gyroscopes, and magnetometers. Using IMUs customized by Imagineering, the *Stuntronics* figures work "through a really neat system of an IMU and some very custom code and the right algorithms to actually turn all that motion into something that looks really beautiful when you see it through the air." The first humanoid-looking robot, which used pneumatics, looked a bit like he was wearing a backpack. They called him "Sky Rider." Half-scale all-electronic figures followed, then the full-size *Stuntronics* figures.

The goal was to create believably human figures that could do what a human performer could not—at least, not without getting hurt or exhausted. "It can tuck into a very, very tight tuck under a lot of g-forces," Dohi said. "One of the things that makes this particular robot unique is that we're doing things with this robot that you wouldn't dare do with a human performer."

The prototype *Stuntronics* figures were tossed into the air thousands of times—many hundreds of times for each figure. In the movies, such physically demanding stunts had been largely taken over by computer-generated characters, but in a park attraction the Imagineers wanted a

mechanical performer to become "the actual bridge to deliver on the expectations guests have when they've seen our movies and come to our parks to enjoy some [similar] experience. And now we can deliver on that," Dohi said.

But that didn't mean the *Stuntronics* figures were just special effects rendered in physical form. They still needed to be performers, with emotional as well as visceral impact. "A lot of places around the world have robotics labs," noted Snoddy. "We think of this as our 'characters lab,' because we're building Disney characters."

The first "onstage" *Stuntronics* figure performed as Spider-Man at the opening of the Disney California Adventure Avengers Campus in June 2021—an integral part of Imagineering's determination that guests on the campus should have as many spontaneous encounters as possible with super heroes during their visits. The campus was meant to seem a living place, populated by the characters whose stories it evoked, and none would be more popular than Spider-Man. On the rooftop of the WEB building, a costumed human performer began the show with dramatic acrobatics and an amplified monologue in the voice of Tom Holland—the actor who played the role in recent Marvel Studios movies. After a series of choreographed human-size feats, the cast member would run out of view, saying, "Here goes something," and from the space where the human Spider-Man had just disappeared, the *Stuntronics* performer would soar into the air—evoking wonder from the gathered guests. Then human Spider-Man would reappear and participate in meet-and-greets with the guests.

Stuntronics technology, Pope explained, was more or less the flipside of the intricate Audio-Animatronics figure developed for the Shaman in Pandora. "These closer performances are part of the story that our audience sees on the big screen, but in many of our properties, there's a lot of performance in big action beats—flying and jumping and kicking and flipping. So the whole grand vision for the *Stuntronics* family is, can we make robots that capture those kinds of performances as well? That Shaman figure, you can't take her and throw her across the room, but

she is a beautiful close-up performer." *Stuntronics* technology, then, might be the stunt doubles for sophisticated performance Audio-Animatronics figures, which can "do something crazy and amazing. They're not as good-looking as the close-up guys, but they can take a hit. Our intent is never to replace [human] stunt performers but maybe to actually open up the envelope of what can be done with practical effects."

Like the close-up guys, *Stuntronics* robots can also adapt to different roles, Dohi said. The distinction between, say, a super hero or a Jedi or a pirate lies not just in costuming but in "capturing in a robot the key movements that these styles of characters would do—their iconic movements. It happens very, very quickly, and you would have no reason to suspect it to be anything else other than that genuine character."

Imagineers were already "looking at the next generation of Stuntronics technology," Snoddy said. "The same people that dreamt this up are still dreaming. And that just goes on and on and on. We all kind of push each other to see what we can do that's even bigger, even further, even crazier. I think you'll see some pretty outrageous things in the next decade."

IV. BEYOND THE BERM

In the nearly seventy years since the founding of Imagineering, its mission had never changed and yet never stayed the same. Today's Imagineers were still elevating the guest experience with wizardry grounded in storytelling and executed with the sophisticated technology of the day, but now they were doing it at parks around the world and under conditions no one could have predicted. Just as Imagineering magic had not remained confined to Disneyland, it was now no longer confined to Disney theme parks. Imagineers had designed baseball stadiums and museums and cruise ships—their fifth and largest, the *Disney Wish*, set sail in 2022, with a sixth and seventh ship soon to follow. The Disney experience permeated dozens of resort hotels. Like the theme parks, the resort hotels were ongoing projects, updated with the latest tech—online check-in, MagicBand keyless entry—and completely renovated

when deemed necessary. Each hotel's theming was not window dressing but integral to the experience of staying there. As Imagineer Scott Trowbridge phrased it, "When you come to one of our parks, like [Magic Kingdom or EPCOT], you shouldn't have to leave the story behind at the end of the day."

That was the mission when, at the D23 Expo in Anaheim in 2017, then Parks and Resorts chairman Bob Chapek announced the "reimagination" of the Disney's Hotel New York at the Disneyland Paris Resort. The property would become Disney's Hotel New York—The Art of Marvel, the company's first super hero–themed resort, combining elements of a fine arts museum, a luxury hotel, and a park attraction. "We're going to create a hotel at Disneyland Paris that would make Tony Stark proud," Chapek said, promising that the destination would "transport our guests to the action-packed, inspiring world of super heroes including Iron Man, the Avengers, and Spider-Man."

The hotel closed for the makeover in 2018 and reopened in June 2021, along with the post-lockdown return of most of Disneyland Paris. It featured more than 350 objects on display, including works representing more than 110 artists. Fifty of the pieces were created specifically for the hotel. The hotel also had a space for temporary exhibitions, dubbed the Jack Kirby Legacy Gallery, after the late comic book artist who co-created Captain America, Iron Man, Black Panther, and many other super heroes.

The ability to update the decor, displays, and activities offered by every resort had become a foundational principle of Disney's hotel development, said Imagineer Bhavna Mistry, portfolio creative executive of Global Resort Design. It was important, she said, that no hotel should be "frozen in time"—a mandate that the design team repeated to themselves as a kind of "elevator speech." She added, "I don't know what's going to come twenty years from now, but I want to leave a roadmap to insert that."

The guests' experience of any property's theming begins upon arrival—according to Mistry, "the first moment of story is when someone sees that building"—and continues all the way into their individual

quarters. "We build what we called a journey to the room," Mistry said. "We need to make the hallway feel dynamic, almost cinematic, if we can." Inside the room, every detail continued the story or emerged from it— from the color scheme of the decor and furniture, to the patterns of the draperies and bedspreads, to the lighting scheme and fixtures, to the tilework in the bathroom.

What that meant, of course, changed from property to property, drawing upon not just Disney characters and story settings but also wider cultural influences. For a five-hundred-room expansion of the Coronado Springs Resort, Mistry related, Imagineers "went back to [Francisco Vázquez de Coronado's] homeland of Spain and discovered an amazingly rich collaboration between Walt Disney and Salvador Dalí. And that's what we used as inspiration for not only the interior design, [but also] the exterior and the flatware in the restaurant. We actually had a number of sessions with the Dalí Museum in St. Petersburg to get to really understand the influence and design beyond just paintings.

At Disney's Hotel New York—The Art of Marvel, the rooms were designed to evoke Manhattan sophistication, augmented by artistic portraits of super heroes. The hotel also offered many interactive opportunities that would be familiar to guests from Disney theme parks and cruise ships: meet-and-greet stations with characters; a Design Studio, which hosted art tutorials for children; the Hero Training Zone, a 420-square-meter outdoor play and sports area; and the Skyline Bar, with projected images of the Manhattan skyline enhanced with occasional animation of super heroes.

Just as the Imagineers had taken lessons from the theme parks and cruise ships into the Disney resort hotels, they had taken hotel and cruise ship lessons into a new, freestanding attraction in Walt Disney World—one linked to the parks but targeting fans who wanted an even more immersive experience than the parks could provide. When it was announced in 2017, *Star Wars*: Galactic Starcruiser took on the inaccurate label "the *Star Wars* hotel," when in fact it was more of an attraction that simply lasted two days and included meals and sleeping quarters. In fact, if it resembled anything Imagineering had done in the past, it was

not the hotels so much as the cruise ships, welcoming guests who would arrive at established launch times for a shared itinerary. Each family group would board a "launch pod" within what appeared to be a spaceport. Their first view of the starcruiser *Halcyon* would be through the pod's (virtual) windows as it quickly lifted them off the planet's surface and up to the orbiting ship.

Trowbridge, creative lead on the project, called it, "a simulated cruise through space—a space version of a cruise ship that you book for a certain journey. It's an opportunity to have an immersive multiday experience in the *Star Wars* galaxy. If *Star Wars*: Galaxy's Edge is a great way to immerse yourself in that world for a couple of hours, *Star Wars*: Galactic Starcruiser is its cousin that invites you to spend a couple of days immersed in the world of *Star Wars*."

The starcruiser had been given, of course, a detailed backstory. The "grand dame" of the venerable interplanetary Chandrila Starline, the *Halcyon* "is not a new ship," Trowbridge said. "It is a well-worn ship. This is a ship with history. Think of it like the *Orient Express* of this [part of the galaxy]." Unlike Disney's seafaring vessels, however, the starcruiser had just a hundred cabins. It represented a new level of attention to individual guests for the Imagineers. "This is a very personalized, very immersive experience," Trowbridge said.

From the menu in the Crown of Corelli dining room to the "climate simulator" area (allowing passengers the sense of being outdoors during their space cruise) to the "Force sensitivity" training workshops (can guests use the Force to move a rock?), everything on the starcruiser was planned to be unique and individualized for each guest. The overriding question the Imagineers faced, Imagineer Ann Morrow Johnson said, was, "How do we create an experience that's unlike things guests will have ever been able to experience before?" Guests would be encouraged to show up in space-appropriate attire—whether they went as far as cosplay or simply chose to wear futuristic finery—although those who simply wore typical resort wear would also be made to feel at home. Once aboard, they could play a role in the story unfolding around them, or they could simply remain themselves and learn how to win at sabacc,

the *Star Wars* card game, from the cast members portraying passengers from other planets. "We have this whole cast of characters that are living onboard the ship with you, playing out the story, asking for your help," Johnson noted. "The hope is that you actually are forming some relationships with these characters and seeing them multiple times over multiple days, that you feel like you're truly helping them with whatever cause you've chosen to align yourself with. We're trying to make sure that the whole of your cruise experience is a complete ecosystem from beginning to end so that you're all living out the same story together."

The *Halcyon* was new to the *Star Wars* canon, but as the attraction was being built, the ship started to appear in other *Star Wars* content, just as the planet Batuu—the home world of *Star Wars*: Galaxy's Edge—had been seeded into other story lines, through streaming series and publishing and games. These were important steps for Imagineering: a shift from shaping intellectual properties into experiences limited to the theme parks, to working with other artists within Disney to weave fresh stories and characters that flowed from attractions back out into the totality of an ever-evolving fantasy world.

Of course, storytelling content original to Imagineering had been growing beyond the parks for decades, as the Pirates of the Caribbean franchise or the 2021 *Jungle Cruise* movie attested. But this was a two-way creative process. It began with a beloved and complex fictional world from outside the parks, then expanded and amplified that mythology through attractions. The park-based narratives would then plug into additional stories both inside and outside the parks. Just as a television series could advance and expand the narrative of Marvel or Pixar movies, *Star Wars*: Galaxy's Edge and the *Halcyon* were mining new characters and story lines that other narratives would then pick up and develop. Those stories could then return to *Star Wars*: Galactic Starcruiser, because the Imagineers could update the attraction as often as they felt necessary, both to keep the experience fresh for returning guests and to advance the story lines through time.

The narrative connection between the *Halcyon* and Batuu's Black Spire Outpost—aka *Star Wars*: Galaxy's Edge—plays out within the *Star Wars*:

Galactic Starcruiser experience. "The *Halcyon* is a cruise ship," observed Johnson. "So just like any good cruise, we've got a shore excursion—in our case to the planet of Batuu." Guests can watch through the starcruiser's virtual windows as the ship approaches the planet, then board shuttles to take them to the surface. They can exit the shuttles directly into *Star Wars*: Galaxy's Edge, the "port excursion" for their cruise. (The virtual windows on the *Halcyon* complicated the attraction's Earth-based certification for overnight accommodations, since it was the first "hotel" in Central Florida without actual windows in the guest rooms. Each room had instead a virtual porthole, with a view into outer space.)

Other than the excursion to the Black Spire Outpost, the guests' experience was to take place aboard the *Halcyon*. In addition to meals in the ship's restaurant, there would be a variety of themed activities that guests could choose from—or forgo—and a cast of interstellar characters they would become familiar with during the cruise, both fellow passengers and members of the ship's crew. "Think of this like a two-day piece of immersive theater, where you get to play a role and decide how to interact with the characters throughout it," Johnson said. "So day one is act one. You're getting to know these characters on board the ship. They're all asking for your help. Because it's *Star Wars*, things are going to go horribly wrong. *Spoiler!* You're on the one fateful cruise that happens to be [not unlike the] *Titanic*. You can choose to join the Resistance or the First Order, or become a smuggler and go on heists, explore the Force—whatever it is that you choose to do. The characters [on day one] will then ask you to go on specific missions when you're on the shore excursion on day two. Whatever you do then has massive ramifications once you're back on board the ship. On the evening of day two we may or may not wind up in a gigantic space battle, because the fate of the galaxy lies with us. Depending on how you play, you become a part of different scenes, and your actions make you feel like we're reaching that epic conclusion as a result of your actions."

"Everything here is an invitation, never an obligation," Trowbridge added. "It's an invitation to go deeper into the story, and we're paying attention to choices you make. You can also change your mind about

anything, because none of it locks you into a track. You can participate in different substories, if you will, before they all come together for this finale." Then, after the battle (if there is one), there would be a big party, worthy of any Disney cruise ship.

Combining the grand visual effects of the Imagineers' latest ride-through attractions with elements from all the other realms in which Imagineering had perfected the guest experience—hotels, restaurants, cruise ships—*Star Wars*: Galactic Starcruiser was in many ways the culmination of seventy years of Imagineering artistry. The project involved architects and game designers, animators and engineers, chefs and makeup artists, hotel managers and theater directors—along with Imagineering's core team of attraction designers and producers.

"It's part immersive theater, part interactive game, part choose-your-path adventure, part excellent guest service," Trowbridge observed. "The people we've brought together to be the day-to-day drivers of this all come from different backgrounds intentionally, to help bring all those different aspects together. Because this works the best when all of those pieces are working together."

As has been the intent from the beginning of Imagineering, "as a guest, you just feel like it's all just magically happening." All of Imagineering, Trowbridge said, was "on this path towards continuing to try to invite our guests to become more participants than spectators in these stories. This is a pretty big step [in that direction]. We're definitely launching something that doesn't have precedent." *Star Wars*: Galactic Starcruiser would be—like every project before it, back to Walt Disney's day—"an invitation to join the adventure."

EPILOGUE
ONLY THE BEGINNING

"Disneyland will never be finished. It's something we can keep developing and adding to. . . . I've always wanted to work on something alive, something that keeps growing. We've got that in Disneyland." —Walt Disney

THE EIGHTEEN-MONTH PARTY recognizing the fiftieth anniversary of the Walt Disney World Resort was dubbed "The World's Most Magical Celebration," and The Walt Disney Company CEO Bob Chapek made sure to acknowledge the role of Walt Disney Imagineering in that milestone. "Walt's biggest dream was to create a fully immersive place unlike anywhere else, where characters and stories could come alive to entertain and delight guests of all ages," Chapek said at a cast member ceremony in the Central Plaza area of Main Street, U.S.A., in the Magic Kingdom. It was September 30, 2021, the night before the celebration kicked off. He went on to thank "all of our extraordinary cast members and Imagineers past and present for their incredible contributions over the last fifty years," calling them "the heart and soul of The Walt Disney Company."

Just as Walt Disney had wished for Disneyland to grow, Walt Disney Imagineering remains a living thing. Every project the Imagineers work on is always in the process of becoming, a growth that continues long after the first guests arrive. Even the very concept of what constitutes an "attraction" can be redefined, as *Star Wars:* Galactic Starcruiser has

demonstrated by merging theme park elements with immersive theater, story-expanding activities, and fantasy accommodations.

Walt Disney Imagineering has also continued to evolve behind the scenes. In late 2021, Barbara Bouza was named president of Walt Disney Imagineering, the first woman to step into that role. Bob Weis, president since 2016, became Global Imagineering Ambassador, following in the footsteps of another former president, Disney Legend Marty Sklar. Also (earlier) in 2021, The Walt Disney Company announced that Walt Disney Imagineering's Glendale facility and staff would be relocated to a new campus to be built in the Lake Nona district of southeastern Orlando, Florida. Other California-based staff in the Disney Parks, Experiences and Products division of the company would also be heading east. The choice will no doubt be a tough one for many Imagineers, whose sentimental attachment to the historic Glendale campus, and all that has been created there, will change forever.

But one thing has not changed since Walt Disney first formed WED Enterprises: to create happiness, Imagineers continue to combine their knowledge, skills, and creativity with their curiosity, their sense of wonder, and their willingness to take risks. They also breathe an essential part of themselves into their creations. "One thing I learned when we were building the Aulani project in Hawaii is this Hawaiian notion of *mana*," Bruce Vaugh, former chief creative executive of Walt Disney Imagineering, told me, referring to "this notion that the spirit and mood of the creator is actually invested in the product that is created. Since we're making a product to make people happy—because we believe that happy people make the world a better place—then those creating [that product] had better be happy too. And that is something that only comes if you're doing what you're passionate about. The unique thing about Imagineering is that there is no sandbox anywhere else in the world that you can play in that has the same collection of people with the same objectives of creating these immersive experiences. There's no other place you can go that would allow you to apply your passionate skills in the same way."

As Walt put it in 1965, "We're not out to make a fast dollar with gimmicks. We're interested in doing things that are fun—in bringing

pleasure and especially laughter to people." That seemingly simple quest has created a new art form and a new kind of artist, one whose canvas is the world itself and whose tools are whatever it takes to turn that world into a fantastic, enveloping story. In 2023, The Walt Disney Company celebrates its hundredth anniversary, a testament to the strength of one man's creative DNA and an unrelenting vision for a better tomorrow. "There's really no secret about our approach," Walt said. "We keep moving forward, opening up new doors, doing new things, because we're curious. And curiosity keeps leading us down new paths. We're always exploring and experimenting. We call it Imagineering."

ACKNOWLEDGMENTS

T HERE ARE SO many people who contributed to this overall biography of Walt Disney Imagineering. I want to thank every Imagineer who spent their valuable time with me, sharing their stories, history, and recollections. This book was built on our widespread original interviews, as well as the many historical interviews, records, books, and public documents. Every single person and their contributions are critically important to the whole story, I just wish we could fit it *all* in.

It is the wonderful team at Walt Disney Publishing who commissioned this biography after the release of *The Imagineering Story* on Disney+ to whom I owe a great debt of gratitude. I want to thank Wendy Lefkon, editor extraordinaire, for a fun and collaborative journey bringing this story to life. Much appreciation also goes to Jennifer Eastwood who contributed her talents and oversight to this book. Thank you to author Jim Fanning who helped edit down the many more pages we had written into a manageable, (yet still very thick) book. What a pleasure to have worked with all of you!

And to my friends at Walt Disney Imagineering; your invaluable time, insights, and endless support keeping all this information in check has been a true gift. I love working with you all, and look forward to more collaborations!

I'd like to acknowledge my family: my grandfather, Ub Iwerks, and my father, Don Iwerks, whose genius, creativity and discipline has inspired my entire career. This project has come full circle for me, and it has been an honor to tell and document your own amazing contributions to the Disney story, from Mickey Mouse to Circle Vision and so much more, thank you for all the magic you have created in this world! And

my younger cousin Mike Iwerks, the talented Imagineer who follows in their footsteps by creating his own audiovisual magic every day, and has been a huge support. My wonderful mother, Betty, whose endless curiosity about virtually everyone and everything has taught me to leave no stone unturned with each interview I do. My partner in everything, Ti Martin, who has been my rock. My beloved sister, Tamara, whose wry humor, eccentricity, and journalistic integrity will always push me to tell better stories. And my artistic brothers, John and Larry, whose teenage antics of hanging around Disneyland after closing and getting caught in the wee hours of the morning, is no longer a family secret.

And lastly, to Mark Catalena and Bruce Steele, what can I say—I couldn't imagine having better collaborators in the telling of this story. It has been no small feat sifting through hundreds of hours of original interviews, thousands of hours of archival footage, countless pages of historical documents, and shaping it all into a personal narrative told from the inside out. I thank you for your tireless efforts, amazing talent, and wonderful teamwork. This could not have been done without you.

SOURCES

OST OF THE MATERIAL IN THIS BOOK, including the vast majority of direct quotations, was collected by author and filmmaker Leslie Iwerks during the six years she spent researching and filming the six-part *The Imagineering Story* documentary series for Disney+. The chief researcher for this project was Mark Catalena, who was also the editor and writer for the documentary series. The research amassed for *The Imagineering Story* and for this book included archival interviews, internal and public documents, company publications, and other materials from a wide range of historical and contemporary sources, much of it compiled with the invaluable assistance of the Walt Disney Archives and Walt Disney Imagineering. The Walt Disney Family Museum also provided a wealth of historical information.

Special thanks also goes to Disney historian Jeff Kurtti, for his important 2008 book, *Walt Disney's Imagineering Legends and the Genesis of the Disney Theme Park*, which filled in some background details for many of the original Imagineers. Some aspects of Imagineer Marc Davis's career were gleaned from Pete Docter and Christopher Merritt's comprehensive 2019 work, *Marc Davis in His Own Words: Imagineering the Disney Theme Parks*. Among the dozens of other books about The Walt Disney Company and the Disney Parks we consulted, some of the most valuable were *Maps of the Disney Theme Parks: Charting 60 Years from California to Shanghai* (2016), by Kevin and Susan Neary, with maps curated by Imagineer Vanessa Hunt; Michael Eisner's memoir, *Work in Progress* (1999), written with Tony Schwartz; and two works by The Imagineers themselves, *Walt Disney Imagineering: A Behind the Dreams Look at Making the Magic Real* (1996) and its sequel, *Walt Disney Imagineering: A Behind the Dreams Look at Making MORE Magic Real* (2010).

Readers will have noted that the authors pored over many newspaper archives in researching this book, with particular attention to contemporary coverage by the *Los Angeles Times,* the *New York Times,* the *Orlando Sentinel,* the *Orange County Register*, and the Associated Press. Other historical accounts were provided by the many well-researched articles by Disney historian Jim Korkis, many of which were published on the Mouse Planet and All Ears websites. Perhaps the most valuable online resources were the Disney Parks Blog and D23.com; the latter includes many detailed retrospective articles as well as the authoritative *Disney A to Z*, the official Disney encyclopedia first compiled by the late founder of The Walt Disney Archives, Dave Smith.

ABOUT THE TEAM

LESLIE IWERKS has produced, directed, and edited award-winning feature and short documentaries, television specials, tributes, corporate films, and digital content for more than two decades. Her body of work encompasses enterprise features (*The Pixar Story*, *Citizen Hearst*, *ILM: Creating the Impossible*, *The Hand Behind the Mouse*) and her acclaimed environmental and social issue films (*Recycled Life*, *Pipe Dreams*, and *Downstream*).

Leslie's desire to innovate and push boundaries in documentaries, film, animation, and new technologies has been cultivated and inspired by her family upbringing. Her grandfather, Disney Legend Ub Iwerks, was the original designer and co-creator of Mickey Mouse and a multi-award-winning visual effects pioneer. Her father, Don Iwerks—also a Disney Legend—founded the large format film company Iwerks Entertainment, building systems in more than two hundred theaters around the world. As a young girl, Leslie would tag along with her dad to the Disney studio Machine Shop and escape into the imaginative backlot movie sets, a period of time that solidified her passion for the behind-the-scenes aspects of moviemaking. She is an adventure and travel enthusiast and has filmed on all seven continents around the world.

BRUCE C. STEELE is the author of *One Day at Disney* and the editor in chief of *Disney twenty-three* magazine and supervisor of the digital *Disney Newsreel* and D23.com. He is a journalist and Disney fan with a long career of profiling both the famous and the unheralded, from the pastry chefs at the Biltmore Estate to the stars of Disney's *Mary Poppins Returns*. A Pennsylvania native and University of Alabama graduate, he started his career at a daily newspaper in Louisiana and before joining Disney worked at the paper in Asheville, North Carolina. In between he was the executive

editor of *Out* magazine and the editor in chief of *The Advocate* newsmagazine and also took time to get an MFA in film studies from Columbia University. He has lived in New York City and Los Angeles, where his husband was a Disney animator. Apart from those for this book, some of his favorite past interviews have been with Emma Watson, Sir Ian McKellen, Episcopal Bishop Gene Robinson, and crawfish farmers in the Louisiana bayou.

MARK CATALENA is a Peabody Award winner and a multiple Emmy nominated producer, director, and editor. For over two decades, he has produced nonfiction programming and documentary films for networks such as PBS, A&E, TCM, and Disney+. Mark cut his teeth on over twenty-five episodes for the A&E series *Biography*. The exclusive on the life and career of Georgia O'Keeffe marked his directorial debut. He later co-directed *Goldwyn* for PBS and the Emmy Award-winning *Stardust: The Bette Davis Story* for TCM. In 2009, he received a Peabody for the documentary *Inventing LA: The Chandlers and Their Times*. In 2012, *Johnny Carson: King of Late Night*, became the highest-rated documentary in the twenty-eight-year history of the PBS series *American Masters*, and he received a Primetime Emmy Nomination for Outstanding Picture Editing. In 2016, Mark joined Leslie's independent production company, Iwerks & Co., where he served as the writer and editor of the six-part docuseries *The Imagineering Story* for Disney+. The experience transformed Mark, from a onetime casual fan into a die-hard devotee, who will always have a soft spot for the bone-rattling Matterhorn and a hankering for Dole Whip.

Discover more Imagineering stories

Women of *Walt Disney* Imagineering

12 Women Reflect on Their Trailblazing Theme Park Careers

Contributing Authors

Karen Connolly Armitage	Tori Atencio McCullough
Becky Bishop	Katie Olson
Paula Dinkel	Pam Rank
Maggie Irvine Elliott	Lynne Macer Rhodes
Elisabete (Eli) Erlandson	Kathy Rogers
Peggie Fariss	Julie Svendsen

Foreword by Ginger Zee